Routledge Handbook of Social and Cultural Theory

If today students of social theory read Jürgen Habermas, Michel Foucault and Anthony Giddens, then proper regard to the question of culture means that they should also read Raymond Williams, Stuart Hall and Slavoj Žižek. The *Routledge Handbook of Social and Cultural Theory* offers a concise, comprehensive overview of the convergences and divergences of social and cultural theory, and in so doing offers a novel agenda for social and cultural research in the twenty-first century.

This *Handbook*, edited by Anthony Elliott, develops a powerful argument for bringing together social and cultural theory more systematically than ever before. Key social and cultural theories, ranging from classical approaches to postmodern, psychoanalytic and post-feminist approaches, are drawn together and critically appraised. There are substantive chapters looking at – among others – structuralism and post-structuralism, critical theory, network analysis, feminist cultural thought, cultural theory and cultural sociology. Throughout the *Handbook* there is a strong emphasis on interdisciplinarity, with chapters drawing from research in sociology, cultural studies, psychology, politics, anthropology, women's studies, literature and history.

Written in a clear and direct style, this *Handbook* will appeal to a wide undergraduate and postgraduate audience across the social sciences and humanities.

Anthony Elliott is Director of the Hawke Research Institute, where he is Research Professor of Sociology at the University of South Australia. His recent books include *Reinvention* (Routledge, 2013) and *The Routledge Companion to Contemporary Japanese Social Theory* (Routledge, 2012, ed. with Atsushi Sawai and Masataka Katagiri).

For those who are looking for a comprehensive guide to modern social and cultural theory, this is the place to start. Informed, comprehensive, invaluable; the book really is a milestone.
—*Professor Nigel Thrift, Vice-Chancellor, University of Warwick, UK*

In a world in which different societies and cultures crisscross constantly, making an impact on each other, what we need is a navigator to instruct where we are and where should we go. This book will be a great guide, providing students and scholars with remarkably helpful and wide-ranging tools to gain an in-depth understanding of the social and cultural realities which we daily encounter in our contemporary globalized world.
—*Atsushi Sawai, Professor of Sociology, Keio University, Japan*

Routledge Handbook of Social and Cultural Theory

Edited by Anthony Elliott

Routledge
Taylor & Francis Group

LONDON AND NEW YORK

First published 2014
by Routledge
2 Park Square, Milton Park, Abingdon, Oxon OX14 4RN

and by Routledge
711 Third Avenue, New York, NY 10017

Routledge is an imprint of the Taylor & Francis Group, an informa business

British Library Cataloguing in Publication Data
A catalogue record for this book is available from the British Library

Library of Congress Cataloging in Publication Data
Routledge handbook of social and cultural theory / edited by Anthony Elliott.
 pages cm
 Includes bibliographical references and index.
 1. Sociology. 2. Culture. 3. Social sciences–Philosophy. I. Elliott, Anthony, 1964–
 HM585.R684 2013
 301–dc23

 2013015581

ISBN: 978-0-415-69609-8 (hbk)
ISBN: 978-0-203-51939-4 (ebk)

Typeset in Bembo
by RefineCatch Limited, Bungay, Suffolk

Printed and bound by CPI Group (UK) Ltd, Croydon, CR0 4YY

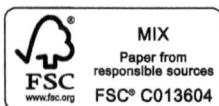

Contents

Contributors

Thomas Birtchnell is a lecturer at the University of Wollongong. His publications include the edited books *Elite Mobilities* (Routledge, 2013, with Javier Caletrío) and *Cargomobilities: Moving Materials in a Global Age* (Routledge, 2014, with Satya Savitzky and John Urry) and the book *Indovation: Innovation and a Global Knowledge Economy in India* (Palgrave Macmillan, 2013).

Ann Branaman is Associate Professor of Sociology at Florida Atlantic University. She is the author of several essays on Erving Goffman, Kenneth Burke, feminist and post-feminist social theories, and connections between contemporary social theories and topics in social psychology.

Patrick Brown is an assistant professor in the Department of Sociology and Anthropology at the University of Amsterdam. His recent books include *Trusting on the Edge: Managing Uncertainty and Vulnerability in the Midst of Severe Mental Health Problems* (Policy Press, 2012, with Michael Calnan) and *Making Health Policy: A Critical Introduction* (Polity, 2012, with Andy Alaszewski).

John Cash is an Honorary Fellow in the School of Social and Political Sciences at the University of Melbourne, where, formerly, he was Deputy Director of the Ashworth Program in Social Theory. His recent publications include 'InSecurity and the Instituted Imaginary' in *Dangerous Others, Insecure Societies* (Ashgate, 2013) and 'Obedience to Authority and its Discontents' in *Responsibility* (Melbourne University Press, 2012). He is also an editor of the *Journal of Postcolonial Studies*.

David Crouch works at the University of Melbourne in the School of Social and Political Sciences and the School of Culture and Communication. His research interests include nineteenth-century print cultures, literary anthropologies and social theory. He has recently published 'Alien Intoxications: The Aggressions of a Brisbane Opium Smoker' in *Australian Literary Studies* (2012).

Anthony Elliott is Director of the Hawke Research Institute, where he is Research Professor of Sociology at the University of South Australia. His recent books include *Reinvention* (Routledge, 2013) and *The Routledge Companion to Contemporary Japanese Social Theory: From Individualization to Globalization in Japan Today* (Routledge, 2012, edited with Atsushi Sawai and Masataka Katagiri).

Sam Han is Assistant Professor of Sociology at Nanyang Technological University (NTU) in Singapore. His recent books include *Web 2.0* (Routledge, 2011) and *The Race of Time: A Charles Lemert Reader* (Paradigm, 2011, with Daniel Chaffee). He can be found at sam-han.org.

Rita Horanyi is a PhD candidate at the University of South Australia researching melancholy in literature under socialism. She is currently also editing a collection of papers on the paradoxical nature of melancholy.

Eric L. Hsu is Postdoctoral Research Fellow at the Hawke Research Institute at the University of South Australia. His publications include *Globalization: A Reader* (Routledge, 2010, edited with Charles Lemert, Anthony Elliott and Daniel Chaffee). His current research is concerned with the emerging sociology of sleep, globalization theory and the social scientific study of time.

Max Kirsch is Professor of Anthropology and UNESCO Chair in Human and Cultural Rights, Florida Atlantic University. His monographs include *Queer Theory and Social Change* (Routledge, 2000), and he is the editor of *Inclusion and Exclusion in the Global Arena* (Routledge, 2006). He is presently working on an ethnography of Big Sugar, legislation and environmentalism in the Florida Everglades.

Charles Lemert is Senior Fellow at the Center for Comparative Research, Yale University; and University Professor Emeritus, Wesleyan. His recent books include *Social Theory: Classical, Global, and Multicultural Readings* (2013, Perseus/Westview, 5th edn) and *Contemporary Social Theory* (Routledge, 2013, edited with Anthony Elliott).

Jordan McKenzie teaches sociology at Flinders University and specialises in the field of social and critical theory. His PhD thesis was titled 'Contentment and Modernity: A Comparative Critique of Zygmunt Bauman and Jürgen Habermas', and his current research interests involve theoretical approaches to the study of emotions with a particular focus on happiness, contentment and sadness.

Anthony Moran is a Senior Lecturer in Sociology at La Trobe University, Australia. He is the author of *Australia: Nation, Belonging and Globalization* (Routledge, 2005) and the co-author (with Judith Brett) of *Ordinary People's Politics: Australians Talk about Life, Politics and the Future of Their Country* (Pluto Press Australia, 2006), and is currently completing a book on multiculturalism in Australia.

Jennifer Rutherford is the Deputy Director of the Hawke Research Institute at the University of South Australia. Her recent books are *Zombies* (Routledge, forthcoming 2013) and *Halfway House: The Poetics of Australian Spaces* (UWA Press, 2010, with Barbara Holloway).

Nick Stevenson is a Reader in Cultural Sociology at the University of Nottingham. His most recent publications include *Freedom* (Routledge, 2012) and *Education and Cultural Citizenship* (Sage, 2011).

Simon Susen is a Senior Lecturer in Sociology at City University London. He is the author of *The Foundations of the Social: Between Critical Theory and Reflexive Sociology* (Oxford: Bardwell Press, 2007). Together with Bryan S. Turner, he edited *The Legacy of Pierre Bourdieu: Critical Essays* (London: Anthem Press, 2011).

Keith Tester is Professor of Sociology at the University of Hull and Visiting Professor at the Bauman Institute at the University of Leeds. His recent publications include *What's the Use of Sociology?* with Zygmunt Bauman and Michael Hviid Jacobsen (Polity, 2013) and *Panic* (Routledge, 2013).

Acknowledgements

There are a number of people I should like to thank who have contributed, either directly or indirectly, to this book. Principal thanks to Gerhard Boomgaarden for suggesting the project in the first place, and for his continued support and engagement throughout. Also at Routledge, Emily Briggs has been exceptionally helpful with all aspects of editorial and production. The Hawke Research Institute at the University of South Australia has been the ideal environment in which to undertake this project, and thanks to its Centre Directors and membership for various helpful insights and suggestions throughout the planning of this book. Special thanks at the Hawke to Jennifer Rutherford, David Radford, Eric Hsu, Nicola Pitt, Daniel Chaffee, Lynette Copus and Maureen Cotton; also at UniSA, many thanks to Pal Ahluwalia. David Radford played a major role in managing the project as a whole, and his editorial assistance was marvellously helpful. I am very much indebted to him for his labours and dedication to the project. Finally and most significantly, my thanks as ever to Nicola Geraghty.

Anthony Elliott, Adelaide

Part I
Contemporary social theory

1

The trajectories of social and cultural theory

Anthony Elliott

The question of the relation between society and culture is paramount in the writings of most social and cultural theorists. The complex, contradictory balance of this relationship, however, has been interpreted, analysed and critiqued for the most part by privileging either society over culture, or culture over society. To work on the question of the relation between society and culture – its interconnections, referrals, disconnections and displacements – has thus involved studying, highlighting and accentuating one term at the expense of the other. What matters in much social theory are the philosophical dimensions and conceptual consequences of defining the 'social' – ranging variously across 'social practices' and 'social forces' to 'social structures' and 'social systems'. Among students of society, an interest in culture appears all too quickly sidelined to the margins of analysis. Conversely, an understanding of society in much cultural analysis is often downgraded in favour of a fascination with, say, ideology, hegemony or discursive formations. So there is usually something missing, something lacking, from these analytical approaches in social and cultural theory. It is as if there is a troubling remainder when a cultural analyst speaks of ideological indeterminacy, and something equally absent when social theorists dismantle everyday life in terms of categories such as globalization and cosmopolitanism.

Much contemporary social theory has arguably shifted the focus of analysis from society to culture to society again – often enough, it is true, under the fashionable banner of 'the social'. 'Society' is a term that is fundamental to public political discourse, yet it is not one with any definitional consensus in the social sciences (see Elliott and Turner 2012). In general terms, society has often been used to denote value consensus, and as such has served as a kind of sorting device for grasping connections and differentials of social norms between different social groups. It has elsewhere been used to signify generalized social association. Certainly, because society has been cast as largely a universal affair in much traditional social analysis (from structural-functionalism to modernization theory), it was not until a significant period of social upheaval and cultural discord in the late 1960s and early 1970s that the western notion of the social as ordered and structured fell on hard times. This dismantling of the concept of society was, in turn, intensified by various theoretical currents – including feminism, multiculturalism and postcolonialism – as well as massive social transformations such as the advent of globalization and new information technologies. Perhaps not unsurprisingly, the discourse of society received a radical deconstruction and reconstruction from within the disciplinary confines of sociology itself. For instance, structuration theory, as advanced by Anthony Giddens in the UK and Pierre Bourdieu in France, unearthed how the structured

features of social action are, by the performance of action itself, constitutive of structured social contexts. Others argued that the idea of structured society is simply dismissive of the infinite social differences that shape global realities.

If social theory throughout the 1980s was turning in on itself, largely preoccupied as it was with issues of interpretation, justification and critique, the same cannot be said of cultural theory. There was a general celebratory sense during the final decades of the twentieth century that cultural theory had reached beyond its distinctively British beginnings, anchored as it had been in the path-breaking works of Matthew Arnold, F. R. Leavis, Richard Hoggart, E. P. Thompson and Raymond Williams, and was now in the business of going global. The whole sensibility of cultural theory during this time was one of transformation and possibility, as both the theoretics and analytics of culture spread throughout the curricula of colleges and universities from San Francisco to Sydney. The topic of culture moved centre-stage across various disciplines and fields in the social sciences and humanities. Culture was increasingly the place to try out competing theories of the world and try on various approaches to grasping everyday life, as the process of interpretative 'reading' was applied to cultural texts, events and objects – all the way from the reading of women's magazines to the study of subcultures. Not that this meant that the term 'culture' was any easier to understand than the term 'society'. Indeed, the doyen of cultural theory Raymond Williams developed the argument that culture was one of the most complex words in the English language.

By the 1990s the underscoring of a general transformation of culture in cultural theory was not only about a transformed relationship to the social sciences and humanities, however. The enhancement of disciplinary knowledge and enrichment of interdisciplinary fields of research was certainly still significant, but many practitioners of cultural theory were seeking an engagement with the wider world reaching well beyond the academic goal of disinterested inquiry. The new cultural theories had ambitions that lay deep in politics and the public sphere. This involved, in effect, a translation of cultural theory, one which connected texts to social transformations, interpretative readings to political interests, and libidinal desire to democratic deliberation. Such is the pitch of the major writings of cultural theorists as diverse as Stuart Hall, Fredric Jameson, Michel de Certeau, Terry Eagleton, John Fiske, Dick Hebdige, Laura Mulvey and Lawrence Grossberg.

One aim of *The Routledge Handbook of Social and Cultural Theory* is to introduce readers to contemporary debates around society and culture. Another aim is to ponder and discriminate the different meanings of these terms. Why 'society' has been elevated over 'culture' in social theory, and why 'culture' often comes at the cost of a rudimentary grasp of 'society' in cultural theory, are fundamental questions explored throughout the volume.

The horizons of social theory: self, society and solidarity

If it is true that classical social theory had in a sense been founded upon the emergence of industrial society, and been associated with questions of the transition from feudalism to early market capitalism, then contemporary social theory has been largely concerned with transitions to post-industrialism, multinational capitalism and advanced modernity. Contemporary social theory, for the most part, has seen itself inaugurate a shift in analytical attention in the social sciences and humanities from institutions to ideology, from class to colonialism, and from economics to ego identity. What perhaps has been most striking is the sheer diversity, indeed the exceptional range, of social theory and its astonishingly abundant traditions of thought. From the 1920s and 1930s onwards, social theory was preoccupied with, among other things, political unrest, power and psychodynamics. By the 1950s and 1960s, however,

social theory was also coming to denote semiotics, signifiers and sexuality. The foundational social-theoretical ideas of Emile Durkheim, Max Weber, Karl Marx and Sigmund Freud were still of immense significance, but they now needed to be supplemented, or 'reread', in the light of new intellectual and political interventions from Germany and France. The terrain of cultural theory was to undergo another of its periodic transformations some decades later, for example during the late 1980s and early 1990s, when postmodernism and debates about postmodernity became all the rage. Today, by contrast, the intellectual and political landscape has changed again, with a whole range of new vital issues ranging from globalization to governance. Even so, what remains evident is that few areas of academic enquiry remain as interdisciplinary, diverse and politically engaged as cultural theory.

But this is rushing ahead. We need to return to social theory, and consider the transition from traditional to contemporary social thought. The early architects of contemporary social theory, working as it happened in Germany, set out by seeing their work as not confined to the province of any one intellectual discipline. Social theory, according to the early critical theorists, needed to include the insights of sociology, philosophy, political science, economics, psychology, in fact the whole stock of formal intellectual disciplines. The term 'critical theory' refers to a series of core ideas worked out by the Institute for Social Research in Frankfurt (the 'Frankfurt School') in the 1920s and 1930s. Pre-eminent among the first generation of Frankfurt critical theorists were Max Horkheimer (philosopher, sociologist and leader of the institute), Theodor Adorno (sociologist, philosopher and musicologist) and Herbert Marcuse (philosopher and political theorist). While there were many other significant scholars associated with the Frankfurt School, including the literary critic Walter Benjamin and psychoanalyst Erich Fromm, it is in the writings of Horkheimer, Adorno and Marcuse that the cultural-theoretical project of linking philosophy and the human sciences, of interweaving theoretical critique with empirical research, most strongly emerges.[1] Among the core issues central to the first generation of critical theorists were the following. What are the core cultural and political dimensions influencing the trajectory of twentieth-century history? What psychological and political factors underpinned the rise of fascism and Nazism? Why are tendencies towards bureaucracy, rationalization and authoritarianism increasingly prevalent throughout developed societies? And how might theoretical critique keep alive hope for alternative political possibilities, or social utopias? All of these issues remain important in contemporary critical theory, especially in the work of its key exponent, Jürgen Habermas. Others who have contributed to the contemporary recasting of critical theory include Axel Honneth, Albrecht Wellmer and Claus Offe. The tradition of critical theory is examined in this handbook by Jordan McKenzie in Chapter 2; these ideas from Germany, so influential throughout social theory and its various applications, are further analysed by many other contributors to the handbook. There is, for example, an especially insightful consideration of Habermas's account of ideology provided by John Cash in Chapter 7. In order to adequately grasp the core continuities and differences between the first and second generation of critical theorists, however, I want now to examine briefly the critique of power structures developed in this Frankfurt tradition of social thought.

Dialectic of Enlightenment, a book written by Horkheimer and Adorno in the 1940s and a foundational text of the critical theory canon, retraces the social-historical character of reason, from its first appearance in Genesis via the Enlightenment through to its institutionalization in the capitalist world economy. With the mass destruction and human tragedy of the Second World War firmly in mind, Horkheimer and Adorno sought to develop a critical perspective on the application of reason to social life and politics. To do this, they coupled Max Weber's analysis of bureaucracy with Marx's critique of political economy. At the level

both of theory and of politics, Horkheimer and Adorno contend that the Enlightenment, in the form of means-end or instrumental rationality, turns from a project of freedom into a new source of enslavement.

For Horkheimer and Adorno, the overall trend of development in western society is that of an expanding rationalization, an instrumental ordering of life in which there is a loss of moral meaning at the levels of society, culture and personality. In the analyses of the first generation of critical theorists, this loss of meaning is captured by the term 'totally administered society', a term that Adorno gave further analytical clarity to when he spoke of a sociopsychological process of fragmentation, or 'logics of disintegration'. Linking Freudian psychoanalysis with Marxism, Horkheimer and Adorno propose a self-cancelling dynamic in which all identities and rationalities are constituted through a violent coercion of inner and outer nature. The broad argument is that, in the early phases of modernization, individuals repressed unconscious desires through the imposition of certain Oedipal prohibitions, resulting in a level of self-control that underpinned and reproduced asymmetrical relations of capitalist power. But this is not so in the administered world of post-liberal industrial societies. In post-liberal societies, changes in interpersonal structures mean that the family is no longer the principal agency of social repression. Instead, human subjects are increasingly brought under the sway of impersonal cultural symbols and technological forms, as registered in the rise of the culture industries (popular music, television and the like). The shift from liberal to post-liberal societies involves a wholesale destruction of the psychological dimension of experience: there is, according to Adorno, a socialization of the unconscious in the administered world that comes at the expense of the mediating agency of the ego itself. The Janus-face of this process reveals itself as the repression of inner nature as the price of dominating external nature. 'Man's domination over himself, which grounds his selfhood', write Horkheimer and Adorno,

> is almost always the destruction of the subject in whose service it is undertaken; for the substance which is dominated, suppressed and dissolved through self-preservation is none other than that very life as a function of which the achievements of self-preservation are defined; it is, in fact, what is to be preserved.
>
> *(1970: 54)*

The idea of the self-destructive character of reason – that is, of a rationality that turns back on itself and creates a new realm of universal domination – is central to the tradition of Frankfurt critical theory, and also receives support, in various guises, from post-structuralist and postmodernist currents of social thought. It is also a core preoccupation of Habermas. Like Horkheimer and Adorno, Habermas is concerned to explore the interrelations between the conditions of social rationalization and the ways in which administrative structures and economic markets come to dominate the lives of human subjects. However, unlike the first generation of critical theorists, Habermas seeks to move beyond the conceptual limitations of a subject-centred conception of rationality by deploying the notion of 'communicative action'.[2] According to Habermas, the first generation of critical theorists developed a fatalistic vision of reason as self-mutilating since it was assumed that instrumental rationality is writ large in all spheres of social action. By contrast, a conception of communicative rationality – which emphasizes the interactions *between* human subjects – prepares the way for a more differentiated social-theoretical analysis of human action and social systems, or so Habermas proposes.

In his major statement from the 1980s, *The Theory of Communicative Action* (1984), Habermas returned to the functionalist systems theory of Talcott Parsons and Niklas Luhmann. He

considered the ways in which functionalism permits an analysis of social rationalization, and considers the limitations of such a purely objectivistic approach to social systems. The theory of communicative action, as elaborated by Habermas, draws from systems theory in order to analyse the financial and bureaucratic imperatives impinging upon the economy and state, and how these systems become increasingly self-reproducing through the impact of the objective steering media of money and power. According to Habermas, the analysis of systemic mechanisms that underpin the institutional complexes of modern culture is not the only methodological basis for social theory. For the reproduction of social life also involves personal identity, social integration and cultural tradition, and it is for this reason that Habermas introduces the notion of lifeworld. For Habermas the lifeworld refers to both the public and the private spheres, to those domains in which meaning and value reside, of deeply layered communicative interactions between subjects, such as the family, education, art and religion.

Habermas thus argues for a dualist theory of society in which he interweaves the concepts of system and lifeworld, without reducing one to the other. Habermas claims however that one can trace a *progressive uncoupling of system and lifeworld* with the shift from traditional to modern forms of social organization. This differentiation or uncoupling is a structural necessity of advanced modern societies: the operation of systemic mechanisms, such as state apparatuses and the market economy, uncoupled from interpersonal relations (that is, operating behind the back of individual agents) is a crucial feature of modernity. But there are also disturbing or pathological features arising from modern social development, and for Habermas these principally stem from the expansion of economic and political steering mechanisms into the interpersonal bases of the lifeworld: the destructive impact of capitalist reification upon interpersonal communication, the weakening of the public sphere through media homogenization, the increasing reliance of individuals upon expert knowledge (scientific, technological, psychotherapeutic) for self-understanding and the fostering of communal bonds. All of these forces threaten autonomous sociability, says Habermas, as the communicative and consensual foundations of the lifeworld come under the increasing pressure and insidious influence of rationalization. Indeed, systems integration in modernity has become rationalized to such an extent that Habermas speaks of an 'inner colonization of the life-world'. Such a colonization can be resisted only through communicative reason. The critical involvement and political participation of individuals within the public sphere – in, for example, ecological, peace and feminist social movements – is regarded by Habermas as an attempt to check and correct the current imbalances between lifeworld and system forces. New social movements, says Habermas, are primarily defensive in character, since they seek to defend the relentless colonization of the lifeworld against the systems.

Habermas's attempt to rethink the *interdependence* of socio-political grids and intersubjective communications has been crucial to the development of contemporary critical theory. According to Axel Honneth (1991), however, Habermas's critical theory of society fails to give adequate recognition to the complex dynamics of social conflict which are, in fact, vital to any reconquest of the lifeworld through communicative action. Against Habermas's tendency to see systems integration processing the moral orientations of individuals, Honneth wants to recover a notion of *praxis* for rethinking domains of intersubjective communication. In particular, the concepts of struggle, conflict and recognition are of core significance to understanding the restructurings of system and lifeworld in the contemporary era. Thus, Honneth adopts a number of psychoanalytic motifs and techniques in order to interpret anew intersubjective pathologies that result in instrumentally one-sided relational patterns of self-development. Honneth's adoption of psychoanalytic theory is, in some respects, a return

to the project of linking Freud and Marx that was pursued by the first generation of critical theorists, especially Marcuse and Adorno. (Habermas has drawn from Freud, but in a methodological rather than a substantive manner. For critical discussions of Habermas's engagement with Freud and psychoanalysis see Elliott 1999; Whitebook 1995.) Honneth draws primarily from the object-relational school of psychoanalysis, an approach that is especially well suited to the *intersubjective focus* of contemporary critical theory.

Whatever a sociological sceptic might think of the analytical purchase of the notion of intersubjectivity, and however varied its meanings might be, it is impossible to deny that the question of the relation between self and society lies at the core of social theory. Indeed, the complex connections between self and society, or subjectivity and societal structure, remain a prominent reference point in most versions of social theory. In general terms, it would be true to say that those schools of thought that have paid special attention to theorizing individual subjectivity and human action have contributed to a deeper understanding of how action and interaction are structured by broader social, cultural and political forces. This is most obviously true of those forms of contemporary social analysis that have drawn from psychoanalytical theory, in the various attempts to delineate the unconscious motivation of human action as well as the symbolic forms of interpersonal and cultural relations. Notwithstanding the importance of these dimensions of human experience for the social sciences and social theory, however, such frameworks encounter difficulty in providing conceptions of social structure or institutional explanation. Institutions certainly appear in the writings of major theorists of human subjectivity, such as Jacques Lacan, Julia Kristeva and Cornelius Castoriadis, and in ways that problematize the connections between self and society. But as understood from the standpoint of more orthodox sociological traditions, institutions are analysed by these authors mostly in terms of their symbolic or semiological meanings, and not in terms of power relations or social transformations.

The seemingly inescapable conclusion is that social theory must start again, through a different optic, for retracing the relation between self and society. Certainly other branches of social theory, such as structuralism and systems approaches, sought to do just that, principally by taking institutional structure as the core ingredient of social explanation. Here there is an explicit attempt to elucidate, in objective terms, the structures and representations upon which social interaction depends but which it cannot explicitly grasp or formulate. In such objectivistic approaches to social-scientific inquiry, there is a methodological break with the immediate experience of individual agents and a focus instead on pattern variables of the structural features of modern industrial societies. But if such attempts to understand institutional structures as arising from more than repetitious patterns of human action have merit, they also have limitations of their own. The central limitation of objectivist social theories is that by according priority to structure over action a deterministic flavour is accorded to the social world and the practical activities of the individuals who make up the world. Many argue that this is especially obvious in the classical social theory of Emile Durkheim, in which society often appears as a force external to the agent, exercising constraint over individual action.[3] Yet the tendency to grant priority to the object (structure) over the subject (agent) is sustained in various guises in contemporary social thought, principally in the work of structuralist and systems-theory analysts.

In one sense, the shift to structuralism underscored not only the power of structures in the lives of people but the force of power itself, especially of unequal power relations. Significantly, power appears in an altogether new light when viewed through the optics of structuralism and post-structuralism. Michel Foucault is widely considered the major theorist connected with structuralism on the social organization of power (though structuralism was a term

Foucault himself rarely used), particularly in terms of the role of structures in the discipline and surveillance of human agency. Broadly speaking, Foucault signalled his debt to structuralism with his contention that discipline 'makes' individuals. The exercise of power, writes Foucault, has increasingly shifted from spectacular, violent and open forms of punishment in societies of the ancient world to more hidden, disciplinary and monotonous types of coercive monitoring in modern societies. The prison, the army, the school, the mental asylum: these and other institutions deploy subtle methods of domination based on the continual monitoring, observing, recording, training and disciplining of human subjects. Foucault's analysis of the rise of the disciplinary society, and in particular the ways in which contemporary methods of surveillance and domination differ from traditional forms of social control, has been tremendously influential in social theory. However, his thesis that the systematic imposition of domination in discourse and surveillance provides a comprehensive model for analysing power relations in modern societies has also been found wanting. Some analysts have argued that Foucault accords the theme of surveillance too much weight; others argue that his model of power is too one-sided, focused only on how power is installed in institutions and not on those actually subjected to domination.[4] It should be pointed out that Foucault does underline that social practices and structures are always contested; ongoing resistance to power, he says, is everywhere. But it is not clear from this post-structuralist programme that Foucault is able to theorize an uncoercive relation to society adequately, or how power and domination interweave.

Foucault, it might be argued, treats the practical relationship of inner and outer nature, of self and society, as an objectivistic fact of structures. To the extent that this is so, his work preserves a series of oppositions and antinomies that have plagued social theory, such as the individual versus society, action versus structure and subject versus object. In recent decades, a variety of social theorists have sought to overcome these divisions. Perhaps the most original formulations of this transformation in contemporary social theory are to be found in the writings of Pierre Bourdieu and Anthony Giddens.[5] Essential to these attempts is the relating of self and society without prioritizing one term at the expense of the other. The conceptualization of such a relation, it is argued, requires attention not to how structure fixes action or how repetitive actions constitute structures, but rather to how action is *structured* and *reproduced* in contexts of daily life.

At any rate it is one thing to grasp how the relation between self and society might interweave from a conceptual angle, and another to engage with what this means for contemporary women and men in their everyday engagements with each other. If women and men need connection and mutuality, they also need independence and freedom – and these very needs raise crucial questions concerning gender relations, patriarchy and feminism. Feminism, perhaps more than any other political and theoretical current within contemporary western societies, has profoundly problematized approaches to questions of self, identity, power, economy, culture, knowledge and justice. Inspired by the re-emergence of the women's movement in the late 1960s, feminist social theorists have developed powerful and productive accounts that locate both women and men within socio-structural relations of gender, as well as accounts of the social and political dimensions of women's troubles and the analysis of male domination (or patriarchy). While feminists stress that the social world is a gendered world, such has been the rapid proliferation and diversification of feminist theorizing that there is by no means a consensus about the source and dynamics of how gender systems are produced, reproduced and transformed. Indeed, the very diversity of women's personal and political positions in society and representations in culture has been increasingly explored in contemporary feminist theory, from issues of child-rearing arrangements, through the

meanings and values of sexual difference, to the denial or suppression of racial and ethnic gendered identities.

In this way, feminism has emerged as an interdisciplinary site of lively controversy in contemporary social theory. Current varieties of feminist and post-feminist social thought are wide-ranging, and include liberal, radical, post-structuralist, postmodernist, post-Marxist, psychoanalytic and Foucauldian forms, with each carrying quite distinct implications for understandings of theory, society and culture (for critical discussions of varieties of feminist social theory see Segal 1999; Hooks 2000; Tong 2009; Donovan 2012). Against the backdrop of this theoretical complexity, the following questions emerge as central in current feminist social thought. How are gender systems of domination and oppression constituted and reproduced across time and space? How does gender relate to sexuality and sexual practice? How does gender interconnect with other forms of social relations such as class and race? How are relations of difference and otherness established between men and women, and how might these relate to the construction of sexualities, masculinities and femininities? What are the important determinants of the widespread socio-political denigration of women and the feminine? How can previously repressed, unarticulated or denied aspects of femininity be reclaimed for creative social relationships?

Much traditional feminist talk assumed that an appeal to women in general was a sufficient foundational basis upon which to construct a radical theory of sexual politics. The distinction between sex and gender was crucial in this respect, and provided the conceptual underpinnings upon which many in the women's movement argued for new articulations of gender identities and sexual politics. Feminists such as Kate Millett (1971) and Ann Oakley (1972) challenged popular understandings of biology as fixed and immutable, and instead concentrated on the construction of biological differences in conjunction with the social environment. If the cultural meanings and representations attached to biological differences of sex are changeable, then it is also possible – and indeed urgent – to promote the reconstruction of the system of gender power that characterizes modern societies. Taken as a whole, however, this unification of women under the sign of a universal male dominance became increasingly implausible. Terry Lovell writes:

> What was most attractive in radical feminist thought – its insistence that gender domination existed in its own right and was not reducible to any other form of domination – was also a source of difficulty at the level of theory and analysis as well as of politics. In radical feminist writings 'patriarchy' becomes near-universal and so pervasive that important historical and cultural differences in the social construction of gender are lost from sight.
> *(1996: 315)*

In time, it was feminists of colour, sex radicals and lesbian feminists who brought issues of their own gender specificities and differences to the fore, while other self-styled critical and postmodern feminists attempted to rethink certain normative issues arising from the reconstruction of gender for social theory.

The circuits of cultural theory: codes, close reading and cultural studies

If social theory has been concerned with the analysis of subjectivity, social relations, urban living, political transformation, technological change and the like, this is equally true of cultural theory. The difference between the two traditions of thought, however, hinges centrally on the importance accorded to the analysis and critique of culture – specifically, the

forms of analysis developed in cultural theory for grasping what Richard Hoggart in *The Uses of Literacy* (1957) termed an individual's 'whole way of life'. From its focus on high culture under Leavisism, in which there is an equation of culture with morality and manners, to the life forms of the everyday and especially working-class culture, inaugurated by the conceptual departures of among others Hoggart and Raymond Williams, cultural theory has been oriented to the central tension between creation and constraint in the living of modern lives. This meant in effect that culture was at once a master idea and an environmental reality that floated both around us and inside us, producing a vision of the self that was culturalist to its very core. Culture, so the argument went, bound identity and society together – sometimes harmoniously, sometimes discordantly. And yet if culture penetrated into the tissue of subjectivity, this was only so because there were the raw materials of emotions, affects and desires on which the discourse of culture could go to work. Culture required, in other words, a heavy component of self-making at the level of both societal reproduction and political transformation (Easthope and McGowan 2004; Barry 2009; Storey 2012; Eagleton 2003).

To invoke the image of culture as that of self-culture is to shift from the early innovations of cultural theorists such as Hoggart and Williams to the Marxist-inspired merging of semiotic and psychoanalytic currents by cultural thinkers as diverse as Louis Althusser, Stuart Hall, Fredric Jameson and Slavoj Žižek. The second section of this *Handbook* opens with chapters largely seeking to map these shifts in cultural theory, with Nick Stevenson addressing the landscape of cultural theory in the UK and Europe, and Sam Han exploring the concept of culture as developed in cultural studies and cultural theory in North America. One common theme that emerges from this recasting of cultural theory concerns the critical analysis of human subjectivity, especially in respect of the Freudian notion of a fundamental division within ourselves as human subjects. Indeed, it was through a blending of Freudian psychoanalysis, structural linguistics and post-structuralist Marxism that some of the most vital work in cultural theory emerged on both sides of the Atlantic, giving rise to the notion of the 'decentred subject'.

The relationship people establish to their own lived experience, as well as their unique ways of interacting with and perceiving others, is captured under the rubric of 'personal identity'. In a profound irony, however, identity is never identical to itself; there is always more to psychic experience than can be emotionally processed at any one time and place at the level of human consciousness. The 'decentring' of identity is one way in which cultural theorists have sought to grasp this point. 'Decentred subjectivity' is a term worth exploring. It implies a profound mistrust in the reliability of consciousness as a basis for knowledge. Consciousness of self is a symptom of broader structural forces, sometimes described as language or the unconscious or social relations, and from this vantage point the Cartesian *cogito* ('I think, therefore I am') is rendered suspect. We can find a prefiguring of the 'decentred subject', a term that takes off in much radical social theory after the impact of structuralist and post-structuralist linguistics, in the writings of Freud, Nietzsche and Heidegger. Each can be seen as questioning, in a profound manner, the philosophical privilege accorded to consciousness. According to these 'grand masters of suspicion', subjectivity is not transparent: the 'subject' is rather its own internal relations, constituted through the unconscious (Freud), the will to power (Nietzsche) or Being (Heidegger).

Significantly, the subject became most comprehensively stripped of traditional notions of both agency and rationality as a result of the force-field of desire itself, in a radical formulation of subjectivity proposed by Freud and psychoanalysis. Freud, in particular, radicalizes the way in which we have come to think about self-identity. For, in suggesting that dreams are the 'royal road to the unconscious', Freud shows the ego not to be the master of its own home.

The presence of unconscious desire was detected at work almost everywhere by Freud – for example, in slips of the tongue, bungled actions, failures of memory, misinterpretations and misreadings. For Freud, unconscious desire has a predominantly sexual or libidinal content, and it is precisely for this reason that the ego blocks off knowledge defensively, shifting the energy that subsists in repressed desire to the moral prohibitions and restrictions of the superego. Ego, id and superego are the key agencies in Freud's model of the human mind, a model designed to help practitioners assist the mentally ill or disturbed. But psychoanalysis is much more than just a therapeutic practice. It is also a radical theory about the fundamental emotional creativity of human beings, focusing as it does on the passions and prohibitions that provide civilization with its basic structure. From this angle alone, Freud's work is instructive for rethinking the emotional dimensions of social life, dimensions that have been reductively and deterministically understood by traditional thought.

Indeed, this is one reason why Freudian psychoanalysis came to exert a profound influence over contemporary social theory, and this influence is reviewed in some detail in the first section of this handbook. But Freud and psychoanalysis have also been central to the development of cultural theory. Culture, in the eyes of various leading theorists, contains and calibrates our deeper desires only by diverting these very energies into wider collective concerns. In this sense, culture energizes itself from the raw powers of desire, sublimating Eros or libido into the relentless work of civilization building. Yet culture is not simply built on a repression of desire alone, since the former is itself also shaped to its roots by other impulses for undoing, dismantling and destruction. The flipside of Eros, builder of civilizations, is Thanatos – a primordial drive for destruction and death which, strictly speaking, exists beyond Freud's pleasure principle. In various elaborations of cultural theory, Thanatos emerges as a ferocious inner compulsion that infiltrates the very contours of culture itself. In this connection, psychological and cultural repression are deeply interconnected, with Thanatos cast as a kind of excess of cultural ordering or regulation which provokes the very resentment and rage that culture is designed to contain. In the second section of the handbook, various authors examine the influence of psychoanalytic ideas on cultural, literary and philosophical sources.

If Freudian theory has come to be associated with the dethroning of the sovereign subject, this is equally true of structuralist linguistics. The key text here is Ferdinand de Saussure's *Course in General Linguistics* (1974 [1916]), a work that profoundly shaped the development of French structuralism and post-structuralism.[6] In developing a critique of meaning, Saussure paid special attention to what is social, as opposed to what is individual, in the production of language. According to Saussure, there is no intrinsic connection between a word and an object, like the term 'dog' and the flesh and blood animal that lies in the back garden. Instead, meaning is constituted through the unity of a sound-image (or signifier) and a concept (or signified). For Saussure, the relation between signifier and signified is *radically arbitrary*. This notion of the arbitrary character of the sign does not mean, absurdly, that individual speakers can make whatever utterances they like in day-to-day conversation and interaction. On the contrary, individual speakers are strongly bound by the conventional usage of linguistic terms in order to be understood. Rather, the principle of relative arbitrariness refers to the internal composition of language as a structure. Language, he suggests, is composed of a set of binary oppositions of signifiers: 'day' is only constituted as a sign in terms of its difference from 'night', 'black' from 'white', and the like. Although in Saussure a certain indebtedness to psychology is still evident, the main focus is upon the analysis of language (*langue*) as a system of collective representations, rather than the actual substance of individual speech (*parole*). That is to say, Saussure was concerned not so much with the actual things about which people

spoke, but rather with how a signifier comes to be isolated from other signifiers in the preservation of difference. 'In language', as Saussure said, 'there are only differences *without positive terms*. Whether we take the signified or the signifier, language has neither ideas nor sounds that existed before the linguistic system, but only conceptual and phonic differences that have issued from the system' (1974: 120). In this framework, therefore, language is considered a system of values structured in terms of their internal and oppositional relations, and speech is the individual or subjective realization of language.

In extending the methods of analysis worked out by Saussure, cultural theorists influenced by structuralist linguistics seek to discern the complex, contradictory connections between language and the production of culture. This concern with signifying practices has come to be referred to as theory's 'linguistic turn', and anthropologist Claude Lévi-Strauss's *The Elementary Structures of Kinship* (1969) is widely considered one of the first main experiments in sociological semiotics. Linguists and social scientists, Lévi-Strauss contends, 'do not merely apply the same methods, but are studying the same thing' (1969: 493) – a statement that underwrites the structure of language as of central importance to the explication of culture. The interest in and enthusiasm for linguistics here can be characterized as a theoretical weapon for (1) the critique of a system of signs at any given point in time as an approach to the explication of meaning, and (2) the critical appraisal of objective structures, which makes the speech of the human subject possible in the first place. As noted elsewhere in this handbook, the French semiologist Roland Barthes traced out the main characteristics of Saussurian linguistics, and applied this theory to the study of cultural life and social practices. Barthes's work is a good example of structuralist cultural theory, as it brings Saussurian concepts to bear upon the explication of social phenomena such as fashion, food and furniture. Cultural life for Barthes is a complex 'system of signs', a relation of relations.[7] Within this complex system can be found the decentred and dispersed human subject, navigating its way through a labyrinth of images, sounds and texts. The human subject, from such a semiological angle, is a product of this continuous play among signs, of signs rationalized or naturalized, of language as a code. Barthes's principal contribution to cultural theory lies in the development of a semiological approach to understanding what modern culture reveals about itself through the signs it produces.

It is in the marriage of structuralist linguistics and psychoanalytical concepts, however, that we find the most radical and comprehensive decentring of the human subject. I have already mentioned the signal importance of Freud's work; yet the work of the French psychoanalyst Jacques Lacan is exemplary for grasping the recasting of subjectivity in the wake of structural linguistics and psychoanalysis. Lacan, in a provocative 'return to Freud', attempts to rework the main concepts of psychoanalysis in line with core Saussurian concepts, such as system, difference and the arbitrary relation between signifier and signified. Lacan's writings are notoriously difficult and elusive. Notwithstanding this, Lacan's Freud has exercised considerable influence in contemporary social theory, from the structuralist Marxism of Louis Althusser to the deconstructive feminism of Luce Irigaray.[8] One of the most important features of Lacan's psychoanalysis is the idea that the unconscious, just like language, is an endless process of difference, lack and absence. For Lacan, as for Saussure, the 'I' is a *linguistic shifter* that marks difference and division in the social field; there is always in speech a split between the self that utters 'I' and the word 'I' that is spoken. The human subject both is structured by and denies this splitting, shifting from one signifier to another in a potentially endless play of desires. Language and the unconscious thus thrive on difference: signs fill in for the absence of actual objects at the level of the mind and in social exchange. This is central to Lacan's theory that social relations, or what he calls the

symbolic, depend on the repression of desire. 'Civilization is built upon a renunciation of drives', wrote Freud (1961: 51–52), and Lacan's account of the unconscious–language relation is an impressive attempt to theorize this insight in terms of the intersubjective workings of desire and recognition.

The repression of desire is at one with the very constitution of the self, and according to Lacan this is a process that leaves the human subject forever scarred or internally divided. In his much celebrated essay 'The mirror stage as formative of the function of the I', Lacan emphasized the *narcissistic positioning* of the child on an imaginary level of perception. At some point between six and eighteen months, the child identifies with itself by seeing its image reflected in a mirror. The mirror stage, Lacan argued, founds an imaginary identity through a narcissistic relationship to images and doubles. The child reacts with a sense of jubilation in seeing itself whole and complete in the mirror, yet this self-recognition is in fact a *misrecognition* since the child is still dependent upon other people for its own physical needs. The process of self-identification, because it occurs via a mirror that is outside and other, is actually one of alienation. In a word, the mirror *lies*. The very process of achieving self-identification, which is necessary to becoming a positioned subject in the social world, renders the child at odds with itself.

What are the gains of this decentring of the subject in structuralist and post-structuralist thought? To begin with, instead of taking consciousness as given, the psychoanalytic post-structuralism of Lacan represents a radical demystification of human subjectivity. Structure predates experience, the mirror frames imaginary perception: the individual subject is a product of the 'discourse of the Other', that is, signification. Lacan's argument that the subject finds an imaginary identity through an image granted by another represents a major advance on approaches that uncritically assume that the ego or the 'I' is at the centre of psychological functioning. In stressing that the 'I' is an alienating fiction, a misrecognition that masks the split and fractured nature of unconscious desire, cultural theorists influenced by Lacan locate a sense of otherness at the heart of the self – a theme that runs deep in contemporary thought. The radical edge of such an approach is that it runs counter to much received wisdom, specifically the assumption that experience is unproblematic and that meaning is transparent. By highlighting that all self-knowledge is fractured and fragile – with the individual subject caught between the imaginary traps of narcissistic mirroring and the symbolic dislocations of language – structuralist and post-structuralist social theory underwrite the view that subject and society are discontinuous with each other. The social world may never seem the same again after one reads Lacan, if only for the reason that Lacan's writings capture something of the strangeness that pervades the mundane and familiar in daily life.

A novel and critical engagement with Lacan's Freud is developed in an interesting way in the writings of Julia Kristeva. Kristeva, a leading intellectual and practising psychoanalyst in France, develops what might best be termed a post-Lacanian account of processes of significa-tion. Kristeva's critique of the subject is at once Lacanian (most notably in terms of her argu-ment for the imaginary framing and symbolic decentring of the subject) and post-Lacanian (through her connection of psychic process to being and action). She explicitly reintroduces the Freudian notion of drives into the linguistic abstractions of Lacanian theory, termed the 'semiotic', in order to account for the subject's psychic investment in the mirror stage as preparatory to the constitution of the 'I'. It is obvious to Kristeva that the signifying relations between subject and society are not eternally fixed and given. And in order to counter the Lacanian tendency to view the constitution of the subject as a subjectless process, she focuses on the structuration of the passions as central to experiences of autonomy and alienation, subjectivity and subjection. There is, in other words, a hiatus between what Kristeva asserts

of the semiotic, heterogeneous nature of psychic experience and a structuralist notion of system in which language speaks the subject.

As regards the recasting of personal identity in the wake of systematic structural transformations, there is arguably no greater shift underway in our time than that of globalization. The advent of the global electronic economy is a game changer, certainly for the analysis and critique of personal and professional life but also for a whole array of general categories developed in and through social and cultural theory. In this connection, it has been argued by many that the twenty-first century has ushered into existence a 'new era'. Globalization, new communication technologies and the arrival of Web 3.0, the techno-industrialization of war, the privatization of public resources, the advent of a seemingly unstoppable universal consumerism: these are just some of the profound institutional transformations that have taken place at the level of both personal life and planetary systems. Such institutional transformations directly underpin arguments within the social sciences that we stand at the beginning of a radical political transition, a transition that leads us to bid farewell to an era dominated by industrial capitalism. Gone is the oppressive, repetitive grind of industrial labour. Instead, industrialization is replaced by the age of the computational microchip. The floating images and virtual codes of the mass media come to be seen as that point where technology invades the inner world of the individual subject, the opening of a new world beyond that of modernity itself.

A baffling variety of terms have arisen in the attempt to describe novel forms of life beyond modernity, including the 'information society', 'consumer society', 'post-industrial society', 'post-capitalist society', 'postmodernism' and 'postmodernity'. Some of the debates about a possible historical transition beyond modernity have concentrated upon institutional dynamics, particularly those that see a shift from industrial production to the production of information as the basis for a new form of political power. Some of the debates, by contrast, have concentrated on more cultural and aesthetic issues, especially in the realms of art, architecture and mass culture. These controversies have as a common thread, however, the global expansion of cultural, economic and political systems of the developed societies. In this connection, the diagnosis of a postmodern social condition – by far the most debated idea arising from these controversies – is often enough represented as involving the end of modernity and the dissolution of the Enlightenment.

Four contemporary cultural theorists in particular have come to be identified with the controversial argument that the concept of postmodernity is best deployed as a description of contemporary experience. Jean-François Lyotard, Jean Baudrillard, Fredric Jameson and Zygmunt Bauman have, notwithstanding differences in argument, become the symbolic bearers of the case for a *radical postmodernism*.[9] Radical postmodernism is a form of cultural critique that considers modernity dissolved, and which generates new critical terminologies to comprehend the globalized, mediated nature of today's social, cultural and political world. Modernist expectations and sentiments, according to these theorists, are increasingly undermined in the contemporary era. It is less clear, however, if there is any coherence or meaning to the systems of thought that have replaced modernism and modernity. From this angle, the modernist drive to order, control and regulate society has been at the cost of repressing 'other worlds' and 'other voices', such as women, blacks, gays and colonized peoples.

Other cultural theorists have questioned the value of such a broad-ranging historical periodization and global diagnosis, contending that it is not really possible to make sense of the debate over modernity, postmodernity and the geo-political transformations of globalization in this manner. Rather than viewing the modernity/postmodernity debate and the globalization thesis in terms of endings, some cultural theorists have suggested that globalized

modernity is becoming radicalized or intensely reflexive or being pushed to its limits. These arguments might be grouped under the banner of *pragmatic postmodernism* or *global liquidization*, and theorists associated with this approach include Zygmunt Bauman and Seyla Benhabib. Here the political consequences of advanced globalization are understood as entering into an embarrassing contradiction with its programmatic promises of freedom and justice, such that the condition of postmodernity is understood as an ability to reflect back upon certain core assumptions, practices and illusions of the modern age.

Much of the focus of recent cultural theory in terms of grasping the illusions of modernity has been on race. Recent debates on race, multiculturalism and difference have fuelled discussions of cultural identities and values excluded or marginalized in the academic culture of the West. Issues of imperialism and decolonization, which have been substantially addressed through debates about the nation-state, nationalism and the Third World, have served to highlight the exclusions and omissions of cultural identities and political formations from many of the core institutions of liberal, representative democracies. These debates have in turn underlined the Eurocentric bias of many western cultural theories, and extended appreciation of the interweaving of race, ethnicity and cultural differences as sites for the production and politics of identity.

The participants in these debates are in considerable degree all struggling with a number of core questions and issues, many of which bear the strong imprint of current developments in cultural theory. What are the connections between modernity and its racialized history of identity exclusions? How have racial exclusions and racist dominations become naturalized or normalized in the Eurocentred vision of western traditional thought? How might racist states of mind best be understood? What are the psychic roots of racist practices? How might cultural theory best develop a non-reductionist and anti-essential analysis of racist ideology and racialized discourse? What are the chances of multicultural diversity, and what are the threats of new racisms, in the postmodern, post-communist and postcolonial era of transnationalism? How might the current multiplicity of anti-racisms be linked to critical theory and to cultural theory as a whole?

For many cultural theorists of differentiated social identities and the politics of race, neither the extension of mass consumer markets to previously excluded groups, nor the assimilation and integration of minority histories into dominant or mainstream socio-political contexts, seems an attractive model of anti-racist development. For such critical anti-racists, there is a danger in organizing selves, communities and nations around a politics of identity, most obviously in terms of undermining commitments to diversity in the public, political domain. If too 'inclusivist' or conformist a view is taken of what it means to hold a given identity, perspective or disposition, then we are never far from an unleashing of destructive, paranoid fantasy which underpins racist ideologies and the delegitimation of the political rights of others – or so it is argued.

The *Routledge Handbook of Social and Cultural Theory*

This *Handbook* sets out to provide a reasonably comprehensive account of contemporary cultural life along the twin axes of social theory and cultural theory. The first section of the book examines the ways that social theory has intersected with an array of recent debates on social reproduction and cultural transformations. Jordan McKenzie traces the lineage of the critical theory of the Frankfurt School, from the first generation of critical theorists to the work of Habermas and the more recent conceptual departures of Albrecht Wellmer and Axel Honneth. Sam Han lays out the path of theoretical development to structuralism and

post-structuralism, giving insight into the latent conventions and hidden codes that structure social behaviour and cultural life. Anthony Elliott revisits the agency and structure debate in social theory, paying particular attention to the conceptual approach of structuration. Ann Branaman explores feminist and post-feminist critiques of the intricate links between sexuality, gender and power relations. Keith Tester examines the integration of social theory with everyday cultural experience in the work of Zygmunt Bauman. John Cash reviews the many different definitions of ideology, and explores the relevance of the concept for contemporary social and cultural thought. Elliott examines intersections between psychoanalysis and social theory, paying particular attention to the affective dimensions of cultural change. Patrick Brown looks at sociologies of risk, particularly the way that risk assessment has infiltrated modern institutions and everyday cultural life. Thomas Birchnell gives us insight into the labyrinth of networks – from network computing to social networking. Finally, Eric Hsu looks at the rise of the 'great globalization debate' in recent social theory.

The second section of the book shifts focus to cultural theory, and examines how path-breaking cultural analysts such as Hall, Jameson and Žižek have brought interdisciplinarity to the fore in the critique of culture, communication and capitalism. Here cultural theory is revealed as constituted through a deep and lasting engagement with countercultures and social movements, anti-war protests and national liberation fronts, civil rights demonstrations and the age of feminism. As a result, the analysis and critique of culture comes to denote a mixture of discourse, texts, materiality, ethnography, politics, economics, sociology, social policy, post-structuralism, postcolonial theory, postmodernism and much else. The concept of culture, from this angle, is thus developed not only as a critique of middle-class society and capitalist power, but also as an articulation of wider political transformations bound up with forces such as media, popular culture, the cult of celebrity, subcultures, and so on. Charles Lemert takes stock of these shifts in his opening contribution to this section of the book, looking in particular at differences between cultural and social things.

A lot of cultural theory is preoccupied with the question of defining culture. Much of the most radical cultural theory certainly keeps definitions of culture in mind, but crucially also looks for new connections – new ways of understanding the relationship – between culture and social power. Nick Stevenson – in examining the legacy of British cultural theory from Williams, Thompson and Hoggart to Hall, McRobbie and Gilroy – finds this tradition of thought of continuing importance for engaging with questions of power, culture and society. Sam Han reviews American cultural theory and cultural studies and looks at many of its leading thinkers, from Lawrence Grossberg to John Fiske, as well as the fraught relationship of American cultural studies with American society. Max Kirsch explores how many new cultural ideas have developed through an extraordinary creative dialogue with queer theory. Jennifer Rutherford and David Crouch consider the twists and turns of cultural theory informed by the resources of literature – how structures of language, storytelling and narration are always bound up with cultural determinants and the (re)imagining of alternative worlds. Anthony Moran interrogates the engagement of cultural theory with race, ethnicity, nation and colonialism, highlighting throughout the interrelation of racial exploitation and cultural forms of domination. Simon Susen focuses on 'the place of space' in social and cultural theory. Rutherford and Crouch, once again, provide a novel angle on cultural theory with reference to reception theory – looking at the role of the reader in literature as well as the wider political concern of cultural participation in literature. And Rita Horanyi examines the notion of performativity in cultural theory, from Goffman to Butler and beyond.

Notes

1 There are several fine overviews of the work of the first generation of Frankfurt critical theorists available. In particular, see Jay (1973); Held (1980).
2 For useful introductory analyses of Habermas's social theory see Outhwaite (1994); White (1978); McCarthy (1978). See also the essays in Thompson and Held (1982).
3 See, for example, Durkheim (1952). For an analysis of Durkheim's tendency to equate structure with constraint see Giddens (1971).
4 For detailed discussions of Foucault's work in relation to issues of surveillance and domination see Hoy (1986); Poster (1990); Lyon (1994). Useful discussions of Foucault's theory of power are to be found in Dews (1987) and McNay (1992).
5 For useful introductory overviews and critical appraisals of the writings of Pierre Bourdieu and Anthony Giddens see Thompson (1984: chs 2, 4); Lemert (1991: ch. 7).
6 Saussure was Professor of General Linguistics at the University of Geneva, and his *Course in General Linguistics* was reconstructed from the notes of his students. See Saussure (1974). There are many criticisms made of Saussure's theories, including the important objection that the explication of meaning is isolated from the social environments of language use as well as the psychological processing of signification, representation and affect. For useful discussions of Saussure see Clarke (1981); Giddens (1979: ch. 1).
7 Roland Barthes's work can be divided between his early writings, which fuse semiotics and structuralism, and his later statements, which might be characterized as literary post-structuralism. A useful anthology is Sontag (1983). See also Calvet (1995).
8 For critical discussions of Lacan's work in relation to social theory see Dews (1987); Elliott (1999: ch. 4).
9 The analytical distinction that I propose between radical postmodernism and reflexive postmodernism is intended as a general one. Differences in historical periodization, particularly in terms of whether the modern/postmodern is viewed in terms of repetition or rupture, are of core significance to grasping the ambiguity and controversy that marks this debate. Notwithstanding these reservations, I have suggested these terms as a means to problematize some of the analytical and political assumptions of modernist and postmodernist social theory. For a related schema, see Charles Lemert (1997: ch. 2), who breaks the debate into 'radical modernism', 'strategic postmodernism' and 'radical postmodernism'.

References

Barry, P. (2009) *Beginning Theory: An Introduction to Literary and Cultural Theory*, Manchester: Manchester University Press.
Calvet, L.-J. (1995) *Roland Barthes: A Biography*, Bloomington, IN: University of Indiana Press.
Clarke, S. (1981) *The Foundations of Structuralism*, Sussex: Harvester.
Dews, P. (1987) *Logics of Disintegration*, London: Verso.
Donovan, J. (2012) *Feminist Theory: The Intellectual Traditions* (4th edition), New York, NY: Continuum Books.
Durkheim, E. (1952) *Suicide: A Study in Sociology*, London: Routledge and Kegan Paul.
Eagleton, T. (2003) *After Theory*, New York: Basic Books.
Easthope, A. and McGowan, K. (eds.) (2004) *A Critical and Cultural Theory Reader* (2nd edition), Maidenhead, UK: Open University Press.
Elliott, A. (1999) *Social Theory and Psychoanalysis in Transition* (2nd edition), London: Free Association Books.
Elliott, A. and Turner, B. S. (2012) *On Society*, Cambridge: Polity.
Flax, J. (1990) *Thinking Fragments*, Berkeley, CA: University of California Press.
Freud, S. (1961 [1930]) *Civilization and Its Discontents*, trans. and ed., James Strachey, New York: W. W. Norton.
Giddens, A. (1971) *Capitalism and Modern Social Theory*, Cambridge: Cambridge University Press.
—— (1979) *Central Problems in Social Theory*, London: Macmillan.
Held, D. (1980) *Introduction to Critical Theory*, London: Hutchinson.
Hoggart, R. (1957) *The Uses of Literacy: Aspects of Working-Class Life*, London: Chatto and Windus.
Honneth, A. (1991) *The Critique of Power*, Cambridge, MA: MIT Press.

hooks, b. (2000) *Feminist Theory: From Margin to Center* (2nd edition), Cambridge, MA: South End Press.

Horkheimer, M. and Adorno, T. (1970) *Dialectic of Enlightenment*, London: Allen Lane.

Hoy, D. C. (ed.) (1986) *The Foucault Reader*, Oxford: Blackwell.

Jay, M. (1973) *The Dialectical Imagination*, Boston: Little, Brown and Company.

Lemert, C. (1991) *Sociology after the Crisis*, New York: Westview Press.

—— (1997) *Postmodernism Is Not What You Think*, Oxford: Blackwell.

Lévi-Strauss, C. (1969) *The Elementary Structures of Kinship*, London: Eyre and Spottiswoode.

Lovell, T. (1996) 'Feminist social theory', in B. Turner (ed.) *The Blackwell Companion to Social Theory*, Oxford: Blackwell.

Lyon, D. (1994) *The Electronic Eye: The Rise of Surveillance Society*, Cambridge: Polity.

McCarthy, T. (1978) *The Critical Theory of Jürgen Habermas*, Cambridge, MA: MIT Press.

McNay, L. (1992) *Foucault and Feminism*, Cambridge: Polity.

Millett, K. (1971) *Sexual Politics*, London: Hart-Davis.

Oakley, A. (1972) *Sex, Gender and Society*, London: Temple-Smith.

Outhwaite, W. (1994) *Habermas: A Critical Introduction*, Cambridge: Polity.

Poster, M. (1990) *The Mode of Information*, Cambridge: Polity.

Saussure, F. de (1974) *Course in General Linguistics*, London: Fontana.

Segal L. (1999) *Why Feminism? Gender, Psychology, Politics*, London: Polity.

Sontag, S. (ed.) (1983) *Barthes: Selected Writings*, London: Fontana.

Storey, J. (2012) *Cultural Theory and Popular Culture: An Introduction* (6th edition), Harlow, UK: Pearson Education Limited.

Thompson, J. B. (1984) *Studies in the Theory of Ideology*, Cambridge: Polity.

Thompson, J. B. and Held, D. (eds) (1982) *Habermas: Critical Debates*, London: Macmillan.

Tong, R. (2009) *Feminist Thought: A More Comprehensive Introduction*, Boulder, CO: Westview Press.

White, S. (1978) *The Recent Work of Jürgen Habermas: Reason, Justice and Modernity*, Cambridge, MA: MIT Press.

Whitebook, J. (1995) *Perversion and Utopia*, Cambridge, MA: MIT Press.

Critical theory of the Frankfurt School

Jordan McKenzie

Critical theory is a project of revisionist Marxism envisioned to consider the emancipation of individuals from hegemonic power in post-Enlightenment society. Aside from a select handful of consistent themes and concerns shared among the key figures of critical theory, there are some crucial distinctions between the models employed by different theorists. Within the field of critical theory there are disparate views regarding the debate between idealism and realism, as well as drastically conflicting views regarding the application of traditional philosophy, hermeneutics, phenomenology, positivism and pragmatism. Due to the lack of a single critical theory, the most uniting aspect of the field can be thought to be what it opposes rather than what it stands for. Critical theory aims to redirect traditional agency–structure debates by suggesting that the actions, beliefs and motivations of individuals are subject to influences that can be invisible. Yet the uniting element of critical theory has less to do with a question or a subject than with a methodology of critique that demands the examination of social life, with the intention of resolving inconsistencies and distortions of knowledge.

Historical and intellectual development

The term 'critical theory' is enduringly connected to the Frankfurt Institute (otherwise referred to as the Frankfurt School) and the array of theorists associated with the institute. The school was initially founded as the Institute for Social Research in 1923 under the direction of Carl Grünberg, and from the very beginning it had a strong current of Marxism. The use of Marxist literature evolved into something considerably more radical, however, when Max Horkheimer took over as the head of the institute in 1930. In Horkheimer's inaugural lecture in 1931 he proposed a new model for research in the social sciences under the title 'critical theory'. Horkheimer's original vision for critical theory differs substantially from the later and better-known versions described by Theodor Adorno and again by Jürgen Habermas. Horkheimer sought to bring together a range of divergent fields of social research to create a kind of *ultimate* study of society. This would draw together traditional sociological theorists, such as Marx and Weber, with the philosophy of Hegel and Kant; the psychoanalysis of Freud; the psychology of Fromm; the analysis of music, art and culture through Adorno; and numerous other specialties such as politics, history and literature. Horkheimer's greatest theoretical contributions were focused on the nature of reason and rationality. Yet to many working within and alongside the institute he is often remembered for his ability to

coordinate this vast array of perspectives into something original, daring and highly influential, through the institute's *Journal for Social Research (Zeitschrift für Sozialforschung)*, which ran from 1932 to 1939.

This chapter will consider the range of proposed models for critical theory in an attempt to avoid reducing the school of thought to any one approach, or to oversimplified explanations of the three generations of critical theory. Horkheimer's original definition of critical theory aimed to bring together a broad array of disciplines within the human sciences to create a more all-encompassing study of modernity. Whilst this version of critical theory had a critical edge in its quest to determine the systematic and recurring problems of society, it was arguably more optimistic regarding the potential for resolution through reason and knowledge. For example, Horkheimer was notably more open to the use of empirical data and the incorporation of traditional philosophy including, but not limited to, Kant, Hegel and Schopenhauer. This approach to critical theory has been somewhat overshadowed by the more cultural and aesthetically driven model proposed by Adorno. During the 1940s Adorno began to surpass Horkheimer as the public face of the Frankfurt School, and as he did the common understanding of critical theory changed into what has become the most used version up to the present day. Adorno's brand of critical theory was notably more sceptical of popular culture and its ability to distract the public from restrictions of autonomy, and to promote conformity, as though the decisions of individuals were always their own. This is a unique and radical aspect of critical theory that would later be developed in more detail by Marcuse: namely, that modernity is capable of convincing individuals to forfeit aspects of their autonomy voluntarily. According to Marcuse, this involves subscribing to the ideologies of authorities, and willingly conforming to the values of others in a move that has been described as a form of self-imposed slavery. Whilst this may seem to be an extreme view, it was a fitting evaluation of the somewhat unprecedented conformity of values within Nazi Germany, and the horrifying consequences that would follow. However, this example was not limited to Nazi Germany: the early Frankfurt School theorists identified aspects of this kind of rationality throughout the world, and well beyond the end of the Second World War.

This thinking alludes to a fundamental premise of critical theory: that society is, in many ways, broken. If this is the case then the task of the theorist is to illuminate the aspects of society that are causing problems, such as inequality, poverty and injustice. The spirit of critique is therefore eternally vigilant and sceptical, whilst endeavouring to provide an understanding of society that can lead to practical solutions to social problems. It is not surprising that the school's links to Marxism are highly relevant, and yet the application of Marx in critical theory is often sparing and selective.

The origins of critical theory predominantly lay in Marx's body of work, with particular attention given to the aspects of Marxism often neglected by traditional Marxists. The school's journal, *Zeitschrift für Sozialforschung*, maintained a strong Marxist perspective during the 1930s, with *Capital* being a particularly important influence for Horkheimer and Adorno (Held 1980: 43). The theme of alienation was particularly strong in the critical theory of this era, yet Horkheimer and Adorno soon became sceptical of Marx's teleological understanding of revolution as a response to capitalism. The Frankfurt School theorists sought to re-evaluate the role of revolution on the path to greater equality and increased living standards. Traditional models of revolution were relevant in Marx's era of blatant class conflict and the somewhat formal distinction between the different socioeconomic groups. Yet oppression in the middle of the twentieth century had taken on a more covert and indirect form that made aspects of Marx's approach appear redundant. What was retained from Marx, however, were the values of freedom, egalitarianism and the need for political and democratic accountability from

authorities. Although there were similarities between Marx and the early Frankfurt School theorists regarding the technocratic rationality of the capitalist economy, towards the end of the 1930s the Frankfurt School became somewhat dismissive of the influence of Marx as a central figure in critical theory. Allegedly, the only remaining copies of the school's journal, which indicate the deeply Marxist nature of their work at the time, were locked away by Horkheimer in the school's basement. It seems that this was an act not to dismiss Marx, but rather to leave him in the past, while the focus of the Frankfurt School was on the future.

There is no way to acknowledge sufficiently the motivations and drives of this first generation of Frankfurt School theorists without providing the context within which much of their work was produced. From its inception, the Frankfurt School consisted predominantly of Jewish scholars, and so the influence of Hitler's rise to power and the atrocities that would follow during the Second World War resulted in an unmistakable scepticism about modernity among the school. The school relocated numerous times in order to avoid persecution by the Nazi government, moving to Geneva in 1933, then to New York in 1935, and eventually to California in 1941. The school did not officially return to Germany until 1953, although a number of key members, including Herbert Marcuse and Leo Lowenthal, chose to remain in the United States.[1] While the most influential members of the school were fortunate enough to escape from Nazi Germany, there is no doubt that the atrocities witnessed by members of the school and the people close to them have deeply influenced the unique approach of critical theory. As the Second World War progressed Adorno's more aesthetic and cultural model of critical theory came to be the dominant model for the Frankfurt School. Arguably it is still the most commonly used approach to critical theory. Whilst in exile in the United States Adorno became increasingly concerned with the manner in which the public's perception of society could be distorted through popular culture and misinformation. Here, Adorno focused on the power of hegemonic control through the distraction of individuals from significant abuses of civil rights and democratic principles. The cynicism in both Horkheimer's and Adorno's writing was undoubtedly influenced by the atrocities of the Holocaust, and so there is a need to understand the conditions that informed these perspectives, and this should not be overlooked when discussing the work of the Frankfurt School.

Adorno was eager to distinguish critical theory from traditional social theory due to its recognition of the invisible power of persuasion in modernity. That is to say that prior to the project of critical theory there was an assumption that the relationship of understanding between the individual and society was clear and informed. Both Weber and Durkheim were seen as examples of authoritative social theorists, who overlooked this potential for distortion in the analysis of society (Jarvis 1998: 45). Although Weber warned against the dangers of rationalization in human societies, for the critical theorists his analysis undervalued the role of interpretation for individuals. And whilst Durkheim argued that his model of functionalism was an explanation for the interaction of social systems (Jarvis 1998: 46), neither of these thinkers sufficiently acknowledged the possibility that cultural circumstances could distort the individual's understanding of society. This scepticism is central to the school of critical thought, turning on the idea that any analysis of the social world, as well as interaction with society on an everyday level, is subject to the distortion of ideas and therefore action. Therefore vigilant criticism is necessary for any form of meaningful analysis.

Major claims of the field and its key contributors

To provide a thorough evaluation of every contributor associated with the Frankfurt School would require considerably more space than is available at this point, and so this introduction

to the field of critical theory will provide an overview of the key contributors. This will primarily focus on the work of Horkheimer, Adorno, Marcuse and Habermas, although contributions from Fromm will also be considered in order to provide an accurate description of the variety of specialities within the group. The discussion will begin with Horkheimer on the matter of reason and subjectivity, followed by Adorno on aesthetics and the culture industry. The overview will then move towards Marcuse and the integration of Freudian theory into Marxism with his work on surplus repression and one-dimensional man. Finally the work of Habermas, as the major figure in the second generation of critical theory, will be considered. The key figures of the third generation will be discussed in a later section of this chapter.

Horkheimer: reason and critique

In 1947 Max Horkheimer published two texts that would come to define his substantial contribution to critical theory. *Eclipse of Reason* and *Dialectic of Enlightenment* (which was co-authored with Adorno) were the result of several years of work, and together Horkheimer and Adorno formed a foundation for critical theory out of more than a decade of journal publications, book chapters and public lectures. These texts signify the second phase in Horkheimer's writings, with the first being associated with his work in the 1930s as head of the Frankfurt Institute. An example of the early phase in Horkheimer's work can be seen in an article published in 1941 titled 'The end of reason', which delivers an approach that is deeply cynical of the ability of reason to possess emancipatory potential, particularly within the context of the events occurring in Nazi Germany at the time.[2] Yet in the era of Adorno's conception of critical theory as a new materialist philosophy, rather than an abridged version of the social sciences, *Eclipse of Reason* puts forward the claim that the individual has become detached from the process of reasoning and, in becoming so, experiences a separation from society and from the self (Lohmann 1993: 388). And so, in contrast to Horkheimer's previous position on the matter, *Eclipse of Reason* describes reason as a solution to the self-imposed limitations present in post-Enlightenment society.

Horkheimer begins *Eclipse of Reason* with the claim that for the layperson the question of reason is almost too obvious to warrant an explanation. This is because reason is most commonly used to relate means and ends in order to achieve the desired goal of the individual. In this sense, reason is a process of *how* and not *why*, as the effectiveness of one's reason is judged by its ability to deliver an intended outcome. This approach to reason can be identified in capitalism and came to be a key motivation for the Frankfurt School's ongoing critique of instrumental rationality or means-ends rationality. This kind of instrumental rationality is effective in calculating the best possible option within a structured and reliable framework of possibilities. For example, in making a decision as a consumer, this kind of logic is very helpful in ensuring that you can identify the best possible product for the price. However, this kind of reasoning becomes problematic in circumstances that are significantly less structured. Although the purchase of a new television could utilize instrumental rationality, it is very difficult to justify the more *human* elements of social life, such as love, art, music and morality. There is no calculation or formula that can validate the beauty of a piece of music or the deeply rooted moral code of an individual. Yet, for Horkheimer, human decisions are too often reduced to this kind of instrumental rationality, which forces creative and emotional human beings into rigid structures of rationality. Weber would describe this as the iron cage of rationality, and Habermas later discussed this in terms of the clash of 'lifeworld and system'. Yet, for Horkheimer, the need for a better use of reason

is essential in order to overcome the hegemonic power of social authorities, and therefore to maximize autonomy.

For the modern individual, this means that reason has shifted from something that can be used to navigate the world without coercion to something that individuals must subscribe to and then pursue at all costs. This shift in the use of reason has occurred alongside the break-down of objective truth in modernity. For Horkheimer, the use of instrumental reason was more effective in an age where the ambitions of individuals were linear and justified by social values that were seen to be objectively true, such as religious principles. But as post-Enlightenment society has gradually dismissed its faith in objectivity, the goals themselves have begun to require justification rather than simply the means by which to accomplish them. It is for this reason that Horkheimer and Adorno are highly sceptical of the Enlightenment project, as the superstitions that were to be replaced by reason and the pursuit of knowledge have in fact been replaced by an ideology of consumer culture and capitalism. Therefore the use of reason needs to consider the value of the ends rather than simply the means, and this is the key to establishing autonomy for the individual.

This position was developed significantly in *Dialectic of Enlightenment* (1947), a text that for many has defined the project of critical theory. This was an enormously ambitious project that put forward a critical view of society by arguing that modernity was built upon a false-hood. The Enlightenment, for Horkheimer and Adorno, did not signify a radical shift in the process of modernization, whereby reason and the pursuit of knowledge for its own sake were valued over and above that of superstition and tradition; rather, the nature of society in the middle of the twentieth century suggested that very little had changed. In this sense, they argue that the approach to rationality credited with overcoming the limitations of pre-Enlightenment society is responsible for new and diverse methods of social control that manage to exist with the support and encouragement of individuals (Bernstein 2001: 99). The size and scope of this project are indicative of its greatest flaw, as Horkheimer and Adorno confess in the preface of the new edition that aspects of the book are incompatible with later understandings of the historical context of truth (1994: ix). Yet there are aspects of this infamous text that still have much to offer.

Dialectic of Enlightenment developed a model for understanding society though an all-encompassing critique of society. The central notion of this critique involved the inconsisten-cies between the belief in the values of post-Enlightenment society as a liberating force and the reality of modernity's regulating and domineering presence in the lives of individuals. This regulation of social life occurs through the corruption of information or, more accu-rately, in the way in which information is used to influence human behaviour. As a result, the rationalized approach to reason defines progress through a civilization's ability to control and manipulate nature. Described as 'technocratic rationality', its success occurs through the ability to systematically regulate the world, thus nullifying the validity and accuracy of knowledge by favouring its potential for profit over its capacity for truth. This would not be such a significant problem if this knowledge were not taken for objective truth; and so with knowledge comes influence, and therefore power. The Enlightenment was not the end of myth, but a transition into a different kind of myth, whereby ideology could be presented as truth and the influence of various kinds of authorities becomes more coercive and more discreet.

The location of truth in this argument is considered to be its most central flaw; however, there have been a number of contributions to alleviate this inconsistency (Habermas 1984a; Bauman 1991). *Dialectic of Enlightenment* criticized the reliability of truth that grew out of tradition, history and culture. Instead it called for a reflective and enduringly critical approach

to knowledge through the unwavering dedication to the rules of logic and reason, free from bias and influence. What has been made clear through a variety of critiques, both sympathetic and merciless, is that this is simply not possible, or at least not as simple as Horkheimer and Adorno might have originally thought. The construction of a purified and independent use of knowledge would require a social element that is capable of understanding, and therefore resolving, the distortions of knowledge.[3]

Adorno: aesthetics and the culture industry

The result of this impasse directed Adorno towards a new phase of critical theory that would focus more directly on the distortions of knowledge in popular culture and, in doing so, move away from the philosophical roots of his earlier work. This era saw Adorno become the key figure of Frankfurt School critical theory as he continued to develop a radical and challenging social critique with texts such as *Minima Moralia* (1951), *Negative Dialectics* (1966), *The Authoritarian Personality* (1950), and a number of essays that would eventually form *The Culture Industry* (1991). The end of the Second World War did resulted not in the end of propaganda or of the powerful role of mass deception, but rather in the spread of highly coercive and homogenizing media throughout the world. Just as the Nazi government had used film and music to create conformity among their followers, Adorno believed that popular culture was spreading the ideology of free market capitalism and dramatic social inequality throughout the West.

Before discussing Adorno's critique of popular culture, it is important to understand the foundations of his thought as a critical theorist. In response to Horkheimer's use of reason as a liberating tool, Adorno strongly believed that reason and reality were irreconcilable. Therefore, he considered the inconsistencies or flaws of a society never to be fully alleviated through the use of reason, or through philosophical discourse in general. This is not suggesting that reason is of no use, but rather that, in order to make positive changes to society, one must understand that reason and reality will never perfectly line up. There is the suggestion of this understanding of reason throughout Adorno's work, but it became formalized in 1966 with the publication of *Negative Dialectics* (Buck-Morss 1977: 63). This can be seen as a critical response to philosophical idealism, through a strict application of critical or negative interpretations of society. Critical theory here is re-situated firmly into a position of analysis and critique rather than one that develops solutions that could resolve social problems. As a result, Adorno understood Horkheimer's work as somewhat moralistic, as he proposed new ways of living that would overcome injustice, whilst Adorno focused his concerns on the nature of philosophy and the plausibility of comprehending social problems. Yet Bernstein insists that throughout Adorno's publications there exists an ethical undercurrent that can be used to frame his otherwise grim notion of negative dialectics. Perhaps it would be more useful to think of Adorno's claims regarding the task for philosophers as a form of vigilant critique rather than as ethical advisors, thus leaving the job of navigating moral decisions to individuals. This approach shifts the task of philosophers from articulating the way in which individuals *should* live their lives to creating a set of conditions that would disperse the social distortions that make moral choices problematic. The cultural critique that Adorno developed throughout his career can then be read more sympathetically as a method of identifying sources of distortion in modernity.

Adorno describes a popular culture that encourages conformity and obedience through providing predictable and consistent media. If we consider music as an example, the common structure of a pop song can be seen as something that follows a somewhat strict set of rules

regarding time signatures, scales and arrangement. Whilst this might seem harmless, Adorno argued that the incredible popularity of these predictable songs was indicative of the dangerous brand of rationality that critical theorists are warning against. Through the repetition of these 'rules', listeners become comfortable with the recognizable and familiar nature of the song and begin to dislike songs that do not fit the mould. Furthermore, Adorno suggested that the predictable nature of the pop song allows the listener to envisage what will happen next, and then to feel clever for having the ability to do so. This creates a feeling of reward, despite the lack of real input to the challenge, and this inevitably encourages individuals to accept rather than challenge normativity. Consequently, aspects of popular culture that should be a haven for creativity and originality have become industries of strict regulation and order. This regulation of culture affects not only the objects of production but also the way in which individuals engage with society, by providing a normative structure for the way in which individuals are supposed to perceive a piece of music or a work of art. This inevitably affects the way individuals respond to other kinds of information about the world, such as that relating to news and politics.

However, this unrelenting critique of popular or mass culture has attracted notable criticism in regard to its perceived elitist attitude. Essentially, Adorno is making a bold and scathing criticism of the culture of common individuals, in favour of what could be seen as highly bourgeois tastes. He defends the modernist art that is seen by many as abstract and absurd, whilst criticizing music, film and art that may be simple and repetitive, but feels genuinely meaningful to the general public. Adorno must be questioned at this point: is it not possible that the individual is capable of simultaneously knowing that a song or television show is predictable and structured and finding aspects of it enjoyable? This touches on a much larger criticism about the role of autonomy and creativity among individuals and the potential oversimplification of their domination by the Frankfurt School; this will be discussed in more detail later in the chapter. For now, it is important to note that Adorno sees this as an example of how effective this kind of coercion really is. For Adorno, the normative standards imposed by mass culture have become so deeply rooted that individuals engage with cultural symbols sufficiently 'to buy and use its products even though they see through them' (Horkheimer and Adorno 1994: 167). The only way in which individuals can maintain any form of legitimate autonomy in modernity is through the perpetual critique of knowledge and the ongoing suspicion of various kinds of authorities.

Marcuse: one-dimensional man and the unconscious

Herbert Marcuse developed his integration of Marxist and Freudian concepts predominantly through his texts *One Dimensional Man* (1964) and *Eros and Civilisation* (1955). He put forward the view that modern culture not only has the ability to direct and limit an individual's behaviour, but also applies a reductive element to the otherwise complex nature of individuals. That is to say, it is far too simplistic to claim that critical theorists view the individual as easily manipulated or naïve, as the nature of modern society reduces individuals to a handful of consumer preferences and easily identifiable cultural signifiers. This perspective stands in contrast to the idea that individuals are no more than 'cultural dopes', vulnerable to manipulation, rather than enormously complex beings constantly having to resist the social pressure to become streamlined and categorized.

Perhaps Marcuse's greatest contribution to the field of critical theory is in regard to his integration of Freudian psychoanalysis into the principles of the Frankfurt School. He was certainly not the first to do this; Horkheimer and Adorno were beginning to integrate Freud

and Marx as early as 1927, and Fromm wrote substantially on Freud throughout the 1930s and 40s (Jay 1973: 88). However, Marcuse's use of Freud was unique and in contrast to thinkers such as Fromm due to his resistance to revisionist readings of Freud's work. Although both Horkheimer and Adorno had supported Fromm's revisionist interpretation of Freud in the 1930s, by the mid-1940s Adorno had called for a return to the original principles of psychoanalysis, and Marcuse's *Eros and Civilisation* (1955) became a defining text in this revival. Without dissecting the finer details of Freudian psychoanalysis, the need for an analysis of the inner workings of the individual is necessary for a grounded approach to critical theory. The incorporation of concepts such as repression and the unconscious into more traditional Marxist interpretations of society form a foundation for critical theory to work upon. If critical theory is to take seriously the notion that individuals are often blind to the social conditions that affect their knowledge, beliefs and behaviour, then some explanation of the way in which this occurs within the individual is necessary – although always considered within a social context.

The critical theory of Marcuse is a response to a radically different stage in modern history to that of Horkheimer and Adorno. Whilst the criticism of his predecessors was inspired by the atrocities of the Holocaust, Marcuse produced his most influential works during a time of unprecedented prosperity. And when Horkheimer and Adorno returned to Germany to re-establish the institute in 1953, Marcuse remained in the United States, where he became enormously popular among the student protests of 1968. Much of this popularity was a result of *One Dimensional Man* (1964), a text that reaffirmed the importance of critical theory to the radically different period of western development.

One Dimensional Man proposed that new forms of repression had developed through consumer culture, one that reinforced an ideology of obedience and an acceptance of the status quo. This form of repression is made unique by the extent to which participation is not only voluntary, but also somewhat idealized. Through the turning of wants into needs the consumer preferences of the individual become central aspects of identity construction, such that attempts at autonomy or liberation made by individuals develop into little more than consumer aspirations. In regard to the modern individual, Marcuse states,

> No matter how much such needs may have become the individual's own, reproduced and fortified by the conditions of his existence; no matter how much he identifies himself with them and finds himself in their satisfaction, they continue to be what they were from the beginning – products of a society whose dominant interest demands repression.
>
> *(1964: 5)*

Marcuse differentiates individual needs as being either true or false: false needs are artificial in that they are prescribed by social influences, whilst true needs reflect the motivations of an individual who has seen through the ideology of consumer culture. There is no doubt, however, that the task of distinguishing between true and false needs is neither simple nor always possible. The ability for modern culture to persuade the individual and distort knowledge is exemplified by the extent to which the satisfaction of false needs can be incredibly fulfilling.

This radical vision of liberation through a revolution of the self rather than a traditional revolution of overpowering the state was arguably the most notable idea to come out of the Frankfurt School. However, Marcuse was destined to struggle to convince a nation of Americans – living in a time of incredible economic prosperity – that their autonomy was in

fact severely limited, and that aspects regarding the construction of their identity were actually contributing to restrictions of their freedom. There is no doubt that Marcuse was aware of this problem (1969), and it is arguably still a problem for critical theory today.

Habermas: reason, truth and discourse

The contributions of Frankfurt School critical theory, up to this point, have been somewhat ambiguous in regard to how one might see through the distortions of knowledge and power in modern society – aside from the dedication to the pursuit of reason. Whilst there have been a number of theoretical approaches, it was Jürgen Habermas who first offered a systematic and practical application of critical discourse. Habermas collated almost twenty years' worth of work in the development of this idea to create what has become his magnum opus, *The Theory of Communicative Action* (1984), a mammoth two-volume book totalling over 1200 pages. There are a number of excellent publications available for a detailed analysis of the text (Honneth and Joas 1991; McCarthy 1990; Outhwaite 2009; Thompson 1981), and so here I will only provide a brief overview in order to contextualize Habermas's relationship with the first generation of critical theorists. Habermas is generally considered to be the leading member of the second generation of critical theorists, and, while he draws significantly from Horkheimer, there are some fundamental differences between his work and that of his predecessors. This shift is often referred to as the linguistic turn in critical theory: where the ongoing debate over truth as a subjective or objective phenomenon is deemed to be replaced by the idea that truth occurs within language.

This may seem to be a radical claim, but for Habermas there is a need to rethink the standard definition of truth as something that is socially constructed and developed, rather than a product of the individual or of the world. Perhaps another way to think of this unique approach is that the only means with which individuals are able to interpret and engage with truth is through communication. And so Habermas proposes a model for what he calls discourse ethics; this is the idea that truth can be realized through a process of discussion and debate whereby individuals must defend their differing perspectives with a strict dedication to reason and information. Without using excuses for exiting a debate such as 'Let's just agree to disagree' or 'This is what I think; it is how I was raised', individuals are capable of eventually reaching some form of consensus, and for Habermas this is as close to truth as we can realistically expect. This requires a redefinition of truth to some degree; truth is therefore a perspective that has successfully been defended against critiques, rather than a perspective that is immune to critiques. Something is true, therefore, only until it can be replaced by a superior explanation. The solution to resolving the significant and systematic distortions of information in modernity is therefore civic participation in discourse, whether it be political, moral or scientific. For Habermas, critique is an integral feature not only of liberation, but of knowledge itself.

The second volume of *The Theory of Communicative Action* provides a detailed analysis of what Habermas calls the clash between the lifeworld and the system. According to this view, the process of rational discourse contributes to the creation and maintenance of an intersubjective realm of meaning and values. Intersubjectivity can be thought of as Habermas's explanation of culture; it is essentially the metaphysical glue that holds society together. The experience of living among and engaging with intersubjective meaning is a thoroughly human process for Habermas, but he argues that the increasingly rationalized, regulated and homogenized nature of modernity results in a clash akin to trying to fit a square peg into a round hole. This approach to understanding the relationship between the individual and

society is reminiscent of Weber's critique of rationalization, whereby the approach of effi-
ciency and of productivity are considered to be ideals, not solely for the development of
capitalism, but also for social practices.

This thinking involves a crucial distinction in critical theory between reason and ration-
ality. In this sense, reason – for the most part – refers to the application of logic to mental
functioning, and the individual uses it in order to resolve false or inconsistent ideas. The
dedication to reason is attached to a belief in knowledge for the sake of knowledge, in an
attempt to overcome bias and dangerous ideologies. It is therefore essential to liberation in all
forms. Rationality on the other hand refers to the oppressive social systems that regulate,
monitor and homogenize human behaviour. This can be seen in Weber's iron cage of ration-
ality, or in Horkheimer and Adorno's critique of instrumental rationality. That is to say not
that there are no benefits to rational thinking but that the application of reductive, rational-
ized processes to aspects of human life, such as values and morality, is detrimental to the
autonomy of individuals. Therefore, in critical theory, reason has the potential to resolve
the problems of rationalism. Habermas therefore claims that 'rationality has less to do with
the possession of knowledge than with how speaking and acting subjects *acquire and use
knowledge*' (1984a: 8; emphasis in the original).

Principal contributions to the topic

Autonomy

Critics of the Enlightenment have vehemently suggested that the principles of liberty and
equality are inevitably irreconcilable. Frankfurt School theorists are certainly no exception to
this, as critique holds a unique position in regard to this contradiction. The influence of Marx
in critical theory has led to a clear theme of egalitarianism in the works of its major contribu-
tors. Yet, this form of equality is the result of the individual's access to meaningful autonomy
rather than an attempt to resolve inequality through social regulation by authorities. At the
risk of generalizing the varied perspectives within critical theory, there is an implicit ideal
among critical theorists that values the equal access to autonomy for all individuals as a means
to bridge this contradiction between liberty and equality. The relationship between critical
theory and the work of Marx can help to understand this approach better.

The unifying threads of social thought among critical theorists have less to do with specific
theories or ideas and more to do with a methodology of critique, as a means to strip away
aspects of social life that prevent individuals from seeing the true nature of modernity. This
particular perspective draws more from Marx's approach to autonomy than from his specific
teachings (Buck-Morss 1977: ix), and it is because of this approach that critical theory has
made great contributions in modernizing Marxism. The single greatest example of this is in
regard to the role of revolution in the process of creating a more equal society. For Marx,
revolution in the form of strikes, protests and demonstrations was not only an essential part of
meaningful social change, but an inevitable result of economic inequality. It goes without
saying that much has changed since Marx's time, and the Frankfurt School wisely cut ties
with orthodox Marxism in favour of a redeveloped model of social change. In particular,
Adorno was concerned about the potential of young Marxists to become as blinded by
ideology as those on the far right.

Marcuse's *An Essay on Liberation* (1969) puts forward an ambitious and powerful call for the
consideration of an understanding of autonomy capable of defying the problems of liberalism,
and uniting individuals rather than distinguishing them. From this perspective, Marcuse is

critical of the way in which autonomy becomes distorted into notions of individualism. Rather, autonomy must be thought of as the independence of one's thought, allowing for critique that is lively but also valued by society. Marcuse therefore defines autonomy as a binding mechanism in society. He explains: 'The form of freedom is not merely self-determination and self-realization, but rather the determination and realization of goals which enhance, protect, and unite life on earth' (1969: 46).

Yet this leads to a central theme among first generation critical theorists, a deep-seated scepticism regarding ideology as something that can overpower an individual's better judgement. Although Habermas was also concerned about the potential for ideology to systematically distort knowledge (this was a key factor in his infamous debate with Gadamer), Habermas is unique among critical theorists in that he offers a means not only to see through ideology, but also to find a way to replace it with something else. This substitute is not another ideology but a process of legitimation that allows for reflexive and malleable systems of meaning to be developed at a grassroots level and then adopted at all levels of society.

Conflict

This line of thought raises an interesting point in regard to the role of conflict in modernity. Whilst Marx discussed the role of internal class conflict as a way to prevent a revolt from the working class, critical theorists concluded that conflict is not only unavoidable but necessary in order to create positive social change. To some degree, the problem with the growing middle-class affluence that Marcuse identified in the United States in the postwar era was the way that it made individuals *too* comfortable. Conflict is a natural response to inequality and therefore it is a necessary stage in motivating individuals to demand change. A society without conflict is a society without critique, and this is a frightening prospect for Frankfurt School theorists. For example, in Habermas's model of rational discourse, conflict is an essential part of the process of determining the accuracy and relevance of ideas, whilst weeding out the claims that are no longer beneficial.

The subsequent shift away from the institute's Marxist roots in the 1940s was indicative of a substantial shift in the role of conflict in critical theory. This is essentially a transition from thinking of conflict as existing within class structures, or between the 'haves' and the 'have nots', to an interest in the conflict between the individual and nature (Jay 1973: 256). This is a conflict within modes of self-understanding that exists beyond the scope of capitalism and the present state of class structure, and it signifies something quite significant in this turning point in the institute's development. Rather than the conventional Marxist approach of understanding society through an analysis of class structure and capitalism, in this later phase of critical theory capitalism becomes just one aspect of a larger theory of society.

Idealism and realism

Among the theorists associated with the Frankfurt School, there is a crucial distinction between what could be called critical idealism and critical realism. Put simply, this disagreement speaks to either the cynicism or the optimism that results from viewing the world through a critical lens. For example, Horkheimer could be seen as a critical idealist due to his belief in reason as a liberating force and his optimism regarding interdisciplinary studies of society. Adorno, on the other hand, described the process of liberation from repressive forces to be more of a losing battle and saw the individual as somewhat permanently exposed to forms of manipulation (i.e. the culture industry). For Adorno, the idea that individuals could

eventually become totally autonomous was simply not plausible and therefore the work of critical theory is never complete. Perhaps the most idealistic among the critical theorists is Jürgen Habermas. The model of rational discourse put forward in *The Theory of Communicative Action* has been criticized widely for its idealistic view of consensus and the potential for the purification of language. Yet it raises a rather interesting question within the project of critical theory. Present day theorists such as David Couzens Hoy have suggested that if the project of rational discourse fails to reach a perfect consensus among all members of society then it is a failure in its entirety (Hoy and McCarthy 1994). That is to say that Habermas's idealism is the most problematic aspect of his theory. The question here is: to what extent should technical or practical problems be put aside on the basis that a theory is making positive social change? For example, if a model of communicative action is applied to a problem and there is some doubt that people have fully adopted the communicative requirements necessary to overcome irrational beliefs, and yet the resolution is positive and effective, then is communicative action technically a failure? This speaks to a fundamental disagreement over the aspects of a theory that determine its adequacy: essentially, whether is it perfectly consistent and logical or whether is it capable of creating positive resolutions to social problems.

Knowledge

Knowledge itself plays an interesting role in the development of critical theory, in that knowledge is defined in neither subjective nor objective paradigms. Rather knowledge itself is a culturally defined social construction. Whilst this may seem to be an abstract claim, reliable knowledge is made possible through a process of critique. This shifts the definition of truth from a statement that cannot be falsified to a statement that has been successfully defended from all criticism. Critique, therefore, enables knowledge rather than simply attacking it. Habermas takes this idea a step further and argues that critique itself is a thoroughly unique form of knowledge. He suggests that there are three kinds of knowledge: knowledge as belief, where evidence is predominantly based upon faith; knowledge through the scientific method (and he includes philosophical discourse within this); and finally, knowledge as critique (Habermas 1963). This final version is unique because, unlike the two ideas prior, the element of truth in a critique can only be discovered if acted upon. A scientific claim is true so long as there is sufficient evidence, regardless of whether people believe the idea to be true or relevant. Critique must be acted upon in order to become true and therefore is a radically different kind of knowledge from other forms of social analysis.

The way in which the study of knowledge has been utilized in critical theory varies among the predominant theorists. Critical theorists have adopted a range of vastly different methods of understanding knowledge, from somewhat positivist studies to the analysis of hermeneutics. Despite often being critical of both schools of thought, critical theory has a tendency to avoid siding with any particular thread of social analysis in order to remain independent from tired or outdated modes of thought. In Horkheimer's original description of critical theory, empirical social research was to play a part in developing a rich understanding of society. Adorno's sheer intolerance for empiricism virtually demolished this vision during the 1940s, yet his study in *The Authoritarian Personality* (1950) was arguably an empirical study. This may seem hypocritical, but it reflects the independence of critical thought as a field that employs the best means for research available at the time, and with specific regard to the question at hand. For the most part, critical theory has been fundamentally opposed to positivism as a means to understand the world, due to the idea that knowledge that transcends human interpretation is possible. The scepticism surrounding the potential for scientific knowledge

to overcome the biases of perception and interpretation often makes the idea of empirical social research untenable from the perspective of critical theory.

The most radical opposition to critical theory on the matter of knowledge comes from the field of pragmatism. Aside from Habermas's unconventional adaptation of pragmatics in his later work, the opposition to pragmatism in critical theory is virtually unanimous. Horkheimer described pragmatism as the theory of non-theory, as it rejects philosophical concerns whilst at the same time justifying an otherwise groundless model of instrumental rationality.

Main criticisms

The often radical and controversial nature of the arguments put forward by the Frankfurt School critical theorists has attracted considerable criticism over the years. This section will identify three of the most important angles of critique, as well as consider the potential defences for such critiques.

Cultural dopes and the role of creativity

There are two central aspects of this recurrent critique: the first is in regard to the high value placed on reason as a devaluation of the importance of emotional states and creativity; and the second refers to an under-appreciation of the individual's ability to see through the limitations of their autonomy. The first point identifies a potential contradiction in the work of Horkheimer, as he calls for the application of reason to the problems created by rationalization; yet the individual is more than a purely rational agent. Instead, the individual is a complex culmination of emotional states, knowledge and cultural influence, and to suggest that reason must be the most aspirational aspect of the individual is to reduce them to something deeply rationalized. This, however, reflects an oversimplification of Horkheimer's application of reason. Reason is not the greatest aspect of humanity, nor is it something that the individual should aspire to in every aspect of life, but rather it is a way of seeing through complicated problems and it is capable of determining resolutions. The blurb for *Eclipse of Reason* clearly states that

> If by enlightenment and intellectual progress we mean the freeing of man from superstitious belief in evil forces, in demons and fairies, in blind fate – in short, the emancipation from fear – then denunciation of what is currently called reason, is the greatest service reason can render.
>
> *(1947)*

It is in fact the destruction of this kind of one-dimensional reason that Horkheimer is calling for – ideally, reason would not be necessary as a means to escape from forms of social repression, but to think of the world in such a way would be naïve and foolish.

The second aspect of this critique relates to the extent to which individuals can reflexively engage with contradictory ideas in a creative and meaningful way. This is central to the critique of Adorno's conception of the culture industry and refers to the potential for oversimplification in understanding the role of the individual in critical theory.

Elitism in Adorno's culture of industry thesis

The premise of Adorno's critique of popular culture seems somewhat non-controversial. This is the idea that the music commonly associated with mass culture has been deeply

commodified by what he calls the culture industry. Where his argument becomes controversial is in the distinction between music that is genuine, meaningful and sincere and music that provides a mere aesthetic of validity whilst acting as a vessel for the interests of cultural or economic authorities. The controversy here is in regard to the individual's apparent inability to make this distinction and the questionable tactics of cultural authorities that are able to make a particular piece of music popular or unpopular. There is of course a greater application of this idea in areas of life beyond music, yet it serves as an interesting example of how preferences that are deemed to be one's own can be directed and distorted by industry. Adorno uses the example of the radio station to show this point by arguing that the songs selected for play by a radio station only appear to reflect the preferences of its listeners, when in fact it is the radio station that creates trends and therefore creates demand for the product. Popular music is therefore capable of encouraging conformity, as it entertains the listener without challenging them or motivating them to assess the song or its message critically. There is no doubt that the use of music and film as propaganda during the Second World War was highly influential in the development of this argument, yet Adorno's concern was by no means limited to that era.

Adorno's solution to this homogenization and commodification of art into entertainment was to reject popular music in favour of more experimental and unpredictable genres. This blanket rejection of popular culture in favour of very specific genres of jazz and modern art resulted in a range of criticism centred on Adorno's apparent elitism. There is something very interesting in this opinion, whereby Adorno underestimates the ability of an individual to enjoy something without being coerced by it, or at the very least, the ability to enjoy a song whilst knowing that it is not challenging or truly engaging. If critical theory takes too seriously the idea that an individual may be persuaded without their knowledge or that knowledge can be systematically distorted, the individual is somehow helpless on all fronts. The struggle for autonomy in critical theory should not be mistaken for a lapse in autonomy overall, but rather a project in understanding the faults of a society through critique.

The intractability of Habermas's discourse ethics

The radical notion that the potential for truth lies in the act of speech has been the subject of considerable criticism since Habermas published *The Theory of Communicative Action* in 1981, although this was not the first time that Habermas had been criticized for the impracticality of his ideas.[4] The criticisms of communicative action, however, are more relevant to the matters discussed in this chapter. Because of the vast range of critiques available, this section will focus on two distinct critiques: first a critique of the functionality and consistency of the theory by Anthony Giddens, and then a feminist and humanist critique from Seyla Benhabib.

Giddens (1987: 243) draws attention to the inconsistencies between Habermas's earlier work in *Knowledge and Human Interests* (1968), where knowledge is seen to be the result of interests, and his later work on communicative action, where knowledge is the result of action. In this transition, the crux of Habermas's argument is at risk of being lost in a seemingly endless array of terminology that seems to be swamped by the task of tying up the loose ends of the theory. There is also a problem regarding the role of rationality in communicative action that is indicative of a larger contradiction within Habermas's work. A simplified view of the communicative action thesis could suggest that Habermas is trying to resolve the problems of rationality by implementing an elaborate system of rationality in the form of discourse. Giddens is doubtful that Habermas's particular use of rationality is capable of surviving the inevitable problems that an emphasis on rational thinking can cause. Discourse ethics may in

fact result in the opposite of its intention, in that it may further reinforce the process of rationalization in modernity. This notion echoes the critiques of Horkheimer in the previous section, and the response can be much the same. The ceaseless dedication to reason as a liberating force from the bounds of rationality is an essential aspect of communicative action, as the ability to use reason to navigate a way around myth is a key function of critical theory.

Benhabib (1992) forms a critique of Habermas's discourse ethics with the intention of reviving discourse ethics rather than dismantling it. The key to her unique position involves a relinquishment of the rationalistic principles of communication action, whilst trying to retain the potential for universalism as a social project of discourse. The key to doing this is the acknowledgement of community, gender and postmodernism in the development of discourse ethics. For Benhabib, the individual is oversimplified in Habermas's model. The social aspects of an individual that influence their values, morals and emotions cannot be stripped away in favour of some kind of pure rationality, but rather they must be adopted into the theory in order to involve the individual adequately in democratic processes.

Benhabib puts forward a version of discourse ethics that considers the individual to be not just a collection of ideas, but a culmination of perspectives that are sourced from a variety of experiences. The process of rational thinking cannot be separated from the emotional stances of the individual, and so she presents a model for 'enlarged thinking' that intends to incorporate a more realistic understanding of the individual into rational discourse (1992: 9). Benhabib makes a seemingly minor, yet crucially important, distinction in the process of rational discourse between an individual deciding on a moral position and then defending it through discourse and an individual pre-empting the need for consensus and allowing that to influence their decision. This shifts the somewhat troublesome need for absolute consensus in Habermas's theory towards something more practical. Yet this is a step further into the realm of critical idealism over the critical realism of many of Habermas's detractors. Such a perspective also acknowledges the significance of context in the development of a particular view without unduly considering this process to be predominantly individualized.

Why the area is still important and the future of critical theory

The third generation of critical theorists offer a range of approaches regarding the potential for critical theory today. Although there is a tendency among modern critical theorists to move away from the rationalistic approach of Habermas, the justifications for the return to the principles of first generation critical theory are varied. The subject matter is equally diverse, although one should remember that it is a methodology of critique that unites these theorists rather than a specific subject matter. Just as there were significant stylistic differences between Horkheimer and Adorno within the first generation, the third generation has arguably returned to a debate over the importance of reason and truth. This section will consider the work of Honneth as an example of the revival of Horkheimer's approach to reason, while the recent work of Kompridis can be seen as a revival of the cultural critique of Adorno. It will also consider the work of Wellmer on the construction of truth and Whitebook on the matter of psychoanalysis in critical theory today.

Arguably the most substantive contributor to this third generation has been Axel Honneth, the current director of the Institute for Social Research in Frankfurt. Honneth seeks to reinvigorate the role of reason in the project of critical theory without reducing the complexity of social life and human behaviour to rationalized dissections of communication. He draws significantly on Horkheimer in order to develop a more positive understanding of critique, such that the quality of life for modern individuals can be improved through a critical analysis

of society. The key to Honneth's approach is the need for recognition as a means to tie together the critical analysis of social life with a normative understanding of what is necessary for the acquisition of autonomy. In this approach Honneth proposes three key notions that could improve the relationship between the individual and society under the terminology of love, rights and solidarity. He combines aspects of Hegel and Mead in order to resolve matters of disconnection for the individual, both from themselves and from society, while recognizing the inevitable role of conflict in social life. In fact, conflict becomes a means for the development of normative social structures. Therefore, the use of reason in modes of critique can lead to better suited applications of self-understanding, and this requires a meaningful analysis and justification of our personal relationships, our access to rights and the recognition that individuals attain from others (Honneth 1995: 92). This perspective is further developed in *Disrespect* (2007), where Honneth expands upon the importance of the humiliation of the individual in the project of critical theory. The denial of autonomy, the distortion of knowledge and the manipulation of reason all contribute to a feeling of disrespect for individuals that alienates them from meaningful social processes.

This approach has not been immune to criticism, with the most notable critique occurring in Honneth's debate with Nancy Fraser. Fraser disputes the legitimacy of a normative political theory developed through critique in that she does not believe that critique can draw conclusions regarding the good life. To propose alternate models for how society 'ought' to be could be seen as contrary to the nature of critical theory, in which the task at hand was traditionally a process of evaluation. Yet Fraser does consider the matter of recognition to be a question of justice, and so she manages to sidestep the problem of constructing good life claims by focusing on equal access to the notion of recognition described by Honneth (Fraser 2001: 26). It is worth noting, however, that although Habermas was opposed to the idea that critical theory was capable of contributing to an understanding of the good life, this approach is generally accepted among the third generation. That is to say that the application of reason and critique can, according to modern critical theory, lead to a more utopian approach to social change.

In response to this regeneration of reason there has been a call for a return to the critique of culture and aesthetics that is most commonly associated with Adorno. Nikolas Kompridis has put forward such an argument in *Critique and Disclosure* (2006), which critiques Habermas for his rationalism and champions a revival of Heidegger's notion of world disclosure as a means to understand the individual's relationship with society better. According to Kompridis, this notion of disclosure in critical theory as a means of understanding, knowing and describing the world is not some kind of linguistic other to reason, but rather an integral part of reason itself. There is an element of romanticism commonly associated with some of the early Frankfurt School texts in Kompridis's work, in that there is considerable doubt over the reduction of human behaviour to rational principles. In reference to the loss of romance in the pursuit of reason, he writes,

> We are more inclined to associate the 'romanticism' that fuels such projects with irrationalism and the metaphysical yearning for absolutes than with the idea of human emancipation and flourishing. In effect, what we have witnessed during the course of the last century is the drain of utopian energies from the idea of reason.
>
> *(2006: 92)*

Kompridis has attracted some criticism within the third generation of critical theorists for this call to reconsider the value placed on reason among human subjects. María Pía Lara (2008:

269) argues that although Kompridis manages to show some of the flaws in Habermas's framework, he falls well short of being able to provide a theory that is capable of taking its place. Amy Allen (2011: 1025) proposes that the influence of relationships of power poses a significant challenge to Kompridis's model of disclosure, as interaction with the social world is not free form but constantly encouraged or restricted by systems of power. There is not sufficient space here for an in-depth analysis of these critiques (see also Schoolman 2011; Rush 2011; and for the detailed response to these criticisms Kompridis 2011). Yet it is crucially important to note that critical theory today is as internally critical as it is outwardly critical, and that this dedication to ceaseless interrogation is as much a part of modern critical theory as it was for Horkheimer and Adorno.

A further contribution that seeks to develop the arguments of Horkheimer, Adorno and Habermas can be found in the work of Albrecht Wellmer. Although Wellmer's major contributions to critical theory trace back to the late 1960s (*Critical Theory of Society*, 1971, is of particular interest at this point), his more recent works that address the disputes over the nature of truth in modernity place him among the third generation of critical theorists. In 'Truth, contingency and modernity' (1993), Wellmer seeks to implant his own theory of truth and validity claims in contrast to the potentially metaphysical positions of Habermas, Apel and Putnam, and the arguably relativistic position of Rorty (Wellmer 1993: 110). For example, Habermas argues that his model for discourse ethics has the potential to develop truth claims that are beyond the constraints of cultural norms, whilst Rorty disputes the extent to which this is possible and puts forward a more pragmatic approach to understanding truth. The nature of this discord is related to the role of idealized forms of discourse, and whether the possibility of ideal processes of communication is either plausible or implausible. For Wellmer, however, the distinction between truth and what he calls 'rational acceptability' can be understood as being either weak or strong and, if the former is adopted as a means to understand the connection between ideal truths and the world as it is experienced by individuals, then there is the potential for a resolution of debates around the plausibility of objective knowledge (1993: 111). Wellmer explains:

> The view that I am propounding here is that the validity of moral norms only stretches as far as the validity of the moral judgements that can be – not grounded, but – expressed through these norms. The norms themselves carry, so to speak, a situational index which binds them to the situations in which they have their origins.
>
> *(1991: 204)*

This notion could be thought of as a form of Habermasian discourse ethics, sans the programme of universalism that makes Habermas's work so difficult to defend. Furthermore, Lara (1998: 51) identifies that the major criticism of Habermas in Wellmer's work is in regard to the 'restrictive' nature of his model for communicative rationality, whereby the expressive nature of discourse is not fully recognized as a form of rational thought. The key here is finding stable ground between the extremes of objectivism and relativism, both of which are highly problematic notions in the field of critical theory.

In addition to the current threads in critical theory that can be traced back to either Horkheimer or Adorno, Joel Whitebook's work regarding writings of Marcuse and Freud can also serve as an example of third generation critical theory. For Whitebook, the relevance of critical theory – both today and in the future – depends on the reintegration of psychoanalysis as a central tenet of each generation of theorists. Perhaps the most significant aspect of Whitebook's approach is related to the notion of repression within the use of reason. If we are

to take seriously the claim that society is 'broken' and that the task of critical theory is one of diagnosis, there is the rather serious matter of how individuals who belong to the current broken system are to derive solutions that possess the potential for liberation. According to Whitebook, this problem can be understood through Freud's theory of repression, in which a form of self-censorship can prevent the individual from seeing new solutions to old problems. In *Perversion and Utopia* (1995), Whitebook draws upon Marcuse to suggest that it is potentially through our perversions (understood as circumstances where an individual fails to repress something) that new solutions can be found for the problems of critical theory.

Conclusion

Marcuse was right to suggest that at times when social life seems to be at its best there is the greatest potential for the distortion of knowledge and the limitation of autonomy for individuals. Yet critical theory today is as lively as it is relevant, and the ongoing discovery of new debates is as interesting as the range of new applications for critical theory, ranging from the study of history, education and literature to the study of politics and law. In times of civil unrest, from the pro-democracy uprisings in the Arab Spring to the Occupy movement all over the world, critical theory is ideally placed to consider the potential flaws in the construction of society and to encourage democratic participation among individuals. The somewhat defining notion of critical theory regarding the potential for distortions in knowledge and beliefs is perhaps more relevant today than ever before. The extent to which modern life is mediated by cultural constructions of meaning is unprecedented, and the pace with which change occurs among these constructions can be both liberating and constraining for the modern individual. The task for critical theory is therefore never entirely complete, and the future of the field is as crucial as its past.

Notes

1 It is worth noting at this point that the name 'Frankfurt School' was not adopted until Horkheimer and Adorno returned to Germany in the 1950s and re-established the school (Jay 1973: xv).
2 It is no surprise that the title of this article has also been translated as 'The *death* of reason'.
3 The role of tradition and ideology in the discovery and application of knowledge has since become the subject of a rich and complex debate, most notably between Habermas and Gadamer. See Ricoeur (1990), Habermas (1990) and Gadamer (1990).
4 His earlier work on the public sphere attracted a number of feminist critiques due to his reduction of equality to 'equal among white males'. His description of an all-encompassing public sphere was anything but this. Yet this critique of Habermas is not entirely damning, and there is a need to highlight the importance of Habermas's idealism before disregarding his thesis altogether. Whilst it is fair to say that Habermas's division of the public and private spheres is largely based on a gendered division of labour, his example of eighteenth-century English coffee houses as hubs of democratic participation does show an unprecedented level of equality in terms of class. This particular example of public discourse from *The Structural Transformation of the Public Sphere* (1962) may not have been perfect, but it did indicate a radical step towards a less class-based model for democratic participation.

References

Adorno, T. (1991) *The Culture Industry: Selected Essays on Mass Culture*, London: Routledge.
Allen, A. (2011) 'The power of disclosure: comments on Nikolas Kompridis' *Critique and Disclosure*', *Philosophy and Social Criticism*, 37(9): 1025–31.
Bauman, Z. (1991) *Modernity and Ambivalence*, New York: Cornell University Press.

Benhabib, S. (1992) *Situating the Self*, New York: Routledge.

Bernstein, J. M. (2001) *Adorno: Disenchantment and Ethics*, Cambridge: Cambridge University Press.

Buck-Morss, S. (1977) *The Origin of Negative Dialectics*, New York: Free Press.

Fraser, N. (2001) 'Recognition without ethics?', *Theory, Culture & Society*, 18(2–3): 21–42.

Gadamer, H. G. (1990) [1971] 'Reply to my critics', in *The Hermeneutic Tradition: From Ast to Ricoeur*, ed. by Ormiston, G. and Schrift, A., New York: SUNY Press.

Giddens, A. (1987) *Social Theory and Modern Sociology*, Stanford, CA: Stanford University Press.

Habermas, J. (1963) *Theory and Practice*, Boston: Beacon Press.

—— (1972) [1968] *Knowledge and Human Interests*, London: Heinemann.

—— (1984a) [1981] *The Theory of Communicative Action, Volume 1: Reason and the Rationalization of Society*, Boston: Beacon Press.

—— (1984b) [1981] *The Theory of Communicative Action, Volume 2: Lifeworld and System: A Critique of Functionalist Reason*, Boston: Beacon Press.

—— (1989) [1962] *The Structural Transformation of the Public Sphere*, Cambridge: MIT Press.

—— (1990) [1971] 'A review of Gadamer's *Truth and Method*', in *The Hermeneutic Tradition: From Ast to Ricoeur*, ed. by Ormiston, G. and Schrift, A., New York: SUNY Press.

Held, D. (1980) *Introduction to Critical Theory: Horkheimer to Habermas*, Berkeley, CA: University of California Press.

Honneth, A. and Joas, H. (1991) 'Introduction', in *Communicative Action: Essays on Jürgen Habermas's Theory of Communicative Action*, ed. by Honneth, A. and Joas, H., Cambridge: MIT Press.

—— (1995) *The Struggle for Recognition*, Cambridge: Polity Press.

—— (2007) *Disrespect: The Normative Foundations of Critical Theory*, Cambridge: Polity Press.

Horkheimer, M. (1947) *Eclipse of Reason*, New York: Continuum.

—— (1982) [1941] 'The end of reason', in *The Essential Frankfurt School Reader*, ed. by Arato, A. and Gebhardt, E., New York: Continuum.

Horkheimer, M. and Adorno, T. (1994) [1947] *Dialectic of Enlightenment*, New York: Continuum.

Hoy, D. and McCarthy, T. (1994) *Critical Theory*, Cambridge: Blackwell.

Jarvis, S. (1998) *Adorno: A Critical Introduction*, Cambridge: Polity Press.

Jay, M. (1973) *The Dialectical Imagination: A History of the Frankfurt School and the Institute of Social Research, 1923–1950*, Berkeley, CA: University of California Press.

Kompridis, N. (2006) *Critique and Disclosure: Critical Theory between Past and Future*, Cambridge: MIT Press.

—— (2011) 'On *Critique and Disclosure*: a reply to four generous critics', *Philosophy & Social Criticism*, 37(9): 1063–77.

Lara, M. P. (1998) *Moral Textures: Feminist Narratives in the Public Sphere*, Berkeley, CA: University of California Press.

—— (2008) 'The future of critical theory', *Constellations*, 15(2): 265–70.

Lohmann, G. (1993) 'The failure of self-realization: an interpretation of Horkheimer's eclipse of reason', in *On Max Horkheimer*, ed. by Benhabib, S. *et al.*, Cambridge: MIT Press.

McCarthy, T. (1990) 'Introduction', in *Moral Consciousness and Communicative Action*, by Habermas, J., Cambridge: MIT Press.

Marcuse, H. (1972) [1955] *Eros and Civilisation*, London: Sphere Books.

—— (1964) *One Dimensional Man*, Boston: Beacon Press.

—— (1969) *An Essay on Liberation*, Boston: Beacon Press.

Outhwaite, W. (2009) *Habermas: A Critical Introduction*, Cambridge: Polity.

Ricoeur, P. (1990) [1971] 'Critique of ideology', in *The Hermeneutic Tradition: From Ast to Ricoeur*, ed. by Ormiston, G. and Schrift, A., New York: SUNY Press.

Rush, F. (2011) 'Reason and receptivity in critical theory', *Philosophy & Social Criticism*, 37(9): 1043–51.

Schoolman, M. (2011) 'Situating receptivity: from critique to "reflective disclosure"', *Philosophy & Social Criticism*, 37(9): 1033–41.

Thompson, J. (1981) *Critical Hermeneutics: A Study in the Thought of Paul Ricoeur and Jürgen Habermas*, Cambridge: Cambridge University Press.

Wellmer, A. (1991) *The Persistence of Modernity*, Cambridge: Polity Press.

—— (1993) 'Truth, contingency and modernity', *Modern Philology*, 90: S109–24.

Whitebook, J. (1995) *Perversion and Utopia: A Study in Psychoanalysis and Critical Theory*, Cambridge: MIT Press.

Structuralism and post-structuralism[1]

Sam Han

Introduction

The relationship between structuralism and post-structuralism has been widely misunderstood due to the way in which the ideas associated with both *isms* came into academic discourse. Part, if not the entirety, of the problem was the very fact that these two clusters of ideas (I hesitate to say intellectual movements) – the former a product of the 1950s and the latter of the 1960s–1970s – were lumped into what would in the 1980s and 1990s be known as 'postmodernism'. As structuralism and post-structuralism were, rightly or wrongly, known as the intellectual sources of postmodernism, hopes of a proper understanding in the English-speaking world would be all but jettisoned. Depending on one's intellectual allegiances and sympathies, postmodernism would be seen as either totally revolutionary or intellectual detritus, and with it structuralism and post-structuralism.

Total disdain and complete admiration are two sides of the same anti-intellectual coin. It is no way to give a proper and fair, or even critical, assessment of ideas. But there is at least one identifiable feature of structuralism and post-structuralism that has become a rallying point for many of its detractors. It is, as Charles Lemert writes, their 'specific commitment to the idea that language is necessarily the central consideration in all attempts to know, act, and live' (1997: 104), this linguistic emphasis being mostly drawn from the work of Ferdinand de Saussure. In turn, there was a unique consequence to this substantive and methodological focus on language: a certain inscrutable style of writing and argumentation. For instance, from the semiologist and psychoanalyst Julia Kristeva:

> In this way, only the subject, for whom the thetic is not a repression of the semiotic *chora* but instead a position either taken on or undergone, can call into question the thetic so that a new disposition may be articulated. Castration must have been a problem, a trauma, a drama, so that the semiotic can return through the symbolic position it brings about.
>
> *(2002: 45)*

Needless to say, reading this is tough going.

> The overall effect of the passage is to subject the reader so an insistence triply qualified, presented in the guise of an argument. It is not an argument that one can 'follow' along

a direct line of clear and distinct logical understanding. It is not a statement open to logical or empirical verification, but an invitation to enter a different, postmodern (that is, in 1966, poststructural) language within which one finds that everything is language. The argument which is not an argument is found only in a series of juxtaposed, different elements – conditional 'perhaps' proclamation, structuralism and poststructuralism/ continuity of structuralism, argument/insistence.

(Lemert 1997: 105–6)

This description, by Lemert, is interestingly *not* of Kristeva's but a passage from Derrida. Yet, it still works, as the point regarding the mode and style of argumentation in post-structuralism holds. There is not only a focus on language but a rigorous, and creative, *use* of language. This is reflective of what Lemert identifies as structuralism's wishing to 'destroy the ideal of pure, meaningful communication between subjects as a corollary to the disruption of the metaphysical distinction between subjects and objects' (Lemert 1997: 106). Therefore, language becomes a proxy to metaphysics. When language, so long considered to be the transparent 'tool' of human beings, is questioned, it 'invades the universal problematic', with the lesson being: there is no 'transcendent', 'grand, organizing principle', not limited to language but also including 'God, natural law, truth, beauty, subjectivity, Man, etc' (ibid.). Thus we can see the reason behind the grating feeling that structuralisms caused for many years among so many. It was a bold challenge to western thought's privileging of the individual subject and its ability to know itself.

In this chapter, key ideas and thinkers of structuralism and post-structuralism are discussed, analysed and overviewed. Beginning with the development and claims of structuralism, I discuss the work of Ferdinand de Saussure, Claude Lévi-Strauss and Roland Barthes, with an emphasis on how Saussure's structural linguistics influenced the structural anthropology of Lévi-Strauss and the semiology of Barthes. I then move on to post-structuralism, detailing the critique of Lévi-Strauss levelled by Jacques Derrida in order to make clear the differences, however slight, between the two structuralisms. I principally stress the theme of subjectivity, using the work of Jacques Lacan but also the 'authorship' discussions which took place between Roland Barthes and Michel Foucault. Carrying this theme of subjectivity, I then move on to critiques of structuralist and post-structuralist thinking, focusing on lines of thought that highlight the perceived anti-humanism of these perspectives. In this regard, I offer up the work of Manfred Frank and Anthony Giddens, two of the most judicious critics of structuralisms. The chapter then goes on to summarize some of the future directions of structuralist and post-structuralist theory in order to demonstrate its lasting prescience in various disciplines. But instead of outlining contemporary studies that draw from structuralism or post-structuralism, I look at some of the ways in which they have fuelled thinking in a variety of disciplines. I touch on the work of sociologist Scott Lash, media theorist Mark Poster and historian Hayden White as examples.

The historical and intellectual development of structuralism

Structuralism emerged in a very peculiar time in the postwar intellectual life of France. Sartre, for so long the utter embodiment of what it meant to be an intellectual, was accumulating challengers to his throne, including the liberal sociologist Raymond Aron and his one-time friend Albert Camus, who had distanced himself from Sartre after the latter's allegiance to the Communist Party even after the brutalities carried out under Stalin. But

Aron and Camus were mainstays in the French intellectual scene. They were frequent interlocutors for Sartre in the pages of various periodicals, newspapers and public forums.

With the figure of Sartre also comes the weight of his philosophy. Existentialism, along with Marxism, the two wells from which Sartre drew most frequently, were the main traditions of thought. Structuralism's emergence, as well as that of Claude Lévi-Strauss, its main articulator, was, in effect, a direct challenge not only to existentialism but also to the intellectual status quo of the time.

Structuralism differed from existentialism in important ways. Existentialism drew from phenomenology and inherited the latter's main analytic tool – consciousness. Structuralism, on the other hand, was inspired directly by the linguistics of Ferdinand de Saussure, effectively jettisoning the individual as the starting point of analysis for something Lévi-Strauss believed to be 'above' (or 'below') the individual – structure, as exemplified by language. (It could even be said that structuralism and post-structuralism are explicitly philosophies of language that extend far beyond the eponymous philosophical subfield, which in the analytic tradition goes back to Wittgenstein. They are intellectual moves that can be called what Richard Rorty (1992), in another context, called 'the linguistic turn'.)

Saussure's key insights in *Course in General Linguistics* (1966), collected and published post-humously by his students, consisted of two radical separations: (1) between *la langue* (language itself) and *parole* (speech) and (2) between words ('the signifier') and the things to which they referred ('signified'). The first separation was between *parole* and *langue*. *Parole*, for him, consists of the individual production of meaningful statements: in other words, the way language is put into practice as what are called 'speech acts'. *La langue*, however, is the system of language itself – its grammar, syntax and other rules – that individuals, when speaking or writing, draw upon passively (if one wishes to think of it that way), not engaging in the rule-making process themselves. *Parole*, therefore, can be thought of as heterogeneous, subject to individual interpretation, as is made clear by the varieties of patois and slang that are produced in nearly all languages. *Langue*, on the other hand, is homogeneous, systematic and rigid: in other words, *structured* and thus more open to study in a scientific manner.

Additionally, against the understanding of language as derivative of an innate relationship between word and object, Saussure suggested that the relationship between the signifier and signified was arbitrary. To put a twist on his famous example, the word 'tree', made up of the letters 't', 'r' and 'e', has no relationship to the object in the world. However, for those of us who are English-speaking, 'tree' nonetheless will create an image in our minds of that brown, usually vertical object with green leaves hanging from its limbs called branches. Hence, the relation between 'tree' (signifier) and a tree as existing in the world (signified) is constituted, reinforced and maintained *socially*. That is to say, this relation must be confirmed over and again in use with others. When they come together they form a sign. Language, the system of signs, is then rooted in a system of differences held tenuously together under the sign. Therefore it comes as no surprise that Saussure called his version of linguistics 'semiology' – the study of signs as they are used socially.

Saussure's ideas became popular in the postwar intellectual life of Paris, especially among literary scholars, who saw semiology as the basis of a new way of thinking about literature beyond the individual work itself, as part of a great web of texts. Among them was literary critic Roland Barthes, who was one of the first to adopt Saussure's ideas in the analysis of culture and literature. In two books, *Elements of Semiology* (1977) and his more widely read *Mythologies* (1972), which is appreciated largely as a prefiguring of cultural studies in the Anglophone world, Barthes attempted a popularization of Saussure's ideas. *Mythologies* in particular set out to accomplish this. Consisting mostly of short vignettes that would be

considered cultural criticism, the book culminates with 'Myth today', a more theoretically inclined chapter that argues for myth as a 'semiological system'.

By this, Barthes means that 'myth is a system of communication'. Hence, myth is not 'an object, a concept or an idea; it is a mode of signification, a form' (Barthes 1972: 109). The 'materials of myth', he notes, are already 'conveyed by discourse'. He writes: 'Myth is not defined by the object of its message, but by the way in which it utters this message: there are formal limits to myth, there are no "substantial" ones' (1972: 109). Alternatively, he describes myth as 'a newly acquired penury' which 'signification [fills]' (1972: 118). To explain this rather technical argument, Barthes, as he so well does, gives us a rather brilliant example:

> Take a bunch of roses: I use it to *signify* my passion. Do we have here, then, only a signifier and a signified, the roses and my passion? Not even that: to put it accurately, there are here only 'passionified' roses. But on the plane of analysis, we do have three terms; for these roses weighted with passion perfectly and correctly allow themselves to be decomposed into roses and passion: the former and the latter existed before uniting and forming this third object, which is the sign.
>
> *(1972: 113)*

In other words, the roses are already imbued with passion. The chain of signification is something that needs no voluntary effort on behalf of the giver and receiver of the roses because the work of myth is done through what Barthes calls 'a signifying consciousness'. It is this that allows for the 'very principle of myth' – the transformation of 'history into nature' – to operate successfully. Myth is a semiological system precisely because it is consumed 'innocently' as an inductive, causal process: 'the signifier and signified have', in the eyes of the myth consumer, 'a natural relationship' (Barthes 1972: 131).

While Barthes used Saussurian structural linguistics to analyze everyday mythologies such as the romanticism of roses, in anthropology Lévi-Strauss became the torchbearer of structuralism, beginning with his *Elementary Structures of Kinship* and reaching a boiling point with the publication of *The Savage Mind*. Lévi-Strauss's structural anthropology incorporated aspects of Saussure's semiology to analyze collective phenomena such as what was then called 'primitive religion', in particular the study of myth (Lévi-Strauss 1995). Myths, according to Lévi-Strauss, can be thought of as language. They are both made up of structural elements. While language contains morphemes, phonemes and sememes, myths contain what he dubs 'mythemes'. These units form relations with each other, to form binaries.

Myths are not cosmological explanations of universal, existential questions such as the nature of the universe, life, death and the afterlife, but something else. They exhibit, he argues, a structure much like that of language, since myths must be uttered and spoken. Like Saussure before him, Lévi-Strauss suggests two levels of myth: (1) as they are uttered and spoken and (2) as they are structured. In studying the structured, more rigid aspect of myth, its *langue* if you will, he argues that myths contain a similar structure across cultures, though varying in content, even modern ones. In a widely read essay titled 'The structural study of myth', Lévi-Strauss analyzes the myth of Oedipus, which of course holds a prominent place in western culture, not only as it was written by one of the most revered ancient dramatists, Sophocles, but also because it plays such a prominent role in Freudian psychoanalysis. Knowingly, Lévi-Strauss argues that the structural units of myth present in the Oedipal myth exist in myths of North American Indians, illustrating the presence of the family drama of Oedipus, more specifically the theme of parental attachment, in Zuni and Pueblo mythology. Thus, he argues that the structure of myths is universal, a markedly different position from

those of anthropologists who had treated so-called primitive societies' systems of cultural symbols as chaotic and unorganized.

We can summarize structuralism as not simply a 'turn to language' but as the reorienting of social analysis towards 'difference'. The key difference is of course between 'signifier' and 'signified', the separation of word and object. It is with this key insight into the instability, or the mythological nature, of language, and signification more broadly, that structuralism set itself up for its own structuralist dressing down by post-structuralists.

Major claims and developments of structuralism and post-structuralism

Post-structuralism was as much a radical break from structuralism as it was a logical outgrowth of it. It is, if anything, a critique of structuralism from within. Many commentators have called post-structuralism a 'structuralism of structuralism' (Frank 1989; White 1985). Hence, Derrida's landmark 'Structure, sign and play', which he delivered in Baltimore at Johns Hopkins University, is at once a pointed critique of Claude Lévi-Strauss's structural anthro-pology and an appreciation. Lévi-Strauss, in 1966, was still at the height of his intellectual powers. By then, not only had he occupied the chair once held by anthropologist Marcel Mauss at the Collège de France, one of the most distinguished academic posts any French intellectual could attain, but his book *Savage Mind* had been published and achieved critical success. At the time, Lévi-Strauss was *the* doyen of Parisian intellectual life, due in part to his devastating critique of Sartre, which, in effect, put the last nail in the coffin of existentialism's dominance by structuralism. Hence, to offer a critical reading of Lévi-Strauss, as Derrida did, was to attack the leading intellectual in France.

Derrida's essay critiqued the 'structurality' of structuralism, using the very linguistic theory of Saussure from which Lévi-Strauss drew. The basis of Derrida's critique of Lévi-Strauss is his concept of the 'centre', one of the most oft-used phrases of his writings. In spite of the aura surrounding the word 'deconstruction', which was, at first, Derrida's invocation of Heidegger's *destruktion*, and would later became a part of the popular lexicon, as some commentators have already suggested, Derrida's philosophy could be better described as 'de-centring'. 'Centre' is how Derrida explains the aspect of 'structure' that holds, in his estimation, the metaphysical tendencies of totality, presence and origin. 'The function of this center', he writes, 'was not only to orient, balance, and organize the structure . . . but above all to make sure that the organizing principle of the structure would limit what we might call the *freeplay* of the structure' (1978: 352). This centre that exists in all forms of thought in the western tradition, not just in structuralism, he goes on to argue, is disturbed by the introduction of linguistic analysis. Building on Saussure's insistence of the arbitrariness of the sign, Derrida writes:

> This moment was that in which language invaded the universal problematic; that in which, in the absence of a center or origin, everything became discourse – provided we can agree on this word – that is to say, when everything became a system where the central signified, the original or transcendental signified, is never absolutely present outside a system of differences.
>
> *(1978: 358)*

In both statements, Derrida is taking Saussure's earlier pronouncement of the arbitrariness of sign and radicalizing it to the point where he argues that reality itself must be scrutinized as part of language. By arguing that language allows viewing 'everything' as 'discourse', he is

prefiguring a later statement that he became quite famous for: 'There is no outside-text' (Derrida 1997: 158). (As we shall see below, it is this statement above others that caused most trouble for sceptics of Derrida and post-structuralism.)

Consequently, it is no surprise that his critique of Lévi-Strauss begins from what he views to be the 'centre' of the structure of myths – its supposed 'origin'. But as Derrida points out, even Lévi-Strauss acknowledges that myths do not have an absolute origin. They are passed down from generation to generation; there is no way to know who it was that started it. Hence, myths, for Derrida, are rather 'acentric' structures. In addition, Derrida also points out the rather totalizing nature of Lévi-Strauss's structuralist reading of myth. For Lévi-Strauss, mythical structures are ahistorical and universal. Though varying in content, the structure remains the same across cultures and linguistic groups, not to mention historical periods. For Derrida, this is a *misreading* of Saussurian linguistics, for, in effect, as the tenuous and rather arbitrary relation of the signifier and signified hints at, language 'excludes totalization', as it is a system of infinite potential connections. Derrida calls this element of language 'free play'.

> If totalization no longer has any meaning, it is not because the infinity of a field cannot be covered by a finite glance or a finite discourse, but because the nature of the field – that is, language and a finite language – excludes totalization. This field is in fact that of *freeplay*, that is to say, a field of infinite substitutions in the closure of a finite ensemble.
>
> *(1978: 288)*

'Free play' is in opposition to what Derrida refers to throughout his corpus as the 'philosophy of presence', which he considers to be a metaphysical remnant of Platonism. Presence, for Derrida, was an ideal in western philosophy that was at the root of the concept of being. To 'be' was to be 'here'. But Derrida views this to be disingenuous, as no entity can ever be fully 'present', especially in a system of representative differences such as that of *la langue*. The signifier, the word 'cow' for instance, does not conjure an actual beast when used by a speaker or when written on a page. There exists in every instance of signification, for Derrida, a contingent agreement of meaning that allows for communication built on a foundation of sand. The accomplishment of meaning is never a *fait accompli* but one that is reached tentatively, if looked at from the perspective of the numerous (or infinite) possibilities of the signifier.

> Freeplay is the disruption of presence. The presence of an element is always a signifying and substitutive reference inscribed in a system of differences and the movement of a chain. Freeplay is always an interplay of absence and presence, but if it is to be radically conceived, freeplay must be conceived of before the alternative of presence and absence; being must be conceived of as presence or absence beginning with the possibility of freeplay and not the other way around.
>
> *(Derrida 1978: 294)*

In this way, Derrida juxtaposes his reading of Saussure to Lévi-Strauss's, thus concluding that there are two approaches to structure – one based on the sign, the other based on free play. The former emphasizes 'the sign' as the centre, the privileged element of language. The latter, which he associates with his own approach, focuses less on the accomplishment of the positive identification of the signifier and signified in the sign, but wades in the tenuousness and arbitrariness of the system itself. Thus, Derrida's subsequent writings are full of double entendre, which was one of the major reasons why so many American scholars had such difficulty with his work.

The contributions of structuralisms

In this brief engagement with the differences between Lévi-Strauss and Derrida, I have attempted to draw out the principle themes of post-structuralism – centre, origin and totality. These three, though they are particular to Derrida's lexicon, do indeed point us towards some of the larger concepts utilized by post-structuralist thinkers. In particular, I wish to home in on post-structuralist understandings of subjectivity.

As mentioned above, structuralism and post-structuralism came in the wake of Sartre's existentialism. This is the case not only in terms of intellectual history but also substantively. To be clearer, I mean that structuralism and post-structuralism carry forth a critique of the model of subjectivity that is at the heart of Sartrean existentialism. To begin to unpack this claim, it must be noted that Sartre's orientation vis-à-vis subjectivity is influenced heavily by phenomenology, especially the Husserlian kind. While many critics and commentators of Sartre have highlighted the importance of Heidegger for his thinking – indeed this claim is accurate – Heidegger was in some ways a means for Sartre to get to a certain conclusion about the concept of 'intentionality'. In other words, Heidegger provided Sartre with a way of thinking through and beyond Descartes's dualism.

The Cartesian split is, of course, between subject and object, which differentiates not only the observer and the observed but also mind from matter. This is the famed dichotomy between *res cogitans* and *res extensa*. A result of this radical dualism is the analytic and methodological privileging of the subject. The subject, as in grammar, is the initiator of action. The object, to continue with the grammatical image, is the receiver of action. Hence, in Descartes, the subject maintains an advantaged position.

In Husserlian phenomenology, this translates into the 'epoche', or the bracket. According to Husserl, the proper way of practising phenomenology was to 'bracket' out the question of the existence of the natural world and the objects therein. Instead, the phenomenologist should turn his attention towards the structure of consciousness, that is, the experience of the world. Whether it 'exists' or not is of no consequence. He is to bracket the question of whether an object that we perceive exists outside of our conscious experience. He must remain focused on the subjective experience of the object, not the object itself. As a result, the subject is crowned as king of philosophical reflection. But the king must not be a mad king. The subject must retain stability. It must, in short, be identifiable. This in part means that the subject–object dichotomy must be held rigidly. If not, then the entire enterprise would crumble. This logic extends into social theory, especially its dominant conceptualization of 'the individual', which is most often the subject of consciousness.

One can find in the work of psychoanalyst Jacques Lacan arguments explicitly oriented towards the status of the subject, or in this case the Freudian 'ego' or, more properly, 'the I', made along similar thematic lines as Derrida.

In his 'Mirror stage' essay of 1949, Lacan offers a unique and radical theory of the infant development of the ego, arguing that the infant does not fully realize her body to be a unitary totality until she is able to see herself in a reflection of a mirror, or some other kind of reflective surface. It is only after this stage, he argues, that the child understands herself to be a total unit, an effect of identification with her *imago*, and thus attains the proper coordination of her limbs. 'It suffices', he writes, 'to understand the mirror stage in this context *as an identification*, in the full sense analysis gives to the term: namely, the transformation that takes place in the subject when he assumes [*assume*] an image' (2006: 76). Prior to this stage, the infant experiences her body as fragmented, as different pieces – an arm here, an arm there. But when she views what he calls her 'specular image' she begins to identify with it in all of its totality.

The specular image, which Lacan refers to as the *imago*, is an ideal I, a *representation* of the ego, not the ego itself. In fact, one of the major critiques that Lacan launches is of the 'I's mental permanence', so as to say that the 'I' does not exist prior to this encounter with its *imago*. This then assumes not only the *social* nature of the formation of the ego, but also that the I's primordial nature is necessarily fragmentary.

> [T]he mirror stage is a drama whose internal pressure pushes precipitously from insufficiency to anticipation – and, for the subject caught up in the lure of spatial identification, turns out fantasies that proceed from a *fragmented* image of the body to what I will call an 'orthopedic' form of its *totality* – to the finally donned armor of an alienating identity that will mark his entire mental development with its rigid structure.
>
> *(Lacan 2006: 78, emphasis added)*

Further, Lacan insists that the fragmentary primordial nature of the ego actualizes symptomatically in the appearance of disconnected limbs and exoscopical organs in dreams later in life. Indeed, what he is proposing is no less than a full reconsideration of the way in which identity is viewed, beginning with the Platonic equation of the psyche with the soul through Descartes's 'cogito', as beginning with the self, the I, the internal. But as he says, if he were to build strictly from subjective data to build his theory of the ego, then he would be 'lapsing into the unthinkable, that of an absolute subject' of the Platonic/Aristotelian tradition (Lacan 2006: 79). The moment of the encounter with the mirror, for the infant,

> decisively tips the whole of human knowledge into being mediated by the other's desire, constitutes its objects in an abstract equivalence due to competition from other people, and turns the *I* into an apparatus to which every instinctual pressure constitutes a danger, even if it corresponds to a natural maturation process. The very normalization of this maturation is henceforth dependent in man on *cultural* intervention.
>
> *(2006: 79, emphasis added)*

Lacan's dual emphasis on fragmentation and recuperation of alienation resonates with Derrida's, albeit chronologically later, scepticism towards notions of the centre, origin and totality. By suggesting that the infant experiences her own body as initially fragmented, Lacan is engaging in a de-centring project himself. Whereas Derrida's decentring involved moving away from the characterization of the relation of the signifier and signified under 'the regime of the sign', as he called it, Lacan's, however, is based on the definition of identity as unitary and total, which, judging from the term's current popular usage, remains. Therefore, Lacan concludes, the formation of the ego or the 'I' is a result of a 'misunderstanding' (*méconnaissance*). When humans form their 'sense of self' or identity, he suggests, they do so, in fact, in relation to an image and as a 'function of misrecognition' (2006: 80). At the heart of identity is, therefore, a void, a lack.

The 'empty subject' of Lacan is carried through in other post-structuralist thinkers. This is especially evident in the discussions on 'the author' that took place among those poststructuralists who had backgrounds in literary criticism, including again Barthes, but also Michel Foucault, though he was more of a historian. But history, along with literature, is an area in which authorship plays a crucial part in, among other things, interpretation and legitimacy. In two essays, 'The death of the author' (Barthes 1978) and 'What is an author?' (Foucault 1980), the authors seemingly engage in a debate of sorts on what authorship means in the wake of structural linguistics. But upon closer inspection, the points debated are just as

much about the status of identity and subjectivity in the wake of structuralism's discovery of the constitutive nature of language. It just so happens that Barthes and Foucault make their arguments with particular attention to literature.

One of the shared emphases is the historicization of the figure of the author in modernity. This functional demystification serves to throw a wrench into the dynamics of certainty, which tracing a set of words or a text back to an individual strives to maintain. As Barthes notes:

> [T]he author is a modern figure, produced no doubt by our society insofar as, at the end of the Middle Ages, with English empiricism, French rationalism, and the personal faith of the Reformation, it discovered the prestige of the individual, or, to put it more nobly, of the 'human person.'
>
> *(1978: 142–3)*

The connections between the figure of the author and the idea of the 'human person' are echoed by Foucault, who coined the term the 'figure of man', which he, inspired by Nietzsche, suggests emerged with modernity. Thus, the importance of the author in the culture has very little to do with actual authors but with what Foucault dubs 'the author function'. The author, as Foucault argues, emerges as a metaphor for the property-bearing individual, the hegemonic subject of the capitalist modes of production. As he writes:

> It is as if the author, beginning with the moment at which he was placed in the system of property that characterizes our society, compensated for the status that he thus acquired by rediscovering the old bipolar field of discourse, systematically practicing transgression and thereby restoring danger to a writing which was now guaranteed the benefits of ownership.
>
> *(1980: 108–9)*

Thus authorship is not merely the assignation of written text to a human individual, but a way of representing the subject positions that emerge in a particular socio-historical condition.

For Barthes and Foucault, there is evidence of the 'death' or decline of authorship. According to Barthes, linguistics has furnished an analytic instrument that demonstrates

> that utterance in its entirety is a void process, which functions perfectly without requiring to be filled by the person of the interlocutors: linguistically, the author is never anything more than the man who writes, just as *I* is no more than the man who says *I*: language knows a 'subject,' not a 'person,' and this subject, void outside of the very utterance which defines it, suffices to make language 'work,' that is, to exhaust it.
>
> *(1978: 145)*

Thus, a text does not 'release a single "theological" meaning (the "message" of the Author-God)'; rather, it is 'a tissue of citations, resulting from the thousand sources of culture' (Barthes 1978: 146). Foucault argues a similar point when he asks:

> What is a work? What is this curious unity which we designate as a work? Of what elements is it composed? Is it not what an author has written? Difficulties appear immediately. If an individual were not an author, could we say that what he wrote, said, left behind in his papers, or what has been collected of his remarks, could be called a 'work'?
>
> *(1980: 103)*

Barthes and Foucault raise two important points. For one, they both raise the issue of the explanatory power of the author in the interpretation of a text, or, more broadly, the 'work'. The text, within the idea of the modern author, is decipherable and enclosed. The work of the critic, in turn, is merely to discover 'the Author (or his hypostases: society, history, the psyche, freedom) beneath the work: once the Author is discovered, the text is "explained:" the critic has conquered' (Barthes 1978: 147). Against this author-centric text, Barthes argues for what he calls 'readerly texts'. Barthes again:

> [T]he unity of a text is not in its origin, it is in its destination; but this destination can no longer be personal: the reader is a man without history, without biography, without psychology; he is only that someone who holds gathered into a single field all the paths of which the text is constituted. This is why it is absurd to hear the new writing condemned in the name of a humanism which hypocritically appoints itself the champion of the reader's rights.
>
> *(1978: 148)*

Foucault echoes this also, describing the 'author function' in terms of power, specifically legitimacy. The author, specifically the *name* of the author, he argues, is metonymic of an entire discourse. The author's name provides legitimacy, or, better yet, *authority*.

> The author's name serves to characterize a certain mode of being of discourse: the fact that the discourse has an author's name, that one can say 'this was written by so-and-so' or 'so-and-so is the author,' shows that this discourse is not ordinary everyday speech that merely comes and goes, not something that is immediately consumable. On the contrary, it is a speech that must be received in a certain mode and that, in a given culture, must receive a certain status.
>
> *(Foucault 1980: 107)*

By moving from 'work to text', Barthes effectively decentres the author function. The work of decentring is, in many ways, as Barthes describes, 'counter-theological'. It is a refusal to 'arrest meaning' and so a refusal of a transcendental abstraction such as God, reason, science or the law (Barthes 1978: 147).

In this, there are clear overlaps with the famed 'incredulity to metanarratives' that Jean-Francois Lyotard pronounced in *The Postmodern Condition* (1984). Indeed, it must be mentioned that post-structuralism is often equated to, or even collapsed with, postmodernism. There are very sensible reasons for this. Post-structuralism, as just seen above, is largely a critique of structuralism using some of its own terms. This does very much imply certain assessments of some modern categories and ideas. But post-structuralism, that is, the writers and thinkers associated with it, does not overtly orient itself around 'debunking' the intellectual and political foundations of modernity.

Main criticisms of structuralism and post-structuralism

The debunking of metanarratives is part and parcel of the larger project of moving away from metaphysics, and its foundational intellectual categories. While Derrida has argued this most forcefully, due in part to his debt to Heidegger, who had already attempted a critique of metaphysics (Heidegger 2000), a case can be made to include Foucault, Barthes, Lacan and others as well. Of the many foundational categories of metaphysics, much of which has been

inherited from the Greeks, albeit translated through the Enlightenment, the one that has received most attention from structuralists and post-structuralists intending to 'demystify' it has been subjectivity, as can be seen in the discussion of Lacan, and especially the discussions of authorship. Subjectivity, thus, is also the major issue that critics of structuralism and post-structuralism have in the crosshairs.

Manfred Frank's *What Is Neostructuralism?* (1989), one of the most widely cited assessments of post-structuralism, while containing many criticisms of what he calls 'neostructuralism', hits Derrida, Foucault and Lacan hardest on this very issue. Generally, Frank's project is not only to explicate post-structuralism, which he does rather judiciously, but also to accuse it of 'antirationalism', a charge that has come from other theorists. One who comes to mind the quickest is Jürgen Habermas (1990). For Frank, and perhaps unlike Habermas, the tack he takes has to do with the unnecessary nature of the division between rationalism and its others. In fact, he suggests that the gap between rationalism and antirationalism is rather small and ultimately commensurable. Most interestingly, Frank puts forward the example of Friedrich Schleiermacher as one who was able to negotiate between the two.

Yet in spite of the conciliatory talk, Frank does have a fundamental beef with post-structuralist thinking, especially the position it stakes out regarding subjectivity. For him, the post-structuralists all too happily welcome the death of the subject. As Frank notes, '[b]ut it is one thing to explain the death of subjectivity as a result of the course of the world, and another thing altogether to greet it with applause, as Foucault does'.

> The factual is not already the true; a 'happy positivism' that dissolves this difference mimics, consciously or not, the dominating power. It is true that the individual disappears more and more in the 'code' (of the state, of bureaucracy, of the social machine, of all varieties of discourse), which has become autonomous. And it is also correct that a dead subject emits no more cries of pain. However, that interpretation that would like to extract a scientific-historical perspective from the silence of the subject, and which culminates in the gay affirmation of a subjectless and reified machine (à la Deleuze and Guattari), appears to me to be cynical.
>
> *(Frank 1989: 9–10)*

Moreover, Frank accuses this kind of position, which he attributes most frequently to Foucault, of not only 'nonmorality' (that is, a Nietzschean 'beyond good and evil' position) but even 'amorality'. Thus, for Frank, the task is to take seriously the 'diagnostic power of the talk about the death of the subject' without 'meanwhile lapsing into the opposite extreme of applauding the death of the subject on a moral level' (1989: 10). For instance, a tack that Frank takes is to argue that structuralism and neostructuralism, while talking a big talk, do not follow through in their subjectivity rhetoric. They rely 'explicitly or implicitly on the category of the individual'.

> Even the reified statement 'Language speaks itself' . . . has to employ reflexive pronouns that then hypostatize what was earlier considered a characteristic of the speaking subject as a characteristic of language or of the system itself. The subject that is crossed out in the position of the individual recurs in the position of a subject of the universal: this is a classic case of the 'return of the repressed.'
>
> *(Frank 1989: 10)*

While Frank argues methodologically (and historically), sociologist Anthony Giddens takes a different approach. For Giddens, the structuralist and post-structuralist assaults on

individualized, Enlightenment-derived notions of subjectivity, which we can call 'self-consciousness', are theoretically unproductive. This is especially true since this perspective tends to side too easily with what Pierre Bourdieu (1977) calls 'objectivism'. By this Giddens means that 'structure', for instance, too easily undermines the agency of the individual actor. In his 'structuration theory', Giddens suggests that

> Human social activities, like some self-reproducing items in nature, are recursive. That is to say, they are not brought into being by social actors but continually recreated by them via the very means whereby they express themselves *as* actors. In and through their activities agents reproduce the conditions that make these activities possible.
>
> *(1986: 2)*

This 'recursivity', which Giddens also calls 'reflexivity', goes against the 'objectivist' tendency of structuralism as well as the 'death of the subject' position of post-structuralism, both of which are reductive. On the one hand, structuralism rather simply equates human social activities to a singular set of mechanisms. On the other hand, post-structuralism does away with any explanation. Both, in the mind of Giddens, are misguided.

> We should guard against two forms of reductionism . . . One is a reductive conception of institutions which, in seeking to show the foundation of institutions in the unconscious, fails to leave sufficient play for the operation of autonomous social forces. The second is a reductive theory of consciousness which, wanting to show how much of social life is governed by dark currents outside the scope of actors' awareness [structuralism], cannot adequately grasp the level of control which agents are characteristically able to sustain reflexively over their conduct.
>
> *(1986: 5)*

Structuration theory, and its conceptualization of 'reflexivity', therefore allows for an understanding of human social action that includes both 'structure' and 'agency', to use two rather hackneyed though extant sociological terms. Agents, or individual actors, participate in the constitution of structures.

More importantly, for the present concerns, reflexivity occasions a new way of thinking about the subject beyond 'self-consciousness'. For Giddens, there is no doubt that all of social life is 'monitored' by the self. This monitored character, however, does not mean that terms such as 'purpose' or 'intention', 'reason', 'motive', and so on can so easily be accepted without any sort of critical modification. The usage of these terms has been, as Giddens rightly points out, 'associated with a hermeneutical voluntarism, and because they extricate human action from the contextuality of time-space' (1986: 3).

To remove, or decontextualize, human action would be to de-emphasize what Giddens calls 'practical consciousness', which 'consists of all things which actors know tacitly about how to "go on" in the contexts of social life without being able to give them direct discursive expression' (1986: xxiii). Practical consciousness plays a particularly important role in structuration theory, especially in the way it formulates the human subject. In acknowledging and embracing the subject's inability to articulate the rules and contexts that we may call 'structure', Giddens, largely influenced by psychoanalysis and Bourdieu, does not appeal to the human individual's ability to understand, via language or anything else, that which is 'structuring' his or her actions. This is a position that comes close to that of structuralism

in that it positions human action within a matrix of possibilities that are happening beyond the control of the individual subject. But there is a crucial difference. For Giddens, structures are not merely 'rules' or 'resources', as structuralism and post-structuralism would have it in their elision of structure as language. Is not language, he asks, 'embedded in the concrete activities of day-to-day life' (1986: xvi)? And thus, Giddens leads us to his definition of structure:

> Structure thus refers, in social analysis, to the structuring properties allowing the binding of time-space in social systems, the properties which make it possible for discernibly similar social practices to exist across varying spans of time and space and which lend them 'systemic' form. To say that structure is a 'virtual order' of transformative relations means that social systems, as reproduced social practices, do not have 'structures' but rather exhibit 'structural properties' and that structure exists, as time-space presence, only in its instantiations in such practices and as memory traces orienting the conduct of knowledgeable human agents.
>
> *(1986: 17)*

What distinguishes structuration from structuralisms of various kinds is not only his emphasis on practices and memory, *not* language, but the insistence that the human agents are knowledgeable and are *in on* the social processes that construct the environments in which they live. This 'knowledgeability' requires a *stable* entity called the subject. This stable subjectivity is what Giddens calls 'ontological security'. Ontological security is a sense of order in one's life. It expresses

> an *autonomy of bodily control* with *predictable routines*. The psychological origins of ontological security are to be found in basic anxiety-controlling mechanisms . . . hierarchically ordered as components of personality. The generation of feelings of trust in others, as the deepest lying element of the basic security system, depends substantially upon predictable and caring routines established by parental figures.
>
> *(1986: 50)*

Routinization is key here, especially as it relates to reflexivity, as it is the 'continual "reproving" of the familiar in circumstances of substantial ontological security' (Giddens 1986: 104). Hence, Giddens offers up 'a sense of place' as being of 'major importance in the sustaining of ontological security'. This is so, he argues, because of the 'psychological tie between the biography of the individual and the locales that are the settings of time-space paths through which the individual moves' (1986: 367). He goes on: 'Feelings of identification with larger locales – regions, nations, etc. – seem distinguishable from those bred and reinforced by the localized contexts of day-to-day life. The latter are probably much more important in respect of the reproduction of large-scale institutional continuities' (ibid.).

The importance that Giddens places on 'identification' looms rather large for his position vis-à-vis structuralism and post-structuralism. Identification is usually dealing with singularities: individual subjects identifying with individual places, notwithstanding differences in scope and scale in the examples Giddens provides (regions, nations, etc.). But post-structuralism, for the most part, views subjectivity to be a product of *misidentification*, as noted earlier with Lacan. For Giddens, this would harm ontological security. Giddens's reflexive subject is, at the end, a stable one.

Lasting importance and future developments of structuralism and post-structuralism

Today, principles of structuralism and post-structuralism have made their way into a variety of disciplines. They can be found in the continually widespread scepticism towards foundationalism and anti-essentialism across history, sociology, media studies and theology. This section will review some of the ways in which this has occurred along the lines of two recurring themes.

We can begin by returning to Giddens's 'ontological security'. In an article that assesses the 'reflexive modernization' thesis, most notably associated with the work of German social theorist Ulrich Beck and Giddens, sociologist Scott Lash offers a critique of the subject theory at the root of Giddens's 'ontological security'. Lying beneath Giddens's notion of 'ontological security', Lash argues, is a commitment to 'order', that is, 'how we can cope with . . . psychic and social hazards, and maintain reasonable levels of order and stability in our personalities and in society' (Beck, Giddens and Lash 1994: 117). Thus for Giddens the default setting, or normative mode, of the subject in the contemporary world is what he dubs 'rational individualism'. But, as Lash suggests, there are large-scale social transformations that have occurred that pose a challenge to such a view of subjectivity, particularly to one such as 'rational individualism' embedded in a strong subject–object dichotomy. This is especially so as the means of social formation have been recast by the rise of new technologies and media systems (Beck *et al.* 1994: 148).

The social analyst of new media technologies who has most productively theorized these changes in the context of post-structuralism has been the late Mark Poster. In *The Mode of Information*, Poster diagnoses a 'generalized destabilization of the subject' wherein 'the subject is no longer located in a point in absolute time/space, enjoying a physical, fixed vantage point from which rationally to calculate its options' (1990: 15). This has come to be thanks to 'changes in communication patterns', which, in turn, 'involve changes in the subject' (1990: 11). What has occurred with the rise of new media technologies is the intensification of the 'crisis of representation', in which

> words lose their connection with things and come to stand in the place of things, in short, when language represents itself. The complex linguistic worlds of the media, the computer and the databases it can access, the surveillance capabilities of the state and the corporation, and finally, the discourses of science, are each realms in which the representational function of language has been placed in question by different communicational patterns each of which shift to the forefront the self-referential aspect of language.
>
> *(1990: 13)*

With words separated from things (Poster's way of designating the arbitrary signifier of Saussure), there is inevitably a destabilizing effect on 'the rational individual or centered subject whose imagined autonomy is associated with the capacity to link sign and referent, word and thing, in short a representational function of language' (Poster 1990: 14). Moreover, in this context, it 'becomes pointless', as Poster states, 'for the subject to distinguish a "real" existing "behind" the flow of signifiers, and as a consequence social life in part becomes a practice of positioning subjects to receive and interpret messages'. Thus the mode of information puts into question how subjectivity looks, what form it takes or, as Poster says, its 'very shape' (1990: 15).

Beyond new media studies, structuralist and post-structuralist approaches can be found in the discipline of history, no better embodied than in the work of Hayden White. The

founding editor of *History and Theory*, a journal that did a lot in order to bring structuralist and post-structuralist perspectives to the attention of historians, White, in *The Tropics of Discourse* (1985), considered a classic in the discipline, provides the most distilled argument for the importance of these perspectives for historiography. In it, White makes a strong case for viewing 'historical texts as literary artifacts' and, in doing so, articulates something called *metahistory*, an approach to history that asks about the way in which historical evidence and explanations are constructed (1985: 81). It not only asks about how historians do what they do but also aims to 'demystify' it. If so inclined, we could even call it an 'anti-metaphysical', or decentred, approach to history. If that is the case, then it is necessary to see what aspects of mainstream historiography White critiques, in order to see the influence of post-structuralism on his thinking.

For White, the practice of history gains its explanatory power largely by 'making stories out of *mere* chronicles', a systematic operation of commanding authority and *authorship* through 'emplotment'. Emplotment is the encoding of 'facts contained in the chronicle as components of specific *kinds* of plot structures' (1985: 83). These techniques are, however, not so foreign, as they are reflective of the way in which scientific explanation works, as White notes. It is simply to 'familiarize the unfamiliar' by making 'sense of a set of events which appears strange, enigmatic, or mysterious in its immediate manifestations to encode the set of terms of culturally provided categories, such as metaphysical concepts, religious beliefs, or story forms' (ibid.). In historiography, 'data' are indeed foreign or strange 'simply by virtue of their distance from us in time and their origin in a way of life different from our own' (White 1985: 86). (This sentiment could also be extended to bear on other disciplines.) Quite simply, historians *translate* fact into fictions but do not like to think so. As White puts it:

> The evasion of the implications of the fictive nature of historical narrative is in part a consequence of the utility of the concept of 'history' for the definition of other types of discourse. 'History' can be set over against 'science' by virtue of its want of conceptual rigor and failure to produce the kinds of universal laws that the sciences characteristically seek to produce. Similarly, 'history' can be set over against 'literature' by virtue of its interest in the 'actual' rather than the 'possible,' which is supposedly the object of representation of 'literary' works. Thus, within a long and distinguished critical tradition that has sought to determine what is real and what is 'imagined' in the novel, history has served as a kind of archetype of the 'realistic' pole of representation.
>
> *(1985: 89)*

Otherwise stated, there is an investment in denying (or repressing) the fictive character of history because it operates so strongly in an epistemological capacity for other discourses, especially literature. Undoubtedly, the arguments made here are reflective of the previous discussion of Barthes and Foucault. For White, as with Foucault and Barthes, there is no attachment to the notion of the incrementality of knowledge, which science chiefly holds dear. 'Our knowledge of the past may increase incrementally', he writes, 'but our understanding of it does not' (1985: 89).

History, and historiography, is but a fiction. Yet, we must be careful not to misread the 'but' here. For White, to call something 'fiction' is in no way disparaging. Rather it is to come to grips with the reality of history; therefore to think of history as the imposition of a formal coherency on the world 'in no way detracts from it'. If it were to, then it would mean 'literature did not teach us anything about reality, but was a product of an imagination which was not of this world but some other, inhuman one' (White 1985: 99).

At the very least, we can see the influence of this type of approach to scholarship in the emergence of methodologies and theoretical stances that unabashedly blur the line between fiction and the social sciences/humanities. Stephen Pfohl, for instance, in *Death at the Parasite Café* (1992), writes a collage using various methods which he calls 'social science fiction'. A similar tack is taken by Avitall Ronell, a Derridean, in *The Telephone Book* (1991), which contains comics in addition to academic prose.

What is common in Pfohl and Ronell is the deployment of the first person. Pfohl, the sociologist, describes the kind of ethnography he writes as 'surreal'. 'It invites its readers', he writes, 'not so much to agree with the analysis set forth by its author, but to enter actively into the process of re-searching of one's own HIStorical and biographically given position' (1990: 428). This explains the highly stylized and unusual nature of his writing, especially in comparison with most other social science.

> This is the Parasite Café, a dark if brilliantly enlightened space of postmodernity where a transnational host of corporate informational operatives feed upon the digitally coded flesh of others. Here, bodies are being transferentially invaded and then extended outward into the consumptive networkings of media itself . . . This is the story of the postmodern. What are the social, historical, economic roots of a society of such immense material abstraction? How might the disembodied lure and seductive violence of such a society be subverted, diverted, or transformed? For me these are urgent questions. Why only this morning I found myself eating before the screen, or after, when suddenly my eyes/I's were transferred across the televisionary space of this our ungiving HIStorical present . . . 20 seconds into the future. This is a story of the violent rituals of an ultramodernizing first world culture. This is not a pleasing story to tell.
>
> *(1990: 424)*

Ronell similarly adopts the first person along with a unique (for academic writing) style. She begins an essay in the following manner:

> Please bear with me. I don't know how it started but when it happened, I got up and lit a cigarette, kind of serenely. The click was still resonating in my ear, the smoke crawled up to where it hurt. I had no image, just a sonic blaze in my head.
>
> When they hung up on me, it felt like an amputation. I got to thinking how it was by a thin thread that everything had been related. As long as they kept calling, contact was never really broken, nor was the break clean. This time it was over. I had heard the click, like a gun pointed at your head. Like I said, I got to thinking. About the amputation, to be exact. In a sense, it was a story about the invention of a body part. I had my ear trained on the telephone. I don't know where their voices went when I picked up the receiver, whether they were coming from elsewhere or coming from my insides.
>
> *(1991: 75)*

Though there remain restrictions on form as well as institutional factors, such as the increasingly precarious nature of tenure in North America and Europe, which results in the disciplining of academic writing in both substance and form, there is nevertheless a sign that a shift is under way in the way that academic writing reads and also is distributed. For instance, recent years have seen an uptick in journals and scholarly associations with websites as well as micro-sites, which straddle the line between 'formal' academic writing and 'less formal'

blogging. This not only allows for a quicker turnaround time for academics to engage with events on the ground, but it also reorients, and perhaps even reconstitutes, what theorizing is. It is undoubtedly the case that to make a direct link between structuralism and post-structuralism and shifts in the technological conventions of intellectualism is speculative; I would nevertheless argue that these developments could not have occurred without the structuralisms' rise. As academic discourse shifts along with new media, it will undoubtedly be the case that this trend will continue. While structuralism and post-structuralism may have injected their ideas and approaches into the work of researchers of many stripes, their most lasting impact may be of their no-holds-barred attitude towards overarching principles of any kind, not excluding those of the academy.

Note

1 This chapter contains elements of my chapter in Han (2011).

References

Barthes, R. (1972) *Mythologies*, London: Macmillan.
—— (1977) *Elements of Semiology*, London: Macmillan.
—— (1978) 'The death of the author', in *Image, Music, Text*, London: Macmillan.
Beck, U., Giddens, A. and Lash, S. (1994) *Reflexive Modernization: Politics, Tradition and Aesthetics in the Modern Social Order*, Stanford, CA: Stanford University Press.
Bourdieu, P. (1977) *Outline of a Theory of Practice*, Cambridge: Cambridge University Press.
Derrida, J. (1978) *Writing and Difference*, Chicago, IL: University of Chicago Press.
—— (1997) *Of Grammatology*, Baltimore, MD: Johns Hopkins University Press.
Foucault, M. (1980) 'What is an author?', in D. Bouchard (ed.) *Language, Counter-Memory, Practice: Selected Essays and Interviews*, Ithaca, NY: Cornell University Press.
Frank, M. (1989) *What Is Neostructuralism?*, Minneapolis, MN: University of Minnesota Press.
Giddens, A. (1986) *The Constitution of Society: Outline of the Theory of Structuration*, Berkeley, CA: University of California Press.
Habermas, J. (1990) *The Philosophical Discourse of Modernity: Twelve Lectures*, Cambridge, MA: MIT Press.
Han, S. (2011) 'The fragmentation of identity: post-structuralist and postmodern theories', in A. Elliott (ed.) *Routledge Handbook of Identity Studies*, London: Routledge.
Heidegger, M. (2000) *Introduction to Metaphysics*, New Haven, CT: Yale University Press.
Kristeva, J. (2002) *The Portable Kristeva*, ed. K. Oliver, New York: Columbia University Press.
Lacan, J. (2006) *Ecrits: The First Complete Edition in English*, New York: W. W. Norton.
Lemert, C. (1997) *Postmodernism Is Not What You Think*, 1st edn, Oxford: Blackwell.
Lévi-Strauss, C. (1966) *The Savage Mind*, Chicago, IL: University of Chicago Press.
—— (1969) *The Elementary Structures of Kinship*, Boston, MA: Beacon Press.
—— (1995) 'The structural study of myth', *New Studies in Aesthetics* 26: 85–96.
Lyotard, J.-F. (1984) *The Postmodern Condition: A Report on Knowledge*, Minneapolis, MN: University of Minnesota Press.
Pfohl, S. (1990) 'Welcome to the PARASITE CAFE: postmodernity as a social problem', *Social Problems* 37(4): 421–42.
—— (1992) *Death at the Parasite Café: Social Science (Fictions) and the Postmodern*, London: Palgrave Macmillan.
Poster, M. (1990) *The Mode of Information*, Chicago, IL: University of Chicago Press.
Ronell, A. (1991) *The Telephone Book: Technology, Schizophrenia, Electric Speech*, Lincoln, NE: University of Nebraska Press.
Rorty, R. (1992) *The Linguistic Turn: Essays in Philosophical Method*, Chicago, IL: University of Chicago Press.
Saussure, F. (2011) *Course in General Linguistics*, New York: Columbia University Press.
White, H. V. (1985) *Tropics of Discourse: Essays in Cultural Criticism*, Baltimore, MD: Johns Hopkins University Press.

4

Structuration theories
Giddens and Bourdieu

Anthony Elliott

Historical and intellectual development

The question of the relation between the individual and society, or individual subject and social structure, has been a core preoccupation of social theory. Broadly speaking, this question has been dealt with in most versions of social theory either by emphasizing the creative powers of the individual self or by stressing the determining role of social structures in our lives. That is to say, a dualism is evident in the very way in which the large bulk of social theorists have addressed the question of the relation between self and society. Conceptual approaches that pay particular attention to theorizing human agency and social actors have contributed a great deal to understanding how individual action and daily interaction are structured by broader social, political and cultural sources. Social theories influenced by symbolic interactionism, hermeneutics and psychoanalysis, for example, all allegedly fall into such 'subjectivist' categories. Yet while underscoring the importance of individual agency and personal life to social critique, such frameworks encounter serious problems in providing conceptions of institutional transformation or social structure. By contrast, conceptual approaches that stress the determining influence of social structures in our lives powerfully highlight the force of institutions in the production and reproduction of society. In such 'objectivistic' approaches within social theory, from functionalism to systems theory, there is a methodological break with the immediate experience of individual agents and a focus instead on the changing structural conditions of modern industrial societies. But, again, there are serious limitations here. One key limitation of 'objectivist' social theories is that, by according priority to structure over action, a deterministic flavour is accorded to the social world and the practical activities of the individuals who make up that world. Many social scientists argue that such determinism is especially evident in certain versions of classical social thought, for example in the writings of Durkheim and Marx, in which society often appears as a force external to the agent, exercising constraint over individual action.

In more recent versions of social theory, there have been new attempts to move beyond either 'action approaches' or 'structural analysis'. Considering anew the issue of how the actions of individual agents are related to the structural features of the society from which they spring, social theorists have sought to consider in more detailed ways how action and structure actually presuppose one another. As we will see throughout this chapter, this means that social scientists must seek to provide an account of the conditions and consequences of action as directly embroiled with structure.

In this chapter, I will concentrate on two major attempts in contemporary social theory to account for how reproduced practices have their own distinct structural properties. This approach in social theory is sometimes labelled structuration, and in what follows I shall review the seminal contributions of Anthony Giddens and Pierre Bourdieu.

Key contributors and criticisms

The social theory of Anthony Giddens

Anthony Giddens first came to international prominence in social theory with the publication of his first book, *Capitalism and Modern Social Theory*, which appeared in 1971. The book remains to this day one of the most referenced sociological textbooks on Marx, Weber and Durkheim. In examining the origins of classical sociology in *Capitalism and Modern Social Theory*, Giddens set out the rudiments of a project concerned to reinterpret the theoretical foundations of the social sciences – a project he steadfastly developed from his Durkheimian-titled *New Rules of Sociological Method* (1976) to *Politics, Sociology and Social Theory* (1995). In doing so, Giddens sought to develop some interesting sounding answers – indeed, quite novel answers – to questions that have long plagued social theorists seeking to grasp the complex, contradictory interactions of individual agency on the one hand and social structure on the other. An indication of the novelty of Giddens's approach to the self–society problem can be easily gleaned by looking at his magisterial book *The Constitution of Society* (1984). Regarded as one of the most important books since the grand sociological theorizing of Talcott Parsons, *The Constitution of Society* presented a whole new vocabulary for grasping the age of modernization: 'structuration', 'reflexivity', 'time-space distantiation', 'double hermeneutic' and 'ontological security', just to name a few terms Giddens introduced. Subsequent to *The Constitution of Society*, Giddens produced an astonishing range of books. His analysis of warfare, its new technologies and globalization, as developed in *The Nation-State and Violence* (1985), has been highly influential in political science and international relations. *The Consequences of Modernity* (1990) was Giddens's response to postmodernism, in which he argued that the West and the developed industrial societies were entering conditions of 'reflexive modernization'. And in *Modernity and Self-Identity* (1991) and *The Transformation of Intimacy* (1992) he addressed issues of the self, identity, intimacy and sexuality in the context of social transformations sweeping the globe.

My aim in what follows is to provide a brief overview of Giddens's writings in social theory. Given the broad sweep of his interests as well as his exceptional productivity, I have decided to concentrate on two specific aspects of Giddens's work, namely (a) structuration theory and (b) modernity and modernization as filtered through the lens of Giddens's theory of structuration. After examining Giddens's more substantive contributions to social theory, I shall turn to consider some of the issues raised by his critics.

Giddens's theory of structuration

In a series of books, principally *New Rules of Sociological Method* (1976), *Central Problems in Social Theory* (1979) and *The Constitution of Society* (1984), Giddens sets out a highly original conceptualization of the relation between action and structure, agent and system, individual and society. Broadly speaking, Giddens argues that it is not possible to resolve the question of how the action of individual agents is related to the structural features of society by merely supplementing or augmenting one emphasis through reference to the other. In an attempt to

move beyond such dualism, Giddens borrowed the term 'structuration' from French. The starting point of his analysis is not society as fixed and given, but rather the active flow of social life. In contrast to approaches that downgrade agency, Giddens argues that people are knowledgeable about the social structures they produce and reproduce in their conduct. Society, he argues, can be understood as a complex of recurrent practices that form institutions. For Giddens, the central task of social theory is to grasp how action is structured in everyday contexts of social practices, while simultaneously recognizing that the structural elements of action are reproduced by the performance of action. Giddens thus proposes that the dualism of agency and structure should instead be understood as complementary terms of a duality, the 'duality of structure'. 'By the duality of structure', writes Giddens, 'I mean that social structures are both constituted by human agency, and yet at the same time are the very medium of this constitution' (1976: 21).

Perhaps the most useful way to gain a purchase on the radical aspects of Giddens's social theory is by contrasting his conception of structure with the mainstream sociological literature. Sociologists have tended to conceptualize structure in terms of institutional constraint, often in a quasi-hydraulical or mechanical fashion, such that structure is likened to the biological workings of the body or the girders of a building. Giddens strongly rejects functionalist, biological and empiricist analyses of structure. Following the 'linguistic turn' in twentieth-century social theory, Giddens critically draws upon structuralist and post-structuralist theory, specifically the relationship posited between language and speech in linguistics. He does this, not because society is structured like a language (as structuralists have argued), but because he believes that language can be taken as exemplifying core aspects of social life. Language, according to Giddens, has a virtual existence; it 'exists' outside of time and space, and is only present in its instantiations as speech or writing. By contrast, speech presupposes a subject and exists in time–space intersections. In Giddens's reading of structural linguistics, the subject draws from the rules of language in order to produce a phrase or sentence, and in so doing contributes to the reproduction of that language as a whole. Giddens draws extensively from such a conception of the structures of language in order to account for structures of action. His theorem is that agents draw from structures in order to perform and carry out social interactions, and in so doing contribute to the reproduction of institutions and structures. This analysis leads to a very specific conception of structure and social systems. 'Structure', writes Giddens, 'has no existence independent of the knowledge that agents have about what they do in their day-to-day activity' (1984: 26).

Giddens's theoretical approach emphasizes that structures should be conceptualized as 'rules and resources': the application of rules that comprise structure may be regarded as generating differential access to social, economic, cultural and political resources. In *The Constitution of Society* Giddens argues that the sense of 'rule' most relevant to understanding social life is that which pertains to mathematical formulae – for instance, if the sequence is 2, 4, 6, 8, the formula is $x = n + 2$. Understanding a formula, says Giddens, enables an agent to carry on in social life in a routine manner, to apply the rule in a range of different contexts. The same is true of bureaucratic rules, traffic rules, rules of football, rules of grammar, rules of social etiquette: to know a rule does not necessarily mean that one is able to explicitly formulate the principle, but it does mean that one can use the rule 'to go on' in social life. 'The rules and resources of social action', writes Giddens, 'are at the same time the means of systems reproduction' (1984: 19). Systems reproduction, as Giddens conceives it, is complex and contradictory, involving structures, systems and institutions. Social systems, for Giddens, are not equivalent to structures. Social systems are regularized patterns of interaction; such systems are in turn structured by rules and resources. Institutions are understood by Giddens

as involving different modalities in and through which structuration occurs. Political institutions, for example, involve the generation of commands over people in relation to issues of authorization, signification and legitimation; economic institutions, by contrast, involve the allocation of resources through processes of signification and legitimation.

Routines and rules are different, to be sure. But for Giddens they both enable or guide the practical conduct of social life. Social rules and routines, significantly, are learned and nurtured by individuals in a largely semi-conscious way. People know how to apply countless rules to the conduct of social life – individuals know 'how to go on', as Giddens says – even though they may not be able to explicitly formulate those rules. Parents taking children to school, for instance, involves those women and men in all sorts of conversational exchanges with other parents. For the most part, these exchanges are of a routine nature – mostly involving talk about one's respective children, organizing play-dates and such like. Following the school run, parents then often drive to the city, to their place of employment, and similarly conduct routine conversations about a range of professional and personal matters. What is curious, when viewing this routine through the lens of Giddens's structuration theory, is that things work well enough when people apply the 'rules' of social interaction to these practical situations. Parents talk to other parents at school about matters to do with their children; colleagues talk to other staff at work about corporate and professional matters. But try imagining what might happen if people got regularly mixed up in this routine, and applied the wrong rules. Talking at length about professional, corporate matters in the school grounds is unlikely to impress other parents. Fortunately, though, social rules are usually applied to the appropriate social situation. Rules, remember, form part of the practical consciousness of individuals – and that for Giddens involves knowing 'how to go on', how to apply the right rules to particular social contexts.

To understand this recursive quality of social life it is also necessary to consider Giddens's discussion of human agency and individual subjectivity. Action, according to Giddens, must be analytically distinguished from the 'acts' of an individual. Whereas acts are discrete segments of individual doing, action refers to the continuous flow of people's social practices. On a general plane, Giddens advances a 'stratification model' of the human subject comprising three levels of knowledge or motivation: *discursive consciousness, practical consciousness* and the *unconscious*. He explains this stratification model of agency in *The Constitution of Society* as follows:

> Human agents or actors – I use these terms interchangeably – have, as an inherent aspect of what they do, the capacity to understand what they do while they do it. The reflexive capacities of the human actor are characteristically involved in a continuous manner with the flow of day-to-day conduct in the contexts of social activity. But reflexivity operates only partly on a discursive level. What agents know about what they do, and why they do it – their knowledgeability *as* agents – is largely carried in practical consciousness. Practical consciousness consists of all the things which actors know tacitly about how to 'go on' in the contexts of social life without being able to give them direct discursive expression. The significance of practical consciousness is a leading theme of the book, and it has to be distinguished from both consciousness (discursive consciousness) and the unconscious.
>
> *(1984: xxii–xxiii)*

Discursive consciousness thus refers to what agents are able to say, both to themselves and to others, about their own action; as Giddens repeatedly emphasizes, agents are knowledgeable

about what they are doing, and this awareness often has a highly discursive component. *Practical consciousness* also refers to what actors know about their own actions, beliefs and motivations, but it is practical in the sense that it cannot be expressed discursively; what cannot be put into words, Giddens says following Wittgenstein, is what has to be done. Human beings know about their activities and the world in a sense that cannot be readily articulated; such practical stocks of knowledge are central, according to Giddens, to the project of social scientific research. Finally, the *unconscious*, says Giddens, is also a crucial feature of human motivation, and is differentiated from discursive and practical consciousness by the barrier of repression.

While Giddens accords the unconscious a residual role in the reproduction of social life (as something that 'erupts' at moments of stress or crisis), he nonetheless makes considerable use of psychoanalytical theory in order to theorize the routine patterning of social relations. Drawing from Freud, Lacan and Erikson, Giddens argues that the emotional presence and absence of the primary caretaker (most usually, the mother) provides the foundation for a sense of what he terms 'ontological security', as well as trust in the taken-for-granted, routine nature of social life. Indeed the routine is accorded a central place in Giddens's social theory for (a) grasping the production and maintenance of ontological security and (b) comprehending the modes of socialization by which actors learn the implicit rules of how to go on in social life. To do this, Giddens draws from a vast array of sociological micro-theorists, including Goffman and Garfinkel. His debt to ethnomethodology and phenomenology is reflected in much of the language of structuration theory, as is evident from his references to 'skilled performances', 'copresence', 'seriality', 'contextuality', 'knowledgeability' and 'mutual knowledge'.

In the last few paragraphs I have noted how Giddens approaches issues of human action, agency and subjectivity. It is important to link these more subjective aspects of his social theory back to issues of social practices and structures in order to grasp his emphasis upon duality in structuration theory. Agents, according to Giddens, draw on the rules and resources of structures, and in so doing contribute to the systemic reproduction of institutions, systems and structures. In studying social life, says Giddens, it is important to recognize the role of 'methodological bracketing'. Giddens argues that the social sciences simultaneously pursue *institutional analysis*, in which the structural features of society are analysed, and the *analysis of strategic conduct*, in which the manner in which actors carry on social interaction is studied. These different levels of analysis are central to social scientific research, and both are crucial to structuration theory. Connected to this, Giddens argues that the subjects of study of the social sciences are concept-using agents, individuals whose concepts enter into the manner in which their actions are constituted. He calls this intersection of the social world as constituted by lay actors, on the one hand, and the metalanguages created by social scientists, on the other, the 'double hermeneutic'.

Modernity reappraised: structuration in action

The theory of structuration, as developed by Giddens, has been viewed by some social scientists as a largely dry, abstract affair. For some, the very term 'structuration' was in fact off-putting. Indeed, Giddens's seemingly endless deployment of neologisms – or some supposed – seemed to be more about grand systems building than confronting the fast-changing nature of society in conditions of advanced modernization. Perhaps in response to some such criticisms of the theory of structuration, and certainly in response to the massive social changes unleashed throughout the late 1980s and 1990s as a result of advanced modernity, Giddens turned to address a range of topics – including modernity, globalization,

identity, sexuality and intimacy – in his late writings. In all of these writings, the theory of structuration – whilst rarely discussed in any detail – is drawn upon by Giddens to rethink the state of the world today. Giddens's late writings can thus be viewed, from one angle at least, as the application of structuration theory to some of the big social issues of our times.

In *The Consequences of Modernity* (1990) and *Modernity and Self-Identity* (1991), Giddens develops a comprehensive analysis of the complex relation between self and society in the late modern age. Rejecting Marx's equation of modernity with capitalism, and wary of Weber's portrait of the iron cage of bureaucracy, Giddens instead presents an image of modernity as a juggernaut. As with structuration theory, Giddens's approach to modernity involves considerable terminological innovation: 'embedding and disembedding mechanisms', 'symbolic tokens', 'expert systems', 'the dialectic of trust and risk' and, crucially, 'reflexivity'. Reflexivity, according to Giddens, should be conceived as a continuous flow of individual and collective 'self-monitoring'. 'The reflexivity of modern social life', writes Giddens, 'consists in the fact that social practices are constantly examined and reformed in the light of incoming information about those very practices, thus constitutively altering their character' (1990: 38). Elsewhere Giddens writes:

> To live in the 'world' produced by high modernity has the feeling of riding a juggernaut. It is not just that more or less continuous and profound processes of change occur; rather, change does not consistently conform either to human expectation or to human control.
>
> *(1991: 28)*

The experiential character of contemporary daily life is well grasped by two of Giddens's key concepts: *trust* and *risk* as interwoven with *abstract systems*. For Giddens, the relation between individual subjectivity and social contexts of action is a highly mobile one; and it is something that we make sense of and utilize through 'abstract systems'. Abstract systems are institutional domains of technical and social knowledge: they include systems of expertise of all kinds, from local forms of knowledge to science, technology and mass communications. Giddens is underscoring much more than simply the impact of expertise on people's lives, far-reaching though that is. Rather, Giddens extends the notion of expertise to cover 'trust relations': the personal and collective investment of active trust in social life. The psychological investment of trust contributes to the power of specialized, expert knowledge – indeed it lies at the bedrock of our Age of Experts – and also plays a key role in the forging of a sense of security in day-to-day social life.

Trust and security are thus both a condition and an outcome of social reflexivity. Giddens sees the reflexive appropriation of expert knowledge as fundamental in a globalizing, culturally cosmopolitan society. While a key aim may be the regularization of stability and order in our identities and in society, reflexive modernity is radically experimental however, and is constantly producing new types of incalculable risk and insecurity. This means that, whether we like it or not, we must recognize the ambivalence of a social universe of expanded reflexivity: there are no clear paths of individual or social development in the late modern age. On the contrary, human attempts at control of the social world are undertaken against a reflexive backdrop of a variety of other ways of doing things. Giddens offers the following overview, for example, in relation to global warming:

> Many experts consider that global warming is occurring and they may be right. The hypothesis is disputed by some, however, and it has even been suggested that the real trend, if there is one at all, is in the opposite direction, towards the cooling of the global climate. Probably the most that can be said with some surety is that we cannot be certain that global

warming is *not* occurring. Yet such a conditional conclusion will yield not a precise calcu-
lation of risks but rather an array of 'scenarios' – whose plausibility will be influenced,
among other things, by how many people become convinced of the thesis of global
warming and take action on that basis. In the social world, where institutional reflexivity
has become a central constituent, the complexity of 'scenarios' is even more marked.

(1994: 59)

The complexity of 'scenarios' is thus central to our engagement with the wider social world.
Reflexivity, according to Giddens, influences the way in which these scenarios are constructed,
perceived, coped with and reacted to.

In *The Transformation of Intimacy* (1992), Giddens connects the notion of reflexivity to sexu-
ality, gender and intimate relationships. With modernization and the decline of tradition, says
Giddens, the sexual life of the human subject becomes a 'project' that has to be managed and
defined against the backdrop of new opportunities and risks – including, for example, artificial
insemination, experiments in ectogenesis (the creation of human life without pregnancy), AIDS,
sexual harassment and the like. Linking gender to new technologies, Giddens argues we live in
an era of 'plastic sexuality'. 'Plastic sexuality', writes Giddens, 'is decentred sexuality, freed from
the needs of reproduction . . . and from the rule of the phallus, from the overweening impor-
tance of male sexual experience' (1992: 2). Sexuality thus becomes open-ended, elaborated not
through pre-given roles, but through reflexively forged relationships. The self today, as the rise
of therapy testifies, is faced with profound dilemmas in respect of sexuality. 'Who am I?', 'What
do I desire?', 'What satisfactions do I want from sexual relations?' – these are core issues for the
self, according to Giddens. This does not mean that sexual experience occurs without institu-
tional constraint, however. Giddens contends that the development of modern institutions
produces a 'sequestration of experience' – sexual, existential and moral – which squeezes to the
sidelines core problems relating to sexuality, intimacy, mortality and death (see Elliott 1999).

Giddens, in other words, adopts an idealist language of autonomy, stressing as he does the
creativity of action and the modernist drive to absolute self-realization, while remaining
suspicious of intellectual traditions that prioritize subjects over objects, or actors over struc-
tures. This comes out very clearly in his work on the changing connections between marriage,
the family and self-identity. According to Giddens, individuals today actively engage with
novel opportunities and dangers that arise as a consequence of dramatic transformations
affecting self-identity, sexuality and intimacy. For Giddens, divorce is undeniably a personal
crisis, involving significant pain, loss and grief. Yet many people, he argues, take positive steps
to work through the emotional dilemmas generated by marriage breakdown. In addition to
dealing with financial issues and matters affecting how children should be brought up, separa-
tion and divorce also call into play a reflexive emotional engagement with the self. Charting
territory from the past (where things went wrong, missed opportunities, etc.) and of the
future (alternative possibilities, chances for self-actualization, etc.) necessarily involves exper-
imenting with a new sense of self. This can lead to emotional growth, new understandings of
self, and strengthened intimacies. Against the conservative critique of marriage breakdown,
Giddens sees the self opening out to constructive renewal. Remarriage and the changing
nature of family life are crucial in this respect. He develops this point as follows:

> Many people, adults and children, now live in stepfamilies – not usually, as in previous
> eras, as a consequence of the death of a spouse, but because of the re-forming of marriage
> ties after divorce. A child in a stepfamily may have two mothers and fathers, two sets of
> brothers and sisters, together with other complex kin connections resulting from the

multiple marriages of parents. Even the terminology is difficult: should a stepmother be called 'mother' by the child, or called by her name? Negotiating such problems might be arduous and psychologically costly for all parties; yet opportunities for novel kinds of fulfilling social relations plainly also exist. One thing we can be sure of is that the changes involved here are not just external to the individual. These new forms of extended family ties have to be established by the very persons who find themselves most directly caught up in them.

(1991: 13)

Marital separation, as portrayed by Giddens, implicates the self in an open project: tracing over the past, imagining the future, dealing with complex family problems and experimenting with a new sense of identity. Further experimentation with marriage and intimate relationships will necessarily involve anxieties, risks and opportunities. But, as Giddens emphasizes, the relation between self and society is a highly fluid one, involving negotiation, change and development.

The manner in which current social practices shape future life outcomes is nowhere more in evidence than in the conjunction of divorce statistics, the reckoning of probability ratios for success or failure in intimate relationships, and the decision to get married. As Giddens rightly points out, statistics about marriage and divorce do not exist in a social vacuum; everyone, he says, is in some sense aware of how present gender uncertainties affect long-term relationships. When people marry or remarry today, according to Giddens, they do so against a societal backdrop of high divorce statistics, knowledge of which alters a person's understanding and conception of what marriage actually is. It is precisely this reflexive monitoring of relationships that, in turn, transforms expectations about, and aspirations for, marriage and intimacy. The relationship between self, society and reflexivity is thus a highly dynamic one, involving the continual overturning of traditional ways of doing things.

Giddens, politics and the Third Way

In the late 1990s, Giddens left Cambridge University to take up the high-profile Directorship of the London School of Economics. At the LSE, not only was Giddens more directly involved with the shaping of higher education in Britain, but his writings became more politically focused too. A new political approach had been detailed in his book *Beyond Left and Right: The Future of Radical Politics* (1994). In time, Giddens termed this new political agenda 'the Third Way'. His best-selling *The Third Way* (1997) became hugely influential, and he became an advisor to UK Prime Minister Tony Blair. He was also much in demand as a consultant to governments throughout the world, including that of then American President Bill Clinton. In 1999 Giddens delivered the prestigious Reith Lectures on globalization, entitled 'Runaway World'. In 2003 he was appointed to the House of Lords.

In many appraisals of Giddens's work, the thesis of the Third Way is treated as quite distinct from structuration theory. In some respects, this is understandable. But there are important respects in which we can see that structuration theory informs Giddens's attempt to develop a novel progressive politics of the centre left. In what follows, I want to concentrate on some of Giddens's claims as developed in the thesis of the Third Way – suggesting that these ideas are reflective of an approach to questions of structure and agency informed by structuration theory.

In *Beyond Left and Right*, Giddens asserts that we live today in a radically damaged world, for which radical political remedies are required beyond the neo-liberalism offered by the

right or reformist socialism offered by the left. To this end, Giddens provides a detailed framework for the rethinking of radical politics. This framework touches on issues of tradition and social solidarity, of social movements, of the restructuring of democratic processes and the welfare state, and of the location of violence in world politics. Giddens's interpretation of the rise of radical politics can perhaps best be grasped by contrasting dominant discussions in the fields of critical theory and postmodernism. Theorists of the self-endangerment of modern politics, from Daniel Bell to Jürgen Habermas, characteristically focus upon the loss of community produced by the invasion of personal and cultural life by the global capitalist system. Postmodernist social and political theorists, from Michel Foucault to Jean-François Lyotard, alternatively focus on the contemporary plurality of knowledge claims, and conclude that there are no ordered paths to political development. Giddens's approach, by contrast, takes a radically different tack. He develops neither a lament nor a celebration of the ambivalences of contemporary political processes. Instead, Giddens asks: What happens when politics begins to reflect on itself? What happens when political activity, understanding its own successes and excesses, begins to reflect on its own institutional conditions? At the core of these questions one can readily discern the import of both structuration theory and the thesis of reflexivity.

At the core of advanced modernity, says Giddens, are reflexivity and risk, both of which he isolates as central to transformations in society, culture and politics. By reflexivity, as noted, Giddens refers to that circularity of knowledge and information promoted by mass communications in a globalizing, cosmopolitan world. Reflexivity functions as a means of regularly reordering and redefining what political activity is. Of central importance in this respect is the impact of globalization. Globalizing processes, says Giddens, radically intensify our personal and social awareness of risk, transforming local contexts into global consequences. Thus the panic selling of shares on Wall Street has implications for the entire global economy, from local retail trade to the international division of labour. At the beginning of the twenty-first century, a world of intensified reflexivity is a world of people reflecting upon the political consequences of human action, from the desolation of the rainforests to the widespread manufacture of weapons of mass destruction. In such social conditions, politics becomes radically experimental in character. People are increasingly aware of new types of incalculable risk and insecurity, and must attempt to navigate the troubled waters of modern political culture. This means that, whether we like it or not, we are all engaged in a kind of continual reinvention of identity and politics, with no clear paths of development from one state of risk to another.

It is against this backdrop of transformations in risk, reflexivity and globalization that Giddens develops a new framework for radical politics. The core dimensions of Giddens's blueprint for the restructuring of radical political thought include the following claims:

- We live today in a post-traditional social order. This does not mean, as many cultural critics and postmodernists claim, that tradition disappears. On the contrary, in a globalizing, culturally cosmopolitan society, traditions are forced into the open for public discussion and debate. Reasons or explanations are increasingly required for the preservation of tradition, and this should be understood as one of the key elements in the reinvention of social solidarity. The new social movements, such as those concerned with ecology, peace or human rights, are examples of groups refashioning tradition (the call to conserve and protect 'nature') in the building of social solidarities. The opposite of this can be seen, says Giddens, in the rise of fundamentalism, which forecloses questions of public debate and is 'nothing other than tradition defended in the traditional way' (1994: 6).

- Radical forms of democratization, fuelled by reflexivity, are at work in politics, from the interpersonal to the global levels. But the issue of democratization cannot be confined only to the formal political sphere, since these processes also expose the limits of liberal political democracy itself. As the American sociologist Daniel Bell put this some years ago, the nation-state has become too small to tackle global problems and too large to handle local ones. Instead, Giddens speaks of a 'democratizing of democracy', by which he means that all areas of personal and political life are increasingly ordered through dialogue rather than pre-established power relations. The mechanisms of such dialogic democracy are already set in process, from the transformation of gender and parent–child relations through to the development of social movements and self-help groups. The rise of psychotherapy and psychoanalysis is also cast in a favourable political light by Giddens. Democratizing influences such as these also influence the more traditional sphere of institutional politics as well.
- The welfare state requires further radical forms of restructuring, and this needs to be done in relation to wider issues of global poverty. Here Giddens urges the reconstruction of welfare away from the traditional 'top down dispensation of benefits' in favour of what he terms 'positive welfare'. Welfare that is positive is primarily concerned with promoting autonomy in relation to personal and collective responsibilities, and focuses centrally on gender imbalances as much as class deprivations.
- The prospects for global justice begin to emerge in relation to a 'post-scarcity order'. This is a complex idea, but it is central to Giddens's political theory. Giddens is not suggesting that politics has entered an age in which scarcity has been eliminated. On the contrary, he argues that there will always be scarcities of goods and resources. Rather, a post-scarcity society is a society in which 'scarcity' itself comes under close reflexive scrutiny. Coping with the negative consequences of industrialism, says Giddens, has led to a radical reappraisal of the capitalistic drive for continuous accumulation. This broadening of political goals beyond the narrowly economic is reflected today in the pursuit of 'responsible growth'. Several key social transformations are central here. The entry of women into the paid labour force, the restructuring of gender and intimacy, the rise of individualization as opposed to egoism, and the ecological crisis: these developments have all contributed to a shift away from secularized Puritanism towards social solidarity and obligation.

Criticisms of Giddens's theory of structuration

Having briefly discussed Giddens's theory of structuration, I want now to consider some of the major criticisms of his social theory.

In several celebrated critiques, Margaret Archer (1982, 1990) argues not only that it is undesirable to amalgamate agency with structure, but that it is necessary to treat structure and agency as analytically distinct in order to deal with core methodological and substantive problems in the social sciences. At the core of Archer's critique of Giddens is an anxiety about his claim that structures have no existence independent of the knowledge that human subjects have about what they do in their daily lives. She argues that Giddens's structuration theory fails to accord sufficient ontological status to the pre-existence of social forms, specifically the impact of social distributions of populations upon human action. Archer juxtaposes to Giddens a morphogenetic theory that focuses on the dialectical interplay between agency and the emergent properties of social systems. Similarly, Nicos Mouzelis (1989) argues that while the notion of structuration is appropriate to routine social practices where agents carry out their actions without undue levels of reflection, there are other forms of social life that require

that structure and agency be kept apart. Theoretical reflection upon the social world, for example, involves dualism in Mouzelis's eyes, since there is a shift from the individual to the collective level, and this necessarily depends upon a distancing of our immediate, everyday lives from broader social structures.

In an especially sharp critique of Giddens's structuration theory, John B. Thompson (1989) questions the analytical value of (a) the notion of rules and resources for grasping social structure and (b) conceiving of structural constraint as modelled upon certain linguistic and grammatical forms. According to Thompson, Giddens's account of rules and resources is vague and misleading. Linguistic and grammatical rules, says Thompson, are important forms of constraint upon human action; however, they are not the only forms of constraint in social life, and indeed when considering social constraint the core issue is to understand how an agent's range of alternatives is limited. Thompson acknowledges that Giddens goes some distance in accounting for this by distinguishing between structure, system and institutions. But again he questions Giddens's account of the transformational properties of structures, and suggests there is confusion here between structural and institutional constraint. A worker at the Ford Motor Company, notes Thompson, can be said to contribute to the reproduction of the institution, and thus also be said to contribute to the reproduction of capitalism as a structure, to the extent that the worker pursues their everyday employment activities. However it is also possible that the worker might undertake activities that threaten or transform the institution, but without similarly transforming their structural conditions. 'Every act of production and reproduction', writes Thompson, 'may also be a potential act of transformation, as Giddens rightly insists; but the extent to which an action transforms an institution does not coincide with the extent to which social structure is thereby transformed' (1989: 70).

Other critics have likewise targeted Giddens's conceptualization of subjectivity, agency and the agent. Bryan S. Turner (1992), for example, finds Giddens's theory of the human agent lacking a sufficient account of embodiment. Alan Sica has suggested that, notwithstanding his commitment to macro social theory, Giddens's borrowings from Garfinkel, Goffman, Erikson and others indicates an awareness that a theory of the subject and its complex darkness has been central to the project of contemporary social theory. Sica writes:

> Giddens reinvolves himself with 'the subjective' because he knows that a general theory of action will surely fail that does not come to terms with it. But he fondly thinks, it seems, that by inventing a new vocabulary, by bringing in the ubiquitous 'duality of structure' or 'reflexive rationalization of conduct', he can make good his escape from both the calcified Marxism without a subject (Althusser) or sloppy-hearted Parsonism, which is all norms, values and wishes.
>
> *(1989: 48)*

Sica's argument here rests on a particular sociological reading of the relations between the reflexive monitoring of action, the routinization of day-to-day social processes and the material condition in which all activities are located and undertaken. There is a sense, for Sica, in which Giddens tries to outflank both Althusserian Marxism and Parsonian sociology, only to find that the crippling dualism of subjectivity and objectivity reappears in his beloved sociological upgrading of the routine (whatever is done habitually). On this view, Giddens's ethnomethodological imperialism not only produces a risky suppression of the material conditions structuring routinized activities, but also cancels those unconscious or symbolic dimensions of human experience untrammelled by routine or convention.

There is something intriguingly divided about Giddens's self-actualizing 'subject of routinization', who is at once structured and structuring, commanding and contextual, a post-Freudian master coolly keeping the unconscious contained within the realm of the habitual while all the time remaining unquestionably in ethnomethodological control. Yet these polarities have less to do with Giddens's fundamental concept of routinization as such; rather, sociological problems arise – for reasons I shall explore subsequently – as a consequence of the manner in which Giddens attempts to force an ontological division between discursive and practical consciousness on the one side and the unconscious dimensions of subjectivity or agency on the other. But, for the moment, let us stay with Sica's complaint that Giddens's vision of a routinized subject is disturbingly ungrounded in socio-structural or moral-normative concerns. There can be little doubt that Giddens makes the concept of routinization central to the constitution and reproduction of history and consciousness. 'Routine', writes Giddens, 'is integral both to the continuity of the personality of the agent, as he or she moves along the paths of daily activities, and to the institutions of society, which *are* such only through their continued reproduction' (1984: 60). This is not an expression of sociological determinism (in the sense that all action is pre-programmed) or political conservatism: there is no logical reason why reflexively constituted processes of social reproduction demand an acceptance of *particular* habitual practices. Rather, Giddens's grounding of ontological security in routinization suggests that both existing and alternative (or oppositional) forms of life demand some sort of motivational commitment to the integration of habitual practices across space and time.

In one sense, Giddens pushes the routinized nature of social life to breaking point – or at least to a point where something beyond the routinized is glimpsed. If the structured nature of social interaction is the ability of individuals to do what they do in a routine fashion, then what is it exactly that provides the sense of organizing consistency to such routines? How do the organized routines of daily life come into existence? From the imagination of individuals, or the complex social things of society? Suddenly, the duality proposed by structuration theory returns us to a familiar sociological opposition. But still there are other concerns. There is the question, for example, of how far down routines really go in private life – of whether they actually create identity through providing social consistency from situation to situation, or whether they instead provide a social framework for an already established emotional complexity of the self. And if routines are, in some sense, tied up with the making of identity, how might we come to understand the structured realities of individuals living their routine lives? What, in other words, makes for the social differences between routines in, say, China and North America? How might the notion of routine apply to the Third World? Is the term, as Giddens uses it, a sociologically neutral account of social interaction, or a normative image of western living?

Finally, we may note that this account of the relation between society and the individual, for all its claims of transcending the dualism of subject and object, betrays a sociologically impoverished grasp of the emotional lives of people. At the centre of this criticism is Giddens's use of psychoanalysis. We have seen earlier that Giddens draws on Freud's account of the unconscious to supplement his notion of practical consciousness: like practical consciousness, the unconscious is a sector of human experience that is non-discursive; unlike practical consciousness, there is much in the unconscious that cannot be brought into language due to the barrier of repression established in early infancy. The effects of the repressed unconscious, to be sure, are disabling at moments of societal stress or crisis; but there is for Giddens a certain kind of stability to the unconscious, which is regulated by the force of daily habits and routines. Predictable routines, says Giddens, keep the unconscious at bay. It is worth pausing

to ask of this standpoint, however, whether the unconscious is really 'bracketed' by routines. What of the narcissistic routines promoted by consumer capitalism, in which individuals are encouraged to obsess about their bodies, or constantly measure their physical appearance against the standards of celebrity culture? Is it meaningful to speak of a routine limiting of the unconscious within these parameters of popular culture? Similarly, some critics think that Giddens closes off the radical implications of psychoanalysis for social theory through the bulk of vocabulary of self-organization: 'bracketing anxiety', 'ontological security' and 'emotional inoculation'. All of these terms seem to suggest an individual serenely inserted into the social order; but this is a far cry from the split and fractured individual subject of psychoanalysis.

Thus where Giddens's sociology of routinization is problematic is not its privileging of the capabilities of actors to 'go on' in the contexts of social life without being necessarily able to give them direct discursive expression, but in its assumption that practical consciousness brackets, limits and contains unconscious representation and repressed desire. For Giddens, the repetition of activities that are undertaken in like manner day after day provides the grounding for what he terms 'ontological security', protecting against the unwanted eruption of anxiety. Predictable routines keep the unconscious at bay. And yet anyone with a psycho-analytic orientation reading of Giddens's sociology of routinization is likely to feel unsympa-thetic to such a characterization of the nature of the unconscious. Concentrating mainly upon the notion of repression leaves Giddens to give sociological expression to the widespread cultural fantasy that the fracturing effects of the unconscious must be limited, held in check. But even in the terms of his own stratification model, one has only to raise a few psycho-analytically inspired questions to see the problems here. What kind of good is it for practical consciousness to bracket anxiety at the level of the unconscious? Does such 'bracketing' lead to autonomy of action – that is, does it guarantee it, as it were? What of Freud's speaking up for unconscious passion, for the strangeness and otherness of emotional life, a life not domi-nated by system or custom? Such concerns are not easily addressed from the standpoint of Giddens's structuration theory, a point underscored by both psychoanalytic-inspired critics and feminists. (For further discussion see Elliott 2003: ch. 2.)

Pierre Bourdieu: habitus and practical social life

The French sociologist Bourdieu also developed over several decades a highly influential account of the complex interrelations between self and society, the individual agent and social structure. Like Giddens, Bourdieu is interested in the habits of whole societies. In developing this research interest, Bourdieu coined the term *habitus*, by which he meant the institutional-ized process by which well-practised habits bridge individuals and the wider social things of which they are part. Also like Giddens, Bourdieu argues that social actors exhibit intricate, complex understandings of the social conditions which influence, and are in turn influenced by, their personal decisions and private lives. Bourdieu's formulation is that actors possess a 'sense of the game', which is the basis from which people form a kind of semi-automatic understanding of what is appropriate to differing social situations.

In *Outline of a Theory of Practice* (1977) Bourdieu detailed the concept of *habitus* – that is, how individual dispositions interlock with the specific cultural characteristics of society. 'The structures constitutive of a particular type of environment', writes Bourdieu, 'produce the *habitus*, systems of durable dispositions, structured structures predisposed to function as structuring structures' (1977: 72). Note that social structures for Bourdieu do not actually *determine* individual action. On the contrary, *habitus* is a flexible, open-ended structuring

system, one that enables social actors to have numerous creative strategies at their disposal and thus to cope with unforeseen social structures.

Bourdieu developed his concept of *habitus* from his anthropological studies of the Kabyle tribespeople and, in particular, from close sociological analysis of gift exchanges in Kabyle society. Bourdieu considers that structuralism is correct in its initial diagnosis that society possesses a reality that precedes the individual. This is the point, for example, that language pre-exists us as speaking agents, and will subsequently continue as a social institution long after we have left the planet. If this is so, Bourdieu supposes, then structuralism is right to claim that language has the power to regulate, even shape, our individual speech acts – whether we realize it or not. But where structuralism is palpably insufficient, according to Bourdieu, is in its reduction of social action to a mechanical system of rules that imposes itself upon individuals. Studying the intricacies of gift exchange in Kabyle society, Bourdieu finds that men's sense of honour is facilitated less by an application of pre-established rules than by carrying out a whole range of practices – such as 'playing with the tempo' of response and acknowledgment of a gift. An actor's response to the receipt of a gift is not therefore socially determined by the application of mechanical rules, and nor is it a matter of mere private judgement. It rather involves the creative artistry of the recipient, experimenting within a fluid structuring structure, one marked by group norms of acceptable practice, obligation, reciprocity and honour.

Habitus, in the sense of deeply ingrained dispositions, is a structuring feature of social practices, but it is more than just that. If our practical, or habitual, behaviours have a degree of consistency to them, this is because our bodies are literally moulded into certain forms that interlock with existing social arrangements. One way of thinking about how *habitus* reaches all the way down into bodily needs and dispositions is to consider the process that sociologists call 'socialization'. The notion of socialization refers, broadly speaking, to the training or regulation of children within the structure of bigger social things. The learning of good manners at home, or respect for figures of authority at school, are examples of the socialization process. Bourdieu's account of how *habitus* penetrates the body – what he calls the 'corporeal hexis' – is similar to the idea of socialization, but is much broader in scope. Socialization conveys too much the sense of active or conscious learning, and this is not how Bourdieu thinks we come to act in the world. Instead, he is interested to get at the subtle ways in which messages are relayed to people over time, such that cultural norms become routine patterns of behaviour and, thus, withdrawn from consciousness. The parent who routinely tells their son or daughter to 'sit up straight' at dinner, or who instructs them to 'always say thank you' when offered food at the home of a classmate, is thus going about the business of reproducing the *habitus* of modern society. This is the sense, too, in which *habitus* bites deeply into the very bodies of individuals – structuring the ways in which people come to talk, walk, act and eat. *Habitus*, thus, is deeply interwoven with the stylization of bodies.

What has been discussed so far about social practices and bodies is central to the analysis of human action, and yet it hardly needs saying that – for regular social life to get up and running – such practices must be anchored in wider institutional contexts. Bourdieu seeks to address this by introducing the notion of 'field', by which he means the structured space of positions in which an individual is located. For Bourdieu, there are various kinds of fields – educational, economic, cultural – which contain different kinds of social properties and characteristics. A field, says Bourdieu, pre-exists the individual. It ascribes an objective place to individuals within the broader scheme of social things, and thereby serves as a relation of force between individuals and groups engaged in struggles within certain fields. It is in and through our social interactions in fields – whether these be educational, financial, sporting or scientific

fields – that actors struggle to assert themselves as distinct or noteworthy in the eyes of others and the wider society. Bourdieu calls such struggle the search for 'cultural capital'. Through this notion of capital that is principally cultural in its form and impact, Bourdieu directs our attention to the means whereby social inequalities are generated through classifications of power, displays of taste, and acts of individual consumption. In *Distinction: A Social Critique of the Judgment of Taste* (1984), Bourdieu developed a brilliant analysis of the habits and tastes of French society – which he divided into the working class, the lower middle class and the upper middle class. His argument, broadly speaking, was that whilst economics is the baseline of social order, the struggle for social distinction is played out with other forms of capital too – notably, cultural capital and symbolic capital. Culture then in the sense of fine living, manners, refinement or an elegant ease of social interaction lies at the centre of how individuals demonstrate social sophistication. Such social sophistication requires certain economic capital – for example, expensive private schools. But social struggles for distinction have a cultural dimension too: cultivation of the self is also a matter of learning, aesthetics and the arts.

Cultural capital and symbolic violence

Cultural tastes and social preferences are *habitus*, in Bourdieu's terminology, but they are also an outward expression of power and social class.

In Bourdieu's view, the struggle for capital is more a matter of practices than ideas, which in turn brings us to core distinctions between poverty and affluence in the realm of culture as well as lifestyle practices. As Bourdieu writes:

> If a group's lifestyle can be read off from the style it adopts in furnishing or clothing, this is not only because these properties are the object of the economic and cultural necessity which determines their selection, but also because the social relations objectified in familiar objects in their luxury or poverty, their 'distinction' or vulgarity, their 'beauty' or their 'ugliness' impress themselves through bodily experiences which may be as profoundly unconscious as the quiet caress of beige carpets or the thin clamminess of tattered garish linoleum, the harsh smell of bleach.
>
> *(1984: 77)*

Bourdieu's concept of cultural capital directs our attention to the means whereby social inequalities are generated through the classifying power of taste as expressed in the consumption of culture. Bourdieu found that the possession of specific forms of cultural capital – of intellectuals and artists, for example – is used to maintain social dominance over those who do not possess such competences. This valuable sociological perspective can also be extended to the analysis of popular culture and the media. In 'reality television', for example, new forms of symbolic violence are arguably evident as regards the public humiliation of people and their relegation to an inferior social standing within the social order. Analysing the UK television program *What Not To Wear*, media theorist Angela McRobbie has used Bourdieu's notion of cultural capital to focus on practices of symbolic violence and forms of domination. McRobbie writes:

> Bourdieu's writing allows us to re-examine symbolic violence as a vehicle for social reproduction . . . The victim of the make-over television programme presents his or her class habitus for analysis and critique by the experts. The programmes comprise a series

of encounters where cultural intermediaries impart guidance and advice to individuals ostensibly as a means of self-improvement . . . These programmes would not work if the victim did not come forward and offer herself as someone in need of expert help. On the basis of her own subordinate class habitus, the individual will have a 'feel for the game', a 'practical sense for social reality' which means in the context of the programmes, she will instinctively, and unconsciously, know her place in regard to the experts, hence the tears, the gratitude and the deference to those who know so much better than she does.

(2005: 147–48)

Bourdieu's ideas help us understand why people adopt certain kinds of cultural practices, and how – through habitus adjustment to dominant social classes – conformity with the requirements of consumer culture is maintained.

Criticism of Bourdieu

Bourdieu's work has been subjected to criticisms from various quarters. Critics have questioned, for example, the adequacy of the concept of *habitus* to address the complexity of social experience. The criticism here is that *habitus* overemphasizes the *containment* of cultural dispositions within social structures – thereby downgrading the capacity of individuals to negotiate or transform existing social systems through their creative actions. There may be some truth to this charge, but the criticism needs more precision. Bourdieu's *habitus* emerged as a theoretical innovation in the aftermath of structuralism and post-structuralism; it fitted well enough with a political and intellectual climate in which dissent was still possible, but now conceptualized in a fashion that fully broke with individualistic ways of understanding the world. Society for Bourdieu was less the outcome of individual acts and choices than a structuring, structured field of dispositions in which individuals mobilize themselves and act to exclude others on the base of relevant cultural capital. The *habitus*, in other words, refers to an objectivity ('society') that inscribes itself within identity. There is something about social production that is both enabling and coercive. What is most dynamic about *habitus* for Bourdieu is its status as the condition of sociality: the *habitus* prescribes the kinds of agency demanded by culture. Yet whilst this viewpoint was in some general sense radical, it seemed on the whole to have little of interest to say about specific issues of identity (the concrete negotiations of the self in relation to social relations), even if Bourdieu had provided a whole range of sociological enquiries, from education to aesthetics. Part of the difficulty in this respect is that Bourdieu might be said not to have broken with structuralism thoroughly enough, in the sense that structures in his work continue to confer on us our agency – to such a degree that we misrecognize our fate as our choice. In doing so, Bourdieu's *habitus* neglects the creativity of action which individuals bring to all encounters with social and cultural processes – a matter of profound significance to the question of social change.

 The debate over Bourdieu's contributions to social theory has also addressed many other issues. One central criticism concerns certain *assumptions about society* Bourdieu appears to make in his various sociological analyses. Some critics contend, for example, that he takes the economy for granted, leaving unanalysed the role of economic forces in social life. Whilst Bourdieu was widely seen as sympathetic to the political left, the politics of his social theory was somewhat oblique; he certainly distanced himself from Marx and Marxism. Against this backdrop, some have argued that he elevated cultural capital over economic capital, thus tending to skirt issues of economic oppression. A more interesting line of criticism, in my view, is that his account of symbolic violence assumes a certain kind of consensus with respect

to the norms and values that are central in society. This is less a matter of assuming that people openly agree with one another about societal values than a presupposition that those who exercise cultural and symbolic capital are perceived by others as 'legitimate' bearers of social authority. That is to say, Bourdieu can be criticized for conceptualizing social practice in terms of how social stability is sustained. Such an approach allows him to develop powerful insights into how symbolic domination is wielded in contemporary societies, and yet these insights arguably come at the sociological cost of understanding how social structures – or ways of acting with cultural capital – can be changed. In short, *habitus* might not be so overwhelmingly rigid.

Finally, it is now widely agreed that Bourdieu's commitment to the political notion of resistance led him to overestimate the constraints of social domination operating within specific power structures of advanced capitalism on the one hand, while underestimating the degree to which the world really had changed as a result of the impacts of globalization on the other. Certainly, there can be little doubt that Bourdieu's attacks on globalization and the neo-liberalism promoted by various French conservative governments were provocative. Notwithstanding his commitment to stand shoulder to shoulder with struggling workers, immigrants and others dispossessed from the contemporary French political system, however, Bourdieu failed to develop an outline of what a progressive politics might actually look like in our own time of accelerated globalization. French social theory has often turned on a contrast between some utopian moment of resistance to power as such and the contaminated terrain of reformist social policy, and Bourdieu is no exception in this respect. However, his disquisitions on resistance in general – when coupled to the sociological diagnosis of people's cultural *habitus* – can easily be misinterpreted as a form of defeatist politics. Here comparison between Bourdieu and Giddens is, once again, instructive. Notwithstanding the various criticisms of Giddens's theory of a radical centre or Third Way in contemporary politics, Giddens's work powerfully acknowledges the extent to which the political landscape of modern societies has changed in recent decades – primarily as a result of globalization and the information technology revolution. Certainly Giddens's late political writings have significantly influenced the direction of various centre-left governments – in Britain, Canada, Germany, Brazil, Mexico, Argentina and even France. Bourdieu's political tracts did not exert this kind of policy impact, and it is interesting to consider why this was the case. Whereas Bourdieu pitched his political critique at the level of blue skies resistance to power in general, Giddens's Third Way constituted a new political path, one designed in response to the realities of the global electronic economy. A dynamic economy for Giddens is essential not only to the creation of wealth but for social solidarity and social justice too. Whereas Bourdieu tended to dismiss globalization processes as intrinsically anti-democratic, Giddens recognized that globalism is a much more complex political phenomenon – one that opens out to 'depoliticized global space' and is central to the economic and political problems of our time. By contrast, globalization for Bourdieu appears as a remorseless totalization, one to which the only political counterweight is 'anti-globalization'.

Future developments

Theories of structuration, as represented in the writings of Giddens and Bourdieu, have influenced social theorists seeking to find conceptual pathways beyond the dualism of 'subjectivism' and 'objectivism'. The notion that action is structured in everyday contexts, in and through which the structural features of society are reproduced, has been a major advancement of recent social thought. Giddens's concept of 'reflexivity' and Bourdieu's notion of

'*habitus*' represent, in quite different ways, original formulations of how to rethink the self–society dualism in social theory. The systematic study of processes of structuration has been developed in various ways in recent social theory, and the contributions of – amongst others – John B. Thompson, David Held, Loic Waquant, Charles Lemert, Lois McNay and Jeffrey Prager all offer important new frameworks based to some substantial degree upon structuration theories. Understanding the complex ways in which action and structure intersect in a world increasingly interconnected, mobile and fluid remains a core challenge of social theory in the twenty-first century.

References

Archer, M. S. (1982) 'Morphogenesis versus Structuration: On Combining Structure and Action', *British Journal of Sociology*, 33(4): 455–83.

Archer, M. (1990) 'Human Agency and Social Structure', in Anthony Giddens: *Consensus and Controversy*, ed. J. Clark, C. Modgil and S. Modgil, New York: Faimer.

Bourdieu, P. (1977 [1972]) *Outline of a Theory of Practice*, Cambridge: Cambridge University Press.

—— (1984) *Distinction: A Social Critique of the Judgment of Taste*, London: Routledge & Kegan Paul.

Elliott, A. (1999 [1992]) *Social Theory and Psychoanalysis in Transition: Self and Society from Freud to Kristeva*. First edition: Oxford, UK, and Cambridge, MA: Blackwell. Second edition: London and New York: Free Association Books.

—— (2003) *Critical Visions: New Directions in Social Theory*, New York: Rowman and Littlefield.

Giddens, A. (1971) *Capitalism and Modern Social Theory: An Analysis of the Writings of Marx, Durkheim and Max Weber*, Cambridge: Cambridge University Press.

—— (1976) *New Rules of Sociological Method: A Positive Critique of Interpretive Sociologies*, New York: Basic Books.

—— (1979) *Central Problems in Social Theory: Action, Structure, and Contradiction in Social Analysis*, London: Macmillan.

—— (1984) *The Constitution of Society: Outline of the Theory of Structuration*, Cambridge: Polity Press.

—— (1985) *The Nation-State and Violence*, Berkeley, CA: University of California Press.

—— (1990) *The Consequences of Modernity*, Stanford, CA: Stanford University Press.

—— (1991) *Modernity and Self-Identity: Self and Society in the Late Modern Age*, Stanford, CA: Stanford University Press.

—— (1992) *The Transformation of Intimacy: Sexuality, Love, and Eroticism in Modern Societies*, Stanford, CA: Stanford University Press.

—— (1994) *Beyond Left and Right: The Future of Radical Politics*, Stanford, CA: Stanford University Press.

—— (1995) *Politics, Sociology and Social Theory: Encounters with Classical and Contemporary Social Thought*, Stanford, CA: Stanford University Press.

—— (1997) *The Third Way: The Renewal of Social Democracy*, Cambridge: Polity.

McRobbie, A. (2005) *The Uses of Cultural Studies*, London: Sage.

Mouzelis, N. (1989) 'Restructuring Structuration Theory', *Sociological Review*, 37: 613–35.

Thompson, J. B. (1989) 'The Theory of Structuration', in Held, D. and Thompson, J. B. (eds) *Social Theory of Modern Societies: Anthony Giddens and His Critics*, Cambridge: Cambridge University Press, pp. 56–76.

Turner, B. (1992) *Regulating Bodies*, London: Routledge.

5

Feminist and post-feminist theories

Ann Branaman

Now more than forty years since feminist thinkers entered academia and began the work of introducing feminist studies into the curricula of their respective disciplines, feminist theory has firmly established itself as part of the social and cultural theory canon. The particular feminist theories and theorists included in textbooks and readers vary. Social theory text-books tend to include a chapter that gives a broad overview of the history of feminism and provides some type of categorization of feminist perspectives. Only sometimes do particular theorists figure prominently in the presentation, as many of the perspectives, questions and concerns are so broadly shared. Social theory readers, by necessity, must select the work of some particular feminist theorists. Dorothy Smith, Patricia Hill Collins, Nancy Chodorow and Judith Butler tend to be the most widely excerpted in those readers oriented mostly to an American sociological audience. Post-structuralist theorists such as Julia Kristeva and Luce Irigaray are commonly included in the more international and multidisciplinary social and cultural theory canon, in addition to Butler and varying others. Whatever the selections may be, however, rarely are they representative of a very broad range of central issues in feminist thought, currently or historically. One could master the thinking of Smith, Collins, Chodorow, Butler, Kristeva *and* Irigaray, theorists who have gained recognition as important individual contributors to feminist theory, and still not know a great deal about feminist theory.

Charles Lemert's most broadly inclusive reader in social theory includes short excerpts from the work of each of the following: Charlotte Perkins Gilman, Anna Julia Cooper, Virginia Woolf, Simone de Beauvoir, Betty Friedan, Dorothy Smith, Nancy Chodorow, Audre Lord, Nancy Hartsock, Donna Haraway, Trinh T. Minh-ha, Gayatri Spivak, Patricia Hill Collins, Gloria Anzaldua, Judith Butler, Paula Gunn Allen, Eve Sedgwick, Saskia Sassen and Julia Kristeva (Lemert 2013). This longer set offers a fuller view of the range of feminist theoretical perspectives that have emerged over the past decades; with added contextualiza-tion, a study of this list of theorists would allow for a decent understanding of the central issues that have characterized feminism's history. The contextualization, however, would need to be substantial, and would necessarily lead to the consideration of the work of other feminist scholars and other theoretical formulations.

Until the interventions of feminist scholars and others representing other marginalized voices and perspectives, it had seemed that a classical social theory canon including only a small set of individual social theorists – Marx, Durkheim, Weber and Simmel – could provide a broad view of the central tendencies of nineteenth- and early twentieth-century

modern societies. Know these four theorists, so it had seemed, and you understand modernity. It would take until relatively late in the twentieth century for some of the silenced, hidden or marginalized voices of scholars writing in the period of classical social theory (including Gilman, Cooper, Martineau and Dubois) to receive recognition as classical social theorists themselves and to open up a new dimension of knowledge of early modernity.

Lemert's social theory reader, first published in 1991, was hugely influential in opening up the social theory canon to a broad range of neglected voices. Having identified the valuable contributions of feminist theorists in the classical period of sociology, feminist social theorists in sociology engaged deeply with these neglected women founders, producing scholarly work and a text-reader that featured these newly discovered classical feminist social theorists (Lengermann and Niebrugge-Brantley 1997, 2001). A decade or so later, it would be hard to find any textbook that covered classical social theory that did not include contributions from classical feminist theorists. Feminist theory entered the contemporary social theory canon significantly earlier, but continued through the 1990s and the first decade of the twenty-first century on a trajectory towards near universal inclusion in theory texts and readers. In its efforts to recover feminist voices from the past as well as to firmly establish the centrality of feminist theory within the broader domain of social and cultural theory, feminist theory has contributed significantly to inciting a wariness of canonization and its inevitable tendencies towards partiality, while at the same time constructing its own inevitably partial canon.

Despite the fact that some feminist theorists have gained recognition as centrally valuable contributors, in many respects the development of feminist thought has been a more collective project. The textbook writers and anthologizers whose names we mostly do not remember, arguably, have played a most vital role in the development of feminist theory by developing typologies of feminist theory that focus our attention on core issues of debate and differences of perspective. These have named the 'waves' of feminism: first wave, second wave, third wave and sometimes 'post-feminism'. They have given us the analytic distinctions between liberal feminism, radical feminism (libertarian and cultural), Marxist feminism, socialist feminism, psychoanalytic-feminism, postmodern and post-structural feminisms, intersectional feminism, postcolonial and global feminisms (Tong 2009). They have distinguished ways of conceptualizing gender relations: difference, inequality, oppression and intersectional oppression (Lengermann and Niebrugge 2011). Others categorize feminist social theory according to the social theorist or theoretical perspective that has most influenced their work (McLaughlin 2003). Many social theorists have established a place of centrality within social and cultural theory and feminist social theorists have deeply engaged with them in an effort to explore the usefulness and limits of the perspectives for feminism. These include, for example, postmodernist social theory (e.g. Nicholson 1990) and theories of late modernity (e.g. Adkins 2004; Mulinari and Sandell 2009). Feminist social theories might also be categorized according to their varying levels of feminist analysis: societal structure, culture, institutions, language, socialization, interpersonal interaction and intra-psychic processes.

Historical context

First wave feminism, or the feminist activity in Europe and North America of the nineteenth and early twentieth centuries, is typically characterized as 'liberal feminism' due to its primary focus on women's rights in the public sphere, most notably the right to vote, to own property

and to obtain education. Feminist thought of the era, however, involved a broader set of reflections on topics that would re-emerge with the beginning of the second wave of feminism in the late 1960s.

These included questions about differences between the sexes: were men uniquely capable of reason, self-determination and virtue, or were men and women equal in these capabilities? Were observed differences between men's and women's patterns of behaviour and being rooted in innate differences between them, or were they a product of social convention? Their reflections also included questions of cultural values and principles of social organiza-tion. If apparent differences between men and women are a product of social convention, should these conventions be abandoned such that all human beings have the prerogative to live lives of the highest virtue as defined by Enlightenment conceptions of 'man'? Should the world be governed by abstract and rational principles, or would a better world be one governed more by (some measure of) feeling and human compassion? Is the emancipation of women (or men) possible in a liberal, bourgeois society, or does emancipation depend on a radical restructuring of society?

Mary Wollstonecraft's *A Vindication of the Rights of Women*, published in 1792, is often accorded status as the earliest major work in feminist theory and as influential in inspiring the 'first wave' of feminist activism in the nineteenth century. Her manifesto called for women's equal access to education, attacking the views of eighteenth-century philosophers and educa-tors who had pronounced women unfit for any but a domestic education. Wollstonecraft's central claim was that women were inherently equal to men with regard to their capacity for rational and abstract thought and that they should receive an education commensurate with men so that they could contribute to society on an equal basis.

Wollstonecraft's manifesto epitomized a perspective that would later be called 'liberal feminism'. Her goal for women was equal access to an institution, education, currently restricted to men. She cast women as equal to men in capacities for reason and self-determination, asserting that women were endowed with capacity for all of the virtues of Enlightenment 'man'. She viewed women's education, and the removal of all barriers to their full participation in society, as something to be positively welcomed by and beneficial to men, women, children, families and societies. She did not call for significant changes in the struc-ture of society; she accepted the structure of modern, bourgeois family, including the assump-tion of women's primary responsibility for the home, justifying her call for women's education in part by the positive effect it would have on the family.

Wollstonecraft and the liberal feminist perspective she exemplified have been broadly criticized on the grounds that 1) it uncritically accepts the Enlightenment value placed on reason, autonomy and virtues exercised in the public sphere while implicitly devaluing emotion, interdependence and virtues exercised within the private sphere; 2) it reflects the standpoint only of bourgeois women, as the lives of other classes of women were not so confined to the private sphere, free of requirements of productive labour, or subsumed with 'femininity'; 3) it uncritically accepts the existing structure of society as one conducive to the fulfilment of the Enlightenment values of reason, freedom and self-fulfilment; and 4) it assumes that exclusion of women from the rights and prerogatives of 'man' is a matter of unenlightened prejudice that enlightenment can correct to the betterment of all humanity.

These liberal assumptions would be replicated, to varying extents, in some of the early manifestos of second wave feminism, such as Simone de Beauvoir's *The Second Sex* (2010 [1949]) and Betty Friedan's *The Feminine Mystique* (1963). Beauvoir's liberalism was reflected mostly in her valorization of masculine, Enlightenment ideals, while Friedan's was reflected in her presumption of the problems and interests of white, middle-class housewives and

mothers as *the* problems and interests of women generally. Friedan's founding and leadership of the National Organization of Women in the United States, an organization that focused on the attainment of legal rights and removal of barriers to women's full and equal participation in the public sphere, solidified her status as a 'liberal feminist'.

The categorizing of Beauvoir is more complicated. On some interpretations, she was cast as a liberal feminist (in a philosophical though not political sense) and criticized on much the same grounds as Wollstonecraft for valorizing Enlightenment ideals of reason, autonomy, self-determination and activity in the public sphere while neglecting and sometimes denigrating the value of virtues culturally construed as feminine, activities relegated to women, and the possibilities of genuine fulfilment in the enactment of these. As Wollstonecraft had been, Beauvoir was disdainful of the feminine, conventional women of her time, seemingly valorizing masculine virtues as human virtues, resisting only the notion that women were naturally lacking in these or inevitably destined to the insipidity of their condition.

Yet, Beauvoir was herself critical of Wollstonecraft's liberal feminist perspective on the very point that some critics attribute also to Beauvoir, that is, valorizing masculinity and encouraging women to eschew femininity and conventional expectations of women's proper place in society. The key difference between Beauvoir and Wollstonecraft on this point is Beauvoir's positing of an existential exploitation of women by men (i.e., the casting of woman as man's 'other'). So, while it is true that Beauvoir exhorts women to refuse this position and to claim their own subjectivity, she is also simultaneously casting the apparent autonomous subjectivity of men as false insofar as it rests upon the denial of the subjectivity of women. In this sense, then, her conceptualization was influential on the emergence of second wave radical feminist perspectives that conceptualized gender as an oppressive system in which men exploit women for their own benefits (both materially and psychically).

Critique of liberal feminism might be construed as one of the hallmarks of second wave feminism. Second wave feminism is characterized by the emergence and development of non-liberal feminist perspectives, most notably Marxist-socialist feminism and radical feminism. None of these perspectives or the critiques of liberalism they represented were altogether new, as all of these varieties of perspective could be found in first wave feminist thought (Lengermann and Niebrugge-Brantley 2001). What was new, however, was their increased prominence in shaping the direction of feminist scholarship, activism and consciousness.

There is general agreement among feminist scholars on the distinction between the first two waves of feminist activism and scholarship. But the agreement is far less when it comes to defining 'third wave' feminism and/or 'post-feminism'. The line of demarcation between second and third wave feminism is variously drawn, with some defining second wave feminism narrowly to include only those feminist theories of the late 1960s and 1970s that rested on concepts soon to be problematized by multicultural, postcolonial, global, post-structural and postmodern feminists: most notably, 'woman', 'liberation' and 'patriarchy' or 'male domination–female subordination'. Others consider multicultural, postcolonial and global feminisms as part of second wave feminism, as they had after all emerged early in second wave feminism with internal debates regarding women's differences; they define 'third wave' feminism as including only the feminist theories developed during or after the engagement with postmodern and post-structural theories in the early 1990s.

For some, 'third wave feminism' and 'post-feminism' are synonymous, while others define 'post-feminism' as a perspective, a cultural phenomenon, that has developed among younger generations who no longer identify as feminist, who reject the connections that second wave feminists had drawn between sexuality, femininity and male domination, and who see

themselves as powerful and self-determinative in their freely chosen fashioning of feminine selves and expressions of sexuality (primarily) through participation in consumer culture (McRobbie 2004). This particular definition of 'post-feminism' seems to be most prevalent in the United States and Canada, whereas a broader meaning seems to prevail internationally. According to this broader conception, 'post-feminism' is construed as continuous with and vital to the larger project that is typically called feminist theory.

Within this broader conception, however, there is also variation. For some, post-feminism is feminist theory rooted in post-structuralist and postmodernist thought; the French feminisms of Kristeva, Irigaray, Cixous and Wittig; the Foucauldian feminisms of Bartky and Bordo and others; the postmodern feminism or 'queer theory' of Judith Butler and others; and post-colonial feminist perspectives such as those of Sandoval, Spivak and Mohanty. The broadest conception, however, is one that refers to contemporary feminist thought in general, characterized by a broadly recognized necessity of recognizing differences among women and of the problematic nature of any essentialist definitions of what may have been seen as the core concepts of second wave feminism: 'woman', 'liberation' and 'patriarchy' or 'male domination–female subordination'.

'Post-feminism' in this sense by no means marks a sharp break from the preceding waves, but rather a self-conscious recognition of the complexities involved in any project of critical social analysis and critique. Post-feminism, however, implies neither that the second wave project of 'liberation of women from patriarchy' is complete nor that it is necessarily misguided. The language has come to be problematic and the project can no longer be cast so singularly. But the problems that have concerned feminist theorists throughout feminism's history remain. The task of post-feminist theory is to confront them without a 'woman', without 'liberation' and without 'patriarchy'. Post-feminism, in this sense, remains a project of critical social analysis and critique.

The following presentation of key contributions in feminist social and cultural theory will be organized around the question of the social construction of gender, a question that has been a particularly central one in feminist social and cultural theory. The broader concern with understanding the structure and mechanisms of patriarchy persists, sometimes (appropriately) absent an analysis of the construction of gender. The more social structural and materialist feminist analyses, however, have tended in recent decades to be produced by feminist scholars in social science disciplines who do not self-identify and are not typically regarded as social and cultural theorists. The feminist scholarship that has become classified as 'feminist theory' and recognized for its contributions to social and cultural theory, however, tends predominantly to be work in which the question of the social construction of gender is central.

Key contributions and criticisms

Liberal psychology and the advocacy of 'androgyny'

Ideologies of difference between men and women had long served as justifications for denial of women's rights and restriction of their prerogatives, and so a predominant tendency of second wave feminist thought had been to construe apparent differences between men and women as socially constructed rather than natural. The analysis of the processes by which gender is socially constructed is one of second wave feminist theorists' most vital contributions.

The array of variable understandings of the most important sites of gender construction has generated fruitful debate among feminists of varying theoretical backgrounds and

political orientations, debates that remain unsettled and continue currently. Some analyses, such as that developed in psychology in the 1970s, were more compatible with liberal feminist perspectives; the then emergent study of the psychology of gender in the discipline of psychology led to the conclusion that human beings would be better off if parents were to break from sex-based gender socialization of children and if there were less of a rigid divide between 'masculine' men and 'feminine' women. Rigidly masculine or rigidly feminine personalities, their scientific studies showed, were crippling; androgynous personalities, defined as people who rated themselves relatively high on both masculine and feminine personality traits, were happier and more fulfilled in their lives and enjoyed deeper, more mutually enhancing relationships with others. Sandra Bem's development of the 'Bem Sex Role Inventory' in 1971, and her subsequent research (Bem 1976), laid the foundation for this work.

This psychological perspective was liberal in the sense that it seemingly prescribed the loosening of restrictive gender norms as the path towards equality between men and women, neglecting structural bases of inequality on the one hand and the relationship between gender and power on the other. It is important to understand that the psychological study of sex typing, and the consequent advocacy of androgynous personalities, derived from research developed within the discipline of psychology making no claim to being anything other than this. It was not a feminist vision of change; it made no claim that rigidly sex-typed socialization and personalities was *the* cause of inequalities between men and women or that its elimination would itself be the needed feminist revolution. Its claims stayed within the bounds of its own discipline: 1) people are happier and more well-adjusted to the extent that they integrate in their personalities masculine and feminine traits; and 2) parents should liberalize their approaches to socialization of children, offering the same reinforcements to their male and female children, praising and punishing them equally for the same behaviours while discarding sex appropriateness as a criterion.

In another sense, however, the emerging consensus that gender was socially constructed and that this was at least part of the problem of gender inequality was itself radical. It went beyond liberal feminist efforts to gain rights, remove barriers and create equal opportunity, priorities that need not have been accompanied by a consciousness of gender itself as socially constructed or a problem. Regardless of perspective, most feminists favoured equal rights and equal opportunities. Feminist theorists' analyses of the integral part that gender constructions played in systems of male domination and female subordination led most to see the need for deeper cultural, social and personal changes revolving around constructions of gender.

Radical feminist perspectives on sex and gender

By the mid to late 1970s and continuing at a vigorous pace at least through the 1990s, the theorizing of the processes by which gender was socially constructed became a primary preoccupation of many feminist theorists. In the earlier part of second wave feminism, however, the analyses of feminist theorists centred not so much on the *processes* by which gender was socially constructed as on theorizing the relationship between constructions of gender and feminist politics. The main question was, in other words, what must we *do* about hegemonic constructions of gender if we are to be successful in our liberation from male domination?

Radical-libertarian feminist theorists such as Kate Millett (1970) and Shulamith Firestone (1970) advocated the elimination of the sex distinction itself. Hierarchy, they argue, will always accompany any distinction between human beings about which much is made. So

Ann Branaman

long as males and females are thought to be essentially different varieties of human being, they argued, hierarchy will necessarily persist. Additionally, if the sex distinction were to be eliminated by desegregation, including stylistic and institutional bases of distinction as well as the necessary connection between male and female bodies and human reproduction, as Firestone had advocated, discrimination would become impossible as a consequence of people not being able to find visible evidence of the sex distinction.

Cultural feminism, another variant of radical feminism, regarded liberal feminist philosophy as a misguided valorization of masculinist values and a failure to recognize this as part and parcel of a modern Enlightenment culture thoroughly infested with ideologies of male superiority. Accordingly, they regarded liberal reform as a misguided effort to gain for women the ability to compete on an even footing with men in men's world, a stance that ultimately solidifies the presumption of male superiority. Against radical libertarianism, cultural feminists argued that the elimination of the essential role of women in the reproduction process would eliminate a primary source of women's power. They viewed with suspicion the radical libertarian advocacy of androgyny, arguing that this ideal simply combines 'masculinity' and 'femininity' (as they have been constructed in the context of male domination and female subordination) in equal measure, without calling into question the merits of the purported virtues contained within them (Tong 2009). (This last criticism, I would argue, is misdirected. It is an accurate account of how psychologists who tried to measure 'androgyny' did so. But it would be hard to read Firestone and reach the conclusion that androgyny as operationalized by behavioural scientists was what she had in mind or that her vision for the liberation of women could possibly have entailed an uncritical merging of masculinity and femininity as they had been constructed within the patriarchal society she had problematized to the core.)

The cultural feminist approach to attacking patriarchy, then, was to expose the manifestations of the broadly rooted presumptions of the higher value of men and the masculine and the inferiority of women and the feminine. Wollstonecraft's and Beauvoir's influential treatises were two such manifestations, but mostly cultural feminists directed their attention outward towards exposing the manifestations that were manifold in the broader non-feminist world: for example, representations of female sexuality and the sexual objectification of women, the presumption of the male right to control female bodies, the devaluation of caring and empathy (or emotional labour, as Hochschild [1983] would later call it), the low pay and status accorded to jobs occupied predominantly by women, and the casting of women as inferior in highly influential texts such as those of Freud.

The activism and scholarship classified as 'cultural feminism' shares a common analytic focus on cultural representation, but is otherwise widely heterogeneous. Marilyn French and Mary Daly, two notable contributors to the cultural feminist perspective, both offered critiques of androgyny, for example, but they differed in their respective re-visioning of an alternative model. French's work analysed both 'masculinity' and 'femininity', offering re-interpretations of both that essentially cast aside and replaced formulations rooted in patriarchal gender relations. In place of the masculine 'power-over' others, for example, French offered a reconceptualization of 'power-to' (do for others). French's general strategy was to substantively redefine masculine traits or virtues by infusing them with elements of femininity. Daly's work, by contrast, focused mostly on re-interpreting femininity and, specifically, on distinguishing the positive aspects of femininity from the distortions of feminine traits or virtues that stem from female subordination (Tong 2009).

Cultural feminists' call was to revalue women and femininity and to radically transform the dominant cultural system of meaning to reflect this revaluation. This led to a focus on the

representation of women, men and gender in all types of media and to the analysis of patriarchal meanings embedded within language itself. While broad consensus seems to have emerged among feminist thinkers that the cultural feminist project of revaluation should be at least part of feminism's project, cultural feminist perspectives were broadly criticized for their 'essentialist' conceptions of gender. The contradiction between the broadly shared notion that gender was a social construction and the cultural feminist notion that women *were* different from men, but in ways that should be appreciated rather than denigrated, was one difficulty. The idea of gender as a *problematic* social construction, shaped by patriarchy in undesirable ways, was another source of contradiction. Cultural feminist theories seemed to glorify women and femininity without considering how these had been shaped and distorted as a consequence of their subordination to men and their adherence to dominant cultural standards and expectations of women. Some also seemed inappropriately extreme in their outright vilification of men and masculinity. While these criticisms might fairly apply to some particular versions of cultural feminism, they hardly apply uniformly. A degree of essentialism is difficult for cultural feminists to avoid without arriving ultimately at a radical libertarian perspective. Within cultural feminism, certainly, can be found vilification of men and masculinity, but the vilification of *patriarchal* men and masculinity is not the same as vilifying men and masculinity outright. The most inaccurate of the criticisms, however, is the charge of glorifying women and femininity. The critical examination and re-interpretation of femininity has been central to the cultural feminist effort; only a failure to recognize these reconstructive efforts could lead to the conclusion that they had been uncritically glorified.

Marxist-socialist feminism

Radical feminists contemplated the possibilities of a gender-free society or a culture that inverts the hierarchy of men and masculinity over women and femininity, focusing on the question of what feminists *should* want, reflections that especially engaged feminists outside of the academy. Inside the academy, however, the focus was less on vision and politics than on understanding the oppression of women. Initially, at least, these explanatory efforts were rooted within Marxian theory, a critical theory of human oppression under capitalism.

In the 1960s before second wave feminism had become an identifiable movement, Juliet Mitchell offered an early analysis of the relationship between capitalism and patriarchy, concluding that Marxian theory could not adequately account for the oppression of women in all of its forms (Mitchell 1966). This work was hugely influential both in inspiring the feminist movement and in inspiring further explorations of the interplay of capitalism and patriarchy. Marxist-socialist feminism became the leading framework within the academy in the early years of second wave feminism, especially in the discipline of sociology, where Marxist-socialist perspectives had already made significant inroads. With the entrance of feminists into the discipline of sociology during the 1970s, the exploration of the utility and limits of the framework for understanding male domination and female subordination was a line of theorizing that followed naturally. In this body of theory the focus was not on questions of gender (i.e., masculinity and femininity) but on the material conditions of women's lives.

The basic premise of Marxist-socialist feminist theory was that male domination of women was intertwined with capitalism. Marxist feminist theorists, following from Marx and Engels, argued that capitalism was the fundamental source of male domination of women; with the abolition of private property and the freeing of all workers, male domination would dissolve. Although some feminist theorists would continue to place emphasis on the dynamics of

capitalism and on material aspects of women's (and men's) lives as they were structured in capitalist societies, there were hardly any pure Marxist feminists who would take the strong position that male domination could be thoroughly explained by capitalism and would neces- sarily disappear with socialist revolution. In general, Marxist-socialist feminists believed that capitalism and patriarchy were intertwined (to varying degrees and in varying respects), but that they were also distinct forms of domination that could exist without the other. In contrast to radical feminism, socialist feminists did not assert the priority of patriarchy as *the* funda- mental basis of all other forms of social domination (Tong 2009).

Regardless of the position on this question of priority, however, second wave Marxist- socialist feminists shared a focus on household labour as a primary site of intersection between patriarchy and capitalism. (Marx and Engels, by contrast, had focused on the institution of private property, and concerns about its intergenerational transmission, as a basis for the formation of the patrilineal modern family.) Women's (unpaid) performance of household labour added an additional layer of capitalist exploitation; with women performing this labour for free, the cost of reproducing the labour of men (and women too who worked for wages) was less and the profits thus greater.

But for socialist feminists, women's unpaid performance of household labour also entailed men exploiting women, not merely capitalists exploiting families. Among families in which husbands were the sole wage earners, even as women worked as hard if not harder in the home performing tasks that would cost considerably if performed by hired help, they controlled and had a sense of entitlement to determine how 'their' wages were spent. In addi- tion, the arrangement allowed men a great deal more leisure time than women could have; with paid labour being defined as work and unpaid labour not, men could feel entitled to freedom from household responsibilities during their hours not spent working for wages.

While recognizing that the exploitation of female labour in the household was vital to the functioning of capitalism, socialist feminists also recognized that male domination of women took many forms that were inessential to the functioning of capitalism. In the first place, the profits of the capitalist would remain even if the paid wage were thought of as a shared wage that paid for household labour in addition to the labour outside of the household. Why must the labour of the husband outside of the household be defined as worth more than the wife's labour inside the household? Why must the wife's work in the household go unrecognized? Capitalism itself would be unaffected by such a change in conceptualization, by a change in the division of household labour, or by the equality of authority and rights in the household. Secondly, predominantly male-female domestic violence and rape, phenomena that second wave feminism had exposed as widespread, could not easily be understood as in any way related to capitalism.

Yet, as Marxist-socialist feminists confronted the limits of a purely Marxian framework for making sense of gendered oppression, some came to conceptualize 'patriarchy' as a distinct structure of oppression that required other frameworks of analysis to explain it. The concept of ideology central in Marxian thought, paradoxically, provided an avenue for a shift away from the analysis of class and capitalism, as the focus shifted to examining the ideological basis of patriarchy. Juliet Mitchell's turn to psychoanalytic theory in the early 1970s was particu- larly influential in leading socialist feminism away from its defining concerns and to a focus on the construction of gendered subjectivity that remains a predominant focus in critical social thought. This trend coincided with and is a manifestation of the 'cultural turn' in critical social thought that had emerged out of Marxian theories of ideology (Gramsci and Althusser, most importantly), the Frankfurt School's focus on culture and subjectivity, and post-structuralist social and cultural theories.

Psychoanalytic feminist theories of the construction of gendered subjectivity

For psychoanalytic feminist theories, the key questions were: How do men and women become masculine and feminine? How do they come to the presumption of male superiority and female inferiority? Why are women complicit in their subordination? And from where within them might come the motivation to resist such subordination?

Mitchell's *Psychoanalysis and Feminism* (1974) turned to psychoanalytic theory to find the answers to these questions. Against the earlier feminist rejection of Freud as a consequence of his sexist assumptions and the bias towards gender conformity characteristic of practising psychoanalysts in the middle of the twentieth century, Mitchell challenged feminists to take Freud's work seriously. She argued that, rather than rejecting it as a misguided prescription for gender development, it should instead be viewed as an analysis of the processes by which masculinity and femininity were produced in modern, bourgeois societies (and more or less universally, she suggested). Reading through a Lacanian perspective, Mitchell took to be descriptively accurate Freud's account of the early childhood origins of gender and sexuality, his analysis of the discovery of sex difference, and the acquisition of gender and sexuality. The establishment of 'masculinity' and 'femininity', and the privileging of masculinity over femininity, was intrinsic to the formation of human subjectivity itself. A point that would receive greater emphasis in the writings of her colleague Jaqueline Rose (Rose 1983), the analysis illustrated the psychic discontents that accompanied masculinity and femininity so constructed. In these discontents, they thought, might be the motivation for women to resist their subordination to men.

Mitchell's importance for psychoanalytic feminism was not so much the particular theorizing of the formation of gendered subjectivity that she provided; her greatest influence was in her call for feminists to grapple with psychoanalytic theory, to use it not only to understand how gender is constructed but also to identify intra-psychic sources of contradiction and resistance that might shed light on how subjectivity might be formed differently. Her call was heeded, as psychoanalytic feminist theory became a prominent branch of feminist theorizing in the United States and Europe.

The psychoanalytic feminist theories that developed in the United States shortly after the appearance of Mitchell's path-breaking work had a broader array of influences. Dorothy Dinnerstein's classic *The Mermaid and the Minotaur* (1976) was a more widely accessible analysis that reflected Dinnerstein's direct participation in the feminist movement and that bore the clear imprint of radical feminist perspectives. Nancy Chodorow's classic *The Reproduction of Mothering* (1978) was more academic, less accessible to those not well versed in Freudian and post-Freudian thought, and reflected her academic background in anthropology and American sociology. In particular, her theory of the construction of gender drew heavily on the work of Talcott Parsons, whose functionalist perspective had dominated American sociology throughout most of the 1950s and 1960s, but also on the critical psychoanalytically oriented social theories of the Frankfurt School.

Both Dinnerstein and Chodorow turned to psychoanalytic theory in much the same spirit as had Mitchell: first, with the aim of understanding how masculinity, femininity, and male dominance and female subordination become intra-psychically rooted such that men and women collude in maintaining the gender order; and, second, with the aim of identifying the 'repressed' discontents of these constructions.

Both drew upon post-Freudian object relations theory to develop an account of the construction of gender, departing from the patricentrism of classical Freudian theory (and from Mitchell's version of psychoanalytic feminism) by shifting focus to the early relationship

between the child and the primary caretaker (usually a mother) as the crucible of gendered personality development. Dinnerstein and Chodorow argued that the mother's role as the primary caretaker of children was largely responsible for the development of 'masculinity' in males and 'femininity' in females and a shared assumption of masculine superiority. The emphases of their respective accounts varied: Dinnerstein's focus was on explaining the intra-psychic basis of male domination and female subordination, whereas Chodorow's focus was on explaining the formation of the motivation to mother in girls and the development of the motivation for autonomy and success in boys.

Like Mitchell, Dinnerstein and Chodorow theorized the social construction of gender in a way that placed it deep within the psyche and rendered it difficult to change. Neither offered any solution for change for adult humans whose subjectivities had already been formed, short of possibly a lengthy period of psychoanalysis that might uncover the suffering such constructions had caused and tap into the intra-psychic sources of resistance they had identified. Both concluded, however, with the prescription that men and women be equally involved in the primary parenting of young children; so long as women retain their near exclusive role as primary caretakers of young children, masculinity, femininity, and the collusion of both men and women in maintaining gendered hierarchy will persist.

While garnering much attention, both Dinnerstein and Chodorow drew fire for their presumptions of a male breadwinner–female homemaker family form. This form had been the dominant bourgeois family form in Europe, the United States and other regions of global privilege. For a brief period it extended into the working classes in the United States. In the economically prosperous period after World War II to the early 1970s, white-collar and blue-collar workers alike formed a big middle class sufficiently affluent to allow women to be full-time homemakers. But never was this a model that characterized those who did not share in this prosperity; black families were chief among these, as black working-class men were often relegated to a secondary labour market that did not yield the financial benefits that were common among white men. But as middle-class women moved into the paid labour force in masses beginning in the early 1970s, it was soon to become not such a common family model at all.

Additionally, the theories were limited in their ability to explain some of the mother–child relational patterns that were crucial to their theories. Both, for example, assumed that mothers will identify more with girls and will maintain more permeable emotional boundaries with them, while experiencing male children as sexual others, pushing them out of the symbiotic mother–baby bond much earlier and towards autonomy, and denying them the identification that they give to their daughters. But why should we assume this to be the case? There are any number of factors other than the sex of the child – such as temperament and physical characteristics – that could affect the strength and nature of parental identification.

The theory also failed to account for children who become other than heterosexual. Male homosexuality seemed particularly problematic to explain; lesbianism, on the other hand, seemed difficult to explain away (as both had also in Freud's theory). The explanation for female heterosexuality was, essentially, the girl's turning to the father in compensation for the injury she felt in learning that she could never 'have' her mother on account of her sex and her mother's heterosexuality. This explanation, however, raises the question of why the girl would experience such an injury given the closer bond the mother maintains with her, a bond that the theory suggests is often stronger than that the mother would have with a husband, as a consequence of his guarded emotional boundaries. These are just a few examples of explanations that require explanation.

These theories were limited also in their ability to explain why children who grew up in other familial arrangements seemed to become gendered in much the same way that children

in the male breadwinner–female homemaker arrangement did. While it certainly seemed plausible that children would have strong feelings for their primary caretakers (usually mothers) that would affect their self-identities and their relational patterns, it was not clear why these should necessarily take distinct gendered forms.

Meanwhile, another version of psychoanalytic-feminist theorizing was developing in Europe, particularly in France. This body of 'French feminism', including the work of Luce Irigaray (1985 [1974]; 1985 [1977]) and Julia Kristeva (1984 [1974]), followed Mitchell's lead in turning to Jacques Lacan's reading of Freud as a basis for the development of their narratives of gender construction. Steeped in structuralist and post-structuralist thought more gener-ally, their focus was less on the particularities of parent–child bonds and identifications and more centrally on the formation of subjectivity via the internalization of (patriarchal) language and culture. Given the problematic assumption of the generalizability of the male breadwinner–female homemaker family form in Dinnerstein's and Chodorow's work, Irigaray and Kristeva, when translated into English in the 1980s, seemingly offered an alter-native that did not depend on such an assumption. The period of Irigaray's and Kristeva's highest popularity and influence in the late 1980s and 1990s could also be attributed to the rising influence and popularity of post-structural and postmodern social theories which called for and seemed to hold the promise of liberating critical social thought from its various essen-tialisms. The possibilities for deconstructing the constructions of gender that Irigaray and Kristeva theorized, however, did not in the end seem all that promising.

The central impetus of Irigaray's theoretical mission was an attempt to liberate the 'femi-nine' from its role as subordinate other to the 'masculine'. In Lacan's theory, the feminine remains mired in the realm of the pre-cultural and pre-verbal imaginary, a pre-Oedipal domain in which children have yet to develop a distinct subjectivity. In Lacan's formulation, it is with the resolution of the Oedipus complex that the child enters into language, into the symbolic order, and thereby achieves subjectivity. But since girls never fully resolve the Oedipus complex, he posited, they either remain in the imaginary lacking subjectivity or they enter the symbolic order only to be mute within it. Irigaray accepted this basic formula-tion, but challenged the assumption of its undesirability and its implication of female inferi-ority. She saw potential in both possibilities, remaining in the imaginary and becoming mute within the symbolic order, for deconstructing the masculine–feminine hierarchy. In essence, either possibility frees women from defining themselves as 'feminine', inferior subjects in the masculinized symbolic order in which the 'feminine' is inherently defined from a masculine perspective. Rather than viewing women's lack of a discrete and articulable subjectivity as a deficit, she saw it as something to celebrate (Tong 2009).

Assume that Irigaray (and Lacan) were correct in their assumption of women remaining mired in the imaginary or mute within the symbolic order. Also assume, with Irigaray, that either of these situations, if embraced, implies women's liberation from patriarchy. Women and the feminine are only inferior through the perspective of men and the masculine; if women never fully enter the symbolic order and do not even attempt to define their subjec-tivity with its language, then how can they be thought to be subordinate to men in any other way except in the misconceptions of men? Even if all this could be rightly cast as 'liberation', however, what is the character and quality of this liberated life?

So that their muteness within the symbolic order need not entail a surely impossible depri-vation of meaningful communication with others, Irigaray advocated women's development of an alternate language, one not so fixated on defining discrete subjectivities or on understanding the world through a set of discrete concepts, and one that better fits women's experiences of themselves. She also famously articulated an alternative way of seeing women's

sexuality. Instead of the Freudian and Lacanian conception of women's lack, the passive and receptive nature of their sexuality, she argued that this too reflects a male perspective. From her alternative perspective, women are far from lacking; where the male sexual organ depends for its sexual satisfaction on some form of external stimulation, often the penetration of a female's vagina, the female sexual organs – her 'two lips' – allow a continual self-caressing in which the act of touching can never be distinguished from the experience of being touched (Irigaray 1985 [1977]). Female sexuality, she argues, is much more diffuse, not centred on a single sex organ and not so focused towards a discrete end; rather than limiting female sexual pleasure, this diffuseness is a source of pleasures that far transcend the pleasure of a discrete orgasm that seems to centrally define male sexuality (Tong 2009).

As Irigaray had, Kristeva accepted Lacan's basic formulations: of the imaginary, the symbolic order, the movement from the pre-Oedipal imaginary into the post-Oedipal symbolic order as the basis for establishing subjectivity, the differences in how males and females resolve their Oedipal complexes and the consequent differences in the manner in which they enter the symbolic order. In contrast to Lacan, who posited a complete abandonment of the imaginary with the entry into the symbolic order, Kristeva argued that some of the imaginary accompanies the child as they enter the symbolic order. This was important to her conceptualization of a possibility for the construction of female subjectivity that refuses rigid identification with the patriarchal order but without remaining outside of social relations altogether.

In Kristeva's view, the patriarchal order is never as stable as a more determinist Lacanian account implies. Kristeva rejected the structuralist view of language as fixed and homogenous, constructed on the basis of a unitary social order. Instead, subjectivity is constituted on the basis of both symbolic and semiotic dimensions of experience; even as the patriarchal social order attempts to marginalize the semiotic, subjectivity cannot ever be absolutely divorced from the unconscious processes, heterogeneous drives and maternal power associated with semiotic experience. Subjectivity, as conceived by Kristeva, is inherently a 'subject-in-process' – structured by the symbolic but at the same time, by virtue of the semiotic experience from which it cannot detach itself, subversive of it.

In patriarchal society, however, cultural myths and male ideals of power serve to relegate semiotic experience (and women, who are associated with it) to a marginal position. Subjectivity in patriarchal society becomes a matter of striving to achieve autonomy from semiotic experience – from heterogeneous drives and from the early experience of relation to the mother. The political problem, for Kristeva, is to recover these marginalized experiences – for example experiences of abjection, melancholy and foreignness – in such a way that they can provide a basis for creative resistance (Elliott 1992).

In contrast to Irigaray, who thought remaining in the realm of the imaginary, as Lacan had suggested that some women do, should be regarded positively as a source of women's freedom from patriarchy, Kristeva did not see this outcome as at all compatible with living a meaningful life. Engulfment in abjection – fusion with the marginalized maternal object – consigns one to a life of emptiness, hatred and exclusion of everything outside (Kristeva 1982: 6). But emerging from this fusion did not need to entail loss of this realm of experience. Experiences of abjection, melancholy and foreignness occur within the symbolic order as well; there may be no 'symbolic' meaning in the imaginary realm of exclusively semiotic experience, but the semiotic meaning continues to exist in the symbolic order. Though repressed and marginalized due to the challenge such meanings pose to the coherence of the patriarchal symbolic order, they are important, in Kristeva's view, precisely because they reveal the underlying lack of unity of the patriarchal order and are typically experienced as threatening to subjects whose subjectivity is built upon rigid exclusion of them.

Kristeva defines the abject as an unnameable source of threat – associated with the early experience of fusion with the mother – from which the subject attempts to escape. The abject is excluded from meaning, driven away out of the subject's fear of annihilation. But from its place of exclusion, it ceaselessly challenges the stability of meaning (Kristeva 1982: 1–2). The sight of a foreigner – and Kristeva suggests that women may be the prototypical foreigners – arouses contempt because we displace onto this external foreigner the unnameable source of threat from which we constantly seek to seal ourselves off (Clark and Hulley 1991). The perpetual fear aroused by otherness, however, indicates the fragility of patriarchal mastery.

Because the semiotic can only exert creative power through the mediation of symbolic experience, however, Kristeva suggests that it may be up to men – who have achieved a more stable position within the symbolic order – to experience a crisis in their own system of meaning and to then re-infuse subjectivity with semiotic experience. But she also sees a basis for resistance, a motivation towards the development of an alternative construction of subjectivity, within women's experience. In particular, she suggested that a sort of creativity was inherent in women's depression – a depression that stems not only from failure to identify with a meaning outside, but also from the failure to find sustenance in the un-nourishing maternal bond to which, in their depression, they cling.

Depression, as Kristeva analyses it, is a sign of introjection of the unnourishing maternal object. Despite her warnings of the danger of women silencing, burdening and ultimately killing themselves with this dead maternal weight, Kristeva suggests that depression is a powerful affect and source of integration that allows the subject to resist the emptiness of the symbolic order and to create outside of it. In depression, she suggests, a woman experiences the meaninglessness of the order outside of herself. She attempts to create an integrity apart from the outside world. Depression offers support – although a negative one – that makes up for her failure to be validated within the outside world. Depression marks a refusal to identify with, to construct a meaningful life within, the confines of the patriarchal order that would sever her ties to the maternal, semiotic realm with which she identifies and without which she can experience no meaning. Kristeva characterizes depression as 'the imprint of a humankind that is surely not triumphant but subtle, ready to fight, and creative' (Kristeva 1989: 22).

Irigaray's and Kristeva's versions of psychoanalytic feminist theories have been as heavily criticized as those of Dinnerstein and Chodorow, even though the post-structuralist elements of their work and their advocacy of non-essentialist conceptions of gender and identity and critiques of modern, hierarchical binary modes of thinking caused Irigaray and Kristeva to be viewed as more progressive alternatives throughout much of the 80s and 90s. In different ways, however, Irigaray's and Kristeva's theories had their own problems of 'essentialism' to face. Showing their structuralist roots, both seemed to suggest that the masculinist symbolic order was a cultural universal. Further, the notion that males and females should inevitably differ so fundamentally on their respective paths towards the establishment (or failure of establishment) of subjectivity begs explanation. The only explanation they offer is Lacan's theory of the process. Should we necessarily assume its accuracy?

One general criticism of all versions of psychoanalytic-feminist theorizing is that they assume deep, intra-psychically rooted differences in motivation, in personality attributes, in the very experience of selfhood itself that may not, after all, be so deeply rooted. As psychologists began measuring 'masculinity' and 'femininity' in the early 1970s using instruments such as the Bem Sex Role Inventory, many men and women did not appear to be strongly sex typed at all. So, to many critics, it seemed that psychoanalytic feminist theorists may have been explaining something that did not exist, or at least not the way they assumed; if

'masculinity' and 'femininity' were widely shared stereotypes, they did not closely correspond to the personalities of men and women.

Another source of criticism came from sociologists who studied gender and gender inequality. One of the justifications for turning to psychoanalytic feminist theory was that gender constructions seemed to remain much the same despite changes in women's roles and status in society and a liberalization of parental attitudes regarding the sex-typed socialization of children. Despite the successes of the women's liberation movement, why were so many women continuing to accept their subordination to men? As psychoanalytic feminism emerged in the early 1970s, however, it was quite premature to say that all that much had changed. Some important gains in some areas had been made, but gender hierarchy remained entrenched in most of society's institutions and would require much more time and effort directed at institutions before jumping to the conclusion that meaningful social change would necessarily require reordering the depths of human psyche.

Feminist sociologists have made valuable contributions to thinking about gender constructions and about how gender-based inequalities are maintained despite the expansion of women's rights and the trend in advanced societies towards belief in men's and women's essential equality and rights as human beings. Valuable work has been contributed at nearly every conceivable level of analysis, including non-reflective beliefs about men's and women's different competencies and the self-fulfilling impacts these often have in task-based interaction; gender-differentiated interaction norms in everyday life that, when faithfully followed, give the appearance of gender as an intra-psychic structure; the conceptualization and analysis of 'doing gender' (West and Zimmerman 1987), focusing on the micro-behaviours and verbal accounts that people engage in to demonstrate their gender even in contexts that might not specifically call for gender-differentiated behaviour; behavioural expectations attached to specific (mostly) gender-segregated roles; discrimination in the workplace; occupational and job segregation; the cultural and economic devaluation of 'care' work performed largely by women in the workplace and at home; women's continued subordination of their careers to family needs; the persistence of assumptions of women's primary responsibility for home and children despite full-time participation in the paid labour force; the overrepresentation of women among the world's poor and in the most low-paid and highly exploited jobs; and cultural representations of men and women that reinforce assumptions of differences and inequality. Work addressing these issues is only some of a broader array of sociological work that addresses sources of continued gender hierarchy at levels besides the intra-psychic. With all of these factors in play and with evidence to suggest that gender may not be all as deep as psychoanalytic feminists have assumed, most contemporary feminist sociologists question the utility of the psychoanalytic feminist framework as an effective way of confronting gender-based hierarchies.

Most of this sociological work, however, is not classified as social or cultural theory and thus has not played a significant role in the development of feminist thought, which seems regrettably to have constructed its own exclusive canon, privileging abstract theory over empirical facts and concrete realities. Feminist theorists have, it is true, contributed valuable criticisms of the masculinist biases, of the misguided emphasis on 'objectivity', within sociology and other social sciences. And social and cultural theorists generally maintain a degree of mistrust of empirical social sciences and are often uninterested in their seemingly banal topics and questions. Sometimes, however, social science provides some important information that could contribute to the construction of more informed theories.

A broader critique of psychoanalytic feminist theory concerns its participation in a broader trend among social theorists towards the analysis of ideologies, identities, subjectivity and

cultural representation to the neglect of the material inequalities that are causes of great suffering and pain for many people in the world and that, incidentally, are borne to a greater extent by women. When feminists concern themselves with material bases of oppression and with the lives of women outside of the privileged classes and outside the privileged regions of the world, it is difficult to imagine that psychoanalytic feminist theories could seem even remotely relevant. This is not to say that material bases of oppression are unconnected to matters of identity and recognition. Nancy Fraser's (1995) contemporary classic 'From Redistribution to Recognition: Dilemmas of Justice in a Post-Socialist Age' demonstrates these connections while rightly challenging feminism and other forms of 'identity politics' to increase the attention paid to matters of redistribution.

Intersectional, postcolonial and global feminisms

By the latter part of the 1970s feminism and feminist theory came under attack for their neglect of differences among women, for defining a feminist agenda and theorizing women's situation in terms of the experiences, life situations and problems of white middle-class heterosexual women (Spelman 1988). In particular, they were criticized for inattention to the variability of women's (and men's) experiences as they were affected by factors other than gender (e.g. social class, race, nation, nationality, sexuality, disability, age and marital status). Racial and heterosexist exclusions received the most attention at first, with concurrent social movements against racism and heterosexism. Global and postcolonial feminisms developed alongside critiques of racial and sexual bias, with their compelling critique of the benefits obtained by white middle-class women in the global North at the expense of women of the global South. 'Intersectional theory', so named by Patricia Hill Collins, was a recommended method of feminist analysis that recognized that the experience of male domination and female oppression varies widely according to a person's position within other social hierarchies and should thus be analysed as a 'matrix of domination' that recognizes that most people are both privileged and disadvantaged to varying degrees depending on their class, race, gender, nation, nationality, sexual orientation, disability, and so on (Hill Collins 1990).

Whereas socialist feminism took one path towards its erasure via Mitchell and the French feminists, socialist feminism is perhaps the dominant perspective in feminist theories that focus on the position of women in the global South in the postcolonial era. Feminist theory as it has developed through the 1990s to the present in Europe, North America, Australia, New Zealand and in other pockets of relative global privilege has taken directions that are largely irrelevant to feminists concerned with women in and of the global South who are subjected to highly exploitative and often brutal conditions as a consequence of their global position and their subordinate status as women: women's extreme and harsh exploitation as low-paid workers in global sweatshops; their voluntary and often involuntary participation in the global sex trade; their relatively subordinate position, low pay and harsh conditions as agricultural workers; their exploitation as global nannies and housekeepers; and their disproportionate representation among the world's sufferers of the most extreme poverty.

Much like the original divide between Marxist feminism and socialist feminism, the theorizing of women's role in the global economy varies in the priority it places on capitalism relative to gender. Some focuses mostly on the dynamics of global capitalism, on the exploitation of labour and resources of the global South by the transnational corporations of the global North, viewing women's subordinate status in these contexts as an incidental factor in their predominance as workers in global sweatshops, as low-wage agricultural workers and as members of the global poor. Other work focuses most centrally on gender subordination;

it views gendered hierarchies not only as intertwined with the more general process of the exploitation of the South by the North, but also as independent from this. Global capitalists may use gender subordination as a strategy for obtaining the most inexpensive and highly profitable labour force, but most global feminists see gender subordination as its own system of subordination that preceded and would persist in the absence of such exploitation.

The study of the patterns and particularities of the subordination and exploitation of women in the global South and in postcolonial contexts is an area in which a lot of important work has been and is currently being done. Highly substantive in presentation, in most cases, rarely is it classified as feminist theory. Currently, the dominant theoretical perspective among social theorists who study global social-economic dynamics is world systems theory, a perspective that feminist theorists have found both limited and useful. Global feminist theories grapple with this theory much the way earlier second wave Marxist-socialist feminists grappled with the usefulness of the Marxian framework, but the harsh material realities of the lives of the global underclass that they study militate against this work moving in the cultural and subjective direction reflected in Mitchell's path out of socialist feminism.

Global and postcolonial feminist theories overlap in their concern with the lives and experiences of women who are least privileged in nearly every dimension of the 'matrix of domination'. If a distinction might be drawn, however, it seems to be the case that global feminism is, in most of its manifestations, closely tied to a socialist feminist framework and focuses mostly on material bases of oppression, including both the oppressions women share with men of their class, race and global location, and those that are distinctive to them.

Postcolonial feminist theory, by contrast, seems to be distinguished by its focus on matters of culture and identity (e.g. Mohanty 1988). With its emphasis on the representation of the colonial subject, particularly in literary forms, postcolonial theory has tended to thrive most within English and language and literature departments, while also gaining recognition as a valuable contribution to critical social and cultural theory across disciplines as well. Probably the single most central theoretical contribution of postcolonial theory has been its analysis of the (male) colonizer's feminization of the (male) colonial subject; postcolonial feminist theorists add to this a concern with the representation of female colonial subjects and with the implications for women of the feminization of the male colonial subject. As a consequence of its focus on representation and subjectivity, postcolonial theory in general and postcolonial feminist theory in particular has achieved recognition as part of the canon of feminist social and cultural theory to a much greater extent than work that focuses mostly on material inequalities.

Post-structural and postmodern feminist theory

The emphasis on intersectionality, matrixes of domination and global divisions is one of the substantive developments of feminist theory and scholarship. At much the same time as these emphases spread broadly among feminist scholars in the late 1980s and 1990s, however, feminist social and cultural theory took another more 'theoretical' direction as well. With the emergence of postmodern and post-structural feminist perspectives in the 1990s, interestingly, some of the very same concerns that had already been voiced by critics of earlier feminist perspectives emerged from the engagement of feminist theorists with postmodern and post-structural social and cultural theories.

One key theme of postmodern and post-structuralist theories was the critique of modern binaries, such as culture–nature, man–woman, reason–emotion and mind–body. Binary constructions, they argue, represent the first term in each of these binaries as superior to or

more 'human' than the second, but misrepresent reality by failing to understand that the meaning of the first term is derived from its opposition to the second term and that the oppositions themselves are misrepresentative of human reality. Given the association of women with nature, the portrayal of them as more emotional than rational and more body than mind, and the modern presumption of the superiority of culture, rationality and mind, this postmodern critique resonated strongly with the cultural feminist critique of the andro-centricity of modern values.

Postmodern and post-structural theories also provided a critique of identity that resonated with feminist theorists. These theories challenged modern conceptions of 'man', of any universalistic conceptions of humanity, arguing that such definitions were inevitably partial and reflected the biases of their formulators and implicitly defined all but privileged categories of people in society as less than fully human. Feminist theorists naturally concurred with the postmodern critique of modern concepts of 'man'; some struggled, however, with the exten-sion of the critique to concepts of 'woman'. Postmodern theorists challenged all such identity categories and politics that rest on the assumption of an essential commonality of all people within the categories. On the one hand, feminists were in the early stages of their engage-ment with postmodern social theory at nearly the same time that they were confronting the exclusions of difference within their own constructions of an essential commonality among women and a construction of feminist politics on its basis. But, while recognizing the need to grapple with difference, many feminists were sceptical of postmodern theory (mostly written by privileged white males) as a trustworthy bedmate of feminism. If *all* concepts of identity were inherently exclusionary, upon what ground could feminist politics be waged? As women had so long been cast as man's deficient and subordinate 'other', what were they to make of a theoretical perspective that cast suspicion on 'identity' and 'subjectivity' at the very point that feminism and women had begun to claim their own (Hartsock 1990)?

Feminists also grappled with the implications of modern opposition to 'grand narratives' such as Marxism and feminism. Postmodernists argue that narratives such as these posit a central 'oppression' from which people must be 'liberated'. Such perspectives are inherently exclusionary since they obscure the different causes of suffering; there is no one form of oppression – neither capitalism nor patriarchy – that is at the root of all others. The concepts of capitalism and patriarchy themselves are problematic, according to the postmodern critique, because they imply a unified system of oppression that obscures the many distinct forms each may take and the different impacts that they may have. As for 'liberation', what can this even mean? Postmodern social theorists called into question the core Enlightenment values – reason and freedom – upon which movements such as Marxism and feminism had relied. As Michel Foucault had argued, any movement of liberation is, in reality, a movement seeking to replace one set of power relations with another. Postmodernists advocated more localized and modest political struggles aimed at power structures in which the activists were themselves engaged.

So the initial reaction to postmodern social theory by many feminist theorists was a deep wariness of its implications for feminist politics. Seemingly, it stripped feminism of 'woman', 'liberation' and a coherent narrative about the structure and culture of patriarchy, leaving behind essentially nothing. Other feminist theorists, however, found the postmodern critique compelling and began to rework their thinking and chart a way of engaging 'post-feminist' politics without 'woman', without 'liberation', and without the grand narrative of 'patriarchy' or 'male domination–female subordination'. Donna Haraway's (1985) 'Cyborg Manifesto' was one of the most notable efforts to challenge feminists to take postmodern and post-structural critiques seriously and to move forward without reliance on these essentialist

concepts. For the most part, feminist theorists have been willing to take on this challenge, continuing their efforts to theorize the oppression of women, to articulate the injustice and harm it produces, to envision alternatives, and to reflect on strategies to achieve these. It is just that they are no longer looking to explain *all* oppression or to account for the suffering of *all* women or to devise a single vision and strategy to free *all* humans.

This, arguably, is what it means to be a post-feminist in the broader sense: a feminism without 'woman', without 'liberation' and without 'patriarchy' or 'male domination–female subordination' as a unified organizing principle of society. Post-feminism in this sense, then, is not an abrupt departure from second wave feminism; in fact, second wave feminism began its move in a post-feminist direction from the beginning, as the issues of differences among women were highlighted by women who were not, or were not destined to become, white, middle-class, heterosexual and married women with children. The essentialism of the concept 'woman' was challenged well before postmodern social theory emerged on the radars of feminist theorists, and with it came the rethinking of the meaning of 'liberation' and a recognition that male domination–female subordination was not a unitary system of oppression or even the most fundamental source of oppression for women in different class, race, cultural and global contexts.

In addition to the impetus that postmodern and post-structuralist theories added to feminists' rethinking of their conceptualizations of women, women's interests and feminist politics, postmodern and post-structuralist theories have also led to the creation of post-modern and post-structuralist theories of gender construction. The distinctive defining feature of these is that they view gender construction as a process that occurs much more on the surface of social life, in everyday practices of gendered bodily disciplines and in routine 'performances' of gender.

Sandra Bartky's (1990) extension of Foucault's (1977) analysis of the construction of subjectivity via modern disciplinary practices to an analysis of the wide array of disciplinary technologies that are employed in the construction of femininity is one important example. Judith Butler's theory of gender construction as a compulsory everyday performance is another, and one that has generated the most attention. The theoretical contribution of these theories is their ability to account for the pervasiveness of gender as a structuring principle of everyday behaviour without any notion of gender as a deep, more or less fixed, stable, intra-psychic structure. Theories such as these offer a way of understanding how gender can appear to make such a difference, can construct men and women as fundamentally different kinds of people, when the only real differences between them are the different disciplines they enact upon themselves and the different manners in which they perform their gendered identities.

Queer theory, a perspective linked to Foucault's critique of modern sexual discourses and developed by Judith Butler and others, has focused on conceptualizations of sexuality more than gender. It should also be seen, however, as an important contribution to postmodern and post-structural theorizing of gender construction. One key idea of queer theory is that sex, gender and sexual orientation do not often line up in the consistent ways that are often presumed: man, masculine, heterosexual; man, feminine, homosexual; woman, masculine, homosexual; woman, feminine, heterosexual. There is no necessary, or even a probable, connection between these terms. Following Foucault, queer theory also problematizes the assumption that sexuality is fundamentally constitutive of identity as well as the presumption that the homo–hetero binary is a meaningful way of defining 'sexual orientation'. By self-identifying as 'gay' or 'lesbian' or as some other category, Foucault warned, a person assumes a subjectivity that is locked within the prison of the hierarchical and essentializing categories of modern sexual discourses. In so doing, they adopt the problematic assumption that this identity is the essence of their humanity.

Foucault's focus was on matters of sexual identities, not gender per se, although the extension to gender is an obvious and easy one. If there is so much inconsistency in the ways that sex, gender and sexuality line up, why should the sex/gender of a preferred sexual partner be thought to constitute the 'essence' not only of a person's sexuality but of their entire humanity? And if a masculine or feminine style of self-presentation does not line up in any predictable way with the personalities of the enactors, why should gender itself be so crucial in how we conceive and experience ourselves and others? By highlighting the commonness of 'mis-alignment', or the multitude of possible configurations of sex, gender identity, gender personality and sexual orientation, queer theory deconstructs the presumed essentiality of any of these terms. But, more than this, it challenges the coherence of the terms themselves and calls into question that any of them tell us anything much about a person's essential humanity.

Butler's perspective, and other perspectives that locate gender on the surface of social life rather than in the depths of the human psyche, seems to be the most widely acclaimed and broadly accepted theory of gender construction. An arguable limitation of the perspective, however, is its inability to account for the compulsion to perform gender and to explain the compulsion of some people not to perform gender in the expected manner. In Bartky's application of Foucault to the disciplines of femininity, in addition, how do we account for the motivation to engage (or not engage) in these disciplines? There are good reasons, I would argue, to focus on the outward, verbal and non-verbal, bodily practices and disciplines of gender production. Long before Butler had gained fame for her performative theory of gender, sociologists working within the interactionist, dramaturgical and ethnomethodological traditions had already arrived at a similar concept; they too left unanswered the question of motivation to comply with or to deviate from the expected practices. They do, however, re-conceptualize motivation itself as something not 'inner' and prior but as something that is itself constructed in the doing itself.

Future directions

There is much that is good about the current state of feminist social and cultural theory. The boundaries between the different theoretical frameworks that influence and characterize contemporary feminist thought are not sharply drawn, defensively guarded or subject to bitter contestation. By and large, feminism as a movement and as a body of academic scholarship has progressed in an open-minded and reflective manner. Theory and activism has proceeded with great conviction in particular directions; both have also demonstrated a tendency to pause, reflect, revise and reorient when confronted with other perspectives.

The categorizers and synthesizers of feminist theories have played a vital role in conveying a collection of insights, valuable takeaways and criticisms that have become shared understandings of most feminist scholars. It is true that many of the feminist scholars that have become canonized within feminist theory can often be identified as exemplars of a particular category of feminist theorizing, but mostly the categories are better understood not as distinct camps of feminism and feminist theorizing but rather as mutually influential analytic constructions devised to encapsulate a set of emphases within feminist theory that are broadly accepted as important components of the larger feminist project.

Is there a larger feminist project that could be appropriately labelled in such a singular manner? No and yes. The emphasis on differences among women within feminist theory, and the implications of these both for feminist politics and for feminist theorizing, has generated a broad awareness of the limits of any singular conception of feminism's aim. As second wave feminists grappled with the implications of differences of race, class, sexual

orientation and global location, 'essentialist' concepts of women and women's interests, where they appeared, were almost immediately met with critical attention directed towards the white, middle-class, heterosexual and global privilege of the women whose experiences were depicted and whose aims had been defined. Post-structural and postmodern critiques of essentialist concepts of identity, grand narratives and universalistic liberation movements reinforced these concerns. So, no, then, there is no broadly encompassing feminist project with a singular aim.

There are a couple of central questions and concerns, however, that could be taken as definitive of feminist thought generally. These are, first, the question of how to understand the oppression of women, in all the various forms that this oppression takes. That there is no singular 'patriarchal' system in which women are universally subordinate to men does not change the reality that women continue to be oppressed, in varying ways and in varying respects. There is *no* category of feminist thought that has been rendered obsolete by progressive social change and that does not continue to offer a vital perspective for understanding some part of gender-based oppression. The goal of developing an overarching theory of women's oppression has been largely abandoned, but the goal of understanding and confronting women's oppression in all its various forms and contexts remains.

The second question concerns the 'sex-gender system'. How is gender socially constructed, and how is this related to women's oppression? Depending on the nature of the oppression of women in particular contexts, this question may be more or less relevant. Where laws, cultural traditions and threats of violence are the primary source of women's oppression, the question of the content and process of gender construction is hardly relevant. Where women are disproportionately represented as harshly exploited workers in global factories, the low status of women in their home countries and the workings of global capitalism are much more pressing concerns than the construction of gender. Questions of the construction of gender, arguably, rise in importance in societies where women have rights and equal (legal) status to men, where gendered expectations have much more to do with persisting gender hierarchies. In general, however, there is broad agreement that an adequate understanding of women's oppression and vision for progressive social change must concern itself with the 'sex-gender' system.

Like critical social theories in general, feminist theory grapples with the basic problematic of theorizing a system of oppression, identifying the harm and suffering it causes, envisioning change and developing strategies for implementing it. Among critical social theories, feminism is somewhat unique in that its theorizing necessarily encompasses all levels of social and cultural analysis, from macro political economy to the most micro levels of interpersonal and intra-psychic analysis.

The strength of feminist theory, taken as a whole, is that it has provided a broad and multifaceted vision for the continuance of the 'post-feminist' feminist project. A core part of this vision, however, is to become more grounded and rooted in knowledge of the life conditions and experiences of people of all social classes, races, nationalities, geographical locations, religions, genders, sexualities and ages, and of all of their differences that make a difference. Feminist scholars in various academic disciplines have heeded this call and are doing such work. The difficulty, however, is that there seems to remain a bifurcation between feminist theory and the broader array of feminist scholarship contributing important pieces to the very project that feminist theorists have envisioned.

The analysis of ideology, identity, subjectivity, language and cultural representation that has been so central to feminist social and cultural theory should continue, perhaps in new directions that are less tied to the Freudian, post-Freudian, Lacanian and post-Lacanian

psychoanalytic narratives that have so centrally shaped feminist analyses of the formation of subjectivity. This sort of feminist theorizing, however, should not appear to represent the entirety of feminist theory; feminist theory, I would argue, needs to back up from where it took its sharp cultural turn to where it has a better vision of the multiple roads to be taken.

References

Adkins, L. (2004). 'Reflexivity: Freedom or Habit of Gender?' *The Sociological Review* 52(52): 191–210.

Bartky, S. (1990). *Femininity and Domination: Studies in the Phenomenology of Oppression*. New York: Routledge.

Beauvoir, S. de (2010) [1949]. *The Second Sex*. Trans. C. Borde and S. Malovany-Chevallier, New York: Alfred A. Knopf.

Bem, S. L. (1976). 'Yes: Probing the Promise of Androgyny'. In M. R. Walsh (ed.), *The Psychology of Women: Ongoing Debates*. New Haven, CT: Yale University Press.

Bordo, S. (1993). *Unbearable Weight: Feminism, Western Culture, and the Body*. Berkeley, Los Angeles and London: University of California Press.

Butler, J. (1990). *Gender Trouble: Feminism and the Subversion of Identity*. New York: Routledge.

Chodorow, N. (1978). *The Reproduction of Mothering: Psychoanalysis and the Sociology of Gender*. Berkeley, CA: University of California Press.

Clark, S. and Hulley, K. (1991). 'An Interview with Julia Kristeva: Cultural Strangeness and the Subject in Crisis'. *Discourse*, 13(1): 149–80.

Dinnerstein, D. (1976). *The Mermaid and the Minotaur: Sexual Arrangements and Human Malaise*. New York: Harper & Row.

Elliott, A. (1992). *Social Theory and Psychoanalysis in Transition: Self and Society from Freud to Kristeva*. Oxford: Blackwell.

Firestone, S. (1970). *The Dialectic of Sex: The Case for Feminist Revolution*. New York: William Morrow.

Foucault, M. (1975) [1977]. *Discipline and Punish: The Birth of the Prison*. Trans. A. Sheridan, Harmondsworth: Penguin.

—— (1980). *The History of Sexuality, Vol. 1: An Introduction*. Trans. R. Hurley, New York: Vintage/ Random House.

Fraser, N. (1995). 'From Redistribution to Recognition? Dilemmas of Justice in a "Post-Socialist" Age'. *New Left Review*, 212: 68–93.

Friedan, B. (1963). *The Feminine Mystique*. New York: Norton.

Haraway, D. J. (1985). 'A Manifesto for Cyborgs: Science, Technology and Socialist Feminism'. *Socialist Review*, 80: 65–107.

Hartsock, N. (1990). *Foucault on Power: A Theory for Women?* In L. Nicholson (ed.), *Feminism and Postmodernism*. New York and London: Routledge.

Hill Collins, P. (1990). *Black Feminist Thought: Knowledge, Consciousness, and the Politics of Empowerment*. Boston, Unwin Hyman.

Hochschild, A. R. (1983). *The Managed Heart: Commercialization of Human Feeling*: Berkeley: University of California Press.

Irigaray, L. (1985) [1974]. *Speculum of the Other Woman*. Trans. Gillian Gill, Ithaca: Cornell University Press.

—— (1985) [1977]. *This Sex Which Is Not One*. Trans. Gillian Gill, Ithaca: Cornell University Press.

Kristeva, J. (1982) [1980]. *Powers of Horror*. Trans. Leon Roudiez, New York: Columbia University Press.

—— (1984) [1974]. *Revolution in Poetic Language*. Trans. Margaret Waller, New York: Columbia University Press.

—— (1989) [1987]. *Black Sun*. Trans. Leon Roudiez, New York: Columbia University Press.

Lemert, C. (2013). *Social Theory: The Multicultural, Global, and Classic Readings*. Boulder, CO: Westview Press.

Lengermann, P. M. and Niebrugge, J. (2011). 'Contemporary Feminist Theory'. In G. Ritzer (ed.), *Sociological Theory*, 8th edition. New York: McGraw-Hill.

Lengermann, P. M. and Niebrugge-Brantley, J. (1997). *The Women Founders: Sociology and Social Theory, 1830–1930, A Text with Readings*. New York: McGraw-Hill.

—— (2001). 'Classical Feminist Social Theory'. In G. Ritzer and B. Smart (eds), *Handbook of Social Theory*. Thousand Oaks, CA: Sage.

Ann Branaman

McLaughlin, J. (2003). *Feminist Social and Political Theory: Contemporary Debates and Dialogues* Basingstoke, Hampshire; New York, Palgrave MacMillan.

McRobbie, A. (2004). *Postmodernism and Popular Culture*. London: Routledge.

Millett, K. (1970). *Sexual Politics*. New York: Doubleday.

Mitchell, J. (1966). 'The Longest Revolution'. *New Left Review*, 40: 11–37.

—— (1974). *Psychoanalysis and Feminism: Freud, Reich, Laing and Women*. London: Allen Lane.

Mohanty, C. T. (1988). 'Under Western Eyes: Feminist Scholarship and Colonial Discourses'. *Feminist Review*, 30: 61–88.

Mulinari, D. and K. Sandell (2009). 'A Feminist Re-reading of Theories of Late Modernity: Beck, Giddens and the Location of Gender.' *Critical Sociology* 35(4): 493–507.

Nicholson, L. (1990). *Feminism/Postmodernism*. New York: Routledge.

Rose, J. (1983). 'Femininity and Its Discontents'. *Feminist Review*, 14(1): 5–21.

Spelman, E. (1988). *Inessential Woman: Problems of Exclusion in Feminist Thought*. Boston: Beacon Press.

Tong, R. (2009). *Feminist Thought: A More Comprehensive Introduction*. Boulder, CO: Westview Press.

West, C. and Zimmerman, D. H. (1987). 'Doing Gender'. *Gender & Society*, 1(2): 125–51.

Wollstonecraft, M. (1792). *A Vindication of the Rights of Women*. London: J. Johnson.

6

Zygmunt Bauman and social theory

Keith Tester

Introduction

Zygmunt Bauman was forced to leave his native Poland in 1968. He was one of six professors who were purged from the University of Warsaw, officially because they were the 'spiritual instigators' of student unrest but unofficially – and more accurately – because they had become a thorn in the flesh of the communist state. Five of the six, including Bauman, were Jewish, as propaganda made sure everyone knew (Tester 2004: 77–81). By this time Bauman had published 14 Polish-language books. A fifteenth title was pulped by the authorities shortly before its planned publication. In 1971 Bauman was appointed to the Chair of Sociology at the University of Leeds in the UK, remaining there until his retirement in 1990. From his arrival in the UK to the time of this writing (late 2012) he published 40 or so more books, all but a couple of them first written in English.

This exceptional level of bilingual productivity creates problems for any attempt to provide an overview of Bauman's contribution to social and cultural theory. A survey of the texts would be beyond the scope of this volume. This chapter needs to take a different approach. Consequently it is written in terms of a hypothesis: *Bauman can be so productive, and his vision of the world can be so consistent despite the changing direction of his gaze, because his thought is built on solid foundations.* If these foundations are uncovered it is possible to understand why his work has the content and character it does.

Historical and intellectual development

Before he embarked upon a career in sociology Bauman was a soldier, fighting in the Polish Army against the Nazis on the Eastern Front. Born in 1925, he had avoided the Nazi's genocide by escaping with his birth family to the Soviet Union. For Bauman sociology was part of the project of the construction of a better postwar world in which 'humans could live as humans would' (Bauman in Bauman and Tester 2001: 18). As such, Bauman's sociological career did not have the standard beginning in the seminar room or the library. It started in the historical context of a commitment to build a Poland *for* and *of* humans from out of the ruins of the Second World War. This was a Poland in which 'People needed salvation badly, and whatever colour or shape salvation was to take, it could only *come from society*. Of that society, sociology was to tell the truth' (Bauman in Bauman and Tester 2001: 18). This argument contained the seeds of conflict.

The problem revolved around the status of the truth claims made by – or attributed to – sociology. In the postwar period Poland was firmly pulled into the Soviet bloc and state socialism was imposed upon it. The Soviet version of socialism claimed to be both the product and the agent of the truths of dialectical materialism. They had been revealed by Marx and Engels before being carried into practice by the Communist Party under the firm guidance of Lenin and Stalin. So long as it never deviated from the teaching of Lenin and Stalin the party was 'orthodox' and upholding scientifically valid laws of history. It had the duty to prepare the way for the communist utopia. There could be no legitimate alternative. There was only historical necessity, and the party knew the truth as well as what was, indeed, the necessary use of its power. Leszek Kołakowski, who was purged along with Bauman, wrote the best guide to this 'orthodox' version of Marxism (Kołakowski 1978). Where sociology subordinated itself to the truth claims of the party, the chances for conflict were minimal. Indeed, Bauman's first ever publication was exceptionally uncontroversial. In 1953 he published in Polish a neither translated nor reprinted paper, 'On the historical role of the masses', with Jerzy Wiatr. It identified the 'masses' with the 'proletariat' and was peppered with references to the work of Engels, Lenin and Stalin (Tester and Jacobsen 2005: 224). Yet where sociology staked claims to the independence of its truth claims, the possibilities of conflict were significant.

But how could sociology make such claims? What could spur the break-out from the domination of the party? Specifically, what took Bauman from dull orthodox papers about the masses to castigation as an 'instigator' of unrest? Sociologically it is possible to identify a process of break-out that had two entangled strands. First, Bauman's thought developed in the historical context of de-Stalinization in Poland. Second, Bauman was able to theorize and make sense of the context through the work of Antonio Gramsci. Although Gramsci wrote in Italy in the 1920s and 1930s he largely did so as a prisoner of Mussolini's fascist regime (Gramsci was a founder of the Italian Community Party and its major intellectual), and his texts only started to become available in the 1950s.

The symbolic moment of de-Stalinization was the Polish October of 1956. A wave of civil disturbances was crushed by the military. The Soviet Union threatened to send in the tanks – as it was soon to do in Hungary – if matters were not brought under control quickly. The leader of the Polish Communist Party struck a deal with Moscow. Poland would be allowed to develop its own brand of communism so long as it never tried to move outside of the Soviet orbit of influence. The Polish October was a moment in which Poland seemed to throw off the shackles imposed from outside. It was a moment of hope summed up by one of Bauman's teachers, Stanislaw Ossowski. For him the Polish October meant 'the destruction of the official myths which concealed our reality . . . the myth of historical necessity as revealed to those who wield power' (Ossowski, quoted in Tester 2004: 45. For a little more on the Polish October see Bauman and Tester 2001: 159–60). The Polish October seemed to point to an alternative, to the possibility of things being neither inevitable nor dictated by laws of historical necessity. But what happened next? The party clung on to power and ushered in a period of economic stagnation, social conformity, a police state and a clampdown on dissent. Hopes were dashed. How could this be explained? Bauman's distinctive sociological voice emerged in an attempt to answer this question.

Bauman learnt to speak thanks to Gramsci. He has said: 'I owe to Gramsci an "honourable discharge" from Marxist orthodoxy' (Bauman in Bauman and Tester 2001: 25). Gramsci gave to Bauman – and it must be said, to others – a licence to theorize and a way of understanding what was happening in the wake of the Polish October. Quite how Gramsci's thought could do this is shown by Leszek Kołakowski. It was a bombshell in the context of a political culture

dominated by the truth claims of a party ostensibly knowing the laws of history yet, after 1956, attempting to do little more than retain its own power. The party claimed to be in possession of truth (even if after 1956 no-one believed the claims or, indeed, the alleged truth), but here was a communist who had never fallen foul of Stalinist orthodoxy (simply because he was in prison, his work hitherto unknown), and the founder of a Communist Party to boot, who was making alternative yet Marxist arguments. Gramsci's texts dissolved orthodoxy from within, and they were proof of the possibility of a different kind of commitment.

Kołakowski identifies four key strands to Gramsci's thought. First, if there are historical laws, as orthodox Marxism-Leninism claimed, then human knowledge can only aspire to know these laws. Knowledge becomes a reflection of an independent world 'out there', which is treated as an object distinct from the subject who knows it. Gramsci completely rejected this claim. For him, all reality is the product of human action, and the only real law of human history is one that identifies reality and truth as the products of human history. Reality is not an object 'out there' waiting to be known scientifically. Instead it is always in the process of being made through the historical action and thought of human actors. Put another way, a world fit for humans is not made by the laws of history. There are no such laws. A world fit for humans is made by humans, and so it is always something to be achieved. It is always different from how we live now because how we live now always stops us from being properly human (Kołakowski 1978: 250). Here then Marx's crucial dictum is upheld: men and women make history but not in the circumstances of their own choosing. This strand plays out in Bauman's discussions of critique and, especially, hermeneutics (Bauman 1976, 1978). It also underpins his lack of interest in 'empirical' research and the associated fetishization of methodology.

Second, if all reality is the product of historical action there can be no difference between everyday consciousness and the 'scientific' knowledge claimed by intellectuals. On the one hand this leads to the famous Gramscian claim about how 'everyone is a philosopher' (Gramsci 1971: 323), and on the other it means socialism is not a truth known only by specialists. Certainly Gramsci gave a crucial role to intellectuals in the development of socialism, but what they say – the claims they make – are inhuman conceits if they do not express lived experience (Kołakowski 1978: 250). To make a claim to 'orthodoxy' or even, in more local terms, to 'disciplinarity' is to seek to put barriers around a body of texts so as to be able to make truth claims about their meaning. Consequently claims to scientificity, knowledge of necessity or truth, raise a sociological question and ought not to be accepted at face value. The question is not, how have these groups come to possess such specialized knowledge but, instead, what are the stakes and implications of the claim of these groups to possess specialized knowledge? Furthermore the role of the intellectual is to speak to, for and about everyday consciousness and its conditions of existence. Anything else is hermetic hubris. Here it is possible to see the roots of Bauman's interest in intellectuals (Bauman 1987).

Third, the party itself becomes a site of Gramscian investigation. It must be an agent and promoter of action and always in touch with lived experience: 'On pain of degenerating into a body of professional politicians fighting for jobs, it must not regard itself as the repository of a "scientific world-view" elaborated outside the empirical consciousness of the proletariat' (Kołakowski 1978: 250). Such an understanding of the party was absolutely antithetical to the Stalinist model, and this Gramscian position opened up a way of understanding what happened in Poland after 1956. The fate of the Polish October could be explained in precisely these terms as a result of the self-reproduction of a degenerate party, more concerned with its own power than with the consciousness and circumstances of those 'outside'. Indeed the party was

a – if not *the* – main concern of Bauman's work in the 1950s, and it carries through to his many contributions on the British Labour Party (Tester and Jacobsen 2005).

Fourth, Kołakowski identifies in Gramsci a concept of revolution which is different from the one stressed by Leninism. For Gramsci the revolution is emphatically *not* about the ability of the party to impose its will upon society. Rather, revolution is in the first instance a process of the 'spiritual emancipation of the working class, transforming it from an object of the political process into a subject and initiator' (Kołakowski 1978: 251). Emancipation in Gramscian terms can only happen when those who have always been told there is 'no alternative' to laws of historical necessity are transformed – in thought and action – from objects manipulated by institutions claiming to have scientific knowledge of what must be done into the subjects and initiators of a human world which has to be made through action. Of course such a world can have no guarantees because it has broken with notions of necessity, and therefore it is ambivalent and contradictory. But for this very reason it is also deeply human. The role of the intellectual is therefore one of encouraging such action but, also, of telling the actors about the unchosen circumstances in which it is their fate so to act. This is the role of sociology, a theme which will be explored in greater detail later on.

The influence of Gramsci on Bauman is quite fundamental, and to a significant degree Bauman's work can be identified as pursuing a Gramscian path (Tester and Jacobsen 2005: 226). But there is a key difference. Gramsci was a politically active and engaged communist. Very little of such a sensibility can be found in Bauman's texts. Bauman does not stand on platforms. Instead he is very self-consciously a sociologist. So what made the difference? What turned a Gramscian inspiration to sociological concerns? At one level the question is inadmissible because Bauman rejects such neat divides separating academic disciplines. This rejection is itself Gramscian in as much as it stresses knowledge as the conscious product of action in general rather than specialized problem solving in the particular. But at another level, Bauman's work is sociological because it views Gramsci through the prism of Simmel. Indeed of all the 'founders' of sociology, Simmel is the one Bauman treats most sympathetically and with most understanding (the same cannot be said of his treatment of Durkheim or Parsons: see for example Bauman 1976, 1978).

By his own admission Bauman has drawn two key messages from Simmel. First, and perhaps most loudly chiming with the Gramscian argument about there being no clear laws of history, Simmel confirmed the absence of some mechanics of social life that can be uncovered given the correct methods. Simmel stressed the essential presence of contradiction, incongruity and what Bauman was later to call 'ambivalence' in social life (Bauman in Beilharz 2001: 335; Bauman 1991). Second, and following on from the theme of contradiction, Simmel showed Bauman how 'for the pencil of every tendency there is an eraser of another' (Bauman in Beilharz 2001: 335). To wish away this ambivalence is actually to demolish the essence of what it means and involves to live a human life. If these two aspects of Simmel's lesson are brought together the message is clear and easily reconcilable with Gramsci. There is no knowable truth to human life other than the truth of human action and its historical fate.

Bauman has identified a third major influence on the development of his thought. In an interview with Beilharz he said Gramsci taught him *what* to do (break out of orthodoxy and see history in terms of action and not laws), Simmel taught him *how* to do it (do not wish away contradiction but grasp it, accept ambivalence as part of the essence of the world for and of humans), and finally, Bauman said, he was taught *why* he ought to do it by his wife, Janina. She wrote two remarkable volumes of autobiography, the first about her experiences in the Warsaw Ghetto and the second about her experiences in communist Poland (for the purposes

of this chapter see especially J. Bauman 1986). The volumes can both be read as explorations of the human consequences of being forced to live according to the dictates of those who claim to know scientifically 'what must be'. As Zygmunt Bauman put it: 'I learned from Janina that *Wertfreiheit* [value freedom] is – as human silence is concerned – not just a pipe-dream, but also an utterly inhuman delusion' (Bauman in Beilharz 2001: 335). The argument applies to the pretence of *social* science as much as to any other science. Then the point turns more than a little Gramscian: 'sociologizing makes sense only in as far as it helps humanity in life, that in the ultimate account it is the human choices that make all the difference between lives human and inhuman' (Bauman 2000b: vii). Where choices are narrowed down life tends towards the inhuman, and where they are made freely and without coercion, life is more human. It is the job of sociology to help ensure 'that the choices are genuinely free, and that they remain so, increasingly so, for the duration of humanity' (Bauman 2000a: 216). Put another way, it is the job of sociology to resist all of the intellectual temptations dominant when Bauman started his work as a sociologist.

This – a sociology both *for* and *of* humans – is the point of commitment around which historical context melded with intellectual development to add a distinctive and continuous ingredient to the mix of Bauman's thought.

Major claims

The preceding argument rather invites a question: so what is the human? The first outlines of a sketch are already in view. Bauman connects the human with praxis. Praxis can be defined as free activity and action as opposed to the managed predictability of institutionalized necessity. So, praxis is the active pursuit of *what could be* over and above passive, reactive acceptance of *what must be*. When Bauman sought to define praxis he did so by equating it with Camus's notion of revolt. Praxis is rebellion against what is, and in praxis 'man' (as Bauman then put it) 'simultaneously fulfils and creates his own values, the revolt being not an intellectual invention, but a human experience and action' (Bauman 1973: 178). For Bauman praxis is expressed in, and indeed is the essence of, human culture. As such to be human is to be the free creator of history and culture.

The claim was clearly stated in a 1967 article on 'Image of man in the modern sociology'. The clumsiness of the English of the title is itself a little insight into the prose style of the article (it was published in an English-language Polish journal), but the paper must not be ignored. It is extremely important for understanding the foundations of Bauman's sociological work. In the paper he outlined the 'image of man' (his phrase) which is the 'cognitive a priori' of his work. A cognitive a priori is 'an intellectual image of investigated world which is prior to any research endeavour' (Bauman 1967: 12). Indeed, 'The pre-empirical image of man is not so much a regrettable "bias" as indispensable pre-condition of any research. One cannot do without it' (1967: 13). It is the foundational assumption making everything else possible. Consequently if claims with the status of a cognitive a priori are uncovered the structure of a body of thought becomes clear. In this 1967 paper Bauman set out his cognitive a priori very clearly indeed.

Bauman identified in contemporary sociology two different images of 'man', pushing in quite contrary directions. The mechanistic image seeks either to generate probabilistic knowledge through the analysis of how human behaviour responds to external stimuli or to develop a systemic knowledge of the foundations of societal equilibrium. Whereas this mechanistic image identifies human action as a response to external stimuli, Bauman advocated instead an 'activistic' image. This alternative image is built on a presumption: 'Human acts

are not only "reactions", but also "procreations". If we remove from the human act all what is possibly determined by the value of "input" variables still something will be left' (1967: 14). It is this residue that 'distinguishes any human being from any machine and is responsible for the fact that the human behaviour is only partly predictable' (1967: 14). Consequently whenever action is predictable, as it is when it is subordinated to laws of historical necessity or to an institution claiming to know 'what must be done', damage has been done to what makes human beings different from anything else in the world. Orthodox Marxism was criticized on precisely this ground. It turned humans into more or less unruly passengers on a train of necessity over which they could rightly exert no control. From this it is no surprise when Bauman's cognitive a priori pushes him towards a commitment to 'the less managerial, even anti-managerial, more traditional, humanistic variation of sociology' which 'aims at making the human behaviour less predictable by activating inner, motivational sources of decision – supplying the human beings with ampler knowledge of their situation and so enlarging the sphere of their freedom of choice' (1967: 15).

The reference to giving to actors 'ampler knowledge of their situation' brings Bauman's work back from philosophy. Bauman's claims about the human are to be read in conjunction with his concern to understand the historical situation in which praxis is implicated. Without the cognitive a priori of an assumption about what it is to be human any picture of the situation lacks purpose. Yet without the context of the situation the cognitive a priori is mere abstraction. The task therefore is always to keep them harnessed to one another.

Although Bauman's work is alert to history, he is not a historian. For Bauman history is to be understood as the process of (a) the human creation of the historical situation, (b) the consolidation of the situation as a constraint on human creation and, finally, (c) praxis as the expression of the irreducibility of what it means to be human. The traces of Marxist dialectics are quite evident here, but more precisely Bauman's attitude towards history is at once Gramscian and Simmelian. It is also methodologically ideal-typical. He tends to overstate the consistencies within a historical situation and quite often simplifies details from the historical record in order to make sure the key features stand out all the more clearly. His methodology and approach to history is *sociological*. The claims he makes are at the level of the analysis of human praxis in a historical situation understood through the prism of an ideal type. His claims are *not* deductions from the archive.

Until the mid-1980s Bauman approached the historical situation in terms of different systems (communism and capitalism). But with the publication of *Legislators and Interpreters* in 1987 the picture starts to be painted on a far more ideal-typical terrain. Now he starts to talk in terms of modernity and postmodernity. What are the dominant features of these ideal-typical presentations of the changing dominant historical situations?

It is easiest to discuss modernity and postmodernity in turn, but it is also necessary to be a little cautious. Bauman often adopts a strategy of definition by negation. He is as likely to say, for example, 'modernity is not like this' as he is to say what it is like. This is more than a peculiarity. It actually reflects a methodological principle Bauman derives from Heidegger's maxim about it only being possible to know a hammer when it is broken. What does this maxim mean? Well, when something can be used predictably we do not think about it. For example, I turned on my computer today and it worked as I expected. I have not checked the USB ports or anything else. It just works and I do not think about it. However, had I turned on my computer and the screen remained blank I would have started examining it. I would have checked everything and paid attention to it. When my computer is broken I begin to know it. (For Bauman on Heidegger see Bauman 1978: 148–71.) So, Bauman is only able to know modernity, or postmodernity, or any other ideal-typical historical situation, because

something is broken. For example, Bauman identifies the emergence of modernity in the moment when the *ancien regime* broke apart. To a very considerable degree modernity can be known in as much as it is *not* the *ancien regime* (Bauman and Tester 2001: 72).

Bearing all this in mind, *what then is modernity*? Bauman answers:

> modernity is, so to speak, the time of 'new beginnings' . . . of dismantling old structures and building new ones from scratch . . . I believe that what set the modern era apart from other times was the obsession with designing and pursuing projects, the tendency to subordinate the present – each successive present – to the project yet to be fulfilled.
>
> *(Bauman and Tester 2001: 72)*

This statement makes it possible to tease out a number of the key features of Bauman's understanding of modernity. First, if modernity is the time of 'new beginnings' it is also the pursuit of the new over the old, the repudiation of tradition and, most importantly, the assumption that such a pursuit can be carried out without legitimate obstacle or hindrance. Second, these 'new beginnings' were not random. They were tied to projects. Going back to the first point, each of these projects in its turn became something to be replaced. According to Bauman no modern project was fulfilled; rather it was overcome by the pursuit of another 'new beginning'. Yet there is much more to be said about the identification of modernity with the design and pursuit of projects. Three questions immediately dangle before us: Who designs the projects? What are the projects about? How are they pursued?

The modern projects were designed by the legislating intellectuals. They claimed to know what had to be done because of their possession of superior knowledge. Specifically they claimed to possess knowledge about how to build an orderly social world which was truly best for humans. Here then the Gramscian critique of the party reappears in a general sociology of modern intellectuals. Indeed, and in an ideal-typical statement, Bauman has said: 'the preoccupation with order, or with an orderly, manageable society, is a common denominator of other modern undertakings: industrialism, capitalism, democracy. Through somewhat different means the same ends have been pursued' (Bauman and Tester 2001: 78). Whereas the *ancien regime* saw humans as just the way they were or, alternatively, as fallen from an ideal state, the legislating classes of modernity were sure human perfection remained in the future and could be made – and if need be rightly imposed – by those who knew what had to be done. Humans then had to be made to fit in with the vision of the perfect order. This is what the projects were about. 'From its inception', Bauman has said, 'modernity was known in one form only: that of "managerial" modernity, an order-designing and order-administering modernity' (Bauman and Tester 2001: 74). Projects changed in as much as the 'new' promised to be able to overcome the problems and failures of the old (2001: 79). The validity of projects was never questioned, just the validity of the ones tried *so far*. The projects, however, needed some means of transition from the minds of the intellectuals as legislators saying what must be done to the managerial practices of institutions. This is the question of *how* the projects were pursued. They were pursued by the modern state in its 'gardening' mode: 'The power presiding over modernity (the pastoral power of the state) is modelled on the role of the gardener' (Bauman 1987: 52). A gardener is someone who has a blueprint of the perfectly ordered garden and, moreover, the ability to rip up the weeds, manage the plants and make sure nothing gets in the way of what is necessary.

For Bauman the Holocaust is the clearest example of these modern projects. Indeed:

> The truth is that every 'ingredient' of the Holocaust . . . was normal . . . in the sense of being fully in keeping with everything we know about our civilization, its guiding spirit,

its priorities, its immanent vision of the world – and of the proper ways to pursue human happiness together with a perfect society.

(2000b: 8)

(Bauman's Holocaust book was first published in 1989, but republished with an extra chapter in 2000. I am using the later version.) For Bauman the mass murder of European Jewry and others who were deemed to be in the way of the perfect society 'arose out of a genuinely rational concern, and it was generated by bureaucracy true to its form and purpose' (2000b: 17; this sentence is emphasised in the original text). The Holocaust is *of* modernity.

The point can even be put more strongly. The Holocaust was typically modern because it was *rational* in its own terms. It was an efficient and instrumental means to the achievement of the end of the perfect society. But in what did the perfect society consist? Nazi ideology equated perfection with racial purity, but Bauman goes beneath the surface and sees the ideal of racial purity as an expression of a distinctly modern ambition to impose upon the unruliness of the world a perfect order founded in human imagination and practice. Bauman's understanding of order is indebted to the 1966 book *Purity and Danger* by the anthropologist Mary Douglas. Like her, Bauman links order to the human propensity to allocate the things of this world to humanly designed systems of classification. Order is praxis, not something waiting to be found 'out there'. Where something fits a classification it is pure, and where it does not fit it is identified as dangerous. This danger is especially pronounced in the cases of those things that seem to cut across the boundaries of the classification and which are both in and out of an order. These *ambivalent* things are problems needing to be dealt with, like weeds in the garden. Nazi ideology had a notion of 'purity' and sought to classify people in terms of it. Like the gay and Roma communities, the Jewish community in Europe – and especially in Germany – did not fit the classifications (Bauman 1991). They were ambivalent because according to the Nazi designs of order they were in places where they ought not to have been. They became a problem to be solved. The strategy of assimilation (making 'them' more like 'us') was rejected, and instead the way to the perfectly orderly and happy society was paved with the instrumentally rational pursuit of the annihilation of the ambivalent. To this extent the Nazis' perpetration of the Holocaust actually stands as the clearest illustration of where the 'gardening' strategy of the modern state can lead. According to Bauman there is nothing about this that is incompatible with modernity. This is why he sees the Holocaust not as an aberration but, instead, as a 'rare, yet significant and reliable, test of the hidden possibilities of modern society' (2000b: 12; this sentence is emphasised in the original text).

Postmodernity is seen by Bauman as a consequence of modernity. He once – and very usefully – distilled the meaning of postmodernity into four propositions. First, postmodernity was identified as a condition in a dialectical relationship with modernity. It is both *post*modern and post*modern*. In terms of dating, Bauman was a little vague. Postmodernity, he said, emerged in Europe and in those parts of the world 'of European descent' in the twentieth century, to take on a distinguishable form in the postwar period (Bauman 1992: 187). Second, postmodernity was identified with the recognition of the consequences of the modern projects. The projects aimed to create an ideal world of perfect humans living perfectly orderly lives in gardens without weeds. But this is not what happened at all (as witnessed by the fate of the communist dream). As such, 'Postmodernity may be interpreted as . . . modernity that acknowledged the effects it was producing throughout its history, yet producing inadvertently, rarely conscious of its own responsibility . . . as by-products often perceived as waste' (1992: 187). Modernity was the project of making everyone and

everything the same (since perfection admits of no alternative), whereas postmodernity is acknowledgement of the inevitability of differences. As Bauman put it,

> The postmodern condition can be therefore described, on the one hand, as modernity emancipated from false consciousness; on the other, as a new type of social condition marked by the overt institutionalization of the characteristics which modernity – in its designs and managerial practices – set about to eliminate.
>
> *(1992: 188)*

Postmodernity means particularity, difference, perpetual change and a lack of clarity. Third, modernity involved the implementation of projects that had a clear goal, and that therefore made history a journey in a definite direction. But since postmodernity entails admission of the inevitability of everything modernity sought to overcome, there can be no single journey with a definite direction, and neither indeed can there be any single possessor of knowledge of any such journey. Rather postmodernity is the acknowledgement of flux. Bauman identified postmodernity as a 'whirlpool appearing in the flow of a river, retaining its shape only for a relatively brief period and only at the expense of incessant metabolism and constant renewal of content' (1992: 189). Fourth, although the word postmodernity highlights continuity and difference, and the indebtedness of the postmodern to the modern, nevertheless postmodernity is 'a self-reproducing, pragmatically self-sustainable and logically self-contained social condition defined by *distinctive features of its own*' (1992: 188). In other words, postmodernity is a distinct historical situation.

Bauman's position on what has replaced modernity has been remarkably consistent, but the label he applies to the postmodern ideal type has changed. By 2000 he had stopped using the word 'postmodernity' and started to speak instead about 'liquid modernity'. Why? One reason was tactical. A number of commentators conflated the message with the messenger. Bauman started to be called a 'postmodernist' simply because he wrote about postmodernity. But more significantly Bauman changed his terminology because the word 'postmodernity' suggests a departure from the modern, a 'leaving modernity behind, being on the other shore' (Bauman and Tester 2001: 97). But, he says, we have not left modernity behind, and many modern dreams and practices continue. Consequently he offered the phrase 'liquid modernity' to try to get to grips with what was both original and continuous about the contemporary historical situation. The phrase liquid modernity 'points to what is continuous (melting, disembedding) and discontinuous (no solidification of the melted, no re-embedding) alike' (Bauman and Tester 2001: 98). Since the publication of the book *Liquid Modernity* in 2000 this has been the label under which Bauman has worked and published a prodigious amount. However, the claims Bauman makes about liquid modernity are entirely compatible with those he previously made about postmodernity. Even though the use of the word 'postmodernity' first brought Bauman to wide notice, its avoidance does not imply any dramatic changes in his major claims. After all: 'I use the term "liquid modernity" . . . for the currently existing shape of the modern condition, described by other authors as "postmodernity", "late modernity", "second" or "hyper" modernity' (Bauman 2011b: 11). What makes liquid modernity modern is 'its self-propelling, self-intensifying, compulsive and obsessive "modernization", as a result of which, like liquid, none of the consecutive forms of social life is able to maintain its shape for long' (2011b: 11).

Bauman's exploration of liquid modernity as the contemporary historical situation is possessed of a freedom and continued curiosity which was beginning to leech out of the work on postmodernity thanks to both the word's false implication of a rupture with everything modern and, indeed, the tendency of some critics to identify the messenger with the message.

Principal contributions

Bauman's principal contribution to social and cultural theory is shaped by the lesson he learnt from the memoirs of his wife, Janina. In the first volume of her autobiography Janina Bauman wrote: 'the hardest of all struggles is to remain human in inhuman conditions' (J. Bauman 1986: x). Zygmunt Bauman's principal contribution to social and cultural theory can be identified, first, as a sustained enquiry into how historical reality pushes towards inhuman conditions (with the Holocaust being the case study of an unusual but not aberrant expression of the historical situation of modernity), second, as a recovery of how it might be possible to remain human even in circumstances as overwhelmingly inhuman as those of genocide, and, finally, as a commitment to the role of sociology itself in this vastly important activity. Put another way, although *what* Bauman says is important for social and cultural theory, his principal contribution is best identified in *why* he says it, and *how*. Let's deal with each of these three points in turn.

A continuous theme in Bauman's thought is the exploration of a tendency of historical conditions to create inhuman situations. The theme reflects the influence of his cognitive a priori. Although Bauman identifies the human with action and with the 'remainder' which is left after all 'inputs' have been bracketed off, he refuses to see this version of what it means to be human as existing outside or independently of society. Bauman's understanding of human beings is thoroughly sociological, and there is no such thing as 'a human being cast in a world that does not contain a society, an entity which has already "prefabricated" the world in which humans carve and mould their *Lebenswelte*' (Bauman and Tester 2001: 59). So, to be human is to be active, but this action and activity is always and necessarily situated in a society that exists before and independently of the actor and action. Once again Marx's thesis about men and women making history but not in the circumstances of their own choosing clarifies the point. The prefabricated world consists in institutions and forms restricting the possibilities of human action, and therefore to be human is to be at once social *and* restricted. To be human is to be prevented from acting freely. So why is the restrictive prefabricated world accepted?

One strand of the answer is obvious. Humans have to accept restriction because they (we) are intrinsically social. As Bauman put the matter, it is 'exceedingly difficult, nay impossible, to think of the "human person" outside of society or of "society" independently of the individuals who compose it. If humans are something "intrinsically" they are *social*' (Bauman and Tester 2001: 43). There is no human independent of the social and consequently neither is there some state of nature where we can be latter-day noble savages and live as nature supposedly intended. Remember: the historical situation, which necessarily includes the human, is rooted in praxis, not an 'out there' amenable to scientific discovery and establishing what 'must be done'. But there is another, more sociological, strand to the answer, and here Bauman develops a thesis recalling Freud. However, Bauman is interested in Freud as a *cultural analyst*, not as the founder of psychoanalysis. What Bauman takes from Freud is hinted at in the title of the book *Postmodernity and Its Discontents* (Bauman 1997).

According to Freud, in civilization we renounce the free pursuit of our desires in exchange for the security of an orderly life together. This is the basis of our sexual neuroses and indeed of war and violence. Bauman offers a variation on this theme. Let us go back to his cognitive a priori. It postulates an image of 'man' which is through praxis always tending to undermine what is otherwise certain. What Bauman makes insufficiently clear, or at least what is so obvious to him it simply does not need to be said, is the status of 'man' as a material being too. As such to be human is to be *a material being engaging in praxis*. In order to be human then two

conditions must be fulfilled. First there must be a resolution of problems of material vulner-ability, and second there must be a capacity to engage in praxis. Here lies the problem: these two conditions are not necessarily compatible. Praxis might unsettle the prefabricated society in which vulnerability is mitigated by institutions, but these institutions by their very prefab-rication impinge upon praxis. For Bauman the historical situation can be interpreted in terms of different ideal-typical resolutions of this contradiction. Modernity dealt with it through the almost total – and therefore inhuman – mitigation of vulnerability at the expense of a lack of freedom, while postmodernity and liquid modernity sharply go in the opposite direction. They enhance freedom but at the expense of the exacerbation of vulnerability.

This is where political power, and indeed the power of politics, resides. For Bauman:

> Human uncertainty and vulnerability are the foundations of all political power: it is against those twin . . . constant accompaniments of the human condition . . . that the modern state has promised to protect its subjects; and it is mostly from that promise that it has drawn its raison d'être as well as its citizens' obedience and electoral support.
>
> *(2011a: 52)*

By this principle, the Holocaust was possible because the Nazi state promised to protect its citizens against all disorder. But the promise could only be delivered if the citizens suspended their moral conscience, and if those who were identified with disorder were annihilated.

Of course for Bauman this principle always has to be put into the context of the times, and this is the basis upon which he has offered the contribution of liquid modernity. It is *liquid* because institutions no longer mitigate vulnerability. Instead men and women are left to their own resources to try to find security. This is because the perfect society is now equated with the life of consumers who are free to buy – or who are 'flawed consumers' – rather than with groups that might be ambivalent in relation to the classifications of order (Bauman 2007). In liquid modernity, Bauman writes:

> the state washes its hands of the vulnerability and uncertainty arising from the logic . . . of free markets. The noxious frailty of social status is now redefined as a private affair, a matter of individuals to deal with and cope using the resources in their private possession.
>
> *(2011a: 53)*

This might well make Nazi-style inhumanity all but impossible, but this liquid modern world nevertheless has its own inhumanities. One of them is the pursuit of love without binding commitment, a love that treats the other person as if they were a tissue, to be used and then thrown away (Bauman 2003). Inhumanity, and more precisely the struggle to remain human in inhuman conditions, is not just written against the large and obvious events of history. The struggle is also woven into what we do in our daily lives today and tomorrow. It is so woven because it is an intrinsic part of what it means to be a material human, engaging in the uncertainties of praxis in a political and social order which promises security just so long as we do what we are told, or buy things to build a shield against vulnerability.

At this point the discussion moves on to consider *why* Bauman develops the arguments he does. *He does it in order to recover the possibility of humanity out of inhuman conditions.* But in what does the recovery consist? The answer to this question takes the discussion to what is likely to prove to be Bauman's principal contribution to social and cultural theory. *The recovery of humanity consists in acting ethically.* This point first emerges at the end of Bauman's Holocaust

book, as a statement of hope and faith in humanity even – or perhaps especially – out of the analysis of the worst inhumanity. Bauman's treatment of the Holocaust takes him to a kind of 'ground zero'. There is nothing about the Holocaust that is peculiar, nothing abnormal. It is, instead, a magnificently clear illustration of where the design and implementation of the perfect order might lead when it is carried out according to the definitely modern instrumental rationality of bureaucracy pursuing the end of the perfect 'garden'. But while this can explain how the Holocaust could be carried out – and indeed the analysis can even go some way towards explaining how the Nazis managed to get the victims not to rebel against their fate – there is one thing it cannot explain. As Bauman announces towards the end of the Holocaust book, his analysis cannot explain why some people were prepared to put everything in peril in order to try to protect the victims. The failure to explain is, however, precisely the point.

Bauman put the matter this way: 'Some ordinary people, normally law-abiding, unassuming, non-rebellious and unadventurous, stood up to those in power and, oblivious to the consequences, gave priority to their own conscience' (2000b: 168). Why did they do this?

> One would search in vain for social, political or religious 'determinants' of their uniqueness. Their moral conscience, dormant in the absence of an occasion for militancy but now aroused, was truly their own personal attribute and possession – unlike immorality, which had to be socially produced.
>
> *(2000b: 168)*

In other words the actions of those who tried to help the victims of the Holocaust cannot be explained in sociological terms. Their decision so to help is rooted in a 'remainder' beyond sociological explanation. On the one hand this takes the discussion straight back to Bauman's cognitive a priori, and on the other hand it takes the discussion forward to his highly influential attempt to add a dimension of ethical theory to sociological analysis.

Acting ethically, for Bauman, means putting care for the other over and above any selfish desires or interests. The ethical action is one putting the self at risk in the name of attending to the needs of the other. The other is, simply, the person with whom one has relationships or a life of mutual dependency. In the situation of globalization this extends the ethical concern to include *everyone* (Bauman 1998). The principle of care for the other threads from the end of the Holocaust book to its most developed statement in *Postmodern Ethics* in 1993. It has become the ethical a priori within which Bauman has worked ever since. But note the title of the 1993 book. The ethical position is not an abstraction but always to be placed in the context of the historical situation in which humans are fated to have to make choices. In short, ethics is about historical praxis.

Bauman identified seven aspects of postmodern ethics and in so doing frequently slipped, in the terms of his discussion, from ethics to morality. First, humans are neither intrinsically good nor intrinsically evil. Instead we are ambivalent actors who have to make choices in circumstances not of our own choosing. Marx again. Second, moral actions are non-rational. According to Bauman, ethical questions arise because we as humans are always in the world with others, and this social being precedes rational means–ends calculations. Third, moral choices are themselves ambivalent or, as Bauman puts it, aporetic. The human always contains the seed of the inhuman because, as Bauman explains, 'the impulse to care for the other, when taken to its extreme, leads to the annihilation of the autonomy of the Other, to domination and oppression' (1993: 11). Fourth, morality is non-universalizable. When Bauman says this he is not falling into the 'anything goes' trap of moral relativism. Instead he is making a point about

how ethical and moral codes imposed from outside have the effect of 'the silencing of moral impulse and channeling of moral capacities to socially designed targets that may, and do, include immoral purposes' (1993: 12). To illustrate this point think again about the social designed garden of the racially perfect Reich, and think too of the rescuers, whose 'moral impulse' was not silenced. Fifth, from the point of view of the rational designs of social order, moral action is irrational and therefore a potential problem in need of management and control. Once again the cognitive a priori appears. Sixth, morality comes before society because we as material humans need to be cared for before we can enter into society. Consequently, 'being *for* the Other before one can be *with* the Other . . . is the first reality of the self, a starting point rather than a product of society' (Bauman 1993: 13). Bauman sees this being for the Other as the basis of a 'moral impulse'. Seventh, the relativity of ethics is a product of society itself trying to manage the unpredictability of being for the Other. Since to be ethical is to be *for* the Other, the ethical itself is neither relative nor variable. It is, instead, categorical.

With these claims about postmodern ethics Bauman manages to establish a categorical position – one clearly compatible with his cognitive a priori – which can be used as a principle of the criticism of the historical situation. The situation can be understood and critiqued in terms of how it manages, manipulates or indeed emancipates the moral impulse. But this understanding can only be achieved through sociology. Consequently sociology itself becomes a fundamentally ethical practice. If, Bauman says, ethics is about social relationships, and if sociology is the study of social relationships, then sociology 'is and cannot but be . . . an inquiry into the ways in which ethical rules are constructed and "made to stick", ways in which choices are made by humans and for the humans, alternative possibilities promoted, stifled and otherwise manipulated' (Bauman and Tester 2001: 45). This gives a programme for sociology, and it also has implications for *how* sociology is to be done.

The programme for sociology becomes one of exploring how and why the rules 'stick'. Here Bauman uses terminology that points back to Gramsci. Gramsci saw what he called 'common sense' as the root of arguments about there being no alternative to how things are, no chance of things becoming different. Bauman has a similar perspective. If sociology is the study of how rules 'stick', and if this 'sticking' is, first, implicated in the manipulation of the moral impulse and, second, a denial of the possibility of things being other than they are, then the practice of sociology becomes an attempt to undermine common sense. Sociology then is an exercise in raising questions and, thereby, emancipating men and women from being told what to do and what choices they ought to make. Sociology becomes an ally of the Gramscian task of changing the objects of history into its subjects.

Main criticisms

There is a problem if the programme of sociology turns it into an encounter with common sense. As Bauman put it:

> Perhaps more than other branches of scholarship, sociology finds its relation with common sense (that rich yet disorganized, non-systematic, often inarticulate and ineffable knowledge we use to conduct our daily business of life) fraught with problems decisive for its standing and practice.
>
> *(1990: 8)*

Quite simply, it has to be possible to maintain the difference and yet also the linkage between these two kinds of knowledge. The difference is necessary because the role of sociology is to

contribute to a world for and of humans. The linkage is necessary because if sociology does not talk with the lived experience of the historical situation it becomes hubris. Once again it is possible to see the shadow of Gramsci.

Bauman identified four ways in which sociology and common sense are distinct. First, sociology ought to be responsible; it ought only to make claims that can be corroborated and ought to refuse to accept anything that is said to be true because 'I know it is true'. Sociology is analytical, not assertive. Second, sociology draws its material from a wider field than common sense. Common sense draws on the everyday, the close at hand and the self-evident, while sociology draws upon a broader field of material; it widens horizons. Third, common sense makes sense of the world through the prism of the sovereign individual acting in almost glorious isolation in terms of her or his own will. By contrast, sociology is the analysis of the historical situation of the action. Finally, common sense is a knowledge that confirms the world and its arrangements (Bauman says common sense is immune to questioning), whereas it is the business of the sociological to 'defamiliarise the familiar'. Sociology is not about confirmation at all. It is in the business of irritation. (This list of the differences between common sense and sociology is drawn from Bauman 1990: 12–15.)

But how is this work of defamiliarization to take place? This is the point around which revolve the most telling criticisms of Bauman's work. The defamiliarization does not take place through empirical research. Given Bauman's cognitive a priori, it is no surprise to find in his work a remarkable absence of empirical data (survey results, ethnographies, statistics). Bauman's texts also demonstrate a consistent and deep lack of interest in questions of methodology. Where sociologists stress methods, Bauman's position implies, they are doing nothing other than trying to preserve the power of a degenerate profession. They are being deliberately self-referential in order to hide from themselves their detachment from the lived experience of the historical situation. Consequently those criticisms of Bauman's work that question his methods and the empirical evidence behind his claims fail. They come from the perspective of the very sociology he explicitly rejects.

The most incisive criticisms of Bauman's work are those that take it on its own terms. Now it is important to remember what Bauman is trying to do. He is attempting to engage humans as the subjects and not the objects of praxis. As such he is less concerned to say to his readers 'this is what is happening' than he is to engage in a conversation with them in the spirit of 'let us think about this together'. But how is this to be done? In order to play this role in changing historical situations Bauman's work has undergone something of a shift in style. The early density has given way to a style relying more on the anecdote and fragment. His books appear in the style of a conversation, diary or collection of letters. For each of these approaches see *Living on Borrowed Time* (Bauman and Rovirosa-Madrazo 2010; this is just one of numerous books of conversations with Bauman), *This Is Not a Diary* (Bauman 2012) and *44 Letters from the Liquid Modern World* (Bauman 2010). But perhaps the most significant change consists in the turn towards a style of sociology that is heavily dependent upon *metaphor*. The metaphors certainly stimulate conversation – this is what Bauman intends them to do – but the question is whether the conversation is about the metaphor or the lived experience of the historical situation which the metaphor attempts to grasp.

The issue of Bauman's metaphors has been discussed most tellingly by Charles Turner. For Turner, Bauman's reliance on metaphor is not always successful. First, Turner says, 'metaphor is never deployed at the level of discourse, so that the work contains no vision of sociology as a distinct intellectual exercise, no clearly defined apparatus for studying society' (2010: 100). This is not an entirely valid point to make against Bauman. As we have seen there is most definitely a 'vision of sociology as a distinct intellectual exercise' in Bauman's work, even if it

is not universally embraced. Indeed it would actually be contrary to the spirit of Bauman's work for his vision to be accepted by everyone, because, if it were, no conversation would be possible. Turner's second point is more cutting. Bauman, he says, uses metaphor as a way of dramatizing his work, and this is a problem because the metaphors are often called upon to go beyond drama: 'Bauman at times has more grandiose aims; not exactly for a conceptual framework, but certainly for something which is required to do a good deal of work' (Turner 2010: 101).

When Turner seeks to illustrate this point he looks immediately to two of Bauman's most influential metaphors. First, Turner focuses on Bauman's association of the Holocaust with the gardening practices of the modern state. The metaphor of 'gardening' is used as both a conversational device – a way of getting us to think about the Holocaust – and *also* as an accurate depiction of the relationship between ordering designs and state practices. Consequently the status of the metaphor slips from one use to another, and in its latter version, Turner (2010: 101) implies, it adds nothing to the weight of existing scholarship on the Holocaust. The second metaphor upon which Turner focuses is 'liquid modernity'. Here Turner sees nothing new beyond the metaphor. On the one hand the connection of modernity and liquidity has been known since Marx and Engels, and on the other hand it 'is the sort of image that is unlikely to lead to anything one could call a serviceable model of social analysis' (2010: 101) beyond the identification of what has become liquid. In short, Turner almost implies, this metaphor is a tautology.

For Turner, Bauman's metaphors lead to an overload of description which manages to hide a lack of 'conceptual and methodological innovation' (Turner 2010: 103). These metaphors as descriptions owe everything to Bauman's intuition; they seem to have validity because they 'appeal rather directly to the reader's own instincts' (Turner 2010: 103), and, the implication seems to be, they will not last.

Importance and future development

It is worth thinking about the possibility of Bauman's metaphors not lasting. It goes to the heart of the future development of his work. It will only develop if it continues to stimulate a conversation about the historical situation of human praxis. This conversation is important because it plays a part in transforming humans from the objects into the active subjects of history. In short, the future development of Bauman's work and the conversation with him can only be achieved in the very praxis the work seeks to recover. From this follow two principles for the assessment and future of the work.

First of all, if Bauman's work inspires the formation of a Baumanian school or distinctive approach it will have failed by its own lights. This point can be put more brutally. If at any time anyone claims to be a 'Baumanian', they have provided sufficient evidence of their absolute failure to understand the work they claim as their own. Back to Gramsci and the critique of the degenerate professionalized party.

Second, the future development of Bauman's work, both by Zygmunt Bauman and by the readers who enter into conversation with the texts bearing his name, remains precisely there, in the future. It cannot be predicted, and, once again, even to attempt to do so is to contradict the principles according to which the work was produced.

Bauman's work connects social and cultural theory to history and to a principled faith in humans if they are left to be the subjects of their own history. But history piles up against praxis in the present. It is the role of sociology to recover humanity and, thereby, to open up the future to the possible, not the probable. Exactly the same point applies to the future of

Bauman's work. The task is to nurture *possible* readings, *possible* conversations and not the probable, institutionally authorized, ones. The task is to keep it human.

References

Bauman, J. (1986) *Winter in the Morning: A Young Girl's Life in the Warsaw Ghetto and Beyond*, London: Virago.

Bauman, Z. (1967) 'Image of man in the modern sociology (some methodological remarks)', *Polish Sociological Bulletin*, 1: 12–21.

—— (1973) *Culture as Praxis*, London: Routledge & Kegan Paul.

—— (1976) *Towards a Critical Sociology: An Essay on Commonsense and Emancipation*, London: Routledge & Kegan Paul.

—— (1978) *Hermeneutics and Social Science: Approaches to Understanding*, London: Hutchinson.

—— (1987) *Legislators and Interpreters: On Modernity, Post-modernity and Intellectuals*, Cambridge: Polity.

—— (1990) *Thinking Sociologically*, Oxford: Blackwell.

—— (1991) *Modernity and Ambivalence*, Cambridge: Polity.

—— (1992) *Intimations of Postmodernity*, London: Routledge.

—— (1993) *Postmodern Ethics*, Cambridge: Polity.

—— (1997) *Postmodernity and Its Discontents*, Cambridge: Polity.

—— (1998) *Globalization: The Human Consequences*, Cambridge: Polity.

—— (2000a) *Liquid Modernity*, Cambridge: Polity.

—— (2000b) *Modernity and the Holocaust*, Cambridge: Polity.

—— (2003) *Liquid Love*, Cambridge: Polity.

—— (2007) *Consuming Life*, Cambridge: Polity.

—— (2010) *44 Letters from the Liquid Modern World*, Cambridge: Polity.

—— (2011a) *Collateral Damage: Social Inequalities in a Global Age*, Cambridge: Polity.

—— (2011b) *Culture in a Liquid Modern World*, Cambridge: Polity.

—— (2012) *This Is Not a Diary*, Cambridge: Polity.

Bauman, Z. and Rovirosa-Madrazo, C. (2010) *Living on Borrowed Time: Conversations with Citlali Rovirosa-Madrazo*, Cambridge: Polity.

Bauman, Z. and Tester, K. (2001) *Conversations with Zygmunt Bauman*, Cambridge: Polity.

Beilharz, P. (2001) *The Bauman Reader*, Oxford: Blackwell.

Douglas, M. (1966) *Purity and Danger: An Analysis of the Concepts of Pollution and Taboo*, London: Routledge & Kegan Paul.

Gramsci, A. (1971) *Selections from Prison Notebooks*, ed. and trans. Q. Hoare and G. Nowell Smith, London: Lawrence & Wishart.

Kołakowski, L. (1978) *Main Currents of Marxism: Its Origins, Growth and Dissolution. Vol. 3: The Breakdown*, trans. P. S. Falla, Oxford: Oxford University Press.

Tester, K. (2004) *The Social Thought of Zygmunt Bauman*, Basingstoke: Palgrave Macmillan.

Tester, K. and Jacobsen, M. H. (2005) *Bauman Before Postmodernity: Invitation, Conversations and Annotated Bibliography 1953–1989*, Aalborg: Aalborg University Press.

Turner, C. (2010) *Investigating Sociological Theory*, London: Sage.

Ideology and social and cultural theory

John Cash

Introduction and historical overview

The concept of ideology has a genealogy that traces through some central moments and dilemmas of modernity and postmodernity and a presence that recurs in the explanation of how societies are reproduced and human subjectivities are organized. Born during the French Revolution, under the shadow of the guillotine, it survived in the person of its originator, Antoine Destutt de Tracy, to become a guiding concept for the realization of the ambitions of the Enlightenment in the period following the Thermidorian Reaction, with its defeat of Robespierre and the Committee of Public Safety. In this revolutionary setting, ideology was conceived as knowledge based on the certainties of first principles and as an antidote to the prejudices and inexact pre-judgements of custom and tradition, especially as communicated through ordinary language. It was conceived, then, as the inverse of its now typical cluster of connotations and meanings in which misrecognition figures large. Yet this very splitting between valid and invalid forms of consciousness, knowledge or belief has continued to haunt notions of ideology throughout its subsequent career.

With de Tracy's accession to a position of considerable political power, these guiding first principles that the science of ideology was regarded as revealing began to find their way into public policy, especially as regards education. At first Napoleon supported the ideologues, but soon their adherence to first principles so infuriated him that he came to regard their new science as an assault on sound common sense and a threat to governmental authority. Napoleon lambasted de Tracy and his fellow ideologues as 'windbags' and proclaimed:

> we must lay the blame for all the ills that our fair France has suffered on ideology, that shadowy metaphysics which subtly searches for first causes on which to base the legisla-tion of peoples, rather than making use of laws known to the human heart.
>
> *(Billig 1982: 12)*

In a premonition of its later history, Napoleon's characterization of ideology as 'shadowy metaphysics' anticipates the appropriation of the term by Marx and Engels in *The German Ideology* (1970). The uncanny co-presence of two joined yet opposite meanings of 'ideology' was now in place. If for the first ideologues 'ideology' was a theory and method for the estab-lishment of veridical truths, by the time it was adopted by Marx and Engels it referred to the opposite of truth; it referenced illusion and deception. However, for Marx ideology was more

than merely tricky and misleading; people went along with it and believed in the errors about the proprieties of social life that ideology promulgated. It had an unexplained capacity to fascinate and deceive.

If Napoleon had debunked ideology, another great political and revolutionary figure, Vladimir Lenin, resuscitated its virtue, at least when it took the proper form of socialist ideology. Truth and error were no longer inside or, alternatively, outside ideology. Rather some, namely socialist, ideologies were valid, as they accurately portrayed the character of social relations as class relations and accurately anticipated the necessary direction of historical change, while other, reactionary, ideologies were invalid and misleading as they served as apologias and justifications for the maintenance of exploitative and alienating social relations. In Lenin's hands ideology, by itself, became a neutral term depicting systems of belief and practice that took on positive or negative connotations depending upon the political system that was advocated. This amounts to a widening of the scope of the concept and highlights that political contestation involves ideological conflict. Some ideologies are progressive; others are conservative or regressive. Some depict the real processes that determine social order and change, whereas others mislead, confuse and oppress. Whatever their tendency, political movements involve the deployment of political ideologies in order to recruit support and to establish their preferred social models as proper forms of social organization. With this move Lenin shifted the term 'ideology' towards the commonplace meaning it holds today, as a descriptive term for one or another set of principles and practices that compete to exercise political and social power.

In effect, Lenin generalized ideology as a common feature of political power and conflict. Already, then, we have seen both restricted and expansive usages of the term 'ideology'. For de Tracy and his colleagues, as for Napoleon and Marx, ideology is restricted to referencing one or the opposite side of a polarity between truth and error. With Lenin, however, ideology is not split in this manner. The truth or falsity of ideology depends on the specific content of particular ideologies. Ideologies can be true or false but also progressive or reactionary. Antonio Gramsci extended this by recognizing that ideologies of various kinds compete to establish their hegemony or dominance and to establish the implicit assumptions and beliefs that count as common sense and thereby support the established social order.

If some ideologies could be regarded as progressive while others were regressive, this was never more apparent than in Nazi Germany as Hitler rose to power. That Germany, the most advanced of the capitalist economies, failed to achieve the transition to socialism thoroughly confounded the Marxist orthodoxy of the time. All the objective conditions were in place for the great transformation to socialism. What got in the way? In addressing this question the Frankfurt School of social theorists introduced ideology as the massive fly in the ointment, so to speak. They also resuscitated another feature of ideology's uncanny other-sidedness, in which a leading feature that had apparently been eliminated had actually only been repressed. Psychology, now in the guise of psychoanalysis, returned to help explain how ideology operated to stall and divert the trajectory towards a rational socialist society in Germany and the other advanced European economies. The original ideologues also relied on a psychological theory, although one very different from psychoanalysis. Indeed, de Tracy's colleague, Pierre Cabanis, one of the founding figures of physiological psychology, proposed and used the term 'ideology' as a term covering what today we refer to as psychology.

De Tracy argued that 'thinking is only sensing' and that, while individual sensations are veridical, they are also 'in [themselves] absolutely internal and non-transmittable' (Billig 1982: 14, 18). They are trapped within the monadic self and rely on natural language for their communication to others. The ideologues argued that in the social act of transmission through

language these veridical sensations were corrupted. This arose from the inexact character of ordinary language. A new precise and uniform language purged of all metaphysics was thus essential, and the ideologues were determined to develop such a language and introduce their method into France's education system. We see, then, that the term 'ideology' encompassed psychology in its very conception, and we will see the return of this often repressed element in several versions of ideology as we proceed. From the Frankfurt School through Althusser to Žižek, a very different kind of psychology to that envisaged by the ideologues, namely psychoanalysis, is incorporated as a supplement to Marxist and related social theories. Language also takes on a more prominent role in understandings of how ideology operates.

Major developments and contributors

Karl Marx (and Friedrich Engels)

Two distinct accounts of ideology are evident in Marx's writings, both of which have influenced more recent conceptualizations. The first is developed in *The German Ideology*, co-authored with Friedrich Engels, where Napoleon's negative coding of the term 'ideology' is carried forward, although the evaluation is switched. Now, Napoleon's 'laws known to the human heart' fall under suspicion.

The German Ideology developed Marx's materialist conception of history by playing out some implications of the distinction between consciousness, ideas and ideology on the one hand and sensuous human activity or practice on the other. Historical materialism does not begin with a focus upon consciousness but with a focus upon the production and reproduction of material life. In their material activity human beings also produce their conceptions of the world. However, with social change and the development of class relations, these conceptions come to represent class interests and, typically, to protect and preserve ruling class interests. They do so by, at once, reflecting class interests and distorting that reflection. Thus, ideology comes to mean any cultural form or system of representation, or any form of consciousness which, at once, captures and distorts class interests, making them appear as universal interests which are the natural attributes of a properly ordered society. Religion is one example of this; liberal political economy is another.

Much of this is illustrated by the famous camera obscura metaphor from *The German Ideology* and in the related discussion of ideologies as 'forms of consciousness' that have 'no history, no development' (Marx and Engels 1970: 47). The camera obscura is a device for capturing an image on a screen or other material, such as paper. The camera obscura inverts the image, presenting it upside down. For Marx and Engels this provided a useful metaphor for their first theory of ideology. As they put it, 'If in all ideology men and their circumstances appear upside-down as in a *camera obscura*, this phenomenon arises just as much from their historical life-process as the inversion of objects on the retina does from their physical life-process' (1970: 47).

The inversion of the image indicates how appearances can deceive. The real action is somewhere else, yet people fall under the spell of the image. Moreover, the image is merely that: an image of something projected onto a two dimensional screen. It is insubstantial and it lacks efficacy. It gets things round the wrong way because it draws attention away from the real life processes that it reflects and, through inversion, distorts. This is the way ideology operates in this first Marxist account.

The story is complicated, however, as *The German Ideology* was only published after the death of both Marx and Engels. Nevertheless it became an important text for later Marxists,

including Louis Althusser, who responds to it at some length in his major essay on ideology. In a series of letters written after Marx's death, Engels was concerned to counter readings that twisted, as he put it, the materialist conception of history into one 'saying that the economic element is the *only* determining one' rather than 'the ultimately determining element'. He continues in his letter to Bloch:

> The economic situation is the basis, but the various elements of the superstructure – political forms of the class struggle and its results, to wit: constitutions established by the victorious class . . ., juridical forms and even the reflexes of all these actual struggles in the brains of the participants, political, juristic, philosophical theories, religious views and . . . dogmas – also exercise their influence.
>
> *(Engels 1972: 294)*

Engels granted, however, that 'Marx and I are ourselves partly to blame for the fact that the younger people sometimes lay more stress on the economic side than is due to it', and, to counter this, he points to nuanced 'application(s)' of the theory by Marx, especially in his study of *The Eighteenth Brumaire of Louis Bonaparte*, in which 'intersecting forces' are addressed.

Nevertheless, the major role accorded to the 'economic side' and the minor one, at most, attributed to ideology are outlined in this famous statement from *The German Ideology*:

> We set out from real, active men, and on the basis of their real life-process we demon-strate the development of the ideological reflexes and echoes of this life-process. The phantoms formed in the human brain are also, necessarily, sublimates of their material life-process, which is empirically verifiable and bound to material premises. Morality, religion, metaphysics, all the rest of ideology and their corresponding forms of conscious-ness, thus no longer retain the semblance of independence. They have no history, no development; but men, developing their material production and their material inter-course, alter, along with this their real existence, their thinking and the products of their thinking. Life is not determined by consciousness, but consciousness by life.
>
> *(Marx and Engels 1970: 47)*

This phrasing harks back to the ideologues, but with a significant difference and another inversion. If real life processes produce mental reflexes and sublimates 'in the human brain', as the ideologues had proposed, these very reflexes and sublimates, as ideologies, are also characterized as echoes and phantoms. They suffer distortion as they move from real life processes to mental representations, as if captured in a camera obscura. The effect of all this is that they 'no longer retain the semblance of independence' and they 'have no history, no development'.

Given this almost thorough rejection of ideology as producing any social or political effects, we might wonder why the concept survived and thrived in later Marxist theory and beyond. Yet, even when cast in this negative light, we can still discern how this early Marxist argument regarding ideology carries several linked implications. First, it debunks idealist explanations of social organization and political power, a task that Engels in his later letters regarded as critical: 'We had to emphasise the main principle *vis a vis* our adversaries, who denied it' (1972: 295). Second, it argues that established ideals and beliefs mislead people into misunderstanding how social organization is produced and transformed. Third, as they are understood through ideology, established social formations tend to be regarded as natural and proper. We can see then that, despite the main tendency of the argument developed in *The*

German Ideology, its implications raise questions as to whether ideology is really so irrelevant after all. Is it really only a second-order effect of real processes located at the level of production? That list of morality, religion and metaphysics is a list of belief systems to which people subscribe and with which they passionately interact. What is left out is any explanation as to why such ideologies can exercise a powerful hold over people's understandings, especially given that their routine experience as productive workers should be telling them something else. This question of how and why ideology works its trickery, and the implications this capacity has for its efficacy, resonates through later theories of ideology. Psychological concerns, subliminally glimpsed though not embraced in some of the formulations of *The German Ideology*, also return to centre stage, as we will see.

It is a moot point whether any psychology figures in Marx's later theory of ideology, as developed in his magnum opus *Capital* and other writings from the final period of his life. In particular, with the argument developed in *Capital* about the fetishism of commodities and the fetishism of capital, it seems clear that any residual or repressed psychologism had been fully eradicated from accounts of how ideology operates. Certainly, that is the near-universal consensus.

In *The Manifesto of the Communist Party* Marx and Engels explained the effects of capitalism's dynamism as follows:

> Constant revolutionising of production, uninterrupted disturbance of all social conditions, everlasting uncertainty and agitation distinguish the bourgeois epoch from all earlier ones. All fixed, fast-frozen relations, with their train of ancient and venerable prejudices and opinions, are swept away, all new-formed ones become antiquated before they can ossify. All that is solid melts into air, all that is holy is profaned, and man is at last compelled to face with sober senses his real conditions of life, and his relations with his kind.
>
> *(1983: 207)*

However, in *Capital* volume 1 this revolutionary shift to facing the real conditions of life with 'sober senses', the true objective of the original ideologues, met with the obstacle of ideology, now operating as a 'fetishism of commodities' and a 'fetishism of capital'.

Belief in a god or totemic figure is the common example of a fetish that Marx had in mind as a starting point for his argument about the fetishism of commodities. The power to produce real effects in the world of persons, animals, plants and things is mistakenly attributed to a fetish which disguises the real causal processes in operation. Clearly, this is consistent with the argument in *The German Ideology* about 'morality, religion, . . . all the rest of ideology and their corresponding forms of consciousness' (Marx and Engels 1970: 47) in that an epiphenomenon – the religion or fetish – has causal agency attributed to it when that agency or power actually resides elsewhere. However, Marx's fetishism of commodities differs from the cultural and psychic processes of inversion and distortion outlined in *The German Ideology* in significant ways. Capitalism and the bourgeois epoch have been so transformative – 'all that is solid melts into air' – that the appearance that social reality takes, the way it presents itself to human consciousness, has diverged from its essence. (Marx is drawing on Hegel's distinction between appearance and essence.) This confounding ideological effect (restricted to bourgeois society) arises from the way the commodity appears to have an intrinsic value in and of itself, a value that excludes or represses recognition of the human labour that went into its production. Marx argues that this is how the fetishism of commodities operates as ideology: by taking the appearance for the essence and inverting the relation between human

labour and the commodity – getting things round the wrong way. As Marx puts it in *Capital*, volume 1:

> *They do this without being aware of it.* Value, therefore, does not have its description branded on its forehead; it rather transforms every product of labour into a social hieroglyphic. Later on, men try to decipher the hieroglyphic, to get behind the secret of their own social product; for the characteristic which objects of utility have of being values is as much men's social product as is their language.
>
> *(1976: 166–67, emphasis added)*

Again we see that ideology – now in the form of the way social reality appears or presents itself to human subjects – disguises a secret truth enigmatically inscribed onto the commodity, yet almost impossible to decipher. The secret truth is that the real relationship that produces commodities with a use value is the relationship between human beings as producers of these very commodities. Under capitalism that is a profoundly unequal and exploitative relationship that most people must suffer in order to survive, as all they have to exchange is their labour power. Yet, as value appears to reside in the commodity itself, in the form of its exchange value, and not in the human labour that has produced it, and as commodity exchange appears as an equal exchange of a certain value for an equivalent value, the ideological trick of keeping secret the truth about the social character of production under capitalism is achieved. The fetishized commodity has blinded people to the real social relations of production that created it. It has turned the tables by disguising and distorting the real social relations between producers as an apparent relation between things. As Marx writes: 'It is nothing but the definite social relation between men themselves which assumes here, for them, the fantastic form of a relation between things' (1976: 165).

While it is clear that, for Marx, capitalism introduces a fold in social reality so that the fetishism of commodities as an appearance trumps and covers over the essence of production as a social relation between human beings, nevertheless there is a significant further aspect that usually goes unremarked. It is captured in Marx's statement, italicized above, that 'They do this without being aware of it'. In the original German this is written as 'Sie wissen das nicht, aber sie tun es'. A more literal translation, as translated by Slavoj Žižek (1989: 28) for instance, is 'they do not know it, but they are doing it'. The German verb 'wissen' is usually restricted to knowing facts or knowing about things, rather than knowing someone, knowing a person. So Marx argues that within capitalist societies we routinely invert the social relation between individuals living within human communities into a relation between commodities. This produces the ideological effect of inverting cause and effect, essence and appearance; the relations between commodities and persons are routinely misconstrued. A similar inversion occurs with what Marx terms the fetishism of capital. It appears as if productive power is immanent in capital itself, whereas Marx argues that this power is actually located in the labourers themselves.

Marx's statement that 'they do not know it, but they are doing it' contains the idea that even when ideology is generated as an effect of how social reality presents itself within bourgeois societies, an accompanying psychological process is also involved. This is not the usual reading; however, it does seem unavoidable. In effect, Marx implicitly anticipates how psychoanalytic theory can supplement the theory of ideology. To trick oneself without being aware you are doing so is to imply that unconscious processes are in play and producing this effect. This is why Lacan argued that Marx invented the symptom (Žižek 1989: 11). A concern with human psychology as either a source or a medium of distortion within the fields

of social production and social relations regularly resurfaces in theories of ideology. This would seem to occur even in those versions where social reality itself appears as a distortion; a secret-producing, self-disguising form of social relations. At the least we can state that the later history of ideology as an analytic concept bears this out. While clearly rejecting 'psychologism' in which *only* psychological factors are considered, many later theories of ideology incorporate a psychological dimension, as conceptualized by psychoanalytic theory.

The Frankfurt School

The Institute for Social Research was established in Frankfurt, Germany, by a group of left-wing intellectuals in the mid-1920s. Its leading figures included Theodor Adorno, Max Horkheimer, Erich Fromm, Herbert Marcuse and Walter Benjamin. The group included philosophers, economists and psychoanalysts, and they all shared a commitment to critical theory modelled on Marx's work (his critique of political economy) and influenced by Kant's critiques and by Hegel. Given their shared commitment to Marxism, the political and economic situation in Russia, Germany and other parts of Europe gave rise to a shared recognition that Marxist theory needed to be supplemented, in order to adequately account for the fact that the transition to socialism was playing itself out in the technologically backward Russia rather than in the most advanced economies and societies, such as Germany. Indeed, in Germany, where, in accord with Marxist theory, this transition had been anticipated, quite a different rough beast was about to be born. There were, it had become evident, gaps in Marxist theory that needed to be remedied, and the theory of ideology was a leading instance. It needed to be supplemented by a better understanding of human psychology as it emerged within and interacted with economic and social conditions.

If the original ideologues had been concerned with realizing the rationality potentials of the Enlightenment, the Frankfurt School became concerned with what they termed the dialectic of Enlightenment. They argued that the Enlightenment project contained an inherent underside in the form of an instrumental rationality that had colonized all aspects of life and had become the hegemonic reality principle of the modern era. This led to a disenchantment of the world, as Weber had already argued, and the emergence of 'a new kind of barbarism', as evidenced in the wars and atrocities of the first part of the twentieth century (Horkheimer and Adorno 2002: xiv). The Frankfurt School drew on psychoanalytic theory to carry forward this analysis of the dialectic of enlightenment. Psychoanalysis was one theory that enabled them to grasp the underside of the Enlightenment project. It enabled them to see the corrosive and destructive element cast in amongst the Enlightenment's illusions about rationality, universality, cosmopolitanism, progress and development.

Erich Fromm and the satisfactions of ideology

Erich Fromm, as a practising psychoanalyst, played a major role in integrating psychoanalysis into the Marxist orientation of the Frankfurt School. Fromm eventually split from the school, but, while still a member and living in Germany prior to Hitler's rise to power, Fromm set out to develop a theory of ideology that integrated Marx and Freud.

In 'The method and function of an analytic social psychology', published in 1932, Fromm argued that the task of a (psycho)-analytic social psychology 'is to explain the shared, socially relevant, psychic attitudes and ideologies – and their unconscious roots in particular – in terms of the influence of economic conditions on libido strivings' (1978: 486). The place where this influence is most fully exercised is the family. As Fromm puts it: 'The family is the

medium through which the society or the social class stamps its specific structure on the child, and hence on the adult. *The family is the psychological agency of society*' (1978: 483, original emphasis). In making this argument Fromm places socialization within the family as the medium that transfers the social demand for a certain type of person, with a particular orientation to authority, into the interior of the human psyche.

This is a radical move. Ideology is no longer merely a false consciousness, nor is it the distorting, indeed inverting, effect of commodity fetishism. Rather, ideology is a culturally available mentality that arises from unconscious processes conditioned by social demands. In turn, ideology satisfies unconscious desires in a manner that preserves social order. Ideology links and integrates, or cements together, the functional requirements for the reproduction of a social order with the psychic desires of socialized subjects. Critical to this capacity is its emotional dimension. Along with a cognitive dimension that declares that current social arrangements are proper or valid, ideology also has an emotional dimension that provides satisfaction and enjoyment. It satisfies unconscious desires because 'the impact of an idea depends essentially on its unconscious content, which appeals to certain drives' (Fromm 1978: 491). For instance, Fromm argued that authoritarian regimes with their demand for obedience to authority and their spectacles of power and submission satisfied sadomasochistic desires that were a characteristic of the German libidinal structure: the typical personality type as socialized within the typical family structure (1978: 484).

The first sentence of Fromm's essay reads: 'Psychoanalysis is a materialistic psychology which should be classed among the natural sciences' (1978: 478). This is a brilliant rhetorical move, as it immediately dispatches any counter-argument that psychoanalysis is only concerned with thoughts, feelings, symptoms, dreams and illusions: everything that might readily be characterized as idealist or part of a so-called superstructure. Like Marxism, psychoanalysis is 'materialistic', as it focuses on human beings as both bodily and social beings with physiologically based drives that demand satisfaction. To validate this argument Fromm draws especially upon Freud's *Three Essays on the Theory of Sexuality*, as they are so clearly concerned with bodily derived experiences and desires. In particular he follows Freud's early distinction between the instincts for self-preservation and the sexual instincts. Fromm points out that while the self-preservative instincts cannot be postponed, for long, and cannot be repressed, sublimated or interchanged, the sexual instincts can be. As Fromm puts it, 'a sexual wish can be satisfied in a way that may be far removed from the original sexual goal'. He extends this by explaining that 'the drives towards self-preservation must be satisfied by real concrete means, while the sex drives can often be satisfied by pure fantasies' (1978: 479).

Ideologies operate as shared fantasies that provide pleasure by satisfying the libidinal drives. Fromm argues:

> neither the external power apparatus nor rational interests would suffice to guarantee the functioning of the society, if the libidinal strivings of the people were not involved. They serve as the cement, as it were, without which the society would not hold together, and which contributes to the production of important social ideologies in every cultural sphere.
>
> *(1978: 493)*

As well as believing in an ideology that matches their personality structure, people are also attached to the ideology because of the substitute gratification it offers. This latter aspect accounts for the power of ideology. However, change in the forces or relations of production can destabilize the complementarity between psyche and society, and then the same psychic

energies that have operated as cement can turn into 'dynamite' that explodes the established social order (1978: 495).

However, while holding out a transformative potential, the main emphasis in Fromm's account of ideology falls heavily on its capacity to cement the society together, thereby promoting a society's reproduction in its current form. This was a principal concern of the Frankfurt School, as Marxist predictions about transformation in the most advanced societies, such as Germany, were not being realized. The capacity of ideology to satisfy people's desires, even against their better interests, provided an explanation for social inertia and the reproduction of established identities and patterns of social relations. In this understanding ideology was in no way epiphenomenal. Rather, it played a central, typically conservative, role in the ordering of society.

Fromm's account of how ideology operates has many strengths, and we will see some of these reiterated in subsequent approaches to ideology – typically without direct reference to Fromm's argument. However, by privileging the significance of socialization within the family so completely, he falls prey to what Dennis Wrong has termed 'the oversocialized conception of man' (1976: 37), in which the split and internally divided human subject of psychoanalysis – hence also the discontented subject – is thoroughly penetrated and shaped by the social demand. Fromm's argument presumes that at each historical moment an overarching and common character type is formed, without excess or remainder. The social conditions dominate and domesticate the psyche. For Freud, human subjects always remain divided and decentred subjects. For Fromm, however, whilst we begin as divided and decentred subjects, after having been stamped by the social logic we become thoroughly stabilized and fixed in a particular subjective orientation that matches the social logic. Once established in childhood, this psychic organization persists into adulthood. The appeal of ideology, its capacity to cement a society together against the better interests of many of its citizens or subjects, is collapsed into the domesticating effects of the family as a social institution that, to reiterate, stamps 'on the child, and *hence on the adult*' (Fromm 1978: 483, emphasis added) an appropriate and efficient character type that has internalized and gains satisfaction from the demands of the social logic.

This socialization approach is unduly restrictive regarding the ways in which the social and the subjective interact. It presumes that each individual, locked away in the crucible of the family, was stamped out as one among many copies of a particular type, the authoritarian type being the main case Fromm had in mind. Thereafter, these individuals enter the broader society predisposed to take satisfaction from those economic, social and political practices that efficiently reproduce the established social formation. Microcosm and macrocosm match, with ideology holding the structure in place by routinely administering substitute gratifications. Of course, socialization is an important formative process, but we should question whether it is as uniform across a society or class as Fromm presumes and whether it is as totalizing in the way it shapes human subjectivity, without any remainder or excess. Taking up this issue of an excess, we should also notice that the account of human subjectivity presented by psychoanalysis includes a recognition that subjectivity can be re-organized in the here and now of the present moment, irrespective of prior socialization effects. Freud (1991) makes this very clear in 'Group psychology and the analysis of the ego', as we will see in discussing Theodor Adorno's approach to ideology.

Theodor Adorno and the eclipse of the individual

For Fromm, ideology is pervasive throughout all societies involving inequality and exploitation. It both legitimates and offers satisfying compensations for such exploitation by attaching

itself to the socially conditioned human psyche. Theodor Adorno understands ideology in a broadly similar way. In his *Lectures on Negative Dialectics* Adorno argues that most people fail to recognize the extent to which 'subjective modes of behavior in modern societies are dependent on objective social structures' (2008: 100). Extending Marx on the fetishism of commodities, Adorno claims that subjective behaviours are 'the mere appearances of those structures'. He continues:

> It follows that since the immediate consciousness of human beings is a necessary illusion, it is in great measure *ideology*. And when I said in my lecture on society . . . that I regarded it as the signature of our age that human beings were becoming ideology, then this is precisely what I meant.
>
> *(2008: 100)*

In the published version of the lecture on 'society' referred to above, Adorno writes that 'it might be said without greatly exaggerating that at present people have literally become ideology in their actual existence, since ideology is preparing to immortalize the false life despite its obvious wrong-headedness' (2008: 241). As a consequence, 'the cementing function which ideologies once possessed has been seeping from them, on the one hand into the overwhelming power of existing circumstances as such and, on the other hand, into the psyche of human beings' (2008: 241). Regarding this invasion of the psyche, Adorno writes:

> Without psychology in which the objective constraints are *continually internalized anew*, it would be impossible to understand how people passively accept a state of unchanging destructive irrationality and, moreover, how they integrate themselves into movements that stand in rather obvious contradiction to their own interests.
>
> *(2005: 271, emphasis added)*

How are objective circumstances and constraints continually internalized anew? Adorno agreed with Fromm on the significance of family socialization. This is evident in *The Authoritarian Personality*, a multiply authored study published in 1950 with which he was centrally involved. However, in 1951 he turned to Freud's 'Group psychology and the analysis of the ego' as the crucial reference for his essay 'Freudian theory and the pattern of fascist propaganda'. In this essay we gain a clearer account of how the thorough-going colonization of human subjectivity envisaged by Adorno actually operates.

Adorno says admiringly of Freud that in 'Group psychology', 'long before the danger of German fascism appeared to be acute', Freud's sensitivity was such that, 'though he was hardly interested in the political phase of the problem, [he] clearly foresaw the rise and nature of fascist mass movements in purely psychological categories' (Adorno 1991: 115). Adorno places Freud's argument in a broader context by arguing that an ideology such as fascism achieves predominance by exploiting human psychology on behalf of the interests of a dominant class.

The psychological process that installs ideology at the level of the human subject is what Freud termed identification. Identification is a major psychoanalytic concept, as it concerns the processes through which the psyche is organized or 'civilized' by internalizing aspects of the subject's relation to others. Identifications are first organized around the relations with the parents, but later this includes other family members, friends and lovers, charismatic individuals and, significantly, ideals and ideologies that present us with images of how we should

or might be. It is through identifications that the ego produces a partial alteration of itself after the model of the object or other with which it identifies.

Freud discerned a particular, regressive kind of identification when a group mentality emerges, one that undoes the prior psychic organization established through socialization. Freud called this 'the libidinal constitution of groups':

> A primary group of this kind is a number of individuals who have put one and the same object in the place of their ego ideal [later termed the superego] and have consequently identified themselves with one another in their ego.
>
> *(1991: 147)*

In this model individualized psychic structures are undone by the emergence of a group mentality. A group of individuals find themselves drawn into a group mentality in which their ego-ideal, or superego, is displaced through internalization of the group ideology or leader and, at the same time, their ego is re-organized through a series of identifications with the members of the group, all of whom share the same ideology or leader as their substitute superego. Through this process ideology colonizes the human subject by making shared beliefs, such as Adorno's example of the 'Fuhrer ideology', the common identification that displaces the superegos of group members, thereby creating homogenous subjects at the level of the ego.

Adorno follows this argument closely, but with two variations. First, he presumes that prior socialization in state capitalist societies predisposes subjects to regress to the group mentality: 'It may well be the secret of fascist propaganda that it simply takes men for what they are: the true children of today's standardized mass culture, largely robbed of autonomy and spontaneity' (1991: 129). From this phrasing we can see that Adorno is thinking beyond those societies in which fascist regimes came to power, as his focus on the United States indicates.

Second, Adorno regards the manipulation of populations so that they identify with a dominant ideology as an induced condition perpetrated on behalf of economic elites and their interests, rather than as a spontaneous psychological regression. While this is how fascist ideology operates, it is also a feature of other ideologies, as his reference to 'today's standardized mass culture' highlights. This is even clearer in the discussion of the culture industry in *Dialectic of Enlightenment*, co-authored with Horkheimer, where they write that the advance of bourgeois society has produced compromised, self-seeking individuals who are 'at odds with themselves and everyone' and who 'are virtually already Nazis' (Horkheimer and Adorno 2002: 125). It comes as no surprise, then, that Adorno (2005: 67), in 'Television as ideology', used the notion of 'psychoanalysis in reverse' to characterize both fascism and the culture industry in the United States and elsewhere. An ideology of domination, alternatively in fascist or in liberal form, has seeped into the interstices of both social reality and human subjectivity, producing a totally administered society and the eclipse of the individual.

There is a further aspect to Adorno's understanding of ideology that relates to the very character of rationality itself. He is driven towards a negative dialectics and the rare achievements of great art because both offer an escape from identity thinking, which is itself ideological. In an extension of Marx's fetishism of commodities argument, Adorno regards concepts as universalizing abstractions (like exchange value) that rob particular objects of their specific, idiosyncratic, ineffable and heteronomous qualities. Identity between objects, and between subjects transformed into objects, is itself ideology, as it reifies, totalizes and supports the domination of nature, including human nature, reducing experience to a

repetition of sameness – as in the culture industry. The dilemma is that rationality is also necessary for any overcoming of domination, yet the perverse near totality that Adorno envisages offers little scope for escape.

Adorno's account of the pervasiveness and invasiveness of ideology produces a very dystopian analysis of the contemporary human condition. Axel Honneth is one of many critics who regard this as unwarranted. Honneth argues that there is more to the story than the internalization of the demands of power into the personality of individuals. As he puts it, 'the behavioral traits required by the market are not simply reflected in the personality patterns of the individual, but rather become socially effective only through the medium of communicative experiences within groups' (1991: 91). As we turn to Jürgen Habermas, with his account of ideology as systematically distorted communication, the strengths of this critique of Adorno should become apparent.

Jürgen Habermas and ideology as systematically distorted communication

Jürgen Habermas, the leading figure in the second generation of the Frankfurt School, like Fromm and Adorno before him, also turned to psychoanalysis, and explicitly Freud's own work, to develop his theory of ideology as systematically distorted communication. This is a significant move, as it locates ideological distortions inside the culture of institutions and the cultural traditions of whole societies. Language becomes the medium within which ideology is inscribed, and it also contains the potential capacity to critique ideological distortions and remove constraints on freedom.

In *On the Logic of the Social Sciences* Habermas characterizes this dual aspect of language and communication. He argues that language is 'a kind of metainstitution on which all social institutions depend', as 'social action is constituted only in ordinary-language communication' (1990: 172). However, language as tradition depends 'in turn on social processes that cannot be reduced to normative relationships'. Consequently, language 'is *also* a medium of domination and social power. It serves to legitimate relationships of organized force' (1990: 172). Habermas continues:

> Insofar as the legitimations do not articulate the power relationship whose institutionalization they make possible, insofar as that relationship is merely manifested in the legitimations, language is *also* ideological. In that case it is not so much a matter of deceptions in language as of deception with language as such.
>
> *(1990: 172)*

The distinction to notice here is that between articulating and merely manifesting. To articulate is to declare something in language, to be up-front, as it were. To merely manifest, on the other hand, is to enact that 'something' symptomatically in a distorted form; the distorted form being, in the case of institutions, language itself – and the communicative interactions it organizes. This is when, how and why language is also ideological.

This take-up of psychoanalysis for a theory of ideology as systematically distorted communication is most fully developed by Habermas in the final three chapters of *Knowledge and Human Interests*. Habermas draws directly on Freud's account of the dream and the symptom as compromise formations in which meaning is expressed in a distorted form. He argues, following Freud, that similar processes are evident in the cultures of institutions and societies and that is how ideologies operate to both establish order and constrain freedom:

> In contrast [to Marx], Freud has acquired in metapsychology a framework for distorted communicative action that allows the conceptualization of the origins of institutions and the role and function of illusions, that is of power and ideology. Freud's theory can represent a structure that Marx did not fathom.
>
> *(Habermas 1971: 281–82)*

In this account institutions have exchanged 'acute external force for the permanent internal compulsion of distorted and self-limiting communication' (1971: 282). Communications organized in such a manner are ideological because they involve the excommunication of unacceptable thoughts, feelings, norms and ideals. Thereby they regulate what counts as the proper way to think, feel, relate and communicate.

Psychoanalysis, as a theory of both psychopathological symptoms and their potential undoing, provides a model of how ideologies constrain and organize intersubjective relations and also of how these very distortions in communication may be displaced and the emancipatory potential of social ideals realized. This is Habermas's version of what Fromm had characterized as the cement that holds together and the dynamite that blows apart the established social and political order.

Freudian theory understands the human subject as a divided subject. Subjected to the constant pressure for satisfaction of the drives, the ego defends against excessive intra-psychic demands through a process that Habermas likens to excommunication. An aspect of language is censored and privatized. This aspect of language, as representative of a wish or desire unacceptable to consciousness, continues to seek expression but cannot be understood or interpreted, even by the would-be speaker. Through repression its meaning has been distorted, and it is only in this compromised form that it can find an alternative route to expression, but now as symptom. Dreams work the same way. As Habermas puts this, 'Freud attempted to render the act of repression comprehensible as a severance from language as such of ideas representing the instincts' (1971: 241). He adds that if repression did not involve '*an operation that is carried out in and with language . . . it would not be possible to reverse the defensive process*' (1971: 241, original emphasis) through the psychoanalytic exchange. Ideology involves this same set of repressive operations, structured as systematic distortions in communication in which certain inadmissible ideas and desires have been purged or excommunicated from discourse. As in psychoanalysis, these distortions can be undone and freedom can be enhanced.

In order to address potential social transformations and the expansion of freedoms, Habermas follows Freud in distinguishing between the delusions of individuals and the illusions of communities and societies. Whereas delusions are in contradiction with reality and can never be realized, illusions harbour wishes and desires that, over time, may be realized through social transformation. The illusions of one generation may become an unnecessary cultural relic to a later generation because there is no longer any need to repress the desires that, previously, only the illusion could satisfy. The new social conditions may allow desires, previously expressed in a distorted form as illusions, to be satisfied in actuality. In this manner Habermas appropriates psychoanalysis both as a theory which explains how cultural forms operate ideologically as media of authority, power and coercion and, in the same movement, as a theory which explains how historical change may give rise to emancipatory potentials.

Knowledge and Human Interests was published in 1968. In the 45 years since then psychoanalysis has faded as a principal reference point for Habermas, and he has outlined an interesting account of how ideology itself is being displaced. In *The Theory of Communicative Action* Habermas argues that the bourgeois period saw two generations of ideologies that both took 'the form of totalizing conceptions of order addressed to the political consciousness of

comrades and partners in struggle' (1987: 354). An example of the first generation would be the Declaration of the Rights of Man and of the Citizen, which was promulgated and adopted in 1789 during the French Revolution. Socialism, fascism and anarchism are examples of the second generation. The common feature of these 'world views' is that they gave coherence to political projects. Habermas argues that circumstances have changed. Through a process of 'internal colonization' instrumental rationality has penetrated so deeply into the lifeworld, the source and now the last resort of communicative rationality, that the very possibility for ideology formation has evaporated. Late capitalist, welfare-state societies have fragmented everyday consciousness to such an extent that it 'is robbed of its power to synthesize'. In this new circumstance 'false consciousness' has been displaced by 'fragmented consciousness' (Habermas 1987: 355). This displacement has opened the way for an internal colonization that forcefully assimilates the lifeworld to the logic and imperatives of instrumental rationality, as contained in public and private bureaucracies and in the power of capital. Instrumental rationality is so pervasive that, in the West at least, there are no sustaining illusions left. Instead there is a fragmented and impoverished everyday consciousness that struggles against the odds to revitalize itself and that has lost the power to synthesize. The functions previously performed by ideology are now achieved, negatively as it were, by a fragmentation that prevents 'holistic interpretations from coming into existence' (Habermas 1987: 355). The need for distortion has been displaced by fragmentation. We might wonder, however, whether the desacralization of the lifeworld leaves no place for ideology as distortion. While fragmentation may in some circumstances displace any functional requirement for distortion, it may also complement distortion by further entrenching constraints upon the scope of social movements to undo or loosen the power of entrenched ideologies and to rescue excommunicated potentialities.

Louis Althusser and ideology as interpellation and misrecognition

Like the Frankfurt School before him, Louis Althusser recognized that Marxism needed a more robust theory of ideology, one that could better explain the entrenchment of capitalism within advanced western democracies. Why were such social formations routinely reproduced, even though they were opposed to the best interests of the great majority of their populations? It was ideology that caused most people to blindly subject themselves to the prevailing social form and to willingly participate in its reproduction by taking their place in the labour process. How was this to be conceptualized within a Marxist framework?

A similar set of concerns had preoccupied Antonio Gramsci. The conventional Marxist account of ideology was far too negative and failed to recognize the full extent to which ideology penetrated common sense and thereby contributed in a major way to the establishment and maintenance of hegemony: the organization of society in a form that promoted class domination. As Gramsci put it: 'Insofar as they are historically necessary, ideologies have a validity that is "psychological"; they "organize" the human masses, they establish the ground on which humans move, become conscious of their position, struggle, etc.' (2010: 171).

Althusser was also in search of an account of ideology as the very ground on which human subjects move and through which they are organized. However, contra Gramsci, he argued that ideology ensured that humans remained unconscious of their real position. In a move comparable to that made earlier by the Frankfurt School, he turned to psychoanalysis to supplement Marxism. It is a commonplace to suggest that Althusser turned to Lacanian psychoanalysis rather than to Freud. While this is largely correct, it should be accepted with qualifications. Althusser took Lacan's famous 'return to Freud' seriously. Consequently he

read Lacan through his prior acquaintance with Freud's work. This is worth mentioning as it helps explain the frequent references to Freud in his most famous essay on ideology, 'Ideology and the ideological state apparatuses', or 'ISA'. Similarly, it helps explain some deviations from Lacan, even as Althusser draws upon his mirror stage argument and his account of the imaginary and the symbolic order. Of course the other theory centrally in play in Althusser's argument is Marxist theory itself.

The ISA essay is where Althusser most fully develops his radical reconceptualization of ideology. Written in the early months of 1969, the essay falls into two parts and 'is made up of two extracts from an ongoing study' (1971: 127, n. 1). In the first part Althusser immediately declares his hand by arguing that ideology is the 'new reality'. By this he means that ideology plays a central role in the reproduction of the conditions of production and that, previously, this had not been adequately observed and theorized. As Althusser puts it:

> The reproduction of labour-power requires not only a reproduction of its skills, but also, at the same time, a reproduction of its submission to the rules of the established order, i.e. a reproduction of submission to the ruling ideology for the workers, and a reproduction of the ability to manipulate the ruling ideology correctly for the agents of exploitation and repression, so that they, too, will provide for the domination of the ruling class 'in words'.
>
> *(1971: 132–33)*

He continues a little later: 'But this is to recognize the effective presence of a new reality: *ideology*' (1971: 133, original emphasis). Significantly, this new reality operates on processes that Marx identified as fundamental, namely the reproduction of labour power, one of the forces of production in Marxist theory. We are as far as we can get from an ideological superstructure of inverted images, echoes and reflexes; with this move ideology has penetrated the 'base'. Moreover, the new reality is not really new. Rather, while the conditions of late modernity reveal the significance of this 'new reality', it has operated as such throughout human history and now needs to be adequately theorized.

Ideology operates across the full range of social institutions, and Althusser terms these ideological state apparatuses or ISAs. They include the family, the religious, the educational, the legal, the political, the trade union, the communications and the cultural ISAs. By this move Althusser radically expands the Marxist theory of the state, which, on his account, had only addressed repressive state apparatuses such as the police and the army. As with Gramsci, if hegemony is principally achieved through ideology, with repression as a last resort, then the range of institutions that produce subjection and secure domination needs to be expanded.

This still leaves the issue of how ideology operates to achieve these effects. To address this Althusser develops an argument that 'ideology has no history' and then adds three following 'theses', which culminate in the central argument that 'ideology interpellates individuals as subjects'. We have already encountered the argument that ideology has no history in *The German Ideology*. Althusser takes up these words verbatim, but thoroughly inverts their intended meaning. Instead of being epiphenomenal, ideology is 'eternal' (or transhistorical), 'exactly like the unconscious' (1971: 161). Indeed ideology is the medium through which human subjects come into being as such: the medium through which the human animal becomes a human subject. This crucial inversion establishes the ground on which the three theses are developed and also introduces the distinction between ideology in general, which is transhistorical, and particular ideologies, which are not. This is more than a mere distinction, however, as the argument that ideology has no history and is eternal like the

unconscious is integral to the further claim that 'ideolog*ies have a history of their own* (although it is determined in the last instance by the class struggle)' (1971: 160, original emphasis).

The issue raised here concerns how the human infant becomes a human subject and, thereafter, performs that very subjectivity throughout life. For Freud our entry into civilization or culture, with all the discontents that generates, provides the answer. For Lacan, in parallel, it is our entry into language and the symbolic order. For Althusser, it is our interpellation or summoning by ideology. There are two principal aspects to this process. The first aspect is the interpellation or construction of human subjects who have the appropriate attitude to power and authority: an attitude embedded in a set of practices that reproduce the social order. Second, this necessary subjection to ideology entails misrecognition, such that human subjects regard themselves as having freely chosen to be the subject they have become. As Althusser concludes, 'the individual *is interpellated as a (free) subject . . . in order that he shall (freely) accept his subjection . . .* "all by himself" ' (1971: 182, original emphasis). Therefore, 'ideology represents the imaginary relationship of individuals to their real conditions of existence' (1971: 162).

To explain this 'trick' of ideology Althusser draws on Lacan's theory of the mirror stage, in which the infant gains its first impression of bodily and psychic separation, independence and coherence, and the imaginary relation this establishes. Freud wrote that, despite its presumed self-sovereignty, 'the ego is not master in its own house' (1953: 143). Lacan could be said to have intensified both aspects of this argument. The ego or 'I' that I take myself to be presumes it is the master of thought, desire and action, whereas actually its thoughts, desires and actions are overdetermined by psychic processes located elsewhere in the unconscious and the symbolic order. The 'I' is captured within the inertia of an imaginary relation and therefore is blind to the 'other scene' – other structures and processes – that overdetermines its characteristics. Despite this immersion in misrecognition, Lacan comments that the fact that the ego 'is imaginary doesn't take anything away from it, the poor ego – I would even go so far as to say that that's what's good about it. If it weren't imaginary, we wouldn't be men, we would be moons' (1988: 243). He goes on to say that the human subject 'may believe that this ego is him, everybody is at that stage, and there is no way of getting out of it' (1988: 243).

The process of interpellation works in a similar manner. Each society generates interpellations, and thereby human subjects, that fit the requirements for the reproduction of the society. However, human subjects resist recognition of this complex overdetermination of their subjectivity; indeed they could not function efficiently if they understood themselves this way. They would be moons instead of men, as Lacan puts it. Without misrecognition human subjects would lack the motivation and the capacity to function as labour power; they would see themselves as just another brick in a very complex wall, indeed what Lacan terms the wall of language. As Althusser comments, 'What is represented in ideology is therefore not the system of the real relations which govern the existence of individuals, but the imaginary relation of those individuals to the real relations in which they live' (1971: 165).

Althusser also argues that 'ideology has a material existence' (1971: 167). However, he is careful to explain that he means the materiality of the ISAs and the practices they organize, and these are not the same as the materiality of a paving stone or rifle. Ideology, then, concerns the practices and beliefs of our routine existence, the taken-for-granted commonsense ways in which we perform our subjectivity while regarding ourselves as the author of who we have become. In a letter to his psychoanalyst René Diatkine, written two years before the ISA essay, Althusser argued that

the ideological cannot be reduced to the conceptual systems of ideology but is an imaginary structure that exists not only in the form of concepts but also in the form of attitudes, gestures, patterns of behaviour, intentions, aspirations, refusals, permissions, bans, etc.

(1996: 75)

It is, then, a way of life and a lived common sense in which we routinely centre ourselves and screen out, through the imaginary relation, the complex processes that determine our subjectivity.

Althusser illustrates his 'central thesis' that 'ideology interpellates individuals as subjects' with a 'theoretical scene' in which a policeman hails or interpellates someone in the street with 'Hey, you there!' (1971: 174). By turning around the subject recognizes that the hail was 'really addressed to him' and takes on the subjectivity ascribed by the authority. The striking originality of this argument lies in its interpellation 'as subjects' aspect. How do we relate to the interpellations that position us as subjects? We relate through the imaginary and presume that the ego *is* master in its own house, that we have freely chosen to be who we have become. Althusser puts it this way: 'those who are in ideology believe themselves by definition outside ideology' (1971: 175). To be a human subject is to misrecognize the processes that produce us as willing subjects. Throughout human history this has been open to exploitation by ideologies (the particular ones that have a history) on behalf of class interests. However, for Althusser, ideology in general, just like the unconscious, will persist even if ideologies that support class interests are defeated and eradicated.

If Althusser's argument involves an integration of Marxism and psychoanalysis, it is the psychoanalytic aspects that have proved most influential and long-lived. Here is a way of analysing subjectivity while attending to the social or cultural settings within which it is produced and organized and without resorting to socialization models. The great limitation of Althusser's argument is its inherent functionalism, which has constrained the otherwise powerful account of the subject by reading the subjective complexity it opens onto back into the logic of reproduction. Within cultural, film, feminist and literary studies, and more broadly throughout the human sciences, interpellation and the imaginary relation were adopted with alacrity as the functionalist aspects were relaxed or dropped. A decentred subject immersed in imaginary misrecognition, yet still capable of decentred 'agency', emerged: the product of social or cultural institutions.

A further issue concerns the moment of interpellation. Is it a once-and-forever subjection, as the hailing would suggest, or is it recurrent, as the emphasis on practices and rituals would suggest? In either case it is usually read as a total subjection from which there is no escape. This reading accords with Althusser's pessimism regarding the entrenchment of capitalism, yet it may involve an over-extension of the argument about ideology in general. That argument does not presume that specific ideologies that challenge capitalism could not arise.

Judith Butler adds psychic complexity to interpellation by emphasizing the ambivalence of the subject in relation to the power that it depends upon for its self-constitution. Butler also emphasizes that interpellation involves reiteration and that this reiteration is 'never merely mechanical' (1997: 16). She recognizes how human helplessness at birth and human vulnerability throughout life are fundamental to the ordering of human subjectivity by society, its representatives and its ideologies. However, whereas Althusser presumes an irresistible ideological power to interpellate subjects effectively and efficiently and thereby settle identity, Butler presumes an ambivalent relation of the human subject to the powers and institutions that interpellate. Human subjects reiterate their subjectivity with ambivalence towards the

institutions that both subject and empower them; hence, sometimes, they can do more than merely reproduce the conditions of subjection; they can alter them. As Butler argues: 'What is brought into being through the performative effect of the interpellating demand is much more than a "subject", for the "subject" created is not for that reason fixed in place: it becomes the occasion for a further making' (1997: 99).

Slavoj Žižek, enjoyment and depoliticization

Slavoj Žižek has developed a complex and multi-layered account of ideology that draws on the psychoanalytic theory of Jacques Lacan to supplement Marxist theory and its later developments, especially by Althusser. One way of putting it would be to say that he destabilizes Althusser's account of the interpellated subject by adhering closely, although with some playfulness, to Lacan's theory of the split and decentred subject of the unconscious. That theory could be said to address the symbolic order and its discontents: in particular the 'objet petit a' that, as a remainder and reminder of the real, resists incorporation into the symbolic order.

Starting with a focus on the symbolic order, the field of language and signification, Žižek uses Alfred Hitchcock's film *North by Northwest* to illustrate how interpellation operates in a Lacanian vein. The film is set at the height of the Cold War and its narrative concerns a ploy by the CIA to mislead some Soviet spies. An entirely fictional CIA operative named George Kaplan is invented and then booked into hotels across the United States. The name 'George Kaplan' becomes a floating signifier that attaches to no-one until it inadvertently finds an unexpected destination. The action begins when the main character, Roger Thornhill, is meeting with business colleagues at the Plaza Hotel in New York and suddenly realizes that he needs to send a telegram. With the intention of arranging for his telegram to be sent, Thornhill summons the bellboy over to his table at the very moment that this bellboy is calling out 'paging Mr George Kaplan'. The Soviet spies watching on, who have tried paging the elusive Kaplan in hotels across America in the hope of catching him, conclude that their ruse has finally worked: that Thornhill *is* Kaplan. For them the call for Kaplan has finally found its destination, and this well-dressed advertising executive, who is actually Roger Thornhill, becomes, for the Soviets, George Kaplan. That is the moment of interpellation, although we might note that it is a re-interpellation in this instance.

In *The Sublime Object of Ideology* Žižek argues that Thornhill's situation is one that we all encounter and endure as a human being: a 'being-of-language'. 'The subject is always fastened, pinned to a signifier which represents him for the other' (1989: 113). This is how the subject is granted a place in the 'intersubjective network of symbolic relations'. As Thornhill's situation highlights in the extreme, interpellation is always arbitrary as it does not match any intrinsic properties of the subject. This creates a quandary for the subject and raises the question 'Che vuoi?' or 'What do you want?' What does the symbolic order (Lacan's big Other) want from me? Žižek tightens this question further: *'Why am I what you [the big Other] are saying that I am?'* (1989: 113). Again, as Thornhill's situation highlights, the subject is left with a troubling question about the Other, now self-addressed, to which there is no clear answer. Yet some kind of response must be organized; faced with the arbitrariness of the symbolic order's demand, the subject resorts to fantasy. For Žižek fantasy has two aspects. First, fantasy is an answer to the desire of the Other and, thereby, also a defence against that desire and the troubling effects it has upon the subject. Second, fantasy is the psychic process that 'provides the co-ordinates of our desire' (1989: 118). Fantasy organizes how we desire by constituting how and what we desire. It teaches the subject how to respond and relate to the symbolic order.

Lacan's concept of the symbolic order and its relation to the real comes into play here. The real and reality are quite distinct for Lacan. Reality, including social reality, is constructed within the symbolic order, but not without a remainder of gaps and fissures that mark the internal limit of the symbolic order: its inherent incompleteness. Due to these gaps, the organization of social reality relies on fantasy as its support. When we enter the symbolic order and become speaking subjects, there is a cut in which the real is displaced. However, there is a remainder and reminder of the real which Lacan terms 'objet [or object] petit a'. This object petit a is the object cause of desire that is forever foreclosed, yet ever desired and sought after within language. The entry into the symbolic order is traumatic: a castration that leaves in its wake a kernel of the real as object petit a.

Furthermore, the symbolic order is itself structured around a central lack. If this were not the case the subject could be totally alienated within the symbolic order. The very fact that the symbolic order cannot fully incorporate the real leaves a space for 'de-alienation'. As Žižek puts it: 'This lack in the Other gives the subject – so to speak – a breathing space, it enables him to avoid the total alienation in the signifier' (1989: 122). This carries significant implications for a theory of ideology because it indicates that there are two levels that need to be addressed simultaneously. The first level is ideology as discourse, as a field of floating signifiers that is unified by the intrusion of a master signifier that establishes an organized meaning. This unifying effect is nicely highlighted when, suddenly, the master signifier disappears. Žižek reports such a moment after the fall of the Ceausescu regime in Romania, when a group of rebels waved 'the national flag with the red star, the communist symbol, cut out, so that instead of the symbol standing for the organizing principle of the national life there was nothing but a hole in its center' (1993: 1). Clearly here was a hole that would eventually be filled, and Žižek reports that several master signifiers or 'ideological appropriations (from the nationalistic to the liberal-democratic)' (1993: 2) attempted to 'kidnap' this opening and mark it as their own. This is an example of ideology operating at the level of the symbolic order, where competing signifiers attempt to stabilize meaning by becoming the master signifier that links the signifying chain together around a sublime object of ideology such as the nation, the religion, the ethnic group, the multicultural society or any other master signifier.

In tandem with ideology as discourse, the further aspect of ideology is enjoyment structured in fantasy. In a move that bears a family resemblance to Fromm's argument that ideologies provide satisfactions or substitute gratifications that bind subjects to the social order, Žižek argues that 'the last support of the ideological effect (of the way an ideological network of signifiers "holds" us) is the non-sensical, pre-ideological kernel of enjoyment' (1989: 124). Accompanying the ego ideal of freedom, democracy, individualism, nationalism, ethnicity or whatever, organized as a discourse with which the subject can identify, is an underside of enjoyment structured by fantasy and enforced by a punitive superego. In performing an ethnic or nationalist identity, for instance, subjects can have it both ways, as it were. They can explicitly celebrate the virtues of their ideals while implicitly enjoying the exclusion or denigration of others. A good example is the way in which western democracies justify wars and interventions through an ideology that explicitly emphasizes freedom and democracy and the liberation or protection of women and girls while implicitly enjoying the exercise of violence and power.

For Žižek ideology is elusive yet omnipresent and is most apparent at those moments when the claim is made that we are now in a post-ideological world. To refute this claim Žižek (1989: 28) returns to the fetishism of commodities and Marx's statement that 'they do not know it, but they are doing it' as his starting point for an account of ideology in late

capitalism. He asks about the location of ideological illusion in this statement: is it in the knowing or in the doing? His counter-intuitive answer is to locate ideology in the doing: in social reality itself. In turn, this move introduces a new element into Marx's formulation. If what matters is the doing rather than the knowing, then the same ideological effect is produced even when people know what they are doing. As Žižek puts it, 'they know very well how things really are, but still they are doing it as if they did not know' (1989: 32). The power of this claim is that it can take account of the cynicism and mistrust that is so pervasive in many societies today and that also marked the former socialist societies. For Žižek the commodity form and its exchange via the universal equivalent of money has belief instanti-ated within its practices. Hence he argues that, instead of the subjects, '*the things (commodities) themselves believe in their place* . . . They no longer believe, *but the things themselves believe for them*' (1989: 34, original emphasis).

Žižek is aware that this argument could seem rather foolish, unless it is first understood that what we call social reality relies on a series of such 'as if' presumptions that are organized into our actions. So, for instance, he argues that we act as if we believe in the almightiness of bureaucracy even though we know that it is not all-powerful. We do so because we believe that others believe in this almightiness. As he puts it, 'our "effective" conduct in the presence of bureaucratic machinery is already regulated by a belief in its almightiness' (1989: 36). We act as if we believe we live in a Kafkaesque world, despite any opinions we may have to the contrary. Moreover, these beliefs should not be understood as operating at 'a "psychological" level'. Rather, they are 'embodied' and 'materialized, in the effective functioning of the social field', and that social field would start to disintegrate if these 'as ifs' lost their efficiency.

A loss of symbolic efficiency is exactly what Žižek discerns as the current dilemma of late capitalist societies. Shared understandings about the proper way to be and relate that were previously located in the big Other and internalized as the ego ideal are in demise. This is why so many committees have arisen to regulate behaviour in a variety of domains, such as medicine and biogenetics and 'the rules of sexual conduct and the protection of human rights' (Žižek 1999b: 332). Such committees, or 'substitute small big Others' (1999b: 334), have sprouted because the big Other no longer operates as 'a symbolic point of reference that would serve as a safe and unproblematic moral anchor' (1999b: 332).

In making this observation in the final chapter of *The Ticklish Subject*, Žižek leans on the risk society argument advanced by Beck, Giddens and others in which individualization has progressed to the point where subjects are free of conventional roles and identities, yet compelled to construct an identity and negotiate the complexities of late modernity without the support of authority. Everything from the proper way to care for and educate children to how to amuse oneself or seduce another is 'increasingly "colonized" by reflexivity, that is, experienced as something to be learned and decided upon' (1999b: 336–37). As Žižek sees it, this enhanced degree of difficulty as regards how to live properly when symbolic efficiency is in demise calls for a strong and resilient subject. However, what if this very demise also affects the psychic organization of the subject? Žižek believes it does. He complains that the theorists of the risk society, however, mistakenly

> leave intact the subject's fundamental mode of subjectivity; their subject remains the modern subject, able to reason and reflect freely, to decide on and select his/her set of norms and so on . . . [they] unproblematically rely on the fact that, in the conditions of the disintegration of symbolic Trust, the reflexive subject of the Enlightenment somehow, inexplicably, survives intact.
>
> *(1999b: 342)*

Žižek, to the contrary, argues that the modern subject, able to reason and reflect freely, is in decline. The risk society presumes and requires 'modern' subjects capable of self-reflexivity, but with the demise of symbolic efficiency the conditions that form such subjects have eroded. Hence Oedipus is being replaced by Narcissus, the ego ideal by the ideal ego. Within Lacanian theory this releases the superego. Now freed from the pacifying effect of the ego ideal, the superego 'orders you to enjoy doing what you have to do' (1999b: 268).

This radical shift in subjectivity involves some perverse effects. For instance, Žižek argues that subjects that are now free from the requirements of the symbolic order introduce domination and submission into their private lives. They also follow the implicit order to consume, and this is an ideologically structured performance par excellence. As discussed above, subjects know that their consumption practices reproduce capitalism, but they do them anyway. Their knowing or not knowing is actually irrelevant, as the ideological effect is inscribed in the doing. For Žižek, the limitation of identity politics around issues of race, gender or sexuality is that such movements, rather than challenging capitalism and its effects, actually share in the depoliticization of the economy. Indeed both the naïve consumer and the identity politics warrior depoliticize the economy through what they do. For this reason 'the depoliticized economy is the disavowed "fundamental fantasy" of postmodern politics' (1999b: 355). The fetishism of commodities triumphs, we might say. Capitalism has become the real that requires its subjects to consume and enjoy. Žižek argues that 'Capital itself is the Real of our age' and notes that this accords with Lacan's distinction between reality and the Real: under capitalism reality is 'the social reality of the actual people involved in interaction and in the productive processes, while the Real is the inexorable "abstract" spectral logic of Capital which determines what goes on in social reality' (1999b: 276).

This is a brilliant reconceptualization of Marx's fetishism of commodities argument, and we should notice how the unconscious as fantasy and as enjoyment are incorporated into this account of the spectre of ideology. Ernesto Laclau argues that it plays fast and loose with Lacanian theory, however, because capitalism 'can operate only in so far as it is part of the symbolic order'; it 'cannot be the Lacanian Real' (Butler, Laclau and Žižek 2000: 291). This observation supports Laclau's general argument about ideology, in that the battle for hegemony and the furthering of anti-systemic movements can be promoted by any number of social movement or group identities. Identity politics is not inherently a depoliticization of the economy. It can be disruptive and transformative.

Judith Butler wonders about the status of the innumerable anecdotes and examples that litter Žižek's expansive writing. She argues that 'the examples function in a mode of allegory that presumes the separability of the illustrative example from the content it seeks to illuminate' (Butler, Laclau and Žižek 2000: 157), and Laclau agrees (2000: 290). Even more telling is that Žižek performs what we might term 'the fetishism of anecdotes', in that his writing plunders popular culture and discrete political moments in order to extract their exchange value (their universal equivalence) for the purpose of theoretical elaboration. He may or may not know it, but in any case he is doing it, we might conclude!

Butler also argues that while Žižek provides valuable insights into psychic reality, 'we are not given to understand whether the social is any more than a lens for understanding a psychic reality that is anterior to itself' (Butler, Laclau and Žižek 2000: 157). This is a damning criticism. We might frame it somewhat differently by reversing the claim, although it may be a two-way street. A frequent concern in reading Žižek is the extent to which Lacanian theory overdetermines social analysis. This is so, for instance, when Žižek argues that, today, the narcissistic subject has displaced the oedipal subject, has eclipsed the internalized yet shared ego ideals and has released the full power of a punitive superego that requires us to enjoy and,

thereby, both inhibits us and sends us in search of a privatized master, while also attaching us to consumption. Is this actually a sound analysis or do the Lacanian presumptions overdetermine the conclusions? We might also notice that this particular account of contemporary, postmodern subjectivity suffers the same limitation as Fromm's authoritarian or sadomasochistic character in being both 'oversocialized' and over-generalized. The effect is to unduly flatten the diverse complexity of the psychoanalytic unconscious and to submit subjectivity thoroughly to the spectral logic of capital. It is unlikely that Žižek intends this oversocialization effect, and his Lacanian response to what we might term Althusser's 'over-interpellated' account of subjectivity indicates as much. Hence, like his colleague Mladen Dolar he recognizes a dimension 'beyond interpellation' in theory (Žižek 1989: 124). The crucial point to note, however, is that, as he takes that theory to an empirical characterization of contemporary subjectivity, any beyond of interpellation is collapsed into an analysis that strongly resembles, although now with a narcissistic psychic organization, the oversocialized subject we encountered in our discussion of Fromm's limitations. Ironically, Althusser's thoroughly interpellated subjects, so long as they participate willingly in social reproduction, are allowed far greater psychic variation than are Žižek's in *The Ticklish Subject*. Moreover, Žižek's ultimate claim that 'It's the Political Economy, Stupid!' (1999b: 347) reinscribes the functionalist aspects of Althusser's theory, itself a depoliticizing move.

Future directions

What happens to the concept of ideology once it is recognized that there is no Archimedean point from which the falsity, distortions and misrecognitions of ideology can be impartially addressed and revealed; if there is no longer any confidence in a neutral ground of science, reason or a metalinguistic vantage point? Althusser was the last great theorist of ideology to insist on a strict division between science and ideology. For him, Marxist science provided the Archimedean point and revealed the direction of social transformation and the forces that propelled it, although it required symptomatic readings and a supplement as regards the operations of both ideology and the ISAs. This refinement of Marxist theory was the work of theoretical practice, which Marx himself had initiated with his discovery of the scientific field of historical materialism. Althusser accepted the implications of his argument about ideology, however, recognizing that he, like everyone else, was constituted as a subject by and within ideology. With this argument the split between science and ideology was reiterated with a new intensity.

Althusser's theory of a necessary and ineradicable misrecognition as constitutive of human subjects, allied with the evident limitations (for many) of Marxist theory as a 'science', promoted a selective take-up of interpellation and necessary misrecognition as the most generative aspects of Althusser's theory. Significantly, both of these relied heavily on the influence of psychoanalysis, incorporated via both Freud and Lacan. Foucault's competing concept of discourse furthered the deconstruction of Althusserian theory while itself gaining currency. Foucault (1984: 60) outlined three reasons why he found the notion of ideology 'difficult': its standing in opposition to 'truth', its necessary reference to a subject and its presumption of an infrastructure from which ideology is separate. We have seen how Althusser reinforces the first of these, deepens the second and addresses the third. On the first, the Archimedean point, Foucault's argument, voiced by others as well, has held sway.

Žižek's response is significant, as he accepts the loss of any neutral position outside ideology. Indeed, as we have seen, he argues that to make such a claim is to be most fully inside ideology. On the issue of truth, even true beliefs or forms of knowledge can be ideological:

'We are within ideological space proper the moment this content – "true" or "false" (if true so much the better for the ideological effect) – is functional with regard to some relation of social domination ("power", "exploitation") in an inherently non-transparent way' (Žižek 1999a: 61).

Human rights violations provide one example of such an ideological justification, or 'lying in the guise of truth', offered by western powers for intervening in the Third World, when the true motives are economic interests and the like.

Ernesto Laclau also accepts the loss of any Archimedean point. His response, first developed with Chantal Mouffe in *Hegemony and Socialist Strategy*, takes the illusion of closure, with its implications of the end of ideology, history and politics, as itself ideological. In a later article he writes: 'what now constitutes a distorted representation is the very notion of an extra-discursive closure', the projection onto an object of 'the impossible fullness of the community' (Laclau 1996: 203, 206). Characterizing the concept of class consciousness as representative of a deeper 'social antagonism' that the illusion of closure attempts to repress enables Laclau and his colleagues to focus on the plurality of struggles that compete to establish hegemony and/or dislocate instituted ideologies. Hence the identity politics that Žižek regards as depoliticizing the capitalist economy are, for Laclau, instances of the plurality of contemporary political struggles.

Our survey reveals several strengths of the concept of ideology that have survived into the contemporary period and are the reasons why ideology will remain a major concept for political, social and cultural analysis. The principal ones are itemized below. However, the overarching strength of 'ideology' is that it integrates all or most of these, depending on particular versions, into the one concept. The first strength is its emphasis on the significance of the symbolic order, or social imaginaries, in constructing social reality. The second is the emphasis placed on misrecognition, the organization of subjectivity and the production or interpellation of (political) identities, processes that manifest at the level of the subject. The third is the emphasis on unconscious processes, in particular enjoyment or satisfaction, but also anxiety, as driving the passionate attachments, often ambivalent, that ideology satisfies. The ideological effect explains why and how such passionate attachments to beliefs, ideals, ways of life, forms of enjoyment and forms of common sense are established and maintained, even against the better interests of the subjects who negotiate their passage through the distorting ways of being and relating that ideological processes immerse them in. Of course, now the decision as to what counts as the better interests has itself been rendered ideological.

References

Adorno, T. (1991) *The Culture Industry*, London: Routledge.
—— (2005) *Critical Models*, New York: Columbia University Press.
—— (2008) *Lectures on Negative Dialectics*, Cambridge: Polity.
Althusser, L. (1971) 'Ideology and ideological state apparatuses', in *Lenin and Philosophy and Other Essays*, New York: Monthly Review Press.
—— (1996) *Writings on Psychoanalysis*, New York: Columbia University Press.
Billig, M. (1982) *Ideology and Social Psychology*, Oxford: Basil Blackwell.
Butler, J. (1997) *The Psychic Life of Power*, Stanford, CA: Stanford University Press.
Butler, J., Laclau, E. and Žižek, S. (2000) *Contingency, Hegemony, Universality*, London: Verso.
Engels, F. (1972) 'Engels to J. Bloch in Konigsberg', in K. Marx, F. Engels and V. Lenin, *On Historical Materialism: A Collection*, ed. T. Borodulina, Moscow: Progress Publishers.
Foucault, M. (1984) *The Foucault Reader*, ed. P. Rabinow, New York: Pantheon.
Freud, S. (1953) 'A difficulty in the path of psycho-analysis', in *Standard Edition of the Complete Psychological Works of Sigmund Freud, Volume 18*, London: Hogarth Press.

—— (1991) 'Group psychology and the analysis of the ego', in *Civilization, Society and Religion*, Harmondsworth: Penguin.

Fromm, E. (1978) 'The method and function of an analytic social psychology', in A. Arato and E. Gebhardt (eds) *The Essential Frankfurt School Reader*, New York: Urizen Books.

Gramsci, A. (2010) *Prison Notebooks, Vol. 3*, New York: Columbia University Press.

Habermas, J. (1971) *Knowledge and Human Interests*, Boston, MA: Beacon Press.

—— (1987) *The Theory of Communicative Action, Vol. 2*, Boston, MA: Beacon Press.

—— (1990) *On the Logic of the Social Sciences*, Cambridge, MA: MIT Press.

Honneth, A. (1991) *The Critique of Power*, Cambridge, MA: MIT Press.

Horkheimer, M. and Adorno, T. (2002) *Dialectic of Enlightenment*, Stanford, CA: Stanford University Press.

Lacan, J. (1988) *The Seminars of Jacques Lacan: Book II*, New York: Norton.

Laclau, E. (1996) 'The death and resurrection of the theory of ideology', *Journal of Political Ideologies*, 1(3): 201–20.

Marx, K. (1976) *Capital: Vol. 1*, Harmondsworth: Penguin.

Marx, K. and Engels, F. (1970) *The German Ideology*, New York: International Publishers.

—— (1983) 'The Manifesto of the Communist Party', in K. Marx, *The Portable Karl Marx*, ed. E. Kamenka, Harmondsworth: Penguin.

Wrong, D. (1976) *Skeptical Sociology*, New York: Columbia University Press.

Žižek, S. (1989) *The Sublime Object of Ideology*, London: Verso.

—— (1993) *Tarrying with the Negative*, Durham, NC: Duke University Press.

—— (1999a) 'The spectre of ideology', in *The Žižek Reader*, ed. E. Wright and E. Wright, Oxford: Blackwell.

—— (1999b) *The Ticklish Subject*, London: Verso.

8

Psychoanalytic social theory

Anthony Elliott

No modern thinker has affected our views on identity and sexuality as forcefully as Sigmund Freud. And, arguably, psychoanalysis has exerted (and continues to exert) a massive influence over modern social thought. Yet what is the relevance of Freud and psychoanalysis to today's world? What does psychoanalysis have to offer our understanding of contemporary social life? It was Nietzsche who spoke of the importance of time to our own self-understanding of mortality. Deeply influenced by Nietzsche, Freud saw time as deeply interwoven with pain, depression and mourning – that is, our ability to confront the most distressing and painful aspects of life is what makes us truly human. The capacity of people to bear guilt and tolerate periods of depression, in a psychoanalytic frame, is essential to personal growth and change. But self-understanding requires attention to our inner world, and this of course takes time – a scarce 'commodity' in our speed-driven information age. The psychoanalytic notion of repressed desire, in particular, has provided for a new cultural emphasis on identity, sexuality, the body, feeling and emotion. From the affirmative politics of countercultural movements during the 1960s to various feminist currents in the 1980s and 1990s, psychoanalysis has been extensively drawn upon to reshape the concerns of contemporary social and political thought. But the broader point is that psychoanalytic ideas have deeply infiltrated the culture of contemporary societies. From Woody Allen's *Annie Hall* to Marie Cardinal's *The Words to Say It*, from Paul Ricoeur's *Freud and Philosophy* to Jacques Derrida's *The Post Card*: psychoanalytic ideas pervade our intellectual life and culture. Freudian psychoanalysis is at once the doctrine and dogma of our age; it influences our everyday understanding of ourselves, other people, and the world in which we live.

In this chapter, after sketching some of the core concepts of psychoanalytic theory, I turn to consider the relevance and power of psychoanalysis in terms of social-theoretical debates in the social sciences. Throughout, the chapter attempts to defend the view that psychoanalytic theory has much to offer social and cultural theorists for the analysis of subjectivity, ideology and sexual politics, and in coming to terms with crises in contemporary culture.

Historical and intellectual development

Freud, psychoanalysis and the repressed unconscious

It is now more than a century since psychoanalysis emerged under the direction of a single man, Sigmund Freud. Freud, working from his private neurological practice, founded psychoanalysis in late nineteenth-century Vienna as both therapy and a theory of the human mind. Therapeutically, psychoanalysis is perhaps best known as the 'talking cure' – a slogan

used to describe the magical power of language to relieve mental suffering. The nub of the talking cure is known as 'free association'. The patient says to the analyst everything that comes to mind, no matter how trivial or unpleasant. This gives the analyst access to the patient's imagined desires and narrative histories, which may then be interpreted and reconstructed within a clinical session. The aim of psychoanalysis as a clinical practice is to uncover the hidden passions and disruptive emotional conflicts that fuel neurosis and other forms of mental suffering, in order to relieve the patient of his or her distressing symptoms.

Theoretically, psychoanalysis is rooted in a set of dynamic models concerning psychic functioning. The unconscious, repression, drives, representation, trauma, narcissism, denial, displacement: these are the core dimensions of the Freudian account of selfhood. For Freud, the subject does not exist independently of sexuality, libidinal enjoyment, fantasy or the social and patriarchal codes of cultural life. In fact, the human subject of Enlightenment reason – an identity seemingly self-identical to itself – is deconstructed by psychoanalysis as a kind of fantasy, and one that is itself secretly libidinal. Knowledge, for Freud as for Schopenhauer and Nietzsche, is internal to the world of desire. In the light of Freudian psychoanalysis, a whole series of contemporary ideological oppositions – the intellect and emotion, commerce and pleasure, masculinity and femininity, rationality and irrationality – are potentially open to displacement.

One of Freud's most substantial findings is that there are psychical phenomena that are not available to consciousness, but which nevertheless exert a determining influence on everyday life. In his celebrated meta-psychological essay 'The unconscious', originally written in 1914, Freud argued that the individual's self-understanding is not immediately available to itself, that consciousness is not the expression of some core of continuous selfhood. On the contrary, the human subject is for Freud a *split* subject, torn between consciousness of self and repressed desire. For Freud, examination of the language of his patients revealed a profound turbulence of passion behind all draftings of self-identity, a radical *otherness* at the heart of subjective life. In discussing human subjectivity, Freud divides the psyche into the unconscious, preconscious and conscious. The preconscious can be thought of as a vast storehouse of memories, most of which may be recalled at will. By contrast, unconscious memories and desires are cut off, or buried, from consciousness. According to Freud, the unconscious is not 'another' consciousness but a separate psychic system with its own distinct processes and mechanisms. The unconscious, Freud comments, is indifferent to reality; it knows no causality or contradiction or logic or negation; it is entirely given over to the search for pleasure and libidinal enjoyment. Moreover, the unconscious cannot be known directly, and is rather detected only through its effects, through the distortions it inflicts on consciousness.

Rejecting the idea that consciousness can provide a foundation for subjectivity and knowledge, Freud traces the psychic effects of our early dependence on others – usually our parents – in terms of our biologically fixed needs. The infant, Freud says, is incapable of surviving without the provision of care, warmth and nourishment from others. However – and this is fundamental in Freud – human needs always outstrip the biological, linked as needs are to the attaining of pleasure. Freud's exemplary case is the small child sucking milk from her or his mother's breast. After the infant's biological need for nourishment is satisfied, there is the emergence of a certain pleasure in sucking itself, which for Freud is a kind of prototype for the complexity of our erotic lives. From this angle, sexuality is not some preordained, unitary biological force that springs into existence fully formed at birth. Sexuality is *created*, not pre-packaged. For Freud, sexuality is 'polymorphously perverse'.

We become the identities we are, in Freud's view, because we have inside us buried identifications with people we have previously loved (and also hated), most usually our parents. And yet the foundational loss to which we must respond, and which in effect sets in motion

the unfolding of our unconscious sexual fantasies, remains that of the maternal body. The break-up or restructuring of our primary emotional tie to the maternal body is, in fact, so significant that it becomes the founding moment not only of individuation and differentiation, but also of sexual and gender difference. Loss and gender affinity are directly linked in Freud's theory (1961b) to the Oedipus complex, the psyche's entry into received social meanings. For Freud, the Oedipus complex is the nodal point of sexual development, the symbolic internalization of a lost, tabooed object of desire. In the act of internalizing the loss of the pre-Oedipal mother, the infant's relationship with the father (or, more accurately, symbolic representations of paternal power) becomes crucial for the consolidation of both selfhood and gender identity. Trust in the intersubjective nature of social life begins here: the father, holding a structural position that is outside and other to this imaginary sphere, functions to *break* the child–mother dyad, thus referring the child to the wider culture and social network. The paternal prohibition on desire for the mother, which is experienced as castration, at once instantiates repressed desire and refers the infant beyond itself, to an external world of social meanings. And yet the work of culture, according to Freud, is always outstripped by unconscious desire, the return of the repressed. Identity, sexuality, gender and signification: these are all radically divided between an ongoing development of conscious self-awareness and the unconscious, or repressed, desire.

Psychoanalysis after Freud

The portrait of the self now found in psychoanalysis has undergone dramatic change since the time of Freud. In this period, clinical and theoretical developments have shifted from the intrapsychic world of object representations to the relationship between the self and others. That is, post-Freudian developments focus on the psychical relations *between* human beings rather than the inner world of the individual subject alone. From this *intersubjective* angle, the dynamics of personal and social conflict appear in a new light. The reproduction of the patriarchal and social order of modern societies is no longer understood as merely rooted in sexual repression and the denial of deep inner passions, as in the classical view of psychoanalysis. Rather, repressive social conditions are traced to various pathologies that underlie human relationships, and their impact on psychic life, selfhood and gender identity. Much of the impetus for this conceptual shift of focus has come from the failure of classical psychoanalysis to make sense of the sufferings of the modern clinical patient. In the post-Freudian period, the clinical picture of typical analysands has been not one of individuals suffering from disturbances in sexual repression and self-control, but rather one of individuals experiencing a deep emotional poverty in relationships with others, coupled with a more general estrangement from the self. Moreover, recent psychoanalytic accounts converge on the point that modern social conditions drive a wedge between self and others, generating in turn a waning in social ties and the sense of political community.

These changes within psychoanalysis are registered in the American post-Freudian tradition and the British school of object relations theory in very different ways. Both traditions of thought share the view that classical Freudian metapsychology is unable adequately to comprehend the nature of human motivation, problems of selfhood and contemporary difficulties in living. They also share a common emphasis upon interpersonal processes in theorizing problems of selfhood and relationship difficulties. Yet there are also fundamental differences between these psychoanalytic traditions. The American post-Freudian tradition breaks into two schools of thought: (1) ego psychology and (2) the interpersonal (or culturalist) model of psychoanalysis. Ego psychology is generally concerned with the

genesis, development and adaptive capacities of the ego. The key figures in this school of psychoanalytic thought include Anna Freud, Heinz Hartmann, Ernest Kris, R. M. Lowenstein, Erik H. Erikson and David Rapaport. The interpersonal tradition in psycho-analysis shares this focus on the rational capacities of selfhood, but also emphasizes the place of social and cultural conditions in its constitution. The key figures in this theoretical tradition include Erich Fromm, Harry Stack Sullivan, Karen Horney and Clara Thompson. The British school of object relations theory, by contrast, focuses on the dynamics and structures of intersubjectivity itself, tracing the complex emotional links between the self and other people. The central figures in this school of psychoanalytic thought include W. R. D. Fairbairn, Harry Guntrip, Melanie Klein, D. W. Winnicott, John Bowlby and Michael Balint.

Key contributors and criticisms

The Frankfurt School: domination after Freud

Freud's relevance to social and cultural theory remains perhaps nowhere better dramatized than in the various writings of the first generation of critical theorists associated with the Frankfurt Institute of Social Research. The Frankfurt School, as it came to be called, was formed in the decade prior to the Nazi reign of terror in Germany, and not surprisingly many of its leading theorists conducted numerous studies seeking to grasp the wave of political irrationalism and totalitarianism sweeping Western Europe. In a daring theoretical move, the school brought Freudian categories to bear upon the sociological analysis of everyday life, in order to fathom the myriad ways that political power imprints itself upon the internal world of human subjects and, more specifically, to examine critically the obscene, meaningless kind of evil that Hitler had actually unleashed. Of the school's attempts to fathom the psycho-pathologies of fascism, the writings of Adorno, Marcuse and Fromm particularly stand out; each of these authors, in quite different ways, drew upon Freudian categories to figure out the core dynamics and pathologies of post-liberal rationality, culture and politics, and also to trace the sociological deadlocks of modernity itself. The result was a dramatic underscoring of both the political dimensions of psychoanalysis and also the psychodynamic elements of public political life.

The philosophical backdrop to the Frankfurt School's engagement with Freud and psycho-analysis was spelt out in particular detail by Adorno, who sketched along with co-author Max Horkheimer – in *Dialectic of Enlightenment* (2002 [1944]) – a bleak portrait of the personal and political pathologies of instrumental rationality. Humanization of drives and passions, resulting in the transformation from blind instinct to consciousness of self, was for Adorno necessary to release the subject from its enslavement to nature. But, in a tragic irony, the unconscious forces facilitating the achievement of autonomy undergo a mind-shattering repression that leaves the subject marked by inner division, isolation and compulsion. The Janus-face of this forging of the self is clearly discerned in Adorno's historicization of Freud's Oedipus complex. According to Adorno, the bourgeois liberal subject repressed unconscious desire in and through Oedipal prohibitions and, as a consequence, achieved a level of self-control in order to reproduce capitalist social relations. But not so in the administered world of modernity. In post-liberal societies, changes in family life mean that the father no longer functions as an agency of social repression. Instead, individuals are increasingly brought under the sway of the logic of techno-rationality itself, as registered in and through the rise of 'culture industries'. The concept of 'repressive desublimation' is crucial here. The shift

from simple to advanced modernity comes about through the destruction of the psychological dimensions of human experience: the socialization of the unconscious in the administered world directly loops the id and the superego at the expense of the mediating agency of the ego itself.

What has been of lasting value in the Frankfurt School's use of Freud is its demonstration of why human subjects, apparently without resistance, submit to the dominant ideologies of late capitalism. The general explanatory model developed by the Frankfurt School to study the socio-psychological dimension of the relation between the individual and culture has received considerable attention in social theory. The following discussion concentrates principally on the social-theoretical reconstructions of psychoanalysis offered by Fromm and Marcuse.

Erich Fromm

Fromm, who had been practising as an analyst since 1926 and was a member of the Frankfurt Psychoanalytic Institute, sought in his early studies to integrate Freud's theory of the unconscious with Marxist sociology. Influenced by Wilhelm Reich's book *Character Analysis* (1970 [1933]), which connects society to the repressed unconscious, Fromm became preoccupied with the cultural consequences of sexual repression, as well as the mediating influence of the family between the economy and the individual. According to Fromm, Freudian psychoanalysis must supplement Marxism in order to grasp how social structures influence, indeed shape, the inner dimensions of human subjectivity. Fromm's concern with the effects of repression, however, differed substantially from the analysis worked out by Reich. In Fromm's view, Reich had been unable to develop an adequate theory of social reproduction because he had reduced Freud's theory of sexuality to a monadic focus on genital sexuality. Yet Freudian psychoanalysis, Fromm maintained, was fundamentally a 'social psychology'. For Fromm, the individual must be understood in his or her relation to others.

The bourgeois nuclear family, Fromm says, is pivotal to understanding the links between individual repression, cultural reproduction and ideological domination. An agency of social reproduction, the family is described as 'the essential medium through which the economic situation exerts its ... influence on the individual's psyche' (Fromm 1932: 43). Fromm contends that the family implants regression at the heart of subjectivity, sustains economic conditions as ideology, and infuses perceptions of the self as submissive, self-effacing and powerless. The central message of Fromm's early work is that the destructive effects of late capitalism are not only centred in economic mechanisms and institutions, but involve the anchoring of domination within the inner life and psychodynamic struggles of each individual.

As the 1930s progressed, Fromm became increasingly sceptical of orthodox Freudianism. He strongly criticized Freud's notion of the death drive for its biological reductionism, and argued that it only served to legitimate at a theoretical level the destructive and aggressive tendencies of capitalism. Significantly, Fromm also became influenced by neo-Freudian analysts – such as Harry Stack Sullivan and Karen Homey – who stressed larger social and cultural factors in the constitution of selfhood. This emphasis on cultural contributions to identity formation was underscored by Fromm in his major books, *Escape from Freedom* (1941) and *The Sane Society* (1955), both of which argued the idea of an essential 'nature of man', a nature repressed and distorted by capitalist patterns of domination.

Although Fromm's early studies on the integration of individuals into capitalism was broadly accepted by other members of the Frankfurt School, his subsequent, more

sociological diagnosis of an essential human nature twisted out of shape by capitalism was strongly rejected. Marcuse, for example, charged Fromm (and other neo-Freudian revisionists) with undoing the critical force of Freud's most important ideas, such as the unconscious, repression and infantile sexuality. According to Marcuse, Fromm's revisionism underwrites the smooth functioning of the ego only by displacing the dislocating nature of the unconscious. Marcuse sums up the central point in the following way:

> Whereas Freud, focusing on the vicissitudes of the primary drives, discovered society in the most concealed layer of the genus and individual man, the revisionists, aiming at the reified, ready-made form rather than at the origin of the societal institutions and relations, fail to comprehend what these institutions and relations have done to the personality that they are supposed to fulfill.
>
> *(Marcuse 1956: 240–41)*

Fromm's attempt to add sociological factors to psychoanalysis, says Marcuse, results in a false political optimism as well as a liquidation of what is truly revolutionary in Freud: the discovery of the repressed unconscious.

Herbert Marcuse

Marcuse, like Fromm, views psychological and political repression as deeply interwoven. For Marcuse, Freudian psychoanalysis is relevant for tracing the exercise of domination upon the inner world of the subject, for understanding how capitalism and mass culture shape personal desires, and for analysing the possibilities of human emancipation. Unlike Fromm, however, Marcuse rejects the view that sociological and historical factors must be added to Freudian theory. Instead, Marcuse seeks to unfold the liberative potential in Freud's work from the inside out, in order to reveal its radical political edge.

Marcuse's reconceptualization of psychoanalysis seeks to develop the 'political and sociological substance' of Freud's work. His analysis proceeds from an acceptance of some of the core claims of psychoanalysis. These include the theory of the unconscious, the conflict between the pleasure and reality principles, the life and death drives, and the view that civilization entails sexual repression. Marcuse contends, however, that Freud was wrong about the permanent cultural necessity of psychological repression. Marcuse agrees that all social reproduction demands a certain level of repression. Yet what Freud did not see, Marcuse argues, is that capitalism creates a crippling (though impermanent) burden of repression. From this angle, individuals are in fact adapting to the destructive forces of capitalist domination, forces that masquerade as the 'reality principle'.

These provocative ideas are developed by Marcuse in his classic *Eros and Civilization* (1956) and *Five Lectures* (1970). The key to Marcuse's interpretation of Freud is the division of repression into 'basic' and 'surplus'. Basic repression refers to that minimum level of libidinal renunciation deemed necessary for facing social life. What this means, in short, is that a certain amount of repression underlies the constitution of the 'socialized subject', a subject capable of sustaining the business of social and sexual reproduction. By contrast, surplus repression refers to the intensification of restraint created in and through asymmetrical relations of power. Marcuse points to patriarchy (especially in terms of family relationships) and to the workplace as socio-symbolic fields containing a surplus of repression. This repressive surplus, says Marcuse, operates through the 'performance principle', a culturally specific form of reality structured by the economic order of capitalism. For Marcuse, the destructive psychological

effects of this principle are highly consequential. 'Performance' recasts individuals as mere 'things' or 'objects'; he replaces eroticism with genital sexuality, and fashions a disciplining of the human body (what Marcuse terms 'repressive desublimation') in order to prevent repressed desire from interfering with capitalist exchange values.

Marcuse presses this reinterpretation of Freud into a critical theory of the psychic costs of modernity. In Marcuse's view, the massive social and industrial transformations that have occurred in the twentieth century – changes in systems of economy and technology as well as cultural production – have produced a radical escalation in psychological repression. The more technocapitalism has advanced, he argues, the more repression has become surplus. The immense productive capacities released from technology, modernism and monopoly capitalism have been turned back upon the individual subject with a vengeance. As a consequence, the personal sphere is subject to decomposition and fragmentation. According to Marcuse, the psychoanalytic division of the individual into id, ego and superego is no longer relevant. A weakening in patriarchal authority within the bourgeois nuclear family, accompanied by the impact of the mass media and commodified culture, has led to an authority-bound, manipulated sense of identity.

Notwithstanding this bleak picture of the contemporary epoch, Marcuse was optimistic about social change. In one sense, he used Freudian psychoanalysis against itself, to trace the emancipatory potentials of modernity. He argued that the performance principle, ironically, generates the economic and social conditions necessary for a radical transformation of society. That is, the material affluence generated by capitalism opens the way for undoing surplus repression. Emancipation for Marcuse is linked to a reconciliation between culture, nature and unconscious pleasure, what he termed 'libidinal rationality'. The preconditions for the realization of libidinal rationality include the overcoming of the split between pleasure and reality, and life and death, and a recovery of repressed needs and aspirations. Through changes in fantasy structures and the social context, Marcuse says, society can become re-eroticized.

Marcuse's analysis of contemporary ideological pressures towards 'surplus repression' contains many insights, but it is also clear that there are important limitations to his approach. For one thing, he fails to point in anything but the most general way to how ideology transforms repression from 'basic' into 'surplus', and so it is far from easy to grasp the complex ways in which culture implants political domination upon the emotional economy of subjects. Similarly, the argument that reason or rationality can be located in repressed drives (the notion of 'libidinal rationality') is underdeveloped. Marcuse's work fails to analyse in any substantive way intersubjective social relationships. Instead, his vision of political autonomy is one in which repressed drives become liberated, and thus transfigure social relations. From this angle, some critics have suggested that Marcuse's conception of the relation between repressed desire and social transformation is individualistic and asocial in character.

Jacques Lacan

Many psychoanalytic theorists have identified loss as central to self-constitution. From the fall from pre-Oedipal Eden, in which the small infant becomes separated from the maternal body, through alarming and painful terrors of the Oedipal constellation, and onto subsequent adult disappointments, rejections and negations: loss infiltrates all emotional transactions between self and others, and so in a sense is at the root from which desire flows uncontrollably. Yet while the intricate connections between loss and selfhood have been emphasized throughout the history of psychoanalysis, perhaps the most remarkable contribution remains that elaborated by the French psychoanalyst Jacques Lacan. The world of illusion that we

fashion to avoid the traumatic and impenetrable mysteries of loss is, for Lacan, the very stuff out of which we are made. According to Lacan, the individual subject is constituted in and through loss, as an excess of lack. In a radical revision of Freud, largely through a widening of the horizons of psychoanalysis to embrace structuralist linguistics and post-structuralist theories of discourse, Lacan makes lack the cause that ensures that as human subjects we are continually falling short, failing, fading and lapsing.

The world of sense perception, for Lacan as for Freud, is born from immersion in a sublimely opaque realm of images, of very early experience of imaginings and imagos, of primitive fantasies of the body of another. Lacan calls this realm, caught between wonderful delight and terrifying anguish, the imaginary. The imaginary for Lacan is a prelinguistic, pre-Oedipal register, solely visual in operation and in which desire slides around and recircles an endless array of part-objects: breasts, lips, gaze, skin. According to Lacan, this imaginary drafting of the world of illusion, of wholeness, is broken apart once the infant comes to identify with, and introject, things or objects beyond itself, thus shifting beyond the lures of the imaginary. This primordial moment of separation is devastating, a loss so painful that it results in a *primary repression* of the pre-Oedipal connection to the maternal sphere, a repression that in one stroke founds the repressed unconscious. Once severed from primary identification with the pre-Oedipal mother, the infant is projected into the realm of language, the differences internal to signification that Lacan calls the Other, or the symbolic order. The symbolic in Lacan's theory is a plane of received social meanings, logic, differentiation. Symbolization and language permit the subject to represent desire, both to itself and to others. Yet the representation of desire, says Lacan, is always stained by a scar of imaginary, maternal identification.

Lacan theorizes the imaginary tribulations of self-constitution largely through a novel consideration of Freud's theory of narcissism. In 'The mirror stage as formative of the function of the I' (1977 [1949]), Lacan contends that the infant apprehends a sense of bodily unity through the recognition of its image in a mirror. The 'mirror' provides the infant with a consoling image of itself as unified and self-sufficient. This reflecting mirror image is not at all, however, what it seems. Lacan says that what the mirror produces is a 'mirage of coherence', an alienating *misrecognition*. In short, the mirror *lies*. Mirroring leads the infant to imagine itself as stable and unified, when in fact psychical space is fragmented, and the infant's physical movements uncoordinated. The reflecting mirror leads the infant into an unfettered realm of narcissism, underpinned by hate and aggression, given the unbridgeable gap between ideal and actuality.

The imaginary can thus be described as a kind of archaic realm of distorted mirror images, a spatial world of indistinction between self and other, from which primary narcissism and aggression are drawn as key building blocks in the formation of identity. But if the imaginary order is already an alienation of desire, then the same is certainly true of the symbolic order of language. The symbolic, says Lacan, smashes the mirror unity of the imaginary. For Lacan, as for Freud, this happens with the entry of the father into the psychic world of the child. In disturbing the mother–child link, the Oedipal father breaks up the self–other unity of the imaginary order. For Lacan, language is the fundamental medium that structures the Oedipal process. The child enters the symbolic via language, which ushers in temporal, spatial and logical differences, which are foundational to self and other, subject and object. Language for Lacan is an intersubjective order of symbolization which carries the force of cultural sanctions, of what he terms 'the Law of the Father' – for it is in and through language that the subject attempts a reconstruction of lost, imagined unities.

Rewriting the unconscious and Oedipus in terms of the symbolic dimensions of language, Lacan's theoretical point of reference is the structural linguistics of Ferdinand de Saussure. It

is not possible here to provide an adequate exegesis of Lacan's appropriation and reconstruction of Saussure's ideas; in what follows I shall only emphasize certain aspects of Lacan's use of Saussure's structural linguistics, particularly those aspects most relevant to the concerns of social theory. In Saussurian linguistics, language is explicated as a system of internal differences. In this view, signs are made up of a signifier (a sound or image) and a signified (the concept or meaning evoked). The meaning of a word arises through its differences from other words: a pencil, for example, is not a pen. A book is not a pamphlet, not a magazine, not a newspaper. Words as such do not 'mean' their objects. Language creates meaning only through an internal play of differences. Now Lacan accepts the key elements of Saussure's structural linguistics, but he radicalizes the relation between the signifier and the signified. Lacan will have nothing of the Saussurian search for the signified, or concept, however 'arbitrary' the relation between signifiers that generate meaning may be. Instead, Lacan inverts Saussure's interpretation of the sign, asserting that the signifier has primacy over the signified in the production of meaning. In Lacan's psychoanalytic reading, the two orders of discourse are always separated by censorship, marked by a bar of repression. The signified, says Lacan, cannot be elucidated once and for all, since it is always 'sinking' or 'fading' into the unconscious; the signified is, in effect, always just another signifier. And for Lacan the signifier is itself coterminous with the unconscious.

Language, as a system of differences, constitutes the subject's repressed desire through and through. The subject, once severed from the narcissistic fullness of the imaginary, is inserted into linguistic and symbolic structures that both generate the unconscious and allow for its contents to traverse the intersubjective field of culture. Access to ourselves and others, however, is complicated by the fact that desire is itself an 'effect of the signifier', an outcrop of the spacings or differences of linguistic structures. From this angle, the unconscious is less a realm on the 'inside' of the individual, or 'underneath' language, than an intersubjective space *between* subjects – located in those gaps that separate word from word, meaning from meaning. 'The exteriority of the symbolic in relation to man', says Lacan, 'is the very notion of the unconscious' (1966: 469). Or, in Lacan's infamous slogan: 'the unconscious is structured like a language'.

Lacan's re-reading of Freud has powerfully influenced contemporary social theory. His emphasis on the centrality of symbolic structures in the constitution of the subject, as well as the disruption caused to these structures through the fracturing effects of the unconscious, has been of core importance to recent debates concerning identity. His stress on the complicated interweaving of language and desire has been original and provocative. Significantly, his work has served as a useful corrective to social-theoretical accounts that portray the self as the site of rational psychological functioning. Moreover, his linguistic reconceptualization of the unconscious powerfully deconstructs theories of representation that presume that mind and world automatically fit together.

There are many limitations, however, of the Lacanian account of subjectivity and social relations. The most important of these, as concerns identity, is Lacan's claim that individuality involves an inescapable sentence of alienation. While it is undeniable that Freud viewed misrecognition as internally tied to ego formation, Lacan's version of this process involves a number of substantive problems. Consider the following: what is it that allows the individual to (mis)recognize itself from its mirror image? How, exactly, does it cash in on this conferring of selfhood? The problem with the argument that the mirror distorts is that it fails to specify the psychic capacities that make any such misrecognition possible. That is, Lacan's account fails to detail how the mirror is constituted as *real*. Related to this is the criticism that Lacan's linguistic reconceptualization of psychoanalysis actually suppresses the radical

implications of Freud's discovery of the unconscious by structuralizing it, reducing it to a chance play of signifiers. In this respect, Lacan's claim that the unconscious is naturally tied to language has come under fire. Here the criticism is that the unconscious is the precondition of language and not the reverse.

Equally serious are the criticisms that have been made of Lacan's account of culture. Lacan's linkage of the 'subject of the unconscious' with the idea of the 'arbitrary nature of the sign' raises the thorny problem of the replication of ideological power. In this connection, Lacan fails to explain how some ideological and political meanings predominate over others in the shaping of the personal sphere. Instead, cultural domination is equated with language as such. It is the subjection of the individual to the symbolic, to the force of the law, that accounts for the fall of the subject. However, as Dews (1987) argues, Lacan's equation of language with domination seriously downplays the importance of power, ideology and social institutions in the reproduction of cultural life.

Louis Althusser

In his famous essay 'Ideology and ideological state apparatuses' (1971), the French Marxist philosopher Louis Althusser sought to integrate structural Marxism and Lacanian psychoanalysis in order to understand the workings of ideology in modern societies. Althusser traces ideology as a discourse that leads individuals to support the reproduction of ruling class power. Althusser argued that society and political life is experienced less in the public world of institutions than in the fantasy realm of the imaginary. 'All ideology', writes Althusser, 'represents in its necessarily imaginary distortion is not the existing relations of production . . . but above all the (imaginary) relationship of individuals to the relations of production and the relations that derive from them' (1971: 38–39). From this angle, ideology provides an imaginary centring to everyday life; ideology confers identity on the self and others, and makes the individual feel valued within the social, cultural network.

What are the psychic mechanisms that underpin ideology? Echoing Lacan, Althusser argues that ideology functions in and through *mirroring*. Like the Lacanian child in front of its mirror image, the ideological mirror implants received social meanings at the heart of the subject's world. Yet, as in the mirror stage, the constitution of social forms necessarily involves a misrecognition, since ideology idealizes and distorts the intersubjective world of society, culture and politics. Through a 'subjection' to ideological discourses of class, race, gender, nationalism and the like, the individual comes to *misrecognize* itself as an autonomous, self-legislating subject. Imaginary misrecognition occurs through a process that Althusser terms 'interpellation'. It is in and through ideology that society 'interpellates' the individual as a 'subject', at once conferring identity and subjecting the individual to that social position. This interweaving of signification and imaginary misrecognition, Althusser contends, is rooted in 'ideological state apparatuses', which include schools, trade unions, the mass media and the like, and whose function is to ensure the subjection of individuals to different social positions in modern class-based societies. Human subjects' coming to overlook the nature of their real decentred subjectivity, says Althusser, is precisely the function of ideology – thus serving to reinforce the dominant power interests of late capitalism.

The theory of ideology developed by Althusser, with its implicit use of Lacanian psychoanalysis, marks one of the major sources of stimulus in twentieth-century social thought. It sets out an array of ideas about the relations between the personal and social domains, the imaginary and institutional life. Althusser's argument that ideology is an indispensable imaginary medium for social reproduction is provocative and important, and it did much to discredit

traditional Marxist theories of ideology as mere false consciousness. Like the unconscious for Freud, ideology for Althusser is eternal. However, it is now widely agreed that there are many problems with Althusser's account of ideology. Most importantly, Althusser's argument about the mirroring distortion of ideology runs into the same kind of theoretical dead end as does Lacan's account of the imaginary. That is, in order for an individual subject to (mis) recognize itself in and through ideological discourse, surely she or he must already possess certain affective capacities for subjective response.

Whatever these shortcomings, the Althusserian/Lacanian model remains a powerful source of influence in contemporary social theory. Indeed, Althusser's Lacan has recently been examined with new interest as concerns the study of subjectivity, society and culture. Fredric Jameson (1984) argues for a return to the Lacanian underpinnings of Althusser's social theory in order to fashion what he calls a 'cognitive mapping' of postmodern symbolic forms. Also, Slavoj Žižek recasts the Althusserian model of 'interpellation' in order to trace the fantasy identifications created in and through cultural forms such as media and film.

Feminism and psychoanalysis

In recent years, some of the most important conceptual advances in psychoanalytic social theory have come from feminist debates on sexual subjectivity and gender hierarchy. Broadly speaking, the major division in psychoanalytic feminism is between Anglo-American object relations theory on the one hand and French Lacanian and post-Lacanian theory on the other. Through the object relations perspective, feminist theorists analyse sexuality and gender against the backdrop of interpersonal relationships, with particular emphasis on the pre-Oedipal child–mother bond. Post-structuralist feminists indebted to Lacanian psychoanalysis, by contrast, deconstruct gender terms with reference to the structuring power of the order of the symbolic, of language as such. What follows concentrates for the most part upon developments in feminist theories of sexual difference that draw from, rework or transfigure Lacanian theory. The central concerns that are touched on include an exploration of the political ramifications of psychoanalysis; the psychic forces that affect women's desexualization and lack of agency in modern culture; the relationship between maternal and paternal power in infant development; and the connections between sexuality, the body and its pleasures. For in addressing these issues, feminist psychoanalytic theorists have sought to enlarge their understandings of polarized sexual identities in modern societies and to rethink the possibilities for restructuring existing forms of gender power.

Lacanian psychoanalysis is probably the most influential current in feminist social theory today. In Lacan's deployment of Saussurian linguistics, as noted above, meaning arises from difference. In the order of language, a signifier attains reference to a signified through the exclusion of other signifiers. In patriarchal culture, that which is excluded is the *feminine*: woman is denied a voice of her own. Lacan (1985) thus claims, in what is regarded by many as a clear indication of his anti-feminism, that 'The Woman does not exist.' Linking the unconscious with the essentially patriarchal organization of language and culture, Lacan defines the feminine in the negative, women as the Other, as something which is outside the symbolic order: this is what gives the masculine unconscious its self-presence as power and authority.

For Lacan, as for Freud, the phallus is the marker of sexual difference *par excellence*. The father and his phallus smash the incestuous unity of the mother–infant bond, and thereby refer the infant to the wider cultural, social network. In contrast to Freud, however, Lacan claims to disconnect the phallus conceptually from any linkage with the penis. The phallus,

says Lacan, is illusory, fictitious, imaginary. It exists less in the sense of biology than in a kind of fantasy realm that merges desire with power, omnipotence and wholeness. In Lacanian theory, the power that the phallus promises is directly tied to maternal, imaginary space. According to Lacan, the infant wishes to be loved exclusively by the mother. The infant painfully learns, however, that the mother's desire is invested elsewhere: in the phallus. Significantly, this discovery occurs at the same time that the infant is discovering itself in language, as a *separate subject*. In this connection, it is important to note that Lacan says that *both* sexes enter the symbolic order of language as castrated. The infant's separation from maternal space is experienced as a devastating loss. The pain of this loss *is* castration, as a result of which sexual subjectivity becomes deeply interwoven with absence and lack.

Lacan was not much interested in the social application of his theories. But this has not prevented feminists from making critical appropriations of Lacanian psychoanalysis for rethinking the social theory of gender. Interest in Lacan's ideas for feminism was initiated in the English-speaking world by Juliet Mitchell, who in her magisterial *Psychoanalysis and Feminism* (1974) used Freud and Lacan to explore the contemporary gender system. In Mitchell's Lacanian-based feminism, an analysis of sexual politics is developed which stresses that the symbolic order of language creates sexual division. Gendered subjectivity, for Mitchell, is necessarily tied to a fundamental loss: that of maternal, imaginary space. In this connection, the phallus, as 'transcendental signifier', functions as an imaginary lining or construction which masks the lack of the human subject at the level of sexual division. Yet the crucial point, according to Mitchell, is that these imaginary scenarios position males and females within unequal gender relations. Man is constituted as a self-determining, autonomous agent, and woman as the lacking Other, as sexual object. Using Lacanian theory against itself, however, Mitchell also explores potentialities for gender transformation. Though the phallus may stand for entry to the symbolic order, Mitchell claims, it is an imaginary object that either sex can secure once and for all.

Though generating much interest at the time, most commentators would now agree that Mitchell's analysis of gender contains serious theoretical and political difficulties. It seems to assume, for example, that the social reproduction of sexuality and gender is a relatively stable affair, without allowing room for the contradictions and ambiguities of split subjectivity and the unconscious. This involves important political implications. For if women are symbolically fixed in relation to masculinity as the lacking Other, via a repression of desire, then it remains far from clear why women would ever feel compelled to question or challenge the contemporary gender system. This point can be made in another way. The Lacanian specification of the feminine as that which is always defined negatively – lack, the Other, the dark continent – carries a number of theoretical and political ambiguities. On the one hand, Lacan's doctrines have been a valuable theoretical resource for feminists analysing how women are rendered the excluded Other in patriarchal discourse and culture. On the other hand, the recurring problem for feminism when set within Lacanian parameters is that all dimensions of human sexuality become inscribed within the signifier and therefore trapped by the law. Lacan's reduction of the feminine to mere oppositeness implies that woman can be defined only as *mirror* to the masculine subject, and thus can never escape the domination of a rigidly genderized discourse.

In opposition to Lacan, however, a number of French feminists have recently sought to articulate an alternative vision of female sexual subjectivity in French psychoanalysis. This approach to revaluing the feminine is generally referred to as post-Lacanian feminism, though it is worth briefly expanding on this label. This branch of feminist psychoanalysis is generally considered 'Lacanian' because theorists associated with it adopt a broadly structuralist

interpretation of gender categories, situating woman as the excluded Other of masculinist discourse and culture. Yet this approach is also 'anti-Lacanian' since such theorists tend to oppose the view that woman can only be defined as the mirror opposite of the masculine subject, and thus never escape the domination of a rigidly genderized discourse. Broadly speaking, post-Lacanian feminists evoke a positive image of femininity, an image that under-scores the multiple and plural dimensions of women's sexuality. Hélène Cixous, for example, speaks of the rhythms, flows, and sensations of the feminine libidinal economy, contrasting this with the exaggerated masculinist stress on genital sexuality. Woman, says Cixous (1976), has the 'capacity to depropriate unselfishly, body without end, without appendage, without principal "parts"' . . . Her libido is cosmic, just as her unconscious is worldwide'. Similarly, Luce Irigaray locates the feminine in the multiplicity of bodily sensations arising from the lips, vagina, clitoris and breasts. In contrast to the imperial phallic compulsiveness of male sexuality, women's capacity and need for sexual expression resides in the multiplicity and flux of feminine desire itself. As Irigaray says of woman: 'Her sexuality, always at least double, is in fact *plural*' (1993). Women, argues Irigaray, need to establish a different relationship to feminine sexuality, establishing a range of displacements to patriarchy through writing as a cultural practice. Speaking the feminine, for Irigaray, can potentially transform the oppres-sive sexed identities of patriarchy. In her more recent work, particularly *An Ethics of Sexual Difference* (1993) and *To Be Two* (2000), Irigaray situates the renegotiation of identities in the frame of ethics, specifically the dilemma of recognizing the otherness of the other sex. An ethics of sexual difference, she argues, would respect the Other in her or his own right, with regard to considerations of finitude, mortality, creation and the divine.

Julia Kristeva

Finally, we can find another meeting point of feminist and psychoanalytic theories in the work of Kristeva, who elaborates the idea of a specifically feminine mode of being that dislo-cates patriarchal language and culture. In *Revolution in Poetic Language* (1984 [1974]), Kristeva contrasts the Lacanian symbolic, the law that the father embodies, with the multiple libidinal forces of the 'semiotic'. The semiotic is a realm of prelinguistic experience – including feel-ings, drives and rhythms experienced by the infant in its pre-Oedipal relation to the mother. According to Kristeva, our semiotic longing for the pre-Oedipal mother, though repressed with entry to the symbolic, remains present in the unconscious and cannot be shut off from society and culture. The semiotic, Kristeva says, is present in the rhythms, slips and silences in speech; and it is subversive of the law of the father since it is rooted in a prepatriarchal connection with the feminine. Yet Kristeva denies that the feminine semiotic has any intrinsic link with gender, because it stems from the pre-Oedipal phase and is thus *prior* to sexual difference. Thus, if the semiotic is 'feminine' it is a femininity that is always potentially avail-able to women and men in their efforts to transform gender power. Kristeva looks to the semiotic as a means of subverting the male-dominated symbolic order. She finds a clear expression of the semiotic in the writings of avant-garde authors such as Mallarmé, Lautréamont and Artaud, which she feels defies patriarchal language. Kristeva also locates semiotic subversion in pregnancy. The psychic experience of giving birth, Kristeva says, reproduces 'the radical ordeal of the splitting of the subject: redoubling of the body, separa-tion and coexistence of the self and of an Other, of nature and consciousness, of physiology and speech' (1981: 31).

In her more recent work, especially *Black Sun* (1989) and *New Maladies of the Soul* (1993), Kristeva situates the emotional turmoil produced by contemporary culture with reference to

depression, mourning and melancholia. In depression, argues Kristeva, there is an emotional disinvestment from the symbolic, from language as such. The depressed person, overwhelmed by sadness, suffers from a paralysis of symbolic activity. In effect, language fails to substitute for what has been lost at the level of the psyche. The loss of loved ones, the loss of ideals, the loss of pasts: as the depressed person loses all interest in the surrounding world, in language itself, psychic energy shifts to a more primitive mode of functioning, to a maternal, drive-oriented form of experience. In short, depression produces a trauma of symbolic identification, a trauma that unleashes the power of semiotic energy. In the force-field of the semiotic – rhythms, semantic shifts, changes in intimation – Kristeva finds a means to connect the unspoken experience of the depressed person to established meaning, thereby facilitating an emotional reorganization of the self.

The foregoing feminist theories represent one of the most important areas of contemporary psychoanalytic criticism. They help explain, more clearly than conventional Lacanian accounts, the ways in which dominant sexual ideologies penetrate everyday life, and also explore the radicalizing possibilities of a feminine transformation of gender. But assumptions are made in these theories which need to be questioned. For one thing, the male-dominated law is opposed in these accounts either by the woman's body or the subversive relationship of women to language. However, some feminists have argued that this merely reinstates a 'female essence' prior to the construction of sexual subjectivity, and is therefore in danger of reinforcing traditional gender divisions through an unintended biologism. Related to this is the concern that these theories erase the mediating factors that link fantasy and social reality, either by displacing the psychoanalytic account of the construction of sexual difference (as in the case of Irigaray and Cixous) or by essentialism (as with Kristeva's merging of the semiotic and motherhood).

Psychoanalysis and postmodern theory

The Enlightenment reading of psychoanalysis – represented in, say, Habermas's rendition of Freud's epigram 'Where id was, there shall ego become' as culturally prefigurative of the possibility for undistorted communication – has come in for sustained criticism in recent years. One of the sources of the suspicion of modernist psychoanalysis, with its characteristic emphasis on maximizing an individual's freedom, derives from the Lacanian argument that the notion of the autonomous ego is itself an imaginary construct. Some authors and analysts associated with the postmodern turn of recent theorizing rework the Lacanian order of the imaginary and apply it to culture and knowledge in general, reinterpreting warnings of the death of the subject as a kind of dawning realization that the whole category of subjectivity is itself illusory. The postmodern critique, which combines elements from the philosophical standpoint of post-structuralism with elements of anti-psychoanalysis, tries to dismantle the distinction between consciousness and the unconscious, cultural prohibitions and repressed libido, subjugation and liberation. In postmodern conditions, with the dramatic speed-up in technologies, the subject is not only *decentred* but *desubjectivized* as well. What this means, at least in its more thoroughgoing versions, is a radical deconstruction of the notion of subjectivity itself. How can psychoanalysis, after all, conceivably represent the subject as a bundle of organized dispositions, affects and appetites when contemporary society is marked in its entirety by fluidity, pluralism, variety and ambivalence? A radical assault on fixed positions and boundaries of all imagination, the postmodern re-writing of psychoanalysis underscores the fluid and multiple trajectories of libidinal enjoyment. The indeterminacy of desire, repetition, the death drive, bodily zones and intensities: these are core elements of the

postmodern celebration of the multidimensional and fragmented aspects of our contemporary imaginary.

Broadly speaking, the aim of postmodern psychoanalysis is to rethink the relationship between desire and politics in a way that opens possibilities for social transformation. In this respect, Lacanian psychoanalysis has been sharply criticized by postmodernists as having politically reactionary implications. In their celebrated postmodern treatise *Anti-Oedipus* (1977 [1972]), Gilles Deleuze and Felix Guattari contend that the Lacanian account of desire, insofar as it binds the subject to the social order, works in the service of repression. Psychoanalysis, in this sense, functions in the service of capitalism, as a kind of vortex around which the unconscious becomes bent out of shape. As Deleuze and Guattari see it, lack in the Lacanian account is almost the opposite of desire, lack being for them just a capitalist ploy by which consumerism can plug the alleged hungers of desire. They argue that psychoanalysis, both Freudian and Lacanian, functions to *personalize desire*, referring all unconscious productions to the incestuous sexual realm of the nuclear family. Oedipal prohibitions, on this reckoning, are just the signifiers that chain desire to normative representations – the point at which we come to desire what capitalism wants us to desire. By contrast, Deleuze and Guattari seek to critique this psychoanalytic privileging of desire routed in lack as a *product* of law. They argue that desire in fact precedes representation: there is nothing at all personal to the flows of libido, which continually burst out anew. Perhaps the most striking feature here of Deleuze and Guattari's use of psychoanalytic concepts lies in their attempt to give the flows of libidinous energy a full-throttle force: a social theory in which the absolute positivity of unconscious productions is underscored, and in which schizophrenia is taken as a potentially emancipatory model.

Deleuze was one of France's most celebrated philosophers of the late twentieth century, and his co-author Guattari was a radical psychoanalyst, opposed to orthodox (both Freudian and Lacanian) theory. *Anti-Oedipus* was a courageous, poetic attempt to explode the normative power of categories like Oedipus and castration in psychoanalysis from the inside out, using psychoanalytic concepts against the colonizing conceptual logic of psychoanalysis itself. Deleuze and Guattari trace the 'free lines' of schizophrenic desire as affirmative force, pure positivity, a series of enabling rhythms and intensities as well as transforming possibilities. From this angle, the schizoid process is what enables libidinal pulsations to be uncoupled from systems, structures or cultural objects, which may in turn transform the production of the political network, making it no longer unfold according to the repressive functioning of law. Rejecting the rigid and closed worlds of Oedipus and capitalism, Deleuze and Guattari wish to speak up for schizophrenia over neurosis, the flows of desire over lack, fragments over totalities, differences over uniformity. 'Schizophrenia', they write, 'is desiring production at the limit of social production' (1977: 35). Against the Oedipalizing logic of capitalist discourse, where desire is channelled into prescribed pathways, Deleuze and Guattari argue that the impersonalized flows of schizoid desire can herald a radical transformation of society.

Similar theoretical directions are taken in the early writings of the French philosopher Jean-Francois Lyotard, who argues that political society is itself secretly libidinal. Whereas Deleuze and Guattari argue that desire is codified and repressed in and through capitalism, Lyotard views contemporary society as an immense desiring system. As he sees it, the postmodern is a vast libidinal circuit of technologies, a culture swamped with seductive signs and images. In underscoring the indeterminacy of intensities, Lyotard effects a shift in focus away from theories of representation and structures of the psyche and towards bodily intensities and erotogenic surfaces. In his book *Libidinal Economy* (1993), Lyotard constructs the excitations of libido on the model of the Möbius strip, conceptualized as an endless series of rotations,

twistings and contortions. The upshot of this, in political terms, is a series of arguments about how best to extract libidinal pleasure and intensity from postmodern culture. 'What would be interesting', writes Lyotard, 'would be to stay where we are, but at the same time to grab all opportunities to function as good conductors of intensities' (1993: 311).

In terms of postmodernism, the work of Deleuze and Guattari, and of Lyotard, underscores the point that contemporary experience is an experience of fragmentation, dislocation, polyvalency. From this angle, the belief that social transformation may be linked to the undoing of hidden meanings or discourses (as suggested in psychoanalytic social theory from Marcuse to Habermas) appears as little more than an ideological fantasy. By contrast, truth in postmodern psychoanalysis is located in the immediacy of libidinal intensity itself. The unconscious cannot be tamed or organized; desire needs no interpretation, it simply is. Moreover, it is within the diffuse, perverse and schizophrenic manifestations of desire that new forms of identity, otherness, fantasy and symbolism can be found.

The issues raised by postmodern psychoanalysis are important, especially when considered in the light of contemporary social transformations such as globalization and new communications technology. It is not apparent, however, that such theories generate any criteria for the critical assessment of social practices, politics or value positions. As Dews (1987) points out, the dissimulation of libidinal intensities urged in many currents of postmodern psychoanalysis is something that can be ideologically marshalled by both progressive and reactionary political forces. Significantly, the view that desire is ipso facto rebellious and subversive is premised upon a naive naturalism, one that fails to examine the social, cultural and political forms in which unconscious passion is embedded. Moreover, there is little consideration of the potential harm, pain and damage that psychical states of fragmentation and fluidity may comprise.

Future developments

There are multiple developments occurring in the deployment, refashioning and transformation of psychoanalysis in the social sciences and humanities in the twenty-first century. From the Frankfurt School to postmodernism, psychoanalysis has become an essential aspect of the critical vocabulary of the academy. While there are many developments that might be noted, I shall in conclusion focus on two recent conceptual departures that I believe are especially fruitful or promising in terms of critical social theory. Both derive from European psychoanalysis: the first concerns the contributions of the late Cornelius Castoriadis, the second the French psychoanalyst Jean Laplanche.

Cornelius Castoriadis: radical and social imaginaries

Castoriadis emerged as one of the most important innovators in European psychoanalysis since Lacan, and his writings have been especially influential in recent social theory. In *The Imaginary Institution of Society* (1987), Castoriadis argues that fantasy is a site of multiple, fractured and contradictory positionings of the individual in relation to self, to other people and to society and history. He claims that the psyche is continually elaborating representations and fantasies; as the flow of representations is produced, so new positionings of self and other are defined, which in turn leads to newer forms of fantasy, identification and cultural association. There is for Castoriadis a delicious indeterminacy at the heart of the Freudian unconscious, such that the regulative hierarchies of self, sexuality, gender and power are constantly rearranged and sometimes transformed, at least partially as a consequence of this ceaseless psychic flux.

At its simplest, Castoriadis's emphasis on the creative nature of the imagination underscores the permutation of fantasies and identifications that selves produce endlessly in relation to society and history. We insert ourselves, through the psychic flux of imagination, at one and the same moment as both creator and created, self and other, identity and difference; we draw on existing social institutions and cultural conventions to produce new images of self and society, which in turn feed back into the cycle of representations. In all this, Castoriadis's central theme is creativity – of the individual self and the broader society. Underlining creativity, his theoretical position is a far cry from the insipid, commercially constructed notion of the 'ever new' in popular culture. What distinguishes his position from popular understandings of creativity is his stress on the open-ended and ambivalent nature of psychic representation and cultural production, and it is this stress which necessarily involves reflecting on the more distressing aspects of violence, aggression and destruction in contemporary culture. 'Creation', writes Castoriadis, 'does not necessarily – nor even generally – signify "good" creation or the creation of "positive values". Auschwitz and the Gulag are creations just as much as the Parthenon and the *Principia Mathematica*' (1991: 3–4). It is hard – says Castoriadis – to grasp, and harder to understand, that socio-political paths or fields of imagination stretch all the way from progressive politics to fanaticism and fascism. But the search for alternative futures, and the search for autonomy and justice, are among the creations in western history that people value highly and judge positively; the practice of critique, of putting things into question, forms a common starting point for a radical challenge to received social and political meanings.

For Castoriadis (1987), the imaginary tribulations of the unconscious are utterly fresh, primary fabrications founded purely in themselves, erupting out of nothing and nowhere, and sprung *ex nihilo* from a disorderly chaos of representational flux. While recognizing that the psyche cannot produce everything out of itself, otherwise there would be no reason for the human subject to open itself to other persons and objects, Castoriadis claims it is meaningless to see psychic reality as simply a 'receptacle' of the external world. For there can be no social practice without a human subject; and with individuals there is psychic organization and emotional experience. Instead, the question of representation for Castoriadis centres on the capacity of the psyche itself to *instantiate* representations. Inherent in the Freudian problematic, he suggests, is the idea that

> the first delegation of the drive in the psyche is the affect, in particular that of displeasure. But we can find nothing in an affect, whether of pleasure or unpleasure, that could account for the form or the content of a representation; at the most the affect could induce the 'finality' of the representative process. *It is therefore necessary to postulate (even if this is only implicitly) that the psyche is the capacity to produce an 'initial' representation, the capacity of putting into image or making an image.* This may appear self-evident. But this image-making must at the same time relate to a drive, at a time when nothing ensures this relation. This may well be the point of condensation and accumulation for all the mysteries of the 'bonding' between the soul and the body.
>
> *(Castoriadis 1987: 282, emphasis added)*

Castoriadis is thus perhaps the first major modern intellectual to place at the centre of his reflections on the social the abstract category of psychical representation itself, at the levels of both the individual ('radical imaginary') and society ('social imaginary'). The imaginary, contends Castoriadis, is a question not just of 'the creation of images in society' but rather of the productive energies of self-creation, which in turn generate social imaginary

Anthony Elliott

significations and the institutions of each particular society. What is radically imaginary about the psychic process of every individual is precisely the representational pleasure of the unconscious monad, initially closed in upon itself, and subsequently forced to shift from self-generating solipsistic fantasy to the shared meanings of society. To the radical imaginary of the psychic monad corresponds the collective order of the 'social imaginary', an aesthetics of imagination that holds together the primary institutions of society (language, norms, customs and law) and the form of relation through which individuals and collectivities come to relate to such objects of representational and affective investment (Castoriadis 1987).

Where then does radical imagination originate? What is the condition of possibility for its eruption? Castoriadis contrasts his position on imagination with the Lacanian emphasis on the scopic dynamics of the imaginary thus:

> I am not fixated on the 'scopic'; one of the gross inadequacies of Lacan's conception of the imagination is his fixation on the scopic. For me, if one is speaking of stages that are worked out, the *imagination* par excellence is the imagination of the musical composer (which is what I wanted to be). Suddenly, figures surge forth which are not in the least visual. They are essentially auditory and kinetic – for there is also rhythm . . . Nor is there anything 'visual' in the social imaginary. The social imaginary is not the creation of images in society; it is not the fact that one paints the walls of towns. A fundamental creation of the social imaginary, the gods or rules of behaviour are neither visible nor even audible but *signifiable*.
>
> *(1997: 182–83)*

Castoriadis's reflections on the imaginary principally concern, one might say, the ways in which a world (at once emotional and social) somehow or other comes to be ordered and organized from groundlessness or chaos; the creation of imagination from 'dull mass'; creation and invention as a consequence of an 'explosion that digs into this mass a hole'. The constitution of these imaginary determinations manifests the creativity that appertains to the psyche as such, and that 'opens an interior space within it'.

Jean Laplanche: enigmatic significations

Laplanche was one of the first post-Lacanians to write of the strange transformations – the condensations, displacements and reversals – of unconscious repression, which results in the formation of an internal foreign other, of what Freud called a thing-presentation, or, if you will, the depths of imagination itself. He has been one of the few major psychoanalytic thinkers, period, to focus on the irreducible creativity of unconscious work, by which he means specifically the field of symbolizing activity.

Laplanche, like Castoriadis, rejects the linguistic imperialism of Lacanian doctrine: 'the message can just as easily be non-verbal as verbal'. And like Kristeva, Laplanche distances himself from a concern with 'transhistorical structures' (phylogenesis, language) in favour of the essential uniqueness and individuality of human imagination. In shifting away from Lacan and back to Freud – returning to prelinguistic psychical representatives or fantasmatic constructions made of images and split from words – Laplanche will emphasize that in the act of *psychic translation* the singular individual *creates* in the strongest sense of the term.

It could be said that Laplanche is out to provide a social theory of our *struggle for representation* in the field of symbolizing activity, which, in a sense, has been the subject of all psychoanalytic theories since Freud unearthed the unconscious logics of the dream. For in his

preoccupation with the problem of translation – by which is meant the psychic force-field of representations, resemblances, contiguities, condensations and reversals – Laplanche's work plays ingeniously on a subtle, but definite, relation between human subjects in the context of symbolic and social formations. For Laplanche, it is essential to grasp that the infant is, from the beginning of life, presented with what he calls 'messages' (both verbal and non-verbal) by parents, messages that the infant is ill-equipped to deal with adequately or understand on an emotional plane. It makes perhaps less difference what the soft caresses of a mother actually signify as regards the self-understandings of the adult, though part of Laplanche's interest turns on the way parents always convey far more than they consciously intend. What matters in Laplanche's scheme is that the infant has been addressed or called with a message, a message that is at once exciting and mystifying.

The striking feature of Laplanche's theorization of the message as enigmatic is its sheer open-endedness. His account of the psychosexual development of the individual subject in terms of the ongoing emotional work of translation and retranslation would make no sense were it not for the recognition that, because of the small infant's initially limited ways of trying to emotionally process proffered messages, psychic life is always, necessarily, imaginative, creative, inventive. In a way that contrasts with the iron determinism of the early Lacan's emphasis on the symbolic subjection of the subject, it is the mystifying element of the message that for Laplanche sparks imaginative associations in the child. What is inescapable for the infant – and subsequently for the adult – is that such mystifying messages demand continual psychic work, are in need of continual translation. Indeed, Laplanche himself has acknowledged that he came up with the concept of 'message', with all this implies of the need for translation, in order to overcome the rigid determinism of psychoanalysis in France since Lacan.

Conclusion

Castoriadis and Laplanche are not alone among those theorists of the contemporary age who have wrestled with the question of imagination as well as individual and social transformations affecting imaginary life. Fortunately, for academic social science but also for the demands of practical social life, there have been a growing number of voices raising pressing political issues about the conditions and consequences of our imaginative interpersonal relations in a postmodern world of fragmentation and fracture. Such authoritative voices today include, to mention only a few, Judith Butler, Drucilla Cornell, Slavoj Žižek, Homi Bhabha, Christopher Bollas, Lynne Segal, Fredric Jameson, Stephen Frosh, Luce Irigaray, Elizabeth Grosz, Nancy Chodorow, Jane Flax, Charles Spezzano, Thomas Ogden and Jessica Benjamin. Each has drawn from psychoanalysis to develop a particular angle on the changing relations between self and society in the contemporary epoch. Each has focused on specific problematics of current social conditions – from feminism to postmodernism, from psychotherapy to literature – in rethinking the terms of both individual and collective imaginaries.

References

Adorno, T. and Horkheimer, M. (2002 [1944]) *Dialectic of Enlightenment: Philosophical Fragments*, Stanford, CA: Stanford University Press.

Althusser, L. (1971) 'Ideology and ideological state apparatuses', in *Lenin and Philosophy and Other Essays*, London: New Left Books.

Castoriadis, C. (1987) *The Imaginary Institution of Society*, Cambridge, MA: MIT Press.

—— (1991) *Philosophy, Politics, Autonomy*, Oxford: Oxford University Press.

—— (1997) *World in Fragments: Writings on Politics, Society, Psychoanalysis and the Imagination*, Stanford, CA: Stanford University Press.

Cixous, H. (1976) 'The Laugh of the Medusa', trans. Keith Cohen and Paula Cohen, *Journal of Women in Culture and Society*, Vol. 1, No. 4 (Summer, 1976), pp. 875–93.

Deleuze, G. and Guattari, F. (1977 [1972]) *Anti-Oedipus: Capitalism and Schizophrenia*, trans. R. Hurley, M. Seem and H. R. Lane, New York: Viking.

Dews, P. (1987) *Logics of Disintegration: Post-structuralist Thought and the Claims of Critical Theory*, London: Verso.

Freud, S. (1961a [1930]) 'The Unconscious', in J. Strachey (ed.) *The Standard Edition of the Complete Psychological Works of Sigmund Freud*, Vol. XXI, London: Hogarth Press.

—— (1961b [1930]) 'Civilization and its Discontents', in J. Strachey (ed.) *The Standard Edition of the Complete Psychological Works of Sigmund Freud*, Vol. XXI, London: Hogarth Press.

Fromm, E. (1932) 'The Method and Function of an Analytic Social Psychology: Notes on psycho-analysis and Historical Materialism', *The Essential Frankfurt School Reader*, Edited by Andrew Arato and Eike Gebhardt, New York: Continuum, pp. 477–96.

—— (1941) *Escape from Freedom*, New York: Holt, Rinehart and Winston.

—— (1955) *The Sane Society*, New York: Holt, Rinehart and Winston.

Irigaray, L. (1993) *An Ethics of Sexual Difference*, Ithaca, NY: Cornell University Press.

—— (2000) *To Be Two*, London: Athlone.

Jameson, F. (1984) 'Postmodernism, or the Cultural Logic of Late Capitalism,' *New Left Review* 1/146: July–August.

Kristeva, J. (1980) *Desire in Language*, trans. Leon S. Roudiez, Oxford: Basil Blackwell.

—— (1981) 'Interview', *m/f*, No. 5, pp. 158–63.

—— (1984 [1974]) *Revolution in Poetic Language*, New York: Columbia University Press.

—— (1986) *The Kristeva Reader*, edited by T. Moi, Oxford: Blackwell.

—— (1989) *Black Sun: Depression and Melancholia*, New York: Columbia University Press.

—— (1993) *New Maladies of the Soul*, New York: Columbia University Press.

Lacan, J. (1966) *Écrits*, Paris: du Seuil.

—— (1977 [1949]) 'The Mirror Stage as Formative of the Function of the I', in J.-A. Miller (ed.) *Écrits: A Selection*, London: Tavistock Press.

Lyotard, J.-F. (1993 [1974]) *Libidinal Economy*, London: Athlone Press.

Marcuse, H. (1956) *Eros and Civilization*, New York: Vintage Books.

—— (1970) *Five Lectures*, Boston: Beacon.

Mitchell, J. (1974) *Psychoanalysis and Feminism*, London: Penguin Books.

Reich, W. (1970 [1933]) *Character Analysis*, trans. T. P. Wolfe, New York: Farrar, Straus and Giroux.

9

Social theories of risk

Patrick Brown

Introduction: a brief historical overview of risk theorizing

Following the Euro-centricity of so many dominant social and cultural theories, an ongoing preoccupation within several of the theoretical frameworks considered elsewhere in this volume is to describe and adequately account for the various dimensions of *modern* social contexts. This involves exploring the corresponding social relations that emerge as features of modernity, and implicit within these analytical approaches are assumptions regarding the particularity of western modernity, and its more recent guises (late, post-, high), so distinguishing such manifestations of society from that which went before, as well as that which exists elsewhere. Weber suggested that a defining hallmark of modernity is a cultural predilection towards 'calculating consequences' and the increased recourse to techniques of planning (rationalizing) which results – with the analysis of these modern approaches to consequences thus becoming integral to his sociological project. Indeed, from a Weberian perspective, 'the central task of universal history is to explain this unique [i.e. modern western] rationalism' (Brubaker 1984: 8).

It is within this apparent shift to new social approaches, or rationalities, for considering futures – departing from fatalism or religiously oriented understandings – from which notions of risk emerge. Indeed, for some, risk is the defining concept of modernity:

> The revolutionary idea that defines the boundary between modern times and the past is the mastery of risk: the notion that the future is more than a whim of the gods and that men and women are not passive before nature.
>
> *(Bernstein 1996: 1)*

Bernstein's contribution is more historical account than social theory, though it importantly details the development of statistical tools for fending against uncertainty as well as a growing awareness that the application of such tools is far more than a straightforward technical exercise (1996: 151).

As a cultural movement, the Enlightenment can be viewed as a significant driver in both the development of techniques for probabilistically considering future outcomes and a shift in dominant perspectives regarding the amenability of the future to human planning and control. The refinement of mathematical approaches towards future uncertainties was accompanied by a transition (referred to above) from perceiving the future as lying in 'God's hands' towards an increasing faith in human-made technologies – with these two developments often seen as fuelling one another. Yet while technological developments have brought an

increasing number of domains under the auspices of measurement, planning and probabilistic prediction, so has the intractability of uncertainty and the limits of control become ever more evident (Wilkinson 2010).

An early account of risk within the social sciences was that of Frank Knight (1921), an economist who recognized the imperfection of judgements regarding the future due to the limited ability of individuals not only in probabilistically calculating the likelihood of a good outcome, but moreover in defining what a good outcome would be (Langlois and Cosgel 1993: 459). Knight's work draws a contrast between an idealized, 'mechanized' model where calculation is straightforward and the messiness of 'organic life' (Langlois and Cosgel 1993: 460). In contrast to certain technical notions of risk – which might define it as 'the probability that a particular adverse event occurs during a stated time period, or results from a particular challenge' (Royal Society 1992: 2) – Knight (1921) draws our attention to the difficulties in considering probabilities but moreover the variability in which events are defined and/or considered adverse or positive.

The ways in which individuals and organizations are increasingly compelled to consider the consequences of their decisions, alongside this inherent difficulty, complexity and disorderliness which is characteristic of how actors consider the future, continues to keep social theorists occupied with conceptualizations of risk and uncertainty – almost a century on from Knight's seminal contribution. The focus of this chapter is on more recent theories of risk and uncertainty within the domains of sociology and anthropology. All share certain preoccupations with one another and indeed with Knight, though the nature of risk, the position of experts in relation to experiences of risk, and the novelty attributed to these configurations differ greatly. The next section considers some of the central themes and thinkers within the field.

Risk and uncertainty: some central themes and thinkers

It has become commonplace, following Mythen (2008: 303) and Wilkinson (2010: 43), to refer to three overarching social and cultural theories of risk that have proved especially influential. While these two reviews both begin with Ulrich Beck's (1992) *Risk Society* thesis, this chapter will follow a more chronological format, starting instead with the 'cultural theory' approach of the anthropologist Mary Douglas (partially formulated with the political scientist Aaron Wildavsky). This position, which sees risk as a product of timeless intra- and inter-group tensions, will then be contrasted with Beck's claims around the novelty and distinctiveness of risk. Although Michel Foucault died before these conceptual discussions had significantly sparked into life, his work has posthumously influenced a third significant stream of risk thinking which follows his considerations of governmentality and various interrelated qualities of knowledge and power.

Mary Douglas and a cultural theory of risk

In the opening section to this chapter it was suggested, following Knight (1921), that beyond the 'mechanistic' (neat and tidy) calculation of risk there is a real world of messiness – rendered so by the difficulties in probabilistic calculation and through the intractable problems of categorizing and defining outcomes. When we add the further issue of how these convoluted outcomes are valued (for example, more positively or more negatively), it becomes palpably evident that that which one person sees as significantly 'risky' may be considered with utter indifference by his or her neighbour – due to varying future perceptions, definitions and value attributions (Heyman, Alaszewski and Brown 2012).

This variation in the consideration of risks is the starting point of cultural approaches – where our central concept is seen less as a technocratic expression of probability and more as a socio-cultural construct (Douglas 1992), or even as totem or ritual (Moore and Burgess 2011). A central argument of Douglas and Wildavsky (1982) is that risks do not simply 'exist'; instead what we choose to focus upon and define as risky is culturally generated and socially constructed. Here Douglas and Wildavsky call into question assumptions about the distinctness of modern societies, as was suggested in the introduction to this chapter: 'We moderns are *supposed* to behave differently, especially because the same science and technology that make us modern also produce our risks and because advanced statistics enable us to calculate them' (1982: 29, emphasis added).

In emphasizing that ascriptions of risk are political rather than probabilistic, Douglas (1992: 39; Douglas and Wildavsky 1982: 30) underlines the similarities between these modern processes of categorizing and seeking explanations for 'problems' and pre-modern delineations around sin, taboo and impurity. In this sense there remains a subtle ambivalence towards the novelty of modernity and risk in Douglas's work. On the one hand there is a suggestion that new technologies stimulate people to call into question what is normal and what is 'other', generating debates about where the line should be drawn between acceptable behaviour – in terms of medical practice, environmental pollution or livestock rearing, for example – and that which is improperly 'risky' and thus worthy of blame. But on the other hand, and most fundamentally for Douglas, the processes by which an object is considered normal or deviant ('out of place'), and the selection of which objects are focused upon and which are ignored, are fundamentally cultural and equated with enduring practices that are visible throughout all societies and groups.

The tension between technological novelty and enduring group dynamics is visible in this example:

> What are Americans afraid of? Nothing much except the food they eat, the water they drink, the air they breathe, the land they live on and the energy they consume. In the amazing short space of fifteen to twenty years, confidence about the physical world has been turned to doubt. Once the source of safety, science and technology has become the source of risk.
>
> *(Douglas and Wildavsky 1982: 10)*

For Douglas and Wildavsky there is something new at hand, and in many ways these social changes are expressed in a language that both problematizes and appeals to technology. Yet underlying these apparent 'sources of risk' are much deeper social processes – above all, tensions emerging in society due to weakening social cohesion. The panics around air, land and water are deeply moral in this respect, driven by a 'sectarian outlook' where a vision of the good society is contrasted with that which is a threat. These distinctions enable processes of definition and exclusion that render group or societal cohesion stronger: 'The sect [or society] needs enemies' (Douglas and Wildavsky 1982: 124), and the definition of risks is essentially a process of labelling enemies – that which is 'unacceptable' and 'out of place': '"risk" does not signify an all-round assessment of probable outcomes, but becomes a stick for beating authority, often a slogan for mustering xenophobia' (Douglas 1992: 39).

Analogous to arguments that anti-immigration posturing by certain right-of-centre political parties becomes popular when people feel economically insecure, or that new linguistic expressions are more likely to emerge during transitional phases of society (Wilkinson 2010), new developments or technologies are more likely to become problematized as risky during

phases of a perceived weakening of social cohesion and societal disharmony. This political function of risk can be seen as 'positively' generating unity around a common sense of foreboding, where members 'shall be motivated to quash movements towards group disunity . . . stand united around a common set of social objectives . . . and shall be morally energised to work together to protect their group from harm' (Wilkinson 2010: 49). In this light the increasing prominence of risk within political debate, and indeed within sociological theorizing, is related to its ideological, 'totemic' (Moore and Burgess 2011) function in binding and undergirding the fabric of society.

Within this framework, explanations of which 'natural dangers' become politicized into moral concerns of risk can be found within the structures and tensions of the particular society. The type of risks (enemies or sins) focused upon will in some senses relate to the model of a good society which influential actors within a particular society esteem and see as needing to be preserved. Seen through this explanatory lens, risks must be able to be counterposed against these prevailing notions of what is valued (Douglas and Wildavsky 1982: 7) – as a means of preserving not only unity but existing hierarchy (Douglas and Wildavsky 1982: 90). In certain cases, the social construction of risk focuses accountability upon experts or leaders who were at fault; in other settings negative outcomes are attributed to the victims themselves. The direction of accountability, and accordingly blame, which risk – as an ideological lens – points actors towards, is therefore a product of social structures and related distributions of power and interests (see Douglas 1992: 78 for a useful typology).

Blame, for Douglas (1992), is very much central to the socio-cultural function of risk. Implicit within notions of risk are always ascriptions of accountability and blame. This interwovenness of risk and blame is one feature which many of the social theoretical frameworks considered in this chapter unite around.[1] Risk, in contrast to danger, is imbued with understandings of consequences as a result of specific decisions – action or inaction (Douglas 1992: 14; Luhmann 1993: 101). Thus in a similar manner by which sin associates dysfunction with inappropriate behaviour of certain persons and corresponding defilement, so does risk point the finger of blame in one particular direction as opposed to another (Douglas 1992: 5).

This importance of the holding of certain individuals to account provides one further basis in analysing why certain dangers are mobilized into risks and not others. The extent to which a particular causal explanation for negative outcomes – and the corresponding selection of people and/or objects held accountable – resonates within existing ideology, beliefs and attitudes is vital to understanding why certain risks rise to prominence, as well as the timing of these moral panics:

> Plenty of dangers are always present. No doubt the water in fourteenth century Europe was a persistent health hazard, but a cultural theory of perception would point out that it became a public preoccupation only when it seemed plausible to accuse Jews of poisoning the wells.
>
> *(Douglas and Wildavsky 1982: 7)*

A key contribution of Douglas's cultural theory that is especially instructive in developing theories around risk – though relatively undervalued within much empirical sociological research – is its careful attention to varying risk perceptions and beliefs between certain social cleavages within a particular society and attempts to explain these. I have already drawn attention to the relevance of social formations, boundaries and hierarchies and their influence on risk perception. Douglas and Wildavsky (1982) develop these considerations into a coherent typology in order to understand attitudes towards risk based on the relationship of

a particular group's members to one another and the 'outside' world, and the format of authority prevalent within this collective.

These two dimensions form an explanatory 'grid-group' model: the extent to which a certain collection of people or an organization delineate themselves and demand group 'buy-in' and commitment alongside a corresponding relationship to others is considered along a horizontal 'group' spectrum (Douglas and Wildavsky 1982: 138–39). 'Grid' meanwhile, as typically represented by a vertical axis intersecting the 'group' spectrum, refers to the level of hierarchy within a collective in terms of positions of authority and 'social distinctions' (ibid.). These intersecting axes create four boxes and four corresponding ideal types of risk orienta- tion held by organizations, social cleavages and individuals. Influenced by Durkheim, a response to Basil Bernstein, and refined by Michael Thompson, the four categories of 'risk perceivers' are briefly sketched below:

1. Douglas (1992: 180) cites the Swedish trade union movement – a tight-knit group with a strong hierarchical structure (high-grid, high-group) – as epitomising the *positional* (earlier known as 'hierarchy') ideal type, one that typically employs 'extensive classification and programming for solving problems of co-ordination' and risk (Douglas 2006: 4).
2. The British trade unions, in contrast, reflect the high-group, low-grid *egalitarian* stereo- type of anti-establishment, anti-hierarchy, activist approaches to labour-related risks (Douglas 1992: 179).
3. *Individualists*, meanwhile, reflect low-grid and low-group tendencies and tend to be the least risk-averse of the four ideal types; they are highly confident in the application of technology (Wilkinson 2010).
4. *Fatalists* are those who experience society as hierarchical but who are not effectively organized to exert influence within this system. These people are considered to typify the apathy of the masses visible within many corners of society (Douglas 2006: 13).

Critiques of cultural approaches to risk

Clearly apparent within Douglas's work on risk, from her book with Wildavsky onwards, is the awareness that a culturally rooted explanation of 'perceptions of right and truth' would inevitably attract critiques of relativism (1982: 186). From the perspective of social theory this is not necessarily problematic; indeed an awareness of the intersubjectively constructed 'reality' of the social world has become commonly accepted following the influence of Schutzian phenomenology. However, Douglas's analysis of risk is not only constructionist, but 'weak' constructionist – in that she makes ascriptions that at times distinguish 'reality' from beliefs about, and perceptions of, this reality. This position is less ontologically consistent and corre- spondingly less epistemologically robust, open as it is to criticisms that an arbitrary distinction is being made between perceptions and the appearance of risk on the one hand and 'reality' on the other. The counter of Douglas and Wildavsky (1982: 187) to potential ontological and epistemological critiques is more pragmatic than philosophical, partly pointing towards the inconsistencies between scientific evidence and beliefs and seemingly letting these speak for themselves, as well as arguing for further empirical examination of their grid-group approach as a means towards solidifying their position through conceptual refinement.

A further concern within the grid-group typology of this 'cultural theory' is a certain ambiguity over whose behaviour and perceptions are being explained – groups or individuals. The answer would seem to be both, but this then leads to possible inconsistencies – for example where Douglas (1992: 179) notes that members of British labour movements may

often act as individualists but also come together collectively to form sects (the latter conforming to the 'egalitarian' ideal type). Prima facie there is an analytical contradiction here, where the risk perceptions and orientations of the same individuals are placed in two separate categories and explained to be different. Although this one example can be explained away with regard to the peculiar circumstances of the trade unions under analysis (1992: 185), broader questions remain as to inconsistencies regarding cases of those individuals who are members of multiple groups and who play different roles in different settings.

Once more there is a pragmatic solution, by which the grid-group categories are emphasized to be modestly ideal-typical and therefore far from deterministic. Moreover the tensions that this query over explanatory units (organization or individual) illuminates throw up useful avenues for further exegesis and exploration of cultural theoretical models of risk. How perceptions and risk sensitivities develop over time when people move and adapt between one form of organization or social setting and another is a salient question in exploring 'how different kinds of organisations provide different controls on the perceptions of their members' and their sensitivities towards risk (Douglas 1992: 78; Desmond, Prost and Wight 2012).

Ulrich Beck and the risk society thesis

In 1986, four years after the publication of Douglas and Wildavsky's *Risk and Culture*, Ulrich Beck published *Risikogesellschaft* in his native language of German. The book was later published in 1992 in English as *Risk Society: Towards a New Modernity*. The subtitle here is indicative of a core theme in Beck's work which, in contrast to Douglas, emphasizes an argument that risks and the social relations they bear upon are not only a novel product of modernity but moreover lead to the creation of new formations within society. As Anthony Giddens writes in his preface to the English edition of the book: 'Just as modernization dissolved the structure of feudal society in the nineteenth century and produced the industrial society, modernization today is dissolving industrial society and another modernity is coming into being' (Beck 1992: 10).

It is important at this point not to set up cultural theory and risk society accounts as wholly at odds with one another. In many senses the two theories work at different levels of analysis between the micro and macro. So while, as outlined in the preceding sections, Douglas is more interested in the enduring nature of group dynamics and how these same dynamics are more recently manifest in the shaping of risk perceptions, Beck is working more towards the level of grand narratives of society. In this latter respect there is a very strong assertion that we are in the midst of a very different phase of social history.

Fundamental to Beck's depiction of the new epoch in which we live is a distinction between 'natural hazards' and 'manufactured risks'. The pre-modern era experienced naturally occurring hazards, while, due to the technological advances of modernity, these are now accompanied by 'latent side effects' of technology that have become more problematic, lethal and global over time. Since the 1970s in particular these human-made risks have become increasingly palpable and contentious (Mythen 2008: 304). The most commonly referred to example of such manufactured risks occurred in the year of publication of *Risikogesellschaft*: the 1986 Chernobyl nuclear disaster. The release of large quantities of radioactive material following a fire and explosion at the plant bears out many of Beck's claims about the nature of manufactured risks in this new modernity:

> the distribution of social problems or 'bads' becomes global rather than being limited to local areas or sections of society;

in this way the rich and powerful are as much afflicted by the 'democratic' impact of risks as more marginalized groups, with the former experiencing the 'boomerang effects' of technological developments coming back to haunt them, in contrast to previous eras where money could buy insulation from danger;

and, as Lash and Wynne note in their introduction to *Risk Society*, technological advances enhance, to a certain degree, understandings of the consequences of 'bads', but contestation remains between experts and lay members over the nature of risks that cannot be resolved straightforwardly (in Beck 1992: 7).

This latter development of a more critical debate within society around risks – their existence, causes and governance – is a feature of what Beck, alongside Giddens, refers to as reflexive modernization. Reflexivity refers to the sense in which society is 'confronted by itself' (Beck 1992: 183), and this takes place in the public sphere, stimulated by the visibility of risks and apparently poor governance of these, as well as in the private sphere, as we will consider below, through individualization. A key theme within this reflexive modernity within broader society is a growing cynicism regarding the Enlightenment dream. Whig assumptions regarding inexorable technological and social refinements, marching hand in hand with one another, become increasingly open to question in this dysfunctional modernity, where technology causes harm, where a lack of scientific consensus is more visible, and therefore where the function of science as a legitimating tool for policy becomes compromised.

Habermasian influences within Beck's work are highly apparent here, in terms of the breakdown of legitimation processes, a concern with the dysfunctionality of the Enlightenment project and the need to 'rescue it', and to this end the placing of faith in the reinvigoration of the public sphere, where, in response to concerns such as genetic technologies, 'hearings are held. Churches protest. Even scientists faithful to progress cannot shake off their uneasiness' (Beck 1992: 203). So even though scientists themselves, as cogs within the machine, may have problems resisting and ethically orienting their work, Beck discusses the possibility of the 'opening up' and politicization of science. Here the runaway trains of science and research can be regulated not by central government but by a legal invigoration of the sub-politics within particular systems – urging communicative reflection rather than mere instrumental reflex (cf. Elliott 2002: 302). This entails establishing the conditions for self-criticism within specific spheres such as medicine, nuclear physics and genetic science, which is 'probably the *only way* that the mistakes that would sooner or later destroy our world can be detected in advance' (Beck 1992: 234).

Notions of the risk society are perhaps most accessible when couched in terms of environmental pollution and nuclear catastrophe, yet Beck also stresses that central features of the new modernity reach into many areas of private lives, from relationships to educational pathways to labour market experiences (Mythen 2005). Once again we see the application of the concept of reflexive modernization, but in this context it is individual actors who are forced to confront their sense of self, identity and life narratives. These challenges to the self are a result of the splintering of relationship norms, the deregulation of the labour market and the shifting dynamics and possibilities of class and status within the new modernity.

In contrast to preceding eras where relatively clear and non-negotiable life narratives were inherited through an individual's embeddedness within local, class-based tradition and normative structures, in the modern era the erosion and corresponding loosening of these structures puts a much greater onus on the individual to make appropriate decisions. In this way the multiplicity of options opened up to actors, for example in terms of career possibilities, creates

significant complexity and uncertainty. Here the concept of *individualization* is applied in considering the way individuals are increasingly required to confront and choose their futures – with a heightened awareness of the contingency of their decisions for future outcomes a result. A recognition of risk within the 'fateful moments' (Giddens 1991: 113) of decision making (regarding relationships, jobs, university courses) thus becomes a feature of a responsibilization for the future that is seen to rest on the shoulders of the individual – rather than being more narrowly bounded by social structure. Heightened monitoring of and reflection on one's narrative and indeed on one's decision making is a result: 'if risks are an attempt to make the incalculable calculable, then risk-monitoring presupposes agency, choice, calculation and responsibility' (Elliott 2002: 298).

This story of the changing experience of the individual is strongly linked within the analytical frameworks of both Beck (1992) and Giddens (1991) to broader economic developments, particularly those of labour market deregulation in the face of pressures that globalized, footloose production places on employers in European welfare states. Precarious labour situations have always existed but, as with natural hazards, were formerly more confined to lower socioeconomic status groups and concentrated in particular geographic locales. In contrast, the risk society is marked by an increasingly commonplace experience of unemployment and short-term job contracts that are experienced across class boundaries. It is in this regard that Beck denotes a shift in the configuration of labour market concerns, with class no longer the fundamental characteristic and risk considerations becoming pervasive and defining (Mythen 2005).

Features of this individualized, risk-aware society are feelings of vulnerability, uncertainty and corresponding anxiety. Beck (1992) and Giddens (1991) both underline the salience of trust in these contexts as a means of reducing complexity and thus attenuating the anxiety associated with feelings of uncertainty and vulnerability (Brown and Calnan 2012). Yet, as trust becomes more relevant and more necessary for individuals, so does it become more problematic. Increasingly these new forms of modernity require actors to place their trust not in local, familiar individuals but in abstract systems of expertise (Giddens 1991). These faceless systems are distant both in the geographical sense and due to a limited amount of familiarizing interactions or 'facework'. These problematic developments, combined with an awareness of the disputable nature of scientific knowledge and the visibility of failings of abstract systems and individual experts (Beck 1992), render a new modernity typified not only by problems of risk but also by an apparent crisis of trust.

Critiques of the risk society approach

Given the breadth and topicality of the arguments made and the macro-level, polemical and thus 'broad brush' approach to the analysis, not to mention the idiosyncratic and provocative writing style, it is unsurprising to note that critiques of Beck's work are numerous and, occasionally, vehement. Beck's approach to much of this critical work has been open and pragmatic, and thus his position has gradually shifted over the period since *Risk Society* was first published. In some senses this has made Beck increasingly 'slippery' to critique over time, in that the seemingly problematic positions he adopts within one work will be mitigated (or confused) by his discussions of the same topic within another of his books.

A straightforward though not especially sophisticated critique has been one which pigeonholes Beck firmly as a post-class scholar through quoting passages from his work where he refers to class as a 'zombie concept', before arguing that class is still significant after all. Such work fails to do justice to Beck's position, which can be regarded more accurately as wrestling with class, and an increasingly complex map of inequality, than as discarding it.

More helpful and nuanced approaches (e.g. Mythen 2005) deconstruct the individualization thesis more carefully and emphasize that while aspects, such as heightened identity work, are seemingly relevant and apt, other claims are lacking in evidence. Mythen (2005: 137) also draws our attention to certain analytical gaps – for example Beck says little about solidarities in the workplace amidst processes of individualization.

A common theme amongst Beck's critics regards the breadth of his claims and the novelty of the era he heralds. Mythen argues that the 'hyperboles' of Beck 'only serve to gloss over evident continuities in social reproduction in Western cultures' (2005: 138; see also Elliott 2002). Developing this critique, Mythen emphasizes the complex interaction between risk, individualization and enduring social stratification – demanding a more textured depiction of this modernity. Furlong and Cartmel (1997), meanwhile, describe an 'epistemic fallacy of late-modernity', where an individualization and erosion of class is perceived to have taken place within the lives of young people, but where the reproduction of inequality continues to feature beneath the surface.

Also scrutinizing individualization and its relation to class, Elliott points to the possibility that processes of individualization 'may directly contribute to, and advance the proliferation of, class inequalities and economic exclusions' (2002: 304), particularly through uneven distribution of various forms of capital. Elliott, echoed by Mythen (2005) and others, argues for the need to empirically explore the assertions made by Beck, denoting the necessity for a more nuanced and complex consideration of class inequality which Beck would latterly seem to have heeded. It is suggested that, unless these tools to refine and sensitize the risk society thesis towards power and domination are developed, much is missed or over-simplified within its analysis.

Elliott (2002) furthermore questions the evolving conceptualizations of reflexivity made by Beck, in terms of their consistency, coherence and analytical depth. In recognizing that not all encounters with risk lead similarly to knowledge producing self-confrontation, Beck delineates between 'reflexivity', where modernity is compromised, and 'reflection', where society's understanding of itself is refined (Elliott 2002: 301–2). Elliott interrogates this distinction, finding neither sufficient explanation as to which of these options will result nor an account of the underlying processes. The emergence of this seemingly arbitrary dualism within Beck's consideration of reflexivity is problematic and analytically shallow, though potentially clarified against the Habermasian backdrop to Beck's work – where the reflective route coheres to patterns of communicative action while the 'autonomized', destructive 'reflex' contains significant parallels with instrumentality and lifeworld colonization.

Michel Foucault, knowledge and governmentality

Beck and Douglas are in many accounts contrasted, as though the former saw risk perceptions as objectively validated while the latter held a highly constructivist position. However, the account presented in this chapter so far underlines that the two positions are much closer than is often recognized.[2] As outlined above, Douglas's work describes how new technologies provoke debates about moralities, as these are encoded within ascriptions of risk. Meanwhile Beck similarly points to the manufactured entities which, by way of their depiction and reception within socio-political contexts, lead to perceptions and experiences of risk – with certain corresponding reactions. Though differences in analytical lenses are undoubtedly apparent, *both* Beck and Douglas see risk as socially constructed. Indeed, as was acknowledged towards the start of the chapter, in terms of the categorization and value attachment that are fundamental to risk, risks are innately social and interpreted. As van Loon describes: 'It is thus

not difficult to see that risks are not real in themselves; they have to be realised in causal articulations of conditions with actions and actions with effects' (2000: 166).

In this latter manner, risk is very much about knowledge of causality. For Beck, the creation of new, human-made problems would not be significant on its own if these problems continued to be seen simply as hazards – happenings. That their manifestation is increasingly explained, causally attributed and therefore deemed potentially avoidable is what stimulates the politics, social dynamics and confrontation that are at the heart of his risk society portrait. The way in which such risk knowledge changes social conditions – and is thus powerful – suggests links to the work of Foucault, who was especially concerned with the influence of knowledge on individuals in society and furthermore with how this knowledge is capable of impacting upon behaviour, of changing how people perceive and manage their conduct.

As noted briefly earlier, Foucault died in 1984 and thus predated the turn towards risk within sociology. Yet his posthumous influence within several streams of sociological theorizing includes a particularly sizeable impact within social theories of risk. A number of theorists, not least those writing on topics of criminology, health practices and the changing role of the state, have found much of relevance within Foucault's analyses of power within modern societies – with a number of these working under an approach referred to as 'govern-mentality'. The starting premise of these insights is a reappraisal of power, not least state power, and its manifestations – in the light of Foucauldian conceptualizations. As Mitchell Dean, one of the foremost proponents of governmentality, writes: 'One of the consequences of Michel Foucault's approach to government has been to undermine the opposition, found in much social and political science, between power and domination, on the one hand, and individual freedom, on the other' (Dean 2007: 108).

In bridging this dualism, governmentality frameworks develop a critique of new forms of liberal governance (Dean 2007: 198), warding against false assumptions that a 'rolling back' of the state means that governmental power and influence across society is reduced. Rather than using a model of power that is exercised 'directly' through institutions, instead Foucauldians emphasize that power is dispersed throughout society – where power is viewed as 'an elaborate exercise between partners where one leads the other in their conduct, but only to the point where the one being led may act within a broad "field of possibilities" ' (Wilkinson 2010: 52). Thus power, in its ubiquitous shaping of actions, is always at work, but this shaping role is bounded through what is perceived and considered possible and appropriate – in other words by configurations of knowledge.

These configurations of knowledge, which guide action, might in some social theoretical frameworks be labelled as ideologies, but within Foucauldian thought they are referred to as discourses. 'Through the circulation of discourses, dominant institutions formulate language and information that generates and fuels prevalent ideas. Foucauldians believe that it is only through the working of discourse that we come to recognise and understand risk' (Mythen 2008: 306). In this approach, not dissimilarly to Douglas's approach, risk as a mode of discourse (for Douglas, a language of morality) is a way of conceptualizing the world and attempting to make it intelligible – calculable (Wilkinson 2010). Again, echoing Douglas, the governmentality lens casts risk as a framework in which consequences and outcomes are linked to, and associated with, certain types or forms of behaviour. It is in the knowledge of these causalities that risk holds individuals to account. For, once an individual is made aware that there is a certain likelihood that a particular aspect of their behaviour will result in x, they come to scrutinize their conduct of this behaviour in a new way.

This activation of responsibility and attention to conduct thus has power over individuals, provoking their awareness and monitoring of behaviour (the 'conduct of conduct') in a

distanced yet decidedly potent fashion: 'power relations are reproduced not by force, but by discourses that facilitate patterns of self-regulation' (Mythen 2008: 306). Empirical research that employs a governmentality framework therefore pays much attention to the considerations of actions of research subjects, but emphasizes – following Foucault – that the subject can never merely exist, but instead is cast and recast through the immersion of the actor within discourses: subjectivity is stimulated, directed and configured through dominant configurations of knowledge.

Foucault, like Beck and Douglas, underlined that the content of these knowledge configurations is defined by powerful interests – but placed greater emphasis upon the pervasiveness and influence of knowledge throughout society. Medicine is one distinct example of an establishment that, through its prominence within society, is able to shape how individuals conceptualize, experience and conduct their bodies. Dominant interests, such as medicine more generally, or psychiatry more particularly (e.g. Castel 1991), are critically analysed in terms of the categorizations that emerge within discourse. These delineations are seen as influential across society yet often arbitrary and confused, especially in their considerations of what is normal and what is 'other':

> if you are not like everybody else, then you are abnormal, if you are abnormal, then you are sick. These three categories, not being like everybody else, not being normal and being sick are in fact very different but have been reduced to the same thing.
>
> *(Foucault 2004: 95)*

The way such 'knowledge' distinctions are, to the extent that they are pervasive, then internalized and impact on individual actors is a focal point of governmentality analyses: 'It is not so much that individualisation gives rise to risk consciousness, but rather that conceptualising the social world in terms of risk promotes an individualising world view' (Wilkinson 2010: 56) which is most relevant to these analyses. This individualizing approach is, once again, interwoven with notions of blame – where poor outcomes are attributable to the responsibilized citizen who failed to appropriately manage their behaviour. The technocratic-scientific language in which risk discourses are expressed suggests a value neutrality, but of course these processes are deeply political in that individualized responsibility enables the state to abdicate its own liability for the conduct of citizens. Public sphere debates, influenced by – while also propagating – this risk discourse, hold morally deficient individuals to account while overlooking the failings of state and society.

Neo-liberal models of the state, especially visible within Anglo-Saxon polities, though a growing influence within mainland Europe (for example in the Netherlands) and elsewhere, are built upon this conception and creation of the responsible subject. An interesting paradox within governmentality accounts, however, is that the application of risk also leads to the demise of the subject – replaced within procedures of scientific-bureaucratic medicine or modern crime management techniques by a dehumanized object. This process is most clearly articulated in the seminal paper by Robert Castel (1991), who describes developments within approaches to 'dangerous individuals' within mental health services – at the nexus of medicine and crime prevention.

Castel depicts a shift away from a 'person-centred' model of care, albeit one based on incarceration of the potentially dangerous, to a risk-centred model where an individual is assessed as risky not so much on their individual presentation and ongoing relationship with the professional but on their technocratic classification as a conglomeration of risk factors:

> A risk does not arise from the presence of particular precise danger embodied in a concrete individual or group. It is the effect of a combination of abstract *factors* which render more or less probable the occurrence of undesirable modes of behaviour.
>
> *(Castel 1991: 287)*

While especially visible within psychiatry, this technicization of the individual–professional relationship is a growing feature of health, social care and many other welfare state services. The predominance of the 'risk lens' leads to an alienating experience for both the professional – reduced to technician – and the service user or patient, who is reduced to an object – deconstructed through logics of various health, welfare or crime risks.

Critiques of the governmentality approach

This creation, and then 'death' (Jones 2001: 165), of the subject – at the hands of discourse – is one straightforward narrative for understanding Foucault's gloomy assessment of the insidious function of knowledge within modernity. It is the most pessimistic of the three accounts considered thus far in this chapter, contrasting particularly with the optimism of Beck, who, seemingly inspired by Habermas, proposes various solutions for rescuing the Enlightenment project. Governmentality approaches, in contrast, tend to offer few answers to the problems raised, and this, in itself, might be seen as a weakness – to the extent that one sees sociological theory as having an emancipatory teleology.

At the heart of this hopelessness lies the limited agency imbued within Foucault's subjects; at least this is one assessment of his work by Giddens (Jones 2001). This may, however, be more of an issue in how his writings have been interpreted, in that Foucault himself (particularly in his later work) clearly denotes that manifestations of power are innately defined by different patterns of resistance and 'counter conducts' (Dean 2007: 9), therefore seemingly drawing attention to potential modes of agency in the midst of domination. Unfortunately, such variations in forms of resistance are not always clearly apparent within governmentality approaches following his work. The extent to which certain actors internalize discourse, and acquiesce through self-monitoring, or not, belies neat explanation within a number of Foucauldian studies. In this sense there is a sharp contrast with the parsimony of Douglas's (2006) categories in distinguishing between different attitudes and perspectives towards risk and government through her grid-group classification.

The neatness of Douglas's typology, her orientation towards specific groups and individuals, as well as the way her work (especially that with Wildavsky in 1982) sets out a clear, comparative research project, has meant that her approach has proved much more influential amongst practitioners in the field of risk management than the other two frameworks referred to in this section (Wilkinson 2010: 80). Foucault's writings – though referencing empirical cases – are, like Beck's, more theoretical and polemical. Both these latter authors, in seeking to offer expansive historical accounts in their musings on modernity, develop formats of analysis which are theoretically fascinating but empirically obtuse, with a number of key concepts difficult to operationalize.

The grand theory approach combined with the impaired agency within governmentality understandings has accordingly resulted in some empirical research that is less then compelling. The ubiquitousness of power within social contexts, as perceived through a Foucauldian lens, creates a concern that researchers will almost inevitably find domination if they go looking for it (Jones 2001: 166). This is not an insurmountable problem, and some fine governmentality studies undoubtedly exist (see especially a number of articles within the

journal *Economy and Society*, e.g. O'Malley 1992; de Goede 2004). Nonetheless a danger remains, especially for less experienced researchers. Great subtlety is needed in considering how, and in what contexts, ambivalence or indifference towards authoritative risk information emerges.

Moving from risk towards a range of rationalities

Contrasting risk logics and priorities

One theoretical framework that has not been addressed thus far, but which is a significant sociological approach to risk, is the work of Niklas Luhmann (1993), rooted in his systems theory of society. Through its grounding within this broader theoretical framework, Luhmann's considerations of risk offer a sophisticated and broad-ranging, if somewhat complex, analysis. This latter issue of complexity, which incidentally is, for Luhmann, the defining problem within modern society, is why a fuller account of his considerations of risk have not been discussed here, due to the confines of the current chapter. Nonetheless it is useful to draw attention to one or two key aspects of his theoretical account that are instructive for our concerns at this stage.

Systems theory helps us understand why two organizations, or individuals, may look at the same phenomenon and conceive of its riskiness (or otherwise) in utterly different terms. It has been noted earlier that Douglas analyses this in the context of group/social dynamics, yet Luhmann offers in some ways a more direct explanation that focuses attention on the specific goals of each person or organization. The teleology or purpose of a particular actor defines the logic and currency of perception and communication, depending on the specialized system in which they are located: 'The economic system observes everything in terms of consequences for liquidity and property; the scientific system observes everything in terms of consequences for knowledge recognised as true' (Japp and Kusche 2008: 78). In this example, a decision may be risky in an economic sense (as regards future property formation) but have no bearing in a scientific sense, or vice versa.

Central to Luhmann's analysis is an increasing functional differentiation between such systems within modernity. This has three significant implications for our considerations of risk: 1) previous hierarchies of knowledge 'dissolve', which means that there is no overarching authority to direct actors (Japp and Kusche 2008); 2) correspondingly actors must refer to their own logics and knowledge in making decisions; and 3) diverging systems of reference and corresponding logics make it increasingly likely that a multiplicity of views exist regarding what is risky or not, with diminishing amounts of 'common ground' (ibid.). Thus, in explaining the variation of views between different actors, this approach points towards the particular logics and rationalities applied within specific systems and/or by specific individuals.

Returning now to some of the questions that emerged in the previous section's discussion of governmentality, from the systems perspective it would seem that the extent to which an individual actor internalizes, or is resistant towards, a particular discourse (for example, knowledge on 'eating well') relates to the priorities and goals of the individual, and the corresponding logics that appear relevant. Where a certain risk discourse, though dominant, is highly differentiated from the logic of a particular individual, group or organization, so is this discourse likely to fall on deafened ears (Brown 2012). More proactively, an individual is able to resist certain discourses to the extent that alternative logics are available that are sufficiently differentiated from the dominant discourse, and which are compatible with the individual's own logics and goals.

Luhmann (1993) typically refers to systems and sub-systems within society or organizations that perform particular functions: science, politics, the legal system, accounting, and so on. The preceding paragraph adapts this position somewhat to suggest that groups and individuals also have their own goals and related logics, as is acknowledged within certain systems theory approaches, which enable them to reduce complexity and cope with everyday decision making. This is a slightly flexible interpretation of Luhmannian systems theory, but it is applied here as useful in seeking to assist further consideration of the different rationalities applied towards risk across society.

As to the genesis of these different logics, it is vital that we do not consider actors (individuals, groups, organizations) through a framework that disregards history. Existing group dynamics and system logics are important, but it is in the biographies of groups and individual actors that we come to appreciate their development and the corresponding emergence of various attitudes and perceptions towards risk. Bourdieusian approaches that consider field, habitus and practice (see Chapter 4) are especially instructive here, particularly in being able to accommodate attitudes and perceptions of risk that function at a less-than-conscious level, and how these develop. Through this framework we derive an understanding of how individual and group 'logics of practice' are linked to specific risk perceptions and behaviour through enduring social contexts and the dispositions these inculcate (Crawshaw and Bunton 2009).

Habitus, as an assemblage of perceptions, preferences and logics, is a useful concept in considering how people's dispositions – rooted within their social spheres and inculcated within social biographies of the individual's life course – shape risk 'decisions'. The extent to which logics are embedded within social contexts and bounded by the taken-for-granted helps us move away from inaccurately narrow models of individual behaviour that overemphasize calculation. Dispositions – for example, 'a gender specific form of habitus which determines the practices of young men through requiring them to demonstrate a particular form of tough working class masculinity' (Crawshaw and Bunton 2009: 279) – sensitize individuals to certain types of risk (such as loss of face from avoiding confrontation) while distracting from others (risk of harm from violence), thus making certain perceptions and behaviour more or less likely. What becomes clear in this example is that, rather than individuals being completely unaware of certain risks, local social contexts configure and inculcate certain patterns of risk priorities. Through habitus some risks are considered ahead of others, reflecting a format in which multiple goals are integrated with one another and where there is a reconciling or 'trade-off' between different time frames (short-term versus long-term).

Risk as one strategy amongst many

Early in this chapter the Royal Society definition of risk was rehearsed (and problematized) as pertaining to future events, probability and time frame. In considering various social theoretical positions, the chapter has continued to draw attention to the fundamental idea that risks do not simply exist; rather, risk is a lens through which the future is perceived, understood and potentially acted upon. For effective sociological analysis it is vital that the lay conception of a risk as a reality which is 'reacted to' is avoided. If, instead, risk is considered a method of approaching the future, and planning or calculating in terms of potential eventualities that lie ahead, it becomes clear that this approach is but one of many.

This understanding is usefully fleshed out by Zinn (2008), who posits risk at one end of a spectrum of approaches by which social actors are able to manage future uncertainty within

their everyday decisions and actions. For Zinn (2008: 442), risk is an example of a 'rational' approach to the future, seeking to harness knowledge accumulated through past experiences, 'weighing up the pros and cons' and therefore calculating (and/or harnessing insurance) as a way of planning around uncertainty. This application of 'rationality' is contrasted with 'non-rational' approaches such as faith and hope. Here there is little or no evidence basis for the belief, thus enabling hope to be maintained even in seemingly despairing situations (Brown and Calnan 2012).

The delineation of this spectrum between the rational and non-rational then enables Zinn to posit further strategies – particularly trust, intuition and emotion – as taking place 'in between' the rational and non-rational. Trust, for example, is rooted in past experiences, assembling knowledge drawn from these as a way of inferring expectations about the future (Brown and Calnan 2012). Yet there is always a limitation – that one never really knows what will happen – and so a 'leap of faith' is always necessary for trust (Möllering 2001). It is this mixing of the rational – applying knowledge acquired from past events – with the non-rational – the inevitable 'leap of faith' – that draws Zinn to consider trust as 'in between'. Yet, as useful as Zinn's (2008) framework is in beginning to delineate between different formats of decision making and acting amidst uncertainty, the use of the concept of rationality in describing this spectrum may potentially lead to confused analyses (as Zinn himself later acknowledges).

In considering why certain ascriptions of rationality are problematic, it is useful to return to notions of trust and its integral leap of faith. Following Simmel amongst others, Möllering (2001) draws attention to the intractable 'problem of inductive knowledge' which any consideration of the future entails: no matter how much is known about the past, there is never a guarantee that what happens in the future will continue to follow observed patterns. This *always* renders necessary a leap of faith, which is simply more explicit within notions of trust. Hence the problem of induction is similarly intractable even when actors are applying a rational, risk-oriented approach. The leap of faith, a 'non-rational' component, is also intrinsic to this 'rational' decision-making context (Brown and Calnan 2012).

From this starting point it can be argued that – whether a more calculative approach is being applied, intuition is being invoked, or individuals are acting 'in faith' – actors are always 'trusting' in something, be that science, personal tacit knowledge or a higher power. There are of course clear differences in these approaches in terms of the way knowledge of the past is invoked and deemed pertinent; the extent to which the unknowableness of the future is recognized; and the format of expectations regarding the likelihood of certain outcomes. These are more analytically helpful ways of differentiating between approaches to uncertainty than the use of rational and non-rational labels (Brown and Calnan 2012). By considering multiple and complex rationalities employed in relation to uncertain futures, a more unassuming framework for analysis is created. Within such a framework – in paying attention to Knight's (1921) cautions regarding actors' abilities to define good futures, their understandings as to what information is relevant or not in planning for these, and the imperfections of the knowledge that is relied upon – sociologists are able to avoid the privileging of certain 'rationalities' over others.

This leads back to approaching risk, as has been acknowledged within various parts of this chapter, as a notion imbued with profound moral weight and corresponding ethical implications. Such considerations relate to the multiplicity of ways in which risk is invoked within political and social life, but also, of course, in the study of the concept by social scientists. By avoiding hierarchies of rational and non-rational behaviour, and by conceptualizing risk perceptions and behaviours as products of social contexts and corresponding logics of

practice, sociologists can seek to ward against the individualizing blame that often rests implicitly within attributions of 'dysfunctional', 'inappropriate' or 'insufficiently rational' risky behaviour.

The significance of sociological analyses of risk: future possibilities

It is when sociological theorizations of risk and uncertainty are contrasted with other frameworks within the social sciences that their analytical purchase becomes more apparent. Behavioural economics and cognitive psychology perspectives on judgement and decision making amidst uncertainty, both significantly influenced by the seminal work of Daniel Kahneman and Amos Tversky, fall into similar problems as those outlined above due to underlying assumptions regarding the rationality or irrationality of the individual. There is the danger in this type of research that, alongside the fascinating insights provided, rationality comes to be applied as a tautological concept that acts as an obstacle, or 'intellectual cul-de-sac' (Brown and Calnan 2012), to richer understandings of differences in perceptions and the influence of social contexts upon these. Sociological approaches, by and large, are less effective in deconstructing the precise nature of judgement biases but add much in linking variations in judgements and behaviours to the everyday social environments.

Behavioural economics approaches have recently become influential within US and UK policy-making circles. Research by the likes of Richard Thaler and Cass Sunstein (for example in their highly praised book *Nudge*, 2008) has garnered the attention of policy advisors, and, though in many ways inspired by psychology, these frameworks make moves towards a more sociological consideration of decision making amidst uncertainty. By focusing on the various ways in which human actors 'follow the herd', some attention is paid to the influence of social norms and individuals' embeddedness within networks of actors. This is leading these behavioural approaches to a greater awareness of social context and group dynamics (Brown 2012).

Although this can be seen as a positive shift, these social contexts continued to be construed rather narrowly, and there is a failure to appreciate many of the sociological considerations that have been noted above. Further engagement with this corpus represents a potentially fruitful path of exciting insights via interdisciplinary collaboration. The synthesis of psychological approaches with conceptualizations such as discourse and conduct, group hierarchies and cohesiveness, and individualization and reflexivity may give rise to fascinating outcomes. The current influence of behavioural economics may also open up new possibilities for sociological engagement to influence policy outcomes (Brown 2012).

Any such engagement would need to draw on approaches that more concretely root dispositions to act within socio-biographical contexts (Brown 2012). To this end Bourdieusian approaches to risk and uncertainty, as sketched above, offer much and as yet remain largely under-explored. The ways in which the concept of habitus, through the Schutzian dimensions of its DNA, enables greater consideration of the less-than-conscious and taken-for-granted aspects of risk behaviour are highly promising. While Kahneman- and Tversky-inspired work separates rational-conscious-calculative functions from their irrational decision-making counterparts, dispositions and 'logics of practice' as inculcated through social contexts offer possibilities for a more nuanced account of the balance between reflective action and less-than-conscious inclination (Crawshaw and Bunton 2009; Brown 2012).

Moving away from the individual and group level of analysis, new avenues of research have emerged that consider the ways in which organizations or larger institutions handle risk and

the types of risk policy that emerge over time. Partly influenced by the work of Michael Power and Christopher Hood, Rothstein (2006) proposes a new domain of theoretically informed research into the 'institutional origins' of risk, especially regarding how path-dependent trajectories towards certain styles of risk management become manifest. Though recognized by theorists in this field, the work of Douglas and Wildavsky (1982) on the varied responses by different 'types' of organization within their explanatory model has not been considered in significant depth. General tendencies towards 'risk colonization' (Rothstein 2006) are explained, but more attention to whether organizations are more or less hierarchical and/or cohesive could offer significant analytical utility in understanding divergent styles of risk governance across organizations.

Finally, and returning to the Weberian starting point of this chapter, there is still the enduring social theoretical conundrum of 'modernity' and the place of risk within the novel or continuing features of current social formations. By focusing on the fundamental issue of suffering, Wilkinson (2010) offers an insightful analysis of the peculiar challenges faced within current times while also emphasizing certain enduring commonalities across history. Partly drawing on Tenbruck, Wilkinson reworks the Weberian concept of theodicy – the problem of reconciling religious belief with continuing suffering – and suggests that current social tensions are similarly rooted in 'sociodicies' – the underlying problem that 'all cultural outlooks on life are bound to fall short of providing people with a wholly sufficient means of dealing with the "irrational force of life" ' (Wilkinson 2010: 29).

This approach, firmly grounded in Weber, provides a range of analytical tools regarding the drive to rationalization in the face of suffering and suggests that, as this process intensifies, so too does the palpable awareness of the irrationality, unpredictability and 'charismatic needs' of social life. Risk is one central feature within this rationalizing response to suffering, and problems surrounding risk, at the individual, organizational and state policy levels, could be usefully considered via the continued presence of 'charismatic needs' and the failings of certain bureaucratic-instrumental approaches to attend to these. This provides a useful foregrounding for new, more overarching theorizing of current social transformations and their relation to risk. It furthermore emphasizes that the roots to such future developments in theorizing this topic may be found in the rich corpus of classical sociology.

Notes

1 Though Beck (1992) is more concerned with the breakdown of accountability and the sub-politics of risk.
2 It is a shame that, though publishing their key works at very similar times, Douglas and Beck each fail to address the work of the other significantly.

References

Beck, U. (1992) *Risk Society: Towards a New Modernity*, London: Sage.
Bernstein, P. (1996) *Against the Gods: The Remarkable Story of Risk*, New York: John Wiley and Sons.
Brown, P. (2012) 'A nudge in the right direction? Towards a sociological engagement with libertarian paternalism', *Social Policy and Society*, 11(3): 305–17.
Brown, P. and Calnan, M. (2012) *Trusting on the Edge: Managing Uncertainty and Vulnerability in the Midst of Serious Mental Health Problems*, Bristol: Policy Press.
Brubaker, R. (1984) *The Limits of Rationality: An Essay on the Social and Moral Thought of Max Weber*, London: Allen and Unwin.
Castel, R. (1991) 'From dangerousness to risk', in G. Burchell, C. Gordon and P. Miller (eds) *The Foucault Effect: Studies in Governmentality*, Hemel Hempstead: Harvester Wheatsheaf.

Crawshaw, P. and Bunton, R. (2009) 'Logics of practice in the "risk environment" ', *Health, Risk and Society*, 11(3): 269–82.

Dean, M. (2007) *Governing Societies: Political Perspectives on Domestic and International Rule*, Maidenhead: Open University Press.

de Goede, M. (2004) 'Repoliticizing financial risk', *Economy and Society*, 33(2): 197–217.

Desmond, N., Prost, A. and Wight, D. (2012) 'Managing risk through treatment-seeking in north-western Tanzania: categorising health problems as malaria and nzoka', *Health, Risk and Society*, 14(2): 149–70.

Douglas, M. (1992) *Risk and Blame: Essays in Cultural Theory*, London: Routledge.

—— (2006) 'A history of grid and group cultural theory'. Available online at http://projects.chass.utoronto.ca/semiotics/cyber/douglas1.pdf (accessed 29 January 2012).

Douglas, M. and Wildavsky, A. (1982) *Risk and Culture: An Essay on the Selection of Technological and Environmental Dangers*, Berkeley, CA: University of California Press.

Elliott, A. (2002) 'Beck's sociology of risk: a critical assessment', *Sociology*, 36(2): 293–315.

Foucault, M. (2004) 'Je suis un artificier', in R.-P. Droit (ed.) *Michel Foucault, Entretiens*, Paris: Odile (interview from 1975; translated by Clare O'Farrell).

Furlong, A. and Cartmel, F. (1997) *Young People and Social Change: Individualization and Risk in Late Modernity*, Buckingham: Open University Press.

Giddens, A. (1991) *Modernity and Self-Identity: Self and Society in the Late Modern Age*, Cambridge: Polity.

Heyman, B., Alaszewski, A. and Brown, P. (2012) 'Health care through the lens of risk', *Health, Risk and Society*, 14(2): 107–15.

Japp, K. and Kusche, I. (2008) 'Systems theory and risk', in J. Zinn (ed.) *Social Theories of Risk and Uncertainty*, Oxford: Blackwell.

Jones, I. R. (2001) 'Health care decision making and the politics of health', in G. Scambler (ed.) *Habermas, Critical Theory and Health*, London: Routledge.

Knight, F. (1921) *Risk, Uncertainty and Profit*, Boston, MA: Houghton Mifflin.

Langlois, R. and Cosgel, M. (1993) 'Frank Knight on risk, uncertainty and the firm: a new interpretation', *Economic Inquiry*, 31: 456–65.

Luhmann, N. (1993) *Risk: A Sociological Theory*, New York: Aldine de Gruyter.

Möllering, G. (2001) 'The nature of trust: from Georg Simmel to a theory of expectation, interpretation and suspension', *Sociology*, 35: 403–20.

Moore, S. and Burgess, A. (2011) 'Risk rituals?', *Journal of Risk Research*, 14(1): 111–24.

Mythen, G. (2005) 'Employment, individualization and insecurity: rethinking the risk society perspective', *Sociological Review*, 53(1): 129–49.

—— (2008) 'Sociology and the art of risk', *Sociology Compass*, 2(1): 299–316.

O'Malley, P. (1992) 'Risk, power and crime prevention', *Economy and Society*, 21(3): 252–75.

Rothstein, H. (2006) 'The institutional origins of risk: a new agenda for risk research', *Health, Risk and Society*, 8(3): 215–21.

Royal Society (1992) *Risk: Analysis, Perception and Management*, London: Royal Society.

Thaler, R. H. and Sunstein, C. R. (2008) *Nudge: Improving Decisions about Health, Wealth and Happiness*, New Haven, CT: Yale University Press.

van Loon, J. (2000) 'Virtual risks in an age of cybernetic reproduction', in A. Adam, U. Beck and J. van Loon (eds) *The Risk Society and Beyond: Critical Issues for Social Theory*, London: Sage.

Wilkinson, I. (2010) *Risk, Vulnerability and Everyday Life*, London: Routledge.

Zinn, J. (2008) 'Risk society and reflexive modernisation', in J. Zinn (ed.) *Social Theories of Risk and Uncertainty*, Oxford: Blackwell.

10

Networks

Thomas Birtchnell

Enmeshed in networks

You are about to catch public transport. As you get on board you notice a couple of seats ahead of you an acquaintance touching their smartphone rapidly; in fact, they are texting you now. As your phone vibrates you realize there are networks of very many different types all around. There are the communications systems, which your phone is a part of, allowing you to keep in touch – even though you are physically co-present in this case – through the touch screen. These same communication systems allow instant contact to distant and near social networks of families, friends and colleagues.

You wave your hand, realizing the acquaintance is saving a seat for you, which explains their seemingly pointless text. As you sit down and start to move another network surfaces in your mind. Around you is a sophisticated transport network with connections, timetables, stops, signs, online ticketing and passengers. Before alighting and debarking these passengers knot together in groups in order to travel, just like you. Sometimes this is taken for granted, as in the daily commute; other times it is stressful and seems to only hang by a thread, as on holidays.

As the next stop approaches you suddenly notice the half-spherical opaque dome attached to the ceiling. Your friend asks you whether you think anyone is on surveillance at the moment. You realize you do not know; there are many distributed power networks that watch you and make you watch yourself, acting on the premise of security, safety and care. These networks are systems of remote and distributed power. As you look up at the hooded camera it occurs to you that to go unseen you would need to have friends in high places. This all-seeing, obvious (and at the same time obscured) distribution of power, literally above your head on this occasion, would make you think twice about fare evasion, if you were that way inclined.

In this example I illustrate the common networks most come into contact with in everyday life. These (some very recent) instances of networks use the term metaphorically; however, the ontology of this metaphor is unclear. Despite this confusion the network is one of the most commonly used terms in the social sciences and indeed across many academic disciplines.

A summary and exposition of the term is a daunting task, made harder by the fact that there are many handbooks dedicated solely to unpicking the finer points of network analysis, some quantitative in scope, others qualitative. All agree that the network is a metaphor, yet there has not been to date a simplified introduction and explanation of this concept, making it seem that this term for complex things is itself complex. Unlike other handbook entries,

this chapter does not presume that the network is only a methodology for research, although network analysis is certainly a popular method in explicating networks. Other authors have created excellent resources for understanding the methodological aspects of network analysis in the social sciences and particularly its development in the disciplines of mathematics, physics and computing (Scott and Carrington 2011). Others have made a strong case for the central place of the network metaphor in social science in and of itself (Cavanagh 2007). What heritages tie these common uses of the word together?

In this chapter I look at the development of social network analysis from a conceptual angle, exclusively focusing on the social science uses of the term as a metaphor, but also informed by its progress in social network analysis of a more quantitative sort. Unlike other handbook entries, this chapter seeks to reconcile the network-as-metaphor and the network-as-tool in defining real-world phenomena.

To assist with this task I begin with a collection of quite eclectic references to illustrate the term's history of use, so the reader can see how it has developed and been used up to the present day. I also gauge how useful the metaphor remains for such diverse topics as communications, transport and power. It comes across as tautological to say that the network as an idea is interlaced, interdependent, complex and striated. But what needs to be made clear is that networks must start somewhere, often simply as relationships between single entities. Network analysis itself has undergone evolutions as it has branched out from defining observable clusters within organic matter in plants, sea creatures, and animal and human bodies to societies, landscapes and communications. It is this dichotomy between the simple and complex, the surface and the in-depth, that the observer of network analysis is struck by in looking at the history of the idea and its use.

'That Napkins, Mantles, a Purse and Rope have been made of it, has been shewn already; and we are told that *Septalla*, Canon of Millan had thred, roaps, net-works, and Paper of it' (Plot 1685: 1060). A discourse concerning incombustible cloth between two London merchants demonstrates early understandings of a network as a finely worked single item. The merit in briefly illustrating the intellectual development of the term 'network' and showing some of its earlier (often hyphenated) uses is to show how the word occurred when not a metaphor. Some of the earliest examples of the use of the metaphor emerge from early observations in what we know now as the disciplines of biology and botany, as well as anatomy, where comparisons are drawn to this original meaning. These were all disciplines in the front line, so to speak, of the gathering complexity of observation. The realization that there were tangled, tightly knit networks linking elements together in language, society, organisms, the landscape and the body represents an epistemological revelation formative in the production of what we know as science and the thinking we now take for granted as 'truth' in the will to knowledge.

After reading this chapter you should hopefully be equipped to understand how the network has been used to capture relationships between all sorts of elements and in turn how social scientists have incorporated the concept into many of their keystone theories. The network as a term now surrounds us: network travel, network computing, social networking, career networking, neural networks, security networks and alumni networks are just some examples. All of these forms are themselves related by a need to describe relationships between points.

Historical development of the network

'The network metaphor? A network metaphor? I don't think so . . . the network is not a familiar object to most people. Certain kinds of nets may be familiar, such as fishing nets to

fishermen' (Lamb 1999: 117). The word 'network' is a metaphor, but a metaphor for what and from where? In this chapter I take the term 'network' and its ontology not only as the evolution of a technical method involving matrices, homophily, cliques, game theory, visualization, simulation, and so on (many excellent handbooks already exist on the history and technical practice of this sort of social network analysis – see for example Prell 2011), but also as a way of thinking in social science theory that has informed many major theoretical streams. Perhaps the word's meaning has evolved in some cases to be almost unrecognizable from its original meaning, but the earliest uses of the term in fact share a common etymology to contemporary applications in medicine, science and social science. To be sure, the original meaning is now clouded due to the term becoming an 'isomorphism' for our times (a common form with differing content), and indeed now everything seems to be a network (Cavanagh 2007: 23). In many ways the development of this isomorphism is tied to how knowledge historically has been constructed from many ambiguous elements through the ordering of 'things'. A single element was tied to 'networks connecting any point in the body with any other', and this was observed in plants, insects and their fossils, indicating a general architecture more widely in nature and cognition (Foucault 2002: 294).

Anatomies

In *A Networked Self* Papacharissi (2011) highlights that even yeasts and the organic organisms in the body share networks with humans that can be unpacked by network analysis. This idea in fact has a long lineage. The cover of Thomas Hobbes's *Leviathan* by Abraham Bosse, printed in 1651, shows a giant King Charles I, composed of more than 300 people, looming over the city (Figure 10.1). Here the network of subjects that make up the 'head' of the state's body politic represents a social network of subjects.

From featuring in observations of visible structures, the network metaphor progressed to featuring in early examinations of organic life, distinguishing between the observable 'net' and the 'work', which suggested an understandable and logical intervention lying behind the complex structure. In a letter from Emanuel Mendes da Costa to the Right Honourable George Earl of Macclesfield, da Costa writes in an account of fossilized plants that the 'impression is much like what might be made by the branches of the common fir, after the leaves are fallen or stript off . . . but, when attentively viewed . . . the sides of the rhombs, or the network, are raised, or in relief' (1757: 230). In his 'Economy of vegetation', physician and natural philosopher Erasmus Darwin also drew parallels between many plants and the body: 'each red cell, and tissued membrane spreads, in living net-work, all its branching threads' (1798: 94). The eighteenth and nineteenth century observers of human and leaf veins, structures that emerged from deeper analysis, were part of a heritage of knowledge about how vital externalities were transmitted efficiently between producing and processing centres. These connections are 'nodes': a companion word that retains its etymological roots from 'knots' as in a 'net' and apropos a 'knot' on a tree trunk or a 'knotted' muscle.

It is evident that the network metaphor was useful in medical terminology, particularly in anatomy, drawing on a similar palette of observations to botanical analysis. James Parsons's analysis of muscular motion, presented before the Royal Society, pointed out 'the form of a chain of distensile vehicles, whose sides are covered with a net-work of elastic longitudinal and transverse blood-vessels' (1744: 39). Similarly, William Hewson, Reader of Anatomy, described his experiments with injections in an account of the lymphatic system in birds where 'some vessels were filled, contrary to the lymph, from the network near the root of the coeliac artery' (Hewson and Hunter 1768: 219). The dense parts of the body made up of

Figure 10.1 Leviathan of Hobbes. Upper half of the frontispiece of the first edition of Thomas Hobbes's book *Leviathan*, published in 1651. © Look and Learn.

many strands of connecting tissues came to be seen as networks – a definable structure in itself – through which the fluids of the body where transmitted as 'information'. Previously this information was understood as invisible or gaseous miasmic 'humours' composed of black bile, yellow bile, blood and phlegm; however, this idea was superseded by the notion of 'circulation'. As an introductory lecture delivered at King's College by Professor of Forensic Medicine W. A. Guy surmised: 'trace the nervous system from its centres, so strongly and skilfully defended from external injury, to the minute and intricate net-work which it weaves about every texture of the frame' (1842: 29). The nature of these ideas about networks, which saw them not only as curious structures, but as having the function of channelling the body's information, became a bedrock of modern medical and indeed scientific understanding, underpinning theories of how the nervous and circulatory systems worked and revealing a wider architecture and logic. The popularity of the term 'network' to describe complex social relationships, where communicative information between the cores and peripheries is transmitted and makes up the state, is also highlighted in the extension of the metaphor again to more abstract social complexities and transfers, not of organic fluids, but of social ideas.

Societies

A rousing article featured in *National Magazine* on the repeal of the Union in Ireland makes the connection between ideas and fluids and the original meaning of the word 'network':

'And we are quite sure, that the well-thinking dissenters of the North see through the flimsy tissue of the network that is set to haul them in' (1830: 639). As the word entered the general lexicon its adoption in the social sciences became widespread, notably in ethnologists' studies of social groups. Hence Thomas Hutchinson, in writing on social and domestic 'traits' of African tribes, makes clear 'the mighty network of ju-juism or fetishism is too extensive in its ramifications to be unravelled in a single lecture' (1861: 334). As social scientists began to unravel and classify social systems the network proved to be a valuable term for the complexity of elements in a system.

At the same time as ethnologists developed complex ideas of relationships between people, the understanding that lineages and family ancestries within the formal science of anthropology were far more complex than previously supposed, spanning millennia rather than thousands of years, saw the birth of the idea of the network in academic parlance. In an address to anthropologists in Nottingham, the President of the British Association W. R. Grove asserts: 'Let anyone assume that one of his ancestors at the time of the Norman conquest was a Moor, another a Celt, and a third a Laplander . . . the pedigree, going back to the time of the Conquest, instead of being represented by diverging lines, would form a network so tangled that no skill could unravel it' (1866: 387). From here it was only a short step to the cooption of the network concept (and its connotations of human organic complexity) to highlight complex subjects such as the 'network of administrative tyranny from which France has not recovered' (Vericour 1872: 15–21). And in parallel the term became part of the lexicon of history as well, attributed to less tangible phenomena than lineages: bureaucratic, political and corporate power. The concept of society as a social network thus emerged at this time as a contained grouping of common factors linked through religion, culture and class: 'This gradual growth of persons out of the rude but strong social network of early times appears more plainly in the institutions of feudalism' (Weeden 1882: 63). From here the network became a powerful tool for social thinkers. The first English edition of Karl Marx's *Capital: A Critical Analysis of Capitalist Production*, translated by Samuel Moore and Edward Aveling and edited by Frederick Engels, referred to the 'circulation of commodities' and, perhaps playing on the example of the weaver and his linen, 'a whole network of social relations spontaneous in their growth and entirely beyond the control of actors' (1887: 86). So what emerges from observation in botany and anatomy is a flexible and dynamic metaphor with universal meaning and allusion to a much more complex cataloguing of knowledge spanning social science. Eventually 'the whole social network' is linked to 'an individual's social environment' (Thouless 1939: 118). And this metaphorical technical use predates, but intimates, the quantitative technical applications now familiar in network analysis.

Mobilities

H. G. Wells was certainly not the first to note the similarity of the built landscape to the social: 'History finds already in its beginnings a thin network of trading and slaving flung over the world of the Normal Social Life, a network whose strands are the early roads, whose knots are the first towns and the first courts' (1912: 7). With the great expansion in populations and infrastructures at the end of the nineteenth century came an increase in comparisons of infrastructures to living organisms: for instance, the comparison of the city to the human body. The shift of the network metaphor from the body to the social and then to the geographical was a logical progression. Indeed, as Justice Alexander B. Hagner read before the Historical Society of Washington in 1897, 'There can be no greater boon to a city than spacious and convenient streets and avenues. They stand for its arteries and veins as public

parks do for its lungs' (1904: 237). The metaphor of the network gained further currency in describing cities and transportation, most obviously in the tapering nodes and connections of railways and roads. For example, the *Railway Shareholder's Manual* describes 'in Prussia, a comprehensive system of lines, embracing the whole kingdom as with a network' (Tuck 1848: xxxviii). While the opening of the Manchester and Liverpool connection in 1830 was seen as the dawn of the railway era, by the second half of the nineteenth century the word 'network' was firmly established as a technical term for rail infrastructure; for instance it was used to describe an 'equally vast railway network . . . a continuous railroad will run from Dover to the Bosphorus, from the Bosphorus down the Euphrates, across Persia and Beloochistan to India, and from India to China' (Baxter 1866: 595). The landscape of railways and urban streets resembles a net, most graphically from the air, where it strikes the observer as like a body or organism in function.

As urban hubs grew and were technically illustrated in the increasingly sophisticated, technical maps – and particularly in early aerial photography – what appeared to viewers to all intents and purposes were networks that could be analysed through tracing relationships between different social centres and trade hubs in the same way as circulations of blood or sap. The term 'network' became formalized and part of a technical lexicon used by transport and logistics experts, although retaining some of the earlier meanings: rail networks are still described as having 'branch lines' and automobiles drive on 'trunk roads'.

Metaphors of power, elements and movement

While 'the excessive use of jargon has now diluted the network metaphor almost to the point of irrelevance' (Gulati 2007: 258), there is, if careful attention is paid to the history of the metaphor, hope for its continuing value. Without an understanding of how the idea of the network developed – initially through comparisons to the structures of the body and of organisms, then to the political and social, and finally to mobilities in transport and finance systems – the network metaphor might indeed seem detached from its origins and intended application. But for social scientists, just as much as mathematicians, computer scientists and even neurologists, the idea of the network has emerged as an heuristic (or way of thinking) for understanding interdependencies, relationships and complexities that range across the body, the world around us and indeed the systems we depend on for movement. Building on this short survey of the evolution of the network metaphor, in the next section I look more closely at the claims made about and developments of network analysis in social science theory and the ways that the network has shaped thinking on complexity, communication, systems, movement and relationships.

Major claims and developments

The network is unequivocally a key concept in the social sciences. In the previous section the etymological threads of the word were tied together in relation to how it was used in various contexts, from anatomical structures to hereditary lineages and transport lexicon. In this section, I turn to the contemporary usages of the network in social science thinking, which has its roots in this rich history. Interestingly, the various different meanings of the term can still be seen to resonate in recent usages, retaining traces of lineages from these historical antecedents in application to empirical analysis. Anatomical ideas influence the notion of distributed 'capillary power' and elites. Relationships between human and non-human actors lie at the core of understandings of the social in actor network theory (ANT). And

the patterning of transport and urban structures influences thought on mobilities and 'network capital'.

Capillary power

In the documentary *La Sociologie est un Sport de Combat* Pierre Bourdieu is seen candidly discussing with students in a seminar the influence Michel Foucault had on his later work on power and elite networks (Carles 2001). Foucault's notion of 'capillary power' is one where power relationships are distributed between a great many points, just like in the circulation of blood through fine branching blood vessels. The idea that Bourdieu sought to document in his research was that elites do not proceed through fixed pathways to power but utilize dispersed networks of all kinds, such as school, leisure and family, to name a few. Thus, what is important when thinking about power and class is that some people are able to access networks that others cannot, to the detriment of their careers, status and opportunities to develop all sorts of 'capital'. Bourdieu then adopted a network-sensitive methodology that set the scene for much of the social network analysis of power that goes on today.

When thinking about power as capillary in the social networks of elites it is not the notion of the 'establishment' or the 'control elite' exercising power from a central core or organizational 'apex' that is pivotal. In applying network ideas to the study of corporate power, we can note that the CEO or director plays far less a significant role than all sorts of intermediaries who act as bridges and brokers in complex relationships where power is exercised through dispersed and sparse networks of individuals (Froud *et al.* 2006). So, just as in the example of the prison or asylum, the warden or the medical doctor is not a centralized source from which power effects dribble down to prisoners and patients; alternatively, they are equally enmeshed in relationships between individuals, which trigger tactical responses to varying dynamics of forces. So the warden who at one moment is kind to a prisoner is at another point brutal, depending on shared company, perceived responsibilities, or institutional conduct and knowledge. Capillary power challenges notions of stratification, instead requiring that attention be paid to power in an everyday sense as felt through relationships. Diffuse power is possible to trace through its effects, and thus 'power relations are less a matter of domination than of circulation', in the same way that blood circulates continuously throughout the body (Shiner 1982: 390).

One of the first important thinkers to introduce the network idea into power was Foucault in his work on discipline and sexuality, and his popularity has considerably grown in recent times across many diverse disciplines, from law to science and technology studies (STS). It is clear that metaphors drawn from the body are central to Foucault's work. Capillary power is a metaphor to 'illustrate the multitude of small intersecting mechanisms through which power passes' (Hunt and Wickham 1994: 49). The notion of capillary power, being diffuse, has considerable importance for rethinking how legislative power is framed and articulated (Golder and Fitzpatrick 2009). Indeed, capillary power suggests 'the way power migrates from the margins of society to the center, like blood returning to the heart' (Alford 2000: 125). The idea that people are affected by forces that arise from capillaries of power within a social anatomy is an extension of the understanding of the body as a system within a system.

Actor network theory

As the narrative example in the beginning of this chapter illustrates, the network is not just a turn of phrase. The many informational and technological flows that automate, predict and

collaborate with users in everyday life have a real impact on people's relationships. Actor network theory foresaw this state of affairs in underlining how technologies and other non-human objects are also part of the networks human actors are a part of. What is interesting about these relationships is how both human and non-human actors are involved together in networks both physical and semiotic.

In a footnote in *Laboratory Life: The Construction of Scientific Facts* Bruno Latour and Steve Woolgar make clear the role of relationships in their thinking on networks:

> Nobody wonders that the first steam engine from Newcastle has now developed into a worldwide railway network ... By the same token, it has to be remembered that the extension of a network is an expensive operation and that steam engines circulate only on the lines upon which [they have] been made to circulate. Even so, observers of science frequently marvel at the 'verification' of a fact within a network in which it was constructed. At the same time they happily forget the cost of the extension of the network.
>
> *(Latour and Woolgar 1979: 186)*

Without understanding Latour and Woolgar's intentions, it would seem strange that a discussion about steam engines should find its way into a book about scientific laboratories. The characterization of the transport network not as a single line (the Stockton and Darlington Railway in 1825), but rather as an entire global network of relationships of all sorts of human and non-human actors, is significant in its inclusion of all sorts of other elements: stations, ferries, bridges, junctions, porters, passengers and terminals. This analysis paints a bigger picture of networks as extensible and nested. And the understanding of networks in this way makes sense to Latour and Woolgar's core analysis. Scientific discoveries might appear to emerge from single sources – genius, innovation and enlightenment – however, there are background networks of actors, citations, specialities, contacts and texts which impact upon scientific progress (1979: 107). Before the advent of the nested communications, transport and power networks that many now take for granted, this concept of networks within networks – relative to themselves but extensible – was difficult to grasp without metaphors from transportation: a network that most people were familiar with from the reduction of the landscape around them through the technology and communications of modernity.

Latour develops this extended metaphor further in his later work on the 'modern', where he takes care to distinguish technological networks from those of facts, laws, politics or actors:

> Thus, in the case of technological networks, we have no difficulty reconciling their local aspect and their global dimension. They are composed of particular places, aligned by a series of branchings that cross other places and require other branchings in order to spread. Between the lines of the network there is, strictly speaking, nothing at all: no train, no telephone, no intake pipe, no television set ... For ideas, knowledge, laws, and skills, however, the model of the technological network seems inadequate.
>
> *(Latour 1993: 118)*

By following this progression of the concept of the network, Latour is able to 'extend ... my refrigerator to the Antarctic by way of chemistry, law, the State, the economy, and satellites' (1993: 144). And by emphasizing how networks are extended and made more complex, Latour establishes an epistemology that allows bridges between science and ideology, modern

and premodern, and technology and society, through the 'Ariadne's thread' of networks (Latour and Woolgar 1979: 121).

The idea that networks are not strictly demarcated, but also contain all sorts of others relationships, including semiotic, material and technological ones, is further elaborated in actor network theory (ANT). What ANT sought to capture is the way the metaphors of networks in the body in the circulation of fluids, chemicals or electricity seamlessly moved to landscapes in the circulations of rail, telephones and sewers – and societies, in the circulations of lineage, language and power. Circulation is key in this idea, as social relations must continue to circulate, or be performed, in order that intangible networks do not dissolve. Thus in ANT the codified knowledge flowing through networks also bears a relationship to the structure of the network itself in the same way the blood flowing through a capillary has a closer relationship to the body's tissue than to the mesophyll of a plant's leaf. So in ANT the actor and network are indelibly linked by ontologies worthy of analysis in themselves. Thus ANT 'understands human and non-human actors as equally able to act' (Mützel 2009: 872).

Latour makes the fundamental quality of ANT clear in 'On recalling ANT' (1999). He clearly locates the word between, on the one hand, the developed concept of an established technical meaning in 'transport' and, on the other hand, a future technical meaning in the 'world wide web' and communications. Latour differentiates considerably the specific 'critical' meaning of network in ANT from these two popular meanings; instead, he focuses on a much older meaning equivalent to the later philosophical botanic concept of the 'rhizome' (in terms of transformation and translation).

In the next section I look at the growing popularity and interconnectedness of the two more recent meanings of the word 'network', which Latour distanced ANT from: transport and information technology. I look in particular at these threads in the concept of 'network capital'. This is a theory that conceptualizes transport and communications in ways that suggest the term 'network' should not be abandoned by social science.

Network capital

Tim Berners-Lee was perhaps being modest when, upon releasing the first application of the world wide web on the mailing list Usenet, he noted: 'This project is experimental and of course comes without any warranty whatsoever. However, it could start a revolution in information access' (1991). The world wide web is just one part of the complexly interwoven system that makes up the networks of human and non-human actors. In the 1990s the home computer that many people had for simple gaming, accounting and word processing suddenly became a window into a wider world through digital networks, which ran through first phone lines and eventually optical cables and wireless telephone masts. What this meant was that the networks already established through much slower forms of communication (the mail) or through one-to-one interactions (telephone) could open up to many online organizations, groups, communities and markets. The formation of networks online meant a new way of ordering and thinking in society based around micro-electronic technologies, which stored and processed information across many online sites. This change precipitated a new networking logic in many societies founded on both extremely efficient and fast transport corridors and online and remote information technologies.

With the opening up of global communication networks, spatial forms no longer determine social relationships; instead they intervene in a complex network of variables, which are fundamentally dominated by relations of production, gender and power (Castells 1983). As the quote from Berners-Lee above highlights, the rapidity of the impact of online networks

and information transfers since the 1990s is in part due to progress occurring at many distributed points and a steady encroachment of electronic communication technologies into organizations, homes and lives. In this development, highly charged urban hubs such as Silicon Valley are innovation and information nodes while peripheral sites have barely changed beyond acquiring a modem or fax.

Transport types (rail, truck, ship) are known as modes, and networks linking these types are known as 'intermodal' transport networks. Only with the progress of the communications technologies outlined in the previous section did networks of mobility properly come to the attention of social scientists. Intermodal transport networks depend on organizational reporting systems: sensors, GPS, relays and the sharing of routines, timetables and customer information. In short, the emergence of the communication-centred network society saw a dramatic expansion and consolidation of transport networks, making life on the move both comfortable and affordable for work and leisure.

The mobilities paradigm's core concern is with networks and the relationships between individuals and remote spaces (tourism), the links between hubs (travel) and the interdependencies of objects, people, information and ideas. The car body, for instance, is just one part of the automobility system, tying together all sorts of relationships in order to keep running (Urry 2007). These relationships include all sorts of systems: petrol stations and ports, oil importers and exporters, car companies and individual consumers, policy makers and law enforcers, and so on. As well, there are networks of desire and culture, which motivate certain types of habits and social practices. Important links here exist between television advertisements, corporate marketing and consumer fashions; notions of freedom in speed, power and privilege; and ideas of obsolescence, demand and supply. Indeed sociologists now think of 'world trade as a network', and the mobilities paradigm extends technical transport understandings of networks to cover these wider systems (Centeno and Cohen 2010: 48).

'Network capital can be distinguished from cultural or economic capital. People with very high network capital experience geographical mobility, extensive institutional contacts, and are "at home" in, and moving across, many diverse settings' (Urry 2012: 70). A principal recent contribution to the mobilities paradigm is the idea of 'network capital', drawing together the transport origins of the network metaphor extant in Latour's ANT and Foucault's ideas on capillary power. In this idea – springboarding from Bourdieu – mobility itself, and face-to-face 'meetingness' in particular, is a source of power. The idea of network capital rests on the metaphorical link to the (anatomical) 'circulation' of capital in analyses of globally transnational networks of power, finance and elites, just as in living anatomies water, electricity, chemicals or blood pass through networks of roots, veins, neurons or capillaries (Urry 1982).

In the same fashion, capital circulates through networks that are complex but, once broken down and scrutinized, analysable. In the nineteenth century the telegraph system in the US frontiers, which allowed access to global communication flows, was a source of power in the sharing of local information (on gold mines or oil wells) with global finance and investment partners. But with the saturation and democracy of modern information technology, physical co-presence has become a valuable commodity in itself, engendering relationships of greater worth than virtual and abstracted communications. There are now important values associated with physical meetings: effort, sincerity, care and the sharing of 'true' character through 'looking someone in the eye'. Therefore, important family occasions (e.g., weddings, birthdays and funerals), job interviews and other 'genuine' meetings demand physical co-presence. Crucially, in the idea of network capital those able to command global flows of physical co-presence are more able to establish powerful and elite networks.

The idea of network capital highlights the role of mobilities and systems of transport infra-structure in the consolidation of power and the intensity of mobile lives. Lash and Urry, for example, dwell not only on the circuits of finance in the industrial age, but also on the impacts of the early rail 'network' in the development of capital. The railways not only circu-lated resources, communications and money, but also were directly funded by abstract networks of financiers and capitalists who got these physical networks 'off the ground' and in turn derived their power from leading highly mobile lives afforded by the systems they laid out (Lash and Urry 1987: 62).

The mobilities paradigm emerged from this conciliatory thinking on communication, power and movement. As the mobilities framework makes clear, social networks directly impact upon demand for travel and transport networks and are intimately tied to social networks. In the idea of 'network capital', power is maintained through face-to-face 'meet-ings' afforded by transportation systems on top of other sorts of communication and are considerably intensified by information technologies that have evolved from relatively slow forms (letters, telegrams) to instantaneous ones (telephone, email, videochat). These tech-nologies also come with systems that keep them in place and running – they are 'complexly folded', and network 'capital' is introduced as a term that indicates access to the means to network, using 'communication technologies, affordable and well-connected transport and safe meeting-places' (Urry 2007: 179). According to this notion, capital not only circulates through the 'anatomy' of capitalism, but, in fact, also stems from the capacity for bodies to circulate themselves, be circulated and create emotional financial benefit from their circulations.

Theorizing power, elements and movement

As illustrated in the development of capillary power – ANT and network capital – social science engagement with the network metaphor began much earlier than might be assumed and continues to bear fruit. Rather than being influenced by the use of the network in tech-nical language and contexts, its use has been inspired by a much longer lineage going back to earlier formations of scientific thought through observation. To be sure, data analysis tech-niques in understanding networks are crucial in moving knowledge forward; however, atten-tion to complex relationships in the ordering of things has also contributed repeatedly to the development of the network metaphor used for empirical analysis.

Principal contributions

In this section I discuss how the ontology of the network underpins some of the keystone theories in social science analysis today. I select two areas where the network concept is contributing to the cutting edge of social science thought and being applied across the areas of anatomies, societies and mobilities in a fashion true to its roots: capillary power and network capital. In reviewing these contributions it is important to take into consideration Latour's point from the previous section that the contemporary idea of a 'network' as a thing-in-itself was uncommon before the 1990s, when network computing became widespread and mathematical and statistical techniques became more widely known. Indeed, in earlier thinking about networks the threads that I have discussed so far (organic structures, built landscapes and social lineages) informed social science thought. In the major ideas of thinkers including Michel Foucault, Bruno Latour and John Urry, the network occurs in dialogue with thinking about anatomy, society and movement. In short, the many uses of the term

Thomas Birtchnell

'network' that we are now familiar with had to be developed and illustrated through observa-
tions initially of the organic and by metaphorical extension to the societal and the
landscape.

Powers

In the eighteenth century an epochal shift took place in how power was distributed and
subjects managed through self-government in anatomo-politics and bio-politics: forms of
control over the bodies of entire populations aligning the concerns of the state with its
subjects. Immurement and confession both took centre roles in practices of discipline and
pleasure. In particular, institutions and spaces arose that depended upon and facilitated expres-
sions of these practices. Power in the spaces of the prison, asylum, clinic and even the bedroom
were not centrally managed but instead were hubs where power invoked and encouraged
subjects. So in the theory of 'capillary power', power relations between actors are not strati-
fied; instead they occur at all points and at any time according to different degrees of force.

Another shift that has taken place is in how intellectual thought approaches thinking on
power. If we return to the cover of Hobbes's *Leviathan*, power is thought to derive from the
'head' of the state and the combination of subjects in a commonwealth (the leviathan being a
mortal 'god' on earth bestowed with sovereignty). Thus the body acts upon the will of the
sovereign and the sovereign is empowered by the commonwealth to inflict its whims on
others. But in the notion of capillary power the relationship between any subjects is instead
defined by equally distributed and branching forces acting upon each other. So the earlier idea
of power emanating from a single source is turned on its head. Power and inequality do not
project from one place, but rather can occur anywhere; that is, power can manifest at any
point. What this theory emphasizes is an awareness of 'microphysics': mobile and non-
localizable connections (Deleuze 2006: 62). Uncertainty about how power is manifesting at
any point influences many distinct personal strategies in a microphysics of forces bleeding into
every aspect of life. For example, a person who disciplines their body because they feel
compelled to do so by those around them in certain spaces (a prison, a school or an army)
might seek to transgress these forces when they perceive power to be lacking in other spaces
(a riot, playground or battlefield). Conversely, at other times they might enforce discipline in
order to go along with moments of forceful power dynamics, in turn inflicting a degree of
force upon others.

Social scientists who research power relations draw on this notion of capillary power to
problematize hierarchy and stratification. If power is a pervasive and localizing force then this
has profound implications for management and governance issues. Regulations and policies
do not represent edicts for people to follow orders unquestionably, but instead are merely
supporting statements to encourage certain agreeable habits and behaviours to come to the
fore in strategic and tactical connections entrenched or intensified in power set-ups. The
contribution this idea has made to policy and governance cannot be underestimated and
differs dramatically from the current status quo in important areas such as climate change
mitigation and transport policy (Schwanen, Banister and Anable 2011).

Elements

ANT continues to be a valuable tool for thinking about networks as not just relationships
between people, but instead relationships of elements between all sorts of different actors,
both human and non-human. A principal contribution is to the analysis of socio-technical

186

systems. A socio-technical system is one where society and technology are intertwined. According to ANT there are seamless webs of actors constituting networks through interminable relationships of technical and non-technical elements. The ways semiotics also blend with social networks is key to this idea.

Analysis of the eruption of Eyjafjallajökull and the consequent ash cloud in 2010 is a case example of how networks of technical semiotics including aeroplane safety standards; human actors such as travellers; non-human actors such as minute particles of ash; and politics and policies around border security, insurance and citizenship all interact and can be analysed productively (Birtchnell and Büscher 2011). In this 'fiasco', media, public and governmental interests all demanded the isolation of a single factor to which to attribute the systemic collapse, where in fact it appears no one element was to blame; instead, a cascading series of factors emerge as contributive to the closure of European air space. An analysis of the multiplicity of elements instead reveals many symbolic, cultural and social perceptions about air travel (Budd *et al.* 2011).

It is not only in systemic disasters where ANT techniques contribute to social science thought. As with the ash cloud event, analysis of socio-technical transitions reveals important links between social and technical actors. Take as another example India's independence movement (Birtchnell 2012). In this transition from empire to self-rule Mahatma Gandhi perceived the implications local changes in technological innovations could yield in large systemic networks. In particular, he focused on the networks weavers in Lancashire and cotton pickers in India shared, and targeted the semiotic and political principles underpinning these relationships. Gandhi also realized that his own identity as a node actor was significant and through micro-managing his personal conduct and appearance, as well as his personal interactions with local individuals in Britain and India, he could diffuse the influence of distant and contradictory colonial node actors, thereby unravelling the various elements of empire.

ANT treats elements as equal in networks, thereby offering a significant theoretical advancement in conceptualizing socio-technical systems. The historical growth in awareness of dependencies, described earlier in this chapter, between all sorts of non-human actors, from computers and automobiles to technical knowledge and symbolic ties, represents a lineage of thought about the complex relationships in the composition of societies.

Movements

In the twentieth century a great intensification of mobilities linked to the discovery of vast reserves of energy and key technical innovations, deriving from the so-called industrial revolution in the second half of the nineteenth century, placed a great value on movement. In the concept of 'network capital' types of movement and meeting presuppose variable degrees of quality, and these differences establish inequalities. For example, the idea that a person's true character can only be judged through face-to-face contact necessitates access and investment in mobility. So a meeting over the telephone or via email represents less network capital than long-distance travel in terms of access to mobility and expenditure of resources.

Therefore, to have 'network capital' is to be able to access wide-ranging, rarefied and delimited systems of movement. These systems diverge from key points of heightened activity (airports, railway stations, car parks) and stretch into every conceivable space afforded by the standardization of roads, rails and flight paths across the world. This capital is not only a direct conversion of financial capital into movement; rather, it is the capacity to utilize dramatic systems of mobility across diverse circumstances and situations with ease and accomplishment, setting some apart from others (Urry 2007).

Those always on the move do not by default have high network capital. To be sure highly mobile elites, celebrities and the super-rich are also incredibly grounded and immobile at many times in their lives, containing their wealth and power in all sorts of significantly fixed property including mansions, islands, palaces and monuments, to list a handful. High network capital might stem from being immobile in many different sites and travelling uninterruptedly from each one.

And those with very low network capital can also be perpetually on the move, examples ranging from refugees and asylum seekers to stranded passengers and flight stewards. These high mobility/low network capital individuals are often unable to derive gain from their routinized, solitary and sometimes desperate movements. Some with high financial capital might also choose to not have network capital at all – the recluse tycoon Howard Hughes, who sealed himself away from society, is a case example (although it is reported that he died en route in an aeroplane). Moreover, some, such as low-ranked but well-funded academics, might seek to develop high network capital in order to increase their financial capital through 'networking' with others of influence.

Furthermore, physical movement is not indicative of high network capital. The incredible surge in mobilities in the twentieth century has not been accompanied by a rapid increase in bodily movement. Instead, as mobile life has become wrapped up with high-energy transport systems and high-technology communication systems, bodily activity has become confined to seats, and 'seatedness' is now a common position for many people, at least in the global North and cosmopolitan parts of the global South. Ironically those jobs and activities that include physical exertion are more likely to be enacted by those with less network capital, excluding perhaps sports elites.

Network thinking

When seen in light of the progress of the network as a metaphor, these strands of thought clearly draw together the common aim behind observations of network structures in anatomies, societies and mobilities. While different social science theories diverged in relation to the question of how to reconcile later manifestations of the network metaphor in technical transport language and information technology, the theories of capillary power, ANT and network capital converged significantly on the microphysics of lived experience.

Critical issues

Technicality

In the previous section I showed how the network concept has influenced all sorts of analyses of power, elements and movement. What I have not done is given any sort of background to quantitative and mathematical forms of social network analysis (SNA), and from these quarters arises critical appraisal of the conceptual framings in this chapter. To be sure, there is a mature and technically well-developed ontology of quantitative approaches to social network analysis. The examples I have explored, while not making direct use of these techniques, problematize somewhat the idea of the 'social' in this canon of techniques.

Of the three theories, capillary power has developed the highest degree of portability to quantitative technical analysis. There have been some very sophisticated graphing experiments with elite networks, and these offer intriguing methods for tracing networks of power beyond simple core–periphery accounts. Yet even in datasets that take into account very

many sources and outlays of power, there is a lack of clarity about how power is to be defined and measured. The origins of the idea in Foucault's assessment stemmed from the need to decouple power from overt and extant relationships in order to argue for a more diverse range of experiences and expressions. An issue with technical definitions of power of this sort is the very many possible variables emerging from such an open and broad catalogue of possible effects. Thus there remain many issues with how power is conceptualized and how significance is quantified.

Many experts in SNA would perhaps depart from treating the human and non-human as equal in technical datasets, and this is an ongoing issue in the reconciling of theory and empirical observation in ANT. As in capillary power, the difficulty lies in quantifying relationship representations for all the possible variables accounting for all sorts of disparate elements: which elements should be included and which left out of datasets? If technical and social elements bear the same weight of significance then this challenges purely 'human' analyses of social networks. The blurring between online and physical identities further complicates this issue, particularly as single individuals can have multiple identities of different significances.

Problems with quantifying the notion of network capital are of a different kind. The theory illustrates that physical relationships between mobile actors are uniquely distinct from virtual or semantic relationships using information technologies. This idea problematizes analyses of social networks where the quality of relationship is conceived of as equal in all cases. For example, much recent analysis of Twitter or Facebook networks depends on the idea that adding or following a friend indicates a proper relationship, which in many cases is far from the reality. But according to the theory these relationships and exchanges could in fact be devoid of meaning and value and instead contain very low levels of network capital. So a technical survey of these kinds of datasets might show a large degree of network activity of very limited value. Merely distinguishing between weak and strong ties does not address this issue, as much of the subtlety of network capital lies in 'off the grid' relationships going on behind the scenes of any informational and virtual exchanges.

What all three of these examples show is that technical approaches more often than not gloss over subtleties in the theorization of networks. The subtleties in all three cases challenge the capacity to collect adequate datasets, account for many diverse variables and adequately graph and visualize slippery empirical observations.

Dilution

A second issue critical to the development of the network concept in the specific cases flagged in this chapter is the problem of dilution. A principal risk in diversifying the network idea is that it becomes a grand theory of everything in the social sciences. Identifying something as a network can lead to the question 'So what?', implying that the term has become diluted to the point where it has no meaning. Moreover, the increasing use of the term 'network' to indicate 'network technology' raises the problem of diluting the efficacy of more general application; in fact, some are suggesting a 'network cosmology' as a counterpoint to pre-digital sociality, which comes pretty close to suggesting everything literally could be a network if the boundaries between digital and non-digital start to blur (Fisher 2010).

Conclusion: network futures

So what does the future hold for the idea of networks in social science analysis? While the network is now a robust frame for thinking through bodies, societies and landscapes, there is

still much work to be done in reconciling the qualitative and quantitative and in preventing the further dilution of meaning of the network metaphor (Savage, Bradley and Smith 2011). By looking at big issues such as financial crises as networks in a qualitative and quantitative sense and flows of capital as the 'lifeblood' that can cause 'serious tremors in the heart of the body politic', social sciences can take an angle that offers an advantage over strictly 'sophisticated mathematical models, data [and] spreadsheets' that nevertheless fail to foresee systemic crisis (Harvey 2010: vi–vii). The three principal contributions that I have summarized (power, elements and movements) all lie within a wider problem of positioning the social sciences to be able to account for the many developments deemed significant in the twenty-first century. As I have illustrated over the last sections of the chapter, the term 'network' broadened out considerably from its specific contexts in order to expand the horizons of the social sciences and opened up new topics of analysis: anatomies, societies and mobilities. In the process of this expansion in areas of inquiry the network concept became greatly diluted. In this chapter I have addressed this dilution through various lineages of thought and approaches to empirical observation.

References

Alford, C. F. (2000) 'What would it matter if everything Foucault said about prison were wrong? "Discipline and punish" after twenty years', *Theory and Society*, 29(1): 125–46.

Baxter, R. D. (1866) 'Railway extension and its results', *Journal of the Statistical Society of London*, 29(4): 549–95.

Berners-Lee, T. (1991) 'WorldWideWeb: summary', alt.hypertext, Google Groups, 6 August.

Birtchnell, T. (2012) 'Elites, elements and events: practice theory and scale', *Journal of Transport Geography*, 24: 497–502. Available online at http://dx.doi.org/10.1016/j.jtrangeo.2012.01.020 (accessed 13 March 2013).

Birtchnell, T. and Büscher, M. (2011) 'Stranded: an eruption of disruption', *Mobilities*, 6(1): 1–9.

Budd, L., Griggs, S., Howarth, D. and Ison, S. (2011) 'A fiasco of volcanic proportions? Eyjafjallajökull and the closure of European airspace', *Mobilities*, 6(1): 31–40.

Carles, P. (2001) *La Sociologie est un Sport de Combat*, Montpellier: CP Productions and VF Films.

Castells, M. (1983) 'Crisis, planning, and the quality of life: managing the new historical relationships between space and society', *Environment and Planning D: Society and Space*, 1(1): 3–21.

Cavanagh, A. (2007) *Sociology in the Age of the Internet*, Maidenhead, UK: McGraw-Hill International.

Centeno, M. A. and Cohen, J. N. (2010) *Global Capitalism: A Sociological Perspective*, Cambridge: Polity.

da Costa, E. M. (1757) 'An account of the impressions of plants on the slates of coals: in a letter to the Right Honourable George Earl of Macclesfield, President of the R. S. from Mr. Emanuel Mendes da Costa, F. R. S.', *Philosophical Transactions (1683–1775)*, 50: 228–35.

Darwin, E. (1798) *The Botanic Garden: A Poem, in Two Parts. Part I. Containing the Economy of Vegetation*, New York: printed by T. and J. Swords, printers to the Faculty of Physic of Columbia College.

Deleuze, G. (2006) *Foucault*, New York: Continuum International.

Fisher, E. (2010) *Media and the New Capitalism in the Digital Age*, New York: Palgrave Macmillan.

Foucault, M. (2002) *The Order of Things: An Archaeology of the Human Sciences*, London: Routledge.

Froud, J., Savage, M., Tampubolon, G. and Williams, K. (2006) 'Rethinking elite research', *Journal of Management and Social Sciences*, 2(1): 25–41.

Golder, B. and Fitzpatrick, P. (2009) *Foucault's Law*, Abingdon, UK: Taylor and Francis.

Grove, W. R. (1866) 'Anthropology at the British Association', *Anthropological Review*, 4(15): 386–408.

Gulati, R. (2007) *Managing Network Resources: Alliances, Affiliations and Other Relational Assets*, New York: Oxford University Press.

Guy, W. A. (1842) 'Introductory lecture, delivered at King's College, October 1, 1842', *Provincial Medical Journal and Retrospect of the Medical Sciences*, 5(106): 23–32.

Hagner, A. B. (1904) 'Street nomenclature of Washington City', *Records of the Columbia Historical Society, Washington, D.C.*, 7: 237–61.

Harvey, D. (2010) *The Enigma of Capital: And the Crises of Capitalism*, London: Profile Books.

Hewson, W. and Hunter, W. (1768) 'An account of the lymphatic system in birds; by Mr. William Hewson, Reader in Anatomy: in a letter to William Hunter, M. D. F. R. S. and by him communicated to the society', *Philosophical Transactions (1683–1775)*, 58: 217–26.

Hobbes, T. (1651) *Leviathan, or, The Matter, Forme and Power of a Commonwealth, Ecclesiasticall and Civill*, London: Andrew Crooke at the Green Dragon in St Pauls Church-yard. Available online at http://www.archive.org/details/leviathanormatt01hobbgoog (accessed 30 January 2012).

Hunt, A. and Wickham, G. (1994) *Foucault and Law: Towards a Sociology of Law as Governance*, London: Pluto Press.

Hutchinson, T. J. (1861) 'On the social and domestic traits of the African tribes; with a glance at their superstitions, cannibalism, etc., etc.', *Transactions of the Ethnological Society of London*, 1: 327–40.

Lamb, S. M. (1999) *Pathways of the Brain: The Neurocognitive Basis of Language*, Amsterdam: John Benjamins Publishing Company.

Lash, S. and Urry, J. (1987) *The End of Organized Capitalism*, Madison, WI: University of Wisconsin Press.

Latour, B. (1993) *We Have Never Been Modern*, Cambridge, MA: Harvard University Press.

—— (1996) *Aramis, or, the Love of Technology*, Cambridge, MA: Harvard University Press.

—— (1999) 'On recalling ANT', in J. Law and J. Hassard (eds) *Actor Network Theory and After*, Oxford: Wiley-Blackwell.

Latour, B. and Woolgar, S. (1979) *Laboratory Life: The Construction of Scientific Facts*, Princeton, NJ: Princeton University Press.

Marx, K. (1887) *Capital: A Critical Analysis of Capitalist Production*, London: Sonnenschein.

Mützel, S. (2009) 'Networks as culturally constituted processes: a comparison of relational sociology and actor-network theory', *Current Sociology*, 57(6): 871–87.

National Magazine (1830) 'The repeal of the Union', *National Magazine*, 1(6): 627–36.

Papacharissi, Z. (2011) *A Networked Self: Identity, Community and Culture on Social Network Sites*, London: Taylor and Francis.

Parsons, J. (1744) 'The Crounian Lectures on Muscular Motion for the years 1744 and 1745. Read before the Royal Society', *Philosophical Transactions (1683–1775)*, 43: iii–86.

Plot, R. (1685) 'A discourse concerning the incombustible cloth above mentioned; address't in a letter to Mr. Arthur Bayly Merchant, and Fellow of the R. Society; and to Mr. Nicholas Waite, Merchant of London; By Rob. Plot. LL. D.', *Philosophical Transactions (1683–1775)*, 15: 1051–62.

Prell, C. (2011) *Social Network Analysis: History, Theory and Methodology*, London: Sage.

Savage, M., Bradley, H. and Smith, D. (2011) 'Symposium on the ESRC, BSA, and HAPS International Benchmarking Review of UK Sociology', *Sociological Review*, 59(1): 149–64.

Schwanen, T., Banister, D. and Anable, J. (2011) 'Scientific research about climate change mitigation in transport: a critical review', *Transportation Research Part A: Policy and Practice*, 45(10): 993–1006.

Scott, J. and Carrington, P. (2011) *The Sage Handbook of Social Network Analysis*, London: Sage.

Shiner, L. (1982) 'Reading Foucault: anti-method and the genealogy of power-knowledge', *History and Theory*, 21(3): 382–98.

Thouless, R. H. (1939) 'The study of society: methods and problems', in F. C. Bartlett, M. Ginsberg, E. J. Lindgren and R. H. Thouless (eds) *The Study of Society: Methods and Problems*, London: Taylor and Francis.

Tuck, H. (1848) *The Railway Shareholder's Manual; or Practical Guide to all the Railways in the World*, London: Effingham Wilson.

Urry, J. (1982) 'Some themes in the analysis of the anatomy of contemporary capitalist societies', *Acta Sociologica*, 25(4): 405–18.

—— (2007) *Mobilities*, Cambridge: Polity Press.

—— (2012) 'Social networks, mobile lives and social inequalities', *Journal of Transport Geography*, 21: 24–30.

Vericour, L. R. de (1872) 'The study of history', *Transactions of the Royal Historical Society*, 1: 9–33.

Weeden, W. B. (1882) *The Social Law of Labor*, Boston, MA: Roberts Brothers.

Wells, H. G. (1912) 'The past and the great state', in H. G. Wells (ed.) *The Great State: Essays in Construction*, London: Harper and Brothers.

11

Globalization

Eric L. Hsu

Since the latter half of the twentieth century, globalization has been one of the most widely discussed issues in the western world and beyond. It has become a 'buzzword' for politicians, journalists and social scientists alike, and it has even entered into the lexicon of popular discourse. Why globalization has garnered so much attention is largely because the concept is thought to have bearing on many key social transformations, such as the spread of new communication and information technologies, the opening up of new hybridized forms of social identity, the acceleration of certain types of economic activity, the development of new environmental hazards and the onset of new geopolitical regimes and challenges.

However, there is still some truth to Anthony Giddens's assertion that 'there are few terms that we use so frequently but which are in fact as poorly conceptualized as globalization' (quoted in Scholte 2008: 1473). After all, it is not unusual for the contemporary popular discourse surrounding globalization to be either confusing or disjointed. Some politicians, for instance, claim to be in support of globalization, while others argue vociferously against it. News media reports frequently invoke the term when discussing a whole range of phenomena that do not appear to have much in common. And more often than not, the meaning of 'globalization' is implied rather than explicitly stated. Likewise, there has been a considerable amount of analytical confusion surrounding the concept in scholastic settings. A common refrain in the academic world has been to note how seemingly muddled and contentious the issue has been (e.g. Bisley 2007; Conley 2008; Jones 2010; Rosenberg 2000, 2005; Scholte 2008). This is primarily because some scholars of globalization have been negligent in pinpointing what aspect(s) of globalization their research is meant to have precise bearing on. This also explains why some critics of globalization theory disparage the concept as a 'catch-all' term which frequently serves as a conduit for 'sloppy' intellectual claim making (e.g. Rosenberg 2000, 2005; Bisley 2007). Thus it is tempting to bypass the scholarly debate on globalization altogether, so as to pursue other, more fruitful, lines of inquiry.

This chapter reviews the debate over globalization by investigating the merits of such a proposition. Should contemporary social thought consign globalization to the dustbin, or is there actually something redeemable about globalization as a concept? This is what leads the chapter to explore the distinct possibility that the optic of globalization is a redundant or flawed way of thinking. A key finding here is that there are some views of globalization which are able to generate new and valuable insights about the conditions of contemporary social life, even though there are also some articulations of the concept that are less analytically beneficial. This is why the main goal of the chapter is to determine which theories of globalization deserve more consideration and which ones are of less importance. Ultimately, this chapter concurs with Tom Conley's argument that the 'generality, contestation and

complexity' of the globalization discourse is not what should render the concept 'worthless' (2008: 141). Although there are sharp and manifold criticisms to be made of the globalization debate, 'it does not follow from these well-taken criticisms that . . . the concept of globalization should be banned in all forms from social explanation' (Scholte 2005b: 391).

Historical and intellectual development

The term 'globalization' is of a relatively recent vintage, even though some of its permutations, like the 'globe', are rooted much further back in the history of the English language (Scholte 2008: 1472). Only from the mid-1980s onwards did the term really begin to take hold within social thought (Bisley 2007). Before then, 'globalization' as an explanatory tool was only used intermittently and without much fanfare. In the early years of the twenty-first century globalization is 'now so well established in the popular imagination that few school-children are oblivious to it, pop stars include it in their lyrics and a whole range of people from politicians to poets variously hail or blame "it" for all manner of changes in the contemporary world' (Jones 2010: 1). Furthermore, so much has been written of globalization in the academic world that 'to read every thought written on the topic would require a lifetime in a library' (ibid.).

The appeal of globalization is commonly said to derive from the term's ability to capture what is 'new' about the contemporary social world and its various developments. This is a central theme in what Nick Bisley has categorized as 'the first bloom of globalization writing', which he dates to around the 'late 1980s' (2007: 12). This first distinct phase of the globalization debate is characterized by Bisley as a period when a diverse group of social thinkers began to postulate that 'significant changes to existing social structures were occurring' and that the concept of globalization was central to explaining such a set of changes (ibid.). Following on from this, for Bisley, was the second phase of the globalization discussion, which primarily served to amplify and substantiate 'the [earlier] claims made about globalization' in the preceding interval (2007: 13). As more and more texts concerning globalization were written in the early 1990s, several propositions about globalization became more solidified. One of these was that 'the state and its attendant norms and institutions (such as sovereignty and nationalism)' were being undermined by the rise of a 'truly global economic system' (ibid.). Another was that the concept of globalization signalled an epochal shift in the experience and analysis of the social realm. It was also during this period that 'globalization swiftly moved from being a concept advanced by a narrow band of specialists to becoming a watch-word of almost all social science'; globalization, in short, 'was everywhere' and 'it became hard to avoid this suddenly fashionable concept' (Bisley 2007: 14).

Bisley notes that, by contrast, the next phase of the globalization debate from the mid to late 1990s 'saw the publication of a range of critical reactions to many of the arguments advanced by globalization advocates', with 'claims about the end of the state and the death of sovereignty' receiving 'particular criticism' (ibid.). This grouping of texts sought to advance what David Held et al. (1999: 5–7) have termed the 'sceptical' view of globalization. Some authors in this vein were interested in exposing the lack of historical depth in the claims made by many advocates of globalization theory. Meanwhile, there were also others who sought to expose the empirical and theoretical shortcomings of the many predictions made about the imminent demise of the nation-state system (e.g. Hirst and Thompson 1996).

Yet, this move in the debate to discredit the globalization concept was met with an equally spirited defence during the fourth phase of the globalization discussion. This came by way of a concerted effort made by a litany of authors which sought to bring more conceptual

sophistication to the theories implicated in the globalization discourse (e.g. Held *et al.* 1999; Giddens 1999). In doing so, these authors made a point of tempering some of the more outlandish claims previously made by those in the preceding periods – preferring instead to think of globalization in more nuanced and 'level-headed' terms. What also characterized the fourth phase of the globalization debate, for Bisley, was the emergence of a view that was highly critical of the motives and outcomes of the globalization phenomenon. This 'anti-globalization' view was informed by – and also informed – activist movements that sought to voice disapproval of neo-liberal policies that eroded democratic control of states and societies, undermined the rights of workers, caused further environmental damage and allowed 'global corporations to ride rough-shod over the world' (Bisley 2007: 16).

Lastly, Bisley suggests that the 'fifth and latest phase' of the globalization debate has been mainly characterized by the desire of some authors to stand up for globalization by high-lighting the economic benefits of the globalization process. This has been coupled with the tendency for many in the globalization discussion to 'talk past one another', as lines of inquiry appear to have become more 'fixed' and unyielding (ibid.). Bisley concludes by suggesting that this unfortunate state of affairs in the globalization debate is what provokes us to 'rethink' how we understand the concept. In the sections that follow, I aim to contribute to such an enterprise by identifying the conceptual impasses that exist in the globalization debate and by suggesting ways these impasses may be resolved.

Main claims and key contributors

What has hopefully been made apparent from the brief historical overview of the globaliza-tion debate thus far is just how contentious the issue has been, especially for scholars working in the social sciences. Hence, this is what provides an impetus to make sure the parameters of the concept are sufficiently well defined, so as to pinpoint what in fact the analytical frame-work of globalization has to offer. To such an end, it is useful first to recall some of the more polemical and extreme claims put forth by globalization theorists in order to establish what, concerning the concept, is actually insightful. Equally, it is useful to establish what may be hyperbolic, misleading or redundant.

Perhaps the most well-rehearsed of these claims is the idea that globalization principally entails the rise of a 'borderless world where economic activity becomes denationalized' (Jones 2010: 9). This is a notion which many authors have associated with the 'hyperglobalist' position (e.g. Held *et al.* 1999; Jones 2010). Hyperglobalist thought has typically posited that globaliza-tion is a wide-sweeping phenomenon that has only come about since the mid to late twentieth century. Globalization from this angle is thought to be of paramount importance because it explains how and why the world economy has in recent times become more 'transnational' in seemingly all of its facets. Key to this shift, from the hyperglobalist perspective of Kenichi Ohmae (1990), has been the onset of a new consumerist outlook across the world which holds that national borders no longer matter as much as they once did. Nowadays, what you consume is not something that is necessarily a function of where you are situated. Likewise, something similar can be said about the production of consumer goods and services, as transna-tional corporations are increasingly exercising their ability to run operations in more than one country or region. For Ohmae, this further contributes to the idea that a new age of global economies is now upon us. The world as it stands today is truly global and not just made up of individual units.

Yet, according to the work of some scholars, it is apt to question this way of thinking. For one thing, this is because the hyperglobalist view may be overstated, especially if those

writing in the 'sceptic' tradition are to be believed. Some social thinkers in this vein, for instance, have demonstrated that the unprecedented emergence of a globalized world economy is in some respects an empirically unfounded claim. Such scholars have been greatly informed by the work of Paul Hirst and Grahame Thompson, who in their seminal text *Globalization in Question?* (1996) cast doubt on the idea that the world is becoming a more economically interdependent and interconnected place. Such a criticism of the hyperglobalist position is principally buoyed by Hirst and Thompson's discovery that the regulatory power of national governments has not been radically superseded by transnational forces as many advocates of the globalization paradigm had previously speculated. For Hirst and Thompson, this point becomes all the more salient if we consider that the worldwide economic market in the Gold Standard period before 1914 was arguably *more* – not less – open to trade than during the 1980s and 1990s (1996: 2). This speaks to the lasting power of the Westphalian system of international relations, whereby nation-states continue to wield a great deal of control and influence in the contemporary era.

It is tempting to conclude then from Hirst and Thompson's work that globalization is more of a misguided expectation than it is a firm, empirical reality, which means that globalization may not be such an insightful framework to use when analyzing the contemporary social world. However, there is cause to keep us from leaping to such rash conclusions. This is provided by the 'transformationalist' strand of thought in the globalization debate, as classified and developed by the work of David Held *et al.* (1999). At the core of the transformationalist thesis is the belief that the believers (hyperglobalists) and naysayers (sceptics) of a globalized economy are both only partially correct. Only when we consider and combine their perspectives do we get a more accurate picture of how globalization operates. What the transformationalists propose is that it is still consistent to believe that nowadays globalization 'is a central driving force behind the rapid social, political and economic changes that are reshaping modern societies and the world order' (Held *et al.* 1999: 7), whilst at the same to be wary of the need for a wholly new understanding of world affairs. For the transformationalists, globalization does not just replace or leave alone existing forms of social organization, such as the nation-state, as the hyperglobalists and sceptics claim, as much as it *reworks* them. Put crudely, this means that globalization does not change everything as we know it, but neither is it an inconsequential development. The broader understanding of globalization that the transformationalist position advances then is one which conceives globalization 'as essentially a historical process replete with contradictions' (ibid.).

One of the benefits of this more nuanced approach is that it contextualizes the supposed wholesale novelty of globalization in the contemporary era. The argument here is that a more insightful understanding of globalization emerges when it is situated in more historically expansive terms. This principally involves recognizing that globalization is not simply 'a product of the contemporary world', since its origins stretch much further back into the distant past (Hopkins 2002: 2). An explicit outcome of adopting such a view of globalization is that this helps us to avoid what Bob Seidensticker has termed 'the birthday present syndrome' – the tendency in the current social landscape to overemphasize the uniqueness of all that which transpires in the present day. There is, in other words, 'nothing completely new under the sun', which is why a longer-term historical study of globalization is merited (Mazlish 2006: 15). A longer-term perspective enables us to grasp the historical antecedents of how the contemporary variant of globalization operates. And just as importantly, it also provides us with a comparative basis from which to differentiate what is truly unique about the process in this day and age.

If, for the moment, we accept C. A. Bayly's view that globalization is a 'progressive increase in the scale of social processes from a local or regional to a world level', as Bruce Mazlish does

(2006: 8), then it is relatively easy to see how globalization can be aptly used to explain the movements of some of those that belonged to earlier time periods. Such is also the argument of Antony Hopkins (2002) and Charles Lemert et al. (2010), both of whom argue that the globalizing process is found not only in the latter half of the twentieth century and onwards, despite much of what the globalization literature intimates. One benefit that arises from adopting this viewpoint is that a greater appreciation of the cultural aspects of globalization is encouraged. This has to do with the fact that a longer-term historical perspective calls into question the view that globalization is merely a western phenomenon, as there have been well-documented non-western examples of globalization throughout the course of ancient human history, such as the imperial aspirations of various Chinese dynasties, as well as the spread of certain religious influences, such as in the case of Buddhism. As Hopkins (2002) and Lemert et al. (2010) suggest, we can only come upon such insights if we do not accord the economic realm an inordinate amount of significance, as has been the customary move of many who write in the hyperglobalist tradition.

The problem with the economic view of globalization is that it tends to be overly simplistic and mono-causal. Under this paradigm, cultural and political inferences seem to flow solely from the economic conditions at hand. And accordingly, this is why authors from both sides of the globalized economy issue seem so out of touch and/or hyperbolic; the world in this sense is either becoming globalized or it is not. In John Tomlinson's view (1999), such an approach overlooks the complexity of globalization provided by a more culturally informed perspective. Why it is useful to consider the sphere of culture is because it alerts us to the contradictions and transformations that globalization inevitably entails. It is towards this end that Tomlinson highlights the ways in which globalization lifts out and transforms cultural meanings. In effect, what the cultural dimension allows us to do is to explain why identities all over the world are able to change without there necessarily having to be a wholesale opening up of economic or political markets.

The optic of culture, in short, forces us to consider a broader range of issues. For one thing, it raises the possibility of there being a sense of global 'unicity' without necessarily implying that the world must be so in all respects. Here, Tomlinson points to the work of Roland Robertson (1992: 6), who maintains that globalization has created the feeling of 'the world as a single place' as an influential frame of reference. By this, Robertson means that how people think about their lives is influenced by their increasing awareness of the world as an 'imagined community' (1992: 183). From this perspective, globalization encourages people to take into account 'the world as a whole' when they are in the process of acting and forming decisions (1992: 26). However, as Tomlinson points out, Robertson is not implying here that globalization somehow creates a uniform world culture. Rather, as Tomlinson writes, Robertson directs our attention to the fact that globalization can be understood as a 'complex and social phenomenological condition – the "global human condition" – in which different orders of human life are brought into articulation with one another' (Tomlinson 1999: 11). This means that globalization is not reducible to the exchange of goods or political processes only. Rather, globalization also involves the negotiation of disparate identities and new contextual frameworks.

Another benefit of adopting a more culturally rich understanding of globalization is that this improves our grasp of the complexities of global processes. Such is the case if we investigate the thesis that globalization is nothing more than the homogenizing of world cultures. The work of Serge Latouche (1996) typifies this sort of argument, in that he contends, like some others do, that non-western cultures are being decimated by the West's global pursuit of economic gain. Latouche believes that those in the 'Third World' especially bear the brunt

of this forced cultural uniformity. According to Latouche, these groups are being seduced by the singular mindset of the West's obsession for continual profit. They are starting to desire mainly what those in the West desire. And in turn, what is happening to these people is that the rich diversity in cultural practice they once had is gradually being eroded.

Some cultural theorists like Tomlinson, however, are sceptical of such claims. For them, globalization does not necessarily involve the imposition of western values on non-western societies, as globalization is a much more complex phenomenon. For Tomlinson, this is because culture does not transfer between social entities in such a direct, uni-linear fashion. This means that cultural texts such as television programmes and clothes are not simply assimilated *in toto* by those on the 'receiving end'. Instead, as Tomlinson writes, 'movement between cultural/geographical areas always involves interpretation, translation, mutation, adaptation, and "indigenization" as the receiving culture brings its own cultural resources to bear, in dialectical fashion, upon "cultural imports"' (1999: 84). This is why people in different parts of the world interpret the same television show or movie persona in quite distinctive ways. These differences suggest that globalization does not necessarily bring about a levelling out of culture. Instead, what many like Tomlinson conclude is that a more theoretical sophistication is needed to get a clearer picture of what is actually occurring. While it is the case that capitalism and other westernized social forms are implicated in the shaping of global culture(s), it is not so clear that globalization only involves the wholesale proliferation of all things western or American (Scholte 2008: 1476–78).

In light of this, some thinkers in this vein have proposed new conceptual images that try to better capture the complexity that globalization actually involves. This is reflected in the uptake of new terminology that has recently arisen. For instance, Ulf Hannerz (1992) speaks of globalization as inaugurating a 'creolization' of identities. This is his notion that globalization cultivates the intermixing of disparate world cultures, even if some of these cultures are and have been more politically and economically powerful than others. According to Hannerz, why creolization is a helpful term is because it captures a point that some social commentators have ignored: that the exchange of culture, even between two unequal groups, is hardly ever only one-sided. From this view, the colonized can also influence the colonizers, just as the periphery can talk back to the core (Hannerz 1992: 265). This, in turn, is significant because it presents a more sophisticated understanding of global processes. What Hannerz encourages us to think about are the ways in which culture circulates in a multi-directional fashion. It is not simply the case that 'poorer' cultures are being 'homogenized' by dominant discourses. Rather they as well as those with supposedly 'greater' cultural prestige (like the West) are both being hybridized in some respects. This suggests that globalization is just as much about cultural gain as it is about loss, even as asymmetrical power relations are significant.

Another neologism that has gained currency within social thought is Roland Robertson's usage of the Japanese business term 'glocalization'. What glocalization refers to is the notion that global processes are also local in their orientation. Globalization is not just a macro-system-oriented affair, since it also involves a localized component in the first instance. From this stance, not only are local discourses remade by overarching global forces but localized issues are also raised to the global level. An example of this is when goods and services that are global or near global in reach are often tailored to the localities that they find themselves in (Robertson 1995: 28). For instance, this explains why the menu at a McDonald's fast-food restaurant varies from country to country. The point though for Robertson is that this is not just a one-way process. Just as McDonald's must tailor its menu to local preferences, the same is true in reverse. What is local also becomes a matter of global importance. Thus an incident

of torture in a US military-run prison camp in Iraq can have reverberations throughout the world as transmitted by the global news media. What this says is that local events are just as consequential on the global stage, as much as global forces are able to transform localities. Here, the emphasis is on how globalization makes the relationship between the local and the global much more complex but at the same time increasingly pertinent.

Another concept that has found some traction within social theoretical debates of globalization is the term 'creative destruction'. This is Tyler Cowen's (2002) application of a term, previously coined by Joseph Schumpeter, which suggests that global cultures create as much as they destroy. In fact, according to Cowen's thesis, cultures in the global age are destroyed *because* new ones are created. This corresponds to the view that cross-cultural exchange does not just lead to a flattening out of cultural tastes and repertoire. In Cowen's view, it is more the case that when cultures come into contact with each other, more – not fewer – forms of cultural expression are created, at least at the outset. For example, Cowen cites the incorporation of Czechoslovakian beads in the South African Ndebele art-making tradition. Even though these beads were not indigenous to Africa, they have become, since the nineteenth century, an essential material for the adornment of aprons, clothing and textiles (Cowen 2002: 8). However, as Cowen notes, the trade-off here is that invariably some cultural aspects get lost because of the 'cultural blossoming' process. The production of new cultural expressions means that older ones may be outmoded. In Cowen's view, this is especially true if we consider what happens to 'poorer' cultures when they come into contact with 'richer' ones. Just as poorer cultures in this situation find new ways of enhancing and preserving parts of their cultural repertoire when they hybridize with the 'richer' culture, they are also forced to leave behind aspects which might have been previously significant. Put differently, Cowen believes that newness begets oldness, just as creativity begets destruction (2002: 55–6). And in turn, he contends this is how we should also understand the richness and complexity of the cultural side of globalization.

Taken as a whole, what all of this new terminology suggests is that globalization is by no means a completely unified or monolithic phenomenon. And this is especially true if we account for the realm of culture. It would be mistaken to assume that economics and politics can completely determine other dimensions of social experience without also some amount of cultural input. Therefore, those who make extrapolations from economic or political conditions alone often miss the more disparate and varied nature of global processes.

Another potential pitfall of adopting an overly economic view of globalization is that it risks overstating how globalization is an 'out-there' phenomenon, 'remote and far away from the individual' (Giddens 1999: 12). Instead, globalization should also be conceptualized as a phenomenon that has bearing on the intimate and personal aspects of our lives. The work of Anthony Elliott has done much to further the study of globalization from this vantage point. For example, Elliott's research (2008) has shown that globalization informs how people relate to their bodies through the prism of cosmetic surgery. According to Elliott, the reason cosmetic surgery is becoming more widespread among some sectors of the population is to a large extent the rise of the new global electronic economy. Key to this new, intensified way of doing business is the 'capacity to change and reinvent oneself', which exists against the backdrop of 'short-term contracts, endless downsizings, just-in-time deliveries and multiple careers' (2008: 122). Accordingly, Elliott suggests that the turn to cosmetic surgery is but one of the many ways that this 'faith in flexibility, plasticity and incessant reinvention' can be demonstrated (ibid.). As this line of thinking goes, to prove that one can keep up with the rough and tumble of today's changing economic environment, one must be willing to go under the surgeon's knife. Given then that globalization plays an important role in reshaping

the 'self' as 'transformations in the new economy and in self-identity . . . are increasingly becoming intermeshed' (2008: 45), Elliott posits that we need to be more aware of the emotional aspects of globalization that pertain to lived experience. Doing so helps us to think of globalization in more multi-faceted terms, such that the 'micro' and 'macro' dimensions of globalization are jointly appreciated.

Besides offering a more culturally informed and longer-term view of globalization, the transformationalist position also emphasizes that there is something novel about the way globalization is experienced in this day and age. This is the claim that the world by and large has recently experienced a major shift that has greatly affected how its social institutions operate. Many scholars date the beginning of this shift to around the mid-twentieth century (e.g. Scholte 2005a; Giddens 1999; Held *et al.* 1999), and what they suggest is that a new 'global' paradigm is now upon us. However, the transformationalists temper this view with the qualification that the changes they describe do indeed have some antecedents in previous time periods. Yet, they also strive to appreciate what cannot simply be captured by proclaiming that the world as it is today is simply 'more of the same'. In this manner then, the transformationalists seem to take a similar approach to the one put forth by Bruce Mazlish (2006), who argues that it is equally as reckless to be dismissive of new developments as it is to ignore the continued relevance of some historical forces, particularly when the matter of globalization is considered.

But what distinguishes the contemporary phase of globalization from its earlier instantiations, if indeed there is something novel about the present situation? A well-developed strand of thought suggests this has to do with the *scale* and *pace* of the globalization phenomenon in the contemporary era. This has to do with the degree to which 'transworld' relations are being expanded as well as the speed at which these expansions are taking place. Such is the argument of Jan Art Scholte (2005a), who points to a number of sectors where this 'acceleration' of globalization has recently been at work. One such sector is the communications sector, which has radically changed on a seemingly worldwide basis. Scholte surveys a wealth of empirical research that details the far-reaching and fast-paced proliferation of communication technologies like the telephone, the internet and the mobile phone, which have made the world a more interconnected place (2005a: 101–4). Transplanetary travel is another sector where the contemporary phase of globalization is distinct from its earlier manifestations. Scholte marshals as evidence research that finds that 'the average number of people crossing state frontiers across the world per day rose from 69,000 in 1950 to over two million in 2000' (2005a: 104). Furthermore, Scholte demonstrates how new transworld relations are increasingly being formed with respect to how money circulates and how finance and systems of production operate, such that there is a supra-territorial quality to how most, if not all, economies run in the current era. Also relevant to this discussion of the novelty of globalization in the present day is Thomas Hyland Eriksen's (2007) argument that a sense of simultaneity has recently arisen in many places all around the world. This has to do with the claim that our sense of time and place has somehow shifted so that events can now be experienced simultaneously, even though individuals may be spatially far apart from one another. Eriksen suggests that the media is a key avenue where this sort of change has taken place, since 'distance has become relative' when it comes to the opportunity to discuss events with others (2007: 44). He points to the fall of communism in Eastern Europe in the autumn of 1989 as one such instance when there was this possibility of a discursive simultaneity, but it may be even more salient to recall the global media coverage of the September 11th attacks in 2001 or the 2012 London Olympics.

Of course, this aspect of 'globalization', according to Eriksen, is only ever a partial and 'not a totalizing phenomenon' (ibid.). This means that, even though the contemporary phase of

globalization is something that is far-reaching, nonetheless it is something that has asymmetrical consequences and causes. Contemporary globalization, in short, does not affect everyone in the same way, as it is marked by a certain amount of social division. Hence, this is what explains why even though 'there is an "IT boom" in India, the country emerging as a major power in the production of information technology, more than half of the Indian population have never made a phone call' (Eriksen 2007: 45).

This would seem to suggest, then, that we need to adopt a different conceptual framework so as to capture the complexities that globalization involves. This is a topic elaborated upon in the work of John Urry (2000), who postulates that globalization undermines much of what we classically assume constitutes the idea of 'society'. Here, what Urry takes aim at is the long-held connection between society and the metaphor of region. If we are to take globalization seriously, this, he suggests, is a link that needs to be re-conceptualized. This is so because such an account of society is ill-equipped to handle the issue of mobilities, which he believes globalization brings to the fore (2000: 2). For support, Urry cites a growing literature that asserts that many traditional categories such as the territorially bounded nation-state are somewhat losing their traditional efficacy as sociological concepts. By and large this has to do with the fact that the mobility of people, goods and objects is becoming more pronounced and varied. This is informed by significant developments in the travel industry as well as advancements made in the tele-communications sector.

Thus, as a corrective, Urry proposes that we replace the link between society and region with the metaphors of networks and fluidity (2000: 33). Adopting this way of thinking allows us to see how a territorially bounded notion of society ultimately fails to capture the current situation. Ours is the world where people and objects flow in and out of networks, which are both virtual and physical, and for reasons that may be either elective or coerced. To argue otherwise then is to focus on the solidity of social structures when we should be noticing how social bonds and boundaries are now being broken, re-organized and in some cases superseded.

Of course, this is not to dismiss that there are those people in the contemporary phase of globalization who are less 'fluid' and 'mobile' than others, whether in the virtual or physical sense. Bryan S. Turner (2007) has argued persuasively for such a balanced view of globalization which also considers various forms of immobility in the contemporary age. A curious paradox of contemporary globalization, as Turner observes, is that the process does not merely generate new types of mobility, for it 'also produces new systems of closure' (2007: 289). This refers to the immobilization of certain individuals, groups and peoples that has occurred partly as a securitized response to the perceived 'threat' to sovereignty caused by the development of economic forms of globalization. Turner's decision here to focus on the immobilized, however, is not to discredit globalization as a phenomenon as much as it is to engender a heightened sense of its dynamism. His aim, in this regard, is to widen the purview of what globalization entails. This is not only to do with the recognition that 'global flows and networks' are key features of the modern world (2007: 288), but also to acknowledge that there are 'sequestrations, exclusions and closures' that are basic features of daily life for much of the world's population in one form or another (2007: 290).

The globalization phenomenon thus fundamentally involves a wide-ranging set of descriptive and analytical tensions. These tensions speak to the need for a more nuanced and multi-faceted account of globalization as a concept utilized by many in the social sciences. For instance, it has been well established that there are conceptual flaws to depicting globalization as merely an economic issue (e.g. Tomlinson 1999; Robertson 1992) or a macro-oriented affair (Giddens 1999; Elliott 2008). It has also been established that globalization is not

exclusive to the contemporary era (e.g. Lemert *et al.* 2010; Hopkins 2002; Mazlish 2006), although there is still something unique about the process that belongs to this period (e.g. Scholte 2005a; Urry 2000). And it is also wrong-minded to posit globalization as a linear process that has uniform consequences and singular causes (e.g. Held *et al.* 1999), as the phenomenon also involves a significant degree of social division (e.g. Eriksen 2007; Turner 2007). The claim of many social researchers is that if these theoretical considerations are taken on board, globalization becomes an indispensable and highly insightful way to describe the changes that the world has recently experienced.

Main criticisms

Criticisms of the globalization debate in the social sciences are as manifold as they are significant. But two lines of argumentation have in particular been recurring. The first vein of criticism centres on the *substantive* content of the globalization discussion as a whole, whereas the second vein relates more to the territory of theoretical concerns. The substantive critique refers to the claim that the age of globalization has already come to a premature end. Such a point is made by John Ralston Saul in his work *The Collapse of Globalism* (2005). Essentially, Saul's main contention is that it is wrong to assume that the globalization impulse will always be upon us. This is so because, just as with other epochs, its pertinence can only last for so long. And indeed at the start of the new millennium, Saul believes globalization has already run its course. Globalization, especially in the economic sense, is something we can begin referring to in the past tense. Saul buttresses this claim by pointing to other issues that have started to supplant globalization's erstwhile prominence: a revival in nationalist sentiment and influence, shifts in geo-political economic philosophies towards more state-centred policies, and the normalization of irregular warfare throughout the world. These, he says, are what we should be investigating, for 'globalism' is increasingly becoming a dated reference and not all that germane to the current times.

The work of Justin Rosenberg (2005) has also played a significant role in advancing the *substantive* critique of the globalization debate. For Rosenberg, what is misleading about the claims made by globalization theorists is that globalization is an unyielding and upward-trending phenomenon. By contrast, Rosenberg reads globalization as more of a misleading 'flash-in-the-pan' phenomenon. He does this by offering an alternative reading of what transpired in the 1990s that is alleged to have been responsible for the emergence of a globalizing state of affairs. Although Rosenberg grants that 'the Soviet collapse in the East and the deregulating thrust of neoliberalism in the West were indeed central to the events of the decade' (2005: 6), he is not convinced that the combination of these two developments amounted to anything more than

> a distinct, and in some ways self-contained historical conjuncture, in which the filling of a socio-political vacuum (generated by the Soviet collapse and its effects) created an enormous sense of temporal acceleration and spatial compression – but one which could by definition only be temporary.
>
> *(2005: 6)*

The analytical error that many globalization theorists make then is to interpret what is ostensibly a 'peak of a cycle' as an inexorable and unyielding new direction in world relations. But more than this, Rosenberg suggests that not only have globalization theorists ignored and been beset by a litany of 'empirical contradictions', but they have also strayed from 'what

social theorists are supposed to do', for globalization scholars have not acted as mere 'interpreters to the spirit of the age'; they have fulfilled the role of its 'ideological amplifiers' (2005: 6–7).

The sum and overlapping result of Rosenberg's and Saul's work, then, is to suggest that the conceptual framework of globalization is of extremely limited value with regard to its substantive elements. From this viewpoint, there is not enough empirical evidence to support the arguments that many globalization theorists have put forth. What is perhaps even more dismissive of the globalization concept, though, is the second line of critique of the globalization debate, one that is more theoretical in its orientation. Justin Rosenberg (2000, 2005), again, has been extremely influential in advancing this polemical viewpoint. Rosenberg's qualm with the globalization paradigm in the theoretical sense is, first, that it is more often than not conceptually muddled. This is especially the case when it comes to those definitions of globalization that are unabashedly circular, such as Margaret Archer's view that 'globalization is the present process of becoming global' (quoted in Scholte 2005a: 15). Rosenberg links this tendency in the globalization debate with the unresolved status of globalization's analytical value. For Rosenberg, what globalization theorists have not yet been able to resolve is whether globalization is a phenomenon that needs to be explained or whether globalization is the concept that in fact does the explaining. Another way of phrasing this problem is by conceptualizing globalization as either an *explanandum* or an *explanans*. The former deals with globalization as a descriptive term that needs to be accounted for, whereas the latter understands globalization as an explanation in its own right.

While Rosenberg (2000: 2–4) considers globalization as an *explanandum* as a viable mode of inquiry, he is vehemently more dismissive of the use of globalization as an *explanans*. Yet, it is this latter usage of globalization that Rosenberg characterizes as being dominant in the globalization discourse. When politicians, policy makers and social researchers alike invoke globalization, it is typically to elucidate why some set of changes has taken place. However, Rosenberg counters by calling into question the analytical worth of an explanation that merely pays attention to the reorganization of time and space, as implied by the definition of globalization as 'the intensification of worldwide relations'. Rosenberg regards the use of this analytical strategy as a type of legerdemain. Only when hard-pressed do those who espouse this way of thinking have to provide a number of qualifications that mainly involve invoking non-global references. In turn, what this says to Rosenberg is that globalization on the whole actually says very little. If all the concept does is direct our view to a more spatially expansive perspective, then this does not explain how people behave or societies operate beyond the *location* of where they operate.

Rosenberg suggests that the 'intellectual redundancy' of globalization becomes even more salient if we consider other, more insightful, concepts, for instance that of capitalism. Where capitalism succeeds – but where globalization fails – is that it is able to specify 'a particular nexus of social relationships . . . from which spatial and temporal implications, among others, might be argued to follow' (2005: 11). Rosenberg notes 'by contrast' that 'the term "globalization" in itself specifies no particular kind of society at all, but simply denotes a process of worldwide spatial expansion and integration per se' (2005: 12). And herein lies the crux of Rosenberg's dissatisfaction with the latter concept. Rosenberg fundamentally disagrees with the proposition that is implicitly advanced by globalization theorists: that space and time 'are the foundational parameters of social explanation' (ibid.). This means that we should not grant a causal power to the globalization phenomenon as so many authors suggest. However, the main consequence of adopting this position is that globalization becomes denuded of almost all of its analytical value.

Consequently, Rosenberg sees fit then to declare a 'post-mortem' on the globalization paradigm. If we keep in mind the empirical failings of globalization theorists as well as their conceptual ones, this therefore leads us to conclude that there is little that is actually insightful or even redeeming about the globalization debate. Indeed Rosenberg's work leaves us with the impression that the 'only real puzzle that we have left is to work out why so many bright people thought [globalization] was so important' (Bisley 2007: 9).

Anticipated future developments

It is clear from Rosenberg's work that the globalization paradigm is not without its own analytical failings. But does it thus follow that globalization should be made a defunct area of study? Has globalization, as Tom Conley (2008: 141) notes, gone the way of postmodernism, whereby those who continue to work with the concept are irrevocably burdened by the need to apologize for the concept's definitional shortcomings? In the sections that remain it is the task of this chapter to provide an answer to such a difficult but pressing query.

To this end, it first bears mentioning that globalization may not be in fact the conceptual framework that encapsulates all of the central issues that are pertinent to the contemporary era, as some have previously suggested. This means that we should not think of globalization as a concept that wholly replaces other modes of analysis. However, does adopting this approach render the globalization paradigm 'intellectually redundant' as far as social scientific research is involved? After all, what even remains redeemable about the globalization debate if the paradigm, according to Rosenberg and Saul, is plagued by an overwhelming number of empirical and theoretical weaknesses?

Jan Art Scholte (2005b) makes a strong case for why we need not accept the view that, moving forward, the concept of globalization should be completely abandoned. This is because the concept comes in an array of forms, not all of which are as flawed as Rosenberg and Saul make them out to be. Scholte begins by unravelling the substantive line of critique, which he regards as being the least persuasive. What is significant here to recognize, according to Scholte (2005b: 391), is that 'no major indicators show any decisive slowdown, let alone reversal, of the [globalization] trend since 2000', if we accept Rosenberg's own definition of globalization as 'a process of worldwide spatial expansion and integration' (2005: 12). While Scholte admits that there have been some 'recent temporary decelerations' in some sectors of society, such as the 'turnover on foreign exchange markets', there is nonetheless an over-whelming amount of evidence in other sectors of life which include 'global health issues, global ecological concerns, global travel, global communications, global military activities, global production chains, global regulations, and global social movements' that suggests that the globalizing trend is still at work (2005b: 391–92). Scholte thus highlights how sceptics of the contemporary phase of globalization like Rosenberg typically avoid addressing the empirical measures that many globalization scholars have found to be consequential. Time and time again, how these sceptics have chosen to respond is by offering 'little more than tired rehearsals of the same two or three (among the possible dozens) proportionate (rather than absolute) indicators relating to international (not the same as global) direct investment, permanent migration, and trade in the late 19th century' (2005b: 392). Appealing to these indicators, however, is simply 'not good enough anymore' (2005b: 393), especially if we want to grasp what is empirically novel about the social world at the start of the new millennium.

The other way in which Scholte defends the analytical value of globalization is by addressing the theoretical qualms that Rosenberg has with the concept. Scholte concedes here that Rosenberg does raise many good points on this front, but the true result of this is to

encourage us to take on a more tempered view of globalization instead of a wholly dismissive one. At one level, this has to do with Scholte's disagreement with Rosenberg's position that space has no causal significance whatsoever. For Scholte, what Rosenberg does by advancing such an extreme position is to imply that 'spatial formations derive from, are a part of, and can be causally reduced to the prevailing mode of production', which thus defines globalization completely 'as a feature and result of contemporary capitalism' (2005b: 393). But from Scholte's view, this implication has its own conceptual blind spots. This is so because there is a compelling case to be made that 'the construction of social space has impacts that are not reducible to the mode of production' (ibid.). In this regard, Scholte surveys instances in the social scientific literature where there is the sentiment that 'space matters' (2008: 1479). Hence, he observes that 'for example, non-Marxist social psychologists might suggest that the geography of communication (e.g. face-to-face vs cyberspace) impacts on interpersonal relationships in ways that are not merely a function of capitalist development either' and that 'likewise, many non-Marxist anthropologists and sociologists might affirm that space (localities, countries, regions, globalities) helps to frame identities in manners that do not wholly and solely respond to the logic of a mode of production' (2005b: 393). What may be perhaps even more telling, for Scholte, is that 'the very field of Human Geography rests on a premise that social space has sufficient importance to merit its own dedicated programme of research' (2005b: 394). Taken in sum, Scholte believes these instances 'provide grounds for a reasonable supposition that space carries some relatively autonomous significance in social relations' (2005b: 393–94). Of course, Scholte also recognizes that it is a mistake to claim that geography is the sole determinant of social life. To reduce social relations to their spatial qualities would be indeed most 'peculiar'. However, as Scholte writes, 'it is possible to argue that space matters without going to a "spacist" extreme. An explanation can incorporate a significant spatial dimension without being "based" on a geographical motor alone' (2005b: 394).

This defence of the significance of space in the globalization paradigm is also linked to Scholte's dissatisfaction with Rosenberg's dichotomous way of conceptualizing globalization as either an *explanandum* or an *explanans*. What Rosenberg does not allow is for globalization to be somehow both, since his thinking consigns globalization to only one of the two poles. Scholte contends that there is another viable way of approaching globalization that avoids such dualistic ways of thinking. This corresponds to Scholte's view that 'history flows from a confluence of inter-related spatial, cultural, economic, political and psychological forces', so that 'a shift in the structure of social space would be interconnected (as both cause and effect) with concurrent shifts in social structures of knowledge, production, governance, and identity' (2005b: 394–95). Implicated in this alternative approach to globalization is a move away from terminology that posits that globalization 'causes' or 'determines' and to a vocabulary that stresses that the phenomenon '"promotes", "encourages", and "advances" concurrent other shifts in social structure' (2005b: 395). The advantage of employing this view of globalization is that a more multi-dimensional understanding of causation emerges and, contrary to Rosenberg's argument, this does not then cause one to be less of a 'credible social theorist' (ibid.). For Scholte, ultimately at issue here are the analytical shortcomings of Rosenberg's meta-theoretical preference for explanatory frameworks like Marxism which are less complex and more certain. Scholte reminds Rosenberg that it may in fact be more – not less – deceptive to provide a social explanation that has a theory of causation that flows from a solitary source. Social life is undoubtedly more complex than that, which is why 'it might be [better] for theory to show greater sensitivity to, respect for, and encouragement of plural experiences and possibilities in history' (ibid.). The same approach should be applied to the study of globalization, which is suggestive of its continuing relevance.

In light of the debate outlined above, there is arguably a case to be made that scholarship on the theme of globalization will continue to serve as a source of valuable insight in the social sciences. However, this will be dependent on whether or not the theorizing of globalization proceeds in a modified form. It is well-argued that we need a more empirically robust understanding of globalization. But equally so, it is critical that we take a more theoretically sophisticated view of what globalization entails. This latter issue rightfully involves, as Rosenberg (2000, 2005) proposes, a fair amount of analytical modesty as to what the paradigm seeks to explain. But from the perspective of Scholte (2005b, 2008), this modesty need not lead to a completely dismissive view of what the conceptual framework has to offer.

What is important to keep in mind is that this is not the first time a concept in the social sciences has been reappraised after a period of it being in vogue as the proverbial 'key to the universe'. Clifford Geertz makes this point when it comes to the issue of culture, but so does Conley when it comes to 'power, politics, policy, the state, interdependence, empire, hegemony power', and so on (2008: 142). Conley suggests that 'just because we cannot agree on what [these terms] mean and what they encompass', this does not mean we have to call into doubt their entire utility as concepts, for they each make valuable contributions to our understanding of the social world (ibid.). Therefore, this is why there is validity to Scholte's argument that 'a definition of globalisation as a respatialisation of social life opens up new knowledge and engages key policy challenges of current history in a constructively critical manner', since 'notions of "globality" and "globalisation" can capture, as no other vocabulary, the present ongoing large-scale growth of transplanetary . . . connectivity' (2008: 1499).

Put differently, there are usages of globalization that are less helpful and even some that generate a misleading view of contemporary world affairs. But it would be a mischaracterization to pronounce the concept as being devoid of any real explanatory significance. Globalization deals with the reorganization of time and space that involves the intensification of 'transplanetary' social relations. It thus captures something that other conceptual frameworks do not, even if those frameworks have some bearing on how globalization itself is articulated. *Contra* Rosenberg and his analytical concerns, this interwoven way of understanding globalization may actually lead to a more sober and insightful grasp of the contemporary social world.

Conclusion

The point of this chapter has been to survey the social scientific debate on the theme of globalization. It has crucially identified a number of striking criticisms of the concept and of the globalization debate as a whole. Some of these criticisms have been constructive in advancing a more sophisticated theory of globalization. For instance, much has been made of the analytical shortcomings of the depiction of globalization as primarily an economic process (e.g. Elliott 2008; Giddens 1999; Hannerz 1992; Robertson 1992; Tomlinson 1999). Much has also been made of globalization's asymmetrical causes and consequences (e.g. Eriksen 2007; Held *et al.* 1999; Turner 2007). And there has been a concerted effort to establish the conceptual benefits of theorizing globalization as a longer-term historical phenomenon (e.g. Lemert *et al.* 2010; Hopkins 2002; Mazlish 2006).

All the while there have been sharp criticisms of the globalization paradigm as a whole, some of which have even resulted in the proclaimed 'post-mortem' of the concept (e.g. Rosenberg 2000, 2005; Saul 2005). Globalization, from this angle, is so utterly rife with theoretical and empirical shortcomings that there is little to salvage from its usage. This chapter has suggested that we need not jump to such hasty conclusions about the demise of

the globalization concept, as there are viable reasons to believe in its continued relevance (e.g. Scholte 2005b, 2008; Conley 2008). One of these reasons centres on the fact that the concept comes in many forms, not all of which are guilty of such hyperbolic and muddled ways of thinking. Another of these reasons has to do with the view that globalization is in need more of some conceptual refinement than of abandonment. This may very well involve a heightened sense of analytical modesty in the way that globalization is deployed. But such is typically the case when more sophisticated modes of explanation are adopted in the social sciences. The term globalization is likely to endure in the wider public debate for the foreseeable future in ways that 'abuse' the concept's scholastic meaning (Conley 2008: 150), and this provides yet another impetus for social researchers to stay with globalization as an insightful concept.

References

Bisley, N. (2007) *Rethinking Globalization*, New York: Palgrave Macmillan.
Conley, T. (2008) 'Globalization, schmobalization?', *Australian Journal of Political Science*, 43(1): 141–51.
Cowen, T. (2002) *Creative Destruction: How Globalization Is Changing the World's Cultures*, Princeton, NJ: Princeton University Press.
Elliott, A. (2008) *Making the Cut: How Cosmetic Surgery Is Transforming Our Lives*, London: Reaktion Books.
Eriksen, T. H. (2007) *Globalization: The Key Concepts*, Oxford: Berg.
Giddens, A. (1999) *Runaway World: How Globalisation Is Reshaping Our Lives*, London: Profile Books.
Hannerz, U. (1992) *Cultural Complexity: Studies in the Social Organization of Meaning*, New York: Columbia University Press.
Held, D., McGrew, A., Goldblatt, D. and Perraton, J. (1999) *Global Transformations: Politics, Economics and Culture*, Stanford, CA: Stanford University Press.
Hirst, P. and Thompson, G. (1996) *Globalization in Question: The International Economy and the Possibilities of Governance*, Cambridge: Polity Press.
Hopkins, A. G. (2002) *Globalization in World History*, New York: W. W. Norton and Company.
Jones, A. (2010) *Globalization: Key Thinkers*, Cambridge: Polity Press.
Latouche, S. (1996) *The Westernization of the World: Significance, Scope and Limits of the Drive Towards Global Uniformity*, Cambridge: Polity Press.
Lemert, C., Elliott, A., Chaffee, D. and Hsu, E. (eds) (2010) *Globalization: A Reader*, London: Routledge.
Mazlish, B. (2006) *The New Global History*, New York: Routledge.
Ohmae, K. (1990) *The Borderless World: Power and Strategy in the Interlinked Economy*, New York: HarperBusiness.
Robertson, R. (1992) *Globalization: Social Theory and Global Culture*, London: Sage.
—— (1995) 'Glocalization: Time-Space and Homogeneity-Heterogeneity', in M. Featherstone (ed.) *Global Modernities*, London: Sage.
Rosenberg, J. (2000) *The Follies of Globalization Theory: Polemical Essays*, London: Verso.
—— (2005) 'Globalization theory: a post mortem', *International Politics*, 42(1): 2–74.
Saul, J. R. (2005) *The Collapse of Globalism: And the Reinvention of the World*, London: Atlantic Books.
Scholte, J. A. (2005a) *Globalization: A Critical Introduction*, New York: Palgrave Macmillan.
—— (2005b) 'Premature obituaries: a response to Justin Rosenberg', *International Politics*, 42(3): 390–99.
—— (2008) 'Defining globalisation', *World Economy*, 31(11): 1471–1502.
Tomlinson, J. (1999) *Globalization and Culture*, Chicago: University of Chicago Press.
Turner, B. S. (2007) 'The enclave society: towards a sociology of immobility', *European Journal of Social Theory*, 10(2): 287–304.
Urry, J. (2000) *Sociology Beyond Societies: Mobilities for the Twenty-First Century*, London: Routledge.

Part II
Contemporary cultural theory

12

Cultural and social things

Is there a difference?

Charles Lemert

If the Greeks are to be trusted, theory is above all else a matter of observing with the inner ear the spectacles of the world about. Hence, Aristotle, *On Rhetoric*, I: 3: 'The hearer must be either a judge, with a decision to make about things past or future, or an observer' – where 'observer' translates the word *theoros*. Whether the observer can refrain from judging is far from clear, especially in modern times, where spectacles major and minor abound.

It may be that the modern usage, 'theory', has lost its vital connection to *theoros*. If so this would be because, in our time, the observer cannot refuse to judge the spectacles at hand – if only by clicking the remote control or browser button in search of some quiet cove out of the audio-visual currents. The consequence of this apparent state of affairs is that theories of social and cultural experiences have so elevated themselves from a world of too many signals and signs as to become hopelessly arid, thus unreal in terms of the original purpose of deep listening to the world about.

As archaic as it may be, this way of putting the question of theory's nature helps to clarify relations between and among cultural and social theories. One of the unintended consequences of the modern world's attempts to come to terms with an ever-compounding number of social and cultural stimuli is what might be called the analytic reflex. Moderns, by nature, will intuitively search for a method to cut the field of stimulations into workable parts. The intuition rises on a reflex arc that for the most part does not pass through the conscious mind. The effect is an analytic division of mental labour.

After John Dewey's classic article, 'The reflex arc concept in psychology' (1896), the first and still clearest sociological expression of the reflex arc of modern life is that of Georg Simmel in 'The metropolis and mental life':

> Man is a creature whose existence is dependent on differences, i.e. his mind is stimulated by the differences between present impressions and those which have preceded. Lasting impressions, the slightness in their differences, the habituated regularity of their course and contrast between them, consume, so to speak, less mental energy than the rapid telescoping of changing images, pronounced differences with what is grasped at a single glance, and the unexpectedness of violent stimuli. To the extent that the metropolis creates these psychological conditions – with every crossing of the street, with the tempo and multiplicity of economic, occupational and social life – it creates in the sensory

foundations of mental life, and the degree of awareness necessitated by our organization
as creatures dependent on differences.

(2002 [1903]:103)

Simmel's idea in 1903 was that the structural transformation of modern society from rural to
urban life was itself a perturbation altering human mental life. He did not, to be sure, use the
term Dewey helped put into play; still, Simmel's 'sensory foundations of mental life' is close
enough.[1] The greater the number of differences in the social and cultural environment, the
greater the mental need to create differences capable of screening out what cannot be taken
in. The screening out in everyday life is, precisely, an analytic cut – a parsing that in
effect sorts stimuli into various mental files available either for later use or, just as often, for
repression from conscious life.

In sciences of all kinds, most awkwardly in the human sciences, the analytic cut is more or
less skilfully lifted from the realm of sheer reflex into the exalted status of fully articulated
analysis. This is the function of scientific categories that are, in their technical state, often
called variables, available for numeric or verbal manipulation. There is no compelling reason
(at least not on this occasion) to cop an attitude, as some do, towards this most basic of scien-
tific manoeuvres. Like all mental procedures analytic methods are good in some ways, bad in
others. But they are acutely interesting and probably confounding when it comes to an
endeavour, like this one, to sort out the differences, if any, between social and cultural
theories.

One might stipulate, as I do, that theories today, whether good or bad, cannot but rely
upon the analytic reflex. The good to be said of this reliance is that it allows us to appreciate
theory, first, as observing and, second, in but a nanosecond after, as the mental impulse about
which one wants to say something, even only mutedly to oneself. This is what writers like
Brian Massumi and Patricia Clough have identified as the fraction of a second delay sepa-
rating the stimulus and the emergence of an affect – a remarkable notion that all mental
labour is, in effect, an after-the-fact judgement as to the meaning of an observation.[2] Whether
it is the interior dialogue of the healthy mind or the interior origins of an external civil
conversation, the affective dialogue arising in a scant half-second deferral from the stimulus
is where theory, well understood, begins. Theory, thus, is having something to say in the
after-affect of hearing (which Aristotle also calls 'observing'), the judgement after the fact of
experience. This is the unstable circumstance of theories of all kinds.

Aristotle's axiom was, after all, an element in his own prolonged dialogue, *On Rhetoric*. In
our noisy world, the danger is that too deep a swoon into the arms of the analytic reflex will
disturb the natural relation of the theorist to the worlds she observes. Aristotle, had he known
what the worlds long after his were to become, would likely have been alarmed at the apparent
necessity of the observer's being habituated to anything like an analytic reflex. In effect,
keeping Aristotle's axiom in mind, today there is no real prospect of a distinction between the
observer and the judge. All must judge among the incalculable differences available for
observation.

Theory, in short, is no longer simply observation of spectacles but judgement. The axiom
applies equally well to scientific observations external to an analytically defined world of
purportedly real events as to observations made amid the experiences of everyday life (what
Alfred Schutz (1959) so aptly called the naïve attitude of everyday life). Sooner or later,
methodically or preconsciously, theories are observations entailing a judgement – critical
determinations of what, for the time being, shall be pragmatically considered real, hence
worthy of our attention. All else is noise which is always background static.

When it comes to observations (which is to say, theories) of social and cultural things, it is important to ponder – in spite of evident differences between the worlds of Aristotle and Simmel – whether there is any point to the presumption of a difference between social and cultural things. The mere presence of the adjectives 'social' and 'cultural' is an analytic value added after experience. Just as in writing we are taught to avoid adjectives, so too in intellectual work we ought to think with as few of them as possible. Just think of the trouble they cause.

How is it possible upon observing the ongoing spectacles of daily life to discern which parts are culture and which are social? A school play is both at once, as is a parade, and a concert, and the list goes on. One might say that the economic dimension of experience is more discernible. Schools charge tuition, parades require flags, concerts usually charge for tickets (except for band music in small towns in summer), and so on. Still, in a broader sense, when considered from the point of view of experience, the things we encounter in ordinary life are screened by the natural analytic reflex, but they are seldom consciously judged in respect to their differences. It is only when, as Simmel said, the differences are sudden or violent that we must adjust ourselves mentally to them. But the difference between cultural and social things, even between them and economic or political things, is seldom truly distinct.

The things of this world are what they are, and we experience them as, literally, things that touch our senses. Without recourse to Kant's proposition that we cannot know things in themselves, we can say (much if not exactly as he did) that we know them as our perceiving minds sort them according to, as Durkheim would add, socially determined categories. Between Kant and Durkheim there was a world of analytic differences, but they agreed that the things of this world, whether mental or collective, are experienced through representations of whatever is real out there and not as the things themselves. This is no less true of the differences between cultural and social things.

Since our subject here is the presence or lack of a difference between social and cultural theories, it is proper to impose an analytic cut of our own, as it may lie at the heart of the practice of sorting social and cultural theories as if the things to which they refer are segregated in lived experience. When pressed, few are they who would say that they are so segregated, yet in the reality of academic cultures the discrimination has become a matter of great urgency.

It is all too simple, at this point, to dust off the tiresome argument about the tragedy of bureaucratization in academic and, therefore, intellectual life. Yet it happens. Universities, in particular, organize people into departments that correspond to fields (which further reclassify people into subfields that in principle could go all the way down to the bottom turtle). These subdividing hierarchies are the measuring rods in respect to which work is assessed and which pay raises or promotions awarded or denied. As a result, people who live and breathe in such institutions take on their cultures as second nature – as a kind of habitus, as Bourdieu would have put it. They are disposed to think that since their work is observed and judged against uncertainly measured standards of departments and fields, they must, as they do, advance this disposition of professional culture to cover the analytic organization of their mental labours.

There is no better illustration of a needless analytic cut than the nomenclature that divides social things from cultural ones. The contrivance whereby cultural and social things are set apart is relatively recent in human history. The earliest, authoritative social scientific use of 'culture' was by the anthropologist Edward Tylor in 1871 in *Primitive Culture*: 'Culture is that complex whole which includes knowledges, belief, art, morals, law, custom, and any other

capabilities and habits acquired by man as a member of society' (p. 1). Theorists of the topic, who since have devised different, presumably more subtle, definitions will recognize in Tylor's words a normal, if elementary, application to social sciences. Before then, the root of the word originated with respect to religious *cults*, after which over many centuries it came to be associated with *cultivation* as in agriculture and horticulture, then microbiology as in a *culture* for nurturing microbes, then *cultured* as in the cultivated habits of the higher social ranks, from which it crossed the line into its more technical meaning as a general, even functionally necessary, dimension of social orders of all kinds. Thus began culture's fate as a distinct analytic category in social science.

Without stressing too much the importance of Tylor's definition, it is of interest to remark that his 1871 *Primitive Culture* occurred not long after two other landmarks in the history of the social theory of culture: Matthew Arnold's *Culture and Anarchy* in 1869 and Marx's *Capital I* in 1867. Arnold's title summarized the point of his classic defence of high culture against the degradations of the new and rising industrial order. 'Culture', he said, was 'the great help out of our present difficulties; culture being a pursuit of our total perfection' (1869: Preface). Arnold did not mention Marx, but there can be little reason to doubt that he at once shared at a remove Marx's distress over the factory system while occupying quite the opposite extreme as regards the status and nature of culture. For Arnold, culture was high culture – the guardian of all that is at risk in the industrial order: 'machinery is the bane of politics, and an inward working, and not machinery, is what we want most' (1869: Preface).

By contrast, Marx, a man of high literary culture himself, famously and for many years, denounced the pretences of culture as the inverted image, the *camera obscura*, of economic reality. It is sometimes overlooked that *Capital I* (Althusser's epistemological break notwithstanding) is the mature theory of the most elementary of all human values. In the mystery of the commodity is hidden the social value of all commodities and, most gruesomely, the alienated human labour from which profit is extracted. 'A commodity appears at first sight, a very trivial thing . . . [when] in reality it is a queer thing abounding in metaphysical subtleties and theological niceties' (1906). Marx's implicit theory of culture in *Capital I* is far less clumsy than the notorious 'opiate of the people' line, but it comes clean to the point that culture arises precisely from the alienation of human labour and the capitalist machine.

Between Arnold and Marx, with Tylor as a shifter, lies the deep historical origins of today's idea that cultural things are different from social, including economic, ones. This precisely, we now recognize, was the agonal uncertainty of nineteenth-century social thought. Marx himself used the word *Ding* repeatedly in his analysis of commodities – a commodity is at once a 'queer *thing* abounding' and the particular instance in a vast social and economic system of just how capital production *reifies* (which is to say: thingifies) human labour. The recovery of material things from what in 1845 Marx and Engels snidely labelled German ideology put an end to his tortuous effort to overcome his own struggles with Hegel and Kant in the earlier writings of the 1840s. On this Althusser (1969; see also Lukács 1972) is correct, even if the assertion of an epistemological break is betrayed by the importance of 'reification' in the writings of the 1850s, only to slip in *Capital I* behind the renewed prominence of its cognate 'alienation'. The desiderata of Marx's materialism aside, there can hardly be a more dramatic statement of the nineteenth century's dilemmas as to the place of capitalism's potent materialism against acculturating effects of German idealism than the essay 'Idealism and materialism' at the beginning of *The German Ideology* (Marx and Engels 1947).

Today's students of culture would do well to ponder the effects of the idealism–materialism controversy, which is rooted in and thus bound by a definite period of modern

thought. Today, early in the twenty-first century, among social theorists the debate is more often one over realism – a development that may in part be due to the effect of information technologies on culture in the broad sense.

Michael Hardt and Antonio Negri, in *Empire* (2000), have advanced the concept of 'immaterial labour'. Their concept derives from a tendentious view of Foucault's biopolitics read through Gilles Deleuze's manifesto 'Postscript on societies of control' (1992),[3] which quite explicitly identifies information technology as at once a system of control and a system of subjugation (in Foucault's sense of subject formation). Right or wrong, *Empire* is a prime illustration of the degree to which even serious, if not vulgar, Marxists today can consider the extent to which labour is no longer the sheer materialization of human value.

What is meant by immaterial labour if it is constituted in cyberspace? Immaterial labour, according to Hardt and Negri, 'in the contemporary economy [is]: the communicative labor of industrial production that has newly become linked in informational networks, the inter-active labor of symbolic analysis and problem solving, and the labor of the production and manipulation of affects' (2000: 30). If, therefore, to any important degree labour subsists in virtual reality, then what remains of the status of human labour? In such a prospect the production of value-embedded concrete things is suspended in the ever more severe contra-diction of capital accumulation between, on the one hand, runaway profit making vested in ventures compounded without durable outcomes and, on the other hand, a global economic misery so profound as to be beyond alienation or reification, as capital flows sweep impover-ished millions into a dustbin outside history.

Even if, as I propose, we take a concept like immaterial labour as no more than diagnostic, such a notion points to the tangled nature of certain sharp analytic distinctions made by social theory. If social reality cannot any longer definitively be divided between material and ideal factors, then what becomes of the collective attitude by which modernity has enveloped 'the human' as the idealized creature-hood superior to animate and inanimate nature? In this respect, Marx no less than Matthew Arnold was caught up uncritically in the modernizing assumption that the human and, thereby, the social are *au fond* cultural things distinct from natural ones.

Bruno Latour in *Reassembling the Social* (2005), among many other writings, recalibrates the social–cultural distinction. He simultaneously dismisses modern culture's self-aggrandizing theory of human superiority and challenges sociology's claim to be, as Durkheim put it, the science of social things – things being, for Latour, of a different order from Durkheim's.

> Even though most social scientists would prefer to call 'social' a homogeneous thing, it's perfectly acceptable to designate by the same word a trail of associations between hetero-geneous elements.
>
> . . . It is possible to remain faithful to the original intuitions of the social sciences by redefining sociology not as the 'science of the social', but as the tracing of associations. In this meaning of the adjective, social does not designate a thing among other things, like a black sheep among other white sheep, but a type of connection between things that are not themselves social.
>
> *(Latour 2005: 5)*

To be sure, Latour's actor network theory is open to criticisms, many of the most notable of which he takes into serious account.[4] Yet, as the few lines quoted allow, Latour also offers a way around the besetting problem that lies at the foundation of culture theories.

Charles Lemert

It is not necessary to reject the idea of the social so much as to loosen its grip on sociology, in particular. Durkheim's justly famous idea first announced in *The Rules of Sociological Method* (1938 [1894]) proposes that sociology is the science of social things – of, that is, social facts which are things in themselves not reducible to psychological or mental facts. The use of the word 'things' (*choses*) is sometimes taken as a figure of speech. Yet, through the years from *Rules* to his last great book, *Elementary Forms of the Religious Life* (1965 [1912]), Durkheim returns again and again to *choses* external to mental life. 'What is a thing? The thing stands in opposition to the idea, just as what is known from outside stands in opposition to what is known from the inside' (1901: Preface).[5] This was Durkheim in 1901, the preface to the second edition of *Rules*, an essay that was, if anything, a strengthening of sociological realism. But it was in *Elementary Forms of the Religious Life* (1965) where, among other things, Durkheim settled accounts with Kant's idealism of the thing-in-itself (*Ding-an-sich*). The French *chose*, like the German *Ding*, would appear just as common as the English 'thing' but for the importance Kant lent it in *Critique of Pure Reason* (1902 [1791]).

Hence, the position I take and recommend: that social theories, whether social or cultural, begin, as Aristotle had it, with the experience of attending to things as they appear in the spectacle of life about us. Theories of such things cannot, therefore, get around their original condition of arising on a reflex arc that, in our day, fuses in the conscious mind the nanosecond between stimulus and affect – an inaudible flicker of what remains, in our day, of a difference between an observation and a judgement (or from the Greek *kritikós*, judgement as critical discernment).

Things begin with things of the world as they impinge. The social theorist can, and usually does, abjure all considerations of whether that impingement is sensual and material or phenomenal and mental – a point that Durkheim himself took up in the last few pages of *Elementary Forms*. It is here that his purpose in surpassing Kant's idealism is directly, if obliquely, confessed.

> What Kant's system does not explain, however, is the origin of this sort of contradiction which is realized in man. Why is he forced to do violence to himself by leaving his individuality, and, inversely, why is the impersonal law obliged to be dissipated by incarnating itself in individuals? . . . Now if the synthesis of particular conceptions which take place in individuals are already and of themselves productive of novelties, how much more efficacious these vast syntheses of complete consciousness which make society must be! (1965: 495)

Here, in the near final statement of his philosophy, Durkheim deploys his theorem of society as *sui generis* less to rid social thought of Kant's idealism than to map the way through the collective consciousness by which modern knowledge might be redeemed. Hence the triumphalism of those last few pages of *Elementary Forms* contained in the line that immediately follows Durkheim's comment on Kant: 'A society is the most powerful combination of physical and moral forces of which nature offers us an example' (1965: 495).

At first look, one might suppose that Durkheim means to locate society in nature. But Latour makes it clear that it is here that metaphor outruns even the redemptive qualities of Durkheim's modernism. In quite a number of places, including *Reassembling the Social*, Latour argues that Durkheim falls wildly short of Gabriel Tarde's theory of the social. Readers of *Suicide* (Durkheim 1951) who have not recently read Tarde might find this strange for the treatment Durkheim gives Tarde in the essay, dismissing imitation as a mere psychological cause of suicide.

But Latour, in an exceptional essay that pulls together many of the ideas dispersed throughout *Reassembling the Social*, offers the reason that Tarde might be given precedence over Durkheim, if the question in mind is that of the status of the social.

> Instead of saying, like Durkheim, that we 'should treat social facts as a thing', Tarde says that 'all things are society', and any phenomenon is a social fact [in the sense that] . . . every science has to deal with assemblages of many interlocking monads.
>
> *(Latour 2002: 122)*

Readers of Gilles Deleuze will recognize that here Latour is implicitly presenting Tarde as if he, Tarde, had anticipated *Thousand Plateaus* some eight decades before the fact.[6] More to the point, Deleuze and Latour cite Tarde favourably in the crucial chapter (if one can call any one segment of *Thousand Plateaus* more crucial than another) on flows segmentarity and micropolitics (Deleuze and Guattari 1987: 218–19; cf. Deleuze 1972: 104, n. 1).

For present purposes, references to extraordinarily complex sources that might, if not controlled, lead to discussions of Leibnitz and Spinoza, monads and folds, assemblages and more can safely be set aside to establish Latour's idea of the status of social things. In short, Latour takes from Tarde the two principles that are central to his idea of sociology:

> Tarde introduced into social theory the two main arguments which [Actor-Network-Theory] has tried, somewhat vainly, to champion: a) that the nature/society divide is irrelevant for understanding the world of human interactions; b) that the micro/macro distinction stifles any attempt at understanding how society is being generated.
>
> *(2002: 188)*

Both principles unsettle Durkheim's theory of social things to the same degree that they disturb the assumptions of the nineteenth-century oppositions between idealism and materialism. It may go too far to interpret Latour's Tarde as the beginning of the break with modernism's early social theory of *the* social as at once an enveloping whole and itself riven by the micro–macro dichotomy.

At the least Latour aims to liberate the social by calling it what Durkheim meant to say: a thing *sui generis* but *sui generis* only as all other things are. Things of all kinds, without distinction, have no inside/outside other than the assemblage of their movements towards, away from and along with other things, whether social or cultural, material or natural. But then what is left for the things thought to be cultural?

Proponents of cultural theory often put forth Durkheim's theory of religious culture and knowledge in *Elementary Forms* as their *locus classicus*. By and large, I agreed with this point of view (Lemert 2006: 8–28), until I found myself required to think seriously about the actual status of cultural things in relation to social ones. It is one thing to treat the facts appertaining thereto as things in the ordinary language sense of the word. It is quite another to study seriously the mysteries that stand behind theories of such things and the unstable analytic categories whereby social and cultural theorists, obedient to the habitus of their disciplines, play god to the things actual beings live among and depend on. Depend on, that is, in the minimal sense that we (if this pronoun applies) would be monads indeed – suspended where only the better gods know without a place in the order of things.

Still, Latour, whatever his reservations as to Durkheim's strong concept of the social, ironically strengthens the value of his contribution. Once the social is properly identified as a thing among all things, each an actant (Latour's awkward term) in a heterogeneous network,

then it is possible to accept that the social and the cultural, inter alia, if different in analytic ways, are connected in the real world as all things are. This idea at least allows cultural theory to enter the world of all other social things and their like, and thus to end an institutionally fixed but intellectually useless distinction.

Notes

1 A closer tie is further suggested by a trilateral comparison of Dewey's reflex arc and Simmel's sensory foundations of mental life with George Herbert Mead's famous line in *Mind, Self, and Society*: 'The Me of this second, is the I of the next' (1934: 174). Mead was a friend and collaborator of Dewey's, and today his sociological followers frequently compare Mead to Simmel. The connections are often a bit strained for textbook purposes, but there is at least one solid one. David Frisby, editor of Simmel's *Philosophy of Money* (2011), notes that in 1901 Mead reviewed Simmel's classic work; see Mead (1901).

2 See, in particular, Massumi (1993) and Clough (2008), among many respective writings. Though Clough does not agree with Massumi in all details, the two articles are excellent both as introductions to the subject and as expositions of its various historical beginnings and tangents from Spinoza to Deleuze and Derrida, and later.

3 One cautionary note is that Deleuze's appreciative note on Foucault's contribution to the idea of control seems to be a rare instance where Deleuze misread Foucault as more evolutionary on the subject than he was. Foucault, in fact, clearly affirmed the transitions from sovereignty to disciplinarity then to biopolitical control, but he always, so far as I can tell, put them into a triangular dynamic that avoided both linear and dialectic methods.

4 For example, see Bloor (1999) and Latour's reply (1999). Also, www.bruno-latour.fr, Latour's homepage, provides a comprehensive archive to and list of his articles and occasional papers, including debates with others.

5 '*Qu'est-ce en effet qu'une chose? La chose s'oppose! à l'idée comme ce que l'on connaît du dehors à ce que l'on connaît du dedans*' – hardly a mere colloquialism.

6 Latour says of the similarity: 'Doesn't one have the impression of reading Deleuze and Guattari's *Mille Plateaux*? The social is not the whole, but a part, and a fragile one at that' (2002: 126). And Tarde on his part does seem at least to be a convenience to Latour, if not an anticipation of Deleuze: '*Quand on considère une de ces grandes choses sociales, une grammaire, un code, une théologie, l'esprit individuel paraît si peu de chose au pied de ces monuments, que l'idée de voir en lui l'unique maçon de ces cathédrales gigantesques semble ridicule à certains sociologues, et, sans s'apercevoir qu'on renonce ainsi à les expliquer, on est excusable de se laisser aller à dire que ce sont là des oeuvres éminemment impersonnelles, – d'où il n'y a qu'un pas à prétendre avec mon éminent adversaire, M. Durkheim, que, loin d'être fonctions de l'individu, elles sont ses facteurs, qu'elles existent indépendamment des personnes humaines et les gouvernent despotiquement en projetant sur elles leur ombre oppressive. Mais comment ces réalités sociales – car, si je combats l'idée de l'organisme social, je suis loin de contredire celle d'un certain réalisme social, sur lequel il y aurait à s'entendre, – comment, je le répète, ces réalités sociales se sont-elles faites?*' (Tarde 1899: 61).

References

Althusser, L. (1969) 'Marxism and humanism', in *For Marx*, London: Penguin.

Arnold, M. (1869) *Culture and Anarchy: An Essay in Political and Social Criticism*, London: Smith, Elder & Co.

Bloor, D. (1999) 'Anti-Latour', *Studies in History and Philosophy of Science*, 30: 81–112.

Clough, P. (2008) 'The affective turn: theorizing the social', *Theory, Culture, & Society*, 25: 1–22.

Deleuze, G. (1972) *Différence et Repetition*, Paris: Press Universitaire de France.

—— (1992) 'Postscript on societies of control', *October*, 59: 3–7.

Deleuze, G. and Guattari, F. (1987 [1980]) *Thousand Plateaus*, Minneapolis, MN: University of Minnesota Press.

Dewey, J. (1896) 'The reflex arc concept in psychology', *Psychological Review*, 3: 357–70.

Durkheim, E. (1901) *The Rules of Sociological Method*, 2nd edn, Paris: Alcan.

—— (1938 [1894]) *The Rules of Sociological Method*, New York: Free Press.

—— (1951 [1897]) *Suicide: A Study in Sociology*, New York: Free Press.

—— (1965 [1912]) *Elementary Forms of the Religious Life*, trans. J. W. Swain, Free Press.

Hardt, M. and Negri, A. (2000) *Empire*, Cambridge, MA: Harvard University Press.

Kant, I. (1902 [1791]) *Critique of Pure Reason*, New York: Collier.

Latour, B. (1999) 'For Bloor and beyond: a reply to Bloor's anti-Latour', *Studies in History and Philosophy of Science*, 30: 113–29.

—— (2002) 'Gabriel Tarde and the end of the social', in P. Joyce (ed.) *The Social in Question: New Bearings in History and the Social Sciences*, London: Routledge.

—— (2005) *Reassembling the Social: An Introduction to Actor-Network-Theory*, Oxford: Oxford University Press.

Lemert, C. (2006) 'Durkheim's ghosts in the culture of sociologies', in *Durkheim's Ghosts: Cultural Logics and Social Things*, Cambridge: Cambridge University Press.

Lukács, G. (1972) 'Reification and the consciousness of the proletariat', in *History and Class Consciousness: Studies in Marxist Dialectics*, Cambridge, MA: MIT.

Marx, K. (1906 [1867]) *Capital: A Critique of Political Economy, Vol. I*, Chicago: Charles H. Kerr and Co.

Marx, K. and Engels, F. (1947) *The German Ideology*, New York: International Publishers.

Massumi, B. (1993) 'The autonomy of affect', *Cultural Critique*, 31: 83–109.

Mead, G. H. (1901) 'Philosophie des Geldes', *Journal of Political Economy*, 9: 616–19.

—— (1934) *Mind, Self, and Society: From the Standpoint of a Social Behaviorist*, Chicago: University of Chicago Press.

Schutz, Alfred (1959) 'Type and eidos in Husserl's late philosophy', *Philosophy and Phenomenological Research*, 20(2): 147–65.

Simmel, G. (2002 [1903]) 'The metropolis and mental life', in G. Bridge and S. Watson (eds) *The Blackwell City Reader*, Oxford: Wiley-Blackwell.

—— (2011) *Philosophy of Money*, ed. D. Frisby, London: Routledge.

Tarde, G. (1899) *Les Lois Sociales*, Paris: Alcan.

Tylor, E. (1871) *Primitive Culture: Researches into the Development of Mythology, Philosophy, Religion, Art, and Custom*, London: John Murray.

British cultural theory

Nick Stevenson

The development of British cultural theory has a long and uneven historical trajectory. The way in which this area of social thought has developed is inevitably complex. The story of its evolution is full of twists and turns, heated controversy and of course moments of genuine innovation. This means that any attempt to tell its history is unlikely to satisfy all of its readers. However, the view presented here attempts to be as fair to its pioneers as it is to more contemporary practitioners. Here I shall argue that any attempt to understand British cultural studies needs to proceed historically. The argument begins with an appreciation of nineteenth-century Romanticism before proceeding to try to understand the impact of some of the most influential writers of the 'first wave' of British cultural theory, like Raymond Williams, E. P. Thompson and of course Richard Hoggart. From there I shall consider the rise of post-structuralism primarily through the contributions of Stuart Hall, Angela McRobbie and Paul Gilroy. Finally I investigate some recent debates in respect of cultural citizenship and policy, especially through the work of Tony Bennett, who has called for a more pragmatically orien-tated study of culture. This is an important argument, especially given the Romantic 'origins' of much British cultural theory. Here British theory is caught between attempts to suggest that culture is the preserve of educated and more spiritual values, and views suggesting that it is a mostly 'ordinary' feature of daily life. How this debate is addressed and perhaps resolved will have a considerable bearing on the future development of British cultural theory. Further, there have been many complaints that the practice of cultural theory has neglected its more radical origins and should seek to develop more critical lines of inquiry. My argument here is that British cultural theory has continually sought to rethink itself in terms of a changing social and cultural environment and in the future this is likely to continue.

Historical and intellectual development

Matthew Arnold and the origins of British cultural studies

Many recent attempts to describe the evolution of British cultural theory have fallen into the trap of dismissing Romanticism as the preserve of cultural elitism. How this assumption came to be made has its own complex history. However, for our purposes we need to recognize that the concept of 'culture' really came into its own with the development of the Romantic movement in the eighteenth and nineteenth centuries. The Romantics opposed the instru-mentality of the dominant capitalist society by insisting that 'culture' was the place of value, imagination, play and spiritual realization. In contrast the industrial culture of the time was seen to exemplify a narrow market-focused rationality or perhaps more accurately a

calculative utilitarianism that was popular within Victorian philosophical circles. The person best known for upholding this critique of the dominant culture of capitalism was the critic Matthew Arnold. While many simply regard Arnold as an impractical snob, he was actually a poet and a critic with a strong interest in European culture that went beyond narrow nationalism. Arnold was also a school inspector, which meant that he was practically concerned with cultural matters as well as with the educated development of the self.

Matthew Arnold was a liberal, but he was critical of the dominant culture of Victorian liberalism, which seemed simply to espouse a version of liberty that was often translated as simply 'doing what you liked'. Arnold was concerned about what would happen if the obsession with liberty allowed people to cultivate selves that were hostile to art, culture and questions of value. Further, while the dominant scientific and industrial culture sought instrumental knowledge, Arnold was more preoccupied by ideas of character, virtue and ideas of the good society. In this respect, the pursuit of culture and religion are linked, as 'culture, in like manner, places human perfection in an *internal* condition, in the growth and predominance of our humanity proper, as distinguished from our animality' (Arnold 1987: 207). In this respect, the expansion of culture and our shared humanity could be considered to be similar, as it developed a sense of sympathy with others who shared the community. Culture, which had been dismissed due to its sheer uselessness, was primarily concerned with the perfectibility of the self and inward forms of critical reflection. The problem in the context of English society was the domination by a purely calculative rationality, the love of wealth and the world and 'people whom we call Philistines' (Arnold 1987: 211). Arnold (1987: 213) sought within culture both beauty and perfectibility, which were mostly undervalued by an increasingly low and debased industrial culture. Culture, in perhaps Arnold's most famous phrase, was 'having for its characters increased sweetness, increased light, increased life, increased sympathy' (1987: 222). Culture is the domain not merely of the symbolic, but where humans can expect to find a deeper meaning to their lives. These deeper meanings can still be found in religion, but equally it is through poetry, literature and the arts more generally that they can also be found. Here we can discern a complex attitude towards the prevailing liberalism of the time through the recognition that it was left to the state in a democratic context to make sure that all classes received the opportunity to become cultural and civilized beings. Arnold in this context took his role as a school inspector seriously, arguing that educational provision was poorly served by private and religious institutions that failed to promote a good society. Further, the idea of the rights of the individual could easily be translated into rights to protest, become brutish and be ignorant, thereby leaving the self to be exploited by the dominant culture of money, commerce and machinery.

Liberal freedoms, Arnold worried, could easily become converted into the rights not to read and think rather than the rights to become perfect and transform the self. Like Matthew Arnold, fellow English Romantic John Ruskin (1987) attacked the main principles of political economy for helping foster a ruthless civilization of economic exploitation rather than one of human sympathy and community. While the dominant culture urged citizens to get rich, Ruskin (1987: 180) was concerned that actual wealth was not really a matter of economic calculation. Wealth is more a matter of art, human sympathy and spiritual community. Similar to Arnold, Ruskin was a deeply conservative thinker who believed in hierarchy and tradition, but was equally concerned with morality. As we shall see, both Raymond Williams and Richard Hoggart sought to radicalize the conservative Romanticism of figures like Arnold and Ruskin as a means of preserving the idea of culture as a protest against capitalism while seeking to connect these concerns to more specifically democratic ideas. However, we need to recognize here that the work of thinkers like Arnold and Ruskin lies at the heart of many of the future debates that came to define British cultural theory.

British cultural studies after Arnold: Richard Hoggart and Raymond Williams

Richard Hoggart would sometimes describe himself as an Arnoldian to the extent to which he continued to believe it important to discuss questions of cultural value. He can also be credited as having produced perhaps the founding text of British cultural studies. Hoggart wrote about English working-class life with all the complexity that Arnold had reserved for art and poetry. Hoggart's (1958) seminal text inspired a generation of educationalists and democratic socialists not only to think about the value of cultural experience, but also to address the quality of cultural and aesthetic engagement more generally. Hoggart (1958) begins his argument like Arnold and Ruskin in seeking to offer a critical judgement of the prevailing capitalist order of the day. Just as Ruskin and Arnold sought to point to the violence of capitalism and the 'cash nexus', Hoggart seeks to question the common assumption that the affluent society was a classless society. In particular Hoggart draws attention to the interpretative context of his book, given that he is 'from the working classes' but feels 'both close to them and apart from them' (1958: 17). This gives him a different vantage point from those who would seek to either demonize or sentimentalize the working class. Hoggart right at the beginning of his study admits his sense of connection and attachment to what he is writing about. Again, just as Arnold and Ruskin had attacked the scientific culture of the Victorian era for saying so little about questions of value, Hoggart's own study begins with an argument that we take seriously the location of cultural analysis and insists that we cannot help but make judgements of value. Hoggart's study of working-class culture is not an objectivist account, but instead offers a critical reading of the complexity of working-class life that admits of the author's own complex location. Hoggart writes not as a cultural scientist might, but as an active interpreter who is neither an insider nor an outsider. Hoggart's class position then is of someone who was born into the working class, but who through the discovery of literature and further education had later become a university lecturer. In this respect, Hoggart (1958: 303) movingly describes the vulnerability and uncertainty of someone who has come from the labouring classes. Hoggart suggests that he is someone both who is 'earnest for self-improvement' (1958: 303) and who feels like an outsider amongst working-class and middle-class people.

Hoggart's essay is mainly concerned with questions of cultural change and transformation from a world where working-class people largely produced their own culture to one where it was being manufactured for them by capitalism. As Hoggart's many critics have pointed out, this tends to give the book a nostalgic quality, as it looked back to an age that seemed at the time of writing to be fast disappearing. This criticism has a point, but it does tend to displace the considerable achievement of the text. Here Hoggart offers a rich account of the ambivalences and contradictoriness of the postwar working-class culture. This culture is often deeply conservative, resents as well as respects its 'betters' and is largely focused on the home and locality. This is also a deeply fatalistic culture that has a strong investment in the ideas of luck. Luck is not something you acquire but is literally something you are born with. However, Hoggart insists that working-class culture can also be creative, as evident in the ability to 'make do' or in popular and communal singing. The working classes are dominated, but they are not victims, demonstrating a considerable amount of guile in the face of often oppressive social and cultural conditions.

The problem for Hoggart was that a new mass culture was being developed through the rise of consumer capitalism. While many saw the development of a range of consumer goods under the sign of 'progress', Hoggart was mostly dismissive of what he perceived to be the new hedonism. This was because mainly under the guise of freedom there had emerged a

capitalist culture that had fostered a cheap relativism. This was a popular attitude whereby anyone expressing a critical attitude towards the popular culture of the day was quickly dismissed as a snob. This attitude, fostered by the popular press and magazines, was built upon working-class ambivalence towards the educated and intellectuals more generally. Such an attitude effectively cancelled the cultural judgements of the critic and any educative or developmental concerns. Hoggart was clear that the main beneficiary of this new disposition was the economic system that aimed to profit from mass culture more generally. Mass culture could not be relied upon to promote a culture of questioning, authenticity and learning, as it was mainly concerned with the need to make a profit. Hoggart termed capitalist-friendly relativism 'democratic egalitarianism' (1958: 273). This attitude tended to dismiss talk of cultural values and standards as 'baloney' (1958: 274). Like Matthew Arnold, Hoggart detected that the other side of 'anything goes' liberalism was actually the dominance of capitalism and hostility to any consideration of cultural value. This deeply cynical attitude masks the idea that within the context of material improvement there may be cultural loss. In this context then a 'more genuine class culture is being eroded in favour of mass opinion' (Hoggart 1958: 343). Here Hoggart identifies the rise of a crass, soulless commercial culture that would eventually displace a more authentic sense of working-class community.

Hoggart's text is no longer much read by cultural students today. This is primarily due to its nostalgic account of working-class life and his disapproval of the new commercialism. However, the text remains important for the complex account it gives of working-class life more generally and the way it disrupts the assumption that economic development is necessarily culturally progressive. Hoggart later became not only an important public intellectual advising the BBC and UNESCO, but a critical educationalist seeking to argue that education should be about the development of a critical and questioning self rather than the enterprising self of school league tables, advertisements and popular television. Hoggart's concerns, as we have seen, can be related back to the English Romantics, but this time with a view that the culture of everyday life (and not just art) can also be of value. However, what is evident in Hoggart is his belief that a more critical and educated disposition would only begin to emerge through a deeper engagement with art and literature. Many have found such a view patronizing and overly neglectful of the critical potential evident within certain versions of mass culture. Further it is no longer clear (after postmodernism) that we can easily separate art and commercial culture in the way that Hoggart assumes; however, he continues to have much to offer those who wish to challenge the dominant hegemony of the market in the age of commercial relativism.

Raymond Williams (1957) criticized Hoggart's book for providing a misleading portrait of working-class culture. For Williams we could not accurately describe class culture in the way that Hoggart had chosen to, as his description neglected to analyse the labour movement. In this sense, for Williams working-class culture could not be thought of as a culture of consumption, as this had actually played little part in its definition and production. Further, many of the descriptions offered of a working-class way of life and speech were misleading, as they were more regionally variable than Hoggart seemed to assume. Indeed, the major cultural contribution of the working class has been not popular song, but rather the invention of trade unions and other labour organizations. Williams describes this movement as being encapsulated in the idea 'of a collective democratic society' (1957: 31). The main cultural achievement of the working class then is not the neighbourliness or the family orientation of Hoggart's account, but the idea that democratic institutions need to be developed to serve the many rather than the few. To this end the working-class movement as a political formation carries within it both a respect for the culture of learning and the arts, and the idea of culture

as a description of a 'whole way of life' (Williams 1957: 32). Here Williams is recognizing that the labour movement is actually the carrier of a more progressive form of liberalism than the one criticized by Arnold, Ruskin and Hoggart. This is a liberalism that seeks to recognize questions of cultural value, but is more concerned with the democratizing of culture than it is with the morally corrupting culture of the market. A progressive working-class movement would need to recognize how the collective solidarity of the working class (described by Hoggart) is often built upon a narrow sense of conformity and fear. For Williams this is not to be overcome by looking backwards nostalgically to a previous time before the arrival of mass culture, but should be disrupted by developing democratic relationships within society's dominant institutions. In the context of a capitalist society the working-class movement is charged with the special responsibility of promoting a culture of development for everyone in a way that could not be carried through either by capitalist cultures of consumption or indeed by Romantic intellectuals.

As Williams (1958: 133) points out, the Arnoldian enthusiasm for bringing educated culture to the vast majority of the people ends up endorsing an authoritarian model of education. Here the state is granted the power to define what is meant by perfection and to offer a form of civilization that would educate the masses. This is, as Williams implies, less a democratic model of education than the imposition of state control. Behind Arnold's desire to bring the culture of civilization to ordinary people lies a notion of 'the unfitness of the masses – they will riot, they will strike, they will not take an interest – such is the nature of that brute' (Williams 1958: 303). A democratic culture, argues Williams, should seek to reaffirm what he calls an 'equality of being' (1958: 305). Such a culture is one that seeks to build mutually respectful relations between teachers and the taught. This only becomes possible if intellectuals give up notions of simply imposing culture upon 'the masses' and if learning involves the formation of complex human relationships. At this point, Williams begins to imagine what a whole society based upon this democratic idea of learning and communication might be like.

This line of criticism brings us to Williams's most important book, *The Long Revolution* (1965). This book is primarily a work of cultural history that seeks to trace the evolution of the possibility of a democratic culture and associated institutions within the British national context. The idea of the long revolution argues that mass literacy, parliamentary democracy and popular forms of communication found within the media of mass communication make possible an educated and participatory democracy. However, capitalism and a class-based society are currently holding in check the spread of a genuinely popular democracy through society. Williams's humanistic analysis makes clear that the democratic potential of the communicative society is underpinned through an idea of human nature. We are, for Williams, cultural, interpretative and creative beings capable of transforming ourselves and our societies. Culture remains important in this context as it offers different interpretations and understandings of our shared society. In a way similar to his criticism of Hoggart, Williams makes clear that the potential of the long revolution is mostly dependent upon the progress of the labour movement. It is the labour movement that is capable of creating a democratic workplace, socialized communications, more representative institutions and less instrumental forms of education and culture. The central democratic vision of the long revolution was significant not only in terms of its optimism, but also because it suggested that cultural change was central to progressive change.

Culture was significant not only because it had value in and of itself, but also because it was the means through which democracy worked. This is culture not as a source of absolute values (or the Arnoldian struggle for perfection) but as something able to offer different ways

of seeing and interpreting the world. Each time we turn on the television, visit a play or attend a music concert we are potentially opening ourselves to a set of voices and perspectives seeking to challenge our view of society. In this conversation between the producers of culture and the audience we require democratic institutions to make sure that the most radical voices are not displaced by more mainstream entertainment or more entrenched vested interests that represent the status quo. If culture was an 'ordinary' process it was importantly communicative as well as being potentially democratic. Where Williams was different from Hoggart was in his argument that to dismiss modern culture simply as mass culture was actually a mistake. Within contemporary communication and much popular culture there existed a democratic potential that was yet unrealized in the context of the dominant capitalist society. Williams's argument was neither nostalgic about the working-class culture of the past nor overly impressed by technological innovation, but saw the potential for the first time in history for the development of a genuinely democratic culture based upon mass participation. Here Williams writes that it is mostly unrealistic to argue 'we shall get an educated and participatory democracy, industries and services with adequate human communications, and a common culture of high quality, by proclaiming the virtue of those things and leaving our training institutions as they are' (1965: 176). Like Hoggart then Williams wants a concerted movement for a less instrumental and more artistic and creative culture, which would not seem possible without radically reforming our cultural institutions. However, as we have seen, for Williams it is the necessity of democratizing human relations that will spark the flow of cultural creativity, not bemoaning the loss of cultural value.

During this period the long revolution's most important critic was E. P. Thompson. Thompson (1961) argues that Williams's grand cultural history (despite its critical potential) ends up producing a view of history as progress. This time it is not science or technology that is celebrated but the development of democracy and communicative institutions. Missing from this view of history is its contested nature. In particular Thompson struggles with the idea of culture as being described as a 'whole way of life'. Missing is the way that culture is caught up more specifically in webs of power and conflict. What is required here is an idea of cultural agency that is actively shaped by human subjects themselves. Williams's account in this respect is overly abstract, and does not adequately deal with concrete instances of cultural conflict and change. For Thompson the idea of the long revolution sounds like an evolutionary progressive account of cultural change. As a radical historian, such a view worried Thompson, as he knew history is full of missed opportunities, radical revolt and violent oppression.

Key contributors and criticisms

E. P. Thompson: culture as agency and radical history

Thompson rejected the idea that 'history' had a pre-given direction and argued that it is made in the process of struggle and opposition. In recording the struggles of the subordinate classes, the historian cannot offer a neutral account but is forced to take sides and to make judgements. In particular Thompson's historical work is seen as helping to invent the idea of 'history from below' and of rescuing the voices and experiences of 'ordinary' people. Here Thompson is questioning the view that history is simply made from above by elites or that it can be seen as a set of structural changes as we move from one social order to another. For E. P. Thompson ordinary people are actively involved in the 'making' of history. Thompson takes seriously active dissenting radical traditions and looks at how they were actively invented

in different historical contexts. For Thompson sociologists and historians should not become victims of ideology and adopt a view from on high and then castigate human beings for failing to live up to an ideal image of what people should be like. In particular Thompson was critical of much Marxist theory for assuming that it had a monopoly on the truth. Instead cultural scholars need to carefully uncover the different ways in which historically the subordinate classes have sought to 'make' their own history. This is not a history or politics without ideals, as often men and women in seeking their liberation are motivated by values such as community or the common good, but they do so in ways that actually oppose other competing visions of society.

Thompson's (1956) first major work is a book about William Morris. Thompson seeks to restore Morris to a socialist tradition, as opposed to those who saw him as a medievalist or as primarily a Romantic artist. In particular it is Morris's Romantic and poetic revolt against the dominant or hegemonic society at the time that interests Thompson. For Thompson the Romantics, despite being middle class, rejected the dominant capitalist society in favour of art, beauty and the value of the imagination. In particular Thompson valued Morris's ability to dream of future possible worlds and his defence of the utopian imagination. Any popular social movement would need this dimension, as it sought to mobilize people for radical change. That is, all movements for change require a vision of a future possible world different from that of the present. Thompson calls this the principle of hope. In the context of late Victorian society, competitive individualism tended to construct an isolated society where people had little fellow feeling and sense of solidarity with their neighbours. Morris the socialist is championed by Thompson as a heroic individual who is able to articulate a vision of a future society that has rid itself of capitalism and where people are able to live more communally and creatively. Yet Morris's failure was that he was unable to connect with the organized working class. Thompson then, similarly to Hoggart and Williams, offers a historical perspective, but returns the argument to its Romantic roots in search of collective struggles that have a concertedly utopian dimension.

These features are also evident in his best-known book, *The Making of the English Working Class*. Here Thompson (1980) seeks to recover the radical culture of the English people as a way of criticizing more 'establishment' voices who have often commented upon their conservatism. Thompson was trying to make two points with the 'making' of the book's title. The first is the idea that the English working class had actively made their own radical traditions of protest, and the second is that the historian could also 'make' history, thereby destroying the myth of the intrinsically conformist nature of the lower orders. Thompson rejected the conservative view of the working-class culture offered by Hoggart while arguing that Williams's cultural history is overly distant from the formation of protest groups and those involved in promoting radical change.

One of the central arguments of the text is that the working classes made themselves through shared experiences and by constructing their own radical culture. The book traces how between 1780 and 1830 a shared class consciousness was to appear amongst the popular classes. What glued together the protest movements of this period was the idea of the 'free-born Englishman'. This historical idea fused together ideas of basic liberties concerned with freedom before the law, and freedom of speech and of consciousness. These freedoms provided a moral consensus that protected the rights of the English commoner against the state. Out of this robust and independent-minded culture arose trade unions, periodicals and friendly societies. Working-class consciousness was made not so much by the arrival of the factory system, but by the development of a radical culture that emerged from below. For the working class the change in their own sense of themselves as a class grew through their agitation against

new forms of exploitation that appeared with capitalism. Previous commonly held ideas of the just price or wage were abandoned with new levels of exploitation that came in with market forces. Thompson is well aware that many historians of the industrial revolution talk about the working class as being 'better off' in simple material terms, but he suggests this does not really account for human experience. For Thompson, 'people may consume more goods and become less happy or less free at the same time' (1980: 231). What the working classes reacted against was the intensification of exploitation, greater job insecurity and increasing human misery.

The working classes made their own radical culture in response to new forms of exploitation and the removal of customary rights, but they did so in such a way that respected the tradition of the 'freeborn Englishman's' emphasis upon liberty. This eventually led to the development of the Chartist movement, which demanded political rights for all working men. Thompson writes: 'Strike a spade into the working-class culture of the north at any time in the thirties, and the passion seems to spring from the ground' (1980: 882).

In a companion volume (published just after Thompson's death in 1991), *Customs in Common*, Thompson seeks to argue that the English have a rebellious traditional culture that has historically fought against capitalism. The class structure of eighteenth-century England was divided between the patricians (landed gentleman) and the commoners (or plebs). What is striking about Thompson's account of radical conservatism is that a period that is often seen as paternalistic and deferential was a period of intense class struggle. The plebeian culture had its own feast days, festivals and links with the agrarian calendar that did not fit well with the discipline required by the factory system. These rituals and traditions were often distinct from those that dominated polite society. Here Thompson writes, 'the same man who touches his forelock to the squire by day' will then 'kill his sheep, snare his pheasants or poison his dog at night' (1991: 66). However, if the first generation of industrial labourers resisted the imposition of Puritanism and the factory system, by the third generation industrial labourers were integrated into an exploitative system of wage labour. By the 1840s Thompson was able to talk of customs that had faded from the collective practice and memory. Such a notion of history does not fit well with notions of progress defined by capitalist modernity. Indeed Thompson ends by wondering whether the people of the future will seek to rediscover pre-capitalist values to regain 'time to live' as a way of protesting against new forms of discipline and control that have accompanied the intensification of work under capitalism. The culture of 'the plebs' then is a resource for the future that may be rediscovered in campaigns that aim to rediscover the pleasures of uncommodified time not at work and to re-establish the struggle to control the labour process.

Thompson's most important critic is fellow Marxist historian Perry Anderson. Anderson (1992) is critical of Thompson's account of English history and offers a different 'reading' of the so-called radical culture of the English. Anderson argues that England's common political culture is very uncomfortable with ideas, dislikes change and is dominated by the hierarchies of class. As a consequence the working class has not produced an ideology to challenge the dominance of public schools and the aristocratic arrogance of the English ruling class. For Anderson, after Chartism the working class became increasingly docile and the lower orders never really threw off their deferential attitude to the upper classes. For Anderson the history of English class society is one of crushing defeat and class-based domination. England as the first society to industrialize did so without a mature socialist ideology to make sense of the changes and help develop a radical consciousness from below.

Thompson (1978) (not surprisingly) found himself in sharp disagreement with these ideas. Thompson argues that Anderson's account accuses the English of having had no 'proper'

revolution but of adopting a deferential reformism. Anderson here neglects to appreciate that so-called 'reformism' has historically brought a number of material gains for the dominated classes, from the welfare state to political rights. Further, Thompson argues that Anderson underestimates the extent to which class domination has not been won for all time, but is an active process where the subordinate classes have to have their needs and interests taken into account. Here Anderson's account misleadingly suggests that after Chartism radical movements from below made little headway. This view neglects the development of social democracy more generally, the social state and welfare rights. Finally Thompson argues that one of the key reasons left unexplored by Anderson for the reformism of the English working class is the failure of socialist societies to offer an alternative to capitalism. For Thompson the failure of state socialism has given English socialists little room for manoeuvre in trying to criticize capitalism. The development of Stalinism and authoritarian socialism in Eastern Europe has allowed the apologists of capitalism to point to the bankruptcy of socialist ideals. Thompson accuses Anderson of an overly reductive argument that fails to appreciate the cultural changes in the working class and the subordinate classes during the historical period under review.

Thompson's contribution to the argument thus far is to suggest that historical analysis can change the ways in which we see the operation of culture. Like Williams he seeks to explode the 'myth' of the intrinsic conservatism of British culture by pointing to its radical past. However, unlike Williams he is less impressed by accounts of cultural 'progress' and prefers to see history as a series of radical ruptures whereby 'the plebs' occasionally interrupt elite rule from below. Williams, on the other hand, tends to view working-class culture as acting in the general interest through its capacity to bring about the democratization of society. Further, Williams paid closer attention to emergent technological cultures like television and suggested they could also be democratized. While his vision was perhaps no less 'utopian' than Thompson's, he was more concerned to point the way forward for the working-class movement. In terms of 'culture', for the first wave of British cultural theory it is class that is important, and the continuation of domination over long historical periods that is the focus of attention.

What was to become significant for Williams and Thompson was an understanding of cultural domination as hegemony. The concept of hegemony was to play a significant role in rethinking the traditions of British cultural theory. Especially significant here are the ideas of the Italian Marxist Antonio Gramsci. Raymond Williams describes hegemony as

> a set of meanings and values which as they are experienced as practices are reciprocally confirming. It thus constitutes a sense of reality for most people in the society, a sense of the absolute because experienced reality beyond which it is very difficult for most members of the society to move, in most areas of their lives.
>
> *(1980: 38)*

Hegemony then is the system of values, interpretations and understandings that dominate a particular society. As Williams points out, the dominant culture in this regard is not static but capable of 'incorporating' and containing more critical and oppositional beliefs and understandings. The idea of hegemony was preferred to more inflexible notions like ideology that seemed more static and less flexible as a concept. Williams is quick to point out that no dominant hegemony ever finally manages to saturate a particular society, as we can always talk of emergent or residual cultures that are never entirely incorporated into the dominant culture. The idea of hegemony then was meant to recognize that cultural domination was historical,

dependent upon relations of power and never final. However, Williams (1980: 34) resisted the idea that anything could become hegemonic, as the relations between capital and labour were involved in 'the setting of limits', and it is in this sense that we need to relate questions of culture back to the economic structure of society more generally. Hegemony not only was about culture, but crucially involved the dominant economic relations of capitalist society. While Hoggart never explicitly uses the term hegemony, this term came to dominate wider debate and understanding within British cultural theory.

Birmingham Centre for Contemporary Cultural Studies

The Birmingham Centre for Contemporary Cultural Studies (CCCS), founded by Richard Hoggart and Stuart Hall, was responsible for reshaping the study of culture in the 1980s. Originally picking up on the idea of 'culture as ordinary', the CCCS extended the study of culture to include commercial popular culture. If consumer culture had previously been dismissed as the mass culture of the market as opposed to a more authentic political or literary culture, then these assumptions were considerably rethought. Especially important in reconfiguring the study of culture in the British context was the impact of Roland Barthes, Louis Althusser and others who were associated with French post-structuralism. If cultural Romanticism tended to make the critic search for a more authentic culture than that suggested by commercial capitalism, this stance was dropped by the CCCS. Instead culture was represented by linguistic representations or discourses and signs that needed to be decoded. It was the ideological coding of cultural texts that was the issue and not the bemoaning of the displacement of the Romantic imagination or a nostalgic culture of class. This usefully focused complex forms of cultural analysis on relatively new forms of consumer and visual culture. The considerable excitement created by this move suggested new possibilities beyond the perceived 'moralism' of previous waves of analysis. However, as we shall see, with every new innovatory moment there is also a sense of other questions from the past becoming displaced and forgotten.

Much of the early work of the CCCS focused upon the impact of youth culture. Especially significant here is the work of Dick Hebdige (1979) on subcultures. This work not only is an attempt to trace the meanings of stylistic innovation, but acts as a critique of previous generations of cultural scholars. Much of these scholars' work, argues Hebdige (here he is mainly referring to Hoggart), focuses upon the attempt to separate 'good' culture from 'bad' culture. Instead Hebdige turns our attention to the study of dominant codes and discourses and how they are interrupted by more subordinate codes. The development of British youth cultures in this respect could be seen as operating as a semiotic cultural struggle that interrupted the idea of 'the normal'. For Hebdige the dominant culture seeks to police stylistic innovation from below through the use of stereotypes or naturalization. Youth cultures such as Mod, Punk and Teds are classified as beyond respectability (as Other) or are thought of as simply being rather trivial. Subcultures are rather like artistic movements that share in the desire to interrupt the dominant codes of normality by taking pleasure in their disruption.

Angela McRobbie (1991) is also a significant figure in the study of youth culture, paving the way for later work within cultural feminism. McRobbie points out that much of the work done on youth culture by Hebdige and others tends to focus upon male working-class sexuality. Missing (or made invisible) in many of these accounts is an exploration of the subjectivity of the author (note this was in evidence in Hoggart, who was taken as a mostly discredited figure by those who studied youth cultures) and a consideration of women's subcultural experience. McRobbie argues that most popular culture legitimates young men's freedom to engage in experimentation with respect to their sexuality. In this respect, girls'

and women's heterosexual identities are more carefully policed than those of young men. Had women been at the forefront of a genuinely 'shocking' cultural experiment like punk, then the effects would have been even more outrageous. Further, the masculine silence concerning subjectivity in terms of the attachment to certain cultural forms simply reconfirms the dominant scientific culture that seeks to invalidate the investment of the self in cultural forms. This is representative of a dominant form of masculinity that is uncomfortable talking about more 'private' as opposed to 'public' forms of experience. Here McRobbie is pointing out that attempts to deconstruct dominant codes can be as exclusionary as the dominant culture. If the study of cultural theory seeks to question domination and exclusion then it should also account for issues related to gender and sexuality.

These studies clearly added to not only the excitement of cultural analysis but its complexity as well. While some have sought to dismiss studies of youth culture as simply a celebration of consumer culture and the wider culture of capitalism, this is mistaken. The CCCS is actually pointing to how the political can be located in the state as well as in more seemingly mundane cultural artefacts like music, clothes and fashion. What is being offered is less a politics of culture than what is often referred to as cultural politics. If a politics of culture is primarily concerned with the organization of culture through different agencies and institutions like social movements, the state and capitalism, then cultural politics tends to focus more on the meaningfulness of culture. Cultural politics is especially concerned with the ways in which dominant meanings seek to police the legitimacy of a variety of modes of cultural expression and experience. These features are especially evident in the theoretical work of Stuart Hall, who took questions of cultural politics into an analysis of political formations and became for a time one of the key architects of the postwar left during the 1980s.

Stuart Hall

Stuart Hall (1988) brought together a concern about class domination and more semiotic forms of analysis. During the 1980s Hall established himself as a significant public intellectual through the popular journal *Marxism Today* and his more cultural work. However, it is probably his analysis of Thatcherism for which he remains best known. Hall draws heavily upon the work of French Marxist Louis Althusser. It was Althusser's analysis of ideology that influenced Hall's work during this period. Althusser famously focused upon what he called ideological state apparatuses (education and the media) as he sought to explain why the working class had not revolted against an unjust society. For Hall it had been Thatcherism's ability to occupy the press, television and other media outlets that best explained its popularity. Thatcherism as a discursive construction was able to occupy the ideological terrain within popular culture. However, Hall was better able to explain the contingent and shifting nature of ideology than Althusser had been. The argument that the structural dominance of the ruling class ensures the dominance of certain ideas is rejected by Hall. Thatcherism was effective as it was able hegemonically to reconstruct and interrupt what might more popularly be understood as 'common sense'. That is, as an ideology it was able to offer explanations as to 'the state we are in' that would satisfy ordinary people. While many on the left argued that a government that so clearly represented the wealthy and powerful would be defeated, Hall's analysis suggested otherwise. Here Stuart Hall insisted along with Althusser that dominance was more of a matter of how things were represented within language rather than any reference to the so-called 'real' conditions of existence. In other words, more traditional Marxist forms of analysis suggested that class conflict is written into the fabric of capitalism and largely generated out of structural contradictions. That the state was largely organized to protect the

interests of private capital rather than the interests of the working class meant that conflict was an inevitable feature of daily life under capitalism. However, Hall's analysis suggests that class conflict is more of a matter of language and discourse than might have previously been supposed. If the dominant ideological force of Thatcherism is that it spoke up for the ordinary person against vested interests like the bureaucratic state, town hall or trade unions, then the project could become hegemonically successful. Democracy, freedom and individualism did not necessarily 'belong' to the left but could become articulated as features of the right. It had been the political right rather than the left that had demonstrated the ability to articulate common sense in such a way that struck a chord with the politics of the time. Thatcherism had won the battle of ideas and become hegemonic by capturing and re-describing the meaning of words like 'democracy' and 'freedom'.

Further, we might reconsider the question of consumerism. Much left cultural analysis from Hoggart to Williams had seemingly labelled 'wanting' consumer objects as either bad or potentially morally dubious. This was because authentic forms of culture could not be purchased through the marketplace, but were more often a matter of more 'serious' forms of cultural engagement like reading literature or visiting an art gallery. Thatcherism, on the other hand, suggested that 'wanting' was not something to feel guilty about and was part of the good society. Instead it was the political left who wanted to make ordinary people feel guilty or ashamed about wanting to own their own home, take holidays abroad or more generally enjoy the pleasures of popular culture. Hall bravely suggested that the left needed to learn from Thatcherism and provide a more careful analysis of the dominant consumer society. This was not because Stuart Hall was a supporter of Margaret Thatcher, but because he felt that the left needed to offer an alternative hegemonic strategy that had some chance of connecting with the popular concerns of the time.

In retrospect what remains radical about Hall's cultural intervention was the argument to take cultural politics seriously. The construction of political images and discourses could no longer be dismissed as the ephemeral culture of the market and was now part of a new political modernity that sought to develop a new politics, not through clinging to Britain's imperial or industrial past but through the critical legacies of new social movements, complex questions of cultural difference and the production of subcultural identities. Contemporary cultures of consumption helped articulate popular pleasures and sensibilities that could not be adequately captured through a moralistic language. Popular culture was not to be dismissed as the culture of the market but could be mined for contradictory and even oppositional meanings.

The problem was, however, that Stuart Hall's reading of hegemony was to separate it from the more materialist forms of analysis evident within Williams. The reduction of culture to the study of the meaningfulness of texts had a tendency to separate it from more economic forms of understanding. If British cultural theory had begun by trying to understand the impact of capitalism upon culture, then this emphasis was in danger of disappearing within an intellectual movement that wanted to look more carefully at the pleasures of consumption. Any understanding of what Williams took to be 'the setting of limits or the exerting of pressure' (1980: 34) by the economy (or even biology) was banished from the analysis. Perhaps what was gained in cultural specificity was lost in ability to relate the cultural to other domains like the workings of the capitalist economy, nature and the frailty of the human body.

We might consider Williams's (1980) writing on nature at this juncture. Williams was a keen critic of social Darwinism, which sought to take certain cultural metaphors like 'survival of the fittest' and suggest that they were 'neutral' scientific observations. These ideas suggest

that capitalism can be legitimated by appealing to ideas derived from the natural sciences. These were not merely cultural constructions but should be seen as explicitly serving certain interests rather than others. For Williams, if we are to understand how this came about we need to look carefully at the society in which these ideas first emerged and how they have been reinvented over time. We could also point to certain 'alternative' understandings of 'nature', mostly evident in the Romantic poets, where it was 'a refuge from man: a place of healing, a solace, a retreat' (Williams 1980: 80). This was a different view of nature from that in which it is simply a source to be mined for profit or something offering symbols of ruthless competition. Williams's cultural materialism never lost sight of the idea that 'nature' was not simply a cultural creation but had a material presence beyond the production of certain metaphors and symbolic forms. As such then Williams's cultural materialism is able to recognize that the symbolic inventiveness of culture has certain 'limits' which are prescribed by human and social relationships.

Further, not everyone who was prominent within British cultural theory was persuaded by the need to learn from post-structuralism and the market. One of the most powerful voices of opposition in this respect came from the historian E. P. Thompson. Here Thompson (1978) subjected Althusserian Marxism to a long, humorous and polemical essay. Again, this essay is no longer widely read and is sometimes dismissed as naïve humanism. However, it is actually a masterful exercise in comic parody and continues to ask a number of critical questions about the dominance of Althusser that were poorly answered at the time. Thompson was especially concerned about Althusser's neglect of history, his attack on humanism, his failure to consider questions of agency and his theoretical high-handedness. Indeed such were Thompson's concerns that he reacted strongly to what he felt was Althusser's politically authoritarian agenda. While many of these criticisms could not be made in relation to Hall's analysis, they do suggest a number of critical questions. First, Thompson is concerned that historical forms of analysis are simply jettisoned in favour of theoretical reflection and analysis. In terms of the CCCS it is notable that while Williams, Hoggart and Thompson were concerned to provide a historical dimension to cultural analysis, this is mostly lacking with the focus upon more contemporary forms of popular culture. What is being lost here is any reference to a history of popular cultural struggle. Much of the work of the CCCS seemed to code previous socialist or working-class struggles as deficient and lacking. The 'decoding' of popular forms of pleasure was more pressing at the time than, say, linking current and previous modes of domination. Second, if the political imagination is formed through discourses that are articulated through the media, where does this leave questions of agency? Hall seems to assume that Thatcherism was a popular project. More to the point might have been divisions within the left or its inability to capture certain sections of the respectable classes. Further, Hall's analysis does not really provide a critical consideration of the considerable amount of grassroots political resistance that was generated by trade unions and nationalist and other social movements. Further, for Thompson (1978: 339) Althusser's concern with language and structure leads the analysis to focus simply on how we are determined and less on how we might become active moral agents. This can also be connected to the way that much post-structuralism treats politics as a textual enterprise and has little (at this stage) to say about how these ideologies are made sense of, interpreted and perhaps even resisted. Similarly Hall's analysis has little to say about the substantive social and political values at stake in any left analysis. Here his main concern is with how an alternative left might be mobilized. For Thompson questions of value and principle needed to be at the heart of any genuine cultural alternative to capitalism. Finally, Thompson's greatest concern is with the authoritarian nature of Althusserian analysis. This charge cannot really be levelled at Hall, given his attempt through *Marxism Today* to

shift the ideological rhetoric in more progressive directions. However, there was a prevailing sense that some of the analysis simply coded existing forms of resistance as ill-formed and mistaken. Hall suggests that for the cultural left to become effective it needs to become a force of political modernity; however, Thompson's analysis suggests that resistance can often come through more conservative features that simply seek to defend traditional practices or react strongly to radical change. Thompson's analysis upholds the unfashionable view that suggests that radicalism can have conservative roots. Again lacking in Hall's work is any concerted attempt to learn from more grassroots formations. Hall's work then was more concerned to criticize the meanings of Thatcherism than to engage in any lengthy analysis of oppositional political cultures. Indeed had we looked closely at these we would undoubtedly have found a host of radical and of course much more conservative elements, all of which wished to oppose Thatcherism. However, before we bend the stick too far, Stuart Hall and his colleagues at the CCCS are to be credited for opening up a number of critical questions and for treating the popular culture of the time as more complex than it had previously been seen to be.

Stuart Hall's later work moved onto the question of identity. Here he explored the extent to which identity could be understood as a complex and discursive construction. This has an obvious similarity with his work on Thatcherism as a hegemonic creation that is never complete and capable of reinvention. However, Hall's more recent work looks much more decisively at racialized modernity and the impact this has had on more contemporary multi-cultural experience and belonging. Stuart Hall's work has been critical in turning British cultural theory away from an exclusive concern with class and location and opening other lines of cultural research into race, sexuality and gender. In the next section, I turn to how the work of Paul Gilroy has invited British cultural theory both to think beyond the nation in the global age and to reconsider questions related to race, multiculturalism and identity.

Paul Gilroy and the postcolonial

Paul Gilroy's (2000) critique of racialized modernity is a defining moment in British cultural theory. First, Gilroy seeks to recover a concern with race and racism as a set of questions that were not central to the founding texts of British cultural theory. The work of Williams, Hoggart and Thompson displayed little interest in questions of race, and was mostly concerned with the categories of class and nationhood. While race later became a concern of Stuart Hall's, much of his earlier work is bound within ideas of nationhood. Here Gilroy seeks to return to critical figures like Franz Fanon and recovers a concern about 'race' that can be located in the European Enlightenment. While the Enlightenment is often seen as a period of freedom and criticism, in Gilroy's view it is more complex, given its often racist overtones. Second, Gilroy seeks to introduce a sense of racialized modernity that cuts across the boundaries of nations and national cultures. The story of racism, colonialism and fascism is a global story and cannot be told within the boundaries of a particular nation-state. Finally, while Gilroy has been heavily influenced by post-structuralism, he tries to reintroduce the idea of more humanistic and critical concerns. If Gilroy is concerned with questions of identity and the discursive construction of the self, he is equally concerned with more ethical and political forms of criticism and practice. Indeed much of Gilroy's text is concerned with the impact of a racialized visual culture, but he is equally concerned with more normative categories like cosmopolitanism and multiculturalism.

Gilroy's central argument is that fascism is often seen as an exceptional event that was defeated by the forces of democracy and modernity. This view is misleading, as the cultures of racialized superiority are still with us and have a long and complex global history. For

Gilroy 'historic associations of blackness with infrahumanity, brutality, crime, idleness, excessive threatening fertility, and so on remain undisturbed' (2000: 22). Here, Gilroy is concerned that despite the impact of social movements and globalization more generally, the categories of race remain more settled and constant than we might think. We need to remember that the concept of 'race' is a human invention that dates from the eighteenth century and that it retains a deep attachment to so-called dispassionate scientific inquiry. The idea that humanity can be unproblematically assigned an identity on the basis of racial types has persisted throughout the modern period and is responsible for the generation of war, hatred, conflict and domination. While many have sought to argue that the period of biological racial theory is at an end, Gilroy powerfully argues that this is a myth. Through popular culture, nationalism and racist movements the ideas and codes associated with the entrapments of race thinking remain alive in our current era. Here Gilroy argues that a critical politics of race needs to make the utopian demand to end all racialized thinking. This can only be achieved through a sustained critique of Enlightenment-based philosophy that sought to refuse the humanity of non-white peoples. Indeed if we look carefully at the rituals and cultures of the nation-state, then not far from the surface we discover the appeal of fantasies of homogeneity and unity. Nation-states have persisted in their attempts to create sameness and to purify cultural difference. As Gilroy argues:

> The national camp puts an end to any sense of cultural development. Culture as process is arrested. Petrified and sterile, it is impoverished by national obligation not to change but to recycle the past continually in an essentially unmodified and mythic form. Tradition is reduced to simple repetition.
>
> *(2000: 84)*

Gilroy's arguments look at how black peoples and cultures were written out of the national story. Instead, the common sense of modernity that as citizens we each belong to a national culture is subjected to critical analysis. Concerted attempts by nations to impose uniformity through shared traditions and memories contain within them the fear of cultural difference. The so called 'national camp' seeks to cancel the significance of 'in-between locations' that could disrupt assumptions of national hierarchy and superiority (Gilroy 2000: 84). There is then a cultural fascism that lingers within the imaginary life of the nation that persists into the present day. However, modernity contains another narrative beyond the everyday fascism of national politics that speaks of the complex dislocation of peoples and diasporic belonging. Ideas of hybridity and diaspora disrupt the cultural homogeneity of nationhood and speak of a more complex sense of identity and attachment. Such features can also be connected to some black popular cultures that have sought to dream of a future beyond racialization.

Significant here is the attempt to locate an emergent cosmopolitan and multicultural ethic that imagines a globalized world beyond racialization. This remains a utopian hope embedded within modernity, even if it is not, of course, its dominant trajectory. If E. P. Thompson (1956) found in the work of those like William Morris a utopian sensibility that acted as a principle of hope, then the same might be said of Gilroy's investment in black popular culture. However, if Morris failed to discover a location within subordinate populations then the same could not be said of the cultural forms analysed by Gilroy. Here we might argue that black music and the politics of protests continue to have an organic link. If we look back to the black American music of the 1960s (especially Stevie Wonder, Marvin Gaye and Sly and the Family Stone), we can detect the kind of utopian spirit to which Gilroy refers. The radical optimism and critique of the music protests in its form, expression and lyric content against

the social and cultural subjugation of black people. The music produced during this period allows for the production of a specifically black aesthetic sensibility that was genuinely global in orientation. Gilroy is concerned, however, that much contemporary music fails to be as radical in terms of the sensibility that it helps foster amongst the listeners and the producers of music. This view certainly seems to have some contemporary relevance. However, Gilroy's critical cultural cosmopolitanism has a tendency to understate the potentially radical cultural potential of nationalism.

Much black politics has been organized not around the transcendence of the nation-state, but around an attempt to have local experiences, cultural traditions and humanity recognized through national citizenship. This feature was undoubtedly present in Gilroy's earlier work, but seems to be missing here. If Thompson, Hall, Williams and Hoggart were all working within national cultures, this was not because they thought they were unproblematic; each recognized their contested nature. Raymond Williams argues in this respect that

> there is a vital difference between thinking about a place in which we live, and of ourselves in relation to it, and the kind of thinking about 'Britain' or 'England', which in this use are not real places but particular interpretations which include definitions of duty, function and character.
>
> *(1965: 122)*

What Williams is pointing to here is the complexity of the investments in questions of nation-hood that are available to the British. Here we might see ourselves as an English conservative, a Welsh nationalist, a Scottish European or indeed other even more complex associations. While it is unlikely that Gilroy should seek to deny these associations, what seems to be missing is an appreciation of the complexity of national cultures or even an acknowledgement that we might distinguish ethnic and civic nationalisms. While this distinction is often easier to make in theory than in actual practice it does not mean that it is entirely mistaken. Historically nationalism has been a double-edged phenomenon. On one level, nationalist movements have been the focus of powerful ethnic exclusivity, hatred, enforced homogeneity and attempts to exclude or swallow the Other. However, over the course of the twentieth century national cultures have provided a sense of belonging, attachment and civil, political and social rights that might be described as emancipatory. These more critical readings are not as evident in some of Gilroy's writing as they might have been.

These critical views aside, there can be no doubting the scale of Gilroy's intellectual ambi-tion in seeking to produce a complex understanding of racialized modernity beyond the categories of nationhood. If British cultural theory began with an attempt to understand the complexities of national cultures (mainly in terms of class), these should not be jettisoned at this point in the argument. However, Gilroy's consideration of the complexity of specifically black aesthetic forms and their ability to constitute a global imaginary beyond the nation points to the limitations of Romantic understandings of the cultural. Part of the force of Gilroy's argument is to ask us to make judgements about contemporary culture. The recovery of the utopian imaginings found within popular music is a clear invitation to deconstruct ideas of literacy and the ephemeral. However, Gilroy is unafraid to pass some harsh judge-ments about some of the more contemporary aspects of modern visual culture. Here he argues that some of the more critical contours of black music cultures have been replaced by an obsession with the black body. If earlier waves of black popular music sought to imagine a world beyond racialized modernity, today hip hop (although not exclusively) focuses upon the visual glorification of the body, sex and aggressive consumer-orientated masculinity.

Here Gilroy is concerned that some of the utopian yearnings of the black musical cultures of the past have been replaced by an aggressive consumer culture.

Here, Gilroy could be accused of the same nostalgic frame of reference that Hoggart was accused of. We could plausibly argue that nostalgia is not of itself always negative, and depends upon the critical sensibilities that are being opened up. Instead of accusing both Gilroy and Hoggart of nostalgia, could we not argue that they are mourning the passing of previous, more vital and critical associations? After all there is no sense in either Gilroy or Hoggart that these imaginings could be unproblematically returned to in the context of the present. Indeed we might be on safer ground if we recognized Hoggart's book as a passionate call for a politics of education beyond the easy formations of mass culture and Gilroy's as the recovery of a non-racialized imagination. The turn to the past and history (which has long been a feature of British cultural theory) is not necessarily reactionary but can be used to throw new light on the present. The return to the past, whether through art and poetry or popular music, continues to provide a critical resource as we seek to criticize an increasingly instrumental and consumer-driven present. Just as Romantic poetry can be utilized to inspire ecological forms of politics that aim to preserve and rethink our connection to nature, the utopian sensibilities contained within some popular music can help inspire more critical and thoughtful forms of politics and protest.

These features then point to areas of continuity within British cultural theory. However, Gilroy's main challenge to British cultural theory still concerns the need to think beyond racialized modernity and the nation-state. In the digital age of twenty-four-hour news, speed and tourism, the act of crossing over borders, whether bodily or virtually, becomes an everyday experience for millions of people. Gilroy's challenge concerns the need to rethink questions of cultural identity in a globalized age while retaining a concern with questions of aesthetics and value. Such features are of course not a return to Romanticism, but can be traced back to an idea that the study of culture needs to be alive to the expression of utopian yearning and places where we can begin to hope for a better and less dominated world.

Culture as policy and citizenship: Tony Bennett

The critical force of the work of British cultural theory has more recently been directed at reviving a critical debate around questions of cultural policy. In particular the seminal contribution of Tony Bennett to the field of policy studies is important here. Bennett (1998) subjects the cultural Marxism and Romanticism prevalent in the work of previous generations to sustained forms of critical analysis. His ambition is to propose that the analysis of culture as a concept becomes substantially revised after the post-structural critique of humanism. More specifically Bennett argues for a form of cultural theory that has become both more specific and more practical. This is especially important if cultural theory is to retain a relevance to the modern world. By seeking to influence and develop a critical understanding of cultural policy, the discipline could achieve these ends. This would largely mean abandoning cultural Romanticism for an attempt to develop theory as a more instrumental discipline that sought to make technical adjustments to the domains of practice, identity and policy. Here cultural theory and cultural studies should seek to produce specific forms of knowledge as a means of intervention into the social and cultural world. This might be policy documents for cultural managers of museums, reports for administrators or concrete forms of advice for social movements. In answer to the question of what cultural theory is for, Bennett suggests that it is to make a direct and pragmatic difference to the world.

If Stuart Hall's attempt to rethink cultural theory drew heavily upon Althusser and Gramsci, then Bennett is strongly influenced by the work of Michel Foucault. This is important if we are to get away from the binary view of power proposed by cultural Marxism. Here the argument is that through an engagement with Foucault we gain a more complex view of power. Power is less constituted through a central struggle between capital and labour but is more pluralistic and complex than cultural Marxism is able to grasp. Once we move away from power as a 'bipolar contest', this opens up the possibility of more specific forms of both intervention and knowledge. Here culture becomes redefined as 'a set of resources for governing' and 'as the domain(s) to which those resources are to be applied with a view to enacting some change of conduct' (Bennett 1998: 68). Notably the cultural does not seek to work on our sense of ourselves, but is more concerned with actions, outcomes and effects.

For Bennett the cultural Romanticism of the past was not only impractical, but of little use to anyone outside of the academy and elitist. Much cultural Romanticism simply sought to dismiss what it assumed to be a degraded and impoverished present for a utopian future contained in either the past or the future. Many Romantic intellectuals failed to recognize that 'the aesthetic disposition forms merely a particular market segment' and that there are other equally valid interests and agencies involved in the governance of culture (Bennett 1998: 199). In other words, cultural Romantics often present their own concerns and readings of the cultural as the only ones that have any validity. This is clearly an elitist sensibility. Rather than seeking to train scholars to make sweeping assessments, cultural theory would do better to recognize the need for more practical knowledge and to produce more technical forms of expertise. Bennett seemingly wishes to replace some of the self-importance of cultural theory with a more pragmatically orientated set of concerns necessary for the functioning of a democratic society.

Jim McGuigan (1996) has subjected Bennett's argument to a sustained critique. Missing from Bennett's analysis is the recognition of the impact that capitalism, class and democracy have on the formation of public culture. The obsession with the formation of specific and local knowledge obscures the centrality of these dynamics. Further, McGuigan objects that Bennett's thesis has become so post-Enlightenment that he neglects to analyse the crucial role that questions of culture play in public self-reflection and critical questions of quality, value and worth. McGuigan carefully reminds us of the role that discussions in culture have played in the setting up of important public institutions and argues that the term can never become detached from more normative concerns. Here McGuigan rescues the voices of critical thinkers like Hoggart and Williams who spoke up for culture's role within a broadly defined democracy. This tradition cannot simply be dismissed as either of little use to policy makers or elitist. Such judgements would fail to connect with the role that both have played as public as well as critical intellectuals.

Future developments

These are important corrections to Bennett's thesis, but perhaps we need to go even further. Fred Inglis (2004) has also contended that questions of culture retain a link to issues related to value. This is as true for Arnold and Hoggart as it is for Gilroy and Williams. The age of postmodern capital has instituted the dominance of a new global elite whose love of money, selfishness and exclusivity do much to shape the contemporary values of our time. The patterns of overwork, high consumption and unsustainable carbon footprints are fast becoming the norm in western societies. In this context, concerns about emancipation, quality, value and worth might be said to be almost countercultural. The idea of culture is at

one level descriptive, but has never finally been able to detach itself from a critical assessment involved in questions of value. It is perhaps this concern that continues to connect the concerns of the present to those of people, like Arnold and Ruskin, with whom we began our discussion. Such a sensibility would find itself at home as much within popular music as within television drama and is as evident in an appreciation of nature as in Romantic poetry.

If 'culture' is to remain a critical value in our time it might be able to point towards more convivial experiences and spaces less impressed by capitalist modernity. This could lead to an extended critique of the 'soulless' lifestyles required by capitalism. Cultures of overwork, stress and fatigue are required of the hard-pressed professional classes. A new counterculture of modernity might seek to win back spaces from the power of capital that, despite the crash of the economic system, continues to require consumers to be high spenders while pushing down wage levels, fostering insecure and temporary forms of employment and punishing the poor. Just as the Romantics asked what kind of culture is fostered in this climate, we should arguably do the same. This is of course not to argue for a return to the concerns of figures like Ruskin and Arnold. However, it is to argue that a number of cultural questions first raised by the Romantic pioneers of British cultural theory are far from answered. Questions related to our relationship with nature, democracy and the role that culture continues to play in critical forms of self-reflection are as relevant today as they were to our ancestors. For all of the current concern with critical issues related to identity, these features are as much related to current debates as they were to previous generations of critical thought and inquiry. Raymond Williams (1980: 267) posed many of these questions through his call for a cultural revolution that would radically democratize the flow of communication and cultural production within society. These 'cultural' questions should not be reduced to reading and re-reading signs and messages, but call for a radical rethinking of the economy, politics and wider cultural institutions and relationships. Here Williams suggests that our first task as cultural theorists is 'to challenge the alienated logic of a capitalist order' (1980: 268) and propose substantive alternatives. This would necessarily involve concrete proposals that suggested the 'abolition of the current imperatives of capital' for a more democratic and emancipatory politics (1980: 269). In this regard, Williams proposed a culturalist and a materialist framework which proposed that we alter not only our ways of seeing things but our ways of doing things as well. Further, as Gilroy (2000) reminds us, the flows of global culture have radically transformed our experience, which simultaneously impresses the logic of capitalism and points to a new radical politics beyond the nation and homogeneous nationhood. Such a critical politics then would need to investigate carefully the potentially emancipatory possibilities of a multicultural and irreverent present. All of this would (despite the importance of Bennett's interventions) point to questions beyond (and within) the world of cultural policy.

Here questions of culture can no longer (if they ever could) be kept separate from a consideration of economics. If Stuart Hall did much in the 1980s to alert a wider audience to the perils of Thatcherism, it is now arguable that the cultural logic of capitalism has become even further impressed in everyday life. The so-called neo-liberal revolution has since the 1980s pressed its logic into many cultural institutions and practices, including the media and education, and has sought to make the commodified life the only kind of life that can be led. Despite the explosion of inequality, job insecurity and most worryingly unemployment within western democracies, neo-liberal frameworks currently show few signs of losing their grip on the public imagination. However, as British cultural studies has continued to remind us throughout its history, no ideology, no matter how dominant, fully saturates our understandings of the world. There need then to be new studies on the location of resistances within our increasingly fractured and fragile world.

Conclusion

This chapter has sought to clarify some of the central debates with British cultural theory. I have argued that the source of these debates remains concerns that can be related to the Romantic revolution of the eighteenth century. There have been considerable attempts to move beyond these concerns, as many of the assumptions made by figures like Arnold and Ruskin can no longer be defended today. However, we saw how post-structuralism sought to critique more humanist versions of culture, but did not do so in a completely convincing way. Positively, the impact of post-structuralism has opened up new lines of inquiry in popular texts and experience and cultural policy. These have been important innovations. However, if the concept of culture is pushed too far and made overly instrumental, this tends to cancel a concern with criticism, judgement and aesthetics. This perhaps means that any understanding of culture will need to continually balance a variety of perspectives at any one time.

British cultural theory has historically sought to rethink itself in response to contemporary forms of social and cultural change. This as we have seen has meant that new generations have sought to think through the implications of political change, globalization and new features associated with identity politics. Unlike other schools of cultural analysis British cultural theory has been impacted upon positively by a range of social movements from trade unions to black politics and from feminism to gay and lesbian studies. All of these movements have opened new and important areas of inquiry that have taken questions of the culture beyond some of the more limited understandings associated with the Romantics. However, as we move into the twenty-first century and the power of the market threatens to penetrate further into our common culture, it will be interesting to see whether the critical debate seeks to return to some of its original questions. If British cultural theory was reinvented during the 1980s, this was because a new generation of scholars came to the fore and explored the complexity of consumer culture. This moment has since passed. The early decades of the new century could yet see British cultural theory become reinvented, but this time through a different set of no less urgent critical concerns. Here I have suggested that these concerns not only need to be rooted in the daily lives of ordinary citizens, but should become reconnected to debates about capitalism, technology commodification, nature and democracy. Yet if these features are to be significant, they will need to become reconstituted within our global times, where cultures are significantly less rooted to the spot and regularly cross over borders. If British cultural theory has only just begun to rethink its practice in terms of these features, it will inevitably continue to draw upon its radical past.

Bibliography

Anderson, P. (1992) *English Questions*, London: Verso.
Arnold, M. (1987) *Selected Prose*, London: Penguin.
Bennett, T. (1998) *Culture: A Reformer's Science*, London: Sage.
Gilroy, P. (2000) *Between Camps: Nations, Cultures and the Allure of Race*, London: Penguin.
Hall, S. (1988) *The Hard Road to Renewal*, London: Verso.
Hebdige, D. (1979) *Subculture: The Meaning of Style*, London: Methuen.
Hoggart, R. (1958) *The Uses of Literacy*, London: Pelican.
Inglis, F. (2004) *Culture*, Cambridge: Polity Press.
McGuigan, J. (1996) *Culture and the Public Sphere*, London: Routledge.
McRobbie, A. (1991) *Feminism and Youth Culture*, Basingstoke: Macmillan.
Ruskin, J. (1987) *Unto This Last and Other Writings*, London: Penguin.
Thompson, E. P. (1956) *William Morris*, London: Lawrence and Wishart.
—— (1961) 'The long revolution', *New Left Review*, 9: 24–33.

—— (1978) *The Poverty of Theory and Other Essays*, London: Merlin.
—— (1980) *The Making of the English Working Class*, Harmondsworth: Penguin.
—— (1991) *Customs in Common*, London: Merlin Press.
Williams, R. (1957) 'Working-class culture', *Universities and Left Review*, 1(2): 29–32.
—— (1958) *Culture and Society*, London: Penguin.
—— (1965) *The Long Revolution*, London: Pelican.
—— (1980) *Culture and Materialism*, London: Verso.

14

American cultural theory

Sam Han

Introduction

'Cultural theory', as contributions to this volume will attest to, is a difficult concept to pare down. What it means is dependent not only on location (that is, geographically where it emerges) but also on intellectual milieu. But in spite of this, 'cultural theory', as it is mainly used in academic and public discourse, has implicit locational and intellectual attachments to Europe. This is evident even in an essay by a prominent and well-respected American studies scholar entitled 'Listening to learn and learning to listen: popular culture, cultural theory and American studies', whose section titles (e.g. 'Contemporary European cultural theory: its aims and intentions') reveal the true meaning behind his usage of the term 'cultural theory'.

This, however, is not to say that cultural theory in the United States does not exist. It does and thrives here. I raise this point because, as this chapter will attempt to show, the formation and development of cultural theory in America is a story of migration, much like the self-professed story of the nation itself, mostly from Europe.

As with the national allegory, the story is not all that simple. What is considered 'American' is difficult to decipher, especially when considering 'American' cultural theory. Are the ideas and concepts 'American'? Are the authors from whom the ideas and concepts are supposedly generated what make cultural theory 'American'? Is the fact that a particular author may have written while residing or visiting the United States enough to consider what is written therein 'American'? Further, does American cultural theory deal specifically with cultural phenomena and objects that are distinctive to the United States? How does globalization, and the instantaneous spread of media content via digital media technologies, affect this notion of 'American culture'?

'American cultural theory' also poses another difficulty: the issue of what exactly falls under the category of 'culture'. What *counts* as culture? Is media content culture? Further, in the era of Web 2.0, is culture something that is produced by powerful centres such as major movie studios in Hollywood such as the Harry Potter franchise or is it the 'memes' found all over the world wide web such as 'Tebowing' and lolcats?

These questions clearly come into play when looking at Alexis de Tocqueville's *Democracy in America* (2004). In what can be argued to be the first example of American cultural theory, 'individualism' is put forth as the key feature of the American character. Surprisingly, individualism is a *critique* of egotism and selfishness levelled by Tocqueville. Unlike its bastardized twentieth-century update, 'rugged individualism', made famous by US President Herbert Hoover, which sought to make broad claims about the 'American way' of economic modernization in contrast to the 'socialist' (that is, the European) way, 'individualism' as used by

Tocqueville was in large part something to be complimented. The impression of the popularity of voluntary associations in the US that was left on Tocqueville is the stuff of lore. For Tocqueville, as many American exceptionalists like to remind us, the distinct quality that was individualism was key in withstanding the tyranny of the majority, as the individual was able to 'recede' into the private sphere and was, culturally, expected to do so.

Expectations form a key trait in the classical sociological perspective on culture. Tocqueville views American culture not as necessarily 'causing' individualism but rather as 'expecting' it. The language is important here. Expectations are not necessarily 'rules' as such. As much sociological research deems, expectations are usually left unsaid and only revealed when one crosses the threshold of acceptability. Returning to Tocqueville for a moment, then, his work highlights an important aspect of all theories of culture: they work largely in the negative, making it very difficult for researchers and analysts to recognize 'culture' when they see it.

But again, is Tocqueville 'capable' of producing American cultural theory? Here is an aristocrat from across the Atlantic (from Normandy specifically) making observations about a foreign culture. (This, I must mention, was something of a tried and true genre for Tocqueville, as he had also written on England and Ireland.) Could the ideas contained in *Democracy in America* be considered an 'American cultural theory'? On the one hand, they must. Tocqueville's observations were made on a visit to America. But, on the other hand, one could argue that American cultural theory could not possibly be found in the writings of a visiting Frenchman. The very fact that he would not have been subject to the socialization process in America would, in this view, preclude him from being intimately acquainted with the *ethos* and *ephemera* of American culture.

For the present purposes, in the case of cultural theory in the United States, 'American' cultural theory will refer not simply to a geographical or biographical marker but to a 'brand' of cultural theory that emerged after World War II and peaked in the 1980s and 1990s as 'cultural studies' in the United States. I hesitate to label this a 'movement', as many of the thinkers and writers associated with it were not contemporaneous. Some, while they knew of each other, did not address one another's work. In response to this difficulty, I will be limiting the boundaries of 'American cultural theory' by engaging in a bit of 'interpretive genealogy' (Aronowitz 1993: 7).

Beginning with the consideration of the outline of the historical and intellectual development of cultural theory in America by starting with figures of what may be called its prehistory, including Adorno, Horkheimer and Susan Sontag, I track the development of theories of culture in the United States, using throughout the term 'American cultural studies/cultural theory'. While less than elegant, I do so because I wish to emphasize the arrival of the Birmingham Centre for Contemporary Cultural Studies to the United States but not place it as being the same as 'American cultural theory'. This would not do justice to the many other theoretical schools that have gained influence in the United States and that have also addressed culture. But if the words 'American cultural theory' mean anything, they signify – if not completely, then in fragmented form – that there will be some sort of association with cultural studies. Therefore, after tracking the early development of American cultural studies/cultural theory, the chapter will proceed to some of its major contributions, specifically focusing on the work of John Fiske, Susan Willis, Janice Radway, Fredric Jameson and Stanley Aronowitz. I then conclude by summarizing the main criticisms of the American cultural studies/cultural theory approach and elaborating some of the outgrowths of this form of cultural theory in scholarship and beyond.

The emergence of 'cultural theory' in America

As in the example of Tocqueville's *Democracy in America,* American cultural theory is a story of cross-Atlantic intellectual germination. A theory of culture came with full force into the United States from Europe during the years leading up to and during World War II. One of the major institutional hubs of this cross-pollination was the Institute for Social Research, which housed many theorists of culture, including Theodor Adorno and Max Horkheimer, who moved from Frankfurt to New York under the same circumstances in exile from Nazism. Horkheimer and Adorno's signature collaboration, *Dialectic of Enlightenment* (2007), was written in the United States. Hence, there are some aspects of the arguments and observations that make reference to the United States. It is arguable that many of these arguments stem from the German-Jewish intellectuals' experiences in a culturally distant (and specific) place. Horkheimer and Adorno spent time first in New York and then in Southern California, and scholars acknowledge that this experience had an effect on their writings (Claussen 2006; Jay 1996).

While a thorough explication of the ideas presented in their book is not appropriate in this context, it is nevertheless worth discussing some of the observations and arguments they make that pertain to the United States in particular and as they pertain to the formation of American cultural theory. In their most celebrated essay, 'The culture industry: enlightenment as mass deception', Adorno and Horkheimer provide arguments about the massification of culture into the culture industry, or as they describe it the '[importing] of culture into the realm of administration', that are predicated on *American* examples (Horkheimer and Adorno 2007: 105). For instance, they suggest that 'advertising [has become] art and nothing else', detached from any product. It becomes

> a pure representation of social power. In the influential American magazines, *Life* and *Fortune* the images and texts of advertisements are, at a cursory glance, hardly distinguishable from the editorial section. The enthusiastic and unpaid picture story about the living habits and personal grooming of celebrities, which wins them new fans, is editorial, while the advertising pages rely on photographs and data so factual and lifelike that they represent the ideal of information to which the editorial section only aspires.
> *(Horkheimer and Adorno 2007: 132)*

They essentially label this as 'advertising for advertising's sake', which, they pointedly note, has parallels to some of the techniques of Nazi propagandist Joseph Goebbels. Notwithstanding Adorno and Horkheimer's heavy hand, their analytic of 'mass culture' is an important precursor to some of the concerns of later developments in cultural theory (and cultural studies especially) in America. Albeit pejorative and all-too-easily dismissive, cultural theory and cultural studies placed at its centre the study of the enjoyment of a variety of popular cultural forms such as Hollywood films, television programmes and music.

In similar fashion to the Institute in Exile, which was hosted by Columbia University, the University in Exile was hosted by the New School for Social Research. As many intellectuals on the faculty of universities across Europe had to flee due to the spread of fascism, the University in Exile hosted key intellectuals from Germany and Italy, and a related school for intellectuals from France called École Libre des Hautes Études formed later in the 1940s (Zolberg and Callamard 1998). The names associated with both schools include Hannah Arendt, Hans Jonas, Claude Lévi-Strauss and Roman Jakobson (though he was Russian and had done doctoral work in Prague). It is the latter two of this list who have great consequence

for the subject of this chapter. Lévi-Strauss and Jakobson encountered one another at the École Libre and are arguably the two major forces behind the fomenting of *structural* anthropology in the United States.

But while Lévi-Strauss and Jakobson were obviously well known within anthropological circles in the United States, it was not until the American cultural critic Susan Sontag began writing articles in the 1960s about intellectual movements in France in a variety of literary magazines that cultural theory – specifically 'structuralism', if not by its actual name then certainly in its principal ideas – began to disperse among the urban literati in the United States. These essays, which mentioned and built upon writers such as Lévi-Strauss, Eugene Ionesco, Roland Barthes and Walter Benjamin, among others, were collected in *Against Interpretation* (Sontag 1969).

The key essays in this collection included the titular essay, 'Against interpretation', which was published in the vanguard literary magazine *Evergreen Review*, and 'On style' and 'Notes on "camp"', both published in *Partisan Review*, the last of which was Sontag's big splash in American intellectual life. As for Adorno and Horkheimer, the significance of the early work of Sontag lies in the recovery of the popular as suitable for serious criticism.

While 'Notes on "camp"' is the clearest expression of this, the theoretical ground upon which Sontag builds her cultural criticism can be found most readily in 'Against interpretation'. The heart of Sontag's approach is the idea that content is overemphasized in the analysis of art and cultural forms more broadly. As a by-product of this overemphasis, there is the penchant for the analyst of art or the cultural critic to hover towards 'interpretation'. But 'interpretation, based on the highly dubious theory that a work of art is composed of items of content, violates art and makes art into an article for use, for arrangement into a mental scheme of categories' (Sontag 1969: 10). The remedy, she states, is 'more attention to form in art'. This places a burden on the way that the observer of art *experiences* it. Sontag prescribes experiencing art as something like 'an excitation, a phenomenon of commitment, judgment in a state of thralldom or captivation' (1969: 21). At other times, she describes this as 'an experience of the form or style of knowing *something*, rather than a knowledge *of* something' (ibid.).

This approach directly informs 'Notes on "camp"'. There Sontag continues her anti-interpretation, anti-content approach by suggesting that 'camp' is a sensibility, 'as distinct from an idea', and also distinct from taste. Both ideas and taste include what may be called content (Sontag 1969: 275). To the contrary, to be 'camp', she notes, is 'to emphasize style', and to do so 'is to slight content'. By 'style' Sontag means something like 'artifice'. She at times uses the term 'stylization' to make the point more firmly. In other words, 'camp' has much to do with 'the love of the exaggerated . . . of things-being-what-they-are-not'. Sontag gives the example of gender bending, using the phrase 'going against the grain of one's sex' (Sontag 1969: 279). As she explains, 'Allied to the Camp taste for the androgynous is something that seems quite different but isn't: a relish for the exaggeration of sexual characteristics and personality mannerisms' (ibid.). But this aesthetic stylization that features being over the top is part and parcel of camp's general trend towards playfulness. She calls this dethroning the serious. 'One can be serious about the frivolous, frivolous about the serious' (Sontag 1969: 297). By treating the 'frivolous' with seriousness, Sontag's anti-interpretation approach can be summarized as 'above all, a mode of enjoyment, of appreciation – not judgment' (Sontag 1969: 291).

While the approaches to culture differ greatly in *Dialectic of Enlightenment* and *Against Interpretation*, there are, between them, at least two similarities. First, there is the idea of mass or popular culture. Prior to the emergence of mass or popular culture, there was,

conceptually at least, a vast canyon between 'high' and 'low' cultures. The former is defined famously by Matthew Arnold as 'the best of what has been said and thought in the world' (Arnold 1993: viii). The qualifier – 'best' – is the sticking point. In equating the entirety of 'culture' to 'the best' there is a dismissal of all other, lower cultural phenomena, which could be called 'folk' cultures. Indeed, the rub here is how certain cultural phenomena get valued and also who gets to do the evaluating. This of course is related to the issue of power. In the Arnoldian cosmos, it is the elite who should have control over what is considered 'culture'. But, according to Adorno and Horkheimer, as well as other members of the Frankfurt School, namely Herbert Marcuse, mass culture signals the collapse of high and lower cultures.

This thesis is, indeed, related to the second parallel theme in Adorno and Horkheimer, and Sontag, which is that capitalism has fundamentally shifted the place and importance of culture in social relations. In this, the influence of the experience of writing in America is clear. In the California of Adorno and Horkheimer (and actually that of Sontag's youth), there was the fullest expression of American monoculture, resulting from the rising middle class of the postwar era. The America of this era was forever imprinted on the minds of many through the new medium of television, which bore depictions of the 'American century' such as *The Adventures of Ozzie and Harriet* and *Leave it to Beaver*. This was of course the America of relative global wealth, featuring a home for every family, a car and some sense of upward mobility. It is under these conditions that Sontag as well as Adorno and Horkheimer wrote. Thus, their writings can easily be considered proto-American cultural theory.

Cultural theory's formalization in America occurred, symbolically at least, with the publication of two books, *Marxism and the Interpretation of Culture* and *Cultural Studies* (Nelson and Grossberg 1988; Grossberg, Nelson and Treichler 1991), both of which were the result of conferences hosted at the University of Illinois at Urbana-Champaign. The former was composed of the collected papers and commentaries from a conference funded by the National Endowment for the Humanities in 1983–84. The latter grew out of a conference at the same institution in 1990. The editors of these two books, Larry Grossberg and Cary Nelson, would become two major figures of cultural studies in the United States. Furthermore, the contributors became associated with cultural studies.

Judging from these books especially, it would be fair to conclude that cultural theory that gained hold in the 1980s and 1990s, largely under the name of 'cultural studies', resulted from yet another cross-pollination from Europe – not, however, from the Continent, but rather from England. It was 'British cultural theory', a term that not so elegantly describes the work of figures such as Raymond Williams, Richard Hoggart and Stuart Hall. As Grossberg describes, the specific context from which cultural theory 'emerged and reinserted itself' was,

> namely, an interrogation of the nature and value of the intersecting social, economic and political changes constituting 'modernization.' The uniqueness of its intervention was to locate these processes within culture, taken broadly as the structures and production of meaning. Thus cultural theory set for itself a double problematic: on the one hand, the primacy of a theory of signification and interpretation; on the other hand, the primacy of a theory, the foundations of a theory of community and politics.
>
> (*Grossberg 1997: 142*)

For Grossberg, the dominant problematic of cultural studies is 'modernity', more specifically, the distinctive effects of the multi-nodal process of modernity on culture, defined broadly as 'either a sensibility or a way of life' (1997: 146). In other words, Grossberg writes, 'the project of cultural studies, as it arises in England, is to understand what it felt like to be alive

at a particular time and place through the interpretation of cultural (that is, artistic and communicative) texts' (ibid.).

British cultural theory, as Grossberg tells it, is a confrontation of two intellectual strands of Marxism, humanistic Marxism and anti-humanist Althusserian structural Marxism. The Birmingham School sought to 'solve' problems in each. Althusserianism, as they had read it, rejected the theory of correspondence between cultural forms, experience and class position (Grossberg 1997: 201). It was, as he defines it, the refusal to identify public and subjective meanings: 'how people fill the void between inadequate collective representations and imperfect private meanings' (Grossberg 1997: 211). (See Chapter 13 in this volume, on 'British cultural theory', for a more detailed discussion of this intellectual history.) The American importation of the ideas of the Birmingham school, which Grossberg was in large part responsible for, homed in on a few specific themes, which, in the main, were detached from the methodological and theoretical concerns of debates internal to Marxist theory, especially in the writings of Gramsci and Althusser.

> Cultural studies is then reducible to a particular theory of the relationship between culture and society or between culture and power, and the history of the formations seen as the teleological or rational achievement of a more powerful and enlightening theory of the relationship.
>
> *(Grossberg 1997: 237)*

This meant that the distinctive feature, or 'calling', of cultural studies in the United States was to focus on 'cultural practices', and the complicated matrix of power in which they exist. Culture then is not ever specific in the sense of reflecting a particular 'signification, ideology, subjectivity or community', but is rather seen as an end product of the negotiations between social structures and everyday life (Grossberg 1997: 238). It follows then that people, the practitioners of culture,

> live their positions in complex, contradictory, and active ways: they reproduce and resist their subordination ... [T]hey live with, within, and against their subordination, attempting to make the best of what they are given, to win a bit more control over their lives, to extend themselves and their resources.
>
> *(Grossberg 1997: 243)*

The focus on this relationship can be said to be distinctive to cultural studies in America.

Major claims and developments of American cultural theory

The work of John Fiske, a contributor, not so coincidentally, to the *Cultural Studies* volume, can be seen as embodying the distinctive focus of American cultural theory on cultural *practices* and the contradictory alignments of power that this creates. Fiske, a media scholar educated in Britain and having taught for many years in Australia and then the United States, has written several books and articles, which are considered to be classics in cultural studies. Furthermore, as the editor of the journal *Cultural Studies*, Fiske not only was a scholar but served as an important institutional figure, a characteristic that he shares with Grossberg and Nelson.

One of Fiske's most important books, due to accessibility and breadth, is *Understanding Popular Culture* (1989). It contains many aspects of Fiske's approach to the study of culture as

well as key case studies which, as we will see later on, come to serve as a fault line in debates about the legitimacy of the type of cultural theory in American cultural studies. The idea that is associated with Fiske most closely is *excorporation*, defined as 'the process by which the subordinate make their own culture out of the resources and commodities provided by the dominant system' (Fiske 1989: 15). The example used by Fiske (and too often lampooned by critics of cultural studies) is that of torn jeans. Torn jeans are, as Fiske argues, the exemplification of what he calls a 'site of struggle', wherein 'what is to be resisted is necessarily present in the resistance to it' (Fiske 1989: 4). Torn jeans represent at once hegemonic American values and a resistance to them. On the one hand, one could extend the theory of commodification to jeans. Jeans, like any other commodity, are embedded in the capitalist mode of production, in everything from their beginnings as work wear to their eventual proliferation as a fashion basic; this makes everyone wearing them complicit, and even participate, in the extension of capitalism's ideology. But by tearing them, the consumer insists upon his or her choice. In the process of customizing or personalizing jeans by ripping them, there is, according to Fiske, 'a refusal of commodification and an assertion of one's right to make one's own culture out of the resources provided by the commodity system' (Fiske 1989: 15). This is excorporation.

Excorporation serves to explain Fiske's larger take on culture, and also why he uses the term 'popular culture' as opposed to 'folk culture' or 'mass culture'. As opposed to the idea of 'incorporation', which views subjects who are subject to the culture industry as mere consumers and recipients of the dominant ideology, excorporation, and the term 'popular culture', views culture not as a *fait accompli*, but as a process of negotiation, as 'the active processes of generating and circulating meanings and pleasures within a social system' (Fiske 1989: 23).

It is important to understand that it is the perspective on culture, propagated by those influenced by the Frankfurt School, against which Fiske and similar cultural theorists are positioning themselves. This contrast in positions can be seen most readily in the way 'pleasure' is dealt with. For Fiske, many left-wing cultural theorists too easily dismiss popular pleasure. Their theories (and politics), in the end, are laden with austerity. This is because they do not see any resistance in the tactics of everyday folks. Instead, they consider that to participate and find pleasure in the dominant culture is to reproduce capitalist domination. This makes people dupes.

This line of argument by many cultural theorists who come out of the Frankfurt School tradition, says Fiske, misrecognizes 'strategy' and 'tactics', a distinction made most prominently by Michel de Certeau in *The Practice of Everyday Life* (2011), a theoretical sourcebook of sorts for much of American cultural theory/studies. Strategies are large scale. They are usually at the scale of winning the war. Tactics are, to extend the metaphor of war, more like raids. By acknowledging the micropolitics of culture, Fiske's theory recognizes that 'forms of opposition are as numerous as the formations of subordination' (1989: 169).

In spite of Fiske's criticism of the 'mass culture' approach most associated with the Frankfurt school, feminist theorists in the cultural studies vein have successfully brought together the two foci: on the one hand, that of Fiske on everyday cultural practices and resistances, homing in on cultural products that are geared towards women, though not necessarily only 'consumed' by women; and, on the other, that of the Frankfurt School on cultural production, focusing on marketing and commodification.

Two representative authors are Susan Willis and Janice Radway. In Willis's seminal *A Primer for Daily Life* (1991), she explores the way in which 'the commodity form', long ago identified by Marx as the 'fetish', which is the sacred or religious object of capitalism, has transformed under contemporary conditions. In particular, she suggests that the proliferation

of 'brand-name marketing represents the Taylorization of consumers' (Willis 1991: 2). This would seem rather in line with the Frankfurt School, yet she is quick to note that 'rather than fragmenting the broad mass of consumers into discrete and manageable units, postmodern advertising assumes a consuming subject capable of being interpolated from a number of angles at once' (ibid.). This sounds more like 'Toyotization' than 'Taylorization'. Willis puts this as the consuming subject's ability to '[recover] use value in daily-life social practice, use value that largely goes unrecognized because [we live] in a world that tends toward homogenization' (Willis 1991: 13). She identifies this contradiction in contemporary capitalism in a variety of cultural phenomena, from Mickey Mouse to the Nautilus workout machine.

Willis's general theory of culture is illustrated in the work of another scholar, Janice Radway, especially her work on 'mail-order culture'. Against the easy dismissal of mail-order culture, the best example of which is the Book-of-the-Month Club, as an 'undifferentiated process of indiscriminate and, above all, passive absorption', Radway suggests that there needs to be a 'more complex understanding of the gendered nature of the assumptions about subjectivity that govern contemporary theories of cultural production, consumption and use' (1992: 513). The debate over mail-order culture, she astutely points out, is really about cultural authority.

As she suggests, the critics of book clubs were alarmed by the increase in the massification of reading and in mass taste's impingement on 'classics'. Indeed, as books were being sold in 'Great Books' packages, the very idea of 'classic' was under threat. Thus, its critics portrayed mail-order culture 'always as undifferentiated, muddled and coercive' (Radway 1992: 522). On the other side, there is the management of the Book-of-the-Month Club, which claimed to be merely making it more convenient for the masses. But according to her, both parties 'resorted to the rights-based language of bourgeois liberalism in order to insist that readers could still operate as autonomous, fully individuated, and self-regulating citizens'(1992: 523). What is missed in this debate, however, is that these evaluators of mass culture were also 'making claims to cultural authority simply by recommending books to others' (ibid.). This, she writes, is a failure to acknowledge the implication of even the recommenders of books in the commodification of culture. This authority was not merely cultural but 'predicated on profoundly gendered and therefore patriarchal norms' (1992: 515).

In sum, we can say that Fiske, Willis and Radway are concerned with two key ideas, which are central to American cultural theory/studies. First, they are focused on the cultural practices of everyday life. This, I call the mass culture–pop culture problematic. Additionally, they are interested in the dynamics of power that are embedded within cultural practices, and the ways in which culture is negotiated by people between social structures and individual realities, or, as Grossberg writes, 'how people fill the void between inadequate collective representations and imperfect private meanings' (1997: 211). This we can call *cultural politics*.

Contributions of American cultural studies

As just noted, one of the principal contributions of American cultural studies is the clarification of the distinction between mass and popular culture. One of the most important American cultural theorists generally, but also one who has contributed greatly to this particular issue, is Fredric Jameson. Jameson's contribution to cultural theory in America cannot be understated. In dozens of books and articles, Jameson has been responsible in large part for pushing onto an American academic audience many strains of European thought, including the critical theory of the Frankfurt School, Russian formalism and French post-structuralism. One of the primary features of Jameson's contributions to cultural theory is his clarification

of the mass culture–pop culture problematic within certain privileged analytic foci: late capitalism and modernism.

For Jameson, the contemporary form that capitalism has taken, which he calls 'late capitalism', a term used by the Marxist economist Ernest Mandel, has wrought certain changes in the trajectory of western culture. While he arrives at this conclusion in a very complicated manner, we can say that for Jameson late capitalism, as a term of periodization, reflects a *post-industrial* capitalism. Late capitalism has commodified everything, including art and culture, and unexpectedly and imperceptibly introduced the 'commodity structure into the very form and content of the work of art itself' (1979: 132). Jameson, clearly influenced by the Frankfurt School, equates commodification with instrumentalization, that is, the 'reorganization along the means/ends split . . . the various forms of activity lose their immanent intrinsic satisfactions as activity and become means to an end' (1979: 131). Thus, Jameson's critique of the Frankfurt School position is that in its critique of the culture industry it valorizes 'traditional modernist high art as the locus of some genuinely critical and subversive, "autonomous" aesthetic production' (1979: 133). But if indeed late capitalism operated to subsume all activity, including high culture, then it follows that it too would be subject to the machinations of financialization. (This is a rather obvious point for those of us today who hear stories of American street artist David Choe potentially being worth hundreds of millions of dollars, most of which came from shares in Facebook, which he received as part of the compensation for painting the walls of Facebook's offices (BBC News 2012).)

Therefore, in Jameson's estimation, there is a lack of a focus on 'high culture' in debates about mass culture–pop culture; meanwhile, in theories of mass culture, 'high culture' takes on the status of lacuna, in the sense that mass culture always '[tends] to define its object against so-called high culture, without reflecting on the objective status of this opposition' (Jameson 1979: 130). Thus, Jameson argues for an approach to culture that reads high and mass culture as part and parcel of the dialectical process of aesthetic production in late capitalism.

The machinations of this interrelation of culture and capitalism can be seen in modernism, which he argues is 'reactive' and 'correlative' to contemporary capitalism. Whereas the Frankfurt School believed modernism to contain some semblance of resistance to capitalism (take, for instance, Adorno's fascination with the music of Schoenberg), Jameson believes that modernism is symptomatic of, not a solution or resistance to, the cultural crisis of contemporary capitalism. This is in large part due to the fact that there is no longer a social group that stands above or beyond the influence of capitalism. As he writes:

> The historically unique tendencial effect of late capitalism on all such groups has been to dissolve and to fragment or atomize them into agglomerations (Gesellschatften) of isolated and equivalent private individuals, by way of the corrosive action of universal commodification and the market marginalized conditions (internal and external pockets of so-called underdevelopment within the capitalist world system). The commodity production of contemporary or industrial mass culture thus has nothing whatsoever to do, and nothing in common, with older forms of popular or folk art.
>
> *(1979: 134)*

What Jameson seems to mean here is that 'the popular' as an adjectival descriptor connoting 'of the people' is somewhat problematic, as 'the people' is in no way singular. Late capitalism atomizes and fragments the people into smaller units. Thus, as cultural theorists, we can no longer speak of 'popular' or 'folk' art. Or put differently, 'popular culture' is no longer a

useful term. This is due, again, to Jameson's particular understanding of the contemporary shape of capitalism.

We can say that the real brunt of Jameson's take on the mass culture–popular culture problematic is political, and concerns specifically the potential for politics beyond class. For him, the issue is whether there is any sort of basis for some kind of group-based consciousness or artistic stance that stands outside of or against capitalist commodification. In classical Marxism, revolutionary consciousness was supposed to be derived from class subjectivity. In the Marxism of the Frankfurt School, revolutionary consciousness (or critical rationality) was to be derived from the artistic avant-garde. But, as Jameson asks, if indeed capitalism has subsumed all within its logic, what is left for the politics of culture?

In many ways, this question posed by Jameson is one of cultural politics, which, as Stanley Aronowitz (1993) rightly notes, is an extension of the larger question of the politics of knowledge, that is, what counts as legitimate intellectual knowledge. For Adorno, jazz music was 'massified', which as many American cultural studies scholars have noted is essentially an elitist position, in the sense that it privileged the 'works whose implied audiences were ruling and middle classes, mainly white and male' (Aronowitz 1993: 26). The backdrop of the emergence of cultural politics, for Aronowitz, as with Jameson (his friend and colleague at *Social Text*, one of the premier cultural studies journals in the United States), is the changing nature of capitalism. But Aronowitz takes a much broader view of the changing contours of capitalism. Instead of homing in on something specific, such as financialization, he points to a wide variety of social-structural changes that can be brought under the term 'neo-liberalism'. Yet again, he takes a different tack than Jameson. He focuses in on the ethno-racial shifts that have followed in the wake of this new capitalist mode of production. He writes:

> In the wake of plant closings and other types of capital flight, technological displacement, and a growth of imports, nativism – never absent in American history – has enjoyed a dramatic revival. Following these developments, many voices have been raised to close the borders to newcomers: this call has been elevated to a legitimate political demand and has been abetted by the rising tide of conservative thought and politics; organized labor, stung by increasing foreign competition from Europe and Japan, has also viewed the large influx of low-wage immigrant labor as a threat to its already eroded living standards; and, of course, the historic shift of immigration from the global north to the south has raised, yet another time, the ever present specter of racism.
>
> *(Aronowitz 1993: 2)*

Thus, for Aronowitz, cultural politics, especially in the United States, is racial politics, which is always knowledge politics. These various themes are intertwined in the way in which this kind of cultural politics of knowledge played out in American universities during the era in which the cultural studies wave swept over American intellectual life.

The 1960s to the 1970s in the United States was a period of social unrest, which resulted not only in the federal civil rights legislation but also, on college campuses, in institutional changes. By the 1980s it was clear that one of these changes was in the realm of academic affairs. In addition to traditional disciplines such as philosophy and economics, black studies (later African-American studies), women's studies, Asian-American studies and others emerged not only as academic concentrations (or 'majors', as they are called in the United States), but also as full-fledged departments, with the power to hire their own tenured faculty. It follows that in time these various departments formed self-standing academic fields of research.

It is precisely that possibility that triggered, according to Aronowitz, the 'canon wars' in the United States, which involved some of the major figures of cultural studies, including Aronowitz himself. The canon wars challenged the hegemonic 'intellectual conservatism' of the American culture of letters, in particular the 'traditional curriculum' with its rigorous protection of 'the prevailing system of educational inequality against the attacks of subalterns' (Aronowitz 1993: 60). The boldest example of this ideological position comes from Allan Bloom, the Yale professor who wrote *The Closing of the American Mind* (1988). This book, which resulted in the eruption of a vigorous debate about new academic areas focused on particular identities, basically reprimanded many top-tier universities for 'pandering to women, people of color, and radicals, who wanted to study Marx, Nietzsche, and Heidegger rather than Plato and Hegel; Richard Wright and Zora Neale Hurston rather than the Greek city-state' (Aronowitz 1993: 60).

As Aronowitz points out, the canon wars, while seemingly about 'preserving the classics' and maintaining levels of 'excellence' at universities, were in effect the politicization of culture and knowledge. In effect, they could be seen as a microcosm of the debates about mass and popular culture. 'Dominant culture' was not necessarily the one practised by the majority. In effect, it is only so by the fact that it is the culture of those who rule. 'Popular culture' is the set of practices performed by the masses. Thus, in the canon wars, the thorny issue is about what counts as legitimate culture, and by whom, that is, by which social group, this legitimacy is evaluated.

While there are many, we can conclude that the principle contributions in American cultural studies consist of, on the one hand, the clarification of the mass culture–popular culture problematic and, on the other, the politicization of culture. These contributions had immediate implications for cultural theory more broadly. It made culture malleable, and bottom-up, not top-down. Cultural objects were 'bereft of intrinsic value'; they 'only [acquire their] value in relation to others within a model and, more widely within a paradigm with "perceptual and semantic ramifications" ' (Aronowitz 1993: 238). The brand of cultural theory that developed in America, which we have been calling American cultural studies, effectively brought back in the idea that culture is articulated through the interpretations and actions of its practitioners; it is never a *fait accompli*.

Main criticisms of American cultural studies

To be certain, there have been innumerable criticisms levelled at this approach to culture. The severest of these has homed in on cultural studies' cultural politics, especially on the politics of resistance, and has come from those who can be described as having 'liberal-left' political persuasions. What distinguishes this particular critique of cultural studies is the emphasis on the perceived devolution of cultural studies' academic rigour. For these critics, the lack of academic rigour takes away from the political intentions of cultural studies. Thus, the very fact that cultural studies takes on pop culture as its object of study becomes a major liability for its liberal-left critics.

As one prominent critic of cultural studies puts it, 'Since its importation to the United States, however, cultural studies has basically turned into a branch of pop-culture criticism' (Bérubé 2009).

In this unusual axis of politics and empiricism, a major criticism is that cultural studies lacks a methodology, which produces a lack of focus on so-called 'research design'. As Francis Mulhern describes it, cultural studies is guilty of a

> procedural equalization of its data: while poetry and popcorn advertisements may not be of equal value in any plausible moral terms, both are potentially interesting as carriers of

social meanings and in that precise sense should be approached with equal analytic seriousness.

(1995: 31)

This equalization translates to cultural studies' politics. It treats too heavy handedly the resistive sensibility of some popular cultural usages. In effect, Mulhern accuses cultural studies of being reductionist. It reads resistance into all types of cultural phenomena, 'encouraging particularism and a narcissistic dissolution of politics in the necessary stricter sense' (1995: 35).

Thus, Mulhern's overall contribution in the critique of cultural studies is the 'pull-back from the reach of culture as a "whole way of life"' (1995: 34), an adage of cultural studies since Raymond Williams. For Mulhern, this ethos gives too much credit to the analysis of popular culture. It is as if the analysis of culture itself 'supersedes the inherited political traditions of the left' (ibid.). But, for Mulhern, politics is distinct from 'other social practices by virtue of its role in determining the character of social relations' (1995: 35). Mulhern acknowledges culture's importance in the 'world of meaning' and that it is 'rich in suggestion', but 'it is not the function of culture to determine social relations by means of deliberation, injunction and coercion' (1995: 35). In sum, the relationship between culture and politics is too strong for Mulhern's taste. Cultural studies, as a discipline, '[dissolves] politics into culture' (1995: 36).

The communications scholar Robert McChesney has worded criticism in this vein even more strongly, saying that he 'pretty much wrote off cultural studies as a political project' (2002: 77) due to what he calls its 'naïveté about the market' (2002: 86). Specifically, McChesney takes to task what he perceives to be cultural studies' utter capitulation to capitalism's invincibility. This, for McChesney, does not 'cut the mustard' for a true left politics. He himself states this: 'The critical issue is whether one maintains a principled critique of capitalism' (2002: 81). Otherwise, we are led to believe, one is complicit in the status quo, or worse yet, functions as its unwitting defender. It follows that McChesney's attack on cultural studies is aimed at its inattention to 'the deterioration of urban America', especially the 'decline of labor and the working class' (ibid.).

McChesney's tactic here is all too common for those on the liberal-left who wish to criticize what they deem the 'cultural left'. Arguments made in this vein usually mirror this concern for the dissolution of 'class society' as an analytic in the humanities and the social sciences. Richard Rorty, a representative figure at least on this point, has even written that the cultural left 'prefers not to talk about money', and deems that its 'principal enemy is a mind-set rather than a set of economic arrangements' (Rorty 1999; see also Stossel 1998). This is especially clear when looking at the way in which cultural studies in the vein of Fiske attempts to reclaim consumerism as a resistive activity or political participation. This, for McChesney, 'reveals a supreme ignorance of elementary social theory' (2002: 85). By identifying some form of political resistance in the ripping of jeans, Fiske, McChesney argues, is guilty of not critiquing capitalism but defending it. Cultural studies had distracted the academic left from 'real' (that is, class-based) politics. It was time to return to political economy.

Lasting importance and future developments of American cultural studies

So, what are we to make of American cultural theory/cultural studies' future? Why is it still relevant? Is it even? In contemporary times, when there seems to be a return to

political economy, out of necessity perhaps amid the global recession of the early 2010s, why should American cultural theory/cultural studies even matter? Isn't it all about, as one famous political operative for former US President Bill Clinton said, 'the economy, stupid'? It may very well be. But no matter how wide the reach of the global recession may be, the matter of culture springs up again, as if out of the pipe you thought you had already fixed and patched up.

Culture, today, matters even more than ever, even in debates that are seemingly about economics. In American social science, for instance, there has even been a reconsideration of the 'culture of poverty' argument (Cohen 2010). A theory used to explain intergenerational poverty, it suggests that the poor not only lack economic opportunity but also maintain a value system distinct from the working mainstream. In other words, this argument suggested that poverty had created a subculture wherein mainstream cultural ideals, such as the accumulation of wealth, were detached from the institutionally normalized means by which to strive for them, namely a job. Hence, finding work becomes, in the special ethical system of the poor, not much of a priority. This, as one can imagine, caught fire in the anti-welfare political era of the 1980s, where Ronald Reagan in the US and Margaret Thatcher in the UK amplified the attack on the basic tenets of social democracies.[1] More recently, with talks of austerity and so-called 'fiscal responsibility' all across the world, issues of culture are tied to what on the surface seem like simply economic concerns. Articles debating whether Spain or Greece is culturally incapable of fiscal stewardship can be found all over magazines and newspapers. While it may always be 'about the economy, stupid', culture always will remain.

To speak of the current state of cultural studies would run counter to the entire project of cultural studies. It was, in effect, an anti-disciplinary project. Therefore, to attempt a 'state of the discipline' sort of exercise in the case of American cultural studies/cultural theory not only would be impossible, as it would be for any field of research, but would be especially inappropriate. Thus, we will look at some of the key branches that extend from the tree of American cultural studies/cultural theory in order to evaluate the 'future' of American cultural theory/cultural studies. These include media studies, science studies and ethnic studies.

It could be said that one piece of the varied legacy of cultural studies in America is media theory. But wait? Isn't this volume a handbook on social and cultural theory? It is on this related point that I believe American cultural studies has made valuable contributions to cultural theory. As Michael Bérubé, one of cultural studies' more sympathetic critics, says, the theory of culture produced by Fiske and others has successfully complicated the theory of mass culture, and its explicit political economy model of media. Bérubé summarizes this kind of position as, 'Enough cultural studies already – we had to get back to good old political economy!' Or, alternatively, he calls this 'the Robert W. McChesney-Noam Chomsky-Edward S. Herman model of mass media' (2009). Furthermore, this position too often poorly mitigates the liberal-left elitism that views people as 'duped' by culture and, by extension, mass media.

This influence also extends to theoretical work happening in the discipline that most obviously studies the effects on audiences of media – communications. This is especially true in the work of James Carey, who can be seen as responsible for spearheading the culturalist approach to communication. The cultural approach to communication turns on a distinction that Carey makes in his widely read collection of essays *Communication as Culture* between the 'transmission view' and the 'ritual view' of communication (1989: 14). In arguing for this approach to communications studies, Carey sides with the latter. For example, the ritual view of communication views the news *not* as information but as *drama*. As Carey says, 'It does not

describe the world but portrays an arena of dramatic forces and action; it exists solely in historical time; and it invites our participation on the basis of our assuming, often vicariously, social roles within it' (1989: 21).

Thus, cultural theory, and the study of culture more broadly, involves an analysis of not only 'the projection of community ideals' but also, and *crucially*, 'their embodiment in material form – dance, plays, architecture, news stories, strings of speech' (Carey 1989: 19). Such study, as he puts it alternatively, tries to explore how cultural forms 'render experience comprehensible' as well as 'the ways in which experience is worked into understanding and then disseminated and celebrated' (1989: 44). To study communication as culture is to undertake a formal analysis of the deep structure of ideology (1989: 50). As Lawrence Grossberg states:

> Cultural studies has always perceived [that] the increasing power of the mass media is reshaping and redistributing the forms and positions of the popular (and consequently, of the masses) within contemporary life. It is here that we can locate the point at which cultural studies intersects not only the theory of ideology and social power, but also mass communication theory and the various theories of postmodernity.
>
> *(Grossberg 1997: 232–33)*

It is nowhere more clear that one of the chief legacies of cultural studies is its differentiation of politics and power. While Mulhern and McChesney view cultural studies as being insufficiently political, defined well within the traditional boundaries of economic justice, cultural studies would say that liberal-left political economy models of media theory do not view social power in proper context. 'Politics' is already couched within the cultural norms and ideals of American society. To criticize cultural studies for not recognizing or misidentifying the place of politics is, in fact, to compliment cultural studies. What I mean is that the contribution of cultural studies to cultural theory in America is in many ways to bring power back into the conversation about culture, which too often viewed it neutrally, devoid of the dynamics of domination and subjugation. But it does not, as many of cultural studies' most ardent defenders would suggest, confuse power and culture, nor does it argue that particular cultural objects (such as torn jeans) bear a certain power dynamic in and of themselves. It is only when these objects are put to use or put into contact with their users that the dynamic of power reveals itself. It treats culture as a *site* of the struggle over power. Thus, cultural objects can embody contradictory political forces, positions and ideologies.

The implications of this kind of position for cultural theory are clear. As Aronowitz writes:

> [I]f the object is bereft of intrinsic value, but only acquires its value in relation to others within a model and, more widely within a paradigm with 'perceptual and semantic ramifications,' one might take the next step to develop a theoretical critique of the authority of existing knowledges – not only the literary canon but also of science itself – that proclaims their independence from the perceptual and semantic ramifications associated with cultural paradigms and contexts.
>
> *(1993: 238)*

If culture can be deneutralized, then science, too, can come under suspicion. While science studies has a rich history of its own, which is distinct from the history of American cultural theory/cultural studies, we can, following Aronowitz, place science studies under the general critique of existing knowledges that is spurred on by cultural studies.

Science studies, according to most sources, traces its beginnings to the history and philosophy of science and the sociology of scientific knowledge. But these approaches had one thing in common. They treated science as a system of knowledge, not one of practices and expertise. In effect, they viewed science as capital-S Science – homogeneous and stable. But like cultural theory in its critique of an overarching capital-C Culture, science studies homed in on *practices* of science, analysing it as less a *fait accompli* and as such, to use a term iterated numerous times, a *site of production*. While, earlier on, science studies had been most influenced by proponents of the so-called 'strong programme', namely figures such as David Bloor from the University of Edinburgh, it would be rather difficult to find someone other than Bruno Latour who would qualify as the face of science studies. In a variety of studies, including *Science in Action* and *Laboratory Life* (Latour 1988; Latour and Woolgar 1986), among others, Latour has not only offered an entirely alternative methodology but an ontology, one that takes a page from cultural studies' insistence on focusing on scientific practices, and not treating science as 'the ideal of transportation of information without discussion or deformation' (Latour 1999: 258). It is, as he says, 'an ideology that never had any other use, in the epistemologists' hands, than to offer a substitute for public discussion . . . a political weapon to do away with the constraints of politics' (ibid.). Hence, Latour insists on the *construction* of scientific facts. Science, to use a phrase by Richard Rorty, does not merely mirror nature but 'is a fierce fight to construct reality'. The laboratory, Latour and Woolgar remark, is a 'set of productive forces', which makes this construction possible. 'Reality is secreted' (Latour and Woolgar 1986: 243).

This explains Latour and Woolgar's attention to even the most banal activities of scientists in a laboratory. For instance, this from *Laboratory Life* on the prototypical work of a scientist in a laboratory:

> a desk belonging to one of the inhabitants of the office space (referred to as the doctors) is covered with paperwork. On the left is an opened issue of *Science*. To the right is a diagram which represents a tidied or summarized version of data sheets lying further to the right. *It is as if two types of literature are being juxtaposed*: one type is printed and published outside the laboratory; the other type comprises documents produced within the laboratory, such as hastily drawn diagrams and files containing pages of figures. Beneath the documents at the center of the desk lies a draft. Just like the drafts of a novel or a report, this draft is scribbled, its pages heavy with corrections, question marks, and alterations. Unlike most novels, however, the text of the draft is peppered with references, either to other papers, or to diagrams, tables or documents ('as shown in figure . . .,' 'in table . . . we can see . . .').
>
> *(Latour and Woolgar 1986: 47)*

We see here the influence of, or parallels to, cultural studies rather clearly. Unlike the institutional approaches of the sociology of scientific knowledge and the reified treatments of science as a set of ideas of the history and philosophy of science beforehand, this approach looks at the daily activities of scientists – and, in this case, in utter detail, without taking much for granted. Clearly, Latour and Woolgar understand that the writing of scientific reports occurs in a fashion such as the one described above, but nevertheless, by homing in on them so closely, they are recasting important lessons of American cultural theory. Science is always arrived at, or 'constructed' in their parlance, in use. Science is the machinations of the laboratory and the interpretive efforts of the scientists within it to produce science.

An additional contemporary area of study that bears the hallmark of American cultural studies/cultural theory is race and ethnic studies. Taking from cultural studies' considerations

of popular culture and cultural politics, embodied particularly well in Fiske's concept of 'excorporation', many studies in this vein focused on resistive aspects of black cultural practice. A representative figure of this kind of scholarship is the historian Robin D. G. Kelley, whose work spans radical labour history, jazz and popular culture. For example, the cultural studies influence can be readily seen in his work just by looking at the object of his analysis in one particular article, about the history of the afro. There he not only cites the work of Fiske, but also adopts a similar approach himself.

In 'Nap time: historicizing the afro', Kelley (1997), like Fiske, Willis and Radway, goes against the mass culture narrative that he calls 'taming of the bush', which is his way of describing the process of the afro, starting as a resistive hairstyle against the white supremacist hegemony, and later coopted by the very forces it sought to critique. He views studies of cultural practices that follow that pattern to be overly simplistic and to underestimate the complicated nature of the negotiation of power that occurs in choosing a certain hairstyle. While the afro is almost always seen in the context of radical black nationalism, as Kelley's article notes, it also has roots in high-fashion circles in the late 1950s, especially among women. It would only later become the symbol of black manhood, 'the death of the "Negro" and birth of the militant, virulent Black man'. This, of course, did lead to the spike of 'natural' products on the marketplace for black hair products. 'Even before the Afro reached its height of popularity, the hair care industry stepped in and began producing a vast array of chemicals to make one's "natural" more natural' (Kelley 1997: 345).

In spite of this cooption, the fact remains that 'the Afro was deeply embedded in a larger racial and gendered discourse about the black body under racism and sexism' (Kelley 1997: 347). For black women especially, having an afro 'was not just a valorization of blackness or Africanness, but a direct rejection of a conception of female beauty that many black men themselves had upheld' (Kelley 1997: 347). Thus, the

> post-Black Power generation of black feminists carved out a new radical aesthetic that built upon the previous era's celebration of African ancestry, but emphasized autonomy, sisterhood, and alternative sexualities. It not only challenged gender conventions in a world where long hair was a marker of femininity, but it was often interpreted [as] a sign of militancy.
>
> *(Kelley 1997: 348)*

But American cultural theory/cultural studies' mark on public discourse can be seen beyond the academy in the pages of one of biggest newspapers in the world: *The New York Times*. In its 'Style' section, the *Times* has a feature called 'Cultural Studies'. While the articles written under this category hardly compare, in at least scholarly rigour, to the contributions of the writers overviewed in this chapter, these articles tend to look at very prescient, pop-cultural phenomena and trends in a serious light. The subjects of recent articles include open marriages, the use of emoticons in business, mourning online, and the proliferation of exclamation points in emails (Ball 2011; Lovett 2012; Newman 2011; Williams 2012). I would argue that without the contributions of American cultural theory/cultural studies, the culture of everyday people would not have been worthy of the scrutiny of the newspaper of record in the United States.

Notes

1 It must be noted that US president Bill Clinton was the one who successfully demolished the already-weak welfare programme in the United States (Clinton 2006).

References

Arnold, M. (1993) *Culture and Anarchy and Other Writings*, ed. S. Collini, Cambridge: Cambridge University Press.

Aronowitz, S. (1993) *Roll Over Beethoven: The Return of Cultural Strife*, Hanover: Wesleyan University Press.

Ball, A. L. (2011) 'Exclamation points and e-mails: cultural studies', *New York Times*, 1 July. Available online at www.nytimes.com/2011/07/03/fashion/exclamation-points-and-e-mails-cultural-studies.html (accessed 21 February 2012).

BBC News (2012) 'Graffiti artist David Choe set for Facebook windfall', *BBC News*, 3 February. Available online at www.bbc.co.uk/news/entertainment-arts-16871764 (accessed 9 February 2012).

Bérubé, M. (2009) 'What's the matter with cultural studies?', *Chronicle of Higher Education*, 14 September. Available online at http://chronicle.com/article/Whats-the-Matter-With/48334/ (accessed 16 February 2012).

Bloom, A. (1988) *The Closing of the American Mind*, New York: Simon & Schuster.

Carey, J. W. (1989) *Communication as Culture: Essays on Media and Society*, New York: Routledge.

Certeau, M. de (2011) *The Practice of Everyday Life*, 3rd edn, Berkeley, CA: University of California Press.

Claussen, D. (2006) 'Intellectual transfer: Theodor W. Adorno's American experience', *New German Critique*, 33(197): 5–14.

Clinton, B. (2006) 'How we ended welfare, together', *New York Times*, 22 August. Available online at www.nytimes.com/2006/08/22/opinion/22clinton.html (accessed 3 December 2010).

Cohen, P. (2010) 'Scholars return to "culture of poverty" ideas', *New York Times*, 17 October. Available online at www.nytimes.com/2010/10/18/us/18poverty.html (accessed 18 February 2012).

Fiske, J. (1989) *Understanding Popular Culture*, Boston, MA: Unwin Hyman.

Grossberg, L. (1997) *Bringing It All Back Home: Essays on Cultural Studies*, Durham, NC: Duke University Press.

Grossberg, L., Nelson, C. and Treichler, P. (eds) (1991) *Cultural Studies*, New York: Routledge.

Horkheimer, M. and Adorno, T. W. (2007) *Dialectic of Enlightenment*, 1st edn, ed. G. S. Noerr, Stanford, CA: Stanford University Press.

Jameson, F. (1979) 'Reification and utopia in mass culture', *Social Text*, 1: 130–48.

Jay, M. (1996) *The Dialectical Imagination: A History of the Frankfurt School and the Institute of Social Research, 1923–1950*, Berkeley, CA: University of California Press.

Kelley, R. D. G. (1997) 'Nap time: historicizing the afro', *Fashion Theory: The Journal of Dress, Body & Culture*, 1(4): 339–51.

Latour, B. (1988) *Science in Action: How to Follow Scientists and Engineers Through Society*, Cambridge, MA: Harvard University Press.

—— (1999) *Pandora's Hope: Essays on the Reality of Science Studies*, 1st edn, Cambridge, MA: Harvard University Press.

Latour, B. and Woolgar, S. (1986) *Laboratory Life: The Construction of Scientific Facts*, ed. J. Salk, Princeton, NJ: Princeton University Press.

Lovett, I. (2012) 'Posting to mourn a "friend": Facebook and Twitter posts on Whitney Houston overran sites early on', *New York Times*, 17 February. Available online at www.nytimes.com/2012/02/19/fashion/facebook-and-twitter-posts-on-whitney-houston-overran-sites-early-on.html (accessed 21 February 2012).

McChesney, R. W. (2002) 'Whatever happened to cultural studies?', in C. Warren and M. Vavrus (eds) *American Cultural Studies*, Urbana, IL: University of Illinois Press.

Mulhern, F. (1995) 'The politics of cultural studies', *Monthly Review*, 47(3): 31–40.

Nelson, C. and Grossberg, L. (eds) (1988) *Marxism and the Interpretation of Culture*, Urbana, IL: University of Illinois Press.

Newman, J. (2011) 'If you're happy and you know it, must I know, too?', *New York Times*, 21 October. Available online at www.nytimes.com/2011/10/23/fashion/emoticons-move-to-the-business-world-cultural-studies.html (accessed 21 February 2012).

Radway, J. (1992) 'Mail-order culture and its critics: the Book-of-the-Month Club, commodification and consumption, and the problem of cultural authority', in L. Grossberg, C. Nelson and P. Treichler (eds) *Cultural Studies*, Stanford, CA: Routledge.

Rorty, R. (1999) *Achieving Our Country: Leftist Thought in Twentieth-Century America*, Cambridge, MA: Harvard University Press.

Sam Han

Sontag, S. (1969) *Against Interpretation*, New York: Dell Books/Laurel Edition.
Stossel, S. (1998) 'The next left: a conversation with Richard Rorty', *Atlantic Monthly*, 23 April. Available online at www.theatlantic.com/past/docs/unbound/bookauth/ba980423.htm (accessed 16 February 2012).
Tocqueville, A. (2004) *Democracy in America*, New York: Library of America.
Williams, A. (2012) 'Open marriage's new 15 minutes', *New York Times*, 3 February. Available online at www.nytimes.com/2012/02/05/fashion/open-marriages-new-15-minutes.html (accessed 21 February 2012).
Willis, S. (1991) *A Primer for Daily Life*, 2nd edn, London: Routledge.
Zolberg, A. and Callamard, A. (1998) 'The École Libre at The New School, 1941–46', *Social Research*, 65(4): 921–51.

Queer theory[1]

Max Kirsch

Definitional beginnings

Most modern scholars and popular purveyors of the term 'queer' agree that its use is by definition an alternative reinterpretation of standard categories, a questioning and re-analysis of standard views about culture and peoples. The significance of 'queer' is that it is also a reaction. It is an active response to the standards and customs of social non-inclusion, against marginalization and against discrimination. The use of queer as a concept and proclamation stems from the gay and lesbian movements for equality that started well before but are symbolically dated to the Stonewall riots. It was the general uprising in the public sphere that reclaimed 'queer' from being a derogatory label and symbolically re-positioned the term for positive resistance against normative exclusion.

The uses of 'queer' moved from public reactions by those intent on building a social movement to the centres of academia, beginning in the humanities and the arts, whose concerned scholars reinterpreted the basic tenets of texts and other forms of representation to include the views and activities of gay and lesbian actors. Similar to much of the counter-analyses that occurred in academia in the 1960s, the usage of 'queer' was also an attempt to break down the barriers between public and academic life. It spread first into the research and writings of philosophy and psychology, English departments and literature and more slowly into the social sciences (and, in rarer cases, the sciences).

In this essay I trace the beginnings of queer theory and its journey through the public and into the academic realms. The focus will be on the changes that have taken place as queer theory has been integrated into the academic disciplines. The main focus will be the emergence of queer theory at a time when fundamental changes were taking place in society as a whole, including those on college campuses.

This essay, then, while including both the public and academic aspects of 'queer', will focus more on the academic debates, discussions and uses of 'queer', or what has become known as 'queer theory'. This is both due to the nature of the publication for which this essay is written and as a result of the debates that have been created over the use of 'queer' during the past few decades. 'Queer theory' has become an important subject of its own, outside of social movements and the reinterpretation of academic works.

The general position here is that queer theory does not represent a separate phenomenon from other developments in academia, but follows the track of theory building as it reflects changes and trends in the culture of the West and its effect on individual and social participation in society. I will argue that queer theory: 1) reflects, for many theorists, their disappointment with the strategies and outcomes of the resistance movements of the 1960s, particularly

the role of labour in these movements and ultimately the dismissal of the belief in the primacy of labour in the analysis of social change that has been common in radical movements of resistance; 2) evolved, in academic circles in particular, from the identity positions in which gay and lesbian studies have been grounded to the postmodern and post-structuralist positions that contend that identity is an 'essentialist' category constraining rather than opening up possibilities for the analysis of gender and sexuality; and 3) has followed the same paths as past social movements into the academy, transforming its status as a populist alliance with an activist agenda into the more individualized and ego-centred realms of university halls and classrooms; resulting in 4) the mirroring of the changes in capitalism and its evolution into late capitalism (Mandel 1972), which emphasizes the individual and the 'self' over the collective. The changes in primary foci have important consequences for the examination of social change, particularly in the rejection of political economy, while often offering isolated reflections on present-day culture and society. In summary, I will come back to the significance and implications of these changes for social movements and social change, and posit some brief conclusions about queer, queer theory and queer studies, and their development and current status.

Historical and intellectual development of Queer theory

The anthropologist Eric Wolf (1972) succinctly (and famously) noted in the early 1970s that mainstream academic disciplines and the theory they produce are part of and reflect the social relations of society, providing analyses that represent and justify the ideologies of power. Just as the 1950s had witnessed the development of very conservative and capitalist-centric theories about economic development (e.g. Rostow 1961), so the upheaval created by the Vietnam War and its incursion into Southeast Asia produced the social movements that were born in the 1960s and 1970s, first as a result of the war and the dangers of the 'military industrial complex' (as President Dwight Eisenhower termed it and warned us against as he was leaving office), and then more broadly encompassing issues of racism, sexism and economic inequality. At the same time, women contended that they had been kept out of decision making in western society, so discussions of social issues also began to encompass the concerns of constituencies that had been excluded from academic departments and academic theory building. Feminist writers in particular changed the landscape of disciplinary directions, further reinterpreting classic research and documenting the roles of women in society previously ignored, and in the process opening up new ground for analysis. Race, sex and class also became central issues as new paradigms were built that included the many categories omitted or treated as secondary in the standard analyses of social life. Fuelled by the general upheaval of the 1960s, the attention paid to differences in sexual desire, gender, and the cultural construction of gender and sexuality gained prominence in the public sphere and in the academy.

In a relatively short period of time, queer theory was established as a major academic area of study, integrated into almost all disciplines. This perseverance in academia, however, has not led to a consensus on what exactly queer theory is or what it represents. In its most general sense, queer theory has encouraged a reinterpretation of standard views about peoples and cultures. As such, its development was a *reaction*: a reaction against non-inclusion, against marginalization and against discrimination. It was also a reaction to the movements of the 1960s and what some judged to be failed theory incorporated into the organization of resistance. For many, then, it is simply an objectification of resistance to dominant theories and models of social life. For others (and this is more in the public realm), its origins

were a statement of an undefined 'anti-establishment' position that has now become settled in post-secondary departments in much the same way that past social movements such as women's studies, Afro-American studies and the more broadly based 'ethnic studies' are now mainstream fields of academic discourse. As a result we can now say that queer studies and queer theory are often interchangeable in college catalogues. It has become a field of study that is established enough to have specialized departmental positions, usually in tandem with fields of inquiry that include discussions of sex and gender, and is staffed by faculty obligated by tenure and promotion protocols to produce novel (and published) academic work. Queer theory politicized the conditions of everyday life and everyday culture within the academy, but what is meant by 'politicized' here is a matter of debate, as we shall see.

The contribution of gay and lesbian and identity studies to queer theory

Gay and lesbian studies grew from the nexus of popular movements. The theory building that highlighted devalued populations in the 1970s and 1980s provided substance for the institutionalization of programmes in American colleges and universities. What galvanized gay and lesbian studies, as Annamarie Jagose (1998) suggests, was the constructionist view proffered by Foucault that homosexuality is a social, or constructed, phenomenon. In positing through his *History of Sexuality* (1990) that there were homosexual acts before there were homosexual identities, Foucault suggested that the position of gay and lesbians was an issue of society and the labelling of behaviour rather than a universalist category of being. This concurred, in approach at least, with the many writings of feminists of the 1970s, who were arguing that concepts of the universality of male dominance needed to be challenged and re-evaluated, along with the position of women in the workforce and their role in the maintenance of communities (see the anthropologists Etienne and Leacock 1980; Leacock 1972, 1981; Nash 1978, 1981; Nash and Safa 1980; Reiter 1975; Ross and Rapp 1977; Safa 1981, among others).

While gay and lesbian studies, as they developed, provided a framework for understanding the social basis of categories and their use in dominant power relations, they also provided a space for the development of *identity* for many faculty and students, and others who had previously been bereft of a place in academia to voice their interests and concerns. Identity became a topic that united those that had been isolated and enabled individuals to find comfort and strength in both feelings and numbers. No longer were solitary faculty or confused students left to negotiate their place in their own psychological realm; the structural availability of institutionalized forums lessened the isolation that had been felt by many. Importantly, this recognition provided available spaces where individuals could discuss and organize around similar needs and demands. Like the consciousness-raising groups of the feminist movement, programmes in gay and lesbian studies were more than academic correlates to discipline-based departments in colleges and universities; they also became avenues for personal growth. Academic scholarship also flourished. The demand for gay and lesbian studies grew exponentially during the 1980s, evidenced by the sheer volume of writing represented in Abolove, Barale and Halperin's reader (1993). But with this productivity in scholarship came new questions about inclusiveness and representation.

(Making) queer theory

Like its predecessor, queer theory was born from the idea that more inclusiveness is better than less. But the writers of queer theory argue that the categories presented by gay and lesbian studies are too narrow to encompass the range of behaviour and sexuality that is

presented by a wide range of preferences. It was also a product of a development of theory in the academy that rejected modernist notions of identity. Thus gay and lesbian studies are an area of inquiry, while queer theory became a critique of that inquiry. Queer theory favours the deconstruction of categories and the identities that have developed within them. It is thus a particular perspective on the place of social construction in those who profess other than heterosexual norms (e.g. gay, lesbian and transsexual), and it is this fact of categorical deconstruction that defines its approach.

This distinction between queer theory and gay and lesbian studies has become a subject of debate and discussion among those focusing on gender and identity studies in the academy (e.g. Kirsch 2006; Lovaas, Elia and Yep 2007). Lancaster and di Leonardo (1997) in their comprehensive introduction to *The Gender/Sexuality Reader* felt it necessary to use the terminology of gay and lesbian studies rather than queer theory as an identifier of scholarship and justified it as an attempt to avoid the debate by using what most academic departments termed their courses of study. While not wholly successful, they were able to temporarily put aside debates solely focused on nomenclature and the newly popular discussions of postmodernism and post-structuralism, and centre their volume and discussion on the gender and sexuality scholarship represented in their reader.

For those dissatisfied with the categories of gay and lesbian studies, however, the introduction of postmodernist and post-structuralist writers was a welcome development in the debate. According to Edgar and Sedgwick, what demarcates queer theory from its postmodern and post-structuralist foundations is its referral to a range of work 'that seeks to place sexuality as the centre of concern and as the key category through which other social, political, and cultural phenomenon are to be understood' (1999: 321). While this definition is now somewhat dated, as the term 'queer' has been applied to almost everything outside of the normative realm (e.g. architecture, space, science – see Betsky on 'queer space' as a 'misuse or deformation of a place, an appropriation of the buildings and codes of the city for perverse purposes': 1997: 5), it does denote the beginnings of the use of queer and queer theory within academia. Hogan and Hudson (1998: 491) place the beginnings of a queer theory with Teresa de Laurentis's use of the term at a 1989 conference at the University of California, Santa Cruz, and cite Sedgwick's *Between Men* (1985) and *Epistemology of the Closet* (1990) as the scholarly works most closely associated with its acceptance into academia. Certainly the publication of Judith Butler's *Gender Trouble* (1990) signalled the beginnings of an era that questioned many of the analyses provided by gay and lesbian studies, and the magnitude of her following, complete with dedicated websites, testifies to the power of her philosophical inquiry into the nature of gender and its role in present-day cultural phenomena.

Queer theory evolved to encompass any analytic strategy used to destabilize and to deconstruct the categories of everyday use: queer theorists object to statements that denote boundaries of any kind. All would seem to agree that the traditional heterosexual–homosexual binary should be abandoned, and that a third or more ways of describing and analysing sex and gender should be proposed. As Jagose put it as late as 1998,

> queer is very much in the process of formation . . . it is not simply that queer has yet to solidify and take on a more consistent profile, but rather that its definitional indeterminacy, its elasticity, is one of its constituent characteristics.
>
> *(1998: 2–3)*

This basic description has not changed in the years that have followed. David Halperin had earlier suggested that even its designation is suspect, for 'Once conjoined with "theory" . . .

queer loses its offensive, vilifying tonality and subsides into a harmless generic qualifier, designating one of the multiple departments of academic theory' (1995: 32). The *principle* of queer, then, became the dissembling of common beliefs about categories in general, from the representation of gender in film, literature and music to their placement in the social and physical sciences to the queering of space, while the *activity* of queer became the 'queering' of culture, ranging from the reinterpretation of characters in novels and cinema to the deconstruction of historical analyses. As *activity* we have seen the assertion of 'queer' identities, notably held as lesbian, gay, transgender, bisexual and transsexual, as variants of human behaviour that have rights on their own terms. As *theory* 'queer's' derivation from postmodernism and post-structuralism leads to the rejection of all categorizations as necessarily produced by dominant 'regulatory regimes'. It situates the individual as the unfettered *self*, separate from claims that would limit its definition.

If the beginnings of queer theory are to be found in the perceived limitations of institutionalized gay and lesbian studies, its momentum has had a paradoxical outcome. The *activity* of queer has been a predominately public phenomenon. Social movements have retaken queer as a form of resistance, producing categories of identity that can be used as a basis for collective action. On the other hand, queer as theory, in postmodern and post-structuralist terms, has rejected the very notion of categories, narrowing the inquiry to the individual self rather than the social field, and thus mirroring, as we shall see, the development of late capitalism as it has developed primarily in the West, and specifically the United States, during the past fifty years.

Principal contributions: theory and politics

Lancaster and di Leonardo (1997) in the continuation of their discussion of gay and lesbian studies and the postmodernism of queer theory in *The Gender/Sexuality Reader* note that

> In the course of the 1980s, a substantial current of gender and sexuality studies withdrew to a narrow, disengaged, and frequently idealistic conception of social constructionism. Postmodernism habitually and synecdochically misidentified Marxism and political economy with older, reductionist, mechanistic schools of thought . . . and thus often simply ignored political-economic contexts in their writing. Ironically, it was in the same decade that work in political economy became increasingly historically sophisticated . . . and took on culture, language, race and gender as key analytic categories.
>
> *(di Leonardo and Lancaster 1997: 4)*

Likewise, Mark Lilla, in an attempt to explain the popularity of queer theory and postmodernism in the United States as opposed to Europe, where its influence was not as evident, argued in an influential article in *The New York Review of Books* that

> the beleaguering fact of the holocaust, the failure of post-colonial experiments in Africa and Asia, the collapse of the Soviet bloc, and the aftermath of the struggles of 1968 left French radicals seriously doubting their premises. [On the other hand] [t]hese same events have had no appreciable effect on American intellectual life, for the simple reason that they pose no challenge to our own self-understanding . . . That the anti-humanism and politics of pure will latent in structuralism and deconstruction . . . are philosophically and practically incompatible with liberal principles sounds like an annoying prejudice.
>
> *(1998: 41)*

In agreement with the analyses cited above, I have argued (Kirsch 2000) that this difference between gay and lesbian studies and queer theory is, in part, generational. Gay and lesbian studies developed from the movements for voice and identity that were prominent during the 1960s and 1970s, when many oppressed and de-valued sectors of the population were rising up to claim their place and their validity in society. These assertions corresponded with worldwide movements for independence, where the logic of colonialism was challenged and new regimes demanded that policy and governance be derived from indigenous sources, challenging the dominant ideologies of colonial powers. Some of these results were disappointing. Just as freedom from colonial powers did not automatically dissolve the relationships of power that oppressed groups, as well as whole populations, were subjected to, the movements for voice and recognition in the (primarily) western capitalist countries were not as inclusive as the intentions that drove their growth. It became clear that the dominant social relations of the society at large were also in play inside social movements. Women, people of colour and those with sexual orientations other than heterosexual ones were often closed out of decision-making processes in organizations that were overwhelmingly dominated by a 'white and male' leadership. Reacting to these differences in recognition, many dissident factions declared these movements invalid. The Students for a Democratic Society (SDS) is but one poignant example of an organization that ultimately dissolved because of struggles over inclusion, voice and direction. Queer theory, while developed by a generation of academics who experienced the tumultuous movements of this period, has primarily been trumpeted by a generation of students that has not witnessed a social movement. Perhaps, too, their attraction is due in part to queer theory's insistence on the impossibility of identity, and to the reality that our versions of ourselves change regularly, and for younger students even more often. The pull of queer theory is often a declaration of independence and of a unique position, what Castells (1997) has referred to as a 'resistance identity'. These students have not yet formulated a 'project identity', where, as Castells notes, 'social actors, on the basis of whatever cultural materials are available to them, build a new identity that redefines their position in society, and by doing so, seek the transformation of the social structure' (Castells 1997: 43; Kirsch 2000: 7). Queer theory, then, is a combination of social influences that have been given shape over time by representatives of the academy and a generation that has not actively engaged in social struggle. That it has been presented as a radical alternative to gay and lesbian studies is a paradox that will be further explored here in an attempt to elucidate the challenges we now face in countering the recent depoliticalization of the gay and lesbian rights movement. Given the current condition of the world economy and the recurrent employment and education crises that are now occurring across the globe, this historical phenomenon may quickly change.

The perspective of society: queer theory, postmodernity and late capitalism

As I have suggested, queer theory stems from movements in academic theory that developed after the upheavals of the 1960s, specifically postmodernism and post-structuralism. The 'post' of postmodernism and post-structuralism supposes something after, beyond what has already been experienced and accomplished. It is both a theoretical and a historical description. As the literary critic Terry Eagleton has so concisely summed it up, 'postmodernity'

> has real material conditions: it springs from an historical, ephemeral, decentralized world of technology, consumerism and the culture industry, in which the service, finance, and information industries triumph over traditional manufacture, and classical class politics

yield ground to a diffuse range of 'identity politics.' Postmodernism is a style of culture which reflects something of this epochal change, in a depthless, decentered, ungrounded, self-reflexive, playful, derivative, eclectic pluralistic art which blurs the boundaries between 'high' and 'popular' culture, as well as between art and every-day experience.

(1997: vii)

'Postmodernity', then, is part of what Mandel (1972) has termed 'late capitalism', and post-modern*ism* is a reflection of this era. It has destabilized everyday experience and with it the identity politics that characterizes much of gay and lesbian studies. In doing so, it has projected a view of experience and change that is very much in sync with the realities of the dominant ideologies of the present period. The thesis here is that queer theory is a reflection of this period, part of the ideological underpinnings of capitalist relations of production. As these connections are elucidated, Wolf's (1972) paradigm that theory is very much the product of the period in which it is written becomes an important baseline for analysis.

We know that in capitalist societies those in power are in control of the means and rewards of production. They are the same individuals and classes that effect the production of what we call the dominant culture, the nexus of relationships and ideas that condition the way that members of society act in accordance with the rules and structure that govern social func-tioning. Capitalism has produced the ideal of the individual as separate and self-sustaining, a position that enhances the role of the self in determining consciousness and action.

Mandel (1972) argued that late capitalism is a period where advances in the attempt to increase profit are centred on the use and further development of technology to automate everyday actions and the labour that has historically prevented the unfettered flow of capital accumulation through class struggle. In late capitalist terms, the individual is presented as the basic unit of production, consumption and indeed being.

Essential criticisms and debates, contested concepts

The focus on the individual as physical unit has produced an ideology in which individuals are viewed, in cultural terms, as successful when they are able to obtain the goods and serv-ices that distinguish them from their peers and those with lesser status (Bourdieu 1982). But ideas do not operate as contained entities any more than individuals do; their genesis is else-where, in the social relations of society that provide the foundation for their development. The ideology that rationalizes capitalist relations is experienced by the individual as the necessity for furthering personal status. The ability to contribute and to reap the rewards of these relations is dependent on class position and location; the *ideal* presented in the construc-tion of social norms is the achievement of those marks of status that define the successful individual, and can be achieved through the purchase of goods. Capitalist ideology has focused on the individual as seller of labour power, and late capitalism has intensified that focus in the realms of both exchange and consumption. In turn, sexuality and desire have become massively consumerized. Roland Barthes (1990) showed us that 'the look' is more important than the act itself. But what does this mean as a unit of analysis? The creation of ideal behaviour in capitalist societies is basic to social control. The ability to *obtain* commodi-ties fixes energy on the acquisition of things as perceived needs. This, of course, does not rule out a rejection of the creation of need; but it does lead to inequalities that are reinforced by the very act of striving.

The integration of advertising and consumerism into the psyche is a multi-layered process, mediated by a dominant 'culture-ideology' (Sklair 1991: 297). The seeding of the

unconscious by social processes such as advertising acts to mask the etiology of desire, sexual or otherwise, which underpins consumer culture.

Queer theory has not addressed the attempts at the creation of uniformity in needs and desires. What the history of advertising shows is that you can appeal to the queer community without condoning individual or group behaviour. While the human need for community enhances the drive for conformity, the realization of the generalized non-acceptance and 'otherness' of queerness fuels arguments for difference as an expression of resistance, while, at the same time, it extols the desire to normalize and consume, evoking courses of action that often result in the buying of uniforms rather than the celebrating of difference.

Communities, both geographic and spatial, have historically acted as agents of resistance to exogenous forces that would transform their role as centres of daily physical and emotional maintenance for individuals, kinship units and groups. The aim of the capitalist engagement of the social realm, then, is the creation of the ego-centred individual and the destruction of communities as places of mutual support and resistance. The abstractions inherent in the foundation of queer theory as ego-centred, while this is not a stated goal, support this managerial variable in the search for cheap labour and the conflicts inherent in the managerial control over capital and labour. In more recent times, transnational corporations have responded to the ability of communities to resist outside domination by actively fighting their influence on social life, and indeed their very existence. In the face of conflict, these transnational corporations have moved their production to other areas where communities and unions are less organized. In the 1970s the mass movement of factories from stable communities to less situated areas where communities did not exist often forced wage seekers to travel to the worksite. The movement of corporations offshore serves to provide, at least initially, resistance-free factories. These are calculated strategies to counter incipient organization.

The separation of worker from both product and community affects every aspect of daily living and emotional life. But there *is* resistance to attempts to destroy solidarity on the part of outside and global forces. As Jeffrey Weeks tells us, *geographic* communities can even act as barricades against the attempt to enforce hegemony. *Emotional* communities – whether they are produced by similarities based on sex, gender, race or class – serve as centres of identification: spaces where individuals realize that there are others like themselves and that provide a counter to the alienation caused by rejection and discrimination (Weeks 1985). Communities can thus provide alternatives to the goals of capitalist production. These movements of resistance cannot be accounted for in queer theory as the abstract individual cannot include how individuals form variants of 'communitas' as a counter to alienation. The social aspect of humanness works against the isolation, no matter the skills of those capitalist managers who attempt to dominate the mechanisms of the reproduction of society.

Further connecting with the tenets of queer theory, Jameson has proposed that the concept of alienation in late capitalism has been replaced with fragmentation (1991: 14). Fragmentation highlights the increased separation of people from one another and from geographic place that is now occurring. It is located in a generalized and growing lack of cultural affect that distinguishes our present period from our past. Which is not to say, in Jameson's words, that 'the cultural products of the postmodern era are utterly devoid of feeling, but rather that such feelings – which it may be better and more accurate, following J.F. Lyotard, to call "intensities" – are particularly free flowing and impersonal' (1991: 16). Here, many postmodernists and post-structuralists argue, is the disappearance of the individual as subject. Yet what is really completed with this disappearance is the *objectification* of the individual as alone and incomparable. As the *idea* of difference becomes embedded in culture it also becomes more abstract:

What we must now ask ourselves is whether it is precisely this semi-autonomy of the cultural sphere that has been destroyed by the logic of late capitalism. Yet to argue that culture today no longer enjoys the relative autonomy it once enjoyed at one level among others in earlier moments of capitalism (let alone in precapitalist societies) is not necessarily to imply its disappearance or extinction. Quite the contrary; we must go on to affirm that the autonomous sphere of culture throughout the social realm, to the point at which everything in our social life – from economic value and state power to practices and to the very structure of the psyche itself – can be said to become 'cultural' in some original and yet untheorized sense. This proposition is, however, substantially quite consistent with the previous diagnosis of a society of the image or simulacrum and a transformation of the 'real' into so many pseudoevents.

(Jameson 1991: 48)

The fragmentation of social life repeats itself in the proposal that sexuality and gender are separate and autonomous from bureaucratic state organization, as queer theory indirectly proposes. If, as in Jameson's terms, differences can be *equated*, then this should not pose a problem for the mobilization of resistance to inequality. However, as postmodernist and post-structuralist writers (and therefore queer theorists) assume a position that this equation is impossible and undesirable, then the dominant modes of power will prevail without analysis or opposition. The danger, of course, is that, while we concentrate on decentring identity, we succeed in promoting the very goals of global capitalism that work against the formation of communities or provide the means to destroy those that already exist, and with them any hope for political action.

Queer theory and the building of communities

For those that are not included in traditional sources of community building – in particular, kinship-based groupings – the building of an 'affectional community . . . must be as much a part of our political movement as are campaigns for civil rights' (Weeks 1985: 176). This building of communities requires identification. If we cannot recognize traits that form the bases of our relationships with others, how then can communities be built? The preoccupation of Lyotard and Foucault, as examples, with the overwhelming power of 'master narratives' posits a conclusion that emphasizes individual resistance and that ironically ends up reinforcing the 'narrative' itself.

Ellen Wood (1986) argues that the production of postmodernist and post-structuralist theory is based on unacknowledged but specific class interests. A class analysis means 'a comprehensive analysis of social relations and power . . . based on a historical/materialist principle which places the relations of production at the center of social life and regards their exploitative character as the root of social and political oppression' (Wood 1986: 14). Such an analysis does not mean overlooking 'the differences which express the social formation', as Marx put it, nor a mechanistic materialism, but it maintains that oppression finds its most extreme and violent expression through economic exploitation and alienation (Marx 1978: 247; Stabile 1994: 48). Stabile further critiques postmodernist theory as

those forms of critical theory that rely upon an uncritical and idealist focus on the discursive constitution of 'the real,' a positivistic approach to the notion of 'difference' and a marked lack of critical attention to the context of capitalism and their own locations within processes of production and reproduction.

(1994: 52)

She continues:

> against the Marxist centrality of class struggle, and in an ironic if unintentional mirroring
> of the mercurial nature of capitalism, Michel Foucault argues: 'But if it is against *power*
> that one struggles, then all those who acknowledge it as intolerable can begin the struggle
> wherever they find themselves and in terms of their own activity (or passivity)'.
>
> *(Stabile 1994: 49)*

It cannot be overemphasized that capitalism creates divisions. The individual is separated from the group *in fact*: not only is labour power embodied in individuals as commodities bought and sold to produce profit, but capitalism is threatened by collectives for the very reason that groups and communities form the basis for resistance to the unequal distribution of the rewards of labour. The task of those managing controlling interests is thus to disentangle such units into their constituent individual parts. The defining aspect of class struggle under capitalism has been the creation and destruction of communities and the control over labour that results. The separation of the individual from society further serves the attempt to divide individuals from each other.

As individuals, we all wrestle with modes of social power that influence how we see ourselves and, in turn, influence our ability to react, defend and assert ourselves. Whether we identify as workers, gays and lesbians, queers, colonial subjects or racial minorities, there is a commonality in the way in which capitalism invokes these categories to maintain ideological hegemony. But recognizing the ideological means through which categorization and oppression operate does not negate the material foundations of their development. The ideological realm cannot be changed unless the economic basis for its generation is challenged and changed.

The connection of queer theory to social change in the 1960s

The initial entrance of social issues into the academy happened during the height of the 1960s, and this was an exciting period. Faculty and students were involved in social change and oriented their research towards societal transformation. For the first time, they were successful in involving the universities and federal funding agencies in supporting this research, which resulted in many books and monographs questioning the prevailing ideas of the day. These changes and movements were taking place in both public and private universities and forums. Students and faculty strikes closed down universities at elite institutions such as Columbia and Yale in the United States, for example, just as they shut down public universities, such as the campuses of the University of California and the University of Michigan. These movements gave voice to those previously underrepresented in academic departments and centres of power. Women were given voice for the first time in university power structures; vulnerable peoples were found writing about their experiences and having their views published along with public intellectuals whose intention it was to engage the society at large in the contributions of change. France in 1968 is probably the most famous of the movements that changed society and academic realities, but the massive changes in US education and cultural attitudes towards any number of aspects of daily living were also a result of this period of substantive transformation.

Much has changed since that time. What was substantially missing during the social movements of the 1960s and 1970s and the changes in the disciplines that resulted from these movements was sustained theoretical debate, or for that matter a unified school of thought.

Particularly in the United States, these movements were more cultural than actually trans-formative in nature. They rarely engaged working men and women and thus the productive side of social relations, even if the theory generated included an engaged labour movement as necessary for fundamental change. Instead, they concentrated on questioning prevailing beliefs and cultural practices that had been dominant until that time.

Queer theory as academic movement and subject

Because there were no sustained theoretical foundations, however, long-term change was easily thwarted by incorporation. Universities easily institutionalized questions of identity and social change: departments that now were named Afro-American studies, Asian studies, women's studies, gay and lesbian studies, colonial and postcolonial studies, and so on all insti-tutionalized the resistance that had resulted in social movements and transformed them into academic subjects and departments. Many of the leaders of these movements became academic faculty members and thus obligated to publish or perish, to enter the academic arena and play the game in the hope of keeping their employment. While their subject matter still contained the language of resistance, their writing and daily living belied their new status. Security has its benefits.

While this change was occurring, the society at large was undergoing a major alteration that was making both governments and peoples more conservative, while globalization resulted in new strategies for capitalist managers to accumulate capital. As an example, in the United States, what is now referred to as the Rust Belt – the area of the country that used to be populated by steel and iron plants – became deindustrialized as multinational companies found cheaper and less resistant labour first in other parts of the country and finally in other countries entirely.

Through movement, deskilling and the destruction of communities and through forced labour, capitalist managers attempt to maximize their positions. In the present era of globali-zation, the current processes of neo-liberalism have substantially weakened the government and public sectors – the very sectors that have traditionally overseen and funded public educa-tion. As wages drop as a result of global competition, politicians win office by promising to cut back on government intervention and taxes; the reigning ideology is that it is the govern-ment's spending practices that are causing the problems of everyday life and the instability of families, not the constructions of capitalist competition that have transformed formerly industrial areas into low-paid service economies or regions of under- and non-employment. Communities struggle to exist as basic services are cut, particularly in urban areas, where primary and secondary education have already been reduced to ruins.

Many leaders of the movements in the 1960s became discouraged and even bitter that societal change on a fundamental level had not been achieved, and the constituents of these movements found themselves at a crossroads concerning why their actions had failed. Many activists turned against resistant action, looking for other theory and explanations of how society works and how individuals might find themselves adapting to what already exists. Importantly, movement theorists turned against Marx and political economy, which they saw as the problem in the variables that made up the methods considered during these times of mass resistance. The most visible of the various movements' leaders joined academic depart-ments, looking for space to re-think their past and their beliefs. These former vocal leaders believed that the 'war' had been lost, and the 1980s and 1990s witnessed a substantially more conservative era, where consuming became more important than production and thought more important than action. But as Terry Eagleton put it:

> *what if this defeat never really happened in the first place?* What if it was less a matter of the left rising up and being forced back, than of a steady disintegration, a gradual failure of nerve, a creeping paralysis? What if the confrontation never quite took place, but people *behaved* as if it did?
>
> *(1997: 19, original emphasis)*

Further developments and the growth of queer theory

Thus during the 1980s and 1990s members of the feminist, gay, lesbian and queer communities began to express doubt that Marxism and the debates around Marxist theory and practice could adequately address their experiences. Was this phenomenon due to the writings of Marx himself, or to crudely interpreted understandings of Marx? The objection to Marxism, for many postmodern and post-structural writers, provoked a bitter backlash against Marx and Marxism as a mode of analysis and as a basis for political programmes. The vehemence expressed suggests that more is at work here than a simple challenge to what has been judged as outdated theory. Marxism was blamed for the failure of all hope for a revolution of both the cultural and the productive forces. Whatever the actual genesis, even critiques of capitalism have become passé. Marxism has been discharged as a whole, often by those who have not read Marx or engaged Marxist scholarship in debate.

For queer theory, what needs to be explored are the implications of this shift away from Marxism and social movements. Much of the theory that claims postmodernism and post-structuralism as its forebears has substantially dismissed phenomena that create the basis for gender inequality and the divisions of identity that we encounter today. To understand gender inequality, gender division and indeed inequality in general, it is necessary to explore modes of reproduction that appear to us as a given, but are in fact particular historical processes.

Changes in the social organization of production and reproduction have necessarily included changes in the relationships among sexes, genders, families and communities. Women, and by extension queers and other minorities, have been left out of the social core of social analyses, which has led to continuing distortions about their roles in, and integration with, society (Leacock 1981: 13).

From collective identity politics to abstract individualism

Queer identities are tied to the practice of capitalism. The competition for cheap wage labour, as essential to a competitive capitalism, became predominant during the nineteenth century, and with it a separation from household economies where families primarily became units of reproduction. Families became essential for the socialization of children and creation of a personal life that fitted with the needs of capitalist consumption, and became largely disconnected from the necessity of wage labour. As an example, D'Emilio (1997) shows that the Puritans did not specifically condemn same-sex relationships; they merely prohibited *all* sexual acts outside marriage. The American colonists had no categories to describe gay and lesbian people or their relationships. Like the trade associations of the nineteenth century that enacted ritualized ceremonies to discourage marriage when it would disrupt social relations, colonial Massachusetts enacted laws that prohibited unmarried individuals from living outside the family structure (Oaks in D'Emilio 1997: 172). In an economy where children were necessary to accomplish household production, the threat posed by relationships that might challenge the stability of family life rendered extra-marital relationships unconscionable, since they had the potential fundamentally to undermine the ability of families to sustain themselves.

Likewise, responding to the necessity for family production, Christianity in Britain condemned procreation outside marriage. As the basis for household production broke down, however, this necessity became less urgent and with it came a separation of procreation from sexuality. The family continued to represent stability, while the freedom of individuals to pursue sexual desire outside heterosexuality could lead, it was reasoned, to deviant socialization and unsustainable forms of labour participation. Homosexuality, prostitution and even masturbation came into popular lore as working against the family and against the state. Sexual freedom was still a threat to competitive capitalism, for wage labourers still needed to be socialized and reproduced. Thus, the spending of semen for reasons other than procreation has been, since early industrialization, synonymous with moral failure, draining the energy needed for work. In the nineteenth and early twentieth centuries it was a common explanation for why businesses failed, and why immigrants were unable to adapt to 'modern' working conditions. The individual became the centre of attention, and moral character a primary goal.

The history of this logic can still be found in contemporary popular culture, in the folklore that players should not have sex before a sports game, for example, because it hinders performance in the same way that people should not carelessly 'spend' money. The primacy of the relationship between people and wage labour – man and machine – replaced the primacy of the productive labour essential to familial endeavours like the family farm.

The changes in productive relations that occurred with the rise of competitive capitalism and industrialization transformed the social sphere in every area. Not only was the family no longer the primary contributor to society as a productive unit, but the expansion of capital, both locally and globally through colonial subjugation, opened up new fields of inquiry and ideologies that rationalized the dominance of nation-states over others.

For instance, medicalization, as Foucault reasoned, became a relationship of domination, a way of positioning difference as abnormal, through the creation of an 'ordered system of knowledge' (1990: 69). With medicalization came definitions of racial categorization. Sexism and racism developed in tandem, allowing the managers of colonialism to rationalize the difficulty of rule with reports of, for example, 'oversexed females with protruding buttocks' (in Sommerville 1997). In this same period, eugenics was becoming the science of the day; race and intelligence were becoming known primarily in the laboratories of evolution and genetics rather than through the analyses of change in social systems.

With the spread of transnational companies and corporations without borders, we have reached a new stage of attempted hegemonic control. The shift from the extraction of goods and services by the advanced capitalist countries from 'other' economies to a concentration on the usurpation of energy in both nature and labour in those countries has transformed the relationships among populations and within communities worldwide. The speed-up of production, the forced migration of individuals and families for work, and the continuing destruction of natural resources all have a profound effect on the access to resources that make self-realization possible. Women and the lower-paid segments of the labour force are the primary targets of transnational corporations seeking the lowest labour costs (see Safa 1981). This current expansion is strikingly similar, particularly with regard to the position of women and minorities, to that which took place in the industrialization of America and Europe during the nineteenth century (Nash and Fernandez-Kelly 1983: xi). The difference now is that the traditional role of the man as labourer has been reversed in the productive process. Women around the world are now the majority of workers involved in industrial production, as the productive process has been feminized with lower wages and less resistant unions. This has left men in their traditional roles as 'providers' (true or not) ideologically out of cycle with growing families and family organization, often causing men to leave in search of

employment or simply self-esteem and leaving many kin groups without males or fathers altogether.

The movements of the 1960s in the United States and Europe were correlated, importantly, with the movements of colonial peoples who demanded their freedoms and their voice in the determination of their own lives. These anti-colonial and independence movements acted as examples for a generation of students and workers who saw the possibilities of gaining control of their own labour and their own bodies. With the transformation in the possibilities for the control of one's own labour came the possibilities for a new culture of sexuality, freedom, cultural expression and control over time. The sexual revolution in particular transformed the lives of whole populations as experimentation and devotion to other than heterosexual relationships became more accepted, if not normalized, at least in the major cities of the West.

The further connection of queer theory to postmodern and post-structural analyses

The rejection of Marx, of leadership, and of collective activity is perhaps what best defines the political aspect of postmodernism and post-structuralism. Although Foucault and Baudrillard, as well as Derrida, Bartes, Lacan and Lyotard – the most widely recognized of the postmodern and post-structuralist theorists – all participated in the politics of the left, it was this participation that demoralized their sense of political struggle. Rejecting class as a category was of particular interest to theorists such as Baudrillard, who saw no progress in what he had thought was the advocating of class struggle in left politics. As he and others saw it, if class was simply the by-product of an elusive category of capital, then as a category in itself it had little meaning. It is a 'universalist and rationalist concept', and Baudrillard tells us that 'When the structure is reversed and the proletarian class triumphs, as in the East, nothing changes profoundly, as we know, in social relations' (1975: 168). Using China and Vietnam as examples of proletarian failure was an odd addition to the discourse of left politics, but one that fitted the overall change in the orientation of theory.

The broad influence of this reworking of analysis and the rejection of 1960s politics (and the failure of its promises) finds its way into a critique of the 'fetishism of labour' with Baudrillard's *The Mirror of Production* (1975), where the entire concept of production as a basis for social reproduction is dismissed. For Baudrillard, the 'code' of social life provides the meaning for commodities and consumption, not the act of labour that Marx argued that commodities embody. The code defines who speaks and who does not, who is heard and who is silenced. Production becomes a discourse – in his words, 'a productivist discourse' (1975: 18) – like all others; it is signified by the code that embraces it, the 'dominant scheme' that determines its definition.

For Baudrillard and his peers, the way people view themselves in contemporary culture is a result of what they do: we are taught to believe that we are to achieve, and achievement is the end result of what we produce, rather than production being the end result of what we achieve. In other words, Baudrillard has turned Marx on his head. He uses the analogy of Lacan's 'mirror stage', where the outside is reflected into consciousness and consciousness is reflected onto the outside, concluding that 'Production, labor, value, everything in which an objective emerges and through which man recognizes himself objectively – [this] is the imaginary' (1975: 19). Thus production and political economy were rejected as a starting point for investigating social systems, from pre-capitalist 'primitive [sic]' to those of the present. To prove his point, Baudrillard – incorrectly – accuses the French anthropologist Maurice Godelier of superimposing categories of production onto pre-capitalist societies, just as he accuses Marx of reifying production as basic to human existence.

From Foucault and Baudrillard we see the development of a turn from 'objective' circumstances to self-reflection, an important precept of queer theory. Perhaps it can be once again explained that the perceived failures of the labour movement in the late 1960s generated this self-reflection, not only in the political arena of action and programme but in the doubting of all that can be called 'truth'. Self-reflection involves our consciousness and an ability of our consciousness to define activity. If we do not believe that there exists an analysis of the truth, then failure is not of consequence.

For the postmodernists and the post-structuralists this self-reflection is superimposed onto previous categories of grand schemes and metanarratives. These are dismissed along with the universalism of the modernist period, a universalism, as found in Marx and political economy, that in their view did not achieve the liberation of its subjects or peoples. As Baudrillard sums up, 'The liberation of the productive forces is confused with the liberation of man: is this a revolutionary formula or that of political economy itself?' (1975: 23). As for historical materialism:

> not only have the categories of historical materialism no meaning outside our own society, but *perhaps in a fundamental way they no longer have any meaning for us* . . . Historical materialism prohibits itself from seeing this. It is incapable of thinking the process of ideology, of culture, of language, of the symbolic in general. It misses the point not only with regard to primitive societies, but it also fails to account for the radicality of the separation in our societies, and therefore the radicality of the subversion that grows there.
>
> *(1975: 109, original emphasis)*

Without discussing the very significant errors that Baudrillard makes in interpreting the decades of work of anthropologists and other social scientists who devoted their careers to the analysis of the origins of stratification and political power, and in which his lack of training and acquaintance with the subject matter becomes clear (and his ignoring of classic work embarrassing), Foucault, Baudrillard and their colleagues position power in the spoken word, which they believe regulates social activity. The analysis is linguistic rather than materialistic, a position that Maurice Bloch (1977) has brilliantly summarized in his own analysis of the genesis of knowledge. As the critique of Marx and political economy is what best defines the political aspect of postmodernism and post-structuralism, we can fairly assume that emancipation must come from within, and the within is constituted by language. What they all have in common is the belief that the proletariat is not a revolutionary grouping capable of challenging capitalism.

The possibility of future developments: reconsidering Marx and political economy

But with these ideas we must return to a basic understanding of the root of exploitation, the misuse of the environment, the abuse of labour, and the genesis of sexual and gender oppression. For despite views to the contrary, we are still dealing with class oppositions today, just as we were at the beginnings of capitalism, and during the development of the 'old' social movements. The facts of exploitation and the means by which basic human needs are met have not changed except in the forms in which these processes have significantly evolved. Human consciousness is itself realized, as Martyn Lee comments, 'objectified in the material products of labor . . . that is why the object of labor – the material artifact – holds a central place in the determination of the ontological health of individuals

Max Kirsch

and society in general' (1992: 43). Which is to say that there is a reality found in the labour processes as part of social relations to the reproduction of self and others that cannot be reduced to language. A politics that does not assume that social change must be oriented towards a confrontation with the very nature of the social structure is not a politics at all. Labour, as *sensuous activity*, as Marx termed it, is a human phenomenon: it encompasses both the means by which we create ourselves and the ways by which we experience the world. The postmodernists and post-structuralists confuse the complex mechanisms by which humans reproduce themselves with the more limiting determinants of ideas and consciousness. Marx and his cohorts, including Adam Smith, saw labour and the market as crucial to the envisioning of how society functions, and how humans are able to obtain the basic necessities for living. In the process, they did not dismiss the more abstract and complex organization of the human mind. While Marx and Engels did emphasize the role of reproduction in the maintenance of society, of labour as an *activity* integral to human *being*, it was not meant to minimize the role of humans as social animals who create culture and therefore create them*selves*. As Marx famously states, 'Circumstances make men just as men make circumstance' (1939: 29). The statement reflects a methodology that is dialectical rather than linear, and, as Mészaros puts it,

> here we come to a crucial question: the complexity of Marx's dialectical methodology. In a mechanical conception there is no clear-cut line of demarcation between 'determined' and its 'determinants.' Not so within the framework of dialectical methodology. In terms of the latter, although the economic foundations of capitalist society constitute the 'ultimate determinants' of the social being of its classes, these 'ultimate *determinants*' are at the same time also '*determined* determinants.' In other words, Marx's assertions about the ontological significance of economics become meaningful only if we are able to grasp his idea of '*complex interactions*' in the most varied fields of human activity. Accordingly, the various institutional and intellectual manifestations of human life are not simply '*built upon*' an economic basis, but also actively *structure* the latter through the immensely intricate and relatively autonomous structure of their own 'Economic determinations' that do not exist outside the historically changing complex of specific mediations, including the most '*spiritual*' ones.
>
> *(1971: 145, original emphasis)*

Of paradoxes, theory and politics, or the future of the discussion

The past movements for sexual, gender, racial and lifestyle equality are closely tied to current concepts of difference, acceptance and assimilation. Contention within the new left movements of the earlier period and the age-related experience of differing generations threw into relief the need for an appreciation of the nature of difference. A lack of a clear vision, coupled with the current social climate that dismisses the analysis of class struggle, however, heightened this awareness to a fault. The priority of 'awareness' over organization has often rendered calls for collective action impotent. At the same time, capital-intensive corporations have been at the forefront of a worldwide expansion that has changed the character of social life, ideologically blurring material distinctions in the workplace and providing a real threat to the organization of resistance. Also, it cannot be forgotten that now over eighty per cent of the world's population does not have adequate access to clean water; most are living on under $2 a day, and over half of the American population is living at or under the poverty level. These questions matter, and a focus on the self is not a political position.

Within these circumstances, queer theory is a unique phenomenon. It is both a consequence of and a reaction to these movements, and it paradoxically reflects the elements of the period of late capitalism that were rapidly transforming the members of social groups into individual beings focused on the self. But it emerged with the partially transformative movements of the 1960s, with their calls for equality and at least participation in social affairs, and for many an anti-capitalist stance. Even the name was an appropriation of a derogatory term that was turned on its head as activists demanded their equality. What then happened is the result of many factors, some of which I have tried to cover in this brief essay. But here most importantly, we need to go back to Wolf's remarks about theory being a product of the era in which it is developed. Queer theory evolved from a radical notion of self-actualization and participation to an isolationist stance that labour was an erroneous variable of analysis, and the analysis of identification, experience and mobilization was an 'essentialist' project, denying the individual their right to non-engagement with the political world. The anthropologist June Nash, in her analysis of the Zapatista uprising in Chiapas, Mexico, has stated that she welcomes the labelling of her work as 'essentialist', as it truly represented the collective experience of communities whose worlds were being militarily challenged, and whose experience was indeed similar, acting as a basis for organization (Nash 2001, and personal correspondence).

I have tried to explain the disappointments of the 1960s as a catalyst for a search for other ways to view individual life, or more accurately the life of the self. In the process, and paradoxically, the individual, and more concretely the self, became the focus of both late capitalism and the theory generated within its boundaries, including queer theory. Analyses became more and more narrowly focused, if allowed at all. Generalizations automatically became 'metanarratives', without Bridget O'Laughlin's insightful comment that a 'vulgar' universalism is not the same as a general theory through which to interpret social representations and organization (1975: 348). Russell Jacoby (1999), among others, also decries the abandonment of universalism in the movement towards particularism, noting that cultural studies and its derivatives ultimately result in an advocacy of the status quo, enacted by those in university positions with status and renown. Jacoby argues that the 'inclusiveness' of universalism implies conformity for these scholars, the real experience and oppression of the marginalized people to which writers so often refer being lost in the drive towards the local and the unique. We all live in social contexts through which our visions can be interpreted. We can argue that the development of new social theory that attempted to incorporate cultural difference more fully was not a denial of Marxism but a project to enrich it with a more fluid analysis of the 'superstructure'. But the emphasis on difference has turned out to be a slippery slope for, in the same way that theorists and activists had asserted the 'base' as objectified, the 'superstructure' became a focal point. A reasoned account of political economy was made to disappear.

The managerial strategies of late capitalism have moved forward in separating individuals from each other, in destroying communities in the search for cheap labour, and in controlling resistance by making every individual responsible only for themselves. With the election of Ronald Reagan we saw the initiation of an era of conservative politics that was indeed reflected in the academy. The 1980s and 1990s became conservative periods and the departments and programmes that had been set up in universities to counter social problems and discrimination became increasingly isolationist and fractious. To be sure, there are still excellent departments focused on subjects without equal access to resources that confront the daily problems of constituents and key players. But academia has been changed by the periods in which we live, and academics have reacted with a voice with more access to the public than

most. This has put those in the academy in a most peculiar and dangerous position. Pierre Bourdieu, one of the most influential French sociologists/anthropologists of the twentieth century, has summed up the infatuation with the experience of the self in this way:

> What, I will be asked, is the role of intellectuals in all this? I make no attempt to list – it would take too long and be too cruel – all the forms of default, or, worse still, collaboration. I need only mention the arguments of so-called modern and postmodern philosophers who when not content with leaving well enough alone and burying themselves in scholastic games, restrict themselves to verbal defense of reason and rational dialogue, or worse still, suggest an allegedly postmodern but actually radically chic version of the ideology of the end of ideologies, complete with the condemnation of grand narratives and a nihilistic denunciation of science.
>
> *(Bourdieu 1998: 227)*

In another example of academic positioning, Carol Stabile notes that the former Marxist theorists Ernesto Laclau and Chantal Mouffe (1985) now complain that Marxism privileges 'class' over other forms of oppression, and she states:

> who better to form the new center for political struggle than intellectuals – so that we get the privileging of intellectuals rather than the privileging of class: what this results in is a convenient move, for a) we don't need to invoke the notion of class at all because the concept is intrinsically essentialist; and b) we do not need to concern ourselves with the class privilege enjoyed by intellectuals since oppressions are, within the discursive field, necessarily unfixed and somehow equivalent.
>
> *(Stabile 1994: 50–51)*

Conclusions: Queer theory, social movements and everyday life: continuing debates and criticisms

One particularly odd contribution to the debate has been current queer theory icon Judith Butler's (1999) defence of her writing style, which many have criticized as unreadable. By way of a column in the editorial pages of *The New York Times*, she complains that the critiques of her writing are a result of a lack of understanding of the complex concepts she is expressing in her explanations and debates in contemporary theory. Not a few wondered why this column was accepted for publication, for the obscure nature of the subject matter ensured that most readers would have no idea of her reference points or for whom her arguments were being made. The column, simply because of its placement and defensive stance, is worth reading.

But perhaps the most damning of this school of theory are those actually involved in social movements, who, when confronted with the complexities and circular reasoning of many postmodernists and post-structuralists, pose a much simpler critique. Those outside the academic tower have remarked that, just as gays, lesbians, transsexuals and others not associated with mainstream heterosexuality (and others associated with the labour movement, for example) were beginning to get name recognition, postmodernists and post-structuralists were asking them to give up their 'labels' as essentialist, because the actuality of self-experience could not be categorized (see Scott 1993). It is easy to see why many would see this as a particularly academic position, ignoring the recognition needed to form collective movements as bases of resistance and necessary for resistant organizing. It is obviously much easier to *deconstruct* theories of social being that to *construct* modes of social action.

It remains to be seen if postmodernism and post-structuralism, and their offspring queer theory, are indeed a passing fad or are here to stay as a conservative alternative to movements and theories of resistance. Certainly many academic departments hired faculty during their height that espoused the conditions of 'queer' in its many facets, so a generation of scholars is indeed ensconced on many university campuses. Yet as we can see from Nash's example and the statement of Bourdieu, there is a general reaction against this focus on the self and the rejection of the real in its collective form, and more scholars are reacting against what we see as an apolitical and dangerous form of ignoring the critical questions of the day. The historical and ethnographic fallacies presented in defence of the postmodernist and post-structuralist critique aside, it is doubtful that it would exist at all without the new political juncture of fragmentation that late capitalism represents and which has led to a new stage in politics (Eagleton 1986; Haraway 1985; Jameson 1991). What is clear is that, if we believe in and want social change that leads towards the elimination of oppression at many levels, we cannot ignore the significant degeneration of social being experienced by peoples around the globe.

We have discussed the reasons and motivations for the development of queer theory and its offshoots. Given the present condition of politics and power, there is clearly a need to reinsert the *social* into the equation of analysis that recognizes the seriousness of what communities and individuals are facing, which is literally destroying the possibilities of reproduction in many communities on every continent.

Resistance to capitalism, then, involves practical struggle on issues that affect all of us on an everyday basis. We cannot pretend to disengage from the reality of discrimination or oppression and claim that we are fulfilling a task of resistance by refusing to engage the domination that exists. The preoccupation of post-structuralists with disengagement as an act of resistance, of parody as re-description, works against the formation of community just as it (falsely) presents acts of self-actualization. That we are members of society *should be self-evident*. How power and domination are actualized and managed is both an empirical and a political question.

Queer theory, then, needs to be refocused to take into account the realities of everyday life in a capitalist world system, and that may be its undoing. But it does require an end to academic posturing, where unintended obfuscation is more valued than strategies for recognition and community building. In a true sense of the personal as political, this includes a full accounting of the location of position by those generating a new kind of 'metanarrative'. Who is included and who is excluded in the context of globalization is the question we must now focus on in order to confront the realities of an expanding competitive capitalism and seemingly shrinking movements of resistance (see Kirsch 2006). The reality of class needs to be reintegrated into forms of resistance that are contributory rather than oppositional.

Given the state of world politics, it is easy to become demoralized again about the possibilities for change and the inclusion of all peoples in an equitable distribution of resources. Not only are we witnessing a rapid growth of extreme poverty, joblessness and disease in both the developed and the underdeveloped worlds, but even cultural production in the forms of literature, art, cinema and science is increasingly bound to 'market forces' and 'commerce' and threatened with destruction (Bourdieu 1998: 225; Kirsch 2006: 1–25).

There is hope. Bourdieu advocates a 'reasoned utopia' against an economic fatalism that would have us believe that the world as it exists is as it should be. This reasoned utopia involves the rejection of the neo-liberal society defined by banks and bankers and the documentation of the social costs of economic structural violence, while laying the foundations for *an economics of well-being* (Bourdieu 1998). As of this writing, the recent demonstrations and movements against the tactics of Wall Street in the name of a healthy economy are now being

recognized around the globe in movements such as Occupy (Occupy Wall Street, etc.) and are gaining headlines not only on university campuses but also through unions and other forms of labour representation. As well, the movements for human rights for indigenous peoples around the world are providing a healthy example of how movements can be built and sustained in ongoing communities.

We hope for a future where arguments around difference and inequality do not exist and are not necessary. The end goal of any movement of resistance to exploitation must be an end to oppression. The paths of strategy and consciousness are not mere abstractions: they depend on the building of identity around issues that can build communities. In a world where the threat of extinction through war and violence is a very real danger, the need for the identification with social movements that might work towards a society where all are valued, both individually and collectively, is only a beginning, but a necessary one. Queer theory was one avenue that began as an alternative to normative expectations by a dominant culture. The lessons that can be learned from alternative ways of thinking and seeing provide a context for movements that can make a difference.

Notes

1 Much of the material for this chapter was first written for two sources. The first was the monograph *Queer Theory and Social Change* (Kirsch 2000). The second was the lead article in two special issues of the *Journal of Homosexuality* (Kirsch 2007).

References

Abolove, H., Barale, M. A. and Halperin, D. M. (1993) *The Lesbian and Gay Studies Reader*, New York: Routledge.
Barthes, R. (1990) *The Fashion System*, Berkeley, CA: University of California Press.
Baudrillard, J. (1975) *The Mirror of Production*, St Louis, MI: Telos Press.
Betsky, A. (1997) *Queer Space: Architecture and Same-Sex Desire*, New York: William Morrow and Co.
Bloch, M. (1977) *The Way They Think: Anthropological Approaches to Cognition, Memory and Literacy*, Boulder, CO: Westview Press.
Bourdieu, P. (1982) *Distinction*, Cambridge, MA: Harvard University Press.
—— (1998) 'A reasoned utopia and economic fatalism', *New Left Review*, 228: 225–30.
Butler, J. (1990) *Gender Trouble*, New York: Routledge.
—— (1999) 'A "bad writer" bites back', *New York Times*, 20 March.
Castells, M. (1997) *The Power of Identity*, Malden, MA: Blackwell.
D'Emilio, J. (1997) 'Capitalism and gay identity', in R. N. Lancaster and M. di Leonardo (eds) *The Gender/Sexuality Reader: Culture, History, Political Economy*, New York: Routledge.
di Leonardo, M. and Lancaster, R. N. (1997) 'Introduction: embodied meanings, carnal practices', in R. N. Lancaster and M. di Leonardo (eds) *The Gender/Sexuality Reader: Culture, History, Political Economy*, New York: Routledge.
Eagleton, T. (1986) *Against the Grain: Essays 1975–1985*, London: Verso.
—— (1997) *The Illusions of Postmodernism*, Oxford: Blackwell.
Edgar, A. and Sedgwick, P. (eds) (1999) *Key Concepts in Cultural Theory*, London: Routledge.
Etienne, M. and Leacock, E. (1980) *Women and Colonization: Anthropological Perspectives*, New York: Praeger.
Foucault, M. (1990) *The History of Sexuality*, 3 vols, New York: Vintage.
Halperin, D. (1995) *Saint Foucault: Toward a Gay Hagiography*, New York: Oxford University Press.
Haraway, D. (1985) 'Situated knowledge', *Feminist Studies*, 14(3): 575–99.
Hogan, S. and Hudson, L. (1998) *Completely Queer: Gay and Lesbian Encyclopedia*, New York: Henry Holt.
Jacoby, R. (1999) *The End of Utopia: Politics and Culture in and Age of Apathy*, New York: Basic Books.
Jagose, A. (1998) *Queer Theory: An Introduction*, New York: New York University Press.

Jameson, F. (1991) *Postmodernism and the Cultural Logic of Late Capitalism*, London: Verso.

Kirsch, M. (2000) *Queer Theory and Social Change*, London: Routledge.

—— (ed.) (2006) *Inclusion and Exclusion in the Global Arena*, New York: Routledge.

—— (2007) 'Queer theory, late capitalism and internalized homophobia', *Journal of Homosexuality*, 52(1/2): 19–45; reprinted in K. Lovaas, J. Elia and G. Yep (eds) (2007) *The Contested Terrain of LGBT Studies and Queer Theory*, New York: Haworth Press.

Laclau, E. and Mouffe, C. (1985) *Hegemony and Socialist Strategy: Towards a Radical Democratic Politics*, London: Verso.

Lancaster, R. and di Leonardo, M. (1997) *The Gender/Sexuality Reader: Culture, History, Political Economy*, New York: Routledge.

Leacock, E. (1972) 'Introduction' to F. Engels, *Origin of the Family, Private Property and the State*, New York: International.

—— (1981) *Myths of Male Dominance*, New York: Monthly Review.

Lee, M. (1992) *Consumer Culture Reborn: The Cultural Politics of Consumption*, New York: Routledge.

Lilla, M. (1998) 'The politics of Jacques Derrida', *New York Review of Books*, 25 June, 36–41.

Lovaas, K., Elia, J. and Yep, G. (eds) (2007) *The Contested Terrain of LGBT Studies and Queer Theory*, New York: Haworth Press.

Mandel, E. (1972) *Late Capitalism*, London: Verso.

Marx, K. (1939) *Selected Works*, vol. 1, New York: International Publishers.

—— (1978) 'Grundrisse', in *The Marx-Engels Reader*, ed. R. C. Tucker, New York: W. W. Norton and Co.

Mészáros, I. (1971) 'Contingent and necessary class consciousness', in I. Mészaros (ed.) *Aspects of History and Class Consciousness*, London: Routledge.

Nash, J. (1978) 'The Aztecs and the ideology of male dominance', *Signs*, 4(2): 349–62.

—— (1981) 'Ethnographic aspects of the capitalist world system', *Annual Review of Anthropology*, 10: 393–423.

—— (2001) *Mayan Visions: The Search for Autonomy in an Age of Globalization*, New York: Routledge.

Nash, J. and Fernandez-Kelly, P. (1983) *Women, Men and the International Division of Labor*, Albany, NY: State University of New York Press.

Nash, J. and Safa, H. (1980) *Sex and Class in Latin America*, South Hadley, MA: Bergin and Harvey.

O'Laughlin, B. (1975) 'Marxist approaches to anthropology', *Annual Review of Anthropology*, Stanford, CA: Stanford University Press.

Reiter, R. (1975) *Toward an Anthropology of Women*, New York: Monthly Review Press.

Ross, E. and Rapp, R. (1977) 'Sex and society: a research note from social history and anthropology', in R. N. Lancaster and M. di Leonardo (eds) *The Gender/Sexuality Reader: Culture, History, Political Economy*, London: Routledge.

Rostow, E. E. (1961). *The Stages of Economic Growth: A Non-Communist Manifesto*, Austin: University of Texas Press.

Safa, H. (1981) 'Runaway shops and female employment: the search for cheap labor', *Signs*, 7(2): 418–33.

Scott, J. (1993) 'The evidence of experience', in H. Abolove, M. A. Barale and D. Halperin (eds) *The Lesbian and Gay Studies Reader*, London: Routledge.

Sedgwick, E. K. (1985) *Between Men: English Literature and Male Homosexual Desire*, New York: Columbia University Press.

—— (1990) *Epistemology of the Closet*, Berkeley, CA: University of California Press.

Sklair, L. (1991) *Sociology of the Global System*, Baltimore, MD: Johns Hopkins University Press.

Sommerville, S. (1997) 'Scientific racism and the invention of the homosexual body', in R. N. Lancaster and M. di Leonardo (eds) *The Gender/Sexuality Reader: Culture, History, Political Economy*, New York: Routledge.

Stabile, C. A. (1994) 'Feminism without guarantees: the misalliances of postmodern social theory', *Rethinking Marxism*, 7(1): 48–61.

Weeks, J. (1985) *Sexuality and Its Discontents*, London: Routledge.

Wolf, E. (1972) *Anthropology*, Upper Saddle River, NJ: Prentice Hall.

Wood, E. (1986) *The Retreat from Class: A New 'True' Socialism*, London: Verso.

16

Social and cultural theory and literature

Jennifer Rutherford and David Crouch

What is literature? For some scholars literature is a generic term for aural, written and sung expression in all its forms across history – from Greek tragedies and medieval chansons to Shakespearean sonnets to contemporary music. Intrinsic to every human culture, literature is seen as a particular way of using language to create another world, an imagined elsewhere made real through storytelling or narration. These linguistic creations are intrinsic to all human cultures because human culture is created through language and language is never merely a way of naming the things in the world; language itself creates non-referential spaces of symbolic play. But for other scholars, literature is a recent phenomenon born in the eighteenth century with the invention of the modern printing press and the emergence of modern reading publics. And, as an art form born in the industrial age, literature is passé, superseded along with the book by the new creative spaces and forms that have emerged in the digital age.

Literary historians, literary critics, philosophers, aestheticians, sociologists and cultural critics have generated profoundly different stories about literature, and these stories often bear little relation to the way writers themselves have understood the craft and the art of literary production. They also often bear little relation to the intimate worlds created between literary works and their readers. Sociology, a relative latecomer to the field of literary enquiry, is no exception. As Roland Barthes suggested at the first international colloquium dedicated to the sociology of literature, in Brussels in 1964, literature presents itself to us (the sociological community) first as an institution and second as a work (1967: 31). Sociologists have tended to answer the question 'What is literature?' with an empirical description of the organizational structures that govern the production and circulation of literature in the modern world. They have mapped the networks and institutional practices that mediate literary production, the social location of writers as literary producers, the production, distribution and consumption of books as social products and the reading habits of social groups – but they have had little to say about the work itself. This opposition, between the institutional organization of literature and the *work* itself, remains a sore point in sociology's dialogue with literature.

Traditionally, sociological thinking about literature reflects little awareness that sociologists might have something to learn from literature. Sociologists have tended to approach literature as a sociological object, firm in the assumption that sociologists have the necessary tools and methodologies to explain literature and its social determinants. The traditional sociology of literature has contributed to a systematic knowledge of many elements of the literary industry but has, effectively, had very little to say about literary works or their specific

forms of social agency. Despite this, the sociology of literature has exerted a profound influence on the development of contemporary literary and cultural studies. In this chapter, we will sketch some of the key thinkers and concepts in the sociology of literature and consider their attempts to define literature as a field subject to scientific sociological investigation. Our discussion will not be exhaustive; the limitations of a chapter of this size make for a very selective reading of a long history of debate traversing disciplines and cultures. Our discussion will focus mainly on the European tradition, but it will extend beyond the disciplinary boundaries of sociology. As has often been remarked (Griswold 1993: 455), the sociology of literature has never really been constituted as a field of knowledge as such, and systematic thinking about the relationship between literature and society extends well beyond the domain of academic sociology. Marxist socio-literary scholarship, for example, was not confined to an academic discourse but became an intrinsic part of Soviet governance. The innovative thinkers that revolutionized socio-poetics in the 1960s and 70s – often explicitly in reaction to Marxist determinism – were also rarely academic sociologists. And more importantly, social and literary theorists have not been the only contributors to poetic thought. Literary acts have often presaged or intervened in socio-poetic discourse. In this chapter we will reference some key moments when individual writers have responded in literary form to the ongoing debates in social poetics, and in response to the social dramas of their day. In the concluding section of the chapter we will turn to recent attempts to create a field of socio-poetics based on a more equal dialogue between literature and sociology. But before proceeding with this discussion, we will turn to an iconic text of modernity in order to suggest why literature is important to sociology, not as an object of analysis, but as a fellow traveller in modern thought.

The space of literature

In the famous opening lines of Kafka's 'The metamorphosis' (1996 [1912]) we are transported into a nightmarish realm: 'When Gregor Samsa awoke one morning from troubled dreams he found himself changed into a monstrous cockroach in his bed' (1996: 11). Gregor has woken to find himself transformed into a giant insect, and, like Gregor, the reader flounders in the bewilderment of this inexplicable transformation. Questions proliferate: Has Gregor become a cockroach or is he dreaming? Why has he become a cockroach? Is this transformation a judgement? Has he done something wrong and brought this upon himself? Is he culpable? What did he do? Will he wake up? If he does not, how will he react to being a cockroach? Is he a human cockroach, and if so how human is he? What were his troubled dreams? Did these dreams have anything to do with his transformation? Should we believe any of this? Are we entering into the experience of a lunatic overtaken by an identification with an insect, or is the author himself mad? Or is he laying a trap for the gullible reader? And why, we might ask, are we bothering to read this? What is the point of reading Franz Kafka, an author whose works, after all, are the origin of a particularly gloomy adjective – 'Kafkaesque', a word that describes a coterie of dark moods and sensations of uneasy bafflement, of thwarted aspiration, of endlessly repeated failure, of instability and treachery, of meaning that hovers but is never announced, and of a pervasive and mounting sense of menace.

To read Kafka is to enter into this experience of the 'Kafkaesque' – a suspended state of bewilderment where questions proliferate without answers. And yet, Kafka's literature captures the concreteness of modernity in such a way that his literary works prefigure many of the most significant currents in social and political thinking of the twentieth and early

twenty-first centuries. His writing has provided some of the most compelling insights into power and the forms it has taken in the twentieth century: its perverted bureaucracies, totalitarian regimes, concentration camps and gulags. It was Kafka's 'The metamorphosis' that forged a connection between the production of waste and the logic of modernity, between Oedipal relations and socioeconomic forms, between desire and antipathy. His writing anticipated and explored, with extraordinary prescience, the future fate of Europe's Jewish communities in the cataclysm of the twentieth century and prefigured much later theorizations of strangeness and foreignness as the condition of the self in late modernity. But these concepts and events cannot explain Kafka's literature any more than Kafka's literature sets out to explain power, authority, alienation or the divided subject. How then can we understand the mode of thinking in play in works of literature and how can poetic thought deepen our understanding of society and culture?

Czechoslovakian writer Milan Kundera (1995) argues that what distinguishes novelistic thought from social or political thought has to do with the way novelists bypass exact accounts of events in order to open up new dimensions in human existence. For Kundera, when Tolstoy enters into lengthy essayistic and philosophical reflections in *War and Peace*, for example, he is not interested in gaining a truthful account of the historical causes and events leading to the Napoleonic wars; the essayistic sections found in *War and Peace* could never be found in a scholarly journal. What distinguishes these reflections from scholarly knowledge is that they open up a metaphysical space in which humans act in a fog of unknowing, subject to history, reacting to it, attempting to dominate it or escape it, but essentially blind to its future path (1995: 199–238).

This deliberate turn into the fog is one of the ways we can distinguish the space of literature from the space of knowledge. Unlike social and political thought, poetic writing is under no compulsion to render the world clear or transparent. Great literary works are not assessed by the clarity of the account they give of the world but by the way they open up new dimensions in human experience (Kundera 1995: 199–238). This is one of the reasons, according to French sociologist Bruno Latour (2005), that sociologists have a lot to learn from novelists. Novelists do not have ready-made templates to standardize social behaviour or to render disparate actions commensurable. Literary objects are objects of uncertainty, their dimensions unknown and unscripted prior to their literary creation. This fluidity and freedom enables literary writers to generate complex figurations of a social world that is never known or mapped in advance – hence the greater capacity of literary works to apprehend social change as it is unfolding. As Latour writes, a greater familiarity with literature might assist sociologists to 'become less wooden, less rigid, less stiff in their definition of what sorts of agencies populate the world' (2005: 303). Let us keep this idea in mind as we consider the way sociologists have attempted to develop systematic accounts of the relationship between literature and society.

Historical and intellectual developments

The sociological positivists

Hippolyte Taine

Credited with being the first sociologist to attempt a systematic sociology of literature, Hippolyte Taine might be better remembered as a master of rhetoric and racial thinking. Taine was a colourful storyteller, but his career was dedicated to replacing the ancient rhetoric of literary history with the new rhetoric of facts. Emile Zola declared Taine's literary

criticism 'the contemporary of the telegraph and the railroad' (Lombardo 1990: 117), capturing his zeal to translate the mechanistic systems of the industrial age into a new scientific methodology. Influenced by Auguste Comte's argument that sociology completed the evolution of the natural sciences, he believed scientific logic and methods would uncover the universal rules determining literature's evolution. In his *History of English Literature*, Taine declares that literature is not 'a mere play of imagination or the solitary caprice of a heated brain but a transcript of contemporary manners' (1871: 1). Behind every literary document lurks 'the man', not an individual author as such, but a psychological type – 'you study the document only in order to know the man' (ibid.). Unlocking the fundamental laws of history and society has to do with identifying the fundamental psychological types that lurk behind the literary work. Behind the modern sonnet, for example, Taine finds 'a Heine', the poet typecast as a typical modern artist: well-travelled, at home in society, of a nervous disposition but assured of his own singularity, and tending to regard himself as something of a deity. Behind the tragedies of the seventeenth century he finds 'a Racine': a royalist and courtier, bewigged and beribboned, a Christian, a master of rhetoric, assiduous, reserved and at home in his correct place in the world. Literature provides the key to discovering these types, and the function of history is not to build up an abstract knowledge of the past, but to 'see the men of other days'. In this early attempt to systematize the relationship between literature and society, literature, then, is imagined as both transparent and mirroring: a repository of cultural manners and a mirror of the *zeitgeist*. It has no special viscosity that would perturb the knowing gaze of a systematizing knowledge. Rather, Taine's imperial gaze discerns through the transparent medium of literature the principle features of human transformations, and 'the general laws which regulate, not events only, but classes of events, not such and such religion or literature but a group of literatures and religions' (1871: 17). These general laws can be encapsulated in three terms: '*race, moment et milieu*'. Every culture has a system of human sentiments and ideas, he argues, but these systems are driven by the motor of race, which in his imagining provides the fundamental spiritual properties of any given society. However diverse the social form, race is 'a simple compendium' of 'elementary faculties' which ultimately determines the evolutions of both cultural types and cultural forms. To these elementary racial forms Taine adds circumstance and epoch. Circumstances (*moment*) are the specific material forces that bear upon a race's evolution such as climate or new environmental factors introduced through migration. Epoch (*milieu*) registers the influence of early cultural forms on the evolution of later forms, but for Taine generic influence is always subsidiary to primordial racial elements. These three concepts of '*race, moment et milieu*' provide Taine with a material explanation for every cultural manifestation. Buttressed by biological analogy, he envisages a future literary history where a clever rationalist can reconstruct an entire civilization from a documentary trace, just as a Cuvier reconstructs a plant's anatomy from a fossilized fragment.

Robert Escarpit: literary facts

A century later, French sociologist Robert Escarpit renewed Taine's attempt to develop a systematic sociology of literature. Critical of Taine's crude translation of scientific and natural processes, Escarpit returned to what he saw as Taine's enduring legacy: his recognition of the social forces shaping literature. In his influential *Sociology of Literature* (1971 [1958]) he sets out to replace literary history's focus on author and work with a sociological analysis of literature as a social institution. Understanding 'the literary fact', he argues, requires building a statistical database of the production, distribution and consumption of literature. Escarpit defines

literature as any work that is not functional but is an end in itself, and any act of reading that is not a means to an end but which satisfies a cultural, non-utilitarian need. The 'literary fact', moreover, is not the work itself, but the system of production, distribution and consumption of books within an economic system, and writing is not the aesthetic practice of creative individuals but a professional practice occurring within an economic system – literature is the 'production segment' of a book, reading its 'consumption segment'. The key methodological question for the sociology of literature, then, becomes how to develop an aggregate knowledge of this non-functional, non-utilitarian fact, given the unavailability of most data related to the book industry. Escarpit proposed a research mission to build a statistical knowledge of all aspects of the book industry: the class and status composition of its writers; the aggregate place of literature within the book market; the machinery and economic determinants of the decisions and strategies exercised by printers, publishers and booksellers; the demographics of reading publics and their consumption patterns. He placed great emphasis on the middlemen in the book industry and their power to determine the distribution of books within the two very different milieu of literary and popular writing. He was no simple advocate of popular culture. If fact, if anything he was provoked by the question of how to expand the ever-shrinking sphere of literary production given what he identified as a market-driven pressure to delimit literary production and to confine its circulation to closed spheres removed from daily life. In contrast to the closed circuits of literature, he argued, popular literature is integrated into daily life but is subject to an economy of increasing standardization. Only books that guarantee mass sales will enter into circulation and only through networks of distribution that allow no possible reply from the public to the publisher. In the popular circuit, the 'public' are constituted as passive and their needs catered for by endlessly reproducing a certain type of book, the natural movement being always towards degradation. Hence the fantasy underpinning his research mission, that a statistical knowledge of the 'literary fact' will provide the necessary database to engineer new solutions to the impasses of both popular and literary circuits.

One of the most striking aspects of Escarpit's methodology is its evacuation of specifically literary criteria from analysis. Drivers of the 'literary fact' are always economic, never aesthetic or subjective. Questions of style, rhetoric, form or generic evolution are the result of the aggregated behaviour of subjects (producers, distributers and consumers) who, in turn, reflect the aggregated ideology of their time. Language and its poetic facility are excluded from analysis, as are the specific struggles of individual writers to find a form of literary expression to articulate the ever-changing flux and chaos of their lives. In Escarpit's system, language itself never acts, writers never create anything, and readers are consumers who are never transformed by the experience of what they have read. Despite this, his quantification of 'the literary fact' influenced a generation of literary scholars who found positivist sociology a strong antidote to the self-valorizing world of traditional literary scholarship. Studies of the book trade, of the demographics of writing and reading communities, of the institutional aspects of literary production, and of the market as the driver of literary production are now central to research in contemporary cultural studies, as is the theoretical principle that cultural products are never merely the products of isolated acts of creative genius but arise out of, and in response to, collective conditions. But, as we will see later in this chapter, more recently some scholars have begun to question the value of the 'thin descriptions' of the literary field produced by positivist methodologies.

Marxist literary criticism

A recurrent assumption in sociological theories of literature has been that literature provides a reflective map of society. Taine, as we have seen, thought literature reflected the manners of

the age. Before him, French philosopher Louis de Bonald argued that through reading the nation's literature 'one could tell what this people had been' (Laurenson and Swingewood 1971: 13). But the conception of literature as the mirror of society achieved political force when Marx and Engels's theory of ideology became the ideology of the Soviet regime. As George Steiner writes of Zhadanovism and Stalinist aesthetics: 'To it we owe the most conse-quent and tragically successful campaign ever waged by a political regime to enlist or destroy the shaping powers of the literary imagination' (1967: 338). Literary Marxism involves, on the one hand, a complex theoretical tradition claiming a scientific basis for its identification of the historical laws underlying the production of literature and art and, on the other, the political machinery of totalitarianism, policing and coercing literary producers to mirror an imaginary history trenchantly refusing to comply with the mythical precepts of dialectical materialism. This contradictory logic played out in Marxist literary criticism from the didac-ticism of Lenin's 'Down with unpartisan *litterateurs*!', to Georg Lukács's adamant insistence that only nineteenth-century realist literature genuinely reflects reality, to Pierre Machery's endeavours to rescue Marxist ideology by reconceptualizing the literary work as reflecting the fragmented ideological structures of real class relations.

Marx understood society as always developing within the framework of a contradiction: in antiquity between free men and slaves, in the Middle Ages between nobility and serfs, in capitalism between the bourgeoisie and the proletariat. The division of labour renders the great mass of people property-less producers labouring for a wealthy and cultured class, creating structural contradictions within society, which people cannot control, but which are, nevertheless, the motors of history. These forces and relations of production (the economic infrastructure) condition the emergence of society's ideational superstructure: its laws and systems of governance and its political, spiritual, ethical and aesthetic forms of consciousness. Because these contradictions emerge and reach consciousness prior to man's capacity to solve them in practice, they are given distorted (i.e. ideological) solutions in the mind that function to conceal them for the interests of the dominant class. Ideology is understood as a distorted projection in consciousness of the structural contradictions in the social organization of the relations of production. And art, as Marxist literary critic Terry Eagleton writes,

> is part of society's ideology – an element in that complex structure of social perception which ensures that the situation in which one social class has power over the others is either seen by most members of the society as 'natural', or not seen at all. To understand literature, then, means understanding the total social process of which it is a part.
>
> *(1976: 6)*

The consequences were far reaching. On the one hand, writers and their works were subject to a new scrutiny as the puppets of bourgeois ideology in the capitalist world; on the other, their role was prescribed as the soothsayers of socialist futures. In 'Party organisation and party literature' Lenin declared: 'literature must become party literature . . . Down with the supermen of literature!' (Steiner 1967: 306). This was a call for *Tendenzpoesie*, which became a canon for Marxist interpretations of literature. For cultural theorists such as Mehring and Plekhanov, writers who did not commit themselves to the socialist cause were, by omission, working in the service of the bourgeoisie. Zhadanov and the first Soviet Writers' Congress of 1934 invoked Lenin as its talisman, evoking interminable discussions over orthodoxy, self-denunciations by authors, and demands for all literature to be, as Steiner writes, 'forged into weapons for the proletariat, the ideal being the reduction of literature into a "small cog and a small screw" in the mechanism of the totalitarian state' (1967: 336–38). Arcane and complex

theoretical debates over the degree of autonomy that might be accorded to cultural produc-
tion preoccupied theoretical Marxism for much of the twentieth century. If the economic
base determined the superstructure, how could literature escape the ideological stranglehold
of its material conditions?

Even a thinker as recondite as Walter Benjamin lent his voice, at times, to the rhetoric of
tendential literature, lauding the Soviet state's refusal to allow writers 'to parade the richness
of the creative personality, which has long been a myth and a fake' (1973: 97). But Benjamin's
highly original, aphoristic and profoundly poetic work always outstripped any authorial
intentionality *qua* socialist aesthetics. And like Bertolt Brecht, Benjamin recognized the limi-
tations of a prescriptive theory of art and attempted to reformulate Marxist aesthetics by
linking art to its productive content. In his most famous essay, 'The work of art in the age of
mechanical reproduction' (1955), Benjamin argues that the emergence of modern capitalist
forms of mass production radically transforms the work of art from a singular, sacred object
defined by its aura (the distance it established between object and viewer) to a non-auratic
commodity freely circulating in the world, creating entirely new modes of consciousness,
perception and audience involvement. Rather than imposing a moral vision on the artist,
Benjamin argued, Marxists should seek to use these new material potentialities to radical
effect. Bertolt Brecht's experiments in epic theatre were a case in point. Brechtian theatre
aimed at divorcing the audience from emotional involvement in the play. Using loosely struc-
tured performances, dramatic techniques such as 'Gestus' (a posture or position taken up by
the actor stopping dramatic action), the visibility of all elements of the stage production, and
montage effects created by musical interludes and disjointed contexts, Brecht stripped away
the naturalism of traditional theatre, ideally creating the dramatic space for a critical reflec-
tion on the different potentialities of action. While often brilliantly witty and intellectually
startling, Brecht's 'dialectic' theatre could never outpace the subjective effects of Marxist
'reason'. In the prologue of *The Caucasian Chalk Circle* (1999 [1944]), for example, rational
discussion leads a group of peasants to give up their land willingly for the common good as
the audience is invited to weigh up the consequences of individual or collective actions.
Forced collectivization is the silent partner of the play.

George Lukács

Hungarian Marxist and social aesthetician George Lukács is often singled out for his resist-
ance to crude Marxist determinism. Steiner describes him 'as a lone and splendid tower in
midst the grey landscape of eastern European and Communist intellectual life' (1967: 341),
and places him in a long line of 'para-Marxists' stretching from Edmund Wilson to Theodore
Adorno who, he argues, share a core set of beliefs concerning the conditioning of literature
by social and historical forces, the centrality of the writer's critical engagement and judge-
ment in relation to a literary work's ideological intention, a suspicion towards aesthetical
articulations of the irrational elements in poetic creation and the demands of pure form, and
a bias towards dialectical proceedings in argument. He distinguishes them from 'vulgar'
Marxists by their respect for the integrity of the artwork and by the practice of criticism
rather than censorship. But Lukács's distinction rests in large part on his refusal to consign the
novels of nineteenth-century realism to the ideological dustbin. Not so the literature of
twentieth-century modernism. The premise underlying works such as *The Historical Novel*
(1937) and *Studies in European Realism* (1948) is that the great literary works of realism create
a totalizing view of human reality in contrast to the shattered forms of the modernist litera-
ture of the twentieth century. Influenced by Simmel's argument that forms give social reality

its structure, he argues that the social element in literature is its form. And the function of form is to create a totalizing whole from all the distinctive facets of life. Defining a work's *Weltanschauung* 'as the formative principle underlying the style of a given piece of writing' (Lukács 1995: 188), Lukács argues that 'Style ceases to be a formalistic category. Rather it is rooted in content; it is the specific form of a specific content: Content determines form' (1995: 189). Unlike modernists who experimented with fragmented form, Lukács privileges literary forms that reflect society as a harmonious whole. The realist literature of the past (of the ancient Greeks, the Renaissance and early nineteenth-century France), he argues, upholds the Aristotelian dictum: 'Man is *zoion politikon*, a social animal'. Hence, the literary characters of realism are seamlessly part of their social and historical environment and embody the complex relations that typify a typical individual's relations to their historical time. Because realist literature aims to represent reality truthfully, and this implies distinguishing between human actions that are abstract and human actions that are concrete, realist fiction explores the consequences of concrete actions for individuals, enabling the artist to distinguish between concrete historical possibilities and abstract impossibilities. For Lukács, it is this capacity to dramatize the rich fabric of life while exposing the inner structures and historical forces shaping individual actions that gives realist literature its non-ideological potential. Realist heroes represent the typical individual acting within the structural tensions and real relations of their society; thus realist literature has the potential to make visible the underlying contradictions unfolding in history.

In contrast, the fragmented forms and disintegrating subjects of modernist literature, in Lukács's view, embody bourgeois ideology. Modernism's *Weltanschauung*, he argues, rests on a view of the human subject as a solitary isolate stranded in a fragmented world. The great crime of the modernists – his sweep takes in Joyce, Faulkner, Kafka, Beckett and Musil – is the failure to present a unified view of human subjectivity or to mirror this unified subjectivity in a coherent and harmonious world. Guilty of ahistoricism, the modernist hero is strictly confined within the limits of his own experience; there is no pre-existent reality acting upon 'him' or being acted upon by 'him'. Instead, abandoning the responsibility to truthfully represent reality, the modernist work creates an entirely subjective world that replaces reality with an attenuated, perverse and static existence. Rather than striving to establish a new order, he finds, modernist works are guilty of diverting into psychopathology, producing such absurdities as the stream of consciousness of lunatics (Faulkner) or the abnormal (Beckett) (1995: 194). But the real crime of modernist works is not ahistoricism – after all, the acceleration of time in modernity inspired Virginia Woolf's famous 'corridor' structure in *To the Lighthouse* – but rather the failure of historical representation in such works to mirror the dialectical laws of history. The traumatic experiences of *his* time, however, delivered themselves to the literary imagination not in the form of harmonious wholes but rather in the asocial, perverse and fragmented worlds of the gulag and the camp. Poignantly, Lukács denounced revelations of Soviet concentration camps as an effort by 'the legatees of Goebbels and Rosenberg to denounce the USSR' (Pike 1985: 183), and it was only in his final years that in a small book, *Solzhenitsyn*, he finally registered that 'the concentration camp is a symbol of everyday Stalinist life', praising Solzhenitsyn for his humanity and his resurrection of the narrative style of the realist novel but criticising him for lacking the theoretical coherence of the socialist outlook (Howe 1971: 644). Convinced of the veracity of the scientific laws underpinning his critical judgement, Steiner's 'lone and splendid tower' ended more like a traffic warden at a broken stoplight, trying to direct the literary traffic of the twentieth century back to the nineteenth century. But literary history was not 'reasonable' and, like history proper, it was moving in another direction. As Milan Kundera writes:

The history of humanity and the history of the novel, are two very different things. The former is not man's to determine, it takes over like an alien force he cannot control, whereas the history of the novel (or of painting, of music) is born of man's freedom, of his wholly personal creations, of his own choices. The meaning of an art's history is opposed to the meaning of history itself. Because of its personal nature, the history of art is revenge by man against the impersonality of the history of humanity.

(1995: 15–16)

Jean-Paul Sartre: beyond commitment

In a famous pamphlet written in the aftermath of the Second World War, *What Is Literature?* (1978 [1948]), Jean-Paul Sartre lent his philosophical weight to a renewal of the idea of 'committed' literature. Writing, Sartre argues, is not about contemplation, aesthetics or imagination: it is about action. Sartre defines writing as an action and asserts that 'the prose writer is a man who has chosen a certain method of secondary action; which we may call action by disclosure' (1978: 14).

To speak, and by extension to write, is to change the nature of things because once we have acted on things through language they are no longer the same . . . to speak is to act; anything which one names is already no longer quite the same.

(1978: 12)

To reveal something in language is to act to change it. Blurring the distinction between speech and writing but claiming a singular function for prose writing, as distinct from poetry, he argues that prose writing is the utilitarian act of a rational agent whose text is a literary message fired at the reader. Sartre conceives of the word as a particular moment of action with no meaning outside this action. In prose, words designate objects transparently, without the medium of language interfering. Always addressing the prose writer, he asks:

'What is your aim in writing?' The committed writer identifies their aim, chooses their act, and then enacts it as a man identifies his object and fires his gun: he knows . . . that words are 'loaded pistols'. If he speaks he fires.

(1978: 14)

Marguerite Duras

But the question for many writers and artists in the aftermath of the holocaust was how to contend with the inadequacy of representation. What narrative, image or trope could represent or mediate a horror beyond the capacity of the human mind to comprehend? In lieu of using words like a fired gun, France's most innovative writer, Marguerite Duras, began experimenting with a new idea of writing in works such as the screenplay *Hiroshima Mon Amour* (1961). Beyond the words or images actually used, her enigmatic and cryptic works aim at an indescribable reality beyond representation. She described this notion of writing as 'the approach of the inner shadow where the archives of the self are to be found' (Adler 1998: 193). Dissolving the idea of the singular work she riffs with form, repeating works in multiple genres, endlessly rewriting the same work so that each new work gestures towards a reality that is ultimately unsignifiable. Fusing individual and collective madness, and endlessly interrogating the relationship between signification and desire, her poetic thought prefigures

much of the socio-poetic and psychoanalytic thought of the latter half of the twentieth century.

Major claims and developments

Texts, readers, discourses

By the 1950s and 1960s new approaches to socio-poetics were emerging, radically distanced from both the didacticism of literary Marxism and the scientism of sociological positivism. Structuralism was radically changing the way European intellectuals were thinking about literary works and the relation between literary works and other cultural forms and artefacts. Russian formalist Vladimir Propp's *Morphology of the Folktale* (1968 [1928]), translated in the 1950s, revolutionized the interpretation of literary forms. Advocating an anti-contextual approach to the study of literature, Russian formalists focused on the intrinsic structures of the literary text, or artwork, in order to discover the poetic laws of creation. Propp analysed Russian folktales by focusing on the actions of the *dramatis personae*: on what is being done rather than by whom and how. Focusing exclusively on the structure of fairy tales he identified 31 functions (or actions) that repeatedly occur in Russian fairy tales, arguing that a structural uniformity occurs across all tales despite differences in content. Influenced by both Saussurian linguistics and the rediscovery of Russian formalism, scholars such as Greimas, Barthes, Lévi-Strauss and Umberto Eco began to analyse cultural artefacts as sets of linguistic functions, composed of oppositions and permutations. For the structuralists, all cultural artefacts involving systems of signs could be analysed in the same way. Myths, comic books, advertisements, detective novels and movies were all *texts*, and as such were structured by the combinations and permutations of their signifying systems. Literature lost its special status and became a text like any other. But structuralism's exclusively synchronic focus and scientistic search for univocal meanings and laws soon gave way to a more fluid analysis of the polyphonic nature of texts and the critical role of readers and reading communities in determining the interpretation of a work, and its life in history. While the relationship between structuralism and what some American scholars labelled post-structuralism was never clear-cut, the critical vocabulary had radically changed. The author, as Foucault and Barthes proclaimed, was dead; critical focus shifted to texts and readers.

Roland Barthes: the death of the author

In his famous essay of 1967, 'The death of the author' (1977 [1967]), Roland Barthes argues that as soon as we begin to narrate a fact, the world of the text becomes its own system of meaning, and the identity of the author subsides, eclipsed by the symbolic logic of the text. The author has no identity; we do not and cannot know the identity of the subject behind the narrator. For Barthes, the moment when the author's identity falls away is the moment when writing begins. In traditional storytelling, he argues, the storyteller may be admired for his craft but has no responsibility for the narrative code. Stories circulate from teller to teller and, while one teller may be better at the craft than others, the idea of genius has no currency. This idea of the individual writer as genius only arises with the rise of capitalism.

> The author is a modern figure, a product of our society insofar as, emerging from the Middle Ages with English empiricism, French rationalism and the personal faith of the Reformation, it discovered the prestige of the individual, of, as it is more nobly

put, the 'human person.' It is thus logical that in literature it should be this positivism, the epitome and culmination of capitalist ideology, which has attached the greatest importance to the 'person' of the author.

(1977: 143)

Reading the literary work in terms of the author's life is a product of the privileging of the individual in bourgeois society. Despite attempts by writers such as Mallarmé and Proust to give authority to language itself ('it is language which speaks, not the author' (1977: 143)), the cult of the author, he argues, continues to dominate criticism. Proposing a new way of thinking about the writer, which he re-names the *scriptor*, Barthes stresses the relation between texts, arguing that no work of literature is original and that what writers in fact do is borrow, assemble and mix writing from multiple sources. The book itself is 'a tissue of signs', without a single meaning or a single support. We cannot read the text in order to find the truth of the author, their complex psychology or the truth of the society. There is nothing beneath the text, and we cannot deduce its meaning through criticism that discovers either the history or the author behind the text.

> we now know that a text is not a line of words releasing a single 'theological' meaning (the 'message' of the Author-God) but a multidimensional space in which a variety of writings, none of them original, blend and clash. The text is a tissue of quotations drawn from the innumerable centers of culture . . . The writer can only imitate a gesture that is always anterior, never original. His only power is to mix writings, to counter the ones with the others, in such a way as never to rest on any one of them.
>
> *(1977: 146)*

This new conception of an intertextual reality, in dialogue with multiple cultural sites – but neither reducible to nor the mirror of any singular source – has profoundly influenced the development of contemporary cultural and literary studies. New approaches to intertextuality and audience studies carry Barthes's seminal influence – often, however, without Barthes's trademark fluidity. Barthes was a baroque thinker, always changing his perspective to produce new and original ways of understanding authority, intertextuality, creativity and socio-historical relations between readers, writers and texts. While the 'death of the author' has become one of the canonical ideas of contemporary cultural studies, Barthes's author did not stay dead for long but returned surreptitiously as his field of enquiry extended into questions of desire, loss, emotional investment and even authorial intention. It is not possible to provide a full exegesis of Barthes's many innovative works here, or of his seminal reconceptualization of rhetoric as a system of signification involving the intertextual and transhistorical transmission of codes; instead we will limit the discussion to a single theoretical coup: Barthes's integration of the psychoanalytic theory of desire into socio-poetic theory.

The definitive challenge to Sartre's textual machismo came in 1973 with the publication of Barthes's slim volume *The Pleasure of the Text* (1990 [1973]) which rudely challenged the Marxist ideal of committed literature by recalling the primary role that pleasure plays in writing and reading. In *The Pleasure of the Text*, Barthes reconceptualizes the text as a site of desire, which interpellates both reader and writer into language as a zone of pleasure. Literature, he argues, is about desire, and a sociology of literature is in need of a science not of facts, but of bliss. Prose modelled on Sartre's ideals, Barthes argues, would completely fail to seduce its reader to enter into, or dwell within, the text. It would be a frigid affair, unable to constitute desire, a prattling text in which the message is paramount, the form irrelevant

and the reader lost. Linking desire with neurosis, Barthes argues that for the writer to seduce the reader, the writing must entail a form of neurosis. Drawing on Lacanian psychoanalytic theory, he uses neurosis in the sense of a form of desire that cannot find itself, be expiated or be satisfied. For Barthes, desire is neurotic. It is something that cannot be put into words but that tries continuously to speak itself. Endlessly unsatisfied, desire never finds its object and is always dissatisfied with any object it obtains. In opposition to a text defined by its message, Barthes advocates the flirtatious text, conceived as a text shot through with neurotic desire, and he puts forward a new maxim for the writer: 'Mad I cannot be, sane I do not deign to be, neurotic I am' (1990: 5–6). The text, he argues, must prove to the reader that 'it desires you'.

In lieu of conceptualizing the text as a mirror of society, or of explaining the social dimensions of a text by its context, Barthes focuses instead on the radical properties of language itself. Sartre, he argues, suppresses the fact that the choices made by writers always face in two directions: either towards society or towards literature or, in Barthes's conception, towards pleasure or bliss (*jouissance*). A pleasurable text offers its readers the pleasure of identification and of belonging to the fictional world it creates. Such books operate entirely within the laws and ideologies of the culture, and they do this by staying within a language of restraint in which language never explores its own domain. But language always possesses the potential to speak its own death in the moment when meaning dissolves into pure aurality and bliss overthrows the constraints of pleasure. Unlike the work of pleasure, the work of bliss operates within the realm of language. Such works are not restrained by ideology, they do not give their readers the pleasure of entertainment, or comfortable fantasies, they do not reproduce generic codes; instead the writer turns away from the social bond to the nature of literature itself – to the domain of language. Barthes conceives of this as a zone of freedom for both the writer and the reader, and, by extension, for society.

Umberto Eco: open texts

Barthes's understanding of texts as psychologically engaging fields of meaning was radically extended by Italian semiotician Umberto Eco, who made the reader the new focus of sociopoetic theorization. Identifying a search for suggestiveness in the evolution of artworks in the western tradition, Eco developed a historical analysis of the evolution of the reader as intrinsic to the work. In *Opera Aperta* (1962), published in English as *The Open Work* (1981), Eco conceptualizes the reader as a performative element of literary works, arguing that literature is distinguished by its specific form of readerly address. All works, Eco argues, are open to the extent that they are susceptible to countless interpretations. In this sense, every act of reading involves both an interpretation and a performance. Differentiating between this aspect of all texts and a specific kind of text emerging in modernity, Eco noted that many contemporary literary works and artworks seem to be unfinished. They seem to be handed in incomplete, leading to indecisiveness and uncertainty on the part of the reader. Why, he asks, do contemporary artists feel the need to work in this direction? What is it about the historical evolution of aesthetic sensibility which, in combination with the forces of modern culture, leads towards the open work? Eco's explanation is that there is a relationship between modernity, textual production, aesthetic sensibility and a new kind of work that consciously manipulates and explores reading positions. While all works may require a reader for their realization, only the modern work is created in a climate in which the reader is the focus of the creative act; and this contemporary awareness of the reader is the result of an aesthetic, theoretical and cultural history.

Traditionally, while aware of the potential interpretive openness of the literary work, writers tried to stabilize and limit textual meaning. In the Middle Ages for example,

allegorical reading confined interpretive possibilities to a set of pre-ordained and rigidly established meanings. Medieval readers had to follow the rules of allegory in order to read in strictly limited ways. Underpinning allegory was the symbology of a univocal ordered cosmos, and a hierarchy of essences and laws determined by the creative logos. The work of art was understood as a mirror of this theocratic society. But in the Baroque, the static and unquestionable definiteness of the classical Renaissance gave way to the first clear lines of a modern sensitivity. 'Man', Eco argues, opts out of the canon of authorized responses and moves into a fluid world that requires a correspondingly fluid creativity. Baroque works of art challenge the position of the viewer. The privileged frontal view gives way and the viewer must shift continuously to see the work in all its aspects, as if the viewer is in a state of perpetual transformation. The artwork, no longer an object that draws on links with a given experience, becomes a potential mystery to be solved. By the late nineteenth century, this search for suggestiveness opens up the work to interpretation; the works of the symbolists, for example, are pregnant with interpretive possibilities.

By the twentieth century, the idea of an ordered world based on universally acknowledged laws had given way to a world based on ambiguity. Directional centres are missing and values and dogmas are replaced by questions. With Joyce the work becomes completely open. Joyce's world is always changing, as it is perceived by different characters and at different times. *In Finnegans Wake* (1939) the reader enters into a work that is both finite and unlimited; the richness of its meaning is the richness of the cosmos. Two or even ten roots combine in the one word, so a single word sets up a knot of different sub-meanings, but the keys in the text sustain the reader in an encounter with an infinitely rich cosmos. Eco argues that the emergence of the open work is a response by modern artists to the emergence of a modern sensibility and a new sense of the individual open to the continuous renewal of life patterns and cognitive processes in works of incomplete structures and fluid forms. In the western tradition, a work had to maintain a coherent identity of its own and display a personal imprint to be a significant act of communication, but open works invite the reader to make the work with the author in a continuously fluid generation of meanings.

Mikhail Bakhtin: discourse

This openness of the work in modernity had also been recognized by Russian literary scholar Mikhail Bakhtin. Writing in the years immediately following the Russian Revolution, Bakhtin's works only began to circulate in the west in the 1970s. Bakhtin suffered years in exile, and dwelt largely in obscurity during the long years of 'the Stalinist night', but his works were radically in advance of his time, in their attentiveness to language conceived as richly historied discourse. His vast literary erudition was married with a non-systematizing understanding of language as a fragile historical entity. Literature, he argues in *The Dialogic Imagination* (1981), is irreducible to the governing imperatives of its social context, however entangled it may be in these social imperatives. Literary history involves temporal, linguistic, spatial and affective transpositions, and literary forms have a life in history beyond their immediate social or national contexts. The novel form, for Bakhtin, exemplifies this transhistorical aspect of literary production. The novel jumps epochs, cultures, languages and ideologies. Its history spans two thousand years and wherever it emerges, he argues, it opens up new relations between language, literature and social reality. In his understanding, the novel's uniqueness arises from the way it combines different forms of autonomous speech, different styles and a diversity of voices into the higher unity of the work. The languages that serve the specific socio-political purposes of the law of the day are an indispensable part of the

novel's language, but the novel creates its world out of the links and interrelationships that arise through the combination of different languages and voices. Bakhtin defines the distinguishing feature of the novel as its *heteroglossia*, that is, its deployment of different speech types and different individual voices within the space of the novel. The novel is 'multi-form' in style, variation and speech, consisting of many different forms of language and speech that combine to form a structured artistic system in which each of these modes of language is subordinated to the work as a whole. The uniqueness of the novel genre consists precisely in this combination of subordinated and yet relatively autonomous forms of language into a work. The novel makes its world out of these numerous social dialects, incorporating dialects for group behaviour, professional languages, jargon, languages of the generations, language of the authorities, languages that serve the specific socio-political purpose of the day and different kinds of narratorial speech.

Bakhtin argues that a historically given drive exists within literature and is at work, unpicking the artificial constraints of literature itself. Literary systems are composed of canons that attempt to sustain rule-bound generic monologues, but an opposing force – Bakhtin calls this novelization – defies monologic generic discourse (the formation of canons) and interrogates what any literary system will admit as literature (Holquist 1981: xxx). What we think of as the novel, he argues, is simply the most condensed and distilled expression of this historical drive. For Bakhtin, style is always a social phenomenon in which we can locate the autonomous destiny of artistic discourse itself. The novel, he argues, is a genre that breaks stylistically with all other genres and with the philosophical conception of poetry that underpins the idea of genre itself. Traditionally, the analysis of genre rested on an analysis of the style of various genres, focusing on single languages and single styles. Genre in the narrow and historical sense of the term is a single style involving a unified language system. Genre is conceived as a form, acting like a container to hold and shape expression. In antiquity, in the classical Greek period, and in the golden age of Roman literature, all the genres of 'high literature' were conceived as mutually reinforcing each other, and the whole of literature was conceived as an organic unity, formed from the totality of all the genres. Classical genres such as the ode, the lyric and tragedy can be written as synchronic chronicles because their formal properties are fixed and rigid. They are older than written language and retain their ancient oral and auditory characteristics. But the novel does not operate like this. According to Bakhtin, the novel ingests and engulfs all other genres and non-literary forms of language. In this sense it is not a genre in any traditional sense of the term. The novel is a genre that became enormously successful in the nineteenth century, and theorists of the novel genre have focused on this period of its historical dominance, narrating its history as rising in the eighteenth century and dying in the twentieth. Bakhtin instead expands the novel genre to include the long prose poems of antiquity, identifying across a long history a common style, and a common rapport to language, and to unfolding reality. Whenever the genre arises, he argues, both in antiquity and the present, it is a completely new literary form that opens up new relations between literature, language and social reality. The novel 'chatters' – from its first emergence outside the harmonious interdependence of the genres of antiquity. It parodies other genres, exposes the conventionality of their forms and language, squeezes some out of existence and incorporates others. In response to the novel other genres become more flexible and free, incorporate non-literary languages, become permeated with laughter, irony and self-parody and enter into a semantic openness, evolving a living relationship with reality and the open-ended present. It is this open-ended contact with the present that the novel appropriates and then spreads, leading Bakhtin to characterize it as the hero in the drama of literary development in our time. When the novel becomes the dominant genre all literature becomes

caught up in a process of becoming and all other genres are novelized. Genres that stubbornly resist and preserve their old canonic forms begin to appear stylized. The novel, then, is the genre that dialogues with the open-ended present; self-critical, parodic and discursive, it opens the hermetically sealed forms of the traditional genres into an open-ended dialogue with unfolding modernity.

Italo Calvino: the return of the author

At the high point of these debates over commitment and pleasure, author, text and reader, Italian novelist Italo Calvino published a parodic, chattering, open-ended novel, *If on a Winter's Night a Traveller* (1993 [1979]). A dazzling poetic parody of the socio-poetic theory of the day, the novel re-staged the author in a literary game that upstaged socio-poetic theory. Lucia Re (1998) attests that Calvino welcomed the clean sweep that structuralism made of traditional idealist assumptions about the value and superiority of literature. He did not believe that poetry was a matter of pure inspiration, nor did he concur with the Marxist understanding of literature as a privileged reflection on the social. But neither did he believe that literature was reducible to the linguistic functions identified by the structuralists. For Calvino, literature's value is unique in that there is a particular kind of intelligence, an understanding of the world, that literature alone can give us. Literature teaches us how to attribute the value of things; it is eminently moral and yet devoid of a specific message.

If on a Winter's Night a Traveller unfolds as a series of short stories that are continuously interrupted by another counter-narrative, constituting a work composed of two different literary forms: the traditional novel, in which the reader identifies with more or less realistic characters, and the postmodern self-conscious novel, in which the author lays bare the mechanics of literary production. Calvino shifts between these literary forms, never letting the reader forget that they are reading, but at the same time sustaining the reader's emotional connection through identification with the characters. He plays a risky game, in which, to use Barthes's terminology, bliss is always in danger of annihilating pleasure. But just when one is fed up with Calvino's discursive antics, the narrative returns and the reader is caught up again in the desire to know what happens next, and the desire, moreover, to make a unity from a story that refuses to take form, but keeps promising a story behind the story, which is a story about a reader and his object of desire – a character (Ludmilla) – and their search to re-find the lost object, a missing story. Calvino also plays a game of doubles with the author and the reader, the fictional reader and narrator within the text, and the external reader and writer outside the text. The narrator, who appears to be the author, addresses the reader as 'you' directly, drawing the reader into the text. But this reader becomes a literary character, and the real reader watches as the author plays with 'you' the reader, while the external reader is denied satisfaction in reading. As Calvino says of the novel:

> I constantly play cat and mouse with the reader, letting the reader briefly enjoy the illusion that he's free for a little while, that he's in control. And then I quickly take the rug out from under him; he realises with a shock that he's not in control, that it is always I, Calvino, who is in total control of the situation.
>
> *(Fink 1991: 103)*

The game Calvino plays with the structuralist and semiotic theories of the 1960s and 70s emphasizes Bakhtin's and Eco's understanding of the artwork as fluidly and energetically *dialoguing* with unfolding social reality, rather than mirroring it, according to systemic social

laws. Calvino's insistence on his own authorial role in the text is reiterated by Milan Kundera's insistence that the literary space is a space of freedom. Writing 'talks back'. Like Bakhtin, Kundera conceptualizes the artwork as transhistorical, its dialogism operating between creators and works and across cultures, language and times. In *Testaments Betrayed* (1995), he reframes the relationship between history and literature to argue that the modern writer – far from just an invention of capitalism or its ideological dupe – exercises historical agency in the formation of western political discourse. The creation of the European novel, he argues, predates and is a necessary precursor to the development of 'the rights of man'. Freedoms we take for granted in the West required the formation of the modern individual. The arts, and in particular the novel, taught readers to be curious about others and to comprehend truths different from their own. The space of modern literature is a space of the imagination irreducible to the promulgation of moral or political truths, and its social value has to do with this opening up of a space of contemplation, reflection and humour. The novel has the enormous significance that it does in the modern world because it opens an imaginary terrain where moral judgement is suspended, a space where characters can be developed that are not exemplars of a moral pre-existing truth, or examples of good or evil, but are autonomous beings grounded in their own morality and their own law.

Pierre Bourdieu: new rules – fields, habitus, illusio

It is precisely this idea of autonomy that Bourdieu interrogates in *The Rules of Art* (1996 [1992]), an immense theoretical and empirical study that aims to establish the social genesis of the literary field, the beliefs that sustain it, the games played in it, and the material or symbolic stakes it engenders. Re-invigorating the idea of a scientific sociology of literature, Bourdieu deploys the conceptual apparatus and methodology of field theory, developed in earlier works such as *Outline of a Theory of Practice* (1972), *Distinction* (1979) and *Homo Academicus* (1984), to argue that the field of cultural production is, like other fields, a space of possibilities that orients and defines the universe of possible choices and action available to its agents. With the concept of *genetic structuralism* he attempts to transcend both the closed internal readings of structuralism and the French tradition of '*explication de textes*' and reductive Marxist explanations of the text as determined by the economic conditions of production. His analysis focuses instead on the literary field as a space of possibilities, which is already constituted prior to one's entry into the 'game'. This space, beyond any individual determination, functions as a system of common reference situating all its agents in reference to each other. The strategies these agents adopt depend on the positions they occupy within the field, determined by ownership of capital and symbolic prestige, by their different dispositions and by the attitudes they adopt (heretical or orthodox) to the rules of the game. The literary field, he argues, has its own particular institutions and specific laws, its relations of force and its dominants and dominated. In Bourdieu's understanding, a literary field is a social universe, which accumulates its own form of capital and is where relations of force of a particular type are exerted, namely who is part of the universe, who is a real writer and who is not. This social universe 'functions like a prism refracting every external determination' (1996: 103), translating works according to its specific logic. In *The Rules of Art* (1996 [1992]) he attempts to show how the idea of an autonomous field of art is a recent historical invention, created by writers such as Flaubert and Baudelaire as a tactical response to the literary field and its constrained possibilities. Bourdieu wants to explain how people choose to do what they do in situations of constrained choice, and how their meaningful actions reproduce the structures that constrain the choices available to them.

Bourdieu begins *The Rules of Art* with an unusual act for a sociologist, a close reading of Flaubert's *A Sentimental Education* (1869), claiming that through this reading Flaubert's famous work will be 'read' for the first time. So what does his close reading amount to? In short, Bourdieu finds that the immanent structure of the novel mirrors the social space that the author himself was situated in, and thus reproduces the literary field as Bourdieu defines it. Once again the text is a mirror of society but this time imagined through the lens of field theory. The permutations of the novel's five key characters reveal an almost systematic set of combinations of the possibilities available to agents within the field according to their dispositions and their relations to the field of power: 'like particles into a force-field', their relations will be determined by the relation and their trajectories, and 'the capital they have inherited, and which contributes to defining the possibilities and impossibilities which the field assigns them' (1996: 9–10). In reading the literary work as a theoretical blueprint, Bourdieu negates its symbolic force as a *work* except in so far as it buttresses the truth claims of the theory it supposedly translates. And he goes one step further than this, claiming that his scientific revelation of the truth of the text brings to knowledge a secret that literature can represent only through an act of veiling. Flaubert, he argues, has revealed the laws of the literary field unwittingly, merely by pursuing the elaboration of a story, but in so doing he has 'uncovered the most deeply buried structures; obscured furthermore because they are at the foundation of Flaubert's own literary strategies for attaining symbolic capital in the literary field' (1996: 25). Science alone, Bourdieu is suggesting, can deliver this unspeakable unconscious of the text:

> It is a vision that one would call sociological if it were not set apart from a scientific analysis by its form, simultaneously offering and masking it . . . It says it only in a mode such that it does not truly say it. The unveiling finds its limits in the fact that the writer somehow keeps control of the return of the repressed.
>
> *(1996: 31–32)*

In casting the literary work's mode of representation as furthering repression, and the author as the unconscious agent of his own unmasking, Bourdieu displays his own unconscious desire for mastery over Flaubert, the literary master. The boundary between the interpretive conjectures of 'scientific disclosure' and literature's multi-perspectival forms of disclosure exists, but neither truth nor repression can be claimed by – or relegated to – either side. As Bruno Latour argues in relation to the sociological assumption of possessing the meta-language that embeds all other meanings: 'as a rule, it's much better to set as the default position that the inquirer is always one reflexive loop *behind* those they study' (2005: 33). And Flaubert's language, and his mode of disclosure, has proved a far more effective *act* than any comparable sociological study if we consider its longevity in reaching audiences, in crossing linguistic, cultural and temporal boundaries, and in inspiring interpretation. Richard Hoggart suggests that one of the particular strengths of fiction is its capacity to reveal truths about an age indirectly, by an oblique showing: 'tell all the truth but tell it slant/success in circuit lies', he quotes, reminding us that the great literary works of the twentieth century have all been told 'slant' (1970: 29). In flattening Flaubert's text into a set of oppositions and their combinations and permutations in the competition for symbolic capital in a universe of finite possibilities, Bourdieu creates a 'thin description' of one dimension of the work. We might also note that Flaubert's *A Sentimental Education* was a flawed work; in fact, it suffered from the rather laboured socioanalysis that Bourdieu maps. If we redirect Bourdieu's argument to Flaubert's *Madame Bovary* (1992 [1857]), one of the greatest literary works of modernity, the 'immanent

laws' of the literary field are no longer so apparent. And yet, Flaubert recognized himself in Emma Bovary ('c'est moi') and through the figure of Emma Bovary is saying something 'slant' about the intersection of the artist's flight into freedom through art, about desire in excess of its historical possibilities, about the romanticism of melancholy and the death of romanticism, and about the human passion for objects in a world commodifying human relations. But this does not make it an incarnation of any theory or reducible to any of the thousands of interpretations the work has inspired.

Bernard Lahire

French sociologist Bernard Lahire takes further issue with the way Bourdieu's field theory fails to take account of writers themselves and the conditions in which they create. In placing emphasis on fields as distinct universes, and on the struggles and competition of agents within them for the appropriation of symbolic capital, field theory fails to register that the literary field does not operate like a universe. In *La Condition Littéraire: La Double Vie des Écrivains* (2006), he argues that Bourdieu's field method enabled a break with structuralism's study of works solely as signifying structures, and it enabled a better understanding of the value of works and their institutional supports, but it failed to recognize the double life of writers. Drawing on an extensive empirical study of contemporary French writers, he argues that writing is not institutionalized like the other professions and neither does it offer its agents the kinds of total universe that Bourdieu identifies. In the literary universe total investment is virtually impossible, except for the very few. In fact, most writers only exist in the literary field in a secondary fashion because literature is not a profession as such; it cannot offer most of its agents even a rudimentary means of survival. Hence most writers move in and out of the literary universe, co-existing in different fields at the same time. From the point of view of the very questions posed by field theory (with its notions of illusio, habitus and investment), Lahire argues that the double life of writers is not an insignificant fact, but central to literary life. The fact that writers co-exist in different fields, for example, raises the question of whether they have incorporated the specific illusio of each. Bourdieu recognized that the literary field was one of the least able fields to sustain or nourish its participants but only recognized the subjective profits gained from this double experience (i.e. the status of writer offsetting the low-status income-earning job). In fact the labour of the second job undermines the very idea of habitus: 'Bourdieu's habitus is conceived as systematic and homogenous but the same individuals combine literary and extra literary activity . . . field theory inevitably leads us to search for specific determining factors that influence social behaviour by looking within relatively autonomous microcosms' (Lahire 2010: 449). But writers are often as much out of the field as in it, and 'out of field' practices are critical for understanding 'in field' practices: 'the money making foot that allows the other one to "dance"' (2010: 448).

Lahire also interrogates the metaphor of the game deployed by Bourdieu to evoke the way fields work with rules, winners and losers. Drawing on Huizinga and Callois's writing on games and play, he recasts the metaphor to emphasize how the literary life *is* like a game and, as such, operates in a different sphere from ordinary life. Games, he emphasizes, are free activities separate from daily life with rules that are distinct from those of ordinary life. Games are generally unproductive, connected with no material interests, fictive – but at the same time utterly absorbing to their players. This idea of free and unconstrained activity corresponds to artistic activities that are often based on desire and vocation rather than obligation. 'Artists in general, and writers in particular, most often experience their activity not as a form of work that is obligatory, forced or constrained, but rather as a response to inner

necessity and personal desire' (2010: 455). As Lahire's extensive interviews with writers reveal, constrained work (involving obligations, time limits, etc.) is generally conceived as contrary to the work itself. Moreover, unlike a range of other social universes, the literary game does not create clear boundaries between experts and laypersons (there is no physician's white coat). The literary universe also rarely has clear and explicit rules but rather is full of uncertainty: 'unlike a whole series of other social universes, the literary game never guarantees a player's permanent position within the game' (2010: 456). Uncertainty rules, in relation to sales, critical reception, the aesthetic value of what one has written and published, and the possibility of publishing again. Hence, literature must be practised independently of any commercial end, and the greater component of literary labour is either free or unprofitable. The game is *fictional* – writers create worlds with words that are separate from everyday uses of language – and yet the game for some becomes the only serious thing in the world, in contrast to the futility and waste of a life given over to everyday appearances and values. Lahire's concept of 'the double life', then, returns sociological attention to aspects of literary production that have been foreclosed from sociological analysis. By returning critical focus to the desire invested in literary production, to literature as a realm of freedom operating outside the rules of ordinary life, and by restoring the significance of a space of invention and imagination in language, he begins the task of developing the much needed conceptualization of what a sociology of literature might be, if it begins from the proposition that writing, writers and the works they create engage in dynamics that are linguistic, literary, inventive and playful and that their import to society begins here.

Future developments

Lahire's recent work highlights a history of missed encounters in the attempt to subject literature to a theoretical discourse that forecloses the agency of literature and the consciousness, discourse and lived reality of its producers. The legacy of this 'missed encounter' remains deeply contradictory. On the one hand, the sociology of literature has almost disappeared from view. As James English writes:

> The Birmingham centre faded from prominence and was summarily 'restructured' out of existence a decade ago. A title search for 'sociology of literature' in Amazon turns up no primers published since 1990; conferences or panels on the sociology of literature are non-existent, at least from the perspective of scholars of literature.
>
> *(2010: vii)*

But on the other hand, he points out, the theoretical questions raised by the sociology of literature radically transformed contemporary literary studies to such an extent that by the 1990s most literary scholars had become sociologists of literature:

> postcolonial studies, queer theory, new historicism – their shared disciplinary mission was to coordinate the literary with the social: to provide an account of literary texts and practices by reference to the social forces of their production, the social meanings of their formal particulars, and the social effects of their circulation and reception.
>
> *(2010: viii)*

One of the offshoots of this 'sociological turn' has been an often unconscious adoption of sociological positivist methodologies divorced from the richer theoretical traditions of

sociology proper. Influential cultural theorist John Frow provides an illuminating insight here. Reflecting on his own 'turn' to empiricist methodologies in *Accounting for Tastes: Australian Everyday Culture* (1999), a work inspired by Pierre Bourdieu's promise that statistical analyses could reveal complex understandings of the shaping of culture, Frow reflects that, while statistical correlations enabled the analysis of reading patterns to be significantly developed, the statistical analysis of the literary field has produced at best 'thin description' (2010: 239). From another direction, debates are emerging within sociology itself concerning the need for a renewed engagement with literary innovation. In 2009 prominent American sociologist Richard Sennett delivered a provocative lecture entitled 'Sociology *as* literature' in which he argued that social scientists are increasingly isolated from the public realm through their enfeebled expression. Sennett identifies an impasse between the depth of knowledge that exists within the disciplines of social science and the paucity of ideas and language in circulation in the public realm and attributes this to the failure of contemporary social scientists to register that the craft of writing is at the ethical and political core of their practice. Citing social thinkers such as Montaigne, de Toqueville and Adam Smith, he argues that in the past social thinkers took it for granted that the dynamism and complexity of the modern world involved a literary challenge: that of creating the verbal means of conveying a new and as yet undisclosed social reality. In Sennett's reading, social writing requires generic innovation; it must invent new literary forms in response to the unfolding complexity of modernity. Barthes's admonition echoes throughout Sennett's lecture: the sociological text must learn to constitute desire. This recognition of literary innovation suggests a new openness on the part of at least some sociologists to the idea that sociologists have something to learn from literature, not least in the creation of new forms in dialogue with the unfolding present.

References

Adler, L. (1998) *Marguerite Duras*, Paris: Gallimard.

Bakhtin, M. (1981) *The Dialogic Imagination*, ed. M. Holquist, trans. C. Emerson and M. Holquist, Austin, TX: University of Texas Press.

Barthes, R. (1967) 'L'analyse rhetorique', in *Littérature et Société: Problèmes de Méthodologie en Sociologie de la Literature*, Brussels: Editions de L'Institut de Sociologie de l'Université de Bruxelles.

—— (1977 [1967]) 'The death of the author', in *Image Music Text*, trans. S. Heath, London: Fontana Press.

—— (1990 [1973]) *The Pleasure of the Text*, trans. R. Miller, Oxford: Basil Blackwell.

Benjamin, W. (1955) 'The work of art in the age of mechanical reproduction', in *Illuminations*, trans. H. Zohn, Suffolk: Fontana/Collins.

—— (1973 [1934]) 'The author as producer', in *Understanding Brecht*, London: Verso.

Bennett, T., Emmison, M. and Frow, J. (1999) *Accounting for Tastes: Australian Everyday Cultures*, Cambridge: University of Cambridge Press.

Bourdieu, P. (1996 [1992]) *The Rules of Art*, trans. S. Emanuel, Stanford, CA: Stanford University Press.

Brecht, B. (1999 [1944]) *The Caucasian Chalk Circle*, trans. E. Bentley, Minneapolis, MN: University of Minnesota Press.

Calvino, I. (1993 [1979]) *If on a Winter's Night a Traveller*, trans. W. Weaver, New York: Knopf.

Duras, M. (1961 [1960]) *Hiroshima Mon Amour: A Screenplay by Marguerite Duras*, trans. R. Seaver, New York: Grove Press.

Eagleton, T. (1976) *Marxism and Literary Criticism*, London: Routledge.

Eco, U. (1981 [1962]) 'The open text', in *The Role of the Reader in the Text: Explorations in the Semiotics of Texts*, London: Hutchinson.

English, J. F. (2010) 'Everywhere and nowhere: the sociology of literature after "the sociology of literature"', *New Literary History*, 41: v–xxiii.

Escarpit, R. (1971 [1958]) *Sociology of Literature*, trans. E. Pick, London: Frank Cass and Co.

Fink, I. (1991) 'The power behind the pronoun: narrative games in Calvino's *If on a Winter's Night, a Traveler*', *Twentieth Century Literature*, 37(1): 93–104.

Flaubert, G. (1992 [1857]) *Madame Bovary*, trans. G. Wall, London: Penguin.

—— (1989 [1869]) *A Sentimental Education*, trans. Douglas Parmée, Oxford: Oxford University Press.

Frow, J. (2010) 'On midlevel concepts', *New Literary History*, 41: 237–52.

Griswold, W. (1993) 'Recent moves in the sociology of literature', *Annual Review of Sociology*, 19: 455–67.

Hoggart, R. (1970) *Speaking to Each Other*, New York: Oxford University Press.

Holquist, M. (1981) 'Introduction', in M. Bakhtin, *The Dialogic Imagination*, ed. M. Holquist, trans. C. Emerson and M. Holquist, Austin, TX: University of Texas Press.

Howe, I. (1971) 'Lukács and Solzhenitsyn', *Dissent Magazine*, November–December, 643–47. Available online at http://dissentmagazine.org/files/Irving%20Howe%20on%20Lukacs%20and%20 Solzhenitsyn.pdf (accessed 9 August 2012).

Joyce, J. (1939) *Finnegans Wake*, London: Faber and Faber.

Kafka, F. (1996 [1912]) 'The metamorphosis', in *The Metamorphosis and Other Stories*, trans. S. Apelbaum, New York: Dover.

Kundera, M. (1995) *Testaments Betrayed: An Essay in Nine Parts*, trans. L. Asher, London: Faber and Faber.

Lahire, B. (2006) *La Condition Littéraire: La Double Vie des Écrivains*, Paris: Éditions la Découverte.

—— (2010) 'The double life of writers', trans. G. Wells, *New Literary History*, 41(2): 435–65.

Latour, B. (2005) *Reassembling the Social: An Introduction to Actor-Network-Theory*, Oxford: Oxford University Press.

Laurenson, D. T. and Swingewood, A. (1971) *The Sociology of Literature*, London: MacGibbon and Kew.

Lombardo, P. (1990) 'Between art and science', *Yale French Studies*, 77: 117–33.

Lukács, G. (1950) *Studies in European Realism*, London: Hillway.

—— (1962) *The Historical Novel*, trans. H. and S. Mitchell, London: Merlin Press.

—— (1995) *The Lukács Reader*, trans. A. Kadarsky, Oxford: Blackwell.

Pike, D. (1985) *Lukács and Brecht*, Chapel Hill, NC: University of North Carolina Press.

Propp, V. (1968 [1928]) *Morphology of the Folktale*, trans. L. Scott, Austin, TX: University of Texas Press.

Re, L. (1998) 'Calvino and the value of literature', *MLN*, 113(1): 121–37.

Sartre, J. P. (1978 [1948]) *What Is Literature?*, trans. B. Frechtman, London: Methuen.

Sennett, R. (2009) 'Sociology as literature', lecture, 2 April, CRASSH, Cambridge. Available online at www.youtube.com/watch?v=4ogeGVpBFZ0 (accessed 20 March 2013).

Steiner, G. (1967) *Language and Silence: Essays 1958–1966*, London: Faber and Faber.

Taine, H. (1871) *History of English Literature*, trans. H. Van Laun, Edinburgh: Edmonston and Douglas.

Race/ethnicity and social and cultural theory

Anthony Moran

Introduction: historical and intellectual development

Within the social sciences and humanities, race and ethnicity have been major objects of study, reflecting the profound ways that they have shaped social life. Historically, the study of race by natural and social scientists involved categorizing different groups of people, and arranging them hierarchically. Such classification gave ideological support to slavery, colonialism and other forms of racial domination. It was assumed that biological race was associated with character, behaviour, disposition (for example, on a continuum from emotional to rational) and intelligence. For early race theorists, race helped explain the differences between civilization and savagery, the rise and fall of nations and the broader course of history. In the twentieth century, coinciding with the undermining of scientific racism from the 1930s onward, the study of race was often aligned with social movements that vigorously challenged racism and discrimination. Intellectuals and activists from those previously referred to as the 'inferior races' started to write and speak back to power and against racist oppression, stereotyping, prejudice and discrimination. More broadly, social science increasingly came to emphasize the role of culture, and social construction, rather than biology (e.g. race, sex) in the ways that people thought, felt, behaved and acted, and this also contributed to a shift of emphasis from race ('biology') to ethnicity ('culture'). 'Race' was reconfigured as the forms of cultural assumptions, and the social constructions, that attach themselves to physical differences between people, and which affect the opportunity structures of societies.

The massive migrations of the nineteenth and twentieth centuries, bringing together many different peoples into single societies (for example in the New World nations of the Americas), stimulated new waves of thinking about how people organized themselves into groups and engaged in collective action, and the relevance of language, culture, myth and tradition. This also stimulated new concerns with the place of ethnicity in the modern world, as did the turbulence of a post-colonizing world, including migrations of peoples from former colonies back to imperial centres of Europe.

This chapter critically examines the important contributions made by social and cultural theorists to the study of race and ethnicity, focusing primarily on developments in thought and argument since the Second World War. It concludes that both concepts remain relevant to our understanding of major social divisions and to the structuring of society, and to our understanding of the globalizing conditions of the twenty-first century.

Key contributors and criticisms

The concepts of ethnicity, race and nation are difficult to distinguish in any definitive way. Sometimes race and ethnicity are used to describe the same social group, and what is referred to in some contexts as racial conflict is referred to as ethnic conflict in others. 'Nation' has connections to both ethnicity and race – in the nineteenth century it was common to refer to the French or German 'races', whereas these days these are typically called nations (Glazer 1983: 234). Ethnicity implies some kind of common culture, but nations also aspire to common culture. Discourses of race are intimately tied historically to the emergence of modern nations in the eighteenth and nineteenth centuries, and some argue that race is still a signifier of nation, often lurking in the background. According to Balibar 'racism is not an "expression" of nationalism . . . but is always indispensable to its constitution' (Balibar and Wallerstein 1991: 54). Further, Balibar claimed that racism always presupposes sexism. Benedict Anderson proposed an alternative view on the sources of nationalism, arguing that 'the dreams of racism actually have their origins in the ideologies of class, rather than in those of the nation' (1991: 149). The ethno-symbolist school of nationalism emphasizes the continuing role of 'ethnic cores' in sustaining the sense of belonging to distinct nations, tying people to place through powerful historical and ethnic symbolism (Smith 2009).

The contemporary study of race is typically focused on the ways that physical differences between peoples become major ways of organizing social life, including access to public goods and other resources. Skin colour, face, eye and body shape, hair type, and skull size and shape have been used as racial markers. Though the biological underpinnings of race arguments have been thoroughly discredited, social scientists argue that we should retain the concept in order to use it in our explanations of forms of social inequality, discrimination and violence; that, while race as a scientific concept has been largely discredited, it is still important because, in everyday life, people often still operate with commonsense understandings of race as they go about their business in society. Social scientists argue that if we simply replace race with a more 'neutral' term like ethnicity then we will fail to see the way that people's physical appearance, especially colour, impacts upon their experience and opportunities in racially mixed societies. Some social scientists of race have argued that modern societies are 'racial formations', structured as racial hierarchies that might subtly shift over time, with some previously subordinated and racially marked individuals and groups rising to new positions of power, but that the basic colour divisions remain, within and between societies in an age of increasing globalization (Omi and Winant 1994).

Max Weber's (1997) famous definition of the ethnic group still captures the meanings and understandings of ethnicity within contemporary social science. Weber argued that ethnic groups were animated by a belief in common descent, based on perceptions of physical similarities and/or common customs, or on memories of immigration or colonization. Historically, such groups had developed a series of cultural traits and symbols that they became conscious of and used as points of differentiation from other groups. Ethnic groups had histories of political organization, which may have still been present or which in other cases persisted as historical memories where groups had been conquered and ruled by other groups, for example through colonization. Belief in ancestry as defining the ethnic group endures, as does at least the assumption of shared cultural traits. To take one prominent example, the historical sociologist and eminent theorist of nationalism and ethno-symbolism Anthony Smith defines ethnie as 'a named and self-defined human community whose members possess a myth of common ancestry, shared memories, one or more elements of common culture, including a link with a territory, and a measure of solidarity, at least among the upper strata' (2009: 27, original emphasis).

Frederik Barth's influential book *Ethnic Groups and Boundaries*, written in collaboration with other like-minded European social anthropologists, was a landmark study in the field of ethnicity from the late 1960s. Barth turned attention to the central importance of boundary making in ethnic identification, group formation and political organization. Barth argued that anthropologists had long recognized that 'cultural variation was discontinuous' and that there were cultural differences attached to discrete ethnic units, but had too often assumed that such differences were maintained by isolation and ignorance. While the differences between groups had been closely studied, and historical boundaries and connections attended to, anthropologists had neglected 'the constitution of ethnic groups, and the nature of the boundaries between them' (Barth 1969: 9). Ethnic groups and the ethnic statuses of individuals in fact organized the vital and intense interactions that contributed to the building of 'embracing social systems' (1969: 10). Ethnic groups were 'categories of ascription and identification by the actors themselves, and thus have the characteristic of organizing interaction between people' (1969: 10).

Barth directed attention to the way that ethnic groups and boundaries were reproduced in contexts of intense interaction, mobility and transactions across ethnic boundaries, through 'social processes of exclusion and incorporation' (Barth 1969: 10). He focused on the interaction between different ethnic groups within ethnically diverse geographical spaces and larger societies, and on how they marked themselves off from each other despite their outward similarities, through the use of a few potently symbolic ethnic markers. For example, in his essay about Pathan (or Pashtun) identity in Afghanistan, Barth (1969: 117–34) showed how the meaning of being Pashtun, which was centred on the male in this strongly patriarchal group socially organized by gender segregation, was individual male autonomy. This autonomy was expressed in a range of ways, from host and guest relations, to economic independence, to performances of political autonomy in decision-making councils. Once a Pathan, in different circumstances such as migration or being enveloped by a different societal organization and/or dominating ethnic group, was unable to exercise a certain level of autonomy, he might cease to be recognized by others, and by himself, as a Pathan, and take on some other ethnic identity in its place. But distinct ethnic groups and boundaries remained, despite such transformations of individual identities.

Barth drew attention away from cataloguing the various cultural traits that supposedly separated one ethnic group from another, and instead highlighted what members of ethnic groups themselves, and those other ethnic groups who recognized them as distinguishable groups, considered to be the few crucial distinguishing traits:

> The features that are taken into account are not the sum of 'objective' differences, but only those which the actors themselves regard as significant . . . [S]ome cultural features are used by the actors as signals and emblems, others are ignored, and in some relationships radical differences are played down and denied.
>
> *(Barth 1969: 14)*

There were two basic types of such differences: first, there were overt signs that people look for and show as indicators of ethnic identity, such as clothes, housing arrangements, language and style of life; second, there were 'basic value orientations: the standards of morality and excellence by which performance is judged' (Barth 1969: 14). But an observer could not simply look objectively from the outside to decide which of these differences the ethnic group itself would focus on and highlight as significant to their identity. Barth's main contention was, thus, that the central focus should be on the social boundary that separates ethnic groups,

not 'the cultural stuff that it encloses' (1969: 15). Those various symbols, signs and emblems were part of the social boundary mechanisms by which groups distinguished themselves from each other.

Barth's concern with ethnic boundaries, his emphasis on the processes of ethnic group formation and maintenance, and his insights about the mutual constitution of ethnic identities, remain relevant to thinking through ethnic group and identity formation today.

Race, racism, enlightenment and modernity

In terms of explaining nineteenth- and twentieth-century notions of race, and the historical emergence of racism, some social and cultural theorists have argued for their close intertwining with modernity and its rationalizing, world-reordering propensities. Zygmunt Bauman, most notably in his work *Modernity and the Holocaust* (1989), argued that racism was not an aberration within modernity, but one of modernity's important tendencies, related to the dream of creating rationally ordered societies. 'Biological race' became an anchoring point amidst the traumatic upheaval of modernity. Dreams of purity were indelibly associated with modernity, and race markers became one important way to carve up, and then clean up, the messy social field.

A related argument draws close links between the Enlightenment and the emergence of beliefs about biological race, and the creation and reproduction of racism. Kant, one of the Enlightenment's leading figures, is considered by philosopher Robert Bernasconi (2009) to be the inventor of the modern concept of race. The main arguments have been presented in the spirit of a broad critique inspired by anti-racism and anti-colonial domination, or post-colonialism. In his book *Racist Culture*, David Theo Goldberg (1993) argues that racism was the product of the Enlightenment, and of the colonial expansion related to it. Through a close reading of key Enlightenment and liberal figures (e.g. Locke, Kant and Hume) he argues that the ideals and claims about equality and reason characteristic of the Enlightenment always, and inherently, involved a process of exclusion. Some sections of humanity, such as 'primitives', Indigenous peoples, black Africans and 'Orientals', were deemed irrational or less rational than their 'white, male, European, and bourgeois' counterparts, and thus not deserving equal treatment (Goldberg 1993: 28). Thus, from a broad discourse of equality and rationality emerged a discourse of different races. Capacity to reason became linked to biologically defined 'race'. The over-confident, universalistic outlook of the Enlightenment was itself crucial to the expansionary aims of the West, and fed the whole colonial racist project (Goldberg 1993: chs 2 and 3). Modernity, as the broader project and expression of the Enlightenment, was deeply connected with racism. Conceiving of both racism and modernity as Foucauldian discursive formations, Goldberg argues that they share a common set of 'preconceptual elements', which form their deep generative structure. These include 'classification, order, value, and hierarchy; differentiation and identity, discrimination and identification; exclusion, domination, subjection, and subjugation; as well as entitlement and restriction' (Goldberg 1993: 49). The entanglement of racism and modernity has intensified, Goldberg argues, as each has come to influence, define and shape the other:

> Racialized discourse . . . emerged only with the displacement of the premodern discursive order and the accompanying epistemic transformations. It developed and matured with the social and intellectual formation of modernity. Indeed, it increasingly came to give definition to the sociocultural order of modernity, furnishing in large measure a central strand of the novel means of tying people, power and history together.
>
> *(1993: 45)*

Other writers have also developed the argument about the relationship between Enlightenment, modernity, racism and the production of racist identities. Henry Louis Gates Jr points out how writing and the capacity to master the 'arts and sciences' were taken as signs of reason, and their absence or relative underdevelopment in black or African cultures was seen as an indicator of their racial inferiority (Gates 1986: 8). Paul Gilroy has proposed the notion of 'racialized modernity', highlighting the way that racism and racial categories continue to permeate the modern world (Gilroy 1993, 2000).

However, Malik (2008) has pointed out that this argument linking Enlightenment with racism is a one-sided reading of Enlightenment figures. Other major figures of the eighteenth-century Enlightenment who, following the historian Jonathan Israel, Malik characterizes as belonging to the 'Radical Enlightenment' were anti-racist in approach, inspired by the equality of all humanity and by the assumption that all of humanity was capable of the reason that Enlightenment so venerated (Malik 2008: ch. 4). Contrary to the view of Goldberg and likeminded critics, scientific classification and the perception of differences – that whole way of seeing – did not lead inevitably to racial classification in hierarchies of superiority and inferiority (Malik 2008: 84). Further, one can point out that this is an overly pessimistic and one-sided reading of modernity itself, arguing for too close a link between the logics of modernity and racism.

W. E. B. Du Bois and Frantz Fanon

Apart from these broad, generalizing accounts, there have been many important interventions, including by black intellectuals such as pioneering figures W. E. B. Du Bois and Frantz Fanon, and later writers such as Henry Louis Gates Jr, Stuart Hall, bell hooks, Patricia Hill Collins, Paul Gilroy, and postcolonial theorists such as Ashis Nandy and Homi Bhabha. These writers in particular, in part because of their own personal experiences of racism and colonialism, have developed unique insights into the workings of race and racism.

Du Bois, one of America's most prolific and insightful analysts of race and of the black experience, argued that the 'colour line' was the dominating problem of the twentieth century. In works stretching from the late nineteenth century through to the 1960s, he articulated the nature of black group life, developed strategies for improving the situation of blacks in America, challenged governments, and produced major historical and theoretical accounts of race and race relations.

In essays like 'The souls of white folk', Du Bois turned the examination of race squarely back onto white people. Writing at that time (in 1920), he had noticed a rising consciousness among white people that they belonged to a white race: 'the world, in a sudden emotional conversion, has discovered that it is white, and, by that token, wonderful' (Du Bois 1975: 30). The 'discovery of personal whiteness among the world's people is a very modern thing', he wrote, 'a nineteenth and twentieth century matter, indeed' (Du Bois 1975: 29–30). This discovery of whiteness entailed an assumption of 'ownership of the earth forever and ever, Amen!' (Du Bois 1975: 30). The belief in this 'extraordinary dictum' was catastrophic for non-white peoples and nations (Du Bois 1975: 31), contributing to the rape of Africa and other colonial exploitation throughout the world.

In *Black Reconstruction in America*, Du Bois (1966) discussed the 'psychological wage' involved in whiteness. Poor white workers were able to tolerate their often desperate economic, social and political situations by drawing a 'psychological wage of whiteness' that shored up their otherwise threatened self and social esteem. In order to experience that 'psychological wage' they had to be able to look down on other, black, workers, and black

people more generally, as inferior to them. They would therefore demand that black people were not paid the same wages as them, or demand their exclusion from jobs that whites dominated. Whites also gained privileged access to public spaces denied to black people in areas where segregation was a reality. Thus, Du Bois also argued that the psychological wage of whiteness drove a wedge between white and black workers, had a major effect on the class system (a black–white division in the class structure), and prevented exploited white workers from joining forces with black workers in unified action to improve the overall position of the working class (Du Bois 1966).

The dying rage of the late colonial period set the scene for Frantz Fanon's incendiary works on race and racism. Fanon was himself an important figure in the decolonization movement in Algeria and other parts of North Africa. Fanon also wrote from a deeply personal, and psychically wounded, position as a black intellectual in the French colonial sphere. As a trained psychiatrist, he challenged ethno-psychology's orthodox views about the causes of the inferiority complexes of black colonial peoples, evident in works such as Mannoni's *Prospero and Caliban*. This approach, he argued, failed to appreciate the intimate ways that black experiences, consciousness and identities had been shaped by a vicious, dehumanizing colonizing process rooted in capitalist exploitation (Fanon 2008).

Inspired by psychoanalysis and phenomenology, in *Black Skin, White Masks* Fanon (2008) explored the deep experiences of racial antagonism, the psychic wounds of race and racism, and the distorted white and black subjectivities produced by racist social systems. According to Fanon, whites become obsessed with scrutinizing blacks: producing images of them, fantasizing about their supposedly wild and sexual qualities, and relating to them with a mixture of fear and desire. One of his major insights was the way that ideals of whiteness were taken up by black people: how even for black people blackness was associated with evil, and whiteness with good. As a psychiatrist he had seen many black patients who consciously, or unconsciously, desired to be white, and who hated their own black skins.

It was only psychoanalysis, Fanon argued, that could help us to explain the black and white narcissisms, 'the affective disorders', into which people were locked in race antagonism (2008: xiv). In ways that were taken up by later cultural theorists of race, he read cultural forms including everyday language, children's comics and stories, novels and films to unearth the racial pathologies that underpinned them, and showed how mass cultural forms created and reproduced racial stereotypes that contributed to the reproduction of racist systems of domination. An important result of and support for this domination was the systematic production of black pathology. Unlike the white child, who typically experiences concordance between family relations and the structures of authority in national society, he wrote, a 'normal black child, having grown up with a normal family, will become abnormal at the slightest contact with the white world' (Fanon 2008: 122).

Writing at a time when the 'Negritude' movement was in full swing, where black intellectuals highlighted the achievements and meanings of black culture and identity, Fanon challenged their assumptions about essential black culture and the Negro spirit, and highlighted the ways that some of the supposed features of Negro racial character were the product of the white imagination and colonial system of domination.

Fanon, like other important critics of European colonialism such as Aimé Césaire, drew a link between the racism to which colonial others were subjected, and the virulent anti-Semitism that infected Europe, culminating in the Holocaust. Though racisms were historically specific, there was a common psychological structure, expressed in specific ways, for example as white racism against black people, or anti-Semitism. As Fanon noted, it was one of his philosophy professors from the Antilles who told him to listen carefully whenever

people started talking about Jews, as they were also talking about blacks. 'Since then', Fanon noted, 'I have understood that what he meant quite simply was that the anti-Semite is inevitably a negrophobe' (Fanon 2008: 101). Whites were phobic about Negro's black bodies, while they were phobic about Jews' intellects (Fanon 2008: 143).

British contributions to the study of race and racism: race relations, Stuart Hall, CCCS and Paul Gilroy

In the Anglo world, the race relations paradigm dominated sociological thinking about race and racism from the 1950s to the 1970s. This tradition had its roots in the sociology of the Chicago School in the 1920s and 1930s, especially the work of Robert Park. The key figures in the British tradition were John Rex and Michael Banton. This paradigm had a strong policy focus, analysing areas of discrimination and disadvantage experienced by different 'races' who self-identified themselves as such. And, in fact, the race relations paradigm was reflected in early British policies first established in response to race rioting in the late 1950s. The 'race relations' Acts that began in the 1960s, which outlawed discrimination in a range of areas including employment, housing, and provision of goods and services, relied more on conciliation and mediation rather than prosecution (e.g. fines or compensation). These policies were also aimed at combating and minimizing white people's prejudices against immigrant groups (Miles and Brown 2003).

According to its critics, the problem with those writing within the race relations paradigm was that, even if they viewed races as socially constructed (and not biological realities), these authors nevertheless assumed that such groups acted as groups with group interests, in relation to other groups, thought of as races – in relationships of cooperation (in rare instances) but in most cases in relations of conflict and antagonism that had to be managed at the societal level (e.g. through 'race relations' Acts of parliament and 'race relations' advisory bodies). Without intending to, this approach naturalized groups as races, and moreover assumed homogeneity of interest, attitude and aspiration within these groups. This way of thinking gave rise to the idea that races could act as political groups, and needed to be addressed by policy makers as such. Instead, critics like Miles and Brown (2003: 91) argue that a sociology of racism needs to examine the processes by which groups of people are constructed as races in particular historical circumstances, and the consequences for the people involved, and for the types of society that they inhabit. The focus should be squarely upon racism, rather than so-called 'race relations'.

As noted in Chapter 13 of this handbook, by Stevenson, Stuart Hall is one of the most important figures in British cultural studies, but throughout his career Hall has also made important interventions in ethnic and racial studies, where he has been an influential figure (Alexander 2009; Hall and Back 2009). Hall's work with the Birmingham Centre for Contemporary Cultural Studies (CCCS) resulted in his major collaborative work *Policing the Crisis* (Hall et al. 1978), which incorporated many of Hall's earlier ideas about the role of media in cultural production, and the focus on youth and crime, framed by his Gramscian-influenced view of hegemony and of organic crises. He and his co-authors argued that an organic crisis of British capitalism contributed to the ideological construction of the young male black 'mugger' in popular media and popular discourse. This folk devil, arising from a moral panic about street crime, was constructed through a proliferation of news stories and also by conservative political figures. The figure of the 'black mugger' served as a focus for political action diverted from the real sources of the 'organic crisis', resulting in the rise to prominence of a political discourse and practice of law and order. This had important

articulations with sections of the white working class. Hall also influenced a younger cohort of students including Paul Gilroy, John Solomos and Hazel Carby, who, together with others from CCCS, wrote the seminal *The Empire Strikes Back*, a major exploration of racism in 1970s Britain. The guiding thesis of the book was that 'the construction of an authoritarian state in Britain is fundamentally intertwined with the elaboration of racism in the 1970s' (CCCS 1982: 9). It contained many provocative essays articulating the complexity of race and the experience of racism in Britain, from examination of the history of racism and its relationship to the British state and British Empire, to situating race within the crises of capitalism, to exploring the constructions of race and the 'black family' within hegemonic common sense, to examining race and education, and the articulation of race and gender.

The influence of Marxism, and in particular Antonio Gramsci and Louis Althusser, led Hall to focus on the ways that societies were 'structured in dominance', and also contributed to his focus on the complex articulations of class and race in contemporary societies, including Britain. In his famous formulation from the late 1970s, class was lived in the modality of race: a formulation he later modified to suggest that the interrelation was more complex, so that race was also lived in the modality of class (Hall and Back 2009). In his essay 'Race, articulation and societies structured in dominance' Hall (1980) challenged not only the economic reductionism of many Marxist accounts of racist societies, which claimed to explain the intricacies of ethnic and racial stratification in terms of internal and external dynamics of capitalist economic relations, but also the sociological reductionism that argued that racial and ethnic relations were constructed purely in the spheres of the social and political, independent of broader economic relations. Each produced a partial account, and had major theoretical blind spots. Examining the work of race relations sociologist John Rex, together with those Marxists, such as Harold Wolpe, who had debated his arguments about racial formations in South Africa and in plantation societies, Hall concluded that racism needed to be understood in its historical specificity, rather than as a generic form. One needed to find a way beyond both economic and sociological reductionism to consider the complex articulations of race in specific historical conjunctures, by considering the interplay in concrete situations of economic, social, cultural, political and legal relations. Neither 'general history' nor appeals to prejudice in human nature would do as explanatory tools for specific racisms:

> One must start, then, from the concrete historical 'work' which racism accomplishes under specific historical conditions – as a set of economic, political and ideological practices, of a distinctive kind, concretely articulated with other practices in a social formation. These practices ascribe the positioning of different social groups in relation to one another with respect to the elementary structures of society; they fix and ascribe those positionings in on-going social practices; they legitimate the positions so ascribed.
> *(Hall 1980: 338)*

Such racist relations were hegemonic, ultimately serving dominant economic interests; and though ultimately rooted in economic relations, which according to Gramsci were always the ultimate originating force in hegemony, societies structured in dominance had to be grasped in terms of their forms and mechanisms of articulation between different levels within a social formation.

In later work, Hall turned his attention more closely to issues of race and representation, and also to the transformation of identities in the context of globalization. For example, in his essays on 'Representation' and the 'Spectacle of the other' in his edited book *Representation* (1997), Hall examined the way that race was constructed within a complex system of representation

across several cultural forms. Examining a range of cultural representations, including painting, art photography, film, advertisements, sport images, and news photos, sketches and cartoons, Hall argued that racial stereotyping involved fetishism and ideological representational practices of reductionism, essentializing, naturalization and the use of binary oppositions.

In the early 1990s Hall, influenced by post-structuralism, wrote about the play of decentred identities that had fragmented previously, and only apparently, unitary black identities, and in particular highlighted the articulations of new ethnicities through art and other cultural practices of young people of colour from immigrant backgrounds. The idea of diaspora, of migration continually disrupting the fixities of identities, became a major theme in his work, including his defence of a form of multiculturalism, and of inclusive national culture, evident in his contribution to the controversial Runnymede Trust report *The Future of Multi-Ethnic Britain* (Commission on the Future of Multi-Ethnic Britain 2000).

In his essay 'Old and new identities, old and new ethnicities', Hall emphasized the decentrings of individual, unitary subjectivity as a result of the interventions of Marx, Freud and Saussure, also highlighting the breakdown of large, imaginary, homogenous, collective social identities of class, race, ethnicity, gender, nationality and the West, which he argued had been undermined by globalizing forces. This meant that we 'are now as attentive to their inner differences, their inner contradictions, their segmentations and their fragmentations as we are to their already-completed homogeneity, their unity and so on' (Hall 1991: 45). Identities, and the desire for them, do not disappear, but they are constantly under revision, their certainties doubted and forever undermined. Subjectivity, individual and collective, is always 'in process', always in formation, and identification is always provisional and ambivalent, as psychoanalysis and new feminist critiques highlighted (Hall 1991: 47).

Paul Gilroy's (1993) work has also dealt with the formations of black identity and consciousness, and how these intersect with class and gender and are also shaped by the diasporic experiences that construct black identities and consciousness beyond the confines of any single nation. As a cultural theorist, Gilroy has been an important figure in taking seriously popular culture, like black forms of music and lyrical expression, and also in examining how these can involve anti-racist practices and discourses, as explained in *There Ain't No Black in the Union Jack* (1987), where he argued that some black artists were organic intellectuals in the Gramscian sense. But Gilroy has also noted more destructive forms of black identity and masculinity evident among hip hop artists like the Florida-based 2 Live Crew, who project a powerful, misogynistic black male sexuality and a subservient, highly sexualized black womanhood, and whom prominent black intellectuals like Henry Louis Gates Jr had defended as legitimate enunciators of the playful, satirical black vernacular culture (Gilroy 1993: 84–86). As Gilroy noted in *The Black Atlantic*, we could add to Hall's perception that race is the modality in which class is lived with the claim that 'gender is the modality in which race is lived':

> An amplified and exaggerated masculinity has become the boastful centrepiece of a culture of compensation that self-consciously salves the misery of the disempowered and subordinated. This masculinity and its relational feminine counterpart become special symbols of the difference that race makes. They are lived and naturalised in the distinct patterns of family life on which the reproduction of the racial identities supposedly relies. These gender identities come to exemplify the immutable cultural differences that apparently arise from absolute ethnic difference. To question them and their constitution of racial subjectivity is at once to be ungendered and to place oneself outside of the racial kin group. This makes these positions hard to answer, let alone criticise.
>
> *(Gilroy 1993: 85)*

In *The Black Atlantic* Gilroy (1993) explored how narratives of modernity interacted with black consciousness and experience, and stressed how black experiences produced a 'counter-culture of modernity'. In conceptualizing the idea of the black Atlantic, Gilroy made use of Du Bois's concept of 'double consciousness' to explain the striving 'to be both European and black' (Gilroy 1993: 1). In *Against Race* (2000), and his essays on the state of identities in multicultural Britain, Gilroy explores the terrain of the initial creation and solidification of a black identity in the 1960s that fractured in the 1970s and 1980s. *Against Race* also shows how key figures of the black identity and consciousness movements, including Marcus Garvey, at times mirrored, and reproduced, the racist and fascist tendencies that oppressed black and other peoples. Gilroy now advocates in place of all race thinking, and of racial identities, a kind of cosmopolitan global humanism that transcends fixed identity categories.

Cultural racism and whiteness

The post-Second World War period, with the rise of human rights frameworks in national and international contexts, the successful campaigns and political struggles of the anti-racist, civil rights and de-colonization movements, is seen by some as rendering race a less salient ordering principle in late modern societies. However, there are many contemporary thinkers who dispute the claim that we have moved beyond race, and in fact see in such a claim an ideological obfuscation of continuing race privilege, and thus a contributor to racist repro-duction. Through arguments about 'cultural racism' and 'whiteness', these theorists and critics have argued for the continuing importance of race, and have emphasized the need to develop more sophisticated understandings of the often hidden workings of race and discrim-ination in many societies.

Martin Barker's (1981) idea of the 'new racism' emerged out of the British context, where British 'patriots' and conservatives argued for the cultural incongruence between British national culture and the new cultures brought to Britain by Caribbean and Indian subconti-nent immigrants after the Second World War. In a context where anti-racism arguments had achieved some success in the 1960s and 1970s, the focus on culture enabled racists to continue to justify forms of racial discrimination and exclusion. These arguments relied less on claims about biological difference, inferiority and superiority, and more on arguments about the conservation of national identity. The idea of the new racism was also taken up in France, where conservatives and nationalists – or the French new right – similarly argued for the preservation of French national culture against the cultures coming in from France's former colonies (Taguieff 1990). The idea of cultural racism has also influenced the concept of Islamophobia, coined to describe the reaction of fear and loathing of Islamic and Middle Eastern peoples in the West.

From the late 1980s a new phase of race studies emerged around the concept of 'whiteness'. This new sub-discipline had historical predecessors, including black writers like Du Bois, Fanon and the novelist James Baldwin, whose influence is apparent in the whiteness studies literature. For example, Du Bois's ideas were taken up by David Roediger (1991) in his book *The Wages of Whiteness*, especially the idea of the psychological wage that white workers get and which compensates them for the tenuous position that they inhabit within capitalist relations.

Theorists of whiteness have argued that, despite the discrediting of racism since the end of the Second World War and the dismantling of scientific racism, and despite the fact that many countries with histories of racism have now introduced anti-discrimination policies and laws, white racism persists, and supports the privileges of white people. One of the main strategies

of whiteness studies, in this respect, is to hunt out the manifold ways in which white people exercise and experience privileges because of their whiteness, and conversely to identify how societies based on white privileges, and what are seen as white norms, systematically exclude and denigrate people of colour. Whiteness, it is argued, is a hidden racial category: white people do not think of themselves as belonging to a race, but perceive race as an issue belonging to other, non-white people; they think of themselves as being without race (Dyer 1997). As Ruth Frankenberg argued in her book *White Women, Race Matters*, whites were usually 'the nondefined definers of other people. Or, to put it another way, whiteness comes to be an unmarked or neutral category, whereas other cultures are specifically marked as cultural' (1993: 197). Richard Dyer's (1997) *White* was a sustained attempt to foreground the hidden racial category of whiteness through a close reading of historical and contemporary visual culture to analyse the main images of embodied whiteness in western societies.

Most of the white women Frankenberg interviewed for *White Women, Race Matters* refused to talk about race at all, claiming that they never noticed race or colour, and in their discourses about their life experiences in American society used strategies of 'essentialization', 'colour evasion' and 'power evasion' to explain away racial difference, division and racial discomfort (Frankenberg 1993). Whiteness theorists argue that if societies imagine themselves as colour-blind, and promote that colour blindness as an egalitarian ethic, they will be blind to the continuing workings of race, including the profound inequalities produced by institutional racism, and will thus allow race privilege to flourish (Doane 2003).

Some critics, particularly those from non-white backgrounds, have challenged the development of whiteness studies by arguing that this was a way for privileged white academics and intellectuals to re-colonize the field of race and racism studies, after black intellectuals had become the leading spokespeople. White intellectuals, they argued, had found themselves on the outside of many debates, as arguments grew about the special privileges, in terms of knowledge of race and racism, that came from occupying a position of subordination in race relations. Increasingly, white intellectuals had been shut out of arguments about black identity, and told that they did not have a right to speak on such matters, or on the situation of other races and their problems, because they were white and simply could not know what it meant to be black, or the true nature of those racialized problems. The development of whiteness studies provided a space for white people to start contributing to race debates again, through explorations of their own whiteness and race privilege; and they could also feel that through those explorations they were challenging racism. New 'whiteness' conferences flowered throughout the world where white academics could go and show their new-found expertise, carefully showing the hidden power and workings of 'whiteness' through analysis of a wide range of phenomena including cultural products like film, television, photography and literature; through close analysis of everyday interaction and language; and through the close study of a multitude of government policies (Fozdar, Wilding and Hawkins 2009).

A second criticism, which is about the actual argumentation and claims of 'whiteness studies', is the way that it involves a narrowing of our understanding of complex social relations. Everything is seen as being about race. Inequalities and patterns in housing, employment, wealth, and political decision making are explained by racial conflict and competition. Much of what goes on in society can be explained by whites attempting to maintain and even improve their position of dominance, to exercise and expand their white privileges. Focusing solely on whiteness as an explanatory framework can systematically obscure from vision a range of other things that are going on; and it can also lead to a failure to look at other possible explanations for social inequalities.

American labour historian Eric Arnesen (2001), for example, is critical of the way that whiteness has come to dominate thinking about the history of labour relations and politics in the US. One common argument has been that Irish Americans who migrated to the US in the nineteenth century were initially racialized as non-white, but came to successfully assert their whiteness and thus took up a position in the racial hierarchy above black workers. Arneson points out that while the Irish were at times racialized, this also involved religion (claims about Catholicism being authoritarian and backward, for example, in a country founded by Protestants). To claim that they were not also perceived as white is simply historically wrong. The critique is also that 'whiteness' as a conscious identity was not anywhere near the main driving force behind a range of political conflicts, as whiteness theorists now claim and argue.

Third, it is argued that whiteness studies advocates a futile politics for white people that does not really achieve anything apart from masochistic self-flagellation; that it involves white people seeing that they have unfair privileges and that they should work to undo their own sense of entitlement and privilege in society, which argues naively for a politics contrary to material and symbolic interests; and moreover, that it does not give white people any sense of a more positive identity. This may be simply a reversal of the entirely damaging race dynamics that led black people to flee their blackness (in Fanon's argument) and so seek to emulate white people, an ideal that they could never achieve because of their blackness. For example, David Roediger, in *Towards the Abolition of Whiteness*, denounced the 'empty culture of whiteness' and whiteness as a 'destructive ideology'. He went on to celebrate the way that white youth were turning to hip hop music, which he claimed offered them 'the spontaneity, experimentation, humor, danger, sexuality, physical movement and rebellion absent from what passes as white culture', together with 'an explicitly, often harsh, critique of whiteness' (quoted in Arnesen 2001: 8).

The ethnic revival and theorizing ethnicity

The so-called 'ethnic revival' in the second half of the twentieth century led social scientists to renew their focus on ethnic organization, competition, conflict and politics. The assumptions about the disappearance of ethnic differences and identification that underpinned modernization theory gave way to a renewed investigation of how modernity, and modern political structures, reproduced and transformed ethnic mobilization. Group relations in culturally plural societies, both in the West and in the decolonizing societies of Asia and Africa, could not always be explained by theories and assumptions about race and race relations. People who appeared physically similar might nevertheless be divided by strong symbolic boundaries, marked by language, historical, cultural and religious differences that seemed to have nothing to do with 'race'. In many parts of the world, so-called 'ethnic conflicts' had broken out; in less conflict-ridden situations, people were asserting their ethnic identities and using them to make political claims on the state. More broadly, it was clear that ethnic labels were widely used by people as self-descriptors, and at least appeared to influence important forms of social action.

The work of Nathan Glazer and Daniel Moynihan in the 1960s blazed a new trail in ethnicity studies. They challenged assimilationist assumptions about the disappearance of ethnic communities, traditions and identities in countries of immigration such as the US. In *Beyond the Melting Pot* (1963) they treated New York as a microcosm in which new patterns of ethnic experience and identification had emerged, defying expectation of the disappearance of ethnic groups under the influence of assimilative American culture.

American acculturation did occur, they argued, but it occurred in diverse ways in accordance with different starting points, ethnic backgrounds and particular historical experiences of American life, including racism and discrimination. Two polar positions, that of cultural pluralism (separate ethnic groups reproducing themselves in the American scene in ways similar to their original ethnicities) and that of the melting pot, were equally fanciful. On the one hand, the first and later generations of immigrants did lose much of their traditional cultural habits and traditions, and even language. But, on the other hand, there were still identifiable groups based on ethnicity produced in the American scene:

> Concretely, persons think of themselves as members of that group, with that name; they are thought of by others as members of that group, with that name; and most signifi-cantly, they are linked to other members of the group by new attributes that the original immigrants would never have recognized as identifying their group, but which never-theless serve to mark them off, by more than simply name and association, in the third generation and even beyond.
>
> *(Glazer and Moynihan 1963: 13)*

The ethnic groups in New York, partly based on historical associations with ethnic/national places of origin and ethnic names, with current family, friendship and neighbourhood ties, were also based on interest. According to Glazer and Moynihan, ethnic groups were interest groups, a theme they also took up in their later edited collection *Ethnicity: Theory and Experience* (1975).

In the latter book Glazer and Moynihan (1975) noted the way that ethnicity had become a renewed focus for group formation and collective action, rivalling class and the nation in its capacity to organize people to act collectively. The rise of the welfare state after the Second World War contributed a new stimulus to ethnic group identification and organization; ethnicity became a political resource to use in the battle for political and economic gains. Even in countries where the welfare state did not exist or had only a tentative hold, there was a heightened recognition of the ways that inequalities were organized around cultural and societal norms that meant that some ethno-cultural groups were able to commandeer socie-ty's various resources disproportionately. Organization as a member of an ethnic group rather than as an individual, or as a member of a social class, was recognized as a potent tool to chal-lenge ethno-cultural hierarchies.

Other notable related interventions in the American context include Michael Novak's *The Rise of the Unmeltable Ethnics* (1973), which also challenged the belief that, once the primary groups (families, etc.) of immigrants broke down through mixing in neighbourhoods and entry into mainstream American occupational life, people's ethnicity would disappear. Instead he found that ethnicity flourished in the American scene, and his book was a celebra-tion of ethnic diversity as an antidote to the dull, homogenizing forces of American life, including the dominant White Anglo-Saxon Protestant (WASP) culture, and to atomizing, industrial modernity more generally. Rather than seeing ethnic identification as a defensive posture, as a phenomenon born of fear, he argued that it should be embraced for the way that it unleashed the potential of the imagination: 'The *right* reason to promote ethnicity is that it offers resources to the imagination' (Novak 1973: 82). And nor was focusing on particular-istic identities necessarily limiting:

> it does not seem evident that by becoming more concrete, accepting one's finite and limited identity, one necessarily becomes more parochial. Quite the opposite. It seems

more likely that, by each of us becoming more profoundly what we are, we will find greater unity in those depths in which unity irradiates diversity than we will by attempting, through the artifices of the American 'melting pot', and the cultural religion of science or the dreams of radical utopias, to become what we are not.

(1973: 84)

Novak's book was, in part, a self-conscious exploration and celebration of his own non-WASP, Catholic, Slovakian ethnic identity, and of his membership of the PIGS (Poles, Italians, Greeks and Slavs), who had so often been encouraged, and even required, to hide their ethnic difference in public, while continuing to celebrate and express it in private. *The Rise of the Unmeltable Ethnics* focused on 'white ethnics', many working class in background and orientation, who Novak argued had been either ignored or vilified by mainstream cultural and intellectual elites in America, even as they paid lip service to the honouring of more exotic black, Chicano and Indian ethnic cultures (Novak 1973: 69). The 1970s was to be, he argued, a period of ethnic liberation.

One criticism of Novak's work was that in his conservative, defensive celebration of white ethnics he both underplayed and exacerbated the sources of racial conflict in America. While he recognized that there was a level of resentment of black and other racial minorities by white ethnics, he defended the latter against attacks from liberal intellectuals who labelled them racists. He argued that, if a Pole could fully experience him or herself as a Pole, then he or she would be able to look a militant black man square in the eye. This, however, downplayed the vast difference between the situation and level of discrimination experienced by black Americans and other racial minorities, and also underestimated the extent to which the assertion of white ethnicity in the 1970s was a reaction to the black power movement, and to broader anti-racist struggles more generally (Waters 1990: 157).

Such developments highlighting ethnic group identity became associated with what has come to be called 'identity politics', which goes beyond ethnic to include racial, gender, sexual, gay and lesbian identities. The ethnic form of identity politics has been criticized for the ways that it stimulates ethnic enclaves that can be destructive of broader national commitments and solidarities, inhibits assimilation and broader societal integration, and also imprisons the individual in communities closed off from wider society, and women in patriarchal structures. For social democrats, identity politics in the form of multiculturalism has been criticized for the ways that it has displaced broader civic identities and solidarities, including class-based solidarities broadly concerned with economic inequality. According to one of the leading left critics, Tod Gitlin, after the 1960s the left had fragmented, and people had become obsessed with parading, proclaiming and defending their distinctive identities. This separatist development undermined the meaning of any kind of left, which, he argued, had ultimately to rely upon some notion of a common people beyond differences, upon a 'culture of commonality' (Gitlin 1995: 217).

The 'ethnic revival' argument has been challenged by accounts that stress the lightness with which ethnic identity can be held in plural, ethnically mixed societies. For example, Herbert Gans, in his influential and provocative essay 'Symbolic ethnicity: the future of ethnic groups in America' (1979), claimed that there had been no ethnic revival since the 1960s. Instead, he argued that assimilation and/or acculturation continued apace in American life, but at the same time indicated new ways that ethnicity had become relevant to people's lives. Gans argued that, especially for the third and fourth immigrant generations in the US, ethnicity is expressed symbolically, as emblems and talismans, and in festive events like St Patrick's Day, rather than being a deeply structuring feature of a person's individual and social

life. In part this is because of the broad assimilatory aspects of American life, including broad incorporation into the educational and occupational structures. Symbolic ethnicity becomes a feature of the lives of people from immigrant backgrounds as ethnic organizations diminish in importance as institutions structuring people's everyday lives. Gans was careful to focus his argument on 'white ethnics' who were able to pass into white-dominated American society, and noted that the experiences of racial groups, like African Americans, were very different.

In a similar vein, and inspired by Gans's initial insights about the symbolic nature of some ethnic expression and experience, Mary Waters (1990) has argued for the notion of 'ethnic options', related to the dilution of everyday ethnic group life, and the fact of extensive inter-marriage between people from different ethnic backgrounds. Waters argues that people's ethnic identification could intensify or weaken at different points in their lives, or even shift between identities if they were of mixed ethnic ancestry. In an interview-based study of white, middle-class suburban Americans, she found that ethnicity was an identity option chosen in a voluntary fashion by individuals to suit their current identity needs and their need for community, and that the choice of such ethnic options came at little cost to the individual (Waters 1990: 164). She recognized that this experience of identity was very different from the experience of identity that is typically referred to as racial in character, in the US context for people from black, Asian or Hispanic backgrounds for example, who appeared physically different from white Americans. The white ethnics' experience of ethnicity as symbolic, costless and voluntary led them to underestimate the ways that ethnicity and race worked for those from less advantaged backgrounds, thus leading them to underplay discrimination and the need for anti-discriminatory and affirmative action legislation to confront the effects of racism, and therefore contributing to the reproduction of hierarchical racial and ethnic relations (Waters 1990: 160–64).

Symbolic ethnicity and the 'ethnic options' approach have been criticized by other authors. Inspired by the work of Bourdieu and in particular the concept of habitus, a set of embodied dispositions and capacities that give us a 'feel for the game', Anagnostou (2009) has argued that ethnicity is less a matter of option or choice, and more a lived, embodied experience. He argues that a focus on working-class and subordinate ethnic experiences reveals a different picture of ethnicity and ethnic identity than that depicted by Gans and Waters.

Finally, there has been a renewed focus in more recent literature on 'dominant ethnicity' in culturally plural societies. According to Ashley Doane, a dominant ethnic group is

> the ethnic group in a society that exercises power to create and maintain a pattern of economic, political, and institutional advantage, which in turn results in the unequal (disproportionately beneficial to the dominant group) distribution of resources. With respect to intergroup relations, a key element of dominance is the disproportionate ability to shape the sociocultural understandings of society, especially those involving group identity and intergroup interactions.
>
> *(Doane 1997: 376)*

This argument is sometimes closely associated with whiteness studies, and in fact Doane has himself been an important contributor to that field of study. But other prominent figures such as Eric Kaufmann (2006) have strongly distanced their account of dominant ethnicity from whiteness, which is seen as too closely associated with race, and which is not always relevant for dominant ethnicity. The argument is that nations have been organized around dominant ethnicities (for example, the US around WASP identity, or Australia around a dominant,

British-derived Anglo ethnicity). When the cultural dominance of this ethnicity is challenged within nations, for example by later immigrant groups or longstanding minority ethnic groups, conflicts can erupt based on control and preservation of the nation. According to Kaufmann, 'whiteness' is often peripheral to these conflicts.

Future developments

Though the initial interventions by black feminists now date back thirty or more years, with the early work of bell hooks and Patricia Hill Collins in the US and Hazel Carby in the UK, feminists from non-white backgrounds, including Indigenous and other postcolonial backgrounds, continue to stimulate thinking about the complex intersections between race, class, gender, sexuality, migration and late colonial/postcolonial conditions. The work of black feminists and other women from non-white backgrounds has sometimes married insights from whiteness studies with insights from feminism and postcolonialism to challenge forms of racialized gender dominance that had been ignored, or obscured, by other forms of feminism, and within mainstream anti-racism discourses.

The study of 'everyday racism', associated with writers including Philomena Essed, has brought new emphases to the study of racism in supposedly post-racist, liberal democratic societies. Essed's book *Understanding Everyday Racism* (1991) was based on interview research conducted with black women in the US, and with black Surinamese first-generation immigrant women in the Netherlands. Examples of everyday racism discussed by Essed include the treatment of people of colour by hotel receptionists; everyday experiences of abuse in the streets; the use of stereotypical put-downs, even if these are meant to be jokes; the avoidance or ignoring of people of colour in white-dominated societies; and not taking people seriously because of their colour. The argument here is that, though many countries have put in place policies directly aimed at outlawing racism and racial discrimination, racism continues to operate in the tissues of everyday life – and further, that it is the victims who should be listened to, because it is only really they who can understand the way that racism continues to work its way through everyday social situations. Many white people, for example, are not even aware that they are being racist in some of their actions; it is as if, having grown up in societies organized by race, and by racial hierarchy, they subconsciously or unconsciously reproduce those racial hierarchies through their actions, words and gestures.

Writers emphasizing diasporic, transnational, multicultural and cosmopolitan experiences and positionings continue to disrupt notions of fixed ethnic and racial identity. These writers reflect on the complex world ushered in by globalization, mass migrations and intensified modes of communication, which have meant that ethnic, national and racial identities and experiences often stretch across the globe, disrupting former notions of territorialized identity, home and belonging. There are many important contributors here, and some worthy of mention include Stuart Hall and Paul Gilroy (as discussed above); Steven Vertovec with his work on 'super-diversity'; Floya Anthias with her work on 'translocational positionality', which changes the emphasis of ethnicity studies from identity to spatial and temporal positionings; Pnina Werbner's work on everyday working-class cosmopolitanism and hybrid forms of ethnic identity; and Kwame Anthony Appiah's work on cosmopolitanism, including his arguments about cosmopolitan patriotism and rooted cosmopolitanism.

The renewed attention to dominant ethnicity discussed earlier is also a developing area of study that helps explain some of the politics surrounding national identity and immigration in Europe, with the rise of nationalist right-wing movements, and also some of the agitation against multiculturalism. This work has also proven useful in exploring developments in

Eastern Europe and the former Soviet Union, where ethnic tensions, conflicts and wars have been experienced since the collapse of communism (Kaufmann 2004).

Conclusion

The progress of globalization continues to disrupt and transform group life, but it can hardly be argued that we now live in a post-racial or post-ethnic world. Racial and ethnic identities and social formations now stretch over vast distances, stimulated by diasporic, transnational and cosmopolitan experiences related to immigration and intensive, often instant communication. But racial hierarchies persist within many societies, and the hidden workings of racism continue to distort people's lives and structure their opportunities. The colour line proclaimed by Du Bois to be the problem of the twentieth century continues to find expression in the experiences of poverty, disadvantage, disease, war, violence and early death that distinguish the plight of many people of colour from the lives of white people who live in the wealthy, white-dominated West. The claims of ethnicity continue to inspire people in multiethnic, multicultural nation-states. For these reasons, theorizing about race, racialization and ethnicity continues to be relevant in the twenty-first century.

References

Alexander, C. (2009) 'Stuart Hall and race', *Cultural Studies*, 23(4): 457–82.

Anagnostou, Y. (2009) 'A critique of symbolic ethnicity: the ideology of choice?', *Ethnicities*, 9(1): 94–122.

Anderson, B. (1991) *Imagined Communities: Reflections on the Origin and Spread of Nationalism*, 2nd edn, London: Verso.

Arnesen, E. (2001) 'Whiteness and the historian's imagination', *International Labor and Working-Class History*, 60: 3–32.

Balibar, E. and Wallerstein, I. (1991) *Race, Nation, Class: Ambiguous Identities*, London: Verso.

Barker, M. (1981) *The New Racism*, London: Junction Books.

Barth, F. (ed.) (1969) *Ethnic Groups and Boundaries: The Social Organisation of Culture Difference*, London: Allen & Unwin.

Bauman, Z. (1989) *Modernity and the Holocaust*, Cambridge: Polity Press.

Bernasconi, R. (2009) 'Who invented the concept of race?', in L. Back and J. Solomos (eds) *Theories of Race and Racism: A Reader*, 2nd edn, London: Routledge.

Centre for Contemporary Cultural Studies (1982) *The Empire Strikes Back: Race and Racism in 70s Britain*, London: Hutchinson, in association with the Centre for Contemporary Cultural Studies, University of Birmingham.

Commission on the Future of Multi-Ethnic Britain (2000) *The Future of Multi-Ethnic Britain – The Parekh Report*, London: Profile Books.

Doane, A. W. (1997) 'Dominant group ethnicity in the United States', *Sociological Quarterly*, 38(3): 375–97.

—— (2003) 'Rethinking whiteness studies', in A. W. Doane and E. Bonilla-Silva (eds) *White Out: The Continuing Significance of Race*, New York: Routledge.

Du Bois, W. E. B. (1966) *Black Reconstruction in America*, New York: Russell & Russell.

—— (1975) *Darkwater: Voices from Within the Veil*, Millwood, NY: Kraus-Thomson.

Dyer, R. (1997) *White: Essays on Race and Culture*, London: Routledge.

Essed, P. (1991) *Understanding Everyday Racism: An Interdisciplinary Theory*, Newbury Park, CA: Sage.

Fanon, F. (2008) *Black Skin, White Masks*, New York: Grove Press.

Fozdar, F., Wilding, R. and Hawkins, M. (2009) *Race and Ethnic Relations*, South Melbourne: Oxford University Press.

Frankenberg, R. (1993) *White Women, Race Matters: The Social Construction of Whiteness*, Minneapolis, MN: University of Minnesota Press.

Gans, H. (1979) 'Symbolic ethnicity: the future of ethnic groups in America', *Ethnic and Racial Studies*, 2(1): 1–20.

Gates, H. L., Jr (1986) 'Editor's introduction: writing "race" and the difference it makes', in H. L. Gates, Jr (ed.) *'Race,' Writing and Difference*, Chicago: University of Chicago Press.

Gilroy, P. (1987) *There Ain't No Black in the Union Jack: The Cultural Politics of 'Race' and Nation*, London: Hutchinson Education.

—— (1993) *The Black Atlantic: Modernity and Double Consciousness*, Cambridge, MA: Harvard University Press.

—— (2000) *Against Race: Imagining Political Culture Beyond the Colour Line*, Cambridge, MA: Belknap Press of Harvard University Press.

Gitlin, T. (1995) *The Twilight of Common Dreams: Why America Is Wracked by Culture Wars*, New York: Metropolitan Books.

Glazer, N. (1983) *Ethnic Dilemmas 1964–1982*, Cambridge, MA: Harvard University Press.

Glazer, N. and Moynihan, D. (1963) *Beyond the Melting Pot: The Negroes, Puerto Ricans, Jews, Italians, and Irish of New York City*, Cambridge, MA: MIT Press.

—— (eds) (1975) *Ethnicity: Theory and Experience*, Cambridge, MA: Harvard University Press.

Goldberg, D. T. (1993) *Racist Culture: Philosophy and the Politics of Meaning*, Cambridge, MA: Blackwell.

Hall, S. (1980) 'Race, articulation and societies structured in dominance', in UNESCO (ed) *Sociological Theories: Race and Colonialism*, Paris: UNESCO.

—— (1991) 'Old and new identities, old and new ethnicities', in A. D. King (ed.) *Culture, Globalisation and the World-System: Contemporary Conditions for the Representation of Identity*, Minneapolis, MN: University of Minnesota Press.

—— (ed.) (1997) *Representation: Cultural Representation and Signifying Practices*, London: Sage, in association with Open University.

Hall, S. and Back, L. (2009) 'At home and not at home: Stuart Hall in conversation with Les Back', *Cultural Studies*, 23(4): 658–87.

Hall, S., Critcher, C., Jefferson, T., Clarke, J. and Robert, B. (1978) *Policing the Crisis: Mugging, the State and Law and Order*, London: Macmillan.

Kaufmann, E. P. (ed.) (2004) *Rethinking Ethnicity: Majority Groups and Dominant Minorities*, New York: Routledge.

—— (2006) 'The dominant ethnic moment: towards the abolition of "whiteness"?', *Ethnicities*, 6(2): 231–66.

Malik, K. (2008) *Strange Fruit: Why Both Sides Are Wrong in the Race Debate*, Oxford: One World Publications.

Miles, R. and Brown, M. (2003) *Racism*, 2nd edn, London: Routledge.

Novak, M. (1973) *The Rise of the Unmeltable Ethnics: Politics and Culture in the Seventies*, New York: Macmillan.

Omi, M. and Winant, H. (1994) *Racial Formation in the United States: From the 1960s to the 1990s*, 2nd edn, New York: Routledge.

Roediger, D. R. (1991) *The Wages of Whiteness: Race and the Making of the American Working Class*, London: Verso.

Smith, A. D. (2009) *Ethno-Symbolism and Nationalism: A Cultural Approach*, London: Routledge.

Taguieff, P.-A. (1990) 'The new cultural racism in France', *Telos*, 83: 111–22.

Waters, M. (1990) *Ethnic Options: Choosing Identities in America*, Berkeley, CA: University of California Press.

Weber, M. (1997) 'What is an ethnic group?', in M. Guibernau and J. Rex (eds) *The Ethnicity Reader: Nationalism, Multiculturalism and Migration*, Cambridge: Polity Press.

18

Media and cultural identity

Nick Stevenson

A Brechtian maxim: 'Don't start from the good old things but the bad new ones'.
(Benjamin 1998: 121)

Historical and intellectual development

The technological innovation of contemporary forms of communication has been one of the most startling developments of modern times. In living memory for many contemporary citizens is a world before the Internet, DVD players, downloading music, blog sites, multi-channel television, real-time global communication and digital cameras. Perhaps more so than any other area of our shared cultural life, communications technology has changed very quickly. This then is the first media saturated society. Yet, as we shall see, it is very easy to get carried away with a sense of change and transformation. Here I shall argue that if the media landscape has indeed changed and is continuing to change, there is no need to assume that the critical project in respect of the media of mass communication has entirely altered. Previous generations of critics from Walter Benjamin to Raymond Williams and from Jürgen Habermas to Bertold Brecht have sought to press for an agenda of a radically democratised communications system. The terms of this debate may have radically altered, but its essential features have arguably remained the same. Here I shall argue for the critical recovery of a diverse tradition of thinking that spans both critical theory and cultural studies and that remains central to the future of a more emancipated system of media power. This agenda has radical implications for the ways in which we understand our shared identities as democratic citizens and consumers of media cultural identity more generally. In terms of the relationship between media and cultural identity, the important question remains the extent to which we are able to perceive ourselves as civic actors in an increasingly complex mediascape. To what extent, then, does the media of mass communications aim to foster democratic and critical identities amongst its citizens? This raises a number of inter-related questions which are crucial to the formation of contemporary identities. That is, despite the recent pluralisation of the media of mass communication, the crucial questions in respect of media remain related to voice, autonomy and empowerment. Here I shall seek to investigate the extent to which questions of ownership and control, the technological development of modern media, the mix between public and private media, the commodification of the media and the development of a genu-inely citizens' media might all be said to impact upon questions of media and cultural identity. Here we need to ask to what extent citizens are encouraged to view the media as a means of democratic communication, and alternatively to what extent they are positioned as passive consumers of information within a centrally controlled communication system whose

priorities are largely determined by the respective roles of the economic system and the state. Here we might wonder to what extent media can become a voice for civic protest, alternative perspectives and projects other than those sanctioned by the powerful and influential. In this respect then I shall investigate the role that the media of mass communication plays in respect of the development of social and cultural identities.

Major claims and development: Benjamin, Brecht and Adorno

Writing in the context of the 1930s, both Walter Benjamin and Bertold Brecht made seminal contributions to questions of media, cultural identity and democracy. Arguably Benjamin's great critical insight was that new mediums of communication could actually enhance the development of democratic sensibilities. The model of dialectic thinking that is offered here suggests that if capitalism sought to colonise the media to its own ends, then a more democratic system of media making should seek to release the emancipatory potential latent within new forms of communication. When Benjamin and Brecht were writing in the 1930s, the arrival of the radio, cinema and the camera seemed as pregnant with possibility as new media does today. In particular, both Benjamin and Brecht argued that it was the institution of the division of labour between the producers and the consumers of media that undermined its democratic potential. Media needs to be emancipated from a world where citizens are reduced to being passive listeners and consumers of mass-mediated messages. This they argued can only be achieved if they are able to realise their identities as cultural producers of meaning rather than being merely consumers. If much critical thought during this period could only see the media's role in manipulation, both Brecht and Benjamin pointed towards a more democratic arrangement. The problem with fellow critical Marxist thinkers was that they overwhelmingly saw the media as the site of manipulation and control and were therefore unable to adequately account for how more critical forms of understanding might emerge from within the masses themselves. Crudely put, this view tended to suggest that if the capitalist class owns and controls the large conglomerates that control the economy, then the same could also be said of the media. Hence just as capitalism seeks to run the economy according to the interests of the rich and powerful, its media are unlikely to carry critical or alternative perspectives, preferring instead to propagate views sympathetic with the status quo. However, what Benjamin and Brecht perceived was that if media technology was intrinsically authoritarian and served the interests of capitalism, how could a more democratic system emerge at some point in the future? If capitalism simply imposed a commodified, homogeneous mass cultural identity upon the masses, then it was difficult to perceive how an alternative system of communication might emerge. Indeed, if the fear was that the 'new consciousness industry' had entirely saturated the critical potential of modern society, both Benjamin and Brecht suggested that this was far from the case. In criticising an increasingly capitalist-dominated and authoritarian media system, many critical thinkers had overstated the closed nature of the media and failed to acknowledge its potential for transformation.

Brecht and Benjamin perceived critical potential within the development of a genuinely mass popular cultural identity made up of new technologies. Indeed, unlike more artistic endeavours such as painting and writing, the new media of the 1930s were not restricted to the educationally privileged classes. Both Benjamin and Brecht were excited by the prospect of simple and seemingly easy-to-use technological forms that could potentially enable ordinary citizens to become writers as well as readers. The key to producing more democratic identities lay less in the actual media content and more in the social relations entered into in shaping, producing and receiving media content.

For Benjamin (1973) the development of new media had shattered the hold of more traditional artistic forms. The transportability of images through time and space, the decline in 'aura' of high art, the endless possibilities involved in the reproduction of images and the possibilities heralded by the rise of the popular cultural identity meant that 'at any moment the reader is ready to turn into a writer' (Benjamin 1973: 225). In particular, Benjamin offers a key comparison between the cameraman and the painter. For Benjamin, whereas the painter offers a contemplative view of reality, the cameraman seeks (like a surgeon) to cut into it. New media forms should not be dismissed as simply imposing false consciousness, or indeed as forms of manipulation, but carry within them the seeds of a more emancipated and participatory society. This does not (as many have sought to claim) convert Benjamin into being a technological optimist. Instead, Benjamin was interested in the technological developments of the 1930s as they potentially enabled ordinary people to become authors, thereby democratising the production of culture. Here Benjamin (1978) argues that the politics of a work of art or cultural artefact is less about the ideological position of the text and more about whether it enables the oppressed to become their own authors. Benjamin was rightly suspicious of those who sought to exchange the rule of capital for the rule of well-intentioned intellectuals, whatever their political sympathies. A more democratic system of communication requires new institutional arrangements and a deep questioning of processes of professionalisation and specialisation in the production of culture. In the process of converting readers into authors and consumers into citizens, Benjamin drew directly from a number of features that are evident in Brecht's epic theatre. Cultural producers are urged to use a number of techniques to shock members of the audience into thinking for themselves. The idea of Brechtian theatre was to stir the audience, through certain 'alienation' effects, into assuming a critical, active and reflective disposition. Brechtian theatre classically did this by seeking to remind the audience that they were watching a play (thereby pointing to the artificiality of the setting), by punctuating the flow of the performance through the use of songs and other features, by making the 'ordinary' seem strange and by locating the 'action' in a field of social relationships. All these features Brecht hoped would prevent the audience from viewing works of art as mind numbing forms of mass entertainment. For Brecht and Benjamin, much bourgeois talk about art in the context of the rise of fascism had a self-indulgent tone. The critical task of the present was not to worry about the preservation of 'aura' of the artist but to politicise and democratise art to build a more democratic society. Particularly important at this juncture is the celebrated dispute between Benjamin and Adorno on the nature of art in the context of a capitalist society.

Adorno's (1991) writing on the cultural identity industry sought to outline the impact of capitalism on the production of culture. As Adorno explained through a number of critical modes and essays, the effects of the capitalist mode of production upon cultural identity were almost entirely negative. Adorno's (1991) notion of the cultural identity industry argued that processes of mass production were coming to dominate the cultural sphere. This led to the dominance of instrumental forms of reason coming to administer, control and produce a superficial consumer culture. The dominant cultural identity of capitalism of the 1930s and 1940s sought to repress all forms of conflict, heterogeneity and particularity from the cultural sphere. Here what becomes valued is the exchange of cultural identity over the quality of culture. Mass produced cultural identity is commodified and produces a regressive desire on the part of the audience for the same over and over again. However, despite the critical importance of these arguments, they can seem problematic in more democratic contexts and settings. For example, Adorno's remarks on the jazz of the 1930s describe it as trading upon easily learnt formulas and standardised procedures. If jazz might be viewed positively as

erasing the boundary between high and low culture, Adorno argues that such features replace the prospect of autonomous art with the lowbrow. While Adorno's writing is meant to provoke the reader into critical forms of reflection by pointing to the effects of the progressive commodification of culture, many have been critical of its high cultural tone and lack of democratic resonance. Often missing from these formulations, arguably evident in Benjamin, is a more ambivalent understanding of contemporary cultural technologies.

Habermas and Williams

The debate between Adorno and Benjamin was to play a part in shaping the political writing of a later generation of critical theorists and cultural thinkers, namely Jürgen Habermas and Raymond Williams. Habermas's (1989) idea of the public sphere is a central concept in the development of social and cultural theory and media studies. Habermas's work on the public sphere provides a historical account of the development of the crucial role played by civic spaces such as coffee houses and salons in the eighteenth century in helping to provide the context for the development of democratic ways of life. The purpose of the public sphere was to allow citizens to critically reflect upon themselves, civil society and the practices of the state. It allowed the bourgeoisie, nobles and intellectuals to meet to discuss works of literature, and later more overtly political affairs. While recognising that questions of public discourse were restricted to an elite, Habermas argued that they had a historic critical potential. This was mainly through the establishment of the idea of justification through the use of public reason. The public sphere helped solidify the notion necessary for democracy of the importance of critical forms of engagement with public questions by citizens. It is this that helps establish the foundation of modern democratic societies. Yet the public sphere was a fragile construction, and after the rise of conglomerate capitalism it was replaced by more overt forms of manipulation. After the 1870s, the democratic potential of the public sphere became progressively undermined as the press were run on more overtly commercial lines. The rise of the mass media in the early part of the twentieth century not only eliminated more public forms of discussion but also produced cultural texts where there was little possibility of the audience answering back. Yet contrary to Benjamin, Habermas claims that notions of 'aura' have not been defeated by the invention of new technological forms. The new stars of the media age are well-known personalities, celebrities and charismatic politicians. Indeed, we shall see in the next sections in respect of the debates on the society of the spectacle just how far these processes seem to have gone. Here the importance of rational dialogue had been marginalised by the dominance of mediated mass entertainment. If then Habermas builds upon Adorno's critique of Benjamin, he also criticises Adorno for ignoring the critical potential of ordinary speech and language that could be developed in democratic contexts.

Habermas (1996) was to revise these arguments by moving away from the idea that the public use of reason had been effectively colonised by the operation of money and power. In his later work, Habermas recognises there are actually a number of competing public spheres operating on different levels. These could be global, national or local in orientation and included a number of cultural practices from the theatre, television, the press and popular music, amongst other media. However, Habermas continued to argue that possibilities to get your voice heard and participate in the public sphere were unequally distributed within society. Public opinion is predominantly shaped by powerful vested interests such as spin doctors, pollsters, media moguls and media-trained politicians. However, many of these voices were contested by civil actors from the non-governmental sector who were capable,

depending upon the context, of getting different views and perspectives onto the agenda. The public sphere is an endlessly contested domain where democratic politics is a matter of ongoing controversy. The public sphere in any democratic society needs to be able to focus on a wide range of public arenas on specific questions. Only then through energetic public discourses and civic engagement can democracy be said to become realised as a practice.

Despite Habermas's concern to rethink his earlier work, many have noted its overly rationalistic orientation. The point of engaging in the public sphere is sometimes reduced to the cold exchange of reasons and the need to find agreement amongst a diversity of opinion. What is missing here is a critical politics of voice and learning. If we view the idea of the public sphere through a more pedagogic frame of reference, we need to consider who is empowered to speak, who is silenced and whose voices are rendered Other. Further, what does it mean to produce an 'opinion' and what are the limits of what can be said in public? What role do different artistic forms of expression play in this process and how does this relate to the more formal public sphere? Also, how might more marginal voices and communities become empowered within media debates and on-going forms of controversy? Notably these questions never become central in Habermas's thinking. Elsewhere these concerns have been called cultural citizenship (Stevenson 2003). Here a number of scholars have begun to explore a critical politics of respect. What becomes significant at this juncture is a critical politics of voice, listening and democratic engagement. None of these concerns are adequately dealt with through a paradigm that is overly driven by the ability to reason and argue. Indeed, as we shall see, these features are more closely associated historically with the work of Raymond Williams.

Raymond Williams (1962) coined the idea of the 'long revolution' in the early 1960s. For Williams, liberal democratic national societies were unable to fully incorporate the creative and dialogic potential of all of their citizens. For Williams, the dominant capitalist system had sought to progressively introduce a system of communication and learning where the interests of markets and commerce were predominant. Williams (1980) witnessed first-hand the rapid development of a modern consumer society built upon fantasy and magic seeking to induce citizens to construct their imaginary lives around the need to consume. The capitalist-driven societies of the 1960s witnessed the rapid development of commercial television, magazines, suburban living and privately owned motor vehicles and the logic of consumption spreading into other domains such as the political system. While this period also saw the rise of a number of more sub-cultural developments that became associated with music and new forms of radical culture-politics such as the politicisation of race and gender relations, these were subordinate to new accumulation strategies introduced by the dominant capitalist system. Further, this period also witnessed the partial erosion of earlier distinctions between a literary cultural identity and a mass-produced consumer culture. In this respect, Williams was a distinctive voice, given that his analysis is critical of a cultural conservatism evident on the Left and the Right that sought either to take refuge in the superiority of literature or simply to celebrate the development of new means of communication as opening out a more liberated society. It was not that Williams was unaware of the critical potential of literature, but that, as with Benjamin and Brecht before him, the rise of new media (this time television) offered new opportunities for the development of democratic criticism. Avoiding the twin logics of cultural elitism and technological optimism, Williams was mainly concerned with the development of a society based upon the principles of equality, solidarity and a shared democratic civic status. The progressive intrusion of the power of certain commercial images and brands all selling the consuming life sought to persuade ordinary people that their primary identities were those of consumers rather than citizens. It was here that Williams

began to perceive the different interests that prevail within private as opposed to genuinely public systems of communication.

Williams's writing is also attentive to the need to produce a society based upon the 'common good' where all individual citizens have the possibility of developing their own voices and critical perspectives within a shared democratic context. This could not be a society that was overly driven by the logic of capitalism, given its need for consumers, hierarchy and tendency to restrict education to training for the labour market. A genuinely democratic society required a media and education system that would help sustain a politics of voice, critique and dialogue. Such features evidently could not be solely delivered by a democratic communication system, but would require that the idea of democracy find expression within the work place, the home, the education system and within other dominant social and cultural institutions.

Further, Williams recognised that the media of mass communication was technologically organised in such a way that meant that most of the information that people received flowed from the centre to the periphery. This one-way flow of information was objectionable as it left many citizens passive in the construction of the central meanings of the media. The commercial as well as the public broadcasters had all helped construct a system of communication where the many attended to the voices, opinions and images of the few. Williams perceived this to be a form of social and political control that a more emancipated society would need to overcome. Williams (1980: 62–63), pre-empting much current debate on alternative media, argued that a more democratic and inclusive society required 'not only the general "recovery" of specifically alienated human capacities' but also 'the necessary institution of new and very complex communicative capacities and relationships'. This was a critical politics that insisted that a democratic society would require citizens who not only were following public debates, but had also taken the extra step to become cultural producers and participants in their own right. A democratised society required a politics of voice and the provision of complex public spaces where citizens could potentially share their experiences, critically interrogate the status quo, and of course listen to a complex republic of voices and critical perspectives. The media should be a place where we learn to listen, criticise and produce our own views and perspectives. It was for these reasons that Williams (1980: 62) thought that a democratised society would require more complex forms of communication than existed under capitalism. If the long revolution could be defined as the progressive development of 'an educated culture', then Williams (1962: 176) rightly stressed the importance of mediated forms of communication. As Williams recognised, the media of mass communication were important not only because of the impact they could be said to have on our collective and personal culture, but also because they could highlight latent critical possibilities and alternative ways of living. The media in terms of its wider role within society was the most powerful 'educator' of our shared sense of self and common cultural identity that had yet been produced by modern society. Williams analysed modern media cultures in terms of their ability to communicate a sense of our shared identities as consumers or citizens and their capacity to construct pedagogic and communicative relationships.

Main criticisms

The main argument thus far has been about how to link a critical understanding of the media of mass communication to the formation of cultural identity in a way that is in keeping with the critical spirit of democratic societies. These concerns then arguably go far deeper than the consideration of how cultural identity might be mobilised by particular television programmes

or by the ownership of new media-related technology. Notably questions of communication, ownership and control, technology and the wider purpose of the media are all at stake here. Here I wish to more critically evaluate some of these arguments.

Adorno does make some important criticisms of the work of Benjamin and Brecht. As Richard Wolin (1994) notes, Adorno was worried that the implication of the position outlined by Benjamin and Brecht was that art and cultural identity were potentially reduced to a form of propaganda. Whereas for Adorno, art has a potentially utopian role to play to the extent to which it can resist dominant forms of instrumental reason. Further, Adorno was concerned about what happens in Benjamin's and Brecht's analysis to works of art that are labelled politically unprogressive. Adorno then is clearly worried about the political effect of arguments such as those of Benjamin and Brecht on autonomous art. Indeed, if Benjamin's and Brecht's arguments are pushed to their logical conclusion, we may end up with a cultural sphere where citizens are active producers but mainly see themselves as consumers producing commodified products. This is perhaps to push the argument further than Adorno intended, but is certainly in keeping with the spirit of his criticism. Benjamin in particular overestimates the power of technology to empower a new generation of cultural producers, perhaps underestimating its potential to act as a form of manipulation. In this respect, Adorno points to the ways in which new technologies such as film are connected to the power of the cultural identity industry that reduces art to the narrow margins of profit and loss. Yet in retrospect, while these are important correctives to the argumentative flow of Brecht and Benjamin, it is the seeds of their criticism we can see coming to fruition in later democratically orientated theorists. Undoubtedly Benjamin and Brecht invested too much in the democratic possibilities of media technology, and yet the link that is made here between cultural identity and alternative forms of media production is crucial. As Enzensberger (1970) argues, Adorno's position could well persuade critical thinkers to take refuge in an arts and crafts type of movement rather than to seek to democratise the flow of communication. Adorno's argument is criticised for inadequately appreciating the complexity of technological forms and simply viewing them as commodities. Further, becoming overly concerned with an 'art for art's sake' disposition would fail to politicise the production of art and cultural identity more generally. For Enzensberger, radical attempts to democratise the production of media and cultural identity require civic activists to get their hands dirty and produce alternative cultural forms rather than simply becoming resentful of the ways in which new technological forms are undermining older media. A democratic and indeed socialist strategy in respect of the media is not simply emancipation by technology, but would require the construction of new learning possibilities. This can only be achieved by ordinary members of the public turning new media to civic purposes. This would require a media that did not so much flow from centre to periphery but empowered citizens to produce less authoritarian media structures that developed new networks of communication.

Further, Williams (1989) remains connected to the critical project formulated by Benjamin and Brecht focusing on both how the critical potential of new media had yet to be realised in the present and how a new generation of radical dramatists (such as Ken Loach and Dennis Potter) were seeking to radicalise television through what he called a 'realist' structure of feeling. Williams argued, like Brecht, that this is less naivety about dramatic modes of representation and more an attitude towards the world that promotes a political viewpoint, and offers the possibility of agency and civic momentum. Like Benjamin and Brecht, Williams was concerned to promote a democratic politics of voice that lapsed neither into cultural pessimism nor into technological optimism. An active and vibrant public sphere depends upon a civic realm built less upon indifference and more upon the creation of an active and participatory citizenship.

Williams's politics then were shaped by a broader Left project to democratise systems of public service broadcasting and of course develop a strong civic sphere where the state might be expected to fund alternative artistic and creative ventures without necessarily making a profit. In this respect, Williams was never dismissive of new technological inventions, always seeing within them possibilities for more complex communicative relations and for democratic criticism. In particular, Williams, like many on the New Left, was particularly keen to democratise the idea of public service broadcasting. Notably the idea of a public service broadcaster was not exclusive to the British, with many other democratically inclined citizens seeking to make similar cultural provision within their own societies. What Williams and others liked about the BBC (and later Channel 4) was that it was not dominated by commercial concerns and had historically sought to promote an agenda that was dedicated to 'serious' cultural identity and quality forms of information while encouraging citizens to participate within democratic debates and national forms of identification.

However, since the 1960s there had been a number of key cultural transformations that might be said to have changed the dimensions of the long revolution. If the good society is a society built upon the development of critical and educated perspectives by its citizens, then such features have been overtaken by a number of developments. On the one hand, the development of the Internet and associated media technologies has helped foster a communicative society unlike any seen before. The prospect of masses of people producing their own critical perspectives and engagements is a real possibility in a mass computer society. This, as much democratic criticism has recognised, offers real critical potential for the cultural identity and society of our own times. Also Williams's dream of the educated and participatory society was an overwhelmingly national political vision and would need to be reconstituted in a more global age. The development of global forms of communication increasingly enables the recognition of a diversity of ways in which national publics are connected to an emergent planetary society. As we shall see, this shared sense of global interconnection has arguably reconfigured the domain of radical politics. Further, the increasing penetration of the market into everyday life, class polarisation, the increasing commercialisation of broadcasting and the development of a conservative agenda within education has served to push more critical and democratic questions off the agenda. While these are all key transformations, I shall argue that Williams's central argument that sought to connect the development of communications with the potential development of an educated democracy is still valid. However, while Williams more keenly recognises the threat of commercial media than Habermas (this is certainly true of his more recent writing), neither perhaps gives enough recognition to the powerful interconnections between media, technology and the power of capital to commodify communication.

Notably, the relative decline of public forms of media and the rapid development of new media technologies that are mostly commercially driven has led many to return to the writing of Guy Debord. In Debord's original formation, just as workers are separated from the products of their labour through capitalist social relations, so images take on an autonomous appearance that has little connection with everyday life. The masses consume dramatic images of human misery and suffering that increasingly take on the appearance of unreality. In this respect, the spectacle is not the effect of technology but is the product of a centralised capitalist society that institutes an 'essentially one-way flow of information' (Debord 1994: 19). Capitalist domination is built upon alienation, as people learn to recognise their needs and desires through the images and commodities offered by the dominant system. Needs and desires then are not arrived at autonomously but through a society of affluence where people are driven to consume images and commodities built upon 'the ceaseless manufacture of

pseudo-needs' (ibid.: 33). The society of the spectacle has its roots in the economy and represents the further penetration of capitalism into the psyche of modern citizens. This is the society not of being but of endless cycles of having. Notably, however, some forms of critical theory and Marxism have been complicit with the dominance of the spectacle through the imposition of similarly authoritarian modes of struggle and rule. For Debord, if the alienation effect of the spectacle is to be defeated, then the subjugated would need to revolt against their imposed passivity and 'purely contemplative role' (ibid.: 87). Alienation can only be countered by entering into social and political struggle that has rejected alienated forms of life. This demands a 'theory of praxis entering into two-way communication with practical struggles' (ibid.: 89).

The other way in which the spectacle dominates the lives of modern citizens is through the elimination of historical knowledge. If the rise of capitalism eclipsed the dominance of cyclical time in the medieval world, then it did so by instituting irreversible time. For Debord, this involves ideas of progress that came along not only with capitalist modernity and calculable time, necessary for the disciplining of labour and the production of commodities, but also with spectacular time. Spectacular time prevents the development of historical knowledge as it organises information as dramatic events through the media that are then quickly displaced and forgotten. Similarly, Fredrick Jameson (1991) has argued that commodity capitalism has instituted a society of the timeless present. The emergence of the consumer society has fostered a cultural identity of pastiche, nostalgia and schizophrenia. The mimicry of other styles and the endless recycling of cultural commodities ends with the blurring of distinct cultural periods and the production of cultural material that seems to float free of specific contexts. Here Jameson notes, for example, that cult films such as *Star Wars* are actually nostalgia films, given that they unconsciously recycle the science fiction films of the 1930s. For Jameson, however, it is not clear that radical art and social movements can resist the schizophrenia of the present and produce a sense of historical narrative and perspective required for a more emancipated society. Indeed, what has become problematic about the high modernism represented by artists such as Brecht is that it has become canonised by the mainstream. Works by Brecht and other modernist artists are no longer radical, given their status as classics or as part of university curriculums. Further, other radical artistic forms which have arisen as sub-cultural forms have quickly become commodified and incorporated into the cycles of fashion and consumerism. However, arguably Jameson (1991: 97) too quickly dismisses the culturally contested and fractured nature of civil society and the role of social movements and new artistic forms in recovering a more ethical and political agenda. As Williams (1962: 10) suggested in the 1960s 'the democratic revolution is still at a very early stage'. Indeed, Debord himself argued that such features could only be resisted once 'dialogue has taken up arms to impose its own conditions upon the world' (1994: 154).

However, the development of spectacular capitalism has major implications for any attempt to rethink ideas of the public sphere, and in turn the relationship between media and the formation of democratic identities. For Douglas Kellner (2003), updating Debord's original reflections, in the society of the spectacle, fashion, glamour models, celebrities and icons become increasingly important. Cultural identity becomes dominated by the power of certain images and brands. Society's central feature is the dominance of a new form of technocapitalism whereby capital accumulation, the knowledge revolution and new technology have combined to produce a new kind of society. The cultural identity of the spectacle instigates a new form of domination of mass distraction, profit and the continuing expansion of social and cultural domains that fall under its sway, from politics to sport and from music to the news media. However, Kellner seeks to expand Debord's original ideas by distinguishing

between different kinds of media spectacle. These would include the megaspectacle (large-scale media events attracting mass audiences such as the war on terror and the funeral of Princess Diana), interactive spectacles (involving different levels of audience participation, such as eviction night on *Big Brother*) and more overtly political spectacles such as elections that are increasingly run as sensational media events, only serving to drain them of any more substantial ethical criteria.

Henry Giroux (2006) has argued that while these features offer a more detailed analysis than Debord's own, these reflections need to be extended even further in the context of the war on terror. Here the attack on the Twin Towers was explicitly designed to shock. The events of 9/11 impress a new relationship between the power of the image and global politics. This new form of spectacle is quite different from the spectacles of fascism and consumerism that Debord (1998 [1988]: 8) had previously labelled the concentrated and integrated spectacle. For Giroux, fear and terror have become the central components of the spectacle in a post-9/11 world. The war on terror politics explicitly adopts the language and metaphors of war. The society of the spectacle now involves not only the economy and the state but also the considerable power of the media and the rise of political fundamentalism. For Giroux, where Debord was mainly concerned with the dominance of consumer capitalism, in the context of the war on terror: 'the spectacle of terrorism affirms politics (of war, life, sacrifice, and death) over the aesthetics of commodification through an appeal to the real over the simulacrum' (Giroux 2006: 49). Giroux's central point is that control is less exercised through the promise of 'the good life' through consumption than it is through fear. It is then through fear of terrorism, the Other, Muslims, asylum seekers, the urban poor and others who would seemingly threaten our way of life that the erosion of the civic domain is legitimated. Nation-states have been able to exploit the spectacle of terrorism through new legislation that curtails the rights of citizens while subjecting them to increasing amounts of surveillance and control. The spectacle of terror reproduces a war against an ill-defined enemy and, perhaps just as importantly, against democracy and civic freedoms. Further, fundamentalist groups have exploited the politics of the spectacle using images and video technology to promote representations of suicide bombers, of violent deaths and of abuse and torture. Just as the media utilises the spectacle in the search for higher ratings, so terrorist organisations use similar devices to attract potential supporters.

Similarly, Jean Baudrillard (2002) argues that the idea of the spectacle in the context of 9/11 evokes the memory of many disaster films and symbolises the fragility of the American empire. The so-called network society has actually managed to impose 'a single world order', and yet this has created its own forms of resistance and seeds of its own destruction (Baudrillard 2002: 12). However, the politics of war and fear are more part of Debord's original reflections than many seem to be aware. For Debord, the society of the spectacle is likely to produce terrorism as an alternative form of spectacular domination. Terrorism was likely to flourish, as the dominant could be judged 'by its enemies rather than by its results' (Debord 1998 [1988]: 24). Nevertheless both Giroux and Debord are in agreement that the spectacle can only be substantially challenged through the recovery of more democratic modes of dialogue. As we shall see, it has been new media's capacity to potentially encourage more democratic and dialogic forms of communication that has so excited media scholars. As Giroux notes, the idea of a homogeneous mass audience of the spectacle (which is also reminiscent of Adorno's writing) gives a false impression of the diverse forms of popular cultural identity and resistance available within a global media age. If the politics of the spectacle has indeed enabled authoritarian states to attempt to gain control over public life while continuing to induce citizens to desire a commodified life of ease and consumption, more democratic possibilities

are also available. The combination of the seduction of glittering commodities and a fear of the Other may have provided new ways of undermining democratic forms of life, but there continue to exist other radical democratic possibilities. However, an open question at this point would need to explore the extent to which new forms of media promote the commodified life and associated cultures of fear, and to what extent modern electronic cultures give expression to more dissenting and overtly critical ways of life. To what extent can new forms of radical art and democratic practice be said to provide an alternative to the dominant cultural identity of the capitalist spectacle?

Future developments: democracy, media and civic culture

When Williams formulated the idea of the long revolution in the 1960s, he was convinced that the learning and critical society could only emerge out of the agency of the labour movement. However, the 1980s was to see the arrival of a revived aggressive form of capitalism (or neoliberalism) that was hostile to organised labour and sought to remake society in more market-friendly terms, including the lowering of taxes, the shrinking of the social state, privatisation and the increasing global mobility of capital. It was the labour movement in alliance with other creative social movements including environmentalism, feminism and the peace movement that Williams had hoped would radically democratise the rule of capital. However, if some of these movements have made real gains, there is little point denying that since the 1980s society has become increasingly competitive, unequal and consumerist in orientation. Neoliberalism has waged a war on democracy by eroding civil rights and yet more crucially has shut down alternative democratic spaces that might have previously existed within the national media or within education. Both the media and education to this end have become increasingly integrated into the economy, progressively surrendering their independence while being subjected to political forms of control driven by privatisation, commercial forms of programming and, as we have seen, the politics of fear.

However, there have been a number of other perhaps more hopeful cultural transformations that alter this pessimistic picture. The sociologist Manuel Castells (2009) has argued at some length that modern information societies are driven by cosmopolitan elites and computer-generated networks. Yet if computer networks and capital are global, then people are local. Castells argues that one of the fastest growing forms of popular resistance in the information age is the defence of the local against more global flows. Here Castells argues in this respect that one of the major contradictions of the network society is between the 'space of flows' (the control of space organised at a distance) and the attempt to recover the 'space of places' (the attempt to defend the integrity of place). The contrast between these two different spatial logics represents a fundamental fault line in the new information-driven societies where knowledge is increasingly central to the circuits of capital. In new knowledge-driven societies, universities, levels of education, the customisation of products, market segmentation and levels of technology, amongst other features, have become increasingly central to the organisation of the economy. The knowledge society is driven by the need of the economy for 'useful' knowledge. The state in the informational world has lost much of its power, increasingly putting pressure on the provision of welfare while becoming the active manager of global processes it cannot control. If democratic forms of politics face a challenge in respect of the triumph of neoliberalism and the decreasing power of the state, they are also threatened by the rise of fundamentalism. In this context, Castells suggests that new democratic pressures are likely to emerge from below as locals seek to regain control over space. Of course there are dangers that the return to the local could become a form of local retrenchment and

enhance an increasing fear of outsiders. Yet an important feature of the new politics of social movements is the attempt to reconnect the local to more global concerns. Hence the new emphasis upon the local is not necessarily a form of retrenchment but actually an attempt to reconnect local spaces to more critical and global understandings.

The attempt to defend the local in the context of increasing levels of global awareness characterises a number of campaigns, from the arms trade to environmentalism and from fair trade to the development of organic food provision. As Alberto Melucci (1996) argues, the ability of social movements to open new public spaces, re-interpret dominant discourses and suggest alternative frameworks is the central feature determining their success or failure. The development of new forms of interconnection through the Internet, argues Melucci, has radically multiplied the number of communities and networks to which we can belong. This potentially weakens the grip of an older set of coordinates in respect of the construction of cultural identity, allowing for the development of new possibilities. As Kahn and Kellner (2004) argue, the emergence of Internet subcultures has significantly redefined social networking, blogs and other new media forums as places of learning, democracy and struggle. This has given rise to a new politics that can be less accurately described as localisation than as a form of globalisation from below that crucially links the local and the global. It is then the ability to act locally while maintaining a link to global concerns and developments that best describes the new politics of social movements. The interconnection of locally based social movements and global communications networks has allowed for the emergence of globally orientated local identities and agencies. Through developments in new media and social movements, what emerges are new possibilities for democratised social and cultural relationships. Crucially important in this context has been the rise of what has been called the blogosphere, where literally millions of people across the world are taking the opportunity to become cultural producers. Obviously only a small proportion of these pages will be connected to social movements, yet they potentially radically alter the possibilities for critical politics.

The development of the blogosphere is significant given its potential to allow for public forms of communication, the content of which is not directly controlled by powerful media organisations. If old media were centralised and hierarchical in the way that they organised the production of meaning, then new media forms such as blog sites offer the possibility of more horizontal structures that allow for two-way forms of communication. Blog sites make space not only for the development of the voice of particular cultural producers, but also for the posting of alternative opinions and perspectives. If more traditional media disallow the communicative practice of answering back (other than through carefully managed letters pages or other means), then new media forms suggest the emergence of more dialogic and democratic relationships. However, we need to be careful to steer clear of the argument that new technology simply makes the media more democratic. The argument that democratic engagement is the effect of certain technologies is obviously deeply misleading. It is equally troublesome to assume that technologies themselves do not have certain properties that more easily lend themselves to certain political positions rather than others. It is this aspect of the argument taken up by Brecht and Benjamin that I wish to argue has radical implications for the development of more democratic and engaged subjectivities. Indeed, if some of Brecht's and Benjamin's critics were worried that they simply assumed that new media technologies were of themselves democratising, then there is no need to reproduce these arguments now.

Further, if we consider the history of social movements, we discover a long history that sought to develop 'alternative' forms of communication. Perhaps not surprisingly, emancipatory movements in the past have tried to blur the boundaries between professional journalism

and the audience. Many radical publications have sought to encourage participants within particular social movements not only to develop a more civic sense of self, but also to become actively involved through the publication of an alternative press in shaping the aims, objectives and horizons of social movements. While of course many alternative movements have remained connected to more authoritarian modes of politics and communication, others have sought to link communicative and aesthetic questions to the construction of a more active public sphere. As John H. Downing (2001) argues, in this respect there are historically two different models of alternative media. These are a Marxist-Leninist model that seeks to transmit the views of an alternative social elite and a self-management tradition mainly concerned with a more democratic future built upon popular forms of communication and political participation. There is a recognition evident within all of the writers under review that radical politics itself can easily become trapped within new forms of manipulation and authoritarianism. Notably it was the self-management tradition that Raymond Williams sought to defend within his writing on media and communications and wider social movements. It is also the self-management tradition that sits most comfortably with the idea of an active and participatory public sphere. Here the radical democratic demand is not merely to imagine a different future, but also to begin, where possible, to practise the more emancipated future society in the present. Further, as Downing recognises, communication cannot be limited to 'rational' speech but would need to include a wide number of aesthetic practices including dance, theatre, music, performance art and other features. Even before the rise of the Internet, radical social movements had a long history of experimenting with alternative forms of communication. However, many of these publications and aesthetic experiences were unlikely to attract very large audiences. Many radical publications simply failed due to poor circulation and high start-up costs to find large audiences outside of a small circle of committed activists. What then is exciting about the Internet and blogging is that potentially the audiences are greater, as distribution is now not necessarily restricted to a few outlets. The starting of a radical newspaper or television network is mostly restricted to the networks of the rich and powerful, yet anyone with access to the Internet can set up a blog site.

This has caused a considerable amount of debate amongst media scholars discussing the potential rise of the citizen journalist. Here the argument is that mobile phones, digital cameras and access to the Internet potentially allow ordinary citizens to become campaigners writing their own material and discussing their own views. Yet many have argued that despite the more accessible nature of the Internet, most of these sites are read by relatively few people (although we cannot always be sure about this) and that most of the communication that goes on within social movements is in maintaining their own in-group solidarity rather than in conversing with a wide range of citizens. In other words, media, as Castells (2009) recognises, continues to be dominated by television and not interactive forms. Despite the explosion of new media it is still mainstream television networks that have the most influence in shaping the opinions, perspectives and understandings of the majority, and this is likely to remain the case for the foreseeable future. In addition, Castells (2009: 51) adds that timeless time continues to dominate the consciousness of most citizens, despite the new possibilities for resistant identities in the network age. Timeless time is the time of the now and the immediate (and I would add 'the spectacle') that seems to be dominant. Contemporary televisual global cultural identity is constructed through the dominance of 24-hour news, the cultural identity of celebrity, advertisements and quickly forgotten fashions. The challenge for radical movements is not only to connect with local identities and spaces that are under threat from global corporations but also to recover historical memory. In the media-dominated society, many citizens have become disconnected from a complex understanding of their own

histories and radical traditions and it is these understandings that radical movements arguably need to reinvent and rediscover.

What is perhaps missing from the analysis of those such as Castells and Melucci who have sought to outline the radical possibilities of new forms of communication is an emphasis upon commodification. As Adorno (1991), Debord (1994) and Jameson (1991) might recognise, technologies of communication not only are pieces of technology but are themselves commodities. The cultural identity of computers, iPods, flat-screen televisions and, of course, mobile phones are themselves marketed, branded and advertised commodities. If technologies are far from neutral in terms of the effect that they have in shaping certain kinds of conversations we might have, they have also been converted into 'must have' commodities. Further, it is a matter of exploration as to whether these new forms of communication actually enhance the capacity of the civil sphere for dialogue and learning or whether they simply commodify the realm of everyday life. The complexity of these problems can be seen if we look at two recent social movements.

The Make Poverty History campaign came to the fore in 2005 and was utilised by a number of development charities such as Oxfam to promote ideas of global solidarity and to press the governing structures of global finance into action to reduce global poverty. In order to mobilise support amongst a wider public, Make Poverty History tried to create a visible form of politics by gaining the support of well-known campaigning celebrities such as Bob Geldof and rock band U2's lead singer, Bono. The campaign actively encouraged ordinary people to buy fashionable white bands and to text or email the government to end global poverty. In the UK, the BBC ran a series of programmes on global poverty under the strap line 'Africa Lives on the BBC' and during the summer broadcast the high-profile Live 8 concert, which featured Pink Floyd, Madonna and Coldplay. New media and music were deliberately utilised in order to gain support amongst young people. In terms of wider questions of pedagogy, the campaign failed to raise critical awareness about a number of questions in respect of global poverty. There was little historical context or indeed any mention of colonial histories or more exploitative social conditions that have played a role in creating the conditions of global poverty. Further, social movements were not offered media space to develop alternative perspectives and more critical understandings of 'development'. Instead, much of the media focused upon Western forms of generosity and a number of dominant images that gave the impression that the ending of global poverty was a matter of lifestyle choice rather than political contestation. Despite the role of new media and some leading development organisations, the Make Poverty History campaign (with some notable exceptions) was more about the politics of the spectacle than about developing a critical and a radical politics. The media content of the campaign in this respect failed to develop a critical cultural politics, only further impressing dominant ideas about Western superiority and African underdevelopment. This example should serve as a warning that the presence of new media does not necessarily develop more civic and democratic identities, but can actually lead to their cancellation.

Alternatively, we might consider the case of the Transition Movement. The Transition Movement is a complex network organisation whose primary aim might be described as the development of a web-like structure seeking to prepare localities for a post-oil world. In pursuing these ends, the Transition Movement has a relatively flat organisational structural that is mainly driven by the enthusiasm of local members. It is different from other prominent environmental groups such as Friends of the Earth and Greenpeace as it is less centrally organised and is not as concerned to attract the attention of the media through symbolic protest. However, the Transition Movement is distinctive in that it has the aim of becoming a mass

movement of ordinary citizens – the central aim being to promote local forms of resilience in terms of the local growing of food and promotion of low carbon lifestyles. The Transition Movement, like other so-called 'new' social movements, is motivated less by the distribution of wealth than by a politics orientated around questions such as the quality of life, participation and lifestyle. Further, the Transition Movement is extremely web-literate, making use of new media such as web and blog sites, discussion boards and of course YouTube. Much of this material is for the dissemination of information both internal and external to local groups. However, the example of the Transition Movement also points to the use of other media. Local groups regularly organise film nights to get local people interested in their activities and target local media such as radio, television and the press. In this respect, much media criticism could be said to be overstating the role of new media in the formation of oppositional and critical identities. However, it is true to say the Transition Movement is heavily reliant upon easily accessible new media. The use of blog sites and other forms of new media do indeed point to a more dialogic structure than might be said to be available to more traditional movements. The Transition Movement is a good example of a movement that is global and local at the same time. Perhaps these brief examples should caution those who seek to make sweeping assumptions about the role of new media in the formation of resistant identities, and yet it is clear that new communicative forms cannot simply be dismissed as commodified forms but carry with them a set of democratic possibilities.

As we have seen, the relationship between the media and the formation of collective cultural and personal cultural identity is complex. Here I have sought to demonstrate the historically shifting nature of these arguments, and maintain that the media theory produced during different periods (albeit in a modified form) continues to be important to the ways in which we understand these relationships today. Undoubtedly, contemporary media has become increasingly driven by commercial imperatives seeking to promote the dominant cultural identity of the spectacle and is thereby commodifying increasing areas of social and cultural life. As I have argued, this overwhelmingly serves to drive out more democratic spaces, as large media conglomerates and corporations increasingly serve to dominate socially organised communicative relations. Further, in the context of the 'war on terror', media is actively involved in the promotion of fear and the undermining of a shared civic cultural identity based upon liberal freedoms. Yet before this analysis is pushed too far, more democratic and resistant identities through the development of the Internet have been handed new possibilities to develop alternative meanings and critical perspectives. More careful and detailed work needs to be done in this area so that we are able to carefully trace through the kind of complex pedagogic relations that are emerging in this area. Social movements through the use of new media (and other forms of communication) have a potentially transformative role to play in remaking more critical identities in the context of a modern cultural identity that is increasingly being shaped by modern capitalism. Finally, I would argue that the new work on the Internet and social movements should seek to become connected to an earlier radical agenda that sought to argue for a democratised public sphere. Cultural institutions such as the BBC are far from being relics of the past but still, even in the age of the Internet, provide a widely trusted and still mostly (although this is changing) uncommodified zone that is accountable to members of the public and democratically elected politicians. In this respect, Williams's idea of the long revolution is far from over but needs to be expanded to include the radical possibilities of the present.

Given the impact of neoliberalism in creating increasingly unequal, competitive and commodified societies, public broadcasters have a special responsibility to give opportunities to give voice to marginalised members of the public. That this is not happening to the degree

that it might suggests that the public service media is less concerned with serving the public than it is with competing with its commercial rivals, satisfying the rituals of parliamentary democracy and following established rules of professional conduct. If in the 1960s Williams perceived a new generation of working-class voices making themselves heard through new forms of cultural production, today such optimism would be misplaced. Indeed, the bodies of working-class people are often featured on reality television exhibiting criminal behaviour, excessive consumption and 'vulgar' forms of popular taste. These normalising images are based less upon the politics of voice and complexity than upon the politics of class distinction and spectacle. A popular politics of voice and democracy in relation to mediated forms is dependent upon wider social and cultural structures and can never be considered simply to be the effect of new media forms. Yet I have also cautioned against simply dismissing new media as being just another commodity, as it is still capable of radically democratising (often in surprising ways) our shared public spheres. The open question here is: how is the struggle for a more democratic media system likely to be affected by the arrival of new Internet and other technologies? This is a matter not only for theoretical debate, but also for careful analysis and empirical research in the future. While the dominant media system is likely to remain in tension for a number of years to come, what remains to be seen is whether the cultural identity frames it seeks to foster are democratically oriented based upon a cultural identity of voice and critical engagement or whether the politics of the spectacle become even further entrenched within the media system. These crucial questions will keep alive a discussion which we have seen has a long, contested and complex history.

References

Adorno, T. (1991) *The Cultural Industry*. London: Routledge.
Baudrillard, J. (2002) *The Spirit of Terrorism and Other Essays*. London: Verso.
Benjamin, W. (1973) *Illuminations*. London: Fontana.
—— (1978) *Reflections*. New York: A Helen and Kurt Wolf Book.
—— (1998) *Understanding Brecht*. London: Verso.
Castells, M. (2009) *Communication Power*. Oxford: Oxford University Press.
Debord, G. (1994) *The Society of the Spectacle*. New York: Zone Books.
—— (1998 [1988]) *Comments on the Society of the Spectacle*. London: Verso.
Downing, J. (2001) *Radical Media: Rebellious Communications and Social Movements*. London: Sage.
Enzensberger, H. M. (1970) 'Constituents of a theory of the media', *New Left Review*, 64: 13–36.
Giroux, H. (2006) *Beyond the Spectacle of Terrorism*. London: Paradigm Publishers.
Habermas, (1989) *The Structural Transformation of the Public Sphere*. Cambridge: Polity Press.
—— (1996) *Between Facts and Norms*. Cambridge: Polity Press.
Jameson, F. (1991) *The Cultural Turn*. London: Verso.
Kahn, R. and Kellner, D. (2004) 'New media and internet activism: from the "Battle of Seattle" to blogging', *New Media and Society*, 6(1): 87–95.
Kellner, D. (2003) *Media Spectacle*. London: Routledge.
Melucci, A. (1996) *The Playing Self: Person and Meaning in the Planetary Society*. Cambridge: Cambridge University Press.
Stevenson, N. (2003) *Cultural Citizenship*. Basingstoke: Open University Press.
Williams, R. (1962) *The Long Revolution*. London: Pelican.
—— (1980) *Culture and Materialism*. London: Verso.
—— (1989) *What I Came to Say*. London: Hutchinson Radius.
Wolin, R. (1994) *Walter Benjamin: An Aesthetic of Redemption*. Berkeley: University of California Press.

The place of space in social and cultural theory

Simon Susen

Introduction

'Space' has become an increasingly important concept in contemporary social and cultural theory (see, for example: Bourdieu 1991; Gregory and Urry 1985; Hess 1988; Hubbard, Kitchin and Valentine 2004; Keith and Pile 1993b; Knowles and Sweetman 2004b; Massey 1994, 2005; Pile 1996; Pile and Thrift 1995a; Shields 1991, 1999; Soja 1989; Thrift 1996; Urry 1985, 1995; Zieleniec 2007). The diversity of empirical and theoretical studies of space is symptomatic of the multi-layered constitution that characterizes the physical structuration of social life. In light of this complexity, any attempt to provide a comprehensive account of space will be fraught with difficulties. In fact, the possibility of a general theory of space appears to be contradicted by the abundance of interactional spheres that exist in differentiated social settings. Given the variety of both spatial theories and spatial realities, it may be impossible to develop an explanatory framework capable of capturing the multifaceted dimensions underlying the territorial organization of human societies.

One of the most insightful accounts concerned with the fact that the construction of society is inextricably linked to the production of space can be found in the writings of the French philosopher and sociologist Henri Lefebvre, notably in his influential study *The Production of Space* (1991 [1974]; see also Lefebvre 1974, 1996, 2000, 2008a, 2008b, 2008c). Lefebvre's theory of space has been thoroughly discussed in the literature (see, for example: Brenner 2000: 367–76; Butler 2012; Elden 2004; Goonewardena *et al.* 2008; Hess 1988; Keith and Pile 1993a: 24–6, 30, 36; Martins 1982; Merrifield 2006; Shields 1999, 2004: 211–12; Soja 1989; Stanek 2011; Urry 1995; Zieleniec 2007: 60–97), but no attempt has been undertaken to propose a Lefebvrian outline of a general theory of social space, that is, a conceptual framework capable of capturing the transcendental conditions underlying the spatial structuration of *any* society, regardless of its historical specificity. To be sure, such a framework is not meant to suggest that the construction of space can be understood independently of its social conditions of production; rather, it is aimed at shedding light on the fundamental properties that *all* social spaces share, irrespective of their context-specific idiosyncrasies. In this chapter, no attempt shall be made to do justice to the wide-ranging scope of Lefebvre's oeuvre; instead, the following analysis focuses on key insights gleaned from his acclaimed book *The Production of Space*. These insights, as shall be demonstrated in subsequent sections, permit us to develop a tentative outline of a general theory of social space.

Historical and intellectual development

The concept of space in classical sociology

Before examining Lefebvre's theoretical framework, it seems sensible to locate the concept of space in the canon of sociological discourse. In this context, two straightforward observations should be taken into account.

First, the concept of space can be considered a *marginal category* in classical sociology. 'Space has never been central to sociological thought', and therefore 'it remains fair to say that the significance of space for the discipline at large has been peripheral from the beginning' (Lechner 1991: 195). Interestingly, when examining the key works of the 'founding fathers' of sociology – that is, the writings of Marx, Durkheim and Weber – it becomes evident that they did not treat 'space' as an important category of social analysis or attach paradigmatic status to the study of the spatial constitution of society.

Second, space can nevertheless be conceived of as a *central component* of social life. Every human action is spatially situated, for individuals as well as 'groups and institutions have a "place"' (Lechner 1991: 195). This may appear to be a truism, but, at least in sociology, the seemingly most obvious requires critical reflection. Just as it is vital to recognize that 'time' is a fundamental constituent of social life, because individuals and societies are embedded in temporally contingent contexts, it is imperative to acknowledge that 'space' is an integral element of human existence, because individual and collective actors are situated in spatially organized realms of experience. Of course, it may be far from clear *what* exactly we mean by 'space' and *how* it influences, or in some cases even determines, our relation to the world; it is difficult to deny, however, that it *does* have a significant impact upon our daily engagement with reality in general and with society in particular.

Georg Simmel, who is now widely regarded as one of the founding figures of sociology, is an exception in the canon of early modern social thought: 'Among the classical sociologists, only Georg Simmel treated space systematically, but his main contribution was largely ignored' (Lechner 1991: 195). Given the originality of his writings, it is worth considering a number of significant insights provided by his sociology of space (see especially Simmel 1997 [1903]; see also Lechner 1991). In essence, we can identify five central presuppositions underlying Simmel's critical study of the spatial organization of human activities.

First, social spaces are unavoidably shaped by the power-laden relationship between *inclusivity* and *exclusivity* (Simmel 1997: 138–41). The emergence of social configurations is contingent upon their capacity to generate realms of interaction defined by – implicitly or explicitly recognized – rules of inclusion and exclusion. Regardless of whether we are dealing with micro-sociological spaces, which are anchored in people's lifeworlds and their experience of *Gemeinschaft* (at the local level), or with macro-sociological spaces, which come into existence through people's real, and at the same time imaginary, construction of *Gesellschaft* (at the regional, national, continental or global level), spaces composed of human actors are permeated by social dynamics of inclusion and exclusion. As critical sociologists, we need to examine on what grounds human actors are either granted or denied access to a given social space. Whether particular actors are included in or excluded from specific social realms depends largely on their position in relation to other actors. Access to social positions hinges on access to material and symbolic resources, which are asymmetrically distributed and interactionally mobilized through stratifying variables, such as class, ethnicity, gender, age and ability. To the extent that social spaces constitute relationally constructed realms sustained by asymmetrical differentiations, the existence of territorial separations can contribute to, or even be the basis of, processes of demographic segregation.

Second, social spaces are constructible only in terms of the contingent relationship between *unifiability* and *separability* (Simmel 1997: 141–46). Human societies cannot exist without the partitioning of space. Boundaries contribute to both the integration and the disintegration of territorial realms. By definition, social spaces are relationally constructed unities which can be joined with, or separated from, one another. The malleable nature of social space is due to the fact that human life forms are in a constant state of flux: to the extent that social spaces can be united and divided, codified geographical arrangements can, at least in principle, always be reconstructed. As territorial realities that are at the same time unifying and separating, social spaces are sources of both facticity and validity: as sources of facticity, they exist as objective realities determining what *is* possible within a given territory; as sources of validity, they exist as normative realities determining what *ought to be* possible within a given territory. In brief, boundaries of spatial organization are both objective and normative sources of social demarcation.

Third, social spaces are marked by the relationship between *fixity* and *changeability* (Simmel 1997: 146–51). Social spaces have the power to constrain and alter human actions, just as human actions have the capacity to shape and transform social spaces. When experienced by social actors, spatial arrangements may seem natural and given: our constant immersion in spatially differentiated realities can make us blind to the fact that social arrangements are never forever. Situated in the world as embodied entities, we are prone to take space for granted, thereby forgetting that the physical organization of human life forms is socially regulated. To the extent that spaces appear to be fixed and invariable, we tend to reproduce them and thereby strengthen the power of their legitimacy. Since the territorial organization of the social world is historically variable, however, we can also transform spaces and thereby undermine their, seemingly unassailable, authority. The legitimacy of human actions is always imposed or negotiated in relation to the social spaces in which they take place. What may be considered a legitimate form of behaviour in one situation may be regarded as an illegitimate mode of conduct in another context. The grammaticality of social space can be either confirmed or challenged by the performativity of human action.

Fourth, social spaces are generated through the relationship between *proximity* and *distance* (Simmel 1997: 151–59). There is no society without lifeworlds. Only insofar as we are capable of experiencing one another in social spaces of physical proximity are we able to immerse ourselves in the coexistential realm of humanity. The most deterritorialized societies, characterized by the creation of abstract space, cannot dispense with embodied actors, situated in concrete space. Even when we mediate our social interactions through the use of communication technologies, which enable us to transcend space when engaging with others in distant localities, we cannot annihilate our deep-rooted need for the experience of face-to-face relations, which permit us to absorb space when encountering others in intersubjectively constituted realities. The human need for physical proximity can be challenged but not eliminated by the power of social technology. For the creation of society is inconceivable without the formation of community: the abstract space of *Gesellschaft* emanates from the concrete space of *Gemeinschaft*.

Fifth, social spaces are produced through the relationship between *sedentariness* and *mobility* (Simmel 1997: 160–70). High mobility – for example, of nomadic groups – tends to be associated with low degrees of social differentiation. By contrast, low mobility – for instance, of sedentary groups – tends to be accompanied by high degrees of social differentiation. As a consequence, communal forms of mobility often involve the creation of social solidarity: the more we are bound to share the process of 'being on the move' with others, the more likely we are to convert the collective experience of mobility into an existential source of solidarity.

335

Simon Susen

Hence, it is not only the belief in primordial ties based on spatial sedentariness but also joint experience of movement that can bind people together. Both sedentary and mobile engagements with reality are fundamental to the construction of modern society.

Lefebvre's contributions: outline of a general theory of social space

Five significant insights gained from Simmel's sociology of space having been considered, the question that remains is what contemporary theories of space have added to the picture. Drawing on the work of Henri Lefebvre, the following sections aim to provide an outline of a general theory of social space, that is, a conceptual framework capable of capturing the transcendental conditions underlying the spatial structuration of any society, regardless of its historical specificity. As the title of his influential study *The Production of Space* (1991 [1974]) suggests, Lefebvre is concerned with the fact that, far from constituting a sheer given of human life, social spaces need to be *produced* by individual and collective actors in order to assert their existence. Although heavily influenced by Marx, Lefebvre seeks to go beyond a merely economic conception of production. To this end, he distinguishes three types of production.

First, there is a *broad* meaning of production in the sense of *social* production. Lefebvre characterizes production in the wide sense as follows:

> [H]umans as social beings are said to produce their own life, their own consciousness, their own world. There is nothing, in history or in society, which does not have to be achieved and produced. 'Nature' itself . . . has been modified and therefore in a sense produced. Human beings have produced juridical, political, religious, artistic and philosophical forms. Thus *production in the broad sense of the term embraces a multiplicity of works and a great diversity of forms.* . . .
>
> *(1991: 68, emphasis added)*

As humans, we distinguish ourselves from animals in that we have brought about the material and symbolic conditions of our own existence. To be exact, both the economic and the cultural foundations of human life have enabled us to create a social world beyond our natural environment. To recognize that we are productive entities requires acknowledging that we are a socio-constructive species (see Susen 2007: 287–92, 2011: 174–75). The broad meaning of production lies at the heart of the constructivist view of reality, according to which both the material and the symbolic dimensions of the human world are constitutive elements of a socially organized universe. From this perspective, social production, in the large sense, designates any form of activity that contributes to the construction of human existence.

Second, there is a *narrow* meaning of production in the sense of *economic* production. Lefebvre makes the following critical remark on economistic accounts of production:

> Neither Marx nor Engels leaves the concept of production in an indeterminate state. . . . They narrow it down, but with the result that works in the broad sense are no longer part of the picture; what they have in mind is things only: *products.*
>
> *(1991: 68–9, original emphasis)*

Lefebvre is critical of this confined – that is, economistic – conception of production. For such a restricted notion of production, which focuses on the economic dimensions of social life, fails to do justice to the species-constitutive significance of the non-economic facets of

human reality. The point is not to deny that, as Marx and Engels put it, '[t]he production of ideas, of conceptions, of consciousness, is at first directly interwoven with the material activity and the material intercourse of men, the language of real life' (2000 [1846]: 180). Rather, the point is to recognize that both material *and* symbolic dimensions of human reality contribute to the construction of society.

Third, there is a *neglected* meaning of production in the sense of *spatial* production. It is this third form of production that Lefebvre aims to explore in his critical theory of society. The study of spatial production goes beyond both the broad notion of social production and the narrow conception of economic production; for the former is too general to account for the particularity of spatial processes, and the latter is too specific to account for the ubiquity of spatial realities. In order to obtain paradigmatic status in sociology, space needs to be regarded as a constitutive element of the social world, that is, as a fundamental component whose significance is reflected in the fact that it represents both a condition and an outcome of relations between actors. In treating space as a cornerstone of the social world, Lefebvre seeks to demonstrate that spatial production and economic production are inextricably linked: 'social space is produced and reproduced in connection with the forces of production (and with the relations of production)' (1991: 77). In other words, the construction of social relations depends, at once, on the creation of spatial relations and on the formation of economic relations. Just as comprehensive studies of social production must address the question of space, critical accounts of space need to reflect upon the conditions of social production.

In light of the above, it would be fair to suggest that, paradoxically, Lefebvre stands within the tradition of Marxist social thought, whilst seeking to overcome the economic reductionism of its orthodox variants. On the one hand, Lefebvre is firmly situated *within* the horizon of Marxist theory in that he puts forward a *productivist* conception of reality, regarding society as a collective project created by working entities. On the other hand, Lefebvre seeks to go *beyond* the parameters of orthodox Marxist frameworks in that he makes a case for a *spatialist* conception of reality, portraying society as a coexistential conglomerate composed of physically situated entities. Thus, Lefebvre's approach can be described as a *spatio-productivist* account of society. According to this view, human beings are both spatially productive and productively spatial entities: spaces of production hinge on productions of space, and productions of space cannot take place without spaces of production. In short, the production of society is unthinkable without the production of space.

Lefebvre identifies three elements necessary for the production of space: (a) spatial practices (*pratiques spatiales*), (b) representations of space (*représentations de l'espace*), and (c) spaces of representation (*espaces de représentation*) (see Lefebvre 1991: 38–9). These can be defined as follows:

> *Spatial practices* refer to physical and material flows of individuals, groups or commodities: social circulations, transfers and interactions that occur in and across space. Spatial practices, which 'must have a certain cohesiveness' (Lefebvre 1991: 38), guarantee social continuity and are indispensable for the consolidation of social order. Due to their material nature, spatial practices can be termed 'spaces-in-themselves'.

> *Representations of space* manifest themselves in 'conceptualized space, the space of scientists, planners, urbanists, technocratic subdividers and social engineers, as of a certain type of artist with a scientific bent – all of whom identify what is lived and what is perceived with what is conceived This is the dominant space in any society (or mode of production).'
> *(Lefebvre 1991: 38–9)*

337

Representations of space serve the regulation of space, for 'those who control how space is represented control how it is produced, organised and used' (Zieleniec 2007: 74). Given their discursive nature, representations of space can be characterized as 'spaces-for-themselves'.

Spaces of representation – sometimes also translated as 'representational spaces' (Lefebvre 1991: 39) – are directly lived and immediately experienced spaces of everyday life. Insofar as spaces of representation are shaped by social actors, and imbued with meaning in their lifeworlds, they are sources of human freedom. As relatively autonomous realms, created by the 'inhabitants' (Lefebvre 1991: 39) of ordinary life, spaces of representation possess an emancipatory potential in that they enable social actors to challenge the legitimacy of established spatial practices. In light of their simultaneously material and discursive nature, spaces of representation can be conceived of as 'spaces-in-and-for-themselves'.

With Lefebvre's tripartite conceptual framework in mind, and with the aim of illustrating the explanatory power of his spatio-productivist conception of society, it shall be the task of the following analysis to propose a tentative outline of a general theory of social space.

1. The humanity of social space

Social spaces are human spaces. For the emergence of social realms is contingent upon the existence of subjective, and often intersubjective, practices. Just as human beings are situated in a physically organized and symbolically mediated universe, social spaces are shaped by both the objective constraints imposed by the natural environment and the normative arrangements established in the cultural world. Aware of this existential ambiguity, Lefebvre asks the following, rather fundamental, questions: 'Is that space natural or cultural? Is it immediate or mediated . . .? Is it a given or is it artificial?' (1991: 83). Lefebvre is right to assert that '[t]he answer to such questions must be: "Both"' (1991: 83–4). For social spaces, which are objectively situated in a physical world and normatively regulated by meaning-creating actors, exist 'between "nature" and "culture"' (1991: 84). Put differently, every social space is a product *both* of what is physically constituted, and hence objectively present, in a realm of facticity, *and* of what is culturally constructed, and thus normatively relevant, in a sphere of validity. In short, social spaces are human spaces whose existence is contingent upon the practices performed by those who inhabit them.

2. The sociality of social space

What manifests itself in the sociality of social space is an obvious, yet crucial, insight: human spaces are socially constituted realms. Critical sociologies of space need to confront the challenge of 'uncovering the social relationships (including class relationships) that are latent in spaces' (Lefebvre 1991: 90). In the human world, spatial relations are never only physical arrangements but always also social constellations: a 'mutual interference occurs here between natural peculiarities of space and the peculiar nature of a given human group' (1991: 110). To recognize that human spaces are socially created means to account for the fact that they are composed of interrelated, rather than isolated, subjects and objects. It is the relations between, rather than the properties of, subjects and objects which are important to the constitution of social space: 'space is neither a "subject" nor an "object" but rather *a social reality* – that is to say, *a set of relations and forms*' (1991: 116, emphasis added). The historical determinacy of a given social space cannot be dissociated from the relationally constituted setting in which, and through which, it emerges.

3. The constructability of social space

Social space is never simply a given, because it is always constructed by those who bring it into existence: 'For this is a place that has been *laboured on*' (Lefebvre 1991: 76, original emphasis). Human beings constantly act and work upon the world, forming and transforming it according to their needs. Yet, a world that can be constructed can also be deconstructed and reconstructed. Social actors are continuously in the process of reconstructing the spaces and places they inhabit. Rejecting a narrowly economistic sense of production, we are able to recognize that social spaces owe their existence to the daily performances of a *socio-constructive species*. The power of social construction can convert a given space into a place. In fact, the latter is the outcome of the former: a place is a socially generated and culturally signified form of space. Put differently, a place is a space modified by labour and imbued with meaning by culture. (On the distinction between 'space' and 'place', see, for example: Massey 2005: 68, 183–4; Merrifield 1993; Zieleniec 2007: 71, 73.) We are both a productive species of working creatures and a cultural species of meaning-giving beings: as purposive, cooperative and creative actors, we work upon the world; as assertive, normative and expressive entities, we attribute meaning to our existence. Social space is permeated by the species-constitutive forces of production and interpretation, which ensure that there is always a still-to-be to social space: a still-to-be-developed, a still-to-be-transformed and a still-to-be-signified. The very possibility of spatial production rests upon the performative resources of social action.

4. The economy of social space

Economic production and spatial production are intimately interrelated, because there is no division of labour without a distribution of space. In Lefebvre's words,

> social space is produced and reproduced in connection with the forces of production (and with the relations of production). And these forces, as they develop, are not taking over a pre-existing, empty or neutral space, or a space determined solely by geography, climate, anthropology, or some other comparable consideration.
>
> *(1991: 77)*

On the contrary, the productive forces, as they unfold, take on the shape of a normative space, of a space which is determined by, and at the same time determines, the organization of the division of labour. Spatial relations are unavoidably influenced by economic relations, and vice versa. Lefebvre eloquently captures the ineluctable interdependence of spatial and economic relations in the following passage:

> Is space a social relationship? Certainly – but one which is inherent to property relationships (especially the ownership of the earth, of land) and also closely bound up with the forces of production (which impose a form on that earth or land); here we see the polyvalence of social space, its 'reality' at once formal and material. Though a *product* to be used, to be consumed, it is also a *means of production*; networks of exchange and flows of raw materials and energy fashion space and are determined by it. Thus this means of production, produced as such, cannot be separated either from the productive forces, including technology and knowledge, or from the social division of labour which shapes it. . . .
>
> *(1991: 85, original emphasis)*

Social space, then, is not only inextricably linked to the forces of production, but it is a requirement for their existence. For the spatial structuration of reality is a precondition for the economic organization of society. The steering power of every economy depends on its capacity to control the spatial constitution of society.

5. The ideology of social space

The ideology of social space is reflected in the representations of space which predominate in a given society. Representations of space are the imagined realms of those groups of people who have the power to monitor and control the territorial organization of society. Every social order is a spatial order. The spatial order sustaining a given social order can be maintained by virtue of an ideological apparatus capable of giving legitimacy to the physical configuration of reality. In this sense, the regulation of space 'cannot be separated . . . from the state and the superstructures of society' (Lefebvre 1991: 85). The recognition of the ideological character of social space obliges us to rethink the Marxian model of base and superstructure in terms of a spatialist analysis of human existence. According to Marx, the base consists of economic relations, which constitute the material foundation of society, whereas the superstructure is composed of an ideological apparatus, which serves to legitimize the relations of production underlying a given historical formation. According to Lefebvre, neither the material infrastructure nor the ideological superstructure of society can be divorced from the spatial constitution of reality. Indeed, space itself is both a physical and a symbolic element of society, that is, it is both a foundational and an epiphenomenal force of human reality. As a foundational force, the organization of space is a precondition for the consolidation of society; as an epiphenomenal force, the signification of space is necessary for the creation of a collective imaginary. The distribution of space is never neutral but always value-laden, since the territorial organization of society is impregnated with the symbolic power of ideology. There are no political regimes that are not also spatial regimes, because the control over societal configurations requires at least a minimal degree of power over their territorial organization. The exercise of regulatory social authority is inconceivable without recourse to a legitimizing spatial ideology.

6. The relationality of social space

The various forms in which human actors relate to one another cannot be abstracted from the spatial organization of the society to which they belong. Just as social spaces can determine relations established between people, people can determine relations established between spaces. Every social space designates an interactional arena of possibilities which impacts upon the relations between actors, whilst every group of actors represents a conglomerate of possibilities which shapes the relations between spaces. Social spaces never exist simply in themselves; on the contrary, they exist through the *relations* established between physically embedded subjects. To the extent that 'a space is not a thing but rather *a set of relations* between things (objects and products)', and that 'any space implies, contains and dissimulates social relationships' (Lefebvre 1991: 83, 82–3, emphasis added), the creation of spatial relations is contingent upon the construction of social relations. Social spaces are composed of subjects *and* objects, both of which are imbued with the power of social agency. Agency is not only a privilege of subjects, but also a potential attribute of objects, since both subjects and objects have the power to determine the ways in which worldly practices unfold in a universe of relationally defined circumstances.

Social space contains a great diversity of objects, both natural and social, including the *networks and pathways* which facilitate the exchange of material things and information. Such 'objects' are thus not only things but also *relations*. As objects, they possess discernible peculiarities, contour and form. Social labour transforms them, rearranging their positions within spatio-temporal configurations. . . .

(Lefebvre 1991: 77, emphasis added)

Given the relatively arbitrary nature of all social relations, spaces created by human actors are always subject to change.

7. The structurality of social space

The structural nature of social space is symptomatic of the tangible impact that the territorial organization of society has on human actions. 'Itself the outcome of past actions, social space is what permits fresh actions to occur, while suggesting others and prohibiting yet others' (Lefebvre 1991: 73). To borrow a concept from Pierre Bourdieu, every social space is an *espace des possibles*, literally a 'space of possibles' (Bourdieu 2000: 151; see also Bourdieu and Wacquant 1992: 152–3). Social spaces are structurally constituted realms of possibility. Human actions take place within the territorial limits imposed upon them by spatial realities. Hence, using another Bourdieusian expression, we may describe social space as both a structured and a structuring structure (see Bourdieu 2000: 144; see also Bourdieu and Wacquant 1992: 139). As a structured structure, it is structured by human actions; as a structuring structure, it structures human actions. Our actions have the power to structure the social spaces we inhabit, and the social spaces we inhabit have the power to structure our actions. Human actors cannot escape the structuring power of social space, and vice versa.

8. The visibility of social space

The visibility of social space is fundamental in that it permeates every sighted subject's relation to the world. '[S]ighted human beings navigate the social world visually' (Knowles and Sweetman 2004a: 1). For '[s]eeing comes before words . . . and establishes our place in the surrounding world' (Berger 1977: 7, cf. Mellor and Shilling 1997: 6). In fact, there is a crucial connection between the visualization and the organization of space. In our daily lives, social spaces are often seen but unnoticed. The spatial appears natural to its inhabitants when it imposes its presence on the daily routines of their actions. Human societies are visualized settings of coexistence, capable of exploiting the power of the spectacle to assert the omnipresence of the spatial.

A further important aspect of spaces . . . is their increasingly pronounced *visual character*. They are made with the visible in mind: the visibility of people and things, of spaces and of whatever is contained by them. The predominance of visualization . . . serves to conceal repetitiveness. People *look*, and take sight, take seeing, for life itself.

(Lefebvre 1991: 75, emphasis added; 'look' emphasized in original)

When we take sight for life itself, we transform representations of reality into realities of representation. The visual power of space consists in its capacity to convert social normativities into seen-but-unnoticed objectivities. Social spaces can make human acts appear as if they were mere historical facts. What we all see without noticing is what we all agree upon. What

we all agree upon, however, is never simply objective but always also normative. 'Visual practices are *regulatory*, they demand that certain things are noticed, that other things are denied, and that other things are not seen at all' (Pile and Thrift 1995b: 48, emphasis added). The more we are used to being immersed in particular social spaces on a daily basis, the less likely we are to notice their existence.

9. The rationality of social space

Since human settings serve particular functions with corresponding codes of legitimacy, every social space possesses an idiosyncratic rationality. In the Lefebvrian universe, however, rationality is conceived of not as a metaphysical force inherent in a monological subject or an omnipresent object, but as a social force embedded in spatially constituted contexts. From this perspective, different modes of rationality emanate from spatially structured realms of sociality.

> The *rationality of space* . . . is not the outcome of a quality or property of human action in general, or human labour as such, of 'man', or of social organization. On the contrary, it is itself the origin and source . . . of the *rationality of the activity*.
>
> *(Lefebvre 1991: 71–2, emphasis added)*

In other words, all forms of human agency are shaped by underlying rationalities inscribed in spatially constituted realities. Within the Lefebvrian architecture of society, then, space obtains a foundational status: the rationality that motivates a specific human activity cannot be dissociated from the spatial determinacy of the social reality that defines its own conditions of possibility. The rationality of a particular social space can differ substantially from the rationality of another social space. The more complex a given society, the more spatially differentiated forms of rationality it tends to generate. Different social spaces are sustained by diverging modes of rationality with idiosyncratic sources of legitimacy. The legitimacy of a performative act depends on its acceptability in relation to a social context. In brief, social spaces have the power to impose their self-referential rationality on the development of human agency.

10. The universality of social space

The universality of social space is based on its ubiquity in the human world. In fact, every human action is – directly or indirectly – constrained by the presence of social space.

> (Social) space is not a thing among other things, nor a product among other products: rather, it *subsumes* things produced, and *encompasses* their interrelationships in their co-existence and simultaneity – their (relative) order and/or (relative) disorder.
>
> *(Lefebvre 1991: 73, emphasis added)*

Thus, according to Lefebvre, we need to recognize the foundational status of social space. *All* human relations in *all* societies at *all* times are situated in collectively constructed forms of space. We cannot possibly relate to the world without contributing to the production of space. For 'any activity developed over (historical) time engenders (produces) a space, and can only attain practical "reality" or concrete existence within that space' (Lefebvre 1991: 115). If space is literally all over the place, then it is a transcendental condition of human life. As a transcendental condition of human existence, space is a *conditio sine qua non* of actors'

immersion in the world. Given its ubiquity in the social universe, space constitutes a foundational force in the daily construction of human reality.

11. The historicity of social space

The historicity of social space is due to the temporal contingency that pervades all realms of worldly existence. Every social space has a unique history, just as history takes place through the construction of social spaces. Since '[e]very social space is the outcome of a process', 'every social space has a history' (Lefebvre 1991: 110). The malleable nature of the social manifests itself in the processual nature of the spatial: social spaces are never forever; their constitution changes over time.

> In the *history of space* as such . . . the historical and diachronic realms and the generative past are forever leaving their inscriptions upon the writing-tablet, so to speak, of space. The uncertain traces left by *events* are not the only marks on (or in) space: society in its actuality also deposits its script, the result and product of *social activities*.
>
> *(1991: 110, emphasis added)*

Social spaces have – throughout history – been, and will continue to be, produced and transformed by human actors. The historical variability of people's engagement with their physical reality is symptomatic of the spatial contingency of human agency. To combine Marx's historical materialism with Lefebvre's historical spatialism means to uncover the spatio-material determinacy of the human condition. Accordingly, Marx's famous aphorism on the historical determinacy of human life can be reformulated as follows: 'Men make their own history, but they do not make it just as they please; they do not make it in *spaces* chosen by themselves, but in *spaces* directly encountered, given, and transmitted from the past.'[1] The history of social spaces permeates the unfolding of human practices.

12. The complexity of social space

The increasing complexity of social space is a sign of the growing differentiation of late-modern life forms. In light of this complexity, reductionist accounts of the social in general and of the spatial in particular lack explanatory power.

> A social space cannot be adequately accounted for either by nature (climate, site) or by its previous history. Nor does the growth of the forces of production give rise in any direct causal fashion to a particular space or a particular time.
>
> *(Lefebvre 1991: 77)*

In this sense, Lefebvre's socio-spatial analysis is opposed to three forms of determinism: (a) essentialist determinism, (b) naturalistic determinism and (c) economistic determinism. The problem with *essentialist determinism* is that it does not do justice to the fact that social spaces are *relationally constructed*. Social spaces acquire particular meanings from the relations established between human actors, as well as from the material and symbolic connections between social spaces. The problem with *naturalistic determinism* is that it does not account for the fact that social spaces are *culturally constructed*. Surely, social spaces cannot escape the physical constraints of the natural world; it is by working upon, and attributing meaning to, the physical world, however, that human actors have succeeded in transforming their natural

Simon Susen

environment into an ensemble of social arrangements. As a species, we have learned to challenge the law-governed objectivity of the natural world by immersing ourselves in, and constantly reconstructing, the power-laden normativity of the social world. The problem with *economistic determinism* is that it underestimates the fact that social spaces are *interactionally constructed*. The relative autonomy of spatial realities derives from the self-empowering contingency of human agency, which enables us to challenge the systemic imperatives imposed by the economy. Social spaces are unavoidably shaped, but not necessarily determined, by economic relations. 'The *hypercomplexity* of social space should now be apparent, embracing as it does individual entities and peculiarities, relatively fixed points, movements, and flows and waves – some interpenetrating, others in conflict, and so on' (Lefebvre 1991: 88, emphasis added). In short, the potential complexity of the spatial structuration of the human universe illustrates that society is irreducible to a monolithically constituted totality.

13. The polycentricity of social space

The polycentricity of social space is indicative of its potential complexity. Reflecting upon the diversified nature of highly differentiated societies, Lefebvre reminds us of the fact that '[w]e are confronted not by one social space but by *many* – indeed, by an *unlimited multiplicity or uncountable set of social spaces* which we refer to generically as "social space"' (1991: 86, emphasis added). The polycentric nature of highly differentiated life forms manifests itself in the emergence of pluralized social spaces: commercial spaces, political spaces, cultural spaces, religious spaces, urban spaces, rural spaces, public spaces, domestic spaces, institutional spaces and recreational spaces – to mention only a few. Acknowledging the diversified nature of spatial settings in large-scale societies, Lefebvre's approach precludes any illusions about the possible reducibility of the social to one constitutive element. The diversification of social spaces in highly differentiated collective life forms does not allow for the reduction of society to a monolithically constituted totality. The polycentric distribution of social space is symptomatic of the decentred constitution of highly differentiated societies.

14. The interpenetrability of social space

One crucial feature of social spaces is their interpenetrability. Social spaces are never completely, but only relatively, autonomous, since they necessarily exist in relation to one another and can, in principle, always be permeated by one another. The interpenetrative nature of social spaces stems from their structural intertwinement. 'The *intertwinement* of social spaces is also a law. Considered in isolation, such spaces are mere abstractions' (Lefebvre 1991: 86, emphasis added). Social spaces do not constitute autopoietic systems that exist and function in isolation from one another. Rather than representing completely self-sufficient and self-referential micro-universes, social spaces exist in relation to each other. Given that '[s]ocial spaces interpenetrate one another and/or superimpose themselves upon one another' (Lefebvre 1991: 86, emphasis removed), they are always subject to power relations: the penetrability of one social space by another social space depends on the power of the latter to impose itself upon the former.

> The principle of the *interpenetration and superimposition* of social spaces has one very helpful result, for it means that each fragment of space subjected to analysis masks not just one social relationship but a host of them that analysis can potentially disclose.
> *(Lefebvre 1991: 88, emphasis added)*

In other words, the interpenetrability of social spaces cannot be divorced from the polycentricity of social relations.

15. The separability of social space

What manifests itself in the separability of social space is the differentiability of human coexistence. Even the most rudimentarily developed form of society cannot dispense with a minimal degree of structural differentiation. Yet, the separation of social spaces is never neutral but always power-laden. Separations between social spaces are always also partitions between people: between rooms, flats, houses, buildings, streets, neighbourhoods, cities, regions, countries or continents. Social spaces can be both externally and internally divided: they can be *externally* divided in that they can be separated from one another, and they can be *internally* divided in that the actors situated in them can be separated from one another. Spatial separations necessarily result in normative divisions, for territorial fragmentations inevitably structure the constitution of social interactions.

> The dominant tendency fragments space and cuts it up into pieces. It enumerates the things, the various objects, that space contains. Specializations divide space among them and act upon its truncated parts, setting up *mental barriers and practico-social frontiers*.
> (Lefebvre 1991: 89, emphasis added)

Spatial separations have a tangible impact on how people relate to one another and in fact on how they relate to themselves: there are no spatial separations without social mechanisms of *inclusion* and *exclusion*. Who we are depends on how we are spatially situated in relation to other social actors. The construction of every human identity is contingent upon its spatial determinacy. In order to make sense of reality, we need to be placed in society. How we make sense of the world is influenced by how and where we are situated in space. The more a given society is marked by spatial fragmentations, the more likely it is to produce social separations. 'The *ideologically* dominant tendency *divides space up into parts and parcels* in accordance with the social division of labour' (Lefebvre 1991: 89–90, emphasis added; ideologically emphasized in original).

The control over the partitioning of social space involves the exercise of authority over the partitioning of people. The spatial partitioning of society is epitomized in the separation between centre and periphery, which can be regarded as a form of real sham: it is *sham* because the criteria for the definition of both the former and the latter are part of an ideological imaginary and, therefore, always relatively arbitrary; it is *real* because it leads to the relative empowerment of the spatial core, and the relative disempowerment of the spatial margins, of society. People's social status is reflected in their spatial position: our status as members of a given community cannot be divorced from our relationally contingent location in social space. Separations between social spaces can trigger, or reinforce, the existence of divisions between people.

16. The commodifiability of social space

The commodifiable nature of social space is a paradoxical affair. On the one hand, it is an intrinsic property of social space *that* it can be commodified. On the other hand, it is a relatively arbitrary matter, depending on the economic organization of a particular life form, *if* social space is commodified. There is nothing natural or inevitable about the commodification

of social space; on the contrary, social space tends to be commodified primarily in market-driven societies. Nevertheless, even in capitalist systems some spaces – for example, public spaces – are protected from commodification, in order to avoid them being absorbed by the functional imperatives of the market economy. Yet, the fact that particular social spaces are deliberately excluded from the commodifying logic of the market confirms the view that, in principle, *all* social spaces *can* be commodified. To 'fetishize space in a way reminiscent of the old fetishism of commodities, where the trap lay in exchange' (Lefebvre 1991: 90), means to measure the social worth of space primarily in terms of its market value, rather than in terms of its use value.

> Social space *per se* is at once *work* and *product* – a materialization of 'social being'. In specific sets of circumstances, however, it may take on fetishized and autonomous characteristics of things (of commodities and money).
>
> *(1991: 101–2, original emphasis)*

Given the ubiquity of exchange value under capitalism, it is easy to forget that the commodi-fication of space, far from constituting an inevitable social process, is contingent upon the hegemonic existence of market-driven imperatives.

17. The controllability of social space

Struggles over the control of social space illustrate that the territorial organization of society is impregnated with individual and collective interests. One central concern of human life has always been, and will always remain, the control of social space. Both as members of partic-ular communities and as members of different societies, humans are obliged to organize the space they inhabit in one way or another. The right to spatial control can be at stake on various levels: individuals' control over their private sphere, society's control over its public sphere, landowners' control over their property, or a nation-state's control over its territory – to mention only a few examples. When given the right to be in control of a given space, actors tend to take territorial integrity for granted. By contrast, when being deprived of the right to be in control of a given space, actors are forced to reflect upon the normative status of territorial realities. 'The forces of production and technology now permit of *intervention* at every level of space: local, regional, national, worldwide. Space as a whole, geographical or historical space, is thus modified, but without any concomitant abolition of its underpinnings' (Lefebvre 1991: 90, emphasis added). In brief, the exercise of power over social arrangements is unthinkable without the control over their spatial organization.

18. The usability of social space

Social spaces are used for different purposes. Indeed, as human beings, we *must* make use of space. We are obliged to make use of space because we are compelled to live in space. What may, at first sight, appear to be a truism is, actually, of crucial importance: we need to confront the implications of the fact that relationally constructed realms serve socially specific functions. *That* social spaces can, or need to, be used is relatively uncontroversial; *how* they should be used, however, could hardly be more controversial. In most cases, the function of social space is determined by those who control it. For this reason, Lefebvre insists that

> [t]he arrogant verticality of skyscrapers, and especially of public and state buildings, introduces a phallic or more precisely a phallocratic element into the visual realm; the

purpose of this display, of this need to impress, is to convey an impression of *authority* to each spectator.

(1991: 98, emphasis added)

Space is used not only for the *imposition* but also for the *representation* of power. In fact, it is through the spatial representation of power that both the symbolic imposition and the material imposition of social control become possible. Power needs to have a place in society in order to have an impact upon reality. The more we are forced to accept the organization of the spaces we inhabit, the more we are deprived from exercising autonomy over our physical immersion in the world. The more we are permitted to contribute to the organization of the spaces in which we find ourselves situated, the more we are involved in self-determining the ways in which we participate in, and engage with, reality. Disengagement generates indifference, whereas engagement induces responsibility. If we leave it to 'specialists who view social space through the optic of their methodology and their reductionistic schemata' (Lefebvre 1991: 108) to decide over the territorial organization of society, we miss out on the opportunity to create empowering collective realms shaped by deliberative processes and the assertion of human sovereignty.

19. The contestability of social space

By definition, the organization of social spaces can be contested, because how and by whom realms of action and interaction are used and controlled is always relatively arbitrary. What may appear to be an 'is' when considering the constitution of a given social space is at the same time an 'ought to be'. When we are subject to the *condition* of a spatial setting, we experience the apparent naturalness of its presence. By contrast, when we are engaged in the *construction* of a spatial setting, we contribute to the genuine arbitrariness of its existence. Surely, what can be socially constructed can be socially reconstructed, and what can be socially reconstructed can be individually or collectively fought over. 'Space as locus of production, as itself product and production, is both the weapon and the sign of this *struggle*' (Lefebvre 1991: 109, emphasis added). From a Marxian perspective, '[t]he history of all hitherto existing society is the history of class struggles' (Marx and Engels 1985 [1848]: 79); from a Lefebvrian point of view, the history of all hitherto existing society is the history of spatial struggles.

20. The transformability of social space

The fact that social spaces can, in principle, always be transformed reflects the malleable nature of human existence. Social spaces are in a continuous state of flux, that is, they change over time in terms of their structure, their composition and their inhabitants. In the Marxian world, everybody should have a right to purposeful work; in the Kantian cosmos, everybody should have a right to make use of critical reason; in the Habermasian picture, everybody should have a right to a communicatively structured lifeworld; in the Lefebvrian universe, everybody should have a right to space. Despite the quasi-ubiquity of commodity fetishism under capitalism, the consolidation of non-commodified social spaces is both achievable and desirable: it is achievable because the commodification of space is reversible, and it is desirable because the commodification of space is detrimental. In capitalist society, social spaces are bureaucratically controlled by a means-oriented polity and financially driven by a profit-oriented economy. In an emancipatory society, on the other hand, social spaces are

democratically managed by grassroots-based communities and deliberatively regulated in accordance with the demands of a needs-based economy.

> If the *production of space* does indeed correspond to a leap forward in the productive forces . . ., and if therefore this tendency . . . must eventually give rise to a *new mode of production* which is neither state capitalism nor state socialism, but the collective management of space, the social management of nature, and the transcendence of the contradiction between nature and anti-nature, then clearly we cannot rely solely on the application of the 'classical' categories of Marxist thought.
>
> *(Lefebvre 1991: 102–3, original emphasis)*

From this perspective, the social struggles that determine the course of history have to be conceived of as spatially constituted conflicts. The formation of autonomous lives depends not only on the creation of purposeful activity (Marx), critical minds (Kant) or communicative lifeworlds (Habermas), but also on the construction of autonomous spaces (Lefebvre). As subjects capable of immersion, we live in social spaces; as subjects capable of transformation, we can change them.

Main criticisms and limitations

The production of space plays a pivotal role in the construction of social reality. Thus, a comprehensive theory of the social must confront the challenge of providing a critical account of the spatial. Drawing upon the work of Henri Lefebvre, the foregoing analysis has proposed an outline of a general theory of social space, that is, of a conceptual framework that permits us to identify the key elements that determine every ordinary subject's spatial immersion in the world. Such an outline is aimed at developing the conceptual tools necessary to understand the very possibility of society in terms of its spatial determinacy. Whilst the preceding analysis has sought to identify various – arguably transcendental – features of social space, it also raises a number of serious questions about the explanatory limitations of Lefebvre's approach. It is the task of this section to reflect upon these limitations, before considering recent and possible future developments in the sociology of space in the final part of this chapter.

1. Social spaces are *human* realms. As such, they are permeated by both the objectivity of the natural world and the normativity of the cultural world. Yet, it is far from clear to what extent the critical study of space obliges us to abandon the very distinction between 'the natural' and 'the cultural'. To the extent that human lifeworlds are both physically constituted and symbolically structured, the *confluence* of the givenness and meaning-ladenness of social space escapes the binary logic of a functional dichotomy between objectivity and normativity.
2. Social spaces are *collective* realms. The idiosyncrasy of a culturally created space cannot be divorced from the sociality generated by its inhabitants. Nonetheless, while it is important to recognize the collective constitution of social spaces, we must not lose sight of their potentially *individualizing* function. Human subjects have the ability to develop a sense of autonomy and identity within real and imagined spheres of spatiality.
3. Social spaces are *constructed* realms. Human beings constantly act upon, and attribute meaning to, their physical and cultural environment. Yet, although it is crucial to remind ourselves of the constructedness of social arrangements, we must be careful not to overlook the constraining power of the *'hard' dimensions* of spatial realities: the lawfulness of

physical, geological and biological factors is irreducible to the arbitrariness of historical accidents.

4. Social spaces are *productive* realms. Different economies generate different forms of spatiality, for the division of labour constitutes the material infrastructure of social reality. Arguably, however, the dynamic development of technology has created a *global network society*, whose advanced production, information and transportation systems transcend local, regional and national boundaries.

5. Social spaces are *ideological* realms. Every regulatory authority requires a symbolically constituted representation of spatiality. This insight, though, does not permit us to explain the *relative autonomy* of the discursive frameworks that emerge in particular spatial realities. While language games arise within spatially constituted life forms, the creative playfulness of the former can challenge the constraining influence of the latter.

6. Social spaces are *relational* realms. Just as people can determine relations between spaces, spaces can determine relations between people. Relational accounts of space derive their explanatory power from their epistemic capacity to capture the interconnectedness underlying different modes of agency. They tell us remarkably little, however, about the extent to which the ontological specificities of subjects and objects can *rise above* the spatiotemporal contingency of relationally constituted realities.

7. Social spaces are *structural* realms. As structured structures, they are brought into existence by human actions; as structuring structures, they shape the nature of human actions. Yet, *regimes of space* are always impregnated with *regimes of time*: every spatial interaction takes place in a culturally codified syntax of temporal organization. Immersion in time is by no means a less significant precondition for the emergence of social structures than immersion in space.

8. Social spaces are, at least potentially, *visible* realms. Often spaces are seen without being noticed, for visual perception does not always trigger critical reflection. Even when both seen and noticed, however, spaces have an *underlying and imperceptible* physical constitution, which may be studied scientifically, but which escapes our commonsense grasp of reality.

9. Social spaces are *idiosyncratic* realms. In this sense, not only are they sustained by distinctive forms of rationality with self-referential codes of legitimacy, but they also serve as vehicles for the situational contingency of human agency. Yet, foundational forms of rationality – notably purposive and substantive rationality – are not necessarily determined by the prevalence of a given spatial rationality, because cognitive modes of motivation are *irreducible* to the logic of a specific location. Put differently, rationality is a privilege of human beings, rather than of their environment.

10. Social spaces are *ubiquitous* realms. Given that space is all over the place, we have to accept that physical situatedness is a precondition for our engagement with reality. In the digital age, however, the construction of *cyberspace* allows for the experience of hyperreality, which transcends traditional notions of bodily determinacy.

11. Social spaces are *historical* realms. Social actors make their own history, but they do so in spaces directly experienced, shaped by and passed on from the past. There is no such thing as an ahistorical social action taking place in a timeless space. Yet, the explanatory challenge consists in identifying the specific *conditions* that make some spaces relatively *stable and durable*, and others comparatively *malleable and transposable*.

12. Social spaces are potentially *complex* realms. Instead of reducing society to a monolithically constituted totality, we need to face up to its spatially constituted complexity. It may be fairly straightforward to illustrate that social spaces are composed of multi-layered and

Simon Susen

interwoven elements; it is rather difficult, however, to shed light on the main constituents that account for the *specificity* of a particular type of spatiality.

13. Social spaces are *polycentric* realms. Yet, an important question that poses itself – not only to Luhmannian systems theorists and Bourdieusian field theorists, but also to Lefebvrian space theorists – can be phrased as follows: given that, particularly in highly differentiated societies, various interactional realities overlap, what criterion or criteria should we use to define the boundaries of a spatial setting? More specifically, does the *preponderance* of a particular spatial realm depend primarily on *objective* factors (e.g. structural circumstances), *intersubjective* factors (e.g. relational arrangements), *subjective* factors (e.g. cognitive projections), or a combination of these elements? Critical sociologists have a major task on their hands when seeking to provide evidence-based parameters for a non-reductive analysis of space.

14. Social spaces are *interpenetrable* realms. The relational realms shaped by human subjectivities permeate one another as spatial objectivities. The analytical challenge, however, consists in exploring not only the penetrability of, but also the *hierarchy* between, different spatial realities in the formation of society.

15. Social spaces are *separable*, and hence potentially divisive, realms. Divisions between social spaces reflect partitions between people: our spatial position cannot be dissociated from our social position, for we need to have a locus in space in order to occupy a place in society. Yet, if we admit that spaces can be separated both physically and symbolically through the construction of objective and interpretive boundaries, we need to problematize the *potential discrepancy* between really existing demarcations and phenomenologically projected classifications: although 'spaces-in-themselves' and 'spaces-for-themselves' – that is, 'realities of space' and 'conceptions of space' – are intimately intertwined, they do not necessarily coincide.

16. Social spaces are *commodifiable* realms. In capitalist markets, the exchange value of social space tends to be predominant over its use value. Nevertheless, even in commodified social realities there is room for *meaningful* activities. The presence of an instrumental teleology does not necessarily prevent social actors from mobilizing the self-empowering resources inherent in substantive rationality.

17. Social spaces are, at least potentially, *controllable* realms. The power over a given social formation requires the control over its spatial organization. Yet, even the exogenous regulation of people's space does not guarantee control over their minds. Social actors have privileged access to their subjectivity *regardless* of their spatial environment.

18. Social spaces are *usable* realms. People need to be able to make use of space, in order to engage with and act upon the world. The philosophically more interesting question, however, is to what extent humans either have a moral right to use spaces as *means to an end* or have a moral obligation to treat spaces as *ends in themselves*. The tension between the instrumental nature of *Verstand* and the value-laden constitution of *Vernunft* comes to the fore when grappling with the ethical implications of our relation to space.

19. Social spaces are *contestable* realms. Legitimate actors are nothing without legitimate spaces, just as legitimate spaces are nothing without legitimate actors. The struggle over the right to space is a struggle over the right to live. It is far from clear, however, on what *normative grounds* it is possible to distinguish between universally defensible and tribalistically motivated reasons for the right to space. An emancipatory politics must resist the temptation to endorse primordial and exclusionary conceptions of *Lebensraum*.

20. Social spaces are potentially *transformable* realms. A critical sociology of space allows us to put our capacity to reconstruct reality at centre stage. As immersive entities, we are thrown into social spaces; as transformative entities, we can change them. Social

struggles, in addition to shaping the course of history, have a place in space. This does not mean, however, that *every* social struggle is reducible to a struggle for and over space.

Recent and possible future developments

Having reflected upon some of the key limitations and questions arising from Lefebvre's approach, let us, in the final part of this chapter, consider recent and possible future developments in social and cultural theories of space. Given that, unavoidably, such an analysis is selective and limited in scope, this closing section does not aim to do justice to the range and complexity of the various explanatory frameworks that have been developed over the past few decades in the sociology of space. Rather, it will focus on a few central issues relevant to contemporary studies of space.

a) John Urry is widely recognized as one of the major social theorists of *global flows*, '*mobilities*' and *migration*. Perhaps the most fundamental thesis underlying his writings on space (see, for instance: Elliott and Urry 2010; Gregory and Urry 1985; Urry 1985, 1995, 2000, 2007) is the following assumption: the traditional notion that '[e]ach "society" is a sovereign social entity with a nation-state that organises the rights and duties of each societal member or citizen' (Urry 2000: 8) no longer holds true. In other words, whereas in classical sociology '[m]ost major sets of social relationships are seen as flowing within the territorial boundaries of the society' (2000: 8), in the contemporary age 'shifts towards global networks and flows' transcend the narrow logic and 'boundaries of the nation-state' (2000: 198). Given the increasing interconnectedness of the contemporary world, we need to account for the material and symbolic complexity of the global network society, whose transnational character obliges us to revise the conceptual and methodological tools of classical sociology.

b) Manuel Castells, one of the most celebrated contemporary social theorists, is perhaps best known for coining the idea that in the late twentieth century the world witnessed the rise of the *network society*. It comes as no surprise, then, that 'space' is a key category in his major works (see, for example, Castells 1977, 1989, 2001). In his acclaimed trilogy *The Information Age* (Castells 1996, 1997, 1998), he offers a remarkably detailed account of the sociological issues arising from the emergence of informational and communicational networks across the world. According to Castells, the consolidation of the network society is the result of three interconnected processes: (i) the rapid development of information technologies; (ii) the profound restructuring of welfare regimes and the collapse of state socialism; and (iii) the emergence and growing influence of new social movements. To the extent that technological, economic and political '[n]etworks constitute the new social morphology of our societies' (Castells 1996: 500), we live in an age in which the interplay between locality and globality is crucial to the historical development of humanity.

c) Anthony Giddens, arguably one of the most influential and prolific social theorists of the late twentieth century (see, for instance, Giddens 1984, 1991, 2000), maintains that an essential feature of modernity is the *uncoupling of space and time*. Giddens's assertion that this 'time-space distanciation' (see esp. Giddens 1990) is central to social modernization processes is based on the following assumption: '[i]n pre-modern societies, space and place largely coincide' (1990: 18), as people's engagement with reality is limited to their immediate experience of geographically constricted lifeworlds; by contrast, '[t]he advent of modernity increasingly tears space away from place by fostering relations between "absent" others, locationally distant from any given situation of face-to-face interaction' (1990: 18).

Put differently, the perpetual reproduction of the pre-modern world is founded on the experience of social, cultural and territorial embeddedness, whereas under the condition of modernity 'space' has escaped the confining shackles of 'place'.

d) Ulrich Beck is probably best known for his numerous writings on the thesis that the rise of a 'second' or 'reflexive' modernity manifests itself in the emergence of a *'global risk society'* (see, for example, Beck 1992, 1999, 2009). By definition, global risks transcend geographical and demographical boundaries. More importantly, however, global risks require global solutions. In order to overcome the 'methodological nationalism' of classical sociology, we need to understand the various paradigmatic shifts that are indicative of the transition from 'first modernity' to 'second modernity': (i) *Critical reflexivity*: Social actors have become increasingly critical of traditional norms, institutions and belief systems, whose legitimacy is constantly at stake in public debates guided by the search for rational and empirical evidence. (ii) *Complex identities*: Social actors are not only allowed but also expected to construct multifaceted personal identities, as they enjoy an unprecedented degree of individual freedom. (iii) *Ontological continuum*: The condition of 'reflexive modernity' is characterized by the gradual erosion of traditional dichotomies, such as culture versus nature, life versus death, citizen versus foreigner, micro versus macro, local versus global, and place versus space. (iv) *Time-space compression*: Due to the rapid development of globalized production, information and transportation systems, physical proximity is no longer a precondition for social propinquity. (v) *Cosmopolitanism*: In light of the increasing influence of non-governmental actors 'from below' and supranational actors 'from above', the nation-state fails to serve as a viable normative reference point for dealing with the profound political, economic and environmental challenges faced by the global risk society. From this perspective, cosmopolitanism is not only a realistic utopia but also a practical necessity. Social actors have always lived in a global space, but, in the era of 'second modernity', cosmopolitan forms of reflexivity have become a precondition for the long-term survival of humanity.

e) In his abundant writings (see, for instance, Soja 1989, 1996, 2000), Edward Soja aims to demonstrate that 'space' deserves to be treated as a practical foundation of human life as well as a theoretical cornerstone of social and cultural analysis. Drawing on central insights from poststructuralist and postmodernist thought, he insists upon the *normalizing function* of spatial arrangements. To the extent that 'relations of power and discipline are inscribed into the apparently innocent spatiality of social life . . . human geographies become filled with politics and ideology' (Soja 1989: 6). More specifically, Soja seeks to illustrate the validity of three fundamental assumptions. (i) Under the condition of late modernity, capitalism has been restructured in such a way that 'the spatial' is both materially and symbolically preponderant over 'the temporal'. (ii) 'Space' constitutes a central component of social life. (iii) Given its pivotal role in processes of social reproduction and transformation, the concept of 'space' needs to be given analytical priority in critical theory. Soja's 'triple dialectic of space, time, and social being' (1989: 12), then, is aimed not only at the (re-) spatialization of critical theory, but also at the deconstruction of the problematic opposition between space (often misrepresented as a fixed, stable and immobile state of being) and time (commonly conceived of as a dynamic, fluid and volatile mode of becoming). His insistence upon the ontological interdependence of *spatiality*, *historicity* and *sociality* is inspired, at once, by the defence of a critical human geography, by the postmodern incredulity towards determinist accounts of history, and by the Marxist-Weberian suspicion towards instrumental rationality. Arguably, this *trialectics of being* lies at the heart of any society, regardless of its typological specificity.

f) Doreen Massey is commonly regarded as one of the most prominent contemporary British geographers. In her various writings (see, for example, Massey 1994, 1995, 2005), she aims to demonstrate that space is a product of interrelations (*relationality*), a physical realm composed of heterogeneous parts (*multiplicity*) and an open reality constantly under construction (*malleability*). The first assumption is motivated by the conviction that spaces are shaped primarily by the *relations* and *interactions* between subjects and objects, rather than by their alleged properties. The second claim is based on the view that, particularly in highly differentiated settings, spaces are constructed by *multiple* and *heterogeneous* subjects and objects, whose diversified identities are indicative of the complexity of polycentric societies. The third presupposition suggests that spaces are *malleable* and *dynamic* modes of being, that is, they are in a constant state of flux, even when this is not immediately obvious. While insisting on the relational, multifaceted and malleable nature of social space, Massey's empirical studies shed light on the manifold ways in which social spaces are differentiated in terms of sociological variables, notably class, ethnicity and gender. Her substantive investigations have five major theoretical implications. (i) Just as there is no space without place, there is no place without space. (ii) Space is situated in time, while time is located in space. (iii) To the extent that space is shaped by and through society, society is constructed by and through space. (iv) The construction of space is imbued with meaning, and the creation of meaning takes place in space. (v) Spatial power is a form of social power, at the same time as social power is a form of spatial power. It is the task of a radically anti-essentialist politics to challenge hegemonic practices and beliefs, thereby reminding us of the fact that '[i]t is not spatial form in itself (nor distance, nor movement) that has effects, but the spatial form of particular and specified social *processes* and social *relationships*' (Massey 1984: 5, emphasis added).

g) In her plentiful writings (see, for instance, Sassen 2001, 2007, 2008), Saskia Sassen aims to demonstrate that, contrary to common wisdom, 'place' plays a crucial role in the construction of an increasingly interconnected global society. This, she claims, is illustrated in the managerial and economic power exercised by professional elites in metropolises such as London, New York and Tokyo. Their existence indicates that we are confronted with a curious paradox: on the one hand, we live in a world of increasing mobility, volatility and dispersal of both capital and labour; on the other hand, the contemporary age is characterized by the concentration of power, resources and wealth in metropolitan centres with global influence. In other words, the dynamic interplay between space and place is fundamental to globalization processes. To be exact, the simultaneous globalization and localization of social reality is reflected in five key tendencies: *economic transnationalization* (geographical scattering of commercial activities), *economic specialization* (outsourcing of productive, distributive and administrative services), *economic concentration* (agglomeration of financial power in urban areas and metropolises), *economic tertiarization* (concentration of a highly specialized service sector in global cities) and *economic urbanization* (hierarchization of global cities in terms of their influence on the worldwide network of knowledge, information and services). As these tendencies unambiguously show, 'place' is vital to the global organization of space.

h) Inspired by Lefebvre's approach, one of the key aims of David Harvey's work is to give the concept of 'space' a central place in Marxist social theory (see, for example, Harvey 1989, 2000, 2001, 2006). Far from conceiving of space as a natural given, Harvey regards spatial arrangements as both a cause and an effect of social practices. In the context of modernity, social spatiality is permeated by the systemic logic of the capitalist economy. Harvey insists that, by definition, the spatial organization of human environments contains both an

objective and a *subjective* dimension. In fact, all human societies are composed of both (material) 'spaces-in-themselves' and (symbolic) 'spaces-for-themselves'. At the objective level, the most idiosyncratic places can be absorbed by the standardizing logic of capitalist productivism and consumerism. On the subjective level, the most homogenized spatial arrangements are perceived and experienced differently by interpretive actors with unique life stories. It is one of Harvey's major achievements to have demonstrated that, just as the dialectical construction of human reality is inconceivable without the production of space, the existence of hegemonic systems of domination manifests itself in instrumental modes of geographical organization. Thus, even the 'condition of postmodernity' (Harvey 1989) – commonly associated with unprecedented degrees of complexity, multiplicity and fluidity – constitutes an era characterized by the enduring existence of systematicity, determinacy and instrumental rationality.

i) Given the eclectic nature and large scope of his intellectual work, it is difficult to do justice to the depth and breadth of Nigel Thrift's analysis of space (see, for instance: Leyshon and Thrift 1997; Peet and Thrift 1989; Pile and Thrift 1995a; Thrift 1996). One may suggest, however, that his 'new regional geography' is based on six central assumptions. (i) *Contingency*: Space is socially constructed, both as a material sphere, acted and worked upon by purposive entities, and as a symbolic realm, imagined and experienced by interpretive creatures. (ii) *Temporality*: Space is situated in time, just as time is located in space. Spatial arrangements are imbued with historicity. (iii) *Agency*: Far from representing simply a social fact, space constitutes also a social act. The performativity inherent in social reality permeates spatiality with meaning-laden horizons of human agency. (iv) *Intersubjectivity*: Even in a globalized environment, in which 'space' appears to be preponderant over 'place', interpersonal relations, established in communicatively structured lifeworlds, continue to be vital to the functional reproduction of the social fabric. The most abstract forms of social relations, mediated by money and bureaucratic administration, cannot dispense with mutual understanding, trust and cooperation. (v) *Contextuality*: Notwithstanding the degree of planetary interconnectedness, critical geographers need to be sensitive to local and regional specificities. In fact, globalization is as much about systemic standardization as it is about social differentiation. (vi) *Discursivity*: Just as different spaces create different discourses, different discourses generate different spaces. It is because humans are immersed in space that they play language games in historically specific life forms.

Conclusion

As should be evident from the previous analysis, 'space' – both as a symbolic imaginary and as an empirical reality, as a conceptual tool of critical enquiry and as a constitutive element of society – deserves to be taken seriously by social and cultural theorists. This is essentially due to the fact that all domains of human existence are, directly or indirectly, affected by the production, and constant reinvention, of space. Hence, in order to uncover the social determinacy of the spatial, we need to grasp the spatial determinacy of the social, and vice versa.

As elucidated in the first section of this chapter, it is worth remembering that, although space can be regarded as a marginal category in classical sociology, Simmel's work provides useful insights into the spatial constitution of everyday life. To be exact, his writings shed light on the fact that the social construction of spatial realities is permeated by five power-laden tensions: inclusivity versus exclusivity, unifiability versus separability, fixity versus changeability, proximity versus distance, and sedentariness versus mobility.

As demonstrated in the second section of this chapter, Lefebvre's writings are based on the

assumption that the construction of society is inconceivable without the production of space. As a species, we have learned to shape not only the cultural and economic arrangements of social life, but also the spatial circumstances of our existence. Thus, in order to comprehend how we are embedded in society, we need to understand how we are situated in spatial forms of reality. To this end, the foregoing study has proposed a Lefebvrian outline of a general theory of social space, that is, an analytical framework capable of identifying the transcendental conditions underlying the spatial structuration of *any* society, regardless of its historical specificity. As emphasized in the third section of this chapter, however, it is vital to be aware of the explanatory limitations of Lefebvre's approach, in order to avoid painting a simplistic picture of the spatial organization of human societies.

Finally, as shown in the fourth section of this chapter, there have been considerable developments in recent sociological studies of space. The above overview, which captures only some of these paradigmatic trends, is unavoidably selective and limited in scope. No attempt has been made here to give an exhaustive account capable of doing justice to the variety and intricacy of the explanatory frameworks that have emerged over the past few decades in the sociology of space. Nonetheless, the preceding synopsis has illustrated that several social and cultural theorists – as diverse as Urry, Castells, Giddens, Beck, Soja, Massey, Sassen, Harvey and Thrift – share one central conviction: human actors, given that they are bodily entities, will always have a place in space.

Acknowledgement

I would like to thank Richard Armstrong for his detailed and useful comments on an earlier version of this chapter.

Notes

1 Cf. Marx (2000 [1845]: 329): 'Men make their own history, but they do not make it just as they please; they do not make it under circumstances chosen by themselves, but under circumstances directly encountered, given, and transmitted from the past.'

References

Beck, U. (1992 [1986]) *Risk Society: Towards a New Modernity*, trans. M. Ritter, London: Sage.
—— (1999) *World Risk Society*, Cambridge: Polity.
—— (2009 [2007]) *World at Risk*, trans. C. Cronin, Cambridge: Polity.
Berger, J. (1977 [1972]) *Ways of Seeing*, London: Penguin.
Bourdieu, P. (1991) 'Social space and symbolic space', *Poetics Today*, 12(4): 627–38.
—— (2000 [1997]) *Pascalian Meditations*, trans. R. Nice, Cambridge: Polity.
Bourdieu, P. and Wacquant, L. (1992) *An Invitation to Reflexive Sociology*, Cambridge: Polity.
Brenner, N. (2000) 'The urban question as a scale question: reflections on Henri Lefebvre, urban theory and the politics of scale', *International Journal of Urban and Regional Research*, 24(2): 361–78.
Butler, C. (2012) *Henri Lefebvre: Spatial Politics, Everyday Life and the Right to the City*, London: Routledge-Cavendish.
Castells, M. (1977 [1976]) *The Urban Question: A Marxist Approach*, trans. A. Sheridan, London: Edward Arnold.
—— (1989) *The Informational City: Information Technology, Economic Restructuring, and the Urban-Regional Process*, Oxford: Blackwell.
—— (1996) *The Information Age: Economy, Society, and Culture. Volume I: The Rise of the Network Society*, Oxford: Blackwell.
—— (1997) *The Information Age: Economy, Society, and Culture. Volume II: The Power of Identity*, Oxford: Blackwell.

—— (1998) *The Information Age: Economy, Society, and Culture. Volume III: End of Millennium*, Oxford: Blackwell.

—— (2001) *The Internet Galaxy: Reflections on Internet, Business, and Society*, Oxford: Oxford University Press.

Elden, S. (2004) *Understanding Henri Lefebvre: Theory and the Possible*, London: Continuum.

Elliott, A. and Urry, J. (2010) *Mobile Lives*, London: Routledge.

Giddens, A. (1984) *The Constitution of Society: Outline of the Theory of Structuration*, Cambridge: Polity.

—— (1990) *The Consequences of Modernity*, Cambridge: Polity.

—— (1991) *Modernity and Self-Identity: Self and Society in the Late Modern Age*, Cambridge: Polity.

—— (2000) *Runaway World: How Globalisation Is Reshaping Our Lives*, London: Profile.

Goonewardena, K., Kipfer, S., Milgrom, R. and Schmid, C. (eds) (2008) *Space, Difference, Everyday Life: Reading Henri Lefebvre*, London: Routledge.

Gregory, D. and Urry, J. (eds) (1985) *Social Relations and Spatial Structures*, Basingstoke: Macmillan.

Harvey, D. (1989) *The Condition of Postmodernity: An Enquiry into the Origins of Cultural Change*, Oxford: Blackwell.

—— (2000) *Spaces of Hope*, Edinburgh: Edinburgh University Press.

—— (2001) *Spaces of Capital: Towards a Critical Geography*, Edinburgh: Edinburgh University Press.

—— (2006) *Spaces of Global Capitalism: Towards a Theory of Uneven Geographical Development*, London: Verso.

Hess, R. (1988) *Henri Lefebvre et l'aventure du siècle*, Paris: Métailié.

Hubbard, P., Kitchin, R. and Valentine, G. (eds) (2004) *Key Thinkers on Space and Place*, London: Sage.

Keith, M. and Pile, S. (1993a) 'Introduction part 2: the place of politics', in M. Keith and S. Pile (eds) *Place and the Politics of Identity*, London: Routledge.

—— (eds) (1993b) *Place and the Politics of Identity*, London: Routledge.

Knowles, C. and Sweetman, P. (2004a) 'Introduction', in C. Knowles and P. Sweetman (eds) *Picturing the Social Landscape: Visual Methods and the Sociological Imagination*, London: Routledge.

—— (eds) (2004b) *Picturing the Social Landscape: Visual Methods and the Sociological Imagination*, London: Routledge.

Lechner, F. J. (1991) 'Simmel on social space', *Theory, Culture & Society*, 8(3): 195–201.

Lefebvre, H. (1974) *La production de l'espace*, Paris: Éditions Anthropos.

—— (1991 [1974]) *The Production of Space*, trans. D. Nicholson-Smith, Oxford: Blackwell.

—— (1996) *Writings on Cities*, trans. E. Kofman and E. Lebas, Oxford: Blackwell.

—— (2000 [1968]) *Everyday Life in the Modern World*, trans. S. Rabinovitch, London: Athlone.

—— (2008a [1947]) *Critique of Everyday Life. Volume I*, trans. J. Moore, London: Verso.

—— (2008b [1961]) *Critique of Everyday Life: Foundations for a Sociology of the Everyday. Volume II*, trans. J. Moore and G. Elliott, London: Verso.

—— (2008c [1981]) *Critique of Everyday Life: From Modernity to Modernism (Towards a Metaphilosophy of Daily Life). Volume III*, trans. J. Moore and G. Elliott, London: Verso.

Leyshon, A. and Thrift, N. J. (eds) (1997) *Money/Space: Geographies of Monetary Transformation*, London: Routledge.

Martins, M. R. (1982) 'The theory of social space in the work of Henri Lefebvre', in R. Forrest, J. Henderson and P. Williams (eds) *Urban Political Economy and Social Theory: Critical Essays in Urban Studies*, Aldershot: Gower.

Marx, K. (2000 [1845]) 'The Eighteenth Brumaire of Louis Bonaparte', in D. McLellan (ed.) *Karl Marx: Selected Writings*, 2nd edn, Oxford: Oxford University Press.

Marx, K. and Engels, F. (1985 [1848]) *The Communist Manifesto*, London: Penguin.

—— (2000 [1846]) 'The German ideology', in D. McLellan (ed.) *Karl Marx: Selected Writings*, 2nd edn, Oxford: Oxford University Press.

Massey, D. (1984) 'Introduction: geography matters', in D. Massey and J. Allen (eds) *Geography Matters! A Reader*, Cambridge: Cambridge University Press, in association with Open University.

—— (1994) *Space, Place and Gender*, Cambridge: Polity.

—— (1995) *Spatial Divisions of Labour: Social Structures and the Geography of Production*, 2nd edn, London: Macmillan.

—— (2005) *For Space*, London: Sage.

Mellor, P. A. and Shilling, C. (1997) *Re-Forming the Body: Religion, Community and Modernity*, London: Sage.

Merrifield, A. (1993) 'Space and place: a Lefebvrian reconciliation', *Transactions of the Institute of British Geographers*, 18: 516–31.
—— (2006) *Henri Lefebvre: A Critical Introduction*, London: Routledge.
Peet, R. and Thrift, N. J. (eds.) (1989) *New Models in Geography: The Political-Economy Perspective*, London: Unwin Hyman.
Pile, S. (1996) *The Body and the City: Psychoanalysis, Space and Subjectivity*, London: Routledge.
Pile, S. and Thrift, N. (eds.) (1995a) *Mapping the Subject: Geographies of Cultural Transformation*, London: Routledge.
—— (1995b) 'Mapping the subject', in S. Pile and N. Thrift (eds) *Mapping the Subject: Geographies of Cultural Transformation*, London: Routledge.
Sassen, S. (2001) *The Global City: New York, London, Tokyo*, 2nd edn, Princeton, NJ: Princeton University Press.
—— (2007) *A Sociology of Globalization*, New York: W. W. Norton.
—— (2008) *Territory, Authority, Rights: From Medieval to Global Assemblages*, updated edn, Princeton, NJ: Princeton University Press.
Shields, R. (1991) *Places on the Margin: Alternative Geographies of Modernity*, London: Routledge.
—— (1999) *Lefebvre, Love and Struggle: Spatial Dialectics*, London: Routledge.
—— (2004) 'Henri Lefebvre', in P. Hubbard, R. Kitchin and G. Valentine (eds) *Key Thinkers on Space and Place*, London: Sage.
Simmel, G. (1997 [1903]) 'The sociology of space', in D. Frisby and M. Featherstone (eds) *Simmel on Culture: Selected Writings*, trans. M. Ritter and D. Frisby, London: Sage.
Soja, E. W. (1989) *Postmodern Geographies: The Reassertion of Space in Critical Social Theory*, London: Verso.
—— (1996) *Thirdspace: Journeys to Los Angeles and Other Real-and-Imagined Places*, Oxford: Blackwell.
—— (2000) *Postmetropolis: Critical Studies of Cities and Regions*, Oxford: Blackwell.
Stanek, Ł. (2011) *Henri Lefebvre on Space: Architecture, Urban Research, and the Production of Theory*, Minneapolis, MN: University of Minnesota Press.
Susen, S. (2007) *The Foundations of the Social: Between Critical Theory and Reflexive Sociology*, Oxford: Bardwell Press.
—— (2011) 'Bourdieu and Adorno on the transformation of culture in modern society: towards a critical theory of cultural production', in S. Susen and B. S. Turner (eds) *The Legacy of Pierre Bourdieu: Critical Essays*, London: Anthem Press.
Thrift, N. (1996) *Spatial Formations*, London: Sage.
Urry, J. (1985) 'Social relations, space and time', in D. Gregory and J. Urry (eds) *Social Relations and Spatial Structures*, Basingstoke: Macmillan.
—— (1995) *Consuming Places*, London: Routledge.
—— (2000) *Sociology Beyond Societies: Mobilities for the Twenty-First Century*, London: Routledge.
—— (2007) *Mobilities*, Cambridge: Polity.
Zieleniec, A. (2007) *Space and Social Theory*, London: Sage.

20

Reading and reception

David Crouch and Jennifer Rutherford

Situating reading and reception: historical and intellectual development

To study literature is to study writing, yet intertwined with writing is the practice of reading. Michel Foucault suggests that writing should be conceived of not as a 'product' or a 'thing', but rather as an 'act' (1991: 104). Reading too is an 'act'. Literary and critical theory has had much to say about the business of writing and about the meanings of texts, but to use Wolfgang Iser's phrase, what of 'the act of reading' itself? Reading is seemingly the simple process of receiving and transforming the black marks on a page, and yet the complex dialectic that opens up when an individual consciousness encounters a text – when a reader meets the voice and words of an author – has provoked the curiosity of those interested in precisely what goes on when we read. What reading constitutes, as an activity, a discipline or a dialogue, has long been the subject of debate. For example, reading is often seen to invite a kind of intimacy; it suggests a private, solitary space that the reader inhabits, perhaps a forgetting of the world and a falling into words and fiction. Yet, on the other hand, reading is also understood as a decidedly social activity, a promiscuous process of exchange. In this sense reading is essentially the act of entering another's thoughts and, as such, becomes an intense engagement with something or someone other. It is described as one of those rare moments when the boundaries between the self and the other collapse. The practice of reading is thus an unusual, perhaps unique, instance in which we give over to another, allowing their consciousness to become our own. In 'Phenomenology of reading' (1969) Georges Poulet pointed out that when we read the barrier between us and the book falls away. You are inside the book and it is inside you. Before we begin to read the book is an inert object, separate from us; it cannot become alive or be animated until our consciousness enters into it and realizes it as a work.

Although its roots are considerably longer (the study of reading could be said to have its origins in the philosophic orientation of classical poetics), critical preoccupation with the ideas and processes of reading solidified into a strand of literary theory in the late 1960s and 70s. From the outset it was an adversarial area of research; it not only defined itself in opposition to current trends in scholarship, but also became the site of battles waged within the field. Despite a lineage of debate, dispute and disregard, those working across the terrain of reading, reception and response theory agree that reading itself is an experience that is richly paradoxical. There is a general consensus that the reader is expanded by the meaning-making potential of writing and simultaneously reduced by the restraints the text imposes. Roland Barthes says that 'to read is to struggle to name, to subject the sentences of the text to a semantic transformation' (1975: 92). And, as Michel de Certeau points out, any text that is being read 'is ordered in accord with codes of perception that it does not control' (1984: 170).

The reader actively, imaginatively and perhaps painfully attempts the 'semantic transformation' of a text by bringing to bear a particular personal lens, which carries with it its own modes of meaning making. In other words, those concerned with the theory of reading consider the role of the reader as a creative one, and examine the exchange in which the reader activates the text and brings its meaning into being. This mode of analysis induces questions about the possibility of multiple readings and contradictory interpretations, about the subjective and objective experience of creating meaning through reading. Reading is seen as a sense-making activity, yet the meanings made from texts vary from reader to reader. In response to this indeterminate interpretive activity, some reading theorists have posited the idea of an abstract 'ideal' reader, while others studying the actual responses of everyday readers find personal and cultural history inseparable from individual reading experiences.

Reading is not a natural act; not only is it an acquired skill, dictated by forms and norms that must be learnt, but it is also conditioned by the historical and cultural position of the reader. While reading offers the chimeras of privacy, solitude and escape, it is only made possible by adopting certain social rules, conventions and subject positions that are historically contingent and culturally constructed. Readers make sense of books through the lens of their particular cultural fantasies. Theories of reading have thus stretched between studies of reading as a practice that literally produces the self, to definitions of reading as a political act with the potential to transform or reinforce the normative fabric of society. Some critics see reading and interpretation as a kind of public gesture, while others suggest reading is essentially an individual response to a set of relatively independent textual codes. Contrasting emphases emerge from this division: there is the question of how a text can control and transform the reader, but also a consideration of the reader's power to create and re-create a text.

Critical engagement with the practice of reading began in the 1930s, but it was not until the early 1970s that an emphasis on the reader emerged as a coherent field. The catalyst for this was a reaction against the increasingly hegemonic principles of formalism and new criticism, which were beginning to dominate literary studies; these were methodologies that actively dismissed the meaning-making role of the reader in favour of a focus on structures and significations inherent in the text. The critical landscape in the 1970s was underpinned by a displacement of the autonomous subject as the centre of meaning, and instead posited a socially constructed and bodily situated self, manipulated by power and desire. Such a theoretical environment was seemingly at odds with studies that considered the responses of individual readers. Perhaps as a result, there is no one discipline here, but rather overlapping research orientations with a variety of foundational methodologies and epistemologies. In this chapter we will discuss a number of these approaches, outlining the key contributions to what has come to be known as reader-response criticism or reception theory. The distinction between these terms is still a matter of conjecture, and they are often loosely interchangeable, conflated or instead rigorously defined. Essentially, however, 'reception studies' considers how a group of readers – for example, a class, a gender or the devotees of a specific genre – use and interpret a text, while 'reader-response' criticism attends more specifically to what happens during the reading process itself. While referring to both these emphases, this chapter will rely on the umbrella terms 'reading theory' or 'reader-orientated theory' in order to encompass criticism that broadly maintains that things like textual structure and authorial intent are secondary to (or at least equally worthy of critical consideration as) the interpretive activities of readers. Essentially what these, often divergent, approaches to understanding literature have in common is an insistence on the importance of the reader, a denial of the objective literary text, and an emphasis on an active individual interaction with writing.

With its accent on the reception and response of the reader, reading theory was influenced by phenomenology, a philosophy geared towards individual perception and a way of thinking that conceptualized human consciousness not as merely an inert registration of the world, but rather as actively constituting it. Phenomenology, which originated with German philosopher Edmund Husserl in the early twentieth century, suggests objects in the world – such as books – exist only when experienced by an active consciousness, or a reader. The object of perception and perception itself are mutually dependent and thus human subjectivity becomes the locus of meaning. This philosophy provided support for a focus on the perception and reception of readers. Phenomenologists such as Martin Heidegger suggest that structures of meaning are made before they are lived or thought, that interpretation of the world relies on the endless application of an individual's pre-existing assumptions and beliefs. Those first attempting to create coherent methods for analysing the act of reading used these ideas as a base from which to argue that the interpretation of texts was a dynamic process, at least in part guided by the particular composition and milieu of the reader, who 'functions as mediator between text and author' (Suleiman 1980: 17). Wolfgang Iser (1974), one of the key 'reading theorists', describes how the dialectic interaction between text and reader fuel a 'phenomenology of reading'. Alongside phenomenology, studies of reading have also been influenced by hermeneutics; here the theory of hermeneutics becomes transformed into *rezeptionsaesthetik*, reception aesthetics or reception theory. These ideas and terms were first formulated in the late 1960s when Iser and his colleague Hans Robert Jauss founded the *Die Konstanzer Schule* (Constance School), which developed the first sustained studies of reading and reception theory. These ideas were later taken up and reformulated by American critics such as Stanley Fish and Norman Holland. The claims and approaches developed by these reading theorists, amongst others, will occupy the following section of this chapter. We will then outline some of the oppositions and criticisms levelled at the study of reading, highlight the continued importance of this mode of analysis, and finally conclude by considering what trajectories reader-orientated theories might take in the future.

Key contributors and developments

As we have indicated, the origins of critical thinking about the function and experience of the reader are unclear. It could be said to have started with Plato's and Aristotle's reflections on the effects of poetry and drama (see Aristotle's *Poetics* and Plato's *Phaedrus*), which became part of the Romantic movement's emphasis on a mode that intimately addressed a reader. However, it is generally accepted that this form of criticism rose to prominence in the mid-twentieth century. In her much cited anthology, *Reader-Response Criticism*, Jane Tompkins claims that reader-response theory 'started with I. A. Richards' discussions of emotional response in the 1920s or with the work of D. W. Harding and Louise Rosenblatt in the 1930s' (1980: x). The early work of I. A. Richards foreshadows reading theory's concentration on reader response. In *Principles of Literary Criticism* (1926) Richards outlines a method of textual analysis that emphasizes the reader's emotional reaction to a text and suggests the reader's participatory, moral engagement with the knowledge produced by it. What most clearly suggests him as a precursor of reading theory is his awareness that any reader's encounter with a text necessarily involves a host of individual perspectives and ideas drawn from a specific culture and history. Ironically Richards abandons these concepts in his later work, instead arguing that a text produces its own self-contained meaning, a structural approach that was later adopted by the new critics, the perceived adversaries of reading and reception theories.

Initially omitted or unknown, Louise Rosenblatt's *Literature as Exploration* (1970 [1938]) is now often cited as another early foray into reader-orientated theory. Rosenblatt offers a lucid analysis of the process of exchange enacted between reader and text, suggesting that both are involved in the production of meaning. Forty years later Rosenblatt continued this contribution in *The Reader, the Text, the Poem* (1994 [1978]), conceiving the role of the reader as part of a 'transactional' process and arguing for a critical separation between what she calls 'efferent' and 'aesthetic' reading (1994: 24). The former focuses upon the knowledge the reader takes from the text, while the latter involves a reader's lived experience of writing. This experience is said to derive from the stimulation of the text; it is ordered and limited by the text, but shaped by the reader's thoughts, past and place. While the reader has a responsibility to interact with the text faithfully, Rosenblatt insists on the 'humanness' of readers. She deliberately positions her work in opposition to critics such as Roman Ingarden. While Ingarden's phenomenological criticism suggests that a reader's participation in a text solidifies its meaning, the text is apparently always intentional and reading only a way of filling its 'spots of indeterminacy' (1973: 193). For Ingarden reading does not produce the work, only 'concretizes' it; the connection between text and reader is always a one-way exchange.

In *The Act of Reading* Iser (1978) both develops and undermines Ingarden's work. Ingarden and Iser appear to agree on the premise that writing is constructed from frameworks mobilized by the practice of reading. Iser, however, draws from the structure or 'schemata' of Ingarden's work, and counters Ingarden by claiming that the meaning of a text 'is no longer an object to be defined, but is an effect to be experienced' (1978: 9–10). Ingarden's reader maintains a fixed position in the text, and reading itself is regarded as a mere process of 'filling in'. In contrast, Iser points to the dynamic and nuanced relationship between reader and text. He takes up Ingarden's 'spots of indeterminacy', which he renames 'gaps', and examines how individual readers draw on their knowledge of the world in order to fill these gaps with meaning, thereby entering into an exchange or dialogue with the text. To interrogate this nexus, Iser draws from diverse fields of study, including phenomenology, aesthetics, speech act and gestalt theory. Reading for Iser becomes a process of responding to the multilayered textual blanks left by the author; the text becomes a succession of coordinates, invitations or suggestions on how to make meaning from the words. Meaning is then generated through the interconnection of the blanks in the text. As Iser writes, the 'object itself is a product of interconnections, the structuring of which is to a great extent regulated and controlled by blanks' (1993: 35). While Ingarden suggests that the reader's past experience regulates the knowledge produced by the text, Iser argues that meaning is made by a dynamic, interior linking of these gaps in the text. He describes literature as a process rather than as a library of inert independent objects, and so for him reading becomes a kind of active interaction rather than a passive ingestion.

The Constance School: 'reception aesthetics' and the phenomenology of reading

The formation of Iser and Jauss's Constance School of 'reception aesthetics' at the University of Konstanz is often seen as the inauguration of a coherent reading or reception theory, and Iser is often seen as its founder. As Gabriele Schwab describes: '[s]trongly influenced by Husserl's phenomenology, Ingarden's aesthetics and Gadamer's hermeneutics, this theoretical movement . . . aimed at nothing less than a thorough reconceptualization and reorientation of literary studies, critical theory and, more generally, the practice of interpretation' (2000: 76). The Constance School was based around a focus on the historical examination of how everyday readers respond to literature, which meant that the critic's task was to explain the

effects of a text on a reader, not explain the text in itself. In *The Implied Reader* (1974) and *The Act of Reading* (1978), Iser develops his idea that readers respond to the indeterminacies in texts – 'a network of response-inviting structures' – which inspire the desire to fill them. He suggests the act of reading is 'a process of becoming conscious' and enables the discovery of hitherto unknown 'inner worlds' (1974: 58). This becomes the basis upon which Iser is able to talk about the manner in which readers construct meaning by forming consistencies from the 'gaps' in texts. In *The Implied Reader* literature is described as space drawn by two tensions, 'which we might call the artistic and the aesthetic: the artistic pole is the author's text and the aesthetic is the realization accomplished by the reader' (1974: 21). Iser examines how the *Wirkung*, both the aesthetic effect and response (1978: ix), is determined by the catalytic potential of the text's blank spaces and their relative ability to inspire the reader's imagination. Meaning emerges through the interaction between the 'signals' of the text and the 'reader's acts of comprehension' (1974: 9). His work assumes that writing allows a spectrum of interpretations and that these readings are not only coloured by the reader's experience, but also constantly shifting in accordance with the rhythm and structure of narrative prompts and devices.

Iser does not look at actual readers reading, and instead posits a kind of abstract potential reader, which

> embodies all those predispositions necessary for a literary work to exercise its effect – predispositions laid down not by an empirical outside reality, but by the text itself. Consequently, the implied reader as a concept has his roots firmly planted in the structure of the text; he is a construct and in no way to be identified with any real reader.
>
> *(1974: 34)*

Iser does acknowledge that while the guiding codes of a text may invite particular reactions, the individual reader can never quite equate with the hypothetical reader 'implied' by the text. Individual reading will always include idiosyncrasies and be formed from unique, historically situated subject positions. In light of this, Iser adjusts his lens to focus on the transfer and translation – the interactivity – inherent in the reading process. He suggests that writing conceives an ideal reader, but the act of reading turns this ideal into an 'actual reader' who transforms the text into an imagined event. This dyadic process of interaction becomes complicated by an awareness that the exchange is potentially unequal or uneven. While the text is a map of clues instructing the reader, its existence is entirely dependent on the reader's interaction with it, which potentially undermines any authorial authority, and in fact all textual stability. The map, then, becomes indeterminate and the 'gaps' too frequent; the reader is left to wander the text without direction.

Iser's work differs somewhat from that of his colleague Hans Robert Jauss; both are concerned with the idea of rethinking the idea of writing from the perspective of the reader's production or actualization of the work, but Jauss's project explicitly draws from the work of Hans Georg Gadamer and Martin Heidegger. This leads Jauss to posit what he calls 'the actual reader', a formulation quite different from Iser's 'implied reader'. Jauss's essay 'The identity of the poetic text in the changing horizon of understanding' (1985) could be said to have established the critical foundations of reception theory in Europe by extending Gadamer's literary hermeneutics and Heidegger's phenomenology. What Jauss draws from Gadamer is the idea that the act of interpretation – a reader reading – is always influenced by a pre-existing history and culture; Heidegger allows him to frame this in terms of the complex particularity that occurs when an individual consciousness encounters a work. The activity of interpretation

thus becomes an event that exposes the subjectivity of the reader, and the text itself comes into being only when it ignites the self. From this theoretical base Jauss advances the concept of a 'horizon of expectations'. This concept basically involves the awareness of a set of limitations: the act of interpreting is restrained – or defined – by the values, beliefs and prejudices inherent in the background of the reader. Each reader will bring a necessarily finite range of experiences to their interpretation of a text. Jauss suggests that these limitations – these horizons – do not undermine or garble the original intention of the text in a kind of existential misreading. Rather, they allow for a positive construction which not only actualizes the text but also reveals the 'horizons' of the reading subject. And because this process can occur in places, cultures and histories very different from those of the author, it is an act that ultimately enervates authorial authority and control.

In his works *Toward an Aesthetic of Reception* (1982b) and *Aesthetic Experience and Literary Hermeneutics* (1982a) Jauss emphasizes that the social history of a text also impacts upon the process of interpretation. In this vein he suggests that the worth of a text is based on its ability to expand a reader's horizons of understanding. This means that literary critics should be cognizant of the ways in which a given text was received by the milieu in which it was first circulated and sensitive to the ways in which it was first read. It is not just individual readers who impose 'horizons of expectation'; different cultures and societies from different periods in history will all establish the horizons of their own specific positions. Thus texts do not bring about a fixed response across cultures and generations but are instead always subject to the horizon of expectations that the historically and culturally situated subject brings to them. However, Jauss goes on to propose that these subjective limitations can be objectively understood via an analysis of the structural features of the text and in this way the work has an agency that can either conform to, or contradict, the audience's expectations. This still means that a text is best understood by considering the evolution of its audience rather than the historical circumstances of its production. The intended audience of a text still suggests its intended meaning; however, Jauss argues that this meaning cannot be equated or aligned with readings that come from historically different places. The literary critic should be aware of their own subjective involvement with the text, but also aware of the otherness of the place, time and consciousness of the text – its essential historicity.

Largely because of the cohesive force of Iser and Jauss's Constance School, their form of reading theory was developed as a coherent collaborative project. However, at this point these preoccupations with reading were also vigorously taken up by theorists in the United States, whose ideas were influenced by the European model but contained meagre reference to their American counterparts. In other words, American theorists sustained the trajectory of reception theory as a counter to other models of literary analysis but were largely atomized and never worked collectively towards staking out a shared territory. In fact, as Robert Holub argues, American reader-response criticism became a critical force more by 'virtue of the ingenuity of labelling rather than any commonalty of effort' (1984: xxii–xiii). Iser and Jauss's theoretical foci were embraced in North America at approximately the same time as the, potentially apposite, work of literary deconstruction was gaining significant impetus; both ways of thinking were seen as a balm to the formalist methods of close reading and textual autonomy espoused by new criticism.

Reading as an event: Stanley Fish and the 'interpretive community'

One of the foremost proponents of reader response theory in North America was Stanley Fish. His first major contribution, 'Literature in the reader: affective stylistics' (1980b [1970])

was a foray into the reading theory proposed by Iser and Jauss. Here he argued that making meaning from a text was an event, an act of sense making initiated by the reader. Fish, however, broke down the act of reading into an analysis of individual sentences, suggesting that the meaning of a text is not generated solely by successions of words, and in fact that reading itself does not merely rely on this temporal dimension. Perhaps Fish's most important input into this branch of literary theory was to ask not 'What does this sentence mean?', but instead 'What does this sentence do?' In 'Interpreting the *Variorum*' (1976) Fish provocatively asserts that texts are written by readers, that they are in fact not read but made, since 'authorial intentions' and a reader's interpretation are mutually interdependent activities (Tompkins 1980: xxii). Fish moved from a phenomenological approach towards establishing a coherent epistemological apparatus. His earlier position is encapsulated in his response to Milton's *Paradise Lost* – *Surprised by Sin: The Reader in Paradise Lost* (Fish 1967) – in which he argues that Milton employed a variety of literary techniques in order to lull the reader into a false sense of security that the author then toppled in such a way that the reader was confronted with his or her own self-centred pride – supposedly inspiring an internal recognition which returned them to God's grace. The latter developments of Fish's work centred on the question 'What is really happening in the act of reading?', and this interrogation was most clearly articulated in his collection of essays *Is There a Text in This Class?* (1980a).

Fish's idea of reading is based on the idea of an 'interpretive community' – a group composed of 'those who share interpretive strategies not for reading (in the conventional sense) but for writing texts, for constituting their properties and assigning their intentions' (1976: 182). What constitutes these communities is a set of shared practices that, whilst sometimes divergent, come to define a group of readers. Under his methodology the activity of readers is to the fore, and the act of reading is regarded not as a meaning-making process but rather as a process that itself has meaning (1980a: 158). Clearly drawing from the scholars of the Constance School, Fish argues that a book is only actualized when it is read – assimilated and/or produced in the individual mind of the reader. That said, Fish offers a lucid account of readers not as individuals, but as part of a socio-historical reading public. He acknowledges the private nature of reading but emphasizes its communal imperatives and social conventions. Fish controversially argues that meaning does not reside in the text, instead suggesting the text is a blank that the reader brings into being. Writing is nothing, according to Fish, until it is determined, in fact made, by the reader. He does not deny the text as a palpable reality but describes it as a tabula rasa on which the reader writes. This is an approach to the idea of interpretation that suggests that the irreducible effects of language are almost pedagogically deployed by an author, but ultimately undergo a process of continual shaping and reshaping on the part of the reader. Fish argues that these revisions and re readings do not quash the centrality of the reader but instead provide some insight into the nature of the text being read.

Fish argues against the idea that proficient readers can uncover the one true meaning of a text, or even identify its fundamental structural underpinnings. This allows him to explain how readers are able to generate quite different interpretations of a text. It also allows him to question the idea that a reader's interpretation is always self-conscious, in fact to question whether interpretive practice is based on any conscious sense of self-assertion. The idea here is that the reader's 'interpretive community' teaches him or her to perceive certain emphases, to settle on particular forms and ideas. To highlight this, Fish makes the distinction between authorial intent (the assertion of a particular epistemology) and the reader's interpretation (which is essentially sociological). This leads him to emphasize what the text *does*, as opposed to what it *means*. Like other reading theorists, Fish decides that this indicates, or stems from,

a rejection of the idea that the meaning of a text is embedded in the text itself, and instead moves towards the idea that any and all elements of the text exist only in relation to the interpretive strategies of the reader. Essentially, then, Fish's answer to his own titular question, *Is There a Text in This Class?*, is no, there is not. However, it should be pointed out that Fish's idea of a 'reader' refers to someone trained in the art of reading; as he puts it, this is an 'informed reader, neither an abstraction nor an actual living reader, but a hybrid – a real reader (me) who does everything within his power to make himself informed' (1980a: 49). This dubiously self-centred emphasis leads Fish into an attempt at questioning the text as an object and instead asserting the potential of an educated and aware reading subject, of which Fish is apparently the ideal representative.

Refining the focus: the specificity of reception

Like Fish, Steven Mailloux, an American scholar of reception, rhetorical theory and pragmatist philosophy, suggests that what happens in the process of reading is a communication between author and reader whereby the reader is essentially taught how to read. He claims that because individual readers are influenced by different imperatives and rhetorical conventions, they enact different readings and thus actually create different texts. For example, in *Reception Histories* (1998) Mailloux argues that there are two strands of reading: one that is formal and emphasizes the interpretation of the text, and the other that centres on the authorial matter of the text, and includes the biographical or historical evidence relevant to authorial intent. Countering Fish, Mailloux implies that an emphasis on the reader's response, to the detriment of theoretical engagement, restricts the critical potential of eradicating unworthy, incorrect or unacceptable readings of a text. He repudiates the idealism of theoretical models but does not go so far as to dismiss them in favour of Fish's self-centred perspective. As Mailloux writes in *Rhetorical Power*, to reject theory is to focus 'on the rhetorical dynamics among interpreters within specific cultural settings', and thus 'theory soon turns into rhetorical history' (1989: 144–45). What is important here is that while the act of interpretation might be subjective, it is also deeply political. Mailloux introduces a Foucauldian perspective to reading theory that suggests that interpretation is ultimately part of a 'politics embedded in institutional structures and specific cultural practices' (1989: 149). Moving beyond the 'interpretive communities' of Fish, and Iser's transformations of the reader, Mailloux points to a 'rhetorical hermeneutics' that encompasses the myriad readings of texts produced through the shifting political and historical perspectives of a reader. As he puts it, literary interpretation does not follow the establishment of a text's meaning; instead that meaning is the result of interpretation: 'Texts do not cause interpretations, interpretations constitute texts' (1982: 197).

American sociologist Norman Holland is another key figure in the field of reading theory. His work responds to the ideas promoted by Fish but attempts to develop a theoretical model of literary interpretation based on an intimate study of the individual reactions and responses of his students. To do so, Holland draws somewhat indiscriminately from a range of psychological and psychoanalytic theories. He suggests that the responses of his students – studied as reading subjects – indicate a tendency to interpret texts with reference to their own systems of 'fantasy': in other words, with reference to their own sequestered narratives and private experiences. This is somewhat problematic, as Holland assumes that an individual has a singular reading strategy and that this implies a singular unified identity that can be captured through an attempt to induce students to 'free associate' in their response to the text. In *Five Readers Reading* (1975), for example, Holland uses a bastardized theory of the ego in order to

argue that readers interpret texts according to personal and pre-existing narratives – what he dubs an 'identity theme'. His purpose is essentially to indicate both the multiplicity and the validity of individual readings of a text. He argues that reading is never merely a response to stimulus and that literary criticism is in a state of crisis because it has consistently ignored the 'human' qualities that make writing possible. His 'empirical' study, which analysed the responses of five student readers, oddly concluded that his own interpretations of texts were matched by his subjects' responses. Holland tacitly uses Freudian psychoanalysis as the basis of his theoretical model. He suggests that a text contains its own structures of fantasy and that, even though it regulates and mediates the desires of readers, they will ultimately make these fantasies their own. This means that individual responses to literature are always valid subjective experiences but never solely determined by the reader.

Holland also clearly draws from the work of reading theorists such as Iser and Fish. From Iser he inherits the idea that within a text there is a set of pre-existing ideas that impinge upon any subject, any reader, but also that there are certain subjective codes that define the ways in which that reader defines and understands the world. Drawing from Fish, on the other hand, Holland argues that these 'cultural codes' are derived from a broader set of shared ideas. This leads him to highlight a distinction based on the idea of cultural specificity. In *On Deconstruction* (1983) Jonathan Culler conversely argues that reading is an activity predetermined by a finite number of interpretive possibilities, and suggests that reading is essentially a field of action in which readers read texts in search of concord, tracing a whole construct of ambiguous textual events and guided towards comprehension through a series of authorially determined cues. This is in direct contradiction to the theories laid down by Fish. Culler, as one of many theorists who seek to complicate rather than compact these ideas, suggests that thinkers that privilege the reader (Fish) and thinkers that acknowledge an equal exchange between reader and author (Holland) both ignore the potentially uneven dynamic of interaction invoked by the act of reading. In fact Culler cites Fish's own admission that a text has the potential to become progressively more dominant and the reader more inhibited. As Culler observes, Fish can only counter this observation by arguing that any manipulation of the reader by the text, or by the author, is a product of the interpretive strategies employed by the reader themself. In contrast, Culler describes how the 'story of manipulation will always reassert itself':

> first because it is a much better story, full of dramatic encounters, moments of deception, and reversals of fortune, second, because it deals more easily and precisely with details of meaning, and third, because this sort of reading confers value on the temporal experience of reading. A reader who creates everything learns nothing.
>
> *(1983: 72)*

In this sense the text is unashamedly manipulative; it uses tactics such as deception in order to work, in order to produce a response in the reader. This, then, is a way of explaining the complexity of the reading process without conferring absolute agency on either text or audience, but it is also a way of thinking that highlights the dialogic unevenness of reading and upholds the force of writing. Culler suggests that a reader who creates their own world, who invents or constructs their own interpretation of the world, is treading water, not allowing a text to manipulate, extend or teach them.

From these ideas reading theory also developed an overt political impetus. Given the attention many critics have given to the pedagogical potential of writing, this is not surprising; if writing has the power to teach, indeed to create worlds, it necessarily has the potential to convey or undermine ideologies. This perspective thus led a number of critics to develop the

politics of reading theory, such as variations on feminist reader-response criticism or Marxist histories of reception. Janice Radway, a key scholar of the history of literacy and reading, describes a kind of feminist reading theory, but rather than offering a theoretical account of the ways in which a text can be analysed she attempts to gather the objective material relating to actual women's responses to a text. For example, in *Reading the Romance* (1991) Radway examines how a group of about forty women readers read and interpret contemporary romance novels. She shows that the reading habits of these women are 'tied to their daily routines, which themselves are a function of education, social role, and class position' (1991: 50). However, it is in the act of reading – in her example, reading the romance genre – that her subjects are able to both transcend and reflect upon these routines, these personal lives and habits. In this Radway counters suggestions that genre fiction is merely a numbing distraction unworthy of critical consideration, but also points out that the kind of reading it generates has the potential to inspire reflexive, constructive reflections about a reader's own life.

The politics of reading theory

So towards the latter half of the twentieth century reading theory began to expand out beyond its early roots and take on a variety of critical inflections and political emphases. The discipline began to incorporate a diverse range of ideas drawn from fields such as mind–body theory, empiricism, neuropsychology, genre studies and cultural studies. As one example, American scholar of reading and literary history Jane Tompkins employs the methods of historical studies in her approach to reading. Like Radway, Tompkins's work defends the power and potential of popular culture within her studies of literary reception; however, she looks to the history of reception rather than studying actual reading subjects. This historical approach to reading acknowledges that the past can only be accessed through the object that communicates it, such as books; reading is thus understood as a historical experience in which the past and present intertwine. Tompkins's essay 'The reader in history' (1980) in her edited volume *Reader-Response Criticism* also argues that the disciplinary and historical division between the work of reading theorists and that of the new critics is not nearly as distinct as supposed. Tompkins suggests that both place an emphasis on the prescribed activity of inter-pretation; while the new critics see the process of meaning making stemming from the formal aspects of the text itself, the reading theorists see the creation of meaning happening in or via the mind of the reader. Both, Tompkins suggests, privilege the act of interpretation: 'Although New Critics and reader-oriented critics do not locate meaning in the same place, both schools assume that to specify meaning is criticism's ultimate goal' (1980: 201). Like Radway, she argues that this prescriptive, technical approach to reading may limit the critical capacity to talk about what goes on when a reader encounters genre fiction rather than works of 'litera-ture'. Attempting to identify the complex of things that allows a text or a reader to make meaning via a purely academic discourse may in fact neuter the possibility of any under-standing of the human, informal and everyday aspects of reading.

Tompkins's stance is, in part, an attempt to separate her approach from that of her husband, Stanley Fish. It is (consciously) contradictory in the sense that her ideas are connected to, if not dependent on, the 'authority' of theory while at the same time exhibiting a desire to break from a structured impersonal imposition of ideas onto the incredibly personal act of reading. She deliberatively attempts to declare her independence from her husband, and the yoke of 'theory' itself. As she puts it, she wants to 'declare my independence of it, of him', to 'break away' from her 'conformity to the conventions of a male professional practice' (Tompkins interviewed in Olson 1995: 16). The style and content of her prose is indicative of this

attempt; she deliberately introduces often highly personal observations and admissions that would be considered out of place within the predominantly male conventions of scholarly studies. Part of why she does this is to emphasize the subjective, emotive and everyday dimensions of reading and to draw this recognition back into academic theories of reception, reading and the interpretation of literature. It could, however, be argued that this attempt, however benign, becomes self-defeating. To expand upon this, the following section will address some of the criticisms and conflicts prompted by attempts to theorize and study what goes on when we read.

Oppositions to the field(s) of reading theory

As we observed at the beginning of this chapter, the field of reading theory has always been adversarial, and thus has also had its share of opponents and detractors. The criticism of the field of reading and reception studies comes in a number of guises and from a range of perspectives. One of the most obvious oppositions to the field stems from a very different view of the textual object itself – what a text is, what it contains and what it can do. As just one example of this, Michel de Certeau describes a book as 'a sort of strong-box full of meaning' (1984: 171); in his chapter 'Reading as poaching' (1984) he suggests that a text in itself contains a productive potential. Reading, then, is not imagined as a creative act; instead de Certeau suggests understanding and the making of meaning is based upon a 'social institution' that 'overdetermines' the reader's 'relation with the text' (1984: 171). What this also means is that there is a border, or a divide, a checkpoint set up between the reader and the text that can only be crossed if the reader metaphorically possesses the appropriate 'cultural' passport. This is exemplary of the kind of thinking about the nature of the text that undermines the centrality of the reader. Many scholars regard a critical emphasis on reception to be passé, something that has been, as Paul B. Armstrong has recently put it, 'discredited' and 'its fallacies and naïvetés exposed, as the profession has moved on to other topics' (2011: 87). In fact the question of where meaning lies, be it in the text or in the reader, has come to be seen as an impossible question – and thus reading theory is often dismissed because it tries to quantify artificially the reader's productive or creative powers and simultaneously to identify the textual elements that prompt this potential. This criticism is partly due to a critical or philosophic awareness that the problem of identifying the divide between a subject and an object is ultimately irreducible, a distraction. What this means for reading theory is that the question of where meaning resides – whether it is in the textual *object* or the reading *subject* – comes to be seen as redundant.

Reading theory has also been accused of devolving into an uncritical indulgence of the pleasures of the reader; as Frank Lentricchia writes in *After the New Criticism*, reception becomes a 'theory centered in the delights of the personal reading subject' (1980: 149). Underpinning such objections was a growing theoretical consensus that the subject itself was not the locus of meaning, which was instead always to be found elsewhere, beyond conscious self-aware experience. These kinds of censures were partly based on the unreliability or instability of the idea of the self and on the perceived empirical impossibilities of studying every individual reception of a text, and were derived from a questioning of the initial division by which reading theory attempted to define itself against other approaches to the study of literature. Even Tompkins, who as we have indicated played a key role in framing and expanding the field of reading theory, describes how although 'reader response critics define their work as a radical departure from New Critical principles', a closer inspection of these theories and practices shows 'that they have not revolutionized literary theory but merely transposed

formalist principles into a new key' (1980: 201). This 'new key' is often represented as overly subjective, lacking in critical rigour and methodical limits. It goes against the kind of technical objectivity that the study of literature has asserted in order to justify itself as an academic discipline. A focus on the workings of a text, on elements that produce observable effects, whether a reader is aware of them or not, leaves little interest, perhaps even a distrust, of the individual experience of reading.

Much of the opposition to reading theory centres on the apparent indeterminacy of the discipline's methodological assumptions. Arild Fetveit suggests, for example, that most reception studies mistakenly undermine the potential fecundity of a text as an object in itself, and that this is the result of an unproductive 'anti-essentialism'; he argues 'against overrating the freedom of the reader' and questions any attempt to understand texts based purely on how they are perceived, instead suggesting that the specific characteristics of a piece of writing should be the focus of study, basically a concerted attempt to identify what it is that is inherent and worthy in them (2001: 174). Fetveit however adds that it might be possible to form a useful approach to the study of literature that involves both a recognition of the power of writing and the gathering and processing of empirical data concerning the way texts are received. Fetveit's commentary thus also serves as a good example of the tensions evident in negative responses to reading theory – which could be described as the uncomfortable pull created between empiricism and phenomenology. For instance, these oppositions provoke questions such as: does the framework of reader-orientated theory suppose that all responses to a text are valid? Does this undermine the business of professional literary analysis and make reading utterly relative, and thus scrutiny potentially meaningless? Or, on the other hand, does honouring the artful creation of a text involve a science that can be learnt as a tool for deciphering the vision and understanding an author has shaped into what has become a piece of writing? The limits of interpretation are still the subject of conjecture; the boundaries restricting the meaning a reader can derive from a text are still unclear. However, practically speaking, the parameters of a text must at some level act as a frame or border of interpretive possibilities, thus making the formal components of a text itself appear to be the obvious object of analysis.

The claim that studies of the reader are unmanageably subjective or essentialist reflects an understanding that the reader – in fact any 'subject' – is never a single whole, but instead always divided, multiple and never completely autonomous or even self-aware. The idea of 'the reader' as an unencumbered subject free of interpellation and the pressures dictating permissible social action is uncomfortably thrown into question. The coherent individuated interpretation of a subject or reader thus becomes a kind of false problem. However, this view could actually be said to encourage rather than disparage the field of reading theory because, if this is the case, it is then the task of the reader-response or reception theorist to tease out the underlying matters that constitute the thing that is ineluctable but always evasive in the act of reading. This appears difficult, but arguably this difficulty should not be used as a reason to give up on attempts to understand what it is that happens when we read.

Conclusions, contradictions and new directions

Theoretically grounded thoughts about what happens when writing is consumed still retain a spark of possibility. Attempts at understanding what reading constitutes, thoughts about what the practice can say about being an interpretive being whose world is at least partially constructed of textual objects, have been far from conclusive, but also far from exhaustive. As we have pointed out, arguments about the nature and significance of reading are contradictory. At the

very least, reading theory retains a validity based on the allure of this ongoing incongruity; it is a field that, at its most humble, attempts merely to observe the ways in which literature is perceived and, at its most ambitious, attempts to connect this with the construction of both shared cultures and individual selves. This type of theory has worked its way into a number of other disciplines, most notably in cultural and media studies, where it has been taken up as part of a wider field of audience-orientated analyses. That said, current contributions to the study of reading theory largely employ a historicist perspective, contextualizing past practices of reception and interpretation within the social and cultural events that influenced them. In this sense reading theory could be said to have moved from its philosophical grounding towards a more distinctly socio-historical focus. This is not to discount, but perhaps even to emphasize, the psychological or psychoanalytic possibilities of reading theory, which still suggest that this kind of inquiry has something to say about what it is to be human.

This human imperative suggests that there is still a persistent need for reader-response criticism. So what of the future of reading theory? In asking this question it is impossible not to acknowledge recent cultural developments in practices of writing and the use of text as a means of communication. Since the late twentieth century, and despite the growth of visual culture, there has been a substantial increase in the essential *textuality* of the contemporary world. Given the ongoing metamorphoses of increasingly text-based societies, reading theory appears ever more relevant. Here we refer not only to the prevalence of cultural practices based around textual exchanges such as email, blogging, tweeting and text messaging, but also to different forms of reading facilitated by digital formats, reading devices and new interactive experiences generated between reader and text. New forms of reading and writing are producing new aesthetics, indeed, new ways of encountering and making sense of the world; reading theory has the potential to provide a structure or base by which to understand these changes. The point here is that a focus on the response of the reader is an important critical tool when considering developments in textual experience, such as new literary forms and new ways of reading, online reading modes and screen-based cultures. Whilst hypertext and media 'clouds' of interactive readers suggest new ways of making meaning from text, the ideas inherited from reading theorists such as Iser, Jauss, Fish and Holland are still useful methodological tools. A simple application of any one of their ideas regarding the reader to new forms of reading suggests the need for a closer look at the changes and constants within what goes on when a text is read, retrieved or interpreted. What is apparent even in tentative examinations of the 'act of reading' is that the process of interpreting text is not only materially changing but also becoming more dynamic and thus less passive.

Digital textuality has also stimulated the idea of 'networked' reading, and has continued to blur the division between writer, writing, reader and reading. As one of the early theorists of this phenomenon of 'network textuality', George Landow, writes:

> network textuality – that is, textuality written, stored, and read on a computer network – appears when technology transforms readers into reader-authors or 'wreaders', because any contribution, any change in the web created by one reader, quickly becomes available to other readers. The ability to write within a particular web in turn transforms comments from private notes, such as one takes in margins of one's own copy of a text, into public statements.
>
> *(1994: 14)*

This 'web of reading' has continued to develop, albeit with restrictions and pitfalls unimagined in Landow's techno-utopianism. What digital reading does appear to do is encourage

new approaches to reading and to human interaction with the materiality of the text. Texts can now be layers of links, fluid, multilinear and created in collaboration; they may never exist as words on a 'page'. The study of reading is enriched by the perceptual changes these new intertextual digital forms appear to suggest, and needs to develop conceptual changes in response; the linearity of reading may have to shift to theories of webs, logics of networks and concepts of patterning. However, the ideas about reading described in this chapter can still be used as a way of approaching contemporary reading environments, not least in the fact that these theories sustain the idea that studying the experience of reading can provide critical insights into otherwise insoluble conundrums.

What the theories of reading share, and what they can potentially bring to a study of new forms of reading, is the idea that the text is not the only active agent in the reading process. The reader does not simply assimilate a pre-given meaning but actively constitutes the text through the act of reading. The value of reader-response criticism and reception theory is found in its attempts to connect literary texts, the act of reading and the everyday lives of readers, both physically and psychologically. The exchange, debate and definition of this field continue and remain lively and open to growth. These theories productively maintain a critical awareness that reading and textual analysis are not just acts of social or political engagement, but also individual aesthetic experiences. New reading formations that emphasize interpersonal networks of textual exchange may prompt the development of new conceptual approaches to the unique relationship that reading creates between self and other.

Reading theory has also become relevant to cultural anxieties about the future of the book as a material object. The question of the materiality of the reading device dovetails with the established question of how readers are reading. The nature of the object itself may have a marked impact on the act of reading; new formats, tablets and screens might make different kinds of reading than those associated with yellowing pages, foxed bindings and cloth covers. Anxieties about the book, and about reading itself, have prompted discussion about their materiality, such that the analysis of 'book architecture' is now part of the debate and design of digital reading interfaces. Such dialogues would benefit from a critical emphasis on how readers approach, inhabit or dwell in the architectures of texts.

The idea of the electronic text might be said to compromise the materiality of the book, but the suggestion that the book is becoming increasing immaterial – that it will end up as a form without edges, a pageless temporary thing – is dubious. Both the developers and the users of digital reading software are well aware of the need to preserve and accommodate the physical act of reading. Voytek Bialkowski describes 'a certain tension between the field of codicology – as the material study of the bound textual artefacts we call books – and the study of interface design and on-screen interactions' (2011: 101). However, this tension can be productive rather than divisive; as Bialkowski points out, 'certain codicological concepts' have 'extreme relevance for the cognate study of digital reading interfaces' (2011: 101). Even texts with a purely digital existence are designed with reference to traditional forms and methods of reading, and this is fertile ground for reading theory. Particularly relevant here might be theories of reading that consider the material aspect of the practice, such as studies of the traces readers leave in books, including annotations, bookplates, underlinings, interleavings and graffiti. A history of the way readers leave traces of themselves in books may ground a study of the ways in which digital texts are marked by their readers. Such readerly interventions have the potential to say much about the reader, but also about the process and history of reading itself. Reading theory has the potential to ask what happens when the material behaviours of readers become digitized, to unpack how the 'navigational apparatus' (Hayles 2005: 90) of books remain constant, but also to ask how they have changed, and how

these changes affect both the reader and the work itself. Ultimately it is because reading is so imbricated in social, political and cultural edifices – but also because it is ever intertwined with personal experience – that the study of its effects, influence and dynamism continues to be essential.

References

Armstrong, P. B. (2011) 'In defense of reading: or, why reading still matters in a contextualist age', *New Literary History*, 42(1): 87–113.

Barthes, R. (1975) *S/Z*, trans. R. Miller, London: Cape.

Bialkowski, V. (2011) 'A codicology of the interface: reading practices and digital reading environments', *International Journal of the Book*, 8(2): 101–6.

Culler, J. (1983) *On Deconstruction: Theory and Criticism after Structuralism*, Ithaca: Cornell University Press.

de Certeau, M. (1984) 'Reading as poaching', in *The Practice of Everyday Life*, trans. S. F. Rendall, Berkeley, CA: University of California Press.

Fetveit, A. (2001) 'Anti-essentialism and reception studies: in defense of the text', *International Journal of Cultural Studies*, 4(173): 173–99.

Fish, S. (1967) *Surprised by Sin: The Reader in Paradise Lost*, Cambridge, MA: Harvard University Press.

—— (1976) 'Interpreting the *Variorum*', *Critical Inquiry*, 2(3): 465–85.

—— (1980a) *Is There a Text in This Class? The Authority of Interpretive Communities*, Cambridge, MA: Harvard University Press.

—— (1980b [1970]) 'Literature in the reader: affective stylistics', reprinted in Jane Tompkins (ed.) *Reader-Response Criticism: From Formalism to Post-Structuralism* (1980), Baltimore, MD: Johns Hopkins University Press.

Foucault, M. (1991 [1969]) 'What is an author?', in P. Rabinow (ed.) *The Foucault Reader*, London: Penguin.

Hayles, K. N. (2005) *My Mother Was a Computer: Digital Subjects and Literary Texts*, Chicago: University of Chicago Press.

Holland, N. (1975) *Five Readers Reading*, New Haven, CT: Yale University Press.

Holub, R. (1984) *Reception Theory: A Critical Introduction*, New York: Methuen.

Ingarden, R. (1973) *The Literary Work of Art*, trans. G. Grabowicz, Evanston, IL: Northwestern University.

Iser, W. (1974 [1972]) *The Implied Reader: Patterns of Communication in Prose Fiction from Bunyan to Beckett*, Baltimore, MD: Johns Hopkins University Press.

—— (1978 [1976]) *The Act of Reading: A Theory of Aesthetic Response*, Baltimore, MD: Johns Hopkins University Press.

—— (1993 [1989]) *Prospecting: From Reader Response to Literary Anthropology*, Baltimore, MD: Johns Hopkins University Press.

Jauss, H. R. (1982a) *Aesthetic Experience and Literary Hermeneutics*, trans. M. Shaw, Minneapolis, MN: University of Minnesota Press.

—— (1982b) *Toward an Aesthetic of Reception*, trans. T. Bahti, Minneapolis, MN: University of Minnesota Press.

—— (1985) 'The identity of the poetic text in the changing horizon of understanding', in M. J. Valdes and O. Miller (eds) *Identity of the Literary Text*, Toronto: University of Toronto Press.

Landow, G. P. (1994) 'What's a critic to do? Critical theory in the age of hypertext', in G. P. Landow (ed.) *Hyper/Text/Theory*, Baltimore, MD: Johns Hopkins University Press.

Lentricchia, F. (1980) *After the New Criticism*, Chicago: University of Chicago Press.

Mailloux, S. (1982) *Interpretive Conventions: The Reader in the Study of American Fiction*, Ithaca, NY: Cornell University Press.

—— (1989) *Rhetorical Power*, Ithaca, NY: Cornell University Press.

—— (1998) *Reception Histories: Rhetoric, Pragmatism, and American Cultural Politics*, Ithaca, NY: Cornell University Press.

Olson, G. (1995) 'Jane Tompkins and the politics of writing, scholarship, and pedagogy', *JAC*, 15(1): 1–17.

Poulet, G. (1969) 'Phenomenology of reading', *New Literary History*, 1(1): 53–68.

Radway, J. A. (1991) *Reading the Romance: Women, Patriarchy, and Popular Literature*, Chapel Hill, NC: University of North Carolina Press.

Richards, I. A. (1926 [1924]) *Principles of Literary Criticism*, London: Routledge and Kegan Paul.

Rosenblatt, L. M. (1970 [1938]) *Literature as Exploration*, London: Heinemann.

—— (1994 [1978]) *The Reader, The Text, The Poem: The Transactional Theory of the Literary Work*, Carbondale, IL: Southern Illinois University Press.

Schwab, G. (2000) ' "If only I were not obliged to manifest": Iser's aesthetics of negativity', *New Literary History*, 31(1): 73–89.

Suleiman, S. (1980) 'Introduction: varieties of audience-oriented criticism', in S. Suleiman and I. Crossman (eds) *The Reader in the Text*, Princeton, NJ: Princeton University Press.

Tompkins, J. (1980) 'The reader in history', in J. Tompkins (ed.) *Reader-Response Criticism: From Formalism to Post-Structuralism*, Baltimore, MD: Johns Hopkins University Press.

21

Performance and performativity

Rita Horanyi

Performance and performativity have emerged as key concepts in social and cultural theory. The recent rise of the interdisciplinary field of performance studies has shifted our understanding of performance as mere entertainment to performance as 'a way of *creation* and *being*' (Madison and Hamera 2006: xii, original emphasis). As a result, the concept has expanded to encompass everyday action and interaction, as well as ritual and cultural events beyond the stage, influencing a wide range of academic fields. At the intersection of cultural studies, theatre studies, sociology, anthropology, linguistics, gender studies and psychology, studies of performance and performativity clearly grapple with questions about the complex interrelation between the individual, culture and society.

Historical and intellectual development

According to the *Oxford English Dictionary Online*, the definition of performance includes: the doing of an action or operation; the action of performing a play or piece of music, etc.; the instance of the performing of a play or piece of music, etc.; and the measurement of the quality or efficiency of an action done or an operation or process undertaken. Thus, as Elin Diamond suggests, performance is 'always a doing and a thing done' (1996: 1), both action and event. Indeed, we could add, performance is both process and event, past and present, temporal and spatial, action and representation. Unsurprisingly, academic discourse around performance has tended to slide between these different definitions, reflecting the various disciplinary approaches that have been vital to the evolution of the discipline. In ethnography, for instance, performance consists of the joint actions undertaken by situated individuals in everyday life, just as much as it consists of the rituals, ceremonies and other cultural performances which simultaneously reflect and participate in social action (Turner 1982; Conquergood 1991). In Erving Goffman's (1974b [1959]) sociological work, performance means both an unconscious presentation of self in social situations and a kind of conscious performance for the purposes of 'impression management' akin to a role taken on by an actor; while in the work of Jean-Francois Lyotard (2005) and Jon McKenzie (2006) performance is the modus operandi of postmodernity and late capitalism.

The rise of performance studies as a modern (inter)discipline is frequently attributed to the collaborative efforts of theatre practitioner and academic Richard Schechner and anthropologist Victor Turner, further demonstrating the inherently multidisciplinary nature of the field. However, as with most stories about origins, the beginnings of performance studies are more complex and divergent than a simple narrative would suggest. Schechner and Turner first met in 1977 and went on to organize three conferences related to ritual and performance in

1981–82, but Schechner had already begun expanding the concept of performance as early as 1966, with the publication of his article 'Approaches to theory/criticism'. Schechner argued that western theatre exists on a spectrum with other phenomena, such as ritual, play, games and sport. The study of theatre, he claimed, should not be reduced to the study of literature, but should focus on performance as a unique entity, which involves studying its similarities to other performing activities and using frameworks that acknowledge the relations between these phenomena.

However, Schechner's conviction that theatre ought to be studied as one mode of performance in a broader range of activities was not only influenced by his fruitful dialogues with Turner. Heavily involved in the avant-garde theatre movements of the 1960s as director of The Performance Group, Schechner participated in artistic events that redefined what theatre and performance could mean. Schechner's performance group created 'environmental theatre', which sought to completely recreate the performance space, while elsewhere 'happenings' – a form of improvisatory performance art based around audience interaction – broke down the fourth wall and created a new sense of the contingency and uniqueness of the performance event. These artistic experiments meant that the clear distinction between reality and illusion, fact and fiction, became usefully blurred, only to risk being replaced by a fresh distinction between theatre and performance, where performance embodied a sense of liveness and presence, while theatre remained hopelessly tied to the proscenium arch and the authority of the text.

This division can also be traced back to Antonin Artaud's *The Theatre and Its Double* (1958 [1938]). Artaud's influential manifesto advocated a 'theatre of cruelty' that would liberate theatre from the western reliance on text and language, communicating instead directly through the body and the senses, and using vibrations, sounds, pitch and kinaesthesia to achieve a new language organized into 'veritable hieroglyphs' (Artaud 1958: 90). Artaud writes: 'In our present state of degeneration it is through the skin that metaphysics must be made to re-enter our minds' (1958: 99). Artaud's ideas profoundly influenced theatre practitioners such as Peter Brook, Jerzy Grotowski and Richard Schechner, and resulted in an increased interest in non-western forms of theatre that involve the incorporation of ritual forms, which in turn helped inspire Schechner and Turner's interest in the spectrum of performing behaviours from anthropology to theatre.

These avant-garde experiments also helped foster the focus on embodiment that became a crucial aspect of the growing interest in performance – both in artistic performance praxis and broader theoretical thinking about performance. Dwight Conquergood (1991: 179–80), however, points to yet another intellectual genealogy for the discipline, arguing that the rise of performance is part of the radical rethinking of ethnography in the wake of critical theory and post-structuralism's politicization of science and knowledge. Ethnography is, as Conquergood and others have pointed out (Clifford 1988; Goffman 1989), an embodied form of knowledge, where the observer gains understanding through physical immersion in the experiences and vicissitudes of a group. Dramaturgical or performance-based analogies can provide a way of expressing the situated, processual, intersubjective and participatory nature of field work, as opposed to traditional ethnographical rhetoric's tendency to reclassify the messy, contingent and personal in abstract terms based on observer and observed, knower and known, separating the other in time and space (Conquergood 1991: 182–83). The concept of performance, therefore, challenges the 'textualist bias of Western civilization' (Conquergood 1991: 188). Although Conquergood's work pioneered the use of performance to reconceptualize ethnography, thinkers such as Goffman and Turner also used performance analogies to discuss the embodied and creative aspects of situated action in their ethnography.

Both Goffman and Turner emphasize that meaning is created and negotiated in time and space through the interaction of copresent individuals. Rituals and other similar cultural performances are key examples of the way individuals participate in the creation of embodied social meanings. In fact, the concept of performance may also be usefully applied self-reflexively, enabling performance studies to engage in a struggle 'to open the space between analysis and action, and to pull the pin on the binary opposition between theory and practice' (Conquergood 2002: 45).

Unlike written texts, which present the same information in a variety of different contexts to be interpreted and reinterpreted, a performance always constitutes a unique event that may be played differently. This singularity of the performance event, along with its embodied nature, forms the crux of what is seen as unique to performance – liveness. However, the certainty of this concept of liveness has been thoroughly challenged by Derridean decon-struction and by Philip Auslander's (1996) questioning of the separation between mediated and live performance. In his analysis of Artaud's ideals in 'The theatre of cruelty and the closure of representation', Jacques Derrida (1978) demonstrates the logical limit of the meta-physics of presence that has pervaded western thinking about theatre and performance. Artaud's ideal of immediate communication through the body remains, for Derrida, 'the inaccessible limit of a representation which is not repetition, of a re-presentation which is full presence, which does not carry its double within itself as its death' (1978: 248, original emphasis). For Derrida, there can be no sign that is not marked by repetition, since it is only through its iterability that a sign can communicate and be a sign as such. Artaud's veritable hieroglyphs of the body are no different and therefore remain unable to escape language, and his theatre remains tied to text.

Of course, Derrida is right: it is not possible to completely erase signification (repetition) as Artaud wished. If the sign is defined by its capacity to be repeated, even in the absence of the utterer and the listener, then language is always, according to Derrida, a form of writing. Derrida is not wrong to remind us that intention, context and presence do not entirely govern meaning, that the structure of language precedes the speaker, carrying with it the possibility of making meaning despite or without the speaker's intention. This refusal to separate writing from performance is undoubtedly useful, but it does not mean that the above-mentioned elements of performance (embodiment, transience) cease to exist. The assumption that speech or live performance necessarily emanates from an entirely self-present speaker is worth chal-lenging, but performance is nonetheless embodied and copresent in a way written text is not and in ways the Derridean conception of text fails to theorize adequately. Performance is better conceived of as a point on a continuum with text (both embodied/spatial and linguistic/ temporal communication through codified signs that precede the act), a place where the temporality of codified structures and spatial, embodied interaction coalesce (although the two pure poles of the continuum between language and the body can never be reached). It is therefore possible to conceive of literary works as performances, something that is empha-sized in postmodern literature, where the act of narration is as important as the contents of the narrative itself and the depiction of reality and the process of representing reality often becomes indistinguishable.

Along with this broad and often contradictory reconceptualization of performance has been the recent rise in interest in performativity. Although sometimes used interchangeably, there are some differences between performance and performativity that are worth clari-fying, bearing in mind that the points of overlap have often generated some of the most fruitful points of discussion and debate. Studies of performativity have developed from the productive expansion of philosopher J. L. Austin's concept of performative utterances, which

are utterances that enact rather than describe something. As such, performativity further complicates questions about the agent behind the act, as performative actions and statements enact something, raising important questions about power structures and the possibility of resistance.

Key contributors and criticisms

J. L. Austin and the performative

J. L. Austin first introduced his concept of performative utterances in a series of lectures given at Harvard and later published as *How to Do Things with Words* (1975, hereafter *HDTW*). In these lectures, Austin distinguishes performative utterances (or performatives) from constative utterances (constatives). Constatives are utterances that describe something and can therefore be true or false. Performatives, on the other hand, enact what is said: a performative occurs when 'to *say* something is to *do* something' (Austin 1975: 12, original emphasis). Performatives cannot be true or false, despite the utterance making grammatical sense, because they do not necessarily describe something. However, a performative may *fail* for a variety of reasons, in which case the utterance is 'unhappy' or 'infelicitous' (Austin 1975: 15). Performative utterances are therefore not descriptions of 'some action, inner or outer, prior or posterior, occurring *elsewhere* than in the utterance itself' (Gould 1995: 20, original emphasis). Austin's performative utterances thereby challenged the 'descriptive fallacy' – the idea that all grammatically sensible statements describe something and are either true or false – that had held sway in philosophical thinking about language.

Throughout *HDTW*, however, Austin finds it increasingly difficult to maintain a clear distinction between constatives and performatives, particularly since the 'I state' implicit in constative utterances (or statements) is itself a performative, while many performative utterances describe as well as enact. Consequently, Austin supplants his initially clear distinction between constatives and performatives with the distinction between the locutionary, illocutionary and perlocutionary force of utterances. Austin divides the speech act into three categories: uttering a grammatically sensible statement is a locutionary act; arguing, stating, promising, apologizing, and so on constitute the illocutionary force of speech acts; lastly, the perlocutionary force of an utterance consists of the effect of the speech act, best understood through verbs such as persuading, warning, frightening, coercing, and so forth.

Austin's thinking therefore stresses the importance of considering the speech act in its entirety: 'the more we consider a statement not as a sentence (or proposition) but as an act of speech . . . the more we are studying the whole thing as an act' (1975: 20). This allows an utterance's context to be considered part of its meaning, expanding the limited approach of previous philosophical understandings of language. The sentence 'The bull is going to charge' may be a warning, a question or a statement, but its illocutionary force will depend on the context in which it is uttered and, presumably, the intention of the speaker. However, since Austin suggests that performatives do not reflect any prior reality – whether internal or external – the question of intention in his work remains fiercely contested.

In his controversial essay 'Signature, event, context', Derrida (1988: 15) argues that Austin reintroduces the notion of intention by assuming self-present individuals and that Austin is dependent on an 'exhaustively definable context', that is, a context that can be limited. Culler suggests that what can be considered part of the context of a total speech act cannot be easily limited or defined: 'But total context is unmasterable, both in principle and in practice. Meaning is context-bound, but context is boundless' (1981: 24). It is always possible to add

further contextual information that may change the meaning of particular utterances. Derrida also takes exception with Austin's exclusion of writing as parasitically dependent upon ordinary language. Austin states:

> I mean, for example, the following: a performative utterance will, for example, be *in a peculiar way* hollow or void if said by an actor on the stage, or if introduced in a poem, or spoken in soliloquy. This applies in a similar way to any and every utterance – a sea-change in special circumstances. Language in such circumstances is in special ways – intelligibly – used not seriously, but in ways *parasitic* upon its normal use – ways which fall under the doctrine of the *etiolations* of language. All of this we are *excluding* from consideration.
>
> *(1975: 22, original emphasis)*

For Derrida, Austin's exclusion of writing is telling, as the focus on speech as originary reveals Austin's continued belief that spoken utterances are fundamentally more authentic and closer to the speaker's intention than written language, despite his claim that performatives do not describe the contents of thought. Language is a system composed of signs that are dependent upon their iterability (repeatability) in order to be understood, and, since all language functions in this way, writing cannot be subordinated as parasitic upon ordinary speech. Ordinary speech must be repeatable to be recognisable and meaningful and is therefore dependent on what is excluded here as supplementary – the fact that speech too is always a citation. Derrida writes: 'For, ultimately, isn't it true that what Austin excludes as anomaly, exception, "non-serious", *citation* (on stage, in a poem, or a soliloquy) is the determined modification of a general citationality . . .?' (1988: 17, original emphasis). Although the possibility always exists for a speech act to be mistakenly or falsely committed, it may still function – provided all the contextual requirements are correct in the case of explicit performatives – by virtue of the fact that it is a recognisable sign.[1] This conventional/repeatable element to actions is what performance studies scholar Richard Schechner calls 'restored behaviour' (2006: 34). Schechner suggests that 'all behaviour is restored behaviour – all behaviour consists of recombining bits of previously behaved behaviours' (2006: 35). For Derrida, meaning remains a product of the play of repeated differences within the structure of language; thus, intention remains unable to govern the meaning of the speech acts completely.

However, it is important to note that Derrida does not wish to eradicate intention completely as a consideration in questions of meaning, but wishes to displace intention as the governor and origin of meaning; he also does not collapse the concepts of speech and writing entirely:

> In such a typology, the category of intention will not disappear; it will have its place, but from that place it will no longer be able to govern the entire scene and system of utterance [*l'énonciation*]. Above all, at that point, we will be dealing with different kinds of marks or chains of iterable marks and not with an opposition between citational utterances, on the one hand, and singular and original event-utterances, on the other.
> . . . By no means do I draw the conclusion that there is no relative specificity of effects of consciousness, or of effects of speech (as opposed to writing in the traditional sense), that there is no performative effect, no effect of ordinary language, no effect of presence or of discursive event (speech act). It is simply that those effects do not exclude what is generally opposed to them, term by term; on the contrary, they presuppose it, in an asymmetrical way, as the general space of their possibility.
>
> *(1988: 18, 19)*

From the perspective of performance studies, Derrida's thinking offers an important corrective to a naïve privileging of the live as fully self-present. The drawback of Derridean thinking – despite the attempt to move away from the rigidity of structuralism – is the tendency to overemphasize the linguistic/structural elements of acts to the detriment of contingent/embodied ones, or at least to fail to devote sufficient attention to the latter. Thus, it is possible to concede that both Austin and Derrida are right. As Madison and Hamera state: 'Obviously, words *do something in the world*, and they are reiterative (in terms of Derrida) in that speech, meaning, intent, and custom have been repeated through time and are therefore communicative and comprehensible because they are recognizable in their repetition' (2006: xvi, original emphasis). Allowing for the concept of text and action/event at once, however, performance offers a more complete definition of communicative acts than the Derridean notion of text alone.

Austin states: 'infelicity is an ill to which *all* acts are heir which have the general character of ritual or ceremonial, all *conventional* acts' (1975: 18–19, original emphasis). It is therefore clear that, despite the linguistic focus of Austin's work, performative acts may be corporeal. Austin continues:

> a great many of the acts which fall within the province of Ethics are *not*, as philosophers are too prone to assume, simply in the last resort *physical movements*: very many of them have the general character, in whole or part, of conventional or ritual acts, and are therefore, among other things, exposed to infelicity.
>
> *(1975: 19–20, original emphasis)*

Although Austin does not engage in such an analysis, his work clearly indicates that it is possible to expand his concept of the performative beyond verbal utterances. This has been one of the most fruitful areas in studies of performance and performativity. Feminist thinker Judith Butler, for instance, has expanded upon Austin's idea of the performative (and Derrida's deconstruction of it) to argue that gendered behaviour is not the innate expression of a gendered subject, but the result of the performative reiteration of social norms that sediment into the appearance of gendered being – or, to make the link to Austin more explicit, of actions that enact gendered being rather than describe it.

Erving Goffman's dramaturgical metaphor

Performance is not an unfamiliar concept in sociological thinking thanks to the work of Erving Goffman, particularly his development of the dramaturgical metaphor in *The Presentation of Self in Everyday Life* (1974b [1959]). Born in 1922 in Mannville, Alberta, Canada, Goffman's contributions to sociological theory are micro-sociological, focusing on the study of small-scale interactions or encounters. It was in order to illuminate the rules of what he termed the 'interaction order' that Goffman initially introduced the concept of performance in everyday life and coined the now familiar terms 'impression management', 'teamwork' and 'role distance'. Although Goffman abandoned the dramaturgical metaphor in his later work, the same concerns arguably continued to animate his later thinking, albeit in different guises: namely, a strong focus on the conventional, social elements of the interaction order and the implications of these elements for the self. These concerns lead him later to discuss things like 'ritual', 'display' and 'game' in ways that rework the themes explored in *PSEL*, providing a unifying thread to a body of work that is often seen as brilliantly insightful but lacking a systematic core (Sennett 1973; Sharrock 1976).

Goffman's dramaturgical metaphor proved fruitful for sociological thinking as it showed everyday actions to be constructed by individuals in order to conform to social norms and expectations, which are understood and upheld through processes of interaction. Goffman writes: 'Thus, when the individual presents himself before others, his performance will tend to incorporate and exemplify the officially accredited values of the society, more so, in fact, than does his behaviour as a whole' (1974b: 45). Even the most seemingly natural interaction thereby contains forms of conventional behaviour, forming rituals that are revealing of the common moral values of a society and opening up micro-sociological analysis to larger social questions. While Goffman's focus on interaction does bear upon larger structural issues (this is particularly clear in *Gender Advertisements* (1979) and his late essay 'The interaction order' (1983)), an analysis of the larger structures that constrain individuals or create rules of interaction is often occluded in his work. Larger political, economic or discursive frameworks that interpolate individuals or shape and constrain their interactions, indeed their understanding of the world, are not usually explicitly considered. An exception to this is his late work *Frame Analysis* (1974a), which attempts to provide a formal systematic analysis of the main frameworks that shape our perspectives on the world, and his work on the 'total institution' in *Asylums* (1961). However, this is also because Goffman believed the 'interaction order' was a naturally bounded, relatively autonomous domain much like the political order or the economic order.

By limiting the focus of his work to the interaction order, Goffman successfully made face-to-face interactions an independent area of sociological investigation. During an encounter (sustained face-to-face interaction), Goffman argued, people play various roles or parts, presenting themselves in the best possible light to their audience – a process he called 'impression management'. Furthermore, just like in the theatre, the presentation of self in everyday life may involve the use of props or setting (the various accoutrements in a doctor's office, for instance) and the use of regions (front and back stage) to prevent discrediting information from being seen by an audience. This is not to deny that various professional tools or utensils have a necessary function, but to acknowledge that they also frequently have a performative function. The doctor's coat and stethoscope convey authority, whereas taking a personal phone call in front of a client disrupts the performance of that authority. This is regardless of the truth content of a particular individual's claim or definition of the situation; a doctor may genuinely be a doctor but she or he must still provide a performance of their role to convince and reassure others. These sorts of performances also take place in teams, and 'teamwork' consists of the way individuals take on roles within a team to maintain a particular definition of a situation. 'Role distance' describes a performance that demonstrates an individual's disbelief in the role they are playing. Naturally, this disbelief itself is presumably a performance for the benefit of particular audience members.

Despite its perceptive illumination of the mores and norms of middle-class life, Goffman's work has been criticized for what is seen as its excessively cynical interpretation of social actors and interactions. Philip Manning writes that *PSEL* depicts an 'elaborate series of subclassifications and examples' that represent 'the person as a cynical manipulator of social encounters' (1991: 76). Alvin Gouldner suggests Goffman's emphasis on appearances and impressions reflects 'the new world, in which a stratum of the new middle class no longer believes that hard work is useful or that success depends upon diligent application' (1971: 381). Charles Lemert (1997: xxiii–xxv) also suggests *PSEL* captures the spirit of its time, but that it critically reflects the social strictures and concerns of 1950s America, while Anthony Giddens (1987: 112) argues that, despite the indubitable influence of socio-historical context, Goffman's analyses of the rules of interaction retain a general applicability.

But criticisms of Goffman's work that see his descriptions of middle-class mores and individuals as excessively cynical are one-sided in their understanding of Goffman's arguments. Goffman's definition of cynicism in *PSEL* clearly suggests he does not consider all performances to be manipulative:

> When the individual has no belief in his own act and no ultimate concern with the beliefs of his audience, we may call him cynical, reserving the term sincere for individuals who believe in the impression fostered by their own performance.
>
> *(1974b: 28)*

Performances may be sincere or insincere, but they are certainly not always the calculated choice of a manipulative agent. Efrat Tseëlon describes the disjuncture between Goffman's work and those advocates of 'impression management' who have followed in his wake as follows:

> the Goffmanesque approach views people's presentational behaviour as a process of negotiation. It is a game of *representation*. In contrast, the position advanced by IM [impression management] researchers views presentational behaviour as manipulative. According to this view people present various images of themselves as a strategic move. Unlike Goffman's approach, this 'game' is not an end in itself but a *means to an end* of gaining benefits. It is a game of *misrepresentation*.
>
> *(1992: 116, original emphasis)*

Goffman's work examines the possibility of both representation and misrepresentation throughout *PSEL*, demonstrated by Goffman's elaboration of the counterbalance to cynicism: social tact. Social tact often involves allowing performers to 'save their own show', either through tactful inattention or other 'protective practices' (1974b: 222), pointing to the 'accommodative function of [certain] rituals, which serve to make social life civil and bearable' (Chriss 1999: 67). For example, Goffman describes individuals behaving inauthentically, but for the sake of their audiences rather than themselves:

> We know that in service occupations practitioners who may otherwise be sincere are sometimes forced to delude their customers because their customers show such a heartfelt demand for it. Doctors who are led into giving placebos, filling station attendants who resignedly check and recheck tyre pressures for anxious women motorists, shoe clerks who sell a shoe that fits but tell the customer it is the size she wants to hear – these are cynical performers whose audiences will not allow them to be sincere.
>
> *(1974b: 29)*

Goffman's conception of cynicism here overlaps with his concept of tact. According to Goffman's definition, cynical performers would not be concerned with the audience's beliefs. However, the individuals in the examples above are concerned with their audience's beliefs, albeit in order to maintain them rather than enlighten them, which would presumably be a hopeless task anyway. The premise of the relatively recent movie *Goodbye Lenin* (2003) revolves around an exaggerated version of this sort of social dilemma, as the main character struggles to maintain an elaborate performance of pre-1989 Berlin in order not to disrupt his mother's belief that the Berlin Wall remains standing (the wall fell while she was in intensive care) for fear of causing a potentially fatal shock. Here the motivation for the falsehood is

altruistic rather than egoistic. Indeed, Goffman goes on to suggest that a socially inferior individual may hold a lavish reception for a social superior in order to *'tactfully* [attempt] to put the superior at ease by simulating the kind of world the superior is thought to take for granted' (1974b: 30, original emphasis). Thus, the intertwining of suspicion and trust, egoism and altruism in the interaction order emerges as a central concern in Goffman's work. Criticisms that see Goffman's work as presenting an excessively cynical view of interaction fail to consider sufficiently the elements of Goffman's analysis that highlight the necessity of tact and trust as the basis of social interaction, and ignore the fact that Goffman realistically sees most performances as somewhere on a continuum between the two extremes of whole-hearted sincerity and absolute cynicism (1974b: 31–32).

Goffman's work in *PSEL* also suggests that individuals may be so habituated to performing that they remain unaware of their behaviour as performance. Erin Striff writes:

> *The Presentation of Self in Everyday Life* has been particularly useful in our understanding of the roles we adopt and the drama that we play out during daily life. According to Goffman, these roles can be taken on sincerely . . . or cynically, with the performer knowingly deluding his or her audience. In either case, Goffman emphasises the way in which we are constantly performing, *whether or not we are aware of the roles we are inhabiting.*
>
> *(2003: 5, my emphasis)*

Just because we do not consciously consider certain behaviours to be a performance does not mean they do not constitute a presentation of self. Goffman's interest in gender later in his career builds upon the idea of unconscious performance to argue that gender is not the expression of natural, biologically determined essence but socially constituted through repeated displays we put on for others. West and Zimmerman (1987) build upon Goffman's ideas of performance and display to argue that gender is something we actively 'do', a performance consistently worked on and maintained for the sake of audiences and expectations.

This brings us to the dilemma of the self in Goffman's work. If everyday life consists of an endless array of performances that demonstrate our worthiness to others in a variety of situations, what constitutes an authentic or autonomous self? At various points Goffman draws a distinction between performed and authentic selves (particularly in his discussions of role distance and cynicism), but he never really specifies, as James J. Chriss points out, 'what an authentic self is, much less if it truly even exists' (1999: 66). Jonathan Turner and others (e.g. Gouldner 1971) see this as a major weakness in Goffman's framework, 'as it makes his actor appear too "interpersonally glib and facile" ' (Turner 1988: 94). Indeed, the problem of the self in Goffman is perplexing, partly because Goffman himself tends to vacillate on this point, implying the existence of a 'real' self at some points, only to deny the existence of such a thing elsewhere:

> A correctly staged and performed scene leads the audience to impute a self to a performed character, but this imputation – this self – is a *product* of a scene that comes off, and is not the *cause* of it. The self, then, as a performed character, is not an organic thing that has a specific location, whose fundamental fate is to be born, to mature, and to die; it is a dramatic effect arising diffusely from a scene that is presented, and the characteristic issue, the crucial concern, is whether it will be credited or discredited.
>
> In analysing the self, then, we are drawn from its possessor . . . for he and his body merely provide the peg on which something of collective manufacture will be hung for

a time. And the means for producing and maintaining selves do not reside inside the peg; in fact these means are often bolted down in social establishments.

(1974b: 243–44, original emphasis)

Goffman argues here that the self is a product of the total social situation, in stark contrast to interpretations of his work that suggest a manipulative agent able to stand outside of the social scene. However, Goffman goes on to discuss the attributes of the performer as opposed to the character in the following terms:

He has a capacity to learn, this being exercised in the task of training for a part. He is given to having fantasies and dreams, some that pleasurably unfold a triumphant perform-ance, others full of anxiety and dread that nervously deal with vital discreditings in a public front region . . .

These attributes of the individual *qua* performer are not merely a depicted effect of particular performance; they are psychobiological in nature, and yet they seem to arise out of intimate interaction with the contingencies of staging performances.

(1974b: 246)

Goffman once again implies that the self is split: on the one hand, there is the display presented to others, and, on the other hand, there is the amorphous bundle of inconsistent yearnings that, although heavily influenced by the social, is kept hidden and which drives the presenta-tion of self. This is not the unified individual character we usually think of as a person's self, which Goffman sees as an effect of 'character', that front we present to others that is negoti-ated anew in the intersubjective social space of every encounter. Goffman's vision of the self here is ultimately a remarkably fluid one – at once conscious and unaware, controlled and subject to the social world – which is what makes it so difficult to pin down, but also thoroughly convincing. This vision of the self retains agency for the individual, but is far from the stable entity traditional conceptions of selfhood have visualized, and Goffman's work remains disconcerting and uncomfortable in what it says about our selves. Interpretations of Goffman's work reflect this tension, being divided between those that consider Goffman to give too much knowledge or agency to the actor, who can consistently choose the best course of action for his or her personal gain, and those that see Goffman as emptying the self out into a mere cipher responding to the demands of whatever external social environment, much like Zelig, Woody Allen's famous depiction of the chameleon self.

For all the usefulness of the dramaturgical metaphor in *PSEL*, Goffman was happy to abandon it if he could conceive of a better way of describing the nature of the interaction order. Thus, in *Frame Analysis*, Goffman considers performance in a narrower, more traditional sense:

A performance, in the restricted sense in which I shall now use the term, is that arrange-ment which transforms an individual into a stage performer, the latter, in turn, being an object that can be looked at in the round and at length without offense, and looked to for an engaging behavior, by persons in an 'audience' role.

(1974a: 124)

Philip Manning (1991: 81) argues Goffman rereads the dramaturgical metaphor, this time to analyse the many ways in which the world is not a stage. Social actors may well be playing roles such as friend, employee or father, but they cannot very well (or very easily) stop playing

these roles, unlike a stage actor (Goffman 1974a: 128–29). The strength of Goffman's drama-turgical metaphor may then be analogical rather than strictly metaphorical: social reality is a stage in important ways, but it nonetheless constitutes a separate arena with analogously constructed but not identical rules. This may seem self-evident, but it points to an important natural limitation to the usefulness of the dramaturgical metaphor, and Goffman in fact acknowledges some of these differences in the preface to *PSEL*:

> The stage presents things that are make-believe; presumably life presents things that are real and sometimes not well rehearsed . . . the audience constitutes a third party to the interaction . . . [i]n real life, the three parties are compressed into two; the part one individual plays is tailored to the parts played by the others present, and yet these others also constitute the audience.
>
> *(1974b: 9)*

In *Gender Advertisements*, Goffman presents perhaps his most cogent statement on the relation-ship between performance in everyday life and cultural performances:

> Commercial photographs, of course, involve carefully performed poses presented in the style of being 'only natural.' But it is argued that actual gender expressions are artful poses too.
>
> From the perspective of ritual, then, what is the difference between the scenes depicted in advertisements and scenes from actual life? One answer might be 'hyper-ritualization' . . . Another answer is found in the process of editing. A commer-cial photograph is a ritualization of social ideas with all the occasions and senses in which the ideal is not exhibited having been cut away, edited out of what is made available.
>
> *(1979: 84)*

As hyper-ritualization or hyper-performance, cultural performances reflect back to us in idealized form the norms, values and expectations that shape our quotidian performances, which in turn shape cultural performances. Goffman and performance studies help us realize the full extent to which our everyday actions are performances, albeit ones where the contex-tual structures of power that constrain and create these performances differ, as well as resemble, those found in the theatre.

Victor Turner's anthropological perspective

Victor Turner, in collaboration with theatre academic and practitioner Richard Schechner, is often seen as one of the founders of the modern discipline of performance studies. Turner and Schechner were fascinated by the centrality of performance and theatricality to human expe-rience and culture, and both saw performance as a central mode of human understanding and expression. Cultures all over the globe, from ancient times to the present, demonstrate engagement in some form of performance broadly conceived; consequently, both scholars see performance, like language, as a key condition of human experience. Turner writes: 'For me, the anthropology of performance is an essential part of the anthropology of experience' (1982: 13). Games, ritual, play and cultural performances are not merely removed reflections on social life, but constitute a way of understanding, ordering and engaging in the social world. Heavily intertwined with rituals and ritual behaviour, social life involves per-formances that shape our experiences. Madison and Hamera state: 'In Turner's work we

understand that . . . [p]erformance evokes experience, just as experience evokes performance' (2006: xvii).

It was the centrality of rituals in shaping experiences, particularly in marking different phases or spheres of individual or social life, that first led Turner to consider the importance of performance to social life. Turner was particularly interested in what anthropologist Arnold van Gennep described as liminal phases – transitional periods in between structured social identities, where individuals are separated from society, usually as part of an initiation ceremony or rite of passage. Turner (1982: 26) expands on van Gennep's ideas and sees liminal phases as subverting normal social structures and identities. The liminal phase takes the building blocks of normal social and cultural meanings and recombines them, often in unexpected and unusual ways, in order to strip initiates of their preconceived ideas. Turner therefore sees in the liminal phase a model of creative practice, which similarly involves the recombination of well-known ritual or conventional elements in order to produce something new. Turner (1982: 41) coins the term 'liminoid' for such phenomena, which are betwixt and between, and frequently outside productive or established social structures, but are nonetheless important for the generation of new social and cultural forms. Games might form liminoid phenomena, but certainly artistic practice and other forms of innovation fall into this category.

Turner makes a useful distinction between cultural performances, which are framed by cultural conventions, and social performances. Ceremonies, such as weddings and funerals, and the various theatrical art forms are all considered cultural performances. Social performances, on the other hand, are 'the ordinary day-by-day interactions of individuals and the consequences of these interactions as they move through social life' (Turner 1982: 32–33). Such quotidian performances obviously involve elements of what Goffman referred to as the presentation of self in everyday life. However, Turner maintains that such social performances usually do not involve a self-conscious awareness that their enactments are culturally scripted, and they therefore become examples of a culture or a subculture's particular symbolic practices. As such, they are useful and revealing material for the anthropologist to examine, and these practices become most strikingly visible when contrasted with differing cultural norms in areas such as greeting, eating, drinking, dressing and comportment.

In addition to cultural and social performances, Turner coined the term social drama as a way of understanding schisms in social harmony. Social harmony depends on synchronized, routine behaviour, and it is precisely this unquestioning acceptance of cultural and social norms that is disturbed in times of conflict. Such disturbances give rise to a sequence of stages Turner regards as constitutive of social drama: 'breach, crisis, redress, and *either* reintegration *or* recognition of schism' (1982: 69, original emphasis). The final stage, which involves the resolution of the conflict, is often accompanied by cultural performances to mark either the reinstatement of the status quo or the change in social structure. Due to their centrality in maintaining or changing social structures, social dramas are frequently turned into cultural performances through commemoration or artistic products, which then contribute to the maintenance of social structures. Socialist realist art and monuments, for instance, helped commemorate the new social structure and ideology of the USSR, which was consolidated through new symbolic practices and social and cultural performances. Performance, then, for Turner (1982: 28), is always linked to social structure and 'anti-structure', the latter being those human actions that are beyond or between social systems and frameworks, and to the constant tension or dialectic between them. Performance is therefore central for Turner to the functioning of society and to individual experience; it shapes and reshapes our understanding and experience of the world.

Judith Butler: the performativity of gender

Perhaps no thinker has been more influential or well known in gender and queer studies in the past few decades than Judith Butler. Drawing on a formidable combination of philosophical and theoretical perspectives, Butler's work has striven to debunk essentializing ideas of gender. From her earliest journal articles to her classic books, *Gender Trouble: Feminism and the Subversion of Identity* (1990) and *Bodies That Matter: On the Discursive Limits of 'Sex'* (2011 [1993]), Butler has sought to challenge assumptions regarding the stability of sex as a category, and emphasized and analysed the way gender norms are performatively reiterated within a heteronormative matrix.

In order to unravel Butler's concept of the performativity of gender, it is necessary to adumbrate the intellectual traditions Butler draws upon and intervenes in. Butler quotes Friedrich Nietzsche in arguing that 'there is no "being" behind doing, effecting, becoming', which she extends to gendered being: 'There is no gender identity behind the expressions of gender; that identity is performatively constituted by the very "expressions" that are said to be its results' (Butler 1990: 25). We can see some similarities here to Goffman's thinking, particularly his suggestion that the self is a product of the social situation, an effect created by an individual's actions rather than an expression of their innate character. Although Goffman takes a range of positions on the question of the performer behind the act (see the section above), he does leave room for an agent of some sort. Butler, however, distances herself from Goffman's work:

> As opposed to a view such as Erving Goffman's which posits a self which assumes and exchanges various 'roles' within the complex social expectations of the 'game' of modern life, I am suggesting that this self is not only irretrievably 'outside', constituted in social discourse, but that the ascription of interiority is itself a publically regulated and sanctioned form of essence fabrication. Genders, then, can be neither true nor false, neither real nor apparent.
>
> *(1988: 528)*

Whether Butler's reading of Goffman here is accurate is debatable. Navigation between different roles in various contexts does not necessarily assume the existence of an 'authentic' self behind the acts that constitute the different performances. Although some roles may feel more authentic than others, they too are constituted through repeated acts for a particular audience, even ultimately an internalized one.

Although some critics point to German philosopher G. W. F. Hegel (Salih 2002), the most obvious influence on Butler's mature writing is the work of French philosopher Michel Foucault (1926–84). The method Foucault developed, known as 'archaeology' or later 'genealogy', involved tracing the historical vicissitudes of a dominant discourse and, by unpacking its relation to institutions and its nature as a structure of power, demonstrating how it has created a particular subject position through time. Thus, Foucault analyses, amongst other things, how the modern prison system and the various discourses and expertise accompanying its rise have created the modern criminal, as well as the attempt to reform the criminal into an obedient citizen; how mental institutions and the discourses of psychiatry have created what we think of as madness and sanity; and how medical, legal, religious and psychoanalytic discourses have created particular categories of sexual identity, such as the homosexual. While acts that are what we might call homosexual, criminal or insane have always occurred, Foucault's point is that what we consider to constitute such acts and what

constitutes the subject who commits these acts is something that is historically and discursively determined. Foucault points out that in ancient Greece engaging in homosexual acts did not make one homosexual in the sense of a separate sexual entity. Central to Foucault's ideas is the power of language to shape our understanding of the world and the limits of our thinking. It is for this reason that Foucault's ideas are often associated with the linguistic turn typical of structuralism and post-structuralism. Language, for Foucault, is not a neutral medium merely describing the world as we encounter it, but something intertwined in structures of power that shape what we can know and understand. For Foucault, power creates, and, in Nietzschean fashion, he rejects the notion of an essential self that pre-exists discursive structures. Finally, Foucault's work is particularly concerned with the way discursive structures (ways of speaking about something, but also documents, writing, ways of understanding and seeing) create subjects through processes of corporeal discipline. In *Discipline and Punish: The Birth of the Prison* (1979), Foucault examines the way surveillance mechanisms encourage obedience and control through the continual threat of being watched, creating particular subjects through the application of corporeal disciplinary techniques.

Butler (1988: 530) takes up the task of applying this Foucauldian outlook to gendered subjectivity, engaging in 'a critical genealogy of gender', thereby remedying a notable omission in Foucault's work. Indeed, for a thinker centrally concerned with the nature and effects of power, Foucault was conspicuously silent about the inequalities between the sexes. Butler's work is concerned less with tracing the nature and history of gendered discourses and the inequalities that spring from them (perhaps because feminism has already done such a good job of this) than with analysing the way in which gendered subjectivity is itself created by such discursive structures. This is fruitful terrain that is well in line with Foucault's project, but it is noteworthy that the sort of historical analysis that furnished Foucault's work with such challenging insights is almost entirely absent from Butler's discussions. Butler speaks of changes brought about by reciting and reclaiming formerly derogatory appellations in relation to queer identities, but the 'heteronormative matrix' that determines our gendered actions is never elaborated on in much detail and can seem curiously ahistorical in Butler's theorizations.

Butler's arguments, as I have already mentioned, involve the undermining of essentializing conceptions of gender. This may seem like a curious move for a feminist philosopher; after all, it is surely only through their collective suffering *qua* women that women can take a stand to change an oppressive status quo. While Butler would not disagree with this sentiment, she questions whether this means the identity of women is fixed and essential: 'Certainly, it remains politically important to represent women, but to do that in a way that does not distort and reify the very collectivity the theory is supposed to emancipate' (1988: 53). Further, if what it means to be a woman has been created by discursive formations that are oppressive or limiting for women, then it is necessary to first expose these as constructed. Butler writes:

> Indeed, one ought to consider the futility of a political program which seeks radically to transform the social situation of women without first determining whether the category of woman is socially constructed in such a way that to be a woman is, by definition, to be in an oppressed situation . . . in [the] effort to combat the invisibility of women as a category feminists run the risk of rendering visible a category which may or may not be representative of the concrete lives of women.
>
> *(1988: 523)*

Feminism has, of course, already demonstrated the constructed nature of various conceptions of femininity through ideology critiques and other historically based methods, but Butler, in Foucauldian fashion, claims these structures create the very category of woman itself, arguing that there is no stable gender identity outside discursive formations. Following Nietzsche and Foucault, Butler is (at least at some points) the resolute anti-humanist, claiming all speculations about the nature of pre-discursive subjects to be merely the effects of language. In typical post-structuralist fashion, Butler contends that meaning arises from the differential structure of language, and is therefore inherently unstable and indeterminate. From such a perspective, seemingly fixed terms patiently await a sufficiently trained reader's deconstructive acumen in order for the ideological biases inevitably concealed within them to be unveiled. It follows from this that any subject position one might care to take up will be necessarily unstable, creating what is commonly referred to in post-structuralist parlance as the 'decentred self'. Butler is not alone in drawing upon post-structuralist thinking in relation to gender: queer theorists frequently adopt similar positions, arguing that all sexual identities are shifting, unstable and multiple – in a word, queer – even when their performance in everyday life seems stable, thereby overturning hierarchical oppositions between straight as normal and queer as other (e.g. Kosofsky Sedgwick 1990). For these reasons, Butler is often considered the queer theorist *par excellence*.

Although Butler's ideas regarding the notion of subjectivity owe much to Foucault and post-structuralism, the questioning of an essential self extends back to Nietzsche, and many of these ideas find their roots in the ancient Greek philosophy of Heraclites. The existentialist philosophy of Jean-Paul Sartre similarly stresses that there is no essential subject preceding or separate to individual acts, which is best summed up in the well-known credo 'existence precedes essence'. These ideas influenced feminist writer and existentialist philosopher Simone de Beauvoir, who wrote in her famous treatise *The Second Sex*: 'One is not born, but rather becomes, a woman' (1997 [1949]: 295). Butler is, of course, well-versed in this philosophical tradition but, like most post-structuralists, departs from the existentialist emphasis on freedom, individual choice, responsibility and agency.

Just in case such a heady combination of continental philosophers has not sufficiently perplexed the unsuspecting reader, Butler, rather bafflingly at first, adds psychoanalysis to the mixture. This addition is initially confusing because psychoanalytic conceptions of the self are at odds with the Nietzschean-Foucauldian notion of acts without an actor. Psychoanalysis concerns itself with the creation of the subject, and, in its various post-structuralist inflected guises in particular, this subject is created through language. Nevertheless, this tradition of thinking never relinquishes its belief in pre-linguistic drives that struggle to find expression in language – in other words, in an unconscious. Butler, in good Foucauldian fashion, reverses the causal chain in psychoanalysis, arguing that Kristeva's concept of the 'semiotic' (the rhythms and sounds of the pre-linguistic realm) constitutes a hermeneutic circle and that the Oedipal formation and the symbolic order (the law) create the very forbidden desires they supposedly repress.

Finally, Butler draws on Austin's concept of the performative (and Derrida's deconstruction of it), which I have discussed in depth above. Austin's separation of performative utterances or acts from internal descriptions no doubt attracts Butler to his thinking, while Derrida's ideas allow for a theorization of change or power without recourse to prediscursive speculations about a subject, through the concept of the reiterability or recitability of words.

Apart from undoing essentialized categories of gender, Butler is also concerned, particularly in *Bodies That Matter*, with deconstructing the usual division between sex and gender.

Because the body is always already perceived through a social and cultural lens, sex, Butler argues, is always already gender. Butler writes:

> When Beauvoir claims that woman is an 'historical situation,' she emphasizes that the body suffers a certain cultural construction, not only through conventions that sanction and proscribe how one acts one's body, the 'act' or performance that one's body is, but also in the tacit conventions that structure the way the body is culturally perceived. Indeed, if gender is the cultural significance that the sexed body assumes, and if that significance is codetermined through various acts and their cultural perception, then it would appear that from within the terms of culture it is not possible to know sex as distinct from gender.
>
> *(1988: 523–24)*

Butler here means not that material bodies do not exist, but that our capacity to understand the body cannot be separated from the social. The material and signification are inextricably intertwined. The way some feminist thinking has previously divided sex from gender misleadingly suggests it is possible to come to know the purely material body. Butler argues that social expectations and norms penetrate so deeply into our mundane existence that over time this has 'produced a set of corporeal styles which, in reified form, appear as the natural confirmation of bodies into sexes which exist in a binary relation to one another' and draws upon Claude Lévi-Strauss, Foucault and Monique Wittig to argue historical norms have created a 'compulsory heterosexuality' with the appearance of binary sexes naturally attracted to one another (1988: 524). However, Butler's arguments here should be qualified. Butler suggests that the material and signification cannot be separated because signification is material and the material signifies. However, Butler's analyses tend to belie their own deconstructionist impulse, because she is often far more concerned with the way linguistic signification creates the material than with exploring the way materiality may signify outside of language or the way signification is material. For to understand signification as material would surely involve consideration of speech as embodied or performed. Butler's concept of performativity tends to cut such considerations short, and she tends to place excessive emphasis on the purely structural/textual elements. Susan Leigh Foster (2003: 169) suggests that Butler's notion of the performativity of gender should be replaced with 'choreographies' of gender, as this allows for far greater emphasis on communication through embodiment and analysis of the 'relationality' between acts. The concept of performance, unlike performativity, can allow for such an embracing of the embodied and relational, as has been stressed throughout this chapter.

Another of Butler's influential ideas is the concept of parody or drag. Butler sees in such performances subversive potential, as they may reveal the performative, constructed nature of quotidian gendered actions. However, Butler is careful to distinguish between theatrical performance and everyday life:

> In the theatre, one can say, 'this is just an act,' and de-realize the act, make acting into something quite distinct from what is real. Because of this distinction, one can maintain one's sense of reality in the face of this temporary challenge to our existing ontological assumptions about gender arrangements; the various conventions which announce that 'this is only a play' allows strict lines to be drawn between the performance and life.
>
> *(1988: 527)*

Butler goes on: 'Clearly, there is theatre which attempts to contest or, indeed, break down those conventions that demarcate the imaginary from the real' (1988: 527). However, Butler argues such performances do not necessarily question the divide between 'reality' and 'performance' enough, as they create a new reality, which potentially leads the audience to believe in a real or natural gender behind the actor that may be realized elsewhere. Drag, on the other hand, demonstrates that the act itself is performance:

> The transvestite, however, can do more than simply express the distinction between sex and gender, but challenges, at least implicitly, the distinction between appearance and reality that structures a good deal of popular thinking about gender identity. If the 'reality' of gender is constituted by the performance itself, then there is no recourse to an essential and unrealized 'sex' or 'gender' which gender performances ostensibly express. Indeed, the transvestite's gender is as fully real as anyone whose performance complies with social expectations.
>
> *(1988: 527)*

But how is drag different from other performances that challenge normalized gender assumptions? It is perfectly possible, after all, that a spectator would continue to maintain a belief in a natural gendered identity behind the drag performance. While some parts of the humour of drag may well be due to the recognition that gender is performed – the transvestite's talent lies in their accurate recitation of gestures and corporeal styles – it is perhaps not the case for all spectators that the humour of drag is the 'realization that all along the original was derived' (Butler 1990: 139). It is perfectly plausible that the humour of drag for certain spectators could arise from the enjoyment of the presentation of stereotypically gendered acts with irony, without it at all challenging the assumption that stereotypical behaviours arise from natural, essential categories of femininity and masculinity. The assumption of a natural, essential gender elsewhere or off the stage could remain unshaken.

Although Butler's work has been undoubtedly influential, she has also attracted criticism, particularly for her jargon-laden, impenetrable prose, her tendency to presume too much prior knowledge in her readers and her tendency to present her own often highly idiosyncratic interpretations of other thinkers as generally accepted or agreed upon (Nussbaum 1999). I will attempt to deal here with some of the key theoretical concerns or criticism that have arisen from her work before assessing her contributions in comparison to Goffman.

Despite her averred Foucauldianism, Butler's work lacks detailed analysis of the historical and material practices that create the appearance of a gendered subject. Butler's work is missing both Foucault's historical research – his analysis of the ways particular institutions discipline particular bodies (ironically enough, this was an early criticism Butler made of Foucault) – and the sort of ethnographic detail characteristic of Goffman, which has the ability to make one reconsider the most quotidian of interactions. As such, Butler's work suffers from an excessive focus on discursive structures as monolithic linguistic structures. Susan Bordo aptly summarizes some of the key problems with the Butlerian position:

> In this linguistic foundationalism, Butler is very much more the Derridean than the Foucauldian (although Foucauldian language and ideas dominate in the book). Within Foucault's understanding of the ways in which the body is 'produced' through specific historical practices, 'discourse' is not foundational but rather one of the many interrelated modes by which power is manifest. Equally (if not more) important for him are the institutional and everyday practices by means of which our experience of the body is

organized, for example, the spatial and temporal organization of schools and prisons. Correlatively, determining whether a particular act or stance is 'resistant' or subversive requires examining its practical, historical, institutional reverberations. For Foucault, such determinations can never simply be 'read' from the 'textual surface' of the body. Contrastingly, Butler's analysis of how gender is constituted and subverted takes the body as just such a 'text' whose meanings can be analysed in abstraction from experience, history, material practice, and context.

(1992: 170)

Butler's focus on language risks occluding the significant material aspects of the inequalities she wishes to analyse, a concern feminist and philosopher Martha Nussbaum (1999) has also voiced. In particular, Butler's later work on hate speech borrows heavily from Derrida, and suffers from a linguistic idealism that optimistically ignores the material, economic and political realities that colour the use of hate speech and that prevent the re-contextualizing and re-citing of derogatory terms from straightforwardly effecting social change. Re-citing derogatory appellations in a new context may contribute to changing the negative connotations of particular words, but only in specific contexts, social circles and circumstances. Whether these linguistic changes become widespread might have just as much to do with institutions, class, power, politics and economics as with the nature of language. Furthermore, much like her ideas about drag, the re-citation of derogatory terms need not be understood as a positive reclaiming by others, particularly since there is no agent to intend this re-citation, and intention and context cannot possibly circumscribe the meaning of the act.

Nussbaum (1999) also takes issue with Butler's lack of concern with the material suffering of the oppressed and believes Butler's post-structuralist feminist politics represents a form of quietism that lacks a normative dimension. Nussbaum sees Butler's positing of a decentred subject whose only hope of resistance lies in 'subversive' complicit critique and parody as failing to adequately address what can and should be done to better the lives of the most vulnerable. Because Butler refuses to consider the possibility of a pre-discursive subject (worried as she is that this will congeal into a constricting foundationalism), Butler cannot theorize of agency or subversion from outside the law. Because, for Butler, gender is something that is continually in the process of being made, not fixed for all time (regardless of whether this fixity is socially or biologically determined), it follows that there is the possibility of repeating gendered acts in ways that challenge normative expectations, particularly given Butler's post-structuralist belief in the inherent instability of meaning. This argument allows Butler to theorize resistance, much like Foucault, without positing an essential or natural self outside of the social that would be the locus of such resistance. Hence, drag and parody, which are performances that cite gender and re-contextualize it, reveal the contingency and citational nature of *all* gender norms. Butler draws on Derrida's deconstruction of Austin to argue that performances such as drag reveal the generalized citationality gender is based upon. But, since drag cites the very norms whose naturalness it undermines, drag can only be, at best, a form of complicit critique.

More importantly, we might ask: is it sufficient to leave resistance to the vagaries of linguistic structures (or, better, discourses) that turn upon themselves? And is it really realistic to suppose that even this subversion from within, this turning of discourse upon itself, is done without choice or guidance by any sort of subject, even a fluid one constructed by discourse? Who or what, then, parodies gender norms or responds to the call of the law? Butler's idea of parody involves what Frederic Jameson has elsewhere described as 'blank parody', parody without an original that therefore reveals that the original itself is merely parody, resulting in

a kind of infinite regress. But the best such a form of criticism can do is point out that all normative conceptions are constructed. Whether one particular construction is better or worse than others is not something Butler can or does offer an opinion on. For Nussbaum, this means Butler's thinking falls prey to a sort of relativism: Butler's work can offer no reason why opposing genital mutilation, for instance, might be better or worse than opposing equal rights for minorities, a problem Nussbaum suggests she inherits from Foucault. Nancy Fraser (1989: 31) has also suggested that Foucault is 'normatively confused' because he attempts to be critical of normativity in general. For example, although Foucault claims that power is always accompanied by resistance, Fraser argues that he cannot explain why domination ought to be resisted: 'Only with the introduction of normative notions could he begin to tell us what is wrong with the modern power/knowledge regime and why we ought to oppose it' (1989: 29). Although Butler states in an early journal article that 'a critical genealogy needs to be supplemented by a politics of performative gender acts, one which both redescribes gender identities and offers a prescriptive view about the kind of gender reality there ought to be' (1988: 530), this description of what ought to be is something she generally avoids.

While Nussbaum's criticisms are undoubtedly compelling, it is important to place Butler's ideas in context to avoid a potentially distorted reading of aspects of her work. For instance, when Butler speaks of the fact that there is no outside to language/law/power, she follows the thinking of many theorists loosely referred to as post-structuralist and/or postmodernist who equate power and the law with the structure of language in general, and it is obviously not possible to step outside of linguistic structures. Indeed, Nussbaum's suggestions for changes to laws are not outside power, which is diffuse and multiple, and resistance is formed in response to current discursive structures and therefore formed by them. Similarly, gender norms are not something one can simply opt out of; they shape our identity from the moment we are born. It is demanded that we present a clearly defined gender in everyday life and there are sanctions for those who refuse to do so. Since Butler wishes to displace gender categories entirely, it is little wonder she stresses the importance of the subversion of gender norms. To strive for equal rights for all women is not something Butler would object to, but it does not challenge the very category of woman to do so.

While feminism is often seen as so wildly successful a movement that the term 'post-feminist' is warranted, the ideals of radical feminism remain but distant goals even today. Radical feminism wanted nothing less than a complete overthrow of patriarchy, and a total revolution in everyday life, in relations between the sexes and in the structure of society. Equal rights for women were only part of the social revolution that was to come. As the feminist movement became more radicalized, however, it alienated many women who identified with femininity and heterosexual female sexuality. It is surely the desire to avoid these sorts of pitfalls surrounding proscriptive notions of what women should be that leads Butler to a position that stresses the constructed nature of all identities.

Furthermore, much of what began as a departure from the status quo in radical feminism and other countercultural movements of the new left quickly turned into fashionably alternative, commodified positions that ceased to threaten the capitalist order. This is particularly true in relation to some of the gains of the sexual revolution, which helped spawn both the summer of love and Hugh Hefner. The utopian ideals of the sexual revolution have given way to an obsession with what Ariel Levy (2005) terms 'raunch culture', which is the increasingly mainstream proliferation of commodified, pornographic representations of sexuality that fulfil patriarchal fantasies and continue to objectify and degrade women. This raunch culture is actively embraced and participated in by many women, who increasingly see such things as normal, despite the best attempts of feminist consciousness raising. The question of why it is

that a mere few decades after the height of radical feminism many middle-class women, the beneficiaries of the feminist struggle, think the most empowering thing they could be doing is pole dancing remains open. Butler's theories offer some explanation of the intractability of gender norms, suggesting we are shaped by discursive structures and compelled by the 'hetero-sexual matrix' to enact gender. However, as a theory of social reproduction, Butler's theories are somewhat thin: they do not take into account economic, political or other material structures, for instance. These structures may always be intertwined with language, but this is a different matter to simply relying on the structure of language as a system of difference.

Finally, it is worth examining some of the relative merits of Butler's conception of perfor-mativity compared to Goffman's notion of the presentation of self or his ideas of display and ritual that inform his analysis of gender. Butler writes that gender as an act is 'clearly not one's act alone' (1988: 525). Butler's concept of the act, like Goffman's, presumes a social setting, since a performance is always performed with an appropriate audience in mind, even if this is merely an internal one. In her early journal article 'Performative acts and gender constitution: an essay in phenomenology and feminist theory' (1988), Butler argues for an idea of perform-ance as made up of acts that are at once private and public, personal and political. The actor performs in order to create meaning in public space, but they are not simply the empty vessel of the pre-written script; the self is neither the autonomous, radically free subject of existen-tialism nor the radically decentred product of language:

> it is not a project that reflects a merely individual choice, but neither is it imposed or inscribed upon the individual, as some post-structuralist displacements of the subject would contend. The body is not passively scripted with cultural codes, as if it were a lifeless recipient of wholly pre-given cultural relations. But neither do embodied selves pre-exist the cultural conventions which essentially signify bodies. Actors are always already on stage, within the terms of the performance. Just as a script may be enacted in various ways, and just as the play requires both text and interpretation, so the gendered body acts its parts in a culturally restricted corporeal space and enacts interpretations within the confines of already existing directives.
>
> *(Butler 1988: 526)*

Butler departs from this conception of performance as the contingent, embodied reiteration of cultural scripts and argues for a more post-structuralist account of the subject in her later work. Rather than engaging in the kind of micro-sociological analysis that might allow an in-depth analysis of how quotidian acts are performed to fit with the social norms and expec-tations of various audiences, Butler maintains a broader focus on the structure of language that flattens out our understanding of the various ways in which we learn and enact gender. Goffman's strong focus on interaction can act as corrective to the oversights of Butler's more abstracted theoretical views and allows for an understanding of the way individuals can learn or create social understandings. On the other hand, Butler's focus on the impact of discursive structures can bring to light issues that Goffman's work tends to overlook. An understanding of the way macro-sociological structures such as discourses, economics and politics constrain or shape social interaction is clearly necessary.

Conclusion: future developments

As we have seen, performance studies crosses diverse disciplines, and the concept of perform-ance can encapsulate everything from conventional, quotidian actions, to forms of identity

and being, to social rituals and cultural performances, subversive or otherwise. As such, the sorts of actions, interactions, events and identities that can be analysed as performance or performative are potentially limitless. Although gender identities have received much attention through the work of Butler and other queer theorists, a brief overview of recent developments in the field reveals that interest in race and ethnic identity as performative is increasing, allowing an examination of the way the reiteration of actions within postcolonial power relations creates racial identities (e.g. Bhabha 1994: 146–49). Theories of performativity illuminate particularly well the way different social formations, such as class, religion, gender and race, intersect and are upheld through embodied actions; thus studies of performativity will no doubt continue to plumb social formations to examine the way in which power structures create embodied identities.

But what does the future hold for performance studies more generally? Performance studies academic Peggy Phelan writes: 'One could argue performance studies was a narrow, even a small-minded, version of cultural studies. One could say that performance studies has so broad a focus precisely because it had nothing original to say' (Phelan 1998: 5). This would not seem to suggest an auspicious future. But such an argument, not one Phelan herself actually advocates, would fail to see the way performance functions as an important paradigm that captures something of the unique relation between body and text, the contingent and conventional, a framework that should continue to inform our thinking into the future. The turn to performance need not result in embodiment being fetishized at the expense of an understanding of mediation, but it does perhaps suggest a withdrawal from some of the extremes of post-structuralist thought. The tendency of performance to combine an understanding of the live with an understanding of artifice reflects a general desire to combine the embodied and contingent with understandings of representation, which is occurring in many other disciplines, such as memory studies. What the future of performance studies will look like remains unclear – in fact, it is possible it will even dissolve as a separate entity, as ephemeral and affecting as the events that are its object of study. However, given the institutionalization of performance studies as a discipline in place of theatre studies in many universities around the world, this looks to be unlikely. Performance, as a conceptual apparatus and as an object of study, is here to stay, bringing with it a renewed focus on the singular and embodied reiteration of cultural scripts in a variety of terrains.

Notes

1 It is worth noting that Erving Goffman's analysis of the presentation of self in *The Presentation of Self in Everyday Life* (hereafter *PSEL*) demonstrates a similar awareness of the ever-present possibility of falsehood that haunts all conventional acts. Goffman concludes: 'Because of these shared dramatic contingencies, we can profitably study performances that are quite false in order to learn about ones that are quite honest' (1974b: 73).

References

Artaud, A. (1958 [1938]) *The Theatre and Its Double*, trans. M. C. Richards, New York: Grove Press.
Auslander, P. (1996) 'Liveness: performance and the anxiety of simulation', in E. Diamond (ed.) *Performance and Cultural Politics*, London: Routledge.
Austin, J. L. (1975) *How to Do Things with Words*, Cambridge, MA: Harvard University Press.
Bhabha, H. (1994) *The Location of Culture*, New York: Routledge.
Bordo, S. (1992) 'Review essay: postmodern subjects, postmodern bodies', *Feminist Studies*, 18(1): 159–75.
Butler, J. (1988) 'Performative acts and gender constitution: an essay in phenomenology and feminist theory', *Theatre Journal*, 40(4): 519–31.

—— (1990) *Gender Trouble: Feminism and the Subversion of Identity*, New York: Routledge.

—— (2011 [1993]) *Bodies That Matter: On the Discursive Limits of 'Sex'*, New York: Routledge Classics.

Chriss, J. J. (1999) 'Role distance and the negational self', in G. Smith (ed.) *Goffman and Social Organization: Studies in a Sociological Legacy*, London: Routledge.

Clifford, J. (1988) *Predicament of Culture*, Cambridge, MA: Harvard University Press.

Conquergood, D. (1991) 'Rethinking ethnography: towards a critical cultural politics', *Communications Monographs*, 58(2): 179–94.

—— (2002) 'Performance studies: interventions and radical research', *Drama Review*, 46(2): 145–56.

Culler, J. (1981) 'Convention and meaning: Derrida and Austin', *New Literary History: A Journal of Theory and Interpretation*, 13(1): 15–30.

de Beauvoir, S. (1997 [1949]) *The Second Sex*, trans. H. M. Parshley, London: Vintage.

Derrida, J. (1978) *Writing and Difference*, trans. A. Bass, London: Routledge.

—— (1988) 'Signature, event, context', in *Limited Inc.*, trans. J. Melhman and S. Weber, Evanston, IL: Northwestern University Press.

Diamond, E. (1996) 'Introduction', in E. Diamond (ed.) *Performance and Cultural Politics*, London: Routledge.

Foster, S. L. (2003) 'Choreographies of gender', in E. Striff (ed.) *Performance Studies*, New York: Palgrave Macmillan.

Foucault, M. (1979 [1975]) *Discipline and Punish: The Birth of the Prison*, trans. A. Sheridan, Harmondsworth: Penguin.

Fraser, N. (1989) *Unruly Practices: Power, Discourse and Gender in Contemporary Social Theory*, Minneapolis, MN: University of Minnesota Press.

Giddens, A. (1987) *Social Theory and Modern Sociology*, Stanford, CA: Stanford University Press.

Goffman, E. (1961) *Asylums: Essays on the Social Situation of Mental Patients and Other Inmates*, Harmondsworth: Penguin Books.

—— (1974a) *Frame Analysis: An Essay on the Organization of Experience*, Boston, MA: Northeastern University Press.

—— (1974b [1959]) *The Presentation of Self in Everyday Life*, Harmondsworth: Penguin Books.

—— (1979) *Gender Advertisements*, London: Macmillan.

—— (1983) 'The interaction order', *American Sociological Review*, 48(1): 1–17.

—— (1989) 'On fieldwork', *Journal of Contemporary Ethnography*, 18: 123–32.

Gould, T. (1995) 'The unhappy performative', in A. Parker and E. Kosofsky Sedgwick (eds) *Performativity and Performance*, New York: Routledge.

Gouldner, A. (1971) *The Coming Crisis of Western Sociology*, London: Heinemann.

Kosofsky Sedgwick, E. (1990) *The Epistemology of the Closet*, Berkeley, CA: University of California Press.

Lemert, C. (1997) 'Goffman', in C. Lemert and A. Branaman (eds) *The Goffman Reader*, Malden, MA: Blackwell.

Levy, A. (2005) *Female Chauvinist Pigs: Women and the Rise of Raunch Culture*, New York: Free Press.

Lyotard, J. F. (2005) *The Postmodern Condition: A Report on Knowledge*, trans. G. Bennington and B. Massumi, Manchester: Manchester University Press.

McKenzie, J. (2006) 'Performance and globalization', in D. S. Madison and J. Hamera (eds) *The Sage Handbook of Performance Studies*, London: Sage.

Madison, D. S. and Hamera, J. (2006) 'Performance studies at the intersections', in D. S. Madison and J. Hamera (eds) *The Sage Handbook of Performance Studies*, London: Sage.

Manning, P. (1991) 'Drama as life: the significance of Goffman's changing use of the theatrical metaphor', *Sociological Theory*, 9(1): 70–86.

Nussbaum, M. C. (1999) 'The professor of parody', *New Republic*, 220(8): 37–45.

Phelan, P. (1998) 'Introduction: the ends of performance', in P. Phelan and J. Lane (eds) *The Ends of Performance*, New York: New York University Press.

Phelan, P. and Lane, J. (1998) *The Ends of Performance*, New York: New York University Press.

Salih, S. (2002) *Judith Butler*, London: Routledge.

Schechner, R. (1966) 'Approaches to theory/criticism', *Tulane Drama Review*, 10(4): 20–53.

—— (2006) *Performance Studies: An Introduction*, 2nd edn, New York: Routledge.

Sennett, R. (1973) 'Two in the aisle', *New York Review of Books*, 20(1): 29–31.

Sharrock, W. W. (1976) 'Review of *Frame Analysis*', *Sociology*, 10(3): 32–34.

Striff, E. (ed.) (2003) *Performance Studies*, New York: Palgrave Macmillan.

Tseëlon, E. (1992) 'Is the presented self sincere? Goffman, impression management, and the postmodern self', *Theory, Culture and Society*, 9(2): 115–28.

Turner, J. H. (1988) *A Theory of Social Interaction*, Stanford, CA: Stanford University Press.

Turner, V. (1982) *From Ritual to Theatre: The Human Seriousness of Play*, New York: PAJ Publications.

West, C. and Zimmerman, D. H. (1987) 'Doing gender', *Gender and Society*, 1(2): 125–51.

Index

Note: page numbers in italic type refer to Figures.